W9-CEV-968

# PICASSO
# IN THE COLLECTION OF
# THE MUSEUM OF MODERN ART

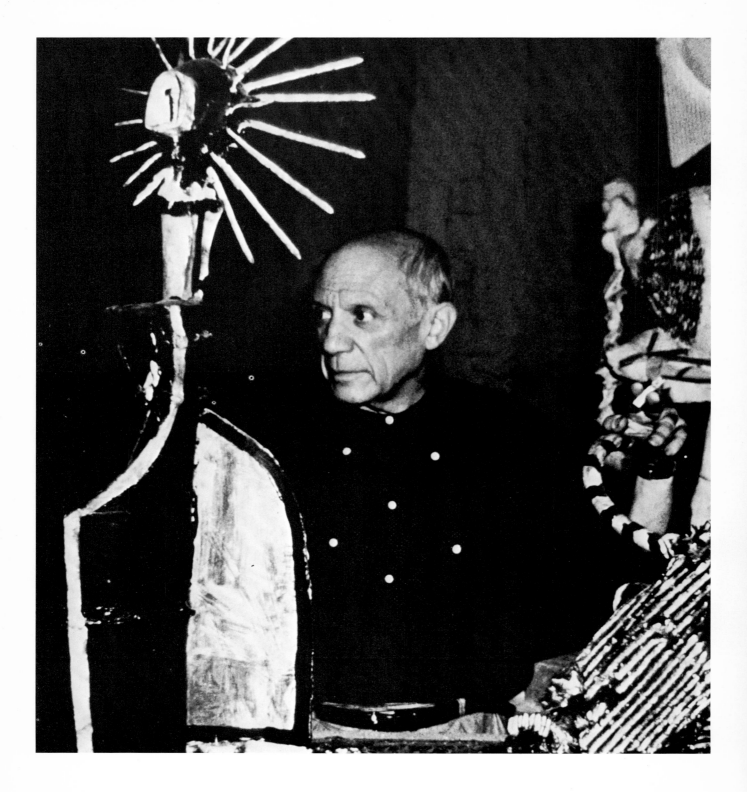

# PICASSO

## IN THE COLLECTION OF
## THE MUSEUM OF MODERN ART

*including remainder-interest and promised gifts*

WILLIAM RUBIN

*with additional texts by Elaine L. Johnson and Riva Castleman*

*Distributed by New York Graphic Society Ltd., Greenwich, Connecticut*

THE MUSEUM OF MODERN ART, NEW YORK

Copyright © 1972 by The Museum of Modern Art

All rights reserved

Library of Congress Catalog Card Number 70-164877

Cloth Binding ISBN 0-87070-537-7

Paperbound ISBN 0-87070-538-5

Designed by Carl Laanes

Type set by Boro Typographers, Inc., New York, New York

Printed and bound by Von Hoffmann Press, Inc., St. Louis, Missouri

The Museum of Modern Art

11 West 53 Street, New York, New York 10019

Printed in the United States of America

*frontispiece:* Picasso with *Goat, Skull and Bottle* (p. 177).

Vallauris, 1954

# CONTENTS

# LIST OF ILLUSTRATIONS

Page numbers marked with an asterisk indicate works reproduced in color.

Picasso in his Studio at Royan with Jaime Sabartés.
On the easel: *Woman Dressing Her Hair*, 1940 (p. 159)

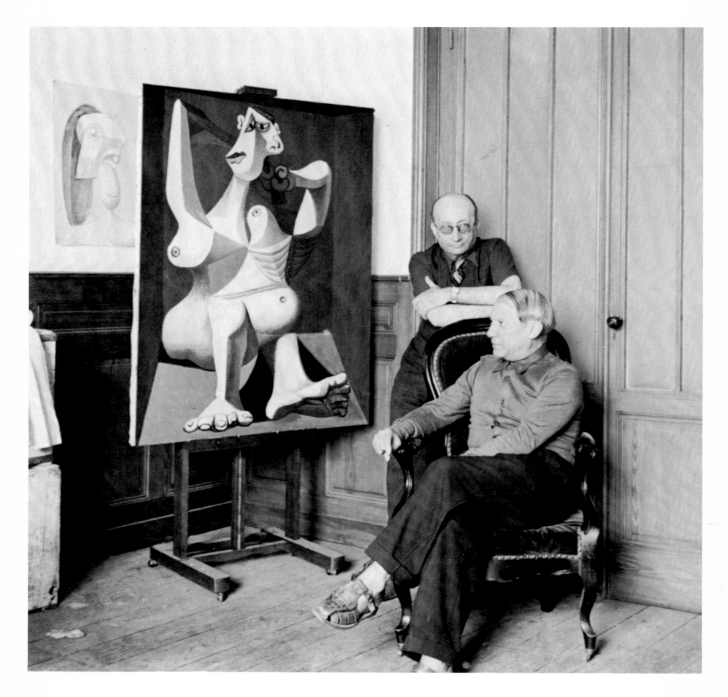

# PREFACE

THIS BOOK, part of a continuing program of publications on aspects of the Museum Collection, is issued in honor of Pablo Picasso's 90th birthday. The paintings and sculptures included in it are either already at the Museum, or fall into the categories of remainder-interest gifts (works that are the property of the institution but remain with the donors for their lifetimes) or promised gifts (works that have been formally committed as future gifts and bequests). The entire group of works, which constitutes by far the most complete and important public collection of Picasso's art, boasts a number of his unique and unrivaled masterpieces, and offers a virtually step-by-step revelation of the development of his Cubism.

The formation of this group of eighty-four paintings and sculptures is the fruit of the efforts of many curators and of the generosity of many trustees and friends of the Museum Collection. But above all, it is a testimony to the connoisseurship, devotion and persuasiveness of Alfred H. Barr, Jr., first Director of the Museum, and later, Director of Museum Collections, until his retirement in 1967. Mr. Barr was often aided by James Thrall Soby, who served the Museum in many capacities including Director of Painting and Sculpture and Chairman of the trustee Committee on the Museum Collections, and by James Johnson Sweeney in the years 1945–46 when he was Director of Painting and Sculpture. René d'Harnoncourt, Director of the Museum from 1949 to 1968, lent special support to projects concerning Picasso's sculpture. Yet if the quality, range and depth of the Museum's Picasso collection is a fitting tribute to Mr. Barr's efforts, the fact that even this large group of works still leaves a number of significant aspects of the artist's explorations unrepresented is an equal tribute to Picasso's astonishing variety.

The lacunae in the Museum's Picasso collection do not exist for want of having tried to fill them. (Indeed, in many cases the specific work that has been sought is one with which Picasso has never wished to part.) But the effort to fill out the collection goes on, and one of this author's greatest pleasures in his four years at the Museum has been the continuing exchange of ideas with Mr. Barr in relation to these possibilities as they arise.

THE FIRST PICASSO TO COME into the Museum Collection was the gouache *Head* of 1909 (p. 59), given by Mrs. Saidie A. May in 1930, the second year of the Museum's existence. Picasso's *Green Still Life* of 1914 (p. 94) came to the Museum in 1934 as a part of the magnificent bequest of Lillie P. Bliss, a Founder of the Museum and its Vice-President at the time of her death in 1931. The next year a third Picasso, *The Studio*, 1927–28 (p. 129), was accessioned; it was the gift of Walter P. Chrysler, Jr., a member of the Museum's newly formed Advisory Committee. The fund provided by that committee made possible the acquisition in 1937 of three more Picassos, *Man with a Hat*, 1912 (p. 78), *Guitar and Fruit*, 1927, and *Seated Woman*, 1926–27. Over the years the latter two were sold, funds from the sale of *Seated Woman* being used in 1964 for the purchase of *Studio with Plaster Head*, 1925 (p. 121).

In 1938 Mrs. Simon Guggenheim established a purchase fund that was continuously replenished until her death in 1969 and that over the years made possible some of the Museum's most important painting and sculpture acquisitions. *Girl before a Mirror*, 1932 (p. 139), had been selected for the Museum by Mr. Barr late in 1937; purchased early the next year, it became the first of the Guggenheim Fund acquisitions. In 1939 *Les Demoiselles d'Avignon*, 1907 (p. 41), was acquired essentially by exchange. Its asking price was largely accounted for by a trade of a minor Degas from the Lillie P. Bliss Bequest (the remainder having been a contribution by two art dealers who preferred to remain anonymous). In that same year, one of Picasso's most important Surrealist drawings, *Two Figures on the Beach*, 1933 (p. 141), was purchased with funds from an anonymous donor.

During the war years three important Cubist pictures were accessioned. In 1944 *Fruit Dish*, 1909 (p. 55), was acquired with funds realized through the sale of works in the Bliss Bequest, and the following year *"Ma Jolie,"* 1911–12 (p. 69), and *Card Player*, 1913–14 (p. 87), were acquired by the same method. At the time of the publication of Mr. Barr's *Picasso: Fifty Years of His Art* in 1946, the Museum owned twelve paintings by Picasso, in addition to one sculpture (*Woman's Head*, 1909, p. 61),

one collage (*Man with a Hat*, 1912, p. 78), and one gouache—the Saidie A. May gift that had initiated the Picasso collection.

Toward the end of the decade the pace of Picasso acquisitions accelerated. In 1949, *Three Musicians*, 1921 (p. 113), which had been on extended loan, was finally purchased, followed the next year by *Harlequin*, 1915 (p. 99), and *Seated Bather*, 1930 (p. 133), and in 1951 by *Still Life with Liqueur Bottle*, 1909 (p. 63), and *Sleeping Peasants*, 1919 (p. 109), the last acquired through the Abby Aldrich Rockefeller Fund. In 1952, *Pierrot*, 1918 (p. 102), came to the Museum in the bequest of Sam A. Lewisohn, and *Three Women at the Spring*, 1921 (p. 115), was given to the Collection by Mr. and Mrs. Allan D. Emil, while *Night Fishing at Antibes*, 1939 (p. 157), was acquired through the Guggenheim Fund. In 1955, A. Conger Goodyear gave the monumental collage-painting *Guitar*, 1919 (p. 105). Meanwhile, a number of important Picasso drawings, watercolors and collages had been given to the Collection by Mrs. Stanley Resor, Sam Salz, Mr. and Mrs. Daniel Saidenberg, and Mr. and Mrs. Werner E. Josten.

The next large infusion of Picassos into the Museum Collection took place in 1956 with donations of five works (including *Glass of Absinth*, 1914, p. 95, and *Pregnant Woman*, 1950, p. 173, both gifts of Mrs. Bertram Smith) and purchases of five others (including *Baboon and Young*, 1951, p. 175). In 1958, following the death of Philip L. Goodwin, an architect (with Edward Durrell Stone and, later, Philip Johnson) of the Museum, and Vice-Chairman of the Board, the Collection received a group of works including Picasso's *The Rape*, 1920 (p. 111).

Before the opening in October 1958 of the exhibition *Works of Art: Given and Promised*, the Museum Collection included thirty-seven paintings and sculptures by Picasso. The nine Picassos in *Given and Promised* included *Two Acrobats with a Dog*, 1905 (p. 32), promised gift of Mr. and Mrs. William A. M. Burden; *Boy Leading a Horse*, 1905–06 (p. 35), promised gift of William S. Paley; *Two Nudes*, 1906 (p. 39), promised gift of G. David Thompson; and *Girl with a Mandolin*, 1910 (p. 67) and *Interior with a Girl Drawing*, 1935 (p. 147), both promised gifts of Nelson A. Rockefeller. It also included *Seated Woman*, 1927 (p. 125), a promised gift of Mr. Soby, whose entire collection, comprising forty-eight paintings and ten sculptures (including two other paintings by Picasso), was pledged to the Museum in February 1961.

In the early 1960s, Picasso acquisitions included five works on paper from the John S. Newberry Collection; *Violin and Grapes*, 1912 (p. 77), a bequest of Mrs. David M. Levy; and the *Vase of Flowers*, 1907 (p. 45), a remainder-interest gift of Mr. and Mrs. Ralph F. Colin. Then, in 1967, Sidney Janis, on behalf of his late wife Harriet and himself, gave the Museum his entire private collection of some one hundred works, which included four Picassos, among them the monumental *Painter and Model*, 1928 (p. 131).

Since the retirement of Mr. Barr, two major groups of promised gifts have been added to the Museum's Picassos. The first consists of seven Cubist paintings—the Museum's choice from among those in the estate of Gertrude Stein. This gift was the result of the initiative of Bates Lowry, then Director of the Museum, at whose suggestion a group of trustees and friends—David Rockefeller, Governor Rockefeller, John Hay Whitney, Mr. Paley and Mr. André Meyer—purchased the estate and pledged to bequeath at least one painting each to the Collection. (These commitments were in addition to other important outright and promised gifts, some of them Picassos, which the same donors had already made.)

The second major group of promised gifts, also seven Picassos—including *Woman Combing Her Hair*, 1906 (p. 37), *Woman with Pears*, 1909 (p. 60), and *Girl Reading*, 1934 (p. 144)—came from the Florene May Schoenborn and Samuel A. Marx Collection. During the lifetime of Mr. Marx, the Museum received from him and his wife, Florene, Matisse's great *Moroccans* and González' *Torso*. Following Mr. Marx's death in 1964, the Museum received title, in the form of remainder-interest gifts, to three other major Matisses, and later, in 1967, was promised a Braque, a Bonnard and a Léger. In 1965–66, the Marx-Schoenborn Collection was exhibited under the rubric *The School of Paris*; and in January 1971, William S. Lieberman, Director of Painting and Sculpture, formally announced to the Board that eighteen other works, including the seven Picassos, were to be bequeathed to the Museum by Florene Marx Schoenborn.

The Drawings Collection of the Museum was the recipient of a munificent bequest of 267 drawings from the collection of Joan and Lester A. Avnet following Mr. Avnet's death in 1970. Mr. Avnet's bequest of superb nineteenth- and twentieth-century drawings, including

six works by Picasso, followed a number of generous gifts made during his lifetime.

The most recent additions to the Museum's Picasso collection, all made within the last year, have been *Repose*, 1908 (p. 47), *The Charnel House*, 1944–45 (p. 167), both acquired by exchange, and *Guitar*, 1912, generously donated by the artist—the only metal construction sculpture of the Cubist period with which he has ever parted.

PERHAPS THE ONLY RATIONALE for yet another book on Picasso is that paradoxically little art history or criticism deals with his individual works. There is a virtual library of publications on Picasso; but after discounting the non-books, ceremonial objects and purely documentary (though invaluable) catalogs and photo albums, only the merest fraction of the serious writing that remains touches on individual works of art except in passing. Nevertheless, it was with some trepidation that I undertook this catalog, and not a little of my commitment to see it through stemmed from the encouragement of Alfred Barr. His great book *Picasso: Fifty Years of His Art* remains today, a quarter of a century after its publication, *the* standard general reference on the artist. It was, indeed, Mr. Barr's reminder to me that *Picasso: Fifty Years of His Art* contains little material on many works now in the Museum's Collection that helped convince me of the value of doing this text. He had urged that I write the entire book from tabula rasa, but given Mr. Barr's scholarship and the lapidary quality of his prose, it seemed to me unnecessary, even presumptuous, to deal with works for which texts of substantial length were to be found in *Picasso: Fifty Years of His Art*—as was the case, for example, with *Les Demoiselles d'Avignon*. This text of Mr. Barr's, along with passages on *Le Chef-d'oeuvre inconnu*, *Minotauromachy* and *Dream and Lie of Franco*, have therefore been reprinted here with his permission. In none of these cases has scholarship of the last twenty-five years rendered his texts obsolete. Except for the addition to the notes on *Les Demoiselles d'Avignon* of a brief discussion of publications after 1946 (p. 195), Mr. Barr's texts have been reprinted unchanged, and with his own notes. It is a pleasure in this way to salute a book on which a generation of art historians and critics was raised and nourished.

IN THE FIVE MONTHS during which this book was in preparation, I had the good fortune to spend a number of evenings with Picasso and to go through old and new work in his studio. Picasso dislikes being interrogated about his own work, but he speaks frequently, and very movingly, about art in general—and about the work of other artists. When he does speak of his own painting, it is rarely about individual works. Like most artists, he has no interest in delimiting the poetry of his iconography by explicating it verbally.

Picasso has never submitted to a formal interview on his work by a critic or scholar. Most of the first-hand remarks and information we possess on individual works —altogether comparatively little—has come from the records of casual conversations with a number of his friends, notably Daniel-Henry Kahnweiler, Brassaï, Roland Penrose and Hélène Parmelin. All Picasso quotations regarding individual pictures from whatever source must therefore be understood to involve some paraphrasing inasmuch as 1) the only two statements the artist has ever expressly approved are general in character, and 2) one does not take notes or use any form of recording device while conversing with Picasso. I have permitted myself only one direct quotation from my conversations with him (p. 72), my wife and I having separately determined to remember and write down those few sentences, and having found virtually no difference in our respective recollections.

Despite Picasso's dislike of interrogation, a circumstance arose that made it possible to pose in passing a number of questions regarding the reading of particular pictures: on the occasion of one visit, I had brought Picasso a provisional mock-up of this catalog, which interested him considerably. As he slowly leafed through the plates, musing about the pictures, we chatted, and he good-naturedly answered a number of my queries. Needless to say, these were far fewer than I should have liked to pose—and not necessarily the most important.

IN ADDITION TO MR. BARR, to whom I am indebted for his encouragement, and for permission to reprint certain of his texts, I want to express my gratitude to my co-authors. Elaine L. Johnson, former Associate Curator in charge of Drawings, has contributed texts on a number of the drawings (excepting those I have treated in conjunction with paintings). Riva Castleman, Associate Curator in charge of Prints, has contributed texts on a number of the etchings and lithographs. (While all paintings, sculptures and drawings in the Museum Collection are reproduced, only

a selection of the most important prints could be incorporated.)

All texts by authors other than myself are signed. The notes and the reference photographs for each work appear under the full catalog entry in the back of the book. The page number of that full entry is given at the end of the short caption that accompanies the reproduction of each work.

So many people have been of help to me in the preparation of this catalog that I can hardly hope to do them all justice. Professor Robert Rosenblum, my friend and colleague at the Institute of Fine Arts, New York University, gave the manuscript a careful and concentrated reading, and discussed its particulars with me at length; I owe him a great debt of gratitude for his encouragement, and for the many valuable suggestions and constructive criticisms he made. Betsy Jones, Associate Curator of the Painting and Sculpture Collection, also graciously consented to read the manuscript, and made helpful suggestions. Picasso's friend and biographer Roland Penrose, his long-time friend and dealer Daniel-Henry Kahnweiler and M. Kahnweiler's associate, Maurice Jardot, have all been extremely helpful in answering queries.

Carl Morse, Managing Editor of the Department of Publications, put immense effort into this book and made numerous excellent suggestions that I have incorporated. The same is true of Carolyn Lanchner, Researcher of the Collection. Both of them worked evenings and weekends, under tremendous pressure, to help get out this catalog in the very short period allotted for it. At no time did they lose their cheerfulness or interest in the project— which did much to sustain the author.

As always occurs during the preparation of such a catalog or exhibition, a heavy burden of duties and responsibilities materializes for my Assistant, Sharon Oswald. Her goodwill is matched only by her professionalism and hard work.

Finally, my special thanks go to Carl Laanes, who designed this book quickly and handsomely, despite a number of unusual problems arising from the format chosen; to Jack Doenias, who saw through the printing of the color plates and the general production of the catalog; and to Inga Forslund, who prepared the list of the Museum's Picasso publications.

*William Rubin*
*October 1971*

# EXHIBITIONS OF PICASSO'S WORK

## AT THE MUSEUM OF MODERN ART

THIS LIST INCLUDES all one-man exhibitions of Picasso at The Museum of Modern Art, as well as others in which a significant number of his works were included.

*Painting in Paris*, January 19 – February 16, 1930. 14 works. Directed by Alfred H. Barr, Jr.

*Memorial Exhibition / The Collection of the Late Miss Lizzie P. Bliss / Vice-President of the Museum*, May 17 – September 27, 1931. 9 works. Directed by Alfred H. Barr, Jr.

*Modern Works of Art: 5th Anniversary Exhibition*, November 20, 1934 – January 20, 1935. 10 works. Directed by Alfred H. Barr, Jr.

*Cubism and Abstract Art*, March 2 – April 19, 1936. 29 works. Directed by Alfred H. Barr, Jr.

*Modern Painters and Sculptors as Illustrators*, April 27 – September 2, 1936. 8 illustrated books. Directed by Monroe Wheeler.

*Fantastic Art, Dada, Surrealism*, December 7, 1936 – January 17, 1937. 13 works. Directed by Alfred H. Barr, Jr.

*Art in Our Time: 10th Anniversary Exhibition*, May 10 – September 30, 1939. 11 works. Painting and Sculpture section directed by Alfred H. Barr, Jr.

*Picasso: Forty Years of His Art*, November 15, 1939 – January 7, 1940. Directed by Alfred H. Barr, Jr. 294 oils, watercolors, gouaches and drawings, 7 collages, 11 sculptures and constructions, and 49 prints.

*Twentieth Century Portraits*, December 9, 1942 – January 24, 1943. 9 works. Directed by Monroe Wheeler.

*Modern Drawings*, February 16 – May 10, 1944. 27 works. Directed by Monroe Wheeler.

*Art in Progress: 15th Anniversary Exhibition*, May 24 – October 15, 1944. 8 works. Painting and Sculpture section directed by James Thrall Soby.

*The Museum Collection of Painting and Sculpture*, June 20, 1945 – January 13, 1946. 13 works. Directed by Alfred H. Barr, Jr.

*Collage*, September 21 – December 5, 1948. 20 works. Directed by Alfred H. Barr, Jr.

*Picasso. The Sculptor's Studio*, January 24 – March 19, 1950. 40 etchings. Directed by William S. Lieberman.

*Masterworks Acquired through the Mrs. Simon Guggenheim Fund*, January 29 – March 23, 1952. 5 works. Directed by Alfred H. Barr, Jr.

*Picasso: His Graphic Art*, February 14 – April 20, 1952. 140 prints and 13 illustrated books. Directed by William S. Lieberman.

*Sculpture of the Twentieth Century*, April 29 – September 7, 1953. 4 works. Directed by Andrew Carnduff Ritchie.

*Paintings from the Museum Collection: xxvth Anniversary Exhibition*, October 19, 1954 – February 6, 1955. 21 works. Installed by Alfred H. Barr, Jr. and Dorothy C. Miller.

*Picasso 75th Anniversary Exhibition*, May 22 – September 8, 1957. 149 oils, watercolors, gouaches and drawings, 11 collages, and 11 sculptures and constructions. Directed by Alfred H. Barr, Jr.

*Works of Art: Given or Promised* and the *Philip L. Goodwin Collection*, October 8 – November 9, 1958. 10 works. Directed by Alfred H. Barr, Jr.

*80th Birthday Exhibition – Picasso – The Museum Collection – Present and Future*, May 14 – September 18, 1962. 80 paintings, sculptures, drawings and collages, 97 prints and 5 illustrated books. Directed by Alfred H. Barr, Jr., Dorothy C. Miller and William S. Lieberman.

*The School of Paris: Paintings from the Florene May Schoenborn and Samuel A. Marx Collection*, November 2, 1965 – January 2, 1966. 14 works. Directed by Monroe Wheeler, installed by Alicia Legg.

*The Sculpture of Picasso*, October 11, 1967 – January 1, 1968. 202 sculptures and constructions, 32 ceramics, 15 drawings and collages, and 24 prints. Selected by Roland Penrose, installed by René d'Harnoncourt.

*Prints by Picasso: A Selection from 60 Years*. October 11, 1967 – January 1, 1968. 50 prints. Directed by William S. Lieberman.

*The Sidney and Harriet Janis Collection*, January 17 – March 4, 1968. 4 works. Installed by Alfred H. Barr, Jr., with Dorothy C. Miller.

*Dada, Surrealism and Their Heritage*, March 27 – June 9, 1968. 12 works. Directed by William S. Rubin.

*Twentieth Century Art from the Nelson Aldrich Rockefeller Collection*, May 26 – September 1, 1969. 26 works. Directed by Dorothy C. Miller.

*Picasso: Master Printmaker*, October 15 – November 29, 1970. 528 prints and 25 books. Directed by Riva Castleman.

*Four Americans in Paris: The Collection of Gertrude Stein and Her Family*, December 19, 1970 – March 1, 1971. 108 works. Directed by Margaret Potter, installed by William S. Lieberman.

*Picasso: Forty Years of His Art*, November 15, 1939 – January 7, 1940

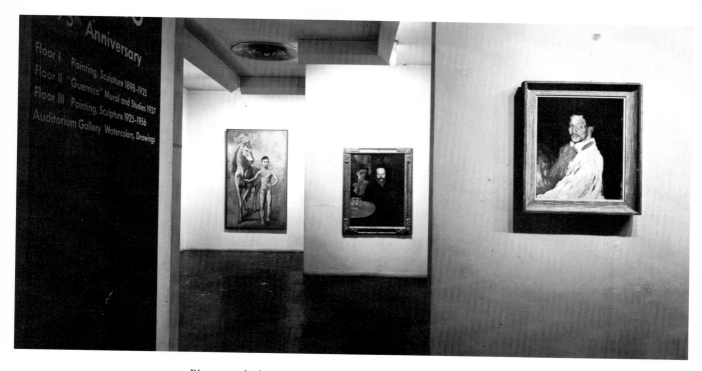

*Picasso 75th Anniversary Exhibition,* May 22 – September 8, 1957

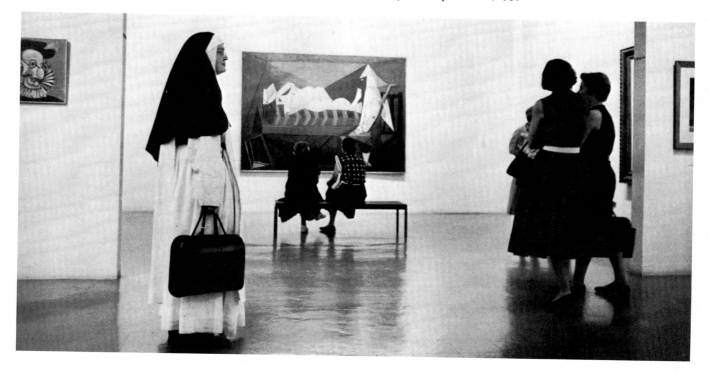

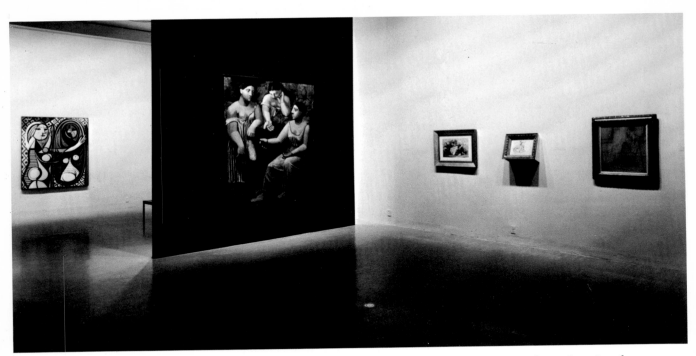

*80th Birthday Exhibition – Picasso – The Museum Collection – Present and Future,* May 14 – September 18, 1962

*The Sculpture of Picasso,* October 11, 1967 – January 1, 1968

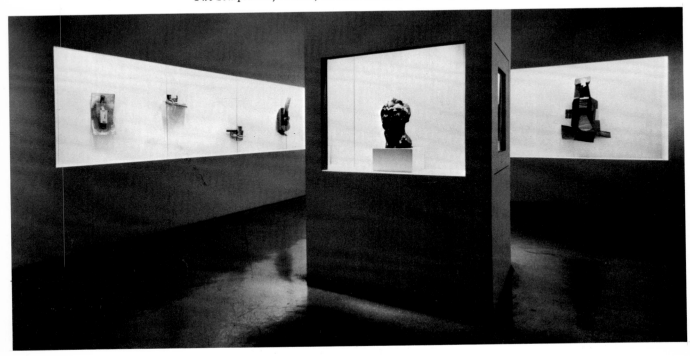

*The Sculpture of Picasso,* October 11, 1967 – January 1, 1968
*Picasso: Master Printmaker,* October 15 – November 29, 1970

Picasso and his wife, Jacqueline

# PUBLICATIONS ON PICASSO
## ISSUED BY THE MUSEUM OF MODERN ART

### MONOGRAPHS

*Picasso: Forty Years of His Art*. Edited by Alfred H. Barr, Jr. 1939. 207 pp., 214 ills. (1 col.)
    Two statements by the artist and bibliography. Includes catalog of exhibition, Nov. 15, 1939 – Jan. 7, 1940, organized in collaboration with the Art Institute of Chicago.
    Three revised editions published, 1939–41.

*Picasso: Fifty Years of His Art*. By Alfred H. Barr, Jr. 1946. 314 pp., ills. (7 col.)
    Based on *Picasso: Forty Years of His Art*, with new and greatly amplified text. Statements by the artist; extensive bibliography.
    Second edition, 1955. Also, reprint edition by Arno Press, New York, 1966 (ills. only in black and white).

*Symposium on "Guernica."* Nov. 25, 1947. 80 leaves. Typed transcript
    Contents: Opening remarks by Alfred H. Barr, Jr., Chairman; Remarks by José L. Sert, Jerome Seckler, Juan Larrea, Jacques Lipchitz, and Stuart Davis; and general discussion.

*Photographs of Picasso*. By Gjon Mili and Robert Capa. 1950. [20] pp. (mostly ills.)
    Installation shots by Mili and Capa and statements by Steichen, Mili and Capa from wall labels for the exhibition, Jan. 24 – Mar. 19, 1950.

*The Sculptor's Studio: Etchings by Picasso*. With an introduction by William S. Lieberman. 1952. 4 pp. plus 24 plates
    A series of etchings from the collection of the Abby Aldrich Rockefeller Print Room of The Museum of Modern Art.

*Picasso: 75th Anniversary Exhibition*. Edited by Alfred H. Barr, Jr. 1957. 115 pp., ills. (pt. col.)
    Catalog of exhibition, May 22 – Sept. 8, 1957.

*Portrait of Picasso*. By Roland Penrose. 1957. 96 pp., ills.
    Based on material collected for the exhibition "Picasso himself," organized by Penrose for the Institute of Contemporary Arts of London, 1956, and amended in connection with the exhibition at The Museum of Modern Art, May – Sept. 1957.
    Second revised and enlarged edition, 1971. 128 pp., 330 ills. (6 col.).

*The Sculpture of Picasso*. By Roland Penrose. 1967. 231 pp., ills.
    Chronology and bibliography. Includes catalog of the exhibition, Oct. 11, 1967 – Jan. 1, 1968.

*Gertrude Stein on Picasso*. Edited by Edward Burns. 1970. [138] pp., ills. (pt. col.)
    Commentaries on Picasso, taken from the writings and notebooks of Gertrude Stein, and illustrated with photographs and works from the Stein collection.
    Published in cooperation with Liveright, New York.

### ARTICLES ON PICASSO

"Picasso 1940–1944." A digest with notes by Alfred H. Barr, Jr.
    In *The Museum of Modern Art Bulletin*, XII, 3, Jan. 1945, pp. 1–9, ills.
Postscripts in XII, 4, Spring 1945, p. 15.

"Picasso at work, August 1944." By John Groth
    In *The Museum of Modern Art Bulletin*, XII, 3, Jan. 1945, pp. 10–11, ills.

"Picasso: his graphic art." By William S. Lieberman
    In *The Museum of Modern Art Bulletin*, XIX, 2, Winter 1952, pp. 1–17, ills.
On the occasion of the exhibition, Feb. 14 – Apr. 20, 1952. Includes checklist of the exhibition.

"Picasso as sculptor." Statements by Julio González
    In *The Museum of Modern Art Bulletin*, XXIII, 1–2, 1955–56, pp. 43–44.

"Works of Art: Given or Promised." By Alfred H. Barr, Jr.
    Commentaries on nine major works by Picasso. In *The Museum of Modern Art Bulletin*, XXVI, 1, Fall 1958, pp. 34–43, 9 ills.
In connection with the exhibition, Oct. 8 – Nov. 9, 1958. Also published in the catalog of the exhibition.

### GENERAL BOOKS AND CATALOGS

*Painting in Paris from American Collections*. Edited by Alfred H. Barr, Jr. 1930. pp. 36–38. 5 ills. of Picasso's work
    Catalog of exhibition, Jan. 19 – Feb. 16, 1930.

*Memorial Exhibition. The Collection of the Late Miss Lizzie P. Bliss*. 1931. pp. 32–33. 2 ills. of Picasso's work
    Catalog of exhibition, May 17 – Sept. 27, 1931.

*International Exhibition of Theatre Art*. 1934. pp. 53–54. 2 ills. of Picasso's work
    Includes catalog of exhibition, Jan. 16 – Feb. 26, 1934.

*The Lillie P. Bliss Collection.* Edited by Alfred H. Barr, Jr. 1934. pp. 56–58, 81–83. 4 ills. of Picasso's work
   Catalog of exhibition, May 14 – Sept. 12, 1934.

*Modern Works of Art.* Fifth anniversary exhibition. Edited by Alfred H. Barr, Jr. 1934. pp. 32–33. 8 ills. of Picasso's work
   Includes catalog of exhibition, Nov. 20, 1934 – Jan. 20, 1935.

*Cubism and Abstract Art.* By Alfred H. Barr, Jr. 1936. pp. 29–42, 78–92, 96–111, 219–221. 26 ills. of Picasso's work
   Includes catalog of exhibition, Mar. 2 – Apr. 19, 1936. Reprint edition by Arno Press, New York, 1966.

*Modern Painters and Sculptors As Illustrators.* By Monroe Wheeler. 1936. pp. 67–71. 5 ills. of Picasso's work
   Includes catalog of exhibition, Apr. 27 – Sept. 2, 1936.
   Third revised edition, 1946. pp. 65–71. 7 ills. of Picasso's work.

*Fantastic Art, Dada, Surrealism.* Edited by Alfred H. Barr, Jr. 1936. pp. 216–217 and passim. 9 ills. of Picasso's work
   Includes catalog of exhibition, Dec. 7, 1936 – Jan. 17, 1937.
   Second revised edition, 1937, and third revised edition, 1947, contain essays by Georges Hugnet.

*Art in Our Time.* An exhibition to celebrate the tenth anniversary of The Museum of Modern Art and the opening of its new building, held at the time of the New York World's Fair. 1939. passim. 11 ills. of Picasso's work
   Catalog of the exhibition, May 10 – Sept. 30, 1939.

*Painting and Sculpture in The Museum of Modern Art.* Edited by Alfred H. Barr, Jr. 1942. pp. 66–69. 7 ills. of Picasso's work
   Supplement edited by James Johnson Sweeney. 1945. p. 12. 1 ill. of Picasso's work.
   —— ——. 1948. pp. 57–58, 84–85 and passim. 16 ills. of Picasso's work.
   —— ——. 1958. pp. 48–49.
   The above catalogs of the Museum's collection are supplemented by publications entitled "Painting and Sculpture Acquisitions," which appeared as Bulletins at various intervals.

*20th Century Portraits.* By Monroe Wheeler. 1942. pp. 13 and passim. 8 ills. of Picasso's work
   Includes catalog of exhibition, Dec. 9, 1942 – Jan. 24, 1943.

*What Is Modern Painting?* By Alfred H. Barr, Jr. 1943. pp. 20, 26–29, 36–38. 3 ills. of Picasso's work. (Introductory series to the modern arts. 2)
   Last revised edition (7th), 1959. Also editions in Spanish and Portuguese, 1953.

*Modern drawings.* Edited by Monroe Wheeler. 1944. p. 13 and passim. 11 ills. of Picasso's work
   Includes catalog of exhibition, Feb. 16 – May 10, 1944. Second revised edition, 1945.

*Art in Progress.* A survey prepared for the fifteenth anniversary of The Museum of Modern Art, New York. 1944. pp. 66–69 and passim. 6 ills. of Picasso's work
   Includes catalog of the exhibition May 24 – Oct. 22, 1944.

*Sculpture of the Twentieth Century.* By Andrew Carnduff Ritchie. 1952. pp. 25–28, 29, 31–32, 231. 13 ills. of Picasso's work
   Published on the occasion of the exhibition 1952–53 at the Philadelphia Museum of Art, the Art Institute of Chicago and The Museum of Modern Art. Also a catalog published. 1952. 47 pp.

*Masters of Modern Art.* Edited by Alfred H. Barr, Jr. 1954. pp. 67–71, 80–83, 92–93, 97. 14 ills. (6 col.) of Picasso's work
   Second edition, 1955. Also foreign-language editions (French, Spanish, 1955; German, Swedish, 1956).

*The James Thrall Soby Collection of Works of Art Pledged or Given to The Museum of Modern Art.* 1961. pp. 62–63. 3 ills. (1 col.) of Picasso's work
   Catalog of exhibition at M. Knoedler & Co., Inc., New York, Feb. 1–25, 1961 (extended to Mar. 4). Catalog with notes by James Thrall Soby. Preface by Blanchette H. Rockefeller. "James Thrall Soby and his collection" by Alfred H. Barr, Jr.

*The School of Paris.* Paintings from the Florene May Schoenborn and Samuel A. Marx Collection. Preface by Alfred H. Barr, Jr. Introduction by James Thrall Soby. Notes by Lucy R. Lippard. 1965. pp. 16–29. 14 ills. (4 col.) of Picasso's work
   Catalog of exhibition, Nov. 2, 1965 – Jan. 2, 1966, in collaboration with the Art Institute of Chicago, City Art Museum of St. Louis, San Francisco Museum of Art, Museo de Arte Moderno, Mexico. All paintings in the collection reproduced.

*Dada, Surrealism, and Their Heritage.* By William S. Rubin. 1968. pp. 124–127, 240 and passim. 12 ills. of Picasso's work
   Includes catalog of the exhibition, Mar. 27 – June 9, 1968.

*Twentieth Century Art from the Nelson Aldrich Rockefeller Collection.* 1969. pp. 12–14 and passim. 13 ills. (3 col.) of Picasso's work
   Foreword by Monroe Wheeler. Preface by Nelson A. Rockefeller. "The Nelson Aldrich Rockefeller Collection" by William S. Lieberman, pp. 11–35. Includes catalog of exhibition, May 26 – Sept. 1, 1969.

*Four Americans in Paris.* The Collection of Gertrude Stein and Her Family. 1970. passim. 39 ills. (6 col.) of Picasso's work
   Partial content: "Matisse, Picasso and Gertrude Stein" by Leon Katz, pp. 51–64. "More adventures" by Leo Stein [recollections of Matisse and Picasso], pp. 96–98. "Portraits: Pablo Picasso" by Gertrude Stein, pp. 101–102.
   Includes catalog of exhibition, Dec. 19, 1970 – Mar. 1, 1971.

*(Compiled by Inga Forslund, Associate Librarian)*

Picasso with his long-time friend and dealer, Daniel-Henry Kahnweiler.
Mougins, summer 1965

# PICASSO
# IN THE COLLECTION OF
# THE MUSEUM OF MODERN ART

Picasso, April 1971

make it the earliest of these self-portraits. But the artist himself does not recall its having been in that show, and it was most likely painted during or after it.[2]

The picture is remarkable for the bravura of its execution—and Picasso's awareness of his astonishing talents surely contributed to the panache and self-assurance with which he presents himself. His mood may also reflect his satisfaction with external events, for though the Vollard exhibition has often been characterized as a failure—largely on the basis of Vollard's unreliable reminiscences —fifteen pictures were in fact sold even before the opening. In a highly laudatory review in *La Revue Blanche*, Félicien Fagus spoke of the "brilliant virility" of the pictures but warned that Picasso's "impetuous spontaneity" might "lead him into facile virtuosity." Indeed, it is hard to believe that these words were not ringing in Picasso's ears when, not long afterward, he adapted the consciously awkward contouring and facture of the early "Blue Period" pictures.

In *Self-Portrait: Yo Picasso* (p. 189:1), probably the picture exhibited at Vollard's, since it was the only other self-portrait painted in the spring of 1901, we see the artist at work. Here, nothing intervenes between us and the unrelenting immediacy of his presence. This directness is enhanced by the absolute frontality of the pose but depends even more on Picasso's penetrating gaze. His eyes were—and remain—his most remarkable physical attribute. Fernande Olivier, his companion from late 1904 until spring 1912, wrote of them as "dark, deep, piercing, strange, and almost staring."

Picasso has said that in 1901 Van Gogh exerted a greater influence on him than did any other artist. The Dutch painter's spirit may be manifest in the unguarded directness of *Self-Portrait*; but that influence is more readily apparent in the motor vigor of Picasso's brushwork—though he has substituted an angular, discontinuous contouring for Van Gogh's curvilinear patterning. Picasso's brushwork is particularly noteworthy in the rectilinear strokes of blue that determine the hairline of the forehead and the contour of the shock of hair that falls toward his right ear. A similar decisiveness is evident in the contouring of the neckline. These "sticks" of color are found in some paintings of the summer and fall of 1901, but they disappear with the development of the more tightly painted fabric of the Blue Period, to reemerge—transformed into a more systematic component of style—in such works of 1907 as the *Vase of Flowers* (page 45).

SELF-PORTRAIT. *Paris, late spring or summer 1901. Oil on cardboard, 20¼ x 12½ inches. (Full Catalog entry and Notes, p. 189)*

Although Picasso drew his own image not infrequently during his teens, the first painted self-portraits he seems to have completed date from 1901, probably just after the twenty-year-old artist arrived in May for his second sojourn in Paris.[1] This picture has sometimes been identified as the one in the catalog list for Picasso's exhibition at the Vollard Galleries in June of that year, which would

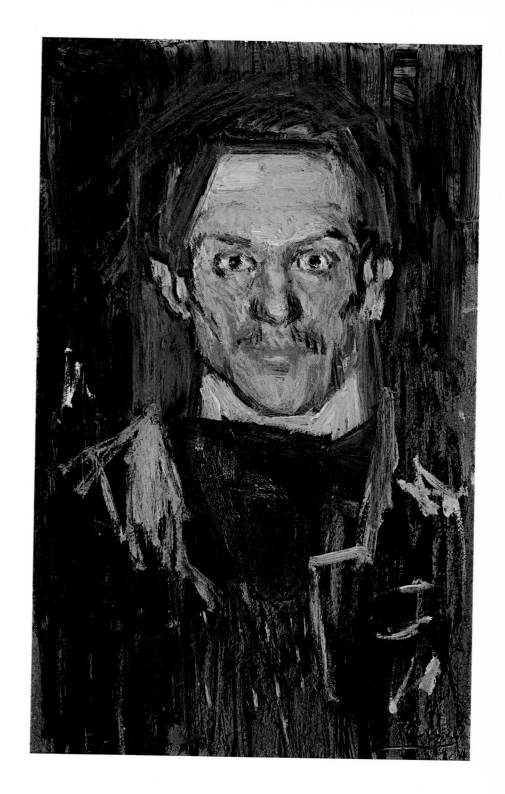

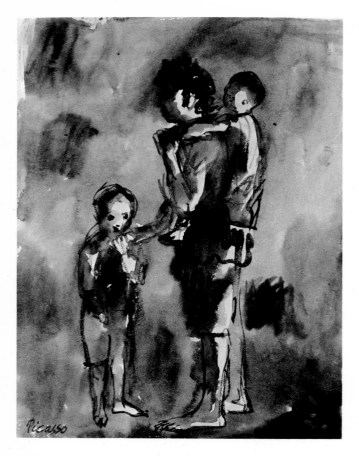

THREE CHILDREN (*verso of* BROODING WOMAN). *Paris,
1903–04. Watercolor, 14½ x 10⅜ inches. (C&N, p. 190)*

BROODING WOMAN. *Paris, 1904. Watercolor, 10⅜ x 14½
inches. (C&N, p. 190)*

Blue dominated Picasso's palette and hence the mood of
his subjects from the end of 1901 until late 1904. His
friend Jaime Sabartés recalled that "a mound of white in
the center [of the palette] constituted the base of a kind
of cement composed mainly of blue. The other colors
formed its border."

The use of a single hue to create a mood, a hue that
floods the picture and usurps the local colors of objects,
was essentially a Symbolist device. Thus it relates Picas-
so's work in these years to late nineteenth-century art
more than to contemporary explorations of color such as
in the work of the painters then gathering around Ma-
tisse, who were soon to be known as Fauves.

Whistler and later, near the turn of the century, Monet
had painted blue pictures which, like their other mono-
chrome works, evoke an ambience of isolation, emptiness
and reverie. These images approximated the moods of the
Symbolist poets, particularly of Verlaine (one of Picasso's
favorites), who in *L'Art poétique* called for an art of nu-
ance rather than color. A number of Cézanne's later pic-
tures, which were also painted in gradations of blue, have
affinities with Symbolist painting and even more closely
anticipate Picasso, insofar as some were portraits and
figure pictures while the Whistlers and Monets were
largely uninhabited landscapes.

Except for the appropriation of the basic Symbolist
device, however, the "Blue Period" paintings have little
in common with late nineteenth-century prototypes, for
Picasso associated the mood-color in a very literal way
with a particular cast of characters: lonely, suffering, pov-
erty-stricken outcasts from society (a subject matter fa-
vored by his Barcelona friend, Isidre Nonell, whose
studio Picasso had borrowed for a while just before 1900).
Beyond the humanitarian sentiments they imply, these
subjects have been considered symbols of Picasso's penu-
rious situation at the time; his sales had fallen sharply
after the Vollard exhibition, and mere survival had be-
come difficult. But the narrowing to these themes perhaps
represented as much an effort to define himself in terms
of a characteristic subject matter as it did a commentary
on the artist's place—or rather lack of place—in society.
To be personal, one had to be sincere; and in Picasso's im-
mediate circle, as Sabartés said, "sincerity... could not be
found apart from sorrow." Despite noble intentions,

however, it often happened, especially in Picasso's imagined compositions—as opposed to the portraits of his friends, which are firmer and more direct—that such sentiments spilled over into sentimentality.

*Brooding Woman* teeters on the edge of this distinction. The long face is unsubtle, and the arms and shoulder are manneristically attenuated to make a parallelogram around the head. The facial type—forehead and nose forming an almost unbroken line and lips pinched tight—appears early in 1902 and had already become familiar in Picasso's art. The shadow of the eye is handled so as virtually to make the figure appear blind, which reinforces the mood of dejection.

The obviousness in the presentation of the subject is compensated for in *Brooding Woman* by a delicacy and fluency in the facture that is uncommon in the Blue Period. This arises in part from the watercolor medium, which Picasso uses here most imaginatively (as in the blotting that divides the highlight of the cheek and the shadow of the jowl). Watercolor also produced an image that is free of the almost enameled surfaces and overemphatic contouring of many Blue Period oils; the blotting and staining on the right are so painterly as to be unreadable, though there are some hints of a figure—perhaps a café waiter or waitress.

*Brooding Woman* represents a stylistic extreme in Picasso's early explorations in mediums other than oil. The year 1904 was devoted largely to such studies; in that year, he executed only seven oil paintings as opposed to some twenty the year before.

SALOME. 1905. Drypoint, 15⅞ x 13¾ inches. (C&N, p. 190)

THE FRUGAL REPAST. 1904. Etching, 18³⁄₁₆ x 14¹³⁄₁₆ inches. (C&N, p. 190)

Two continuing themes, couples in cafés and the haunting solitude of the blind, are brought to ultimate refinement in the etching *The Frugal Repast*. In developing the first theme—couples seated at café tables—Picasso combined two poses used in other compositions: one in which the man is internalized, deep in his own thought, while the woman stares at the viewer—depicted in the paintings *The Two Saltimbanques* of 1901 (p. 190:4) and *The Couple in the Café* of 1903;[1] and the other in which one of the pair casually rests a sensitive, elongated hand on the companion's shoulder—as in *The Couple (Les Misérables)* of 1904[2] and in the lost painting *Pierrette's Wedding*[3] of the same year. The second theme, the portrayal of blindness, particularly the blind man as seen in profile, evolved from the softly delineated head in *The Blind Man's Meal* of 1903 (p. 190:5) into the increasingly defined and emaciated face in *The Frugal Repast*—and later into the even more withdrawn portrait of the acrobat in *The Acrobat and the Young Harlequin* of 1905.[4]

Whereas *The Two Saltimbanques* of 1901 reveals a lack of experience, *The Frugal Repast* is a mature work in which the visual contact made by the female with the viewer emphasizes the blindness of her companion. The artist, whose "eyes were magnificent,"[5] was aware of his gift, which accentuated for him the plight of the sightless and made them the vessels of his own sense of disorientation as he struggled to establish himself in Paris. A mannerism of the late "Blue Period" works, the nearly absolute frontality of both bodies, shoulders hunched in the shivering cold of poverty, also introduces an element of Spanish character into the composition. With their heads slightly inclined to one side or in brave profile, the two figures take the ritual stance of the bullfighter who faces the bull with his entire body, turning his head in dignified, courageous respect as the bull passes. It is this Spanish attitude that seems to transform this otherwise piteous situation into one of self-reliance and determination.

Until he moved into the Bateau Lavoir in April 1904 Picasso had made only one attempt at printmaking. In Barcelona in 1899, under the direction of his friend Ricardo Canals, he had made one etching depicting a bullfighter.[6] In 1904 Canals was also in Paris, and it is quite possible that he brought to Picasso the zinc plate, already used by another artist for a landscape, upon which *The*

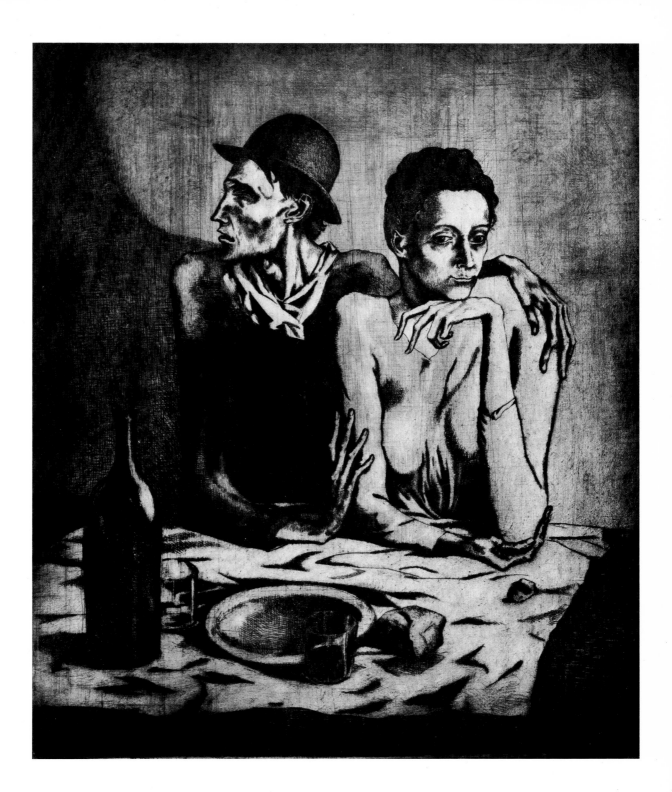

*Frugal Repast* was etched. It is more likely, however, that the plate for *The Frugal Repast* and those for fourteen other prints of 1905, some of which were done in time for an exhibition that opened in February 1905,[7] were from the shop of Eugène Delâtre, who printed the small editions of these prints for Clovis Sagot and Père Soulier.

The facility with which Picasso approaches new materials has always been cause for astonishment. Although only his second print, *The Frugal Repast* was a completely successful essay into the type of etching practiced in Paris at the turn of the century. While Delâtre was a specialist in color printing and could have taught Picasso the then popular color techniques, only one experimental proof in blue was taken of this major, late work of the Blue Period. Picasso did not involve himself in the complicated processes of color printing until the late 1930s.

The large edition of *The Frugal Repast* was printed from the steel-faced plate and published by Ambroise Vollard in 1913 together with thirteen prints of 1905 under the title *Les Saltimbanques*. Of the 1905 prints, the most ambitious is *Salome*. The figure of the portly *saltimbanque* seen in two other prints of the series and in the painting *Family of Saltimbanques* (p. 191:7) represents Herod, while Herodias, seated behind him, is the so-called "Woman of Majorca" seated in the right foreground of the same painting. Salome herself is an adolescent acrobat who may well have been the model for *Girl with a Basket of Flowers*.[8]   *(Riva Castleman)*

MEDITATION. *Paris, late 1904. Watercolor and pen, 13⅝ x 10⅛ inches. (C&N, p. 191)*

Toward the end of 1904, the gloom of the preceding years began to dissipate, and the transition to the "Rose Period" was signaled by a pair of lyrical flower pictures and by a variation on a theme that would recur frequently in Picasso's later art: the sleeper watched.

One of the earliest appearances of this motif, *Sleeping Nude* (p. 191:6)—probably executed several months before *Meditation*—suffers from the fitful bathos of the Blue Period. There, the emaciated male onlooker seems bowed down by the awareness of his inability to know or possess the sleeping woman. He is psychologically turned in upon himself, and his isolation is intensified by his location within a dark mass that is utterly circumscribed and apart from the lighter area of the nude—the "gloom of the mind and the light of the body."[1] That to which the voyeuristic anti-hero of the *Sleeping Nude* can only aspire has obviously been experienced by the watcher in *Meditation*, whom we recognize immediately as Picasso himself. Picasso's thoughts are not turned inward to his own feelings; rather he contemplates the mystery of his new love. Though dressed in blue, he inhabits a world now warmed with red and yellow.

The sleeping woman of *Meditation*, who seems almost to emanate a light of her own, is Fernande Olivier.[2] She met Picasso in the latter part of 1904, became his mistress some months afterward and played a crucial role in the change of mood that led to the Rose Period in the first months of 1905. In her memoirs Fernande tells us that during her first years with Picasso he did all his painting late at night so as not to be interrupted. The nonmanneristic mode in which the artist limned her and himself points to direct experience rather than to imagination as the starting point for this image. One may speculate that the *Sleeping Nude* was executed hard upon his first encounter with Fernande—the nude being Picasso's projection of desire, and the bathetic male an exaggerated personification of his feelings of deprivation. *Meditation*, then, would celebrate the consummation of this first major love relationship of the painter's life.

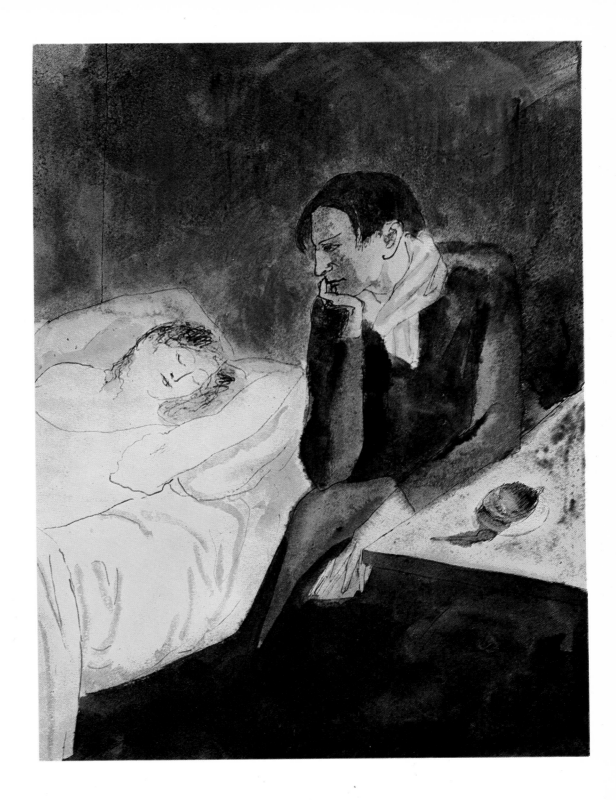

BOY LEADING A HORSE. *Paris, 1905–06. Oil on canvas, 86½ x 51¼ inches. (C&N, pp. 192–93)*

Late in 1905, Picasso began some studies of figures and horses, which at first reflected the ambience of the circus. Soon, however, the varied motifs combined in the artist's imagination to form an image that evoked a more remote world, pastoral and antique in spirit. The large work Picasso had in mind, *The Watering Place*, was never realized, though a gouache study for it exists (p. 192:10).[1] The monumental and superbly assured *Boy Leading a Horse* is a full-scale rendering of one of its central groups.

The classical, more sculptural turn that Picasso's art took late in 1905 was probably influenced by Cézanne, thirty-one of whose paintings had been exhibited in the Salon d'Automne of 1904 and ten more at that of 1905. The monumentality of the boy, whose determined stride possesses the earth, the elimination of anecdote, and the multiaccented, overlapping contouring all speak of the master of Aix.[2]

But Picasso had also been looking at Greek art in the Louvre, and under this influence he showed himself increasingly responsive to the kind of revelatory gesture that is the genius of classical sculpture. In the *Study for Boy Leading a Horse* in the Baltimore Museum of Art (p. 192:11), the youth directs the animal by placing his hand on its neck; but in later studies and in the final painting Picasso chose a gesture whose sheer authority—there are no reins—seems to compel the horse to follow. This "laureate gesture," as it has been called, draws attention by analogy to the power of the artist's hand.[3] Sculptures of idealized, striding male nudes were given as prizes to the winners of the ancient Olympics; that Picasso intended to allude to such laureates can be shown by tracing this very model back through *Girl on Horseback, and Boy* (p. 192:12) to *Boy with a Pipe* (p. 193:13), where his head is wreathed in flowers.

Picasso's interest in classicism at this time was probably stimulated by the views of Jean Moréas, a leader in the neoclassical literary movement that developed out of, but finally reacted against, Symbolism. Moréas was a regular, along with Apollinaire and Salmon, at the soirées that Picasso attended Tuesday evenings at the Closerie des Lilas. The painter's search for an antique image—as distinguished from his contemporary restatement of ancient themes such as the sleeper watched—may also have been stimulated by the painting of Puvis de Chavannes,[4] whose work was featured along with that of Cézanne in the Salon d'Automne of 1904. But in *Boy Leading a Horse* we see that Picasso's classical vision is imbued with a natural *areté* unvitiated by the nostalgia of Puvis' "rosewater Hellenism."[5]

In *Boy Leading a Horse* Picasso makes no concession to charm. The shift of emphasis from the sentimental to the plastic is heralded by a mutation of the Rose tonality into one of terra cotta and gray, which accords well with the sculpturelike character of the boy and horse. The pair is isolated in a kind of nonenvironment, which has been purged not only of anecdotal detail but of all cues to perspective space. The rear leg of the horse dissolves into the back plane of the picture, and the background is brought up close to the surface by the magnificent scumbling on the upper regions of the canvas.

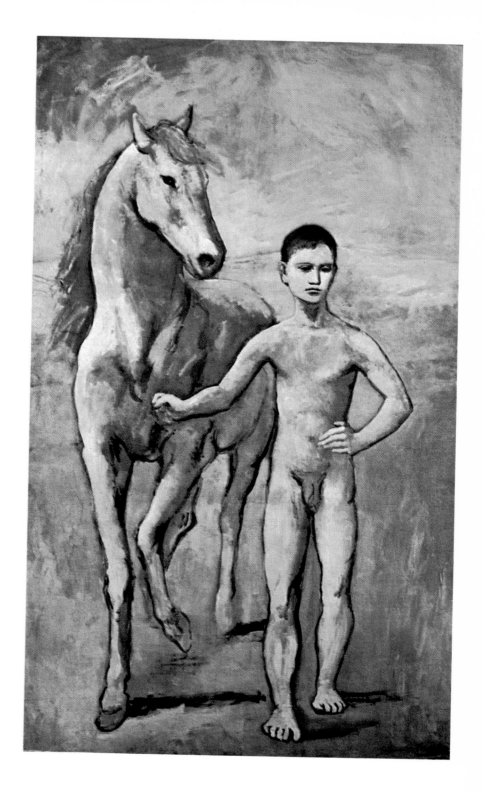

WOMAN COMBING HER HAIR. *Paris, late summer or fall 1906. Oil on canvas, 49⅝ x 35¾ inches. (C&N, pp. 194–95)*

From late spring 1906 until the cessation of work on *Les Demoiselles d'Avignon* about a year later, Picasso's style underwent a remarkable and increasingly rapid transformation. Like many pictures of the year in question, *Woman Combing Her Hair*, painted in Paris after his return from Gosol, combines elements marking different stages in his stylistic evolution. In certain Gosol works these stylistic disparities are visually wrenching, but here they are adjusted in a hierarchical arrangement that makes them easier for the eye to assimilate. The head, its planes relatively purged of visual incident, is the most abstract aspect of the figure, and the most sculptural; its style and facial type reflect Picasso's experience of ancient Iberian sculpture (p. 194:17,18),[1] which helped endow this painted image with more real sculptural plasticity than is to be found in the bronze of 1905–06 (p. 194:19) on which it was based. The torso is less stylized; its monumental but still fleshy contours are more softly, more intimately modeled, the blue-gray underpainting showing through its terra-cotta surface. Finally, the body dissolves into sketchily indicated drapery, comparable in painterly élan to the scumbled passages of *Boy Leading a Horse*. Thus, read from bottom to top, the picture recapitulates successive phases of Picasso's various manners during the first half of 1906.

The pose—a variant of one not uncommon in late nineteenth-century art—is handled so as to give the figure a feeling of maximum compression. And the stability of the configuration is enhanced by the virtual alignment of the upper arm and forearm with the frame, despite the fact that the pose itself would seem to suggest a more Mannerist turning of the body, as in the sketches (pp. 194:20, 195:21). The recollection of Archaic Greek *kouroi* in the striding posture notwithstanding, *Boy Leading a Horse* had been Classical in style and spirit. The treatment of the head in *Woman Combing Her Hair*, however, suggests that Picasso's interests were now reaching back to the pre-Classical.[2]

THE FLOWER GIRL. *Gosol, summer; or Paris, fall 1906. Pen and ink, 24⅞ x 19 inches. (C&N, p. 194)*

This drawing is a refined and stylized version of part of an earlier sketch (p. 194:15), probably executed in Gosol in the Spanish Pyrenees,[1] which depicted a girl accompanying a blind flower vendor. The physiognomy of the child, her long face and thin nose, are characteristic of the peasant types of that area. Picasso, who often worked from memory at this time, has stated, however, that the first sketch was not drawn from life.[2] The flower girl was later incorporated into the painting *Peasants and Oxen*, Paris, 1906 (p. 194:16). That canvas with its angular contours, broken planes, and distorted proportions reflects the style of El Greco, in which Picasso had taken a renewed interest during his Spanish sojourn and the months that followed.[3] *(Elaine L. Johnson)*

Two Nudes. *Paris, fall 1906. Charcoal, 24⅜ x 18½ inches.* (C&N, p. 195)

Two Nudes. *Paris, late fall 1906. Oil on canvas, 59⅝ x 36⅝ inches. (C&N, p. 195)*

Such vestiges of classical beauty and lyrical warmth as survived in *Woman Combing Her Hair* vanish entirely in these massive nudes. The stylization of the heads—especially the heavy-lidded, almost lozenge-shaped eye—and the squat proportions of the figures reflect the continued influence of Iberian sculpture. Indeed, the picture has been called "the culmination of the 'Iberian' phase."[1] But these bulbous, awkward and semihieratic nudes also

have a kinship with Cézanne, as we see him in such pictures as *Five Bathers* (p. 195:22), a type of composition that would continue to influence Picasso right into the earlier stages of *Les Demoiselles d'Avignon.*

As in Cézanne, the shading that models Picasso's nudes is not consistent with any outside source of light and thus seems a property of the monumental forms themselves. Such patterning of light and dark becomes increasingly autonomous—that is, independent of even the motif itself—as Picasso moves into and through Cubism.

*Two Nudes* is sculpturesque in a very specific and modern way, for despite the figures' insistent plasticity, they are modeled not in the round but in relief, and diminish to virtual flatness in a few passages. Notice, for example, that there is no shadow at the edge of the women's abdomens to bend the plane back into space. From now on, Picasso will tend to work increasingly within a shallow space—as closed off here in the back by drapery—in which the relief modeling suggests forms bulging toward the space of the spectator rather than retreating into a perspective space behind the picture plane.

As compared to its formulation in the study for *Two Nudes*, the figure on the right of the painting is in substantially the same posture save for the head (now turned in *profil perdu*) and the right leg, which has been set farther back so as to provide a more architecturally stable support for her massive trunk. In order to assure this support, Picasso has flattened the nude's feet and omitted the front contour of her lower right leg where it joins the foot—the latter decision demonstrating a now more radical willingness to sacrifice verisimilitude in favor of pictorial structure. The posture of the figure on the left of the study has been more obviously altered in the painting. Her right arm has been raised to enhance the almost mirror-image symmetry of the picture, and her left hand now parts a curtain—anticipating the motif of the nude on the extreme left of *Les Demoiselles.*

While *Two Nudes* is not "primitive" in the sense that the word might be applied to many paintings of 1907 and 1908, there is a simplicity and numbing rawness in the facture—particularly in the rough hatching on the arms and the scrubby brushwork of the background. Picasso first painted the figures in pink flesh tones (still visible in the feet and lower legs) but largely overpainted them with deeper terra cottas and red-browns that he no doubt found more consonant with the gravity—both physical and metaphoric—of his subjects.

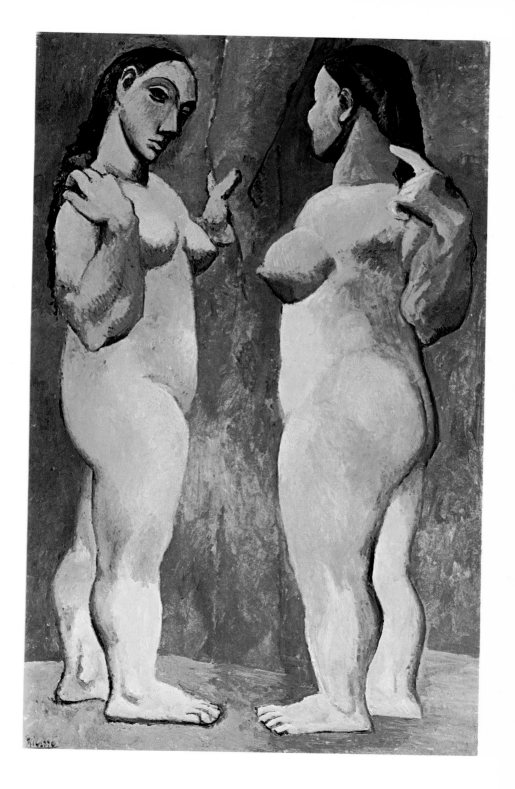

LES DEMOISELLES D'AVIGNON. *Paris, 1907. Oil on canvas, 8 feet by 7 feet 8 inches. (C&N, pp. 195–97)*

The resolution and culmination of Picasso's labors of 1906 is concentrated in one extraordinary picture, *Les Demoiselles d'Avignon*, which was painted for the most part in the spring of 1907 after months of development and revision. Zervos reproduces no less than 17 composition sketches for this canvas.[1] Of the three studies reproduced on page 196 the earliest suggests that the composition of *Les Demoiselles* was inspired by Cézanne's late bather pictures in which the figures and background are fused in a kind of relief without much indication either of deep space in the scene or of weight in the forms.[2] As the painting developed it is also possible that memories of El Greco's compact figure compositions and the angular highlights of his draperies, rocks and clouds may have confirmed the suggestions drawn from Cézanne.[3]

Each of the five figures in the final composition was the subject of considerable study, beginning in several cases in 1906 and continuing in "postscripts" long after the painting was finished. Although their bodies are fairly similar in style the heads of the two right-hand figures differ so much from the others that they will be considered separately.

What happened to Picasso's figure style in the months between the *Two Nudes* of late 1906 (p. 39) and the painting of *Les Demoiselles* may be summarized by comparing the left-hand figures in the two canvases—figures which are quite clearly related in pose and gesture.[4]

Obviously the painter has lost interest in the squat forms, the sculpturesque modeling and the naturalistic curves of the earlier nude. The later figure is drawn mostly with straight lines which form angular overlapping planes and there is scarcely any modeling so that the figure seems flat, almost weightless. The faces of the two figures differ less than their bodies. The mask-like character of the earlier face (p. 39) is carried further in the "demoiselle's" head and the eye is drawn in full view although the face is in profile.

This primitive or archaic convention seems more startling when applied to the noses of the central two figures of *Les Demoiselles* which are drawn in profile upon frontal faces, a device which later became a commonplace of cubism. The faces of the central two "demoiselles" may be compared with that of the transitional *Self-Portrait* (p. 197:27) in which the stylized features of

Iberian sculpture are not yet so exaggerated.

The right half or, more precisely, two-fifths of *Les Demoiselles d'Avignon* differs in character from the rest of the picture. The light browns, pinks and terra-cottas at the left are related to the colors of late 1906, the so-called Rose Period. But, toward the right, grey and then blue predominate with accents of green and orange. The planes too are smaller and sharper and much more active.

The most radical difference between the left and right sides of the painting lies in the heads of the two figures at the right. The upper head is no longer flat but foreshortened, with a flat-ridged nose, a sharp chin, a small oval mouth and deleted ears, all characteristic of certain African Negro masks of the French Congo[5] more than of Iberian sculptures. In the face below the tentative three-dimensional foreshortening of the upper and doubtless earlier head gives way to a flattened mask in which eyes, nose, mouth and ear are distorted or even dislocated. The hand and arm which support this lower head are even more violently distorted. Like their forms, the coloring and hatched shading of these two faces seem inspired in a general way by the masks of the Congo or Ivory Coast, more than by any other source.

Traditionally *Les Demoiselles d'Avignon* was indeed supposed to have been influenced by African Negro sculpture but Picasso has since denied this, affirming that although he was much interested in Iberian sculpture he had no knowledge of Negro art while he was at work on *Les Demoiselles*.[6] Only later in 1907, he states, did he discover Negro sculpture.

Quite recently however Picasso has assured us that the two right-hand figures of *Les Demoiselles* were completed some time after the rest of the composition.[7] It seems possible therefore that Picasso's memory is incomplete and that he may well have painted or repainted the astonishing heads of these figures *after* his discovery of African sculpture, just as only a year before, stimulated by Iberian sculpture, he had repainted the head of Gertrude Stein's portrait months after he had completed the rest of the picture.[8]

Whatever may have been their inspiration, these two heads for sheer expressionist violence and barbaric intensity surpass the most vehement inventions of the *fauves*. Indeed the shocking strangeness of the lower mask anticipates the "surrealist" faces in Picasso's paintings of twenty or thirty years later.

Yet in spite of the interest of these heads and the fame

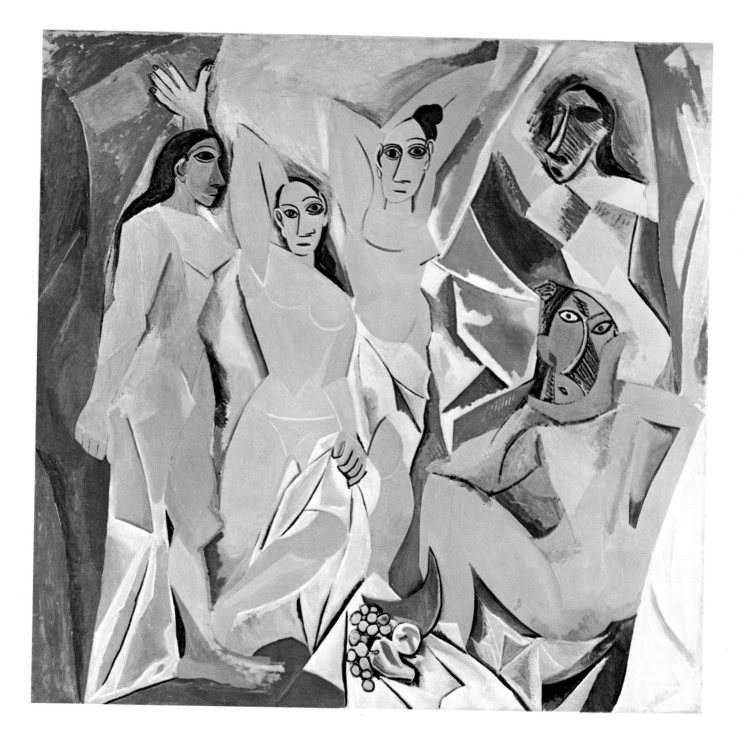

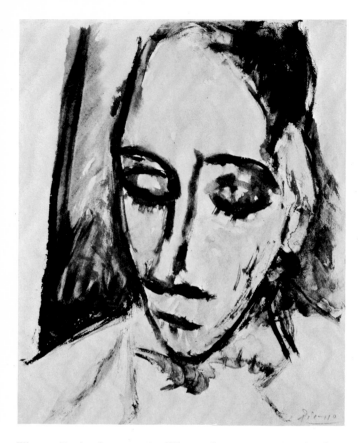

HEAD. *Paris, late 1906. Watercolor, 8⅞ x 6⅞ inches. (C&N, p. 198)*

figures, still life or drapery, into a semi-abstract all-over design of tilting shifting planes compressed into a shallow space is already cubism; cubism in a rudimentary stage, it is true, but closer to the developed early cubism of 1909 than are most of the intervening "Negro" works. *Les Demoiselles* is a transitional picture, a laboratory, or, better, a battlefield of trial and experiment; but it is also a work of formidable, dynamic power unsurpassed in European art of its time. Together with Matisse's *Joie de Vivre*[10] of the same year it marks the beginning of a new period in the history of modern art.

To judge from his work it was at Gosol in the summer of 1906 that Picasso first began to plan a large composition of nudes,[11] but none of these early attempts so closely anticipate *Les Demoiselles d'Avignon* as do certain bather groups of Cézanne which in drawing as well as arrangement inspired the earliest composition studies (p. 196:24, for example).

Picasso explained, in 1939, that the central figure of the early study is a sailor seated and surrounded by nude women, food and flowers. Entering this gay company from the left is a man with a skull in his hand. Picasso originally conceived the picture as a kind of *memento mori* allegory or charade though probably with no very fervid moral intent. Only the three figures at the right and the melons were retained in the final version.

Though its relation to actuality is remote this study recalls the origin of the painting's rather romantically troubador title, *"Les Demoiselles d'Avignon,"* which was invented years later by a friend of Picasso's in ironic reference to a cabaret or *maison publique* on the Carrer d'Avinyó (Avignon Street) in Barcelona.[12]

In a later study (p. 196:25) the sailor has given place to another nude. The figures are shorter in proportion, the format wider.

In the latest, perhaps final, study (p. 196:26) with only five instead of seven figures, the man entering at the left in the earlier studies has been changed into a female figure pulling back the curtain. In the painting itself this figure loses her squat proportions in harmony with other figures and the taller narrower format of the big canvas. All implications of a moralistic contrast between virtue (the man with the skull) and vice (the man surrounded by food and women) have been eliminated in favor of a purely formal figure composition, which as it develops becomes more and more dehumanized and abstract. *(Reprinted by permission of Alfred H. Barr, Jr.)*[13]

of the vividly painted fruit in the foreground, *Les Demoiselles d'Avignon* is more important as a whole than for its remarkable details. Although it was only once publicly exhibited in Europe, and was very rarely reproduced, the picture was seen by other artists in Picasso's studio[9] where its early date, originality, size and power gave it a legendary reputation which persisted after it had passed into the collection of Jacques Doucet about 1920.

*Les Demoiselles d'Avignon* may be called the first cubist picture, for the breaking up of natural forms, whether

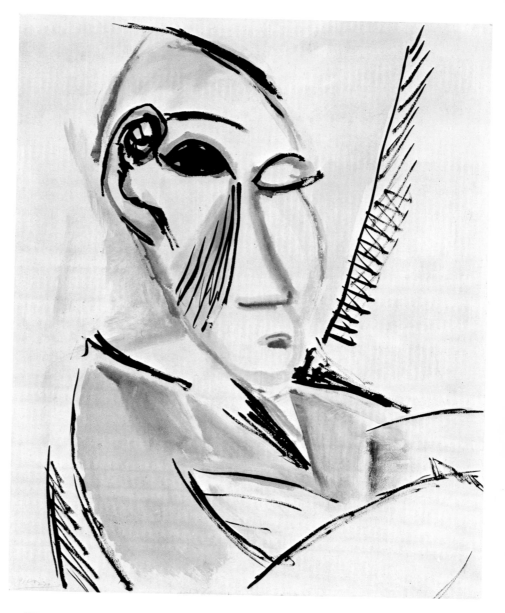

HEAD OF A MAN. *Paris, spring 1907. Watercolor, 23¾ x 18½ inches. (C&N, p. 198)*

Although the studies for *Les Demoiselles d'Avignon* are traditionally dated 1907, it is certain that the earliest—probably including *Head* (opposite)—date from the winter of 1906. By the time the *Head of a Man* was executed,[1] Picasso's conception of *Les Demoiselles* had considerably advanced; in his now firmer and more linear drawing, long striations were introduced to indicate shading—in the shadow of the nose, for instance, which has been displaced over the figure's right cheek. When this special form of hatching was later adapted to the two right-hand figures of *Les Demoiselles*—possibly with the scarification marks of African art in mind—the striations were brushed more assertively and the color became violent.

VASE OF FLOWERS. *Paris, fall 1907. Oil on canvas, 36¼ x 28¾ inches. (C&N, p. 199)*

The brilliant *Vase of Flowers*, probably painted soon after the right-hand figures of *Les Demoiselles*,[1] extends their vigorous linear hatchings into a system that governs the entire picture. But in keeping with the decorative motif, the colors (though still saturated) become less dissonant, and the striations (though still rectilinear) more contained. The directness of the facture is echoed in the simple, almost centralized composition: the vase is situated so that its lip is at the apex of the triangle formed by the table's orthogonals; the fireplace and fern at the left are balanced at the right by the masonry of a large chimney from which hang some of the artist's long-stemmed, gambier pipes.[2] The centrality is also enhanced by the presence in the bouquet of flowers of remote, tertiary hues that appear nowhere else in the composition. Along with green and blue, the stylized blossoms are realized in lavender, rose, pink, purple and fuschia, all of which contrast with the bluntness of the near-primary yellow and blue and the Indian red of the remainder of the picture.

Although Picasso had drawn with short, sticklike strokes of color as early as in the *Self-Portrait* of 1901, their reappearance in 1907 suggests study of the ribbed patterns of copper-covered guardian figures from the Bakota, Gabon[3] (p. 198:30), and possibly also of the veining of leaves, as reflected in certain of the drawings Picasso executed about that time[4] (p. 198:31). Striated hatching is a visual convention, a group of linear signs on a flat surface signifying the shading of forms in relief. Its advantage for the modern painter is that unlike graduated modeling, it does not necessarily lead to an illusion of volume; as used in *Vase of Flowers*, the "sticks" of color flatten the schematic forms so that they can be better assimilated to the two-dimensional surface of the support. This is the aim, too, of the marked tilting of the tabletop toward the picture plane—a practice explored by Cézanne.

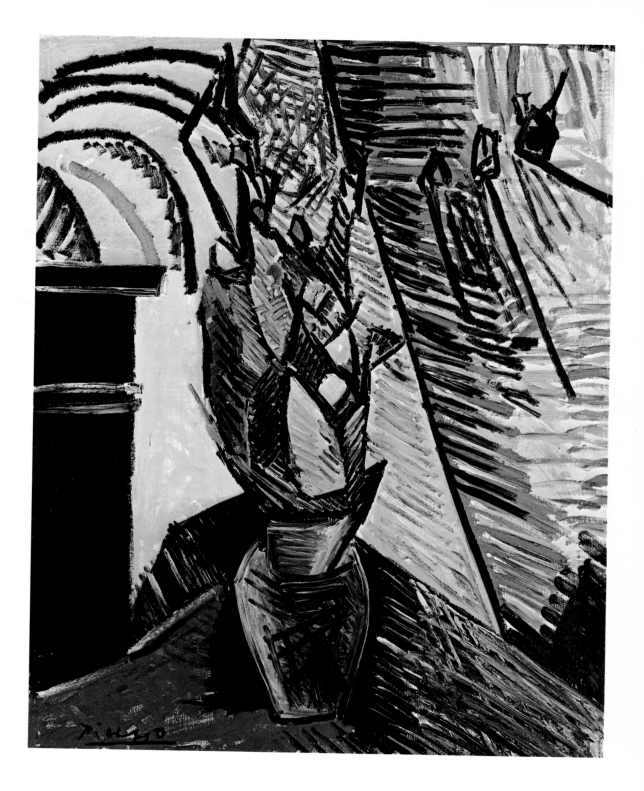

BATHERS IN A FOREST. *1908. Watercolor and pencil on paper over canvas, 18¾ x 23⅛ inches. (C&N, p. 199)*

REPOSE. *Paris, spring or early summer 1908. Oil on canvas, 32 x 25¾ inches. (C&N, p. 200)*

During the winter of 1907 and throughout 1908 Picasso's art ceased to follow the clear line of development that characterized it in the years leading to *Les Demoiselles.* That picture had left so many unanswered questions and

posited so many new possibilities that Picasso naturally returned to it as a point of departure—though never literally—for some time after abandoning it. To the extent that it is possible to generalize in regard to his style during the complicated year that followed *Les Demoiselles, Repose* marks a stage roughly midway between the "African" postscripts of the great painting and the reemergence of Cézanne's influence in the work of the late summer and early autumn of 1908.

*Repose* is a reworking of the upper half of the motif of a large canvas titled *Seated Woman* (p. 200:35) which was executed in the first months of 1908. In the latter canvas the nude is seated on what appears to be the edge of a bed; she has dozed off with her head resting on her right hand and her right elbow propped on her lap. The picture's vigorous shading is contained within heavy black contour lines and realized with the striations that go back to the right-hand figures of *Les Demoiselles,* except that contrasting, saturated color has given way to monochromy.

Why did Picasso return to the *Seated Woman* and make a new version of its upper half? Perhaps he was dissatisfied with the head and bust of the figure, which, to be sure, are less successfully defined than the rest. In any event, he effected a number of subtle changes in his second version. In *Repose* the tilt of the head is less acute, and it is turned slightly more into a three-quarter view, away from the picture plane. The black contouring has been simplified and made less vehement; it no longer tends to isolate so strongly the planes of the arms and chest. Moreover, the coalescence of the planes is fostered by the substitution of thinly brushed shading for the impasto striations of the earlier picture. That shading is, in turn, allowed to model planes in relief.

The influence of the primitive abides in *Repose*—but it is more assimilated, more generalized and, hence, less manifest than in the paintings of late 1907. The barbaric energy of those earlier figures has been contained—transmuted from an active into a passive state—and their violent contours have given way to a linear network that adumbrates the scaffoldings of Analytic Cubism. The manner in which Picasso has framed this figure, bringing her monumental form close up to the picture plane where she fills the space of the canvas almost to crowding, endows her with a sense of immense if dormant power, virtually Michelangelesque in scale (one thinks of the personification of *Night* in the Medici Chapel).

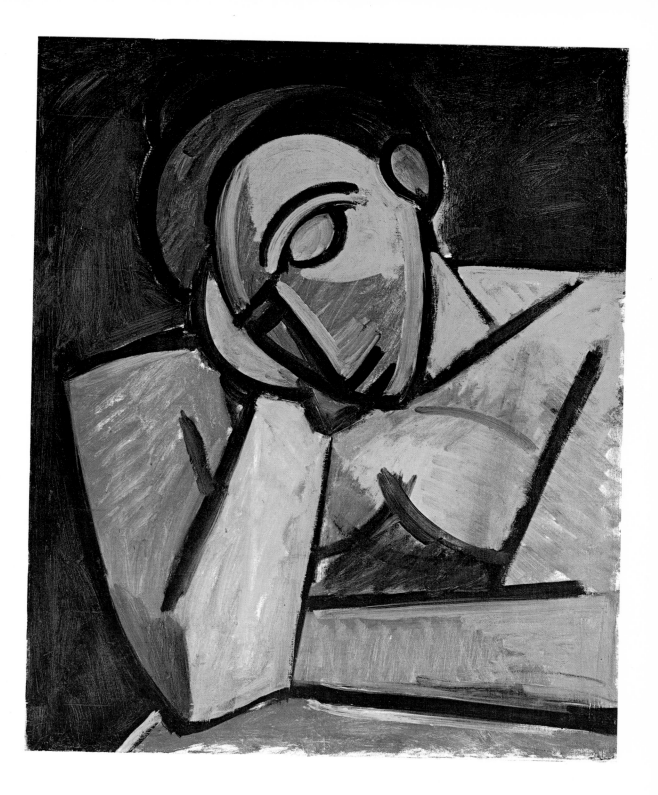

FRUIT AND GLASS. *Paris, summer 1908. Tempera on wood panel, 10⅝ x 8⅜ inches. (C&N, p. 200)*

Given the fluctuations of Picasso's style in 1908, this superb little still life is difficult to place securely. Zervos (II, part 1, 123) assigned it to the last months of the year, hence after the paintings executed at La Rue des Bois, a village not far from Paris where Picasso stayed for a number of weeks beginning late in August. Picasso is not sure, but believes it was executed before his departure. The probable accuracy of his recollection is supported by the modeling of the fruit, which is similar in style to that of *Pears and Apples* (p. 200:36), a painting that Zervos himself placed in the summer months. In the landscapes of La Rue des Bois, Picasso was to explore the Cézannian technique of *passage* (see below, p. 50). The appreciation of Cézanne in *Fruit and Glass* is of a different order, focusing not on *passage*—the silhouettes here are unbroken—but on relief modeling, sophisticated analogies between forms, and finely tuned adjustments in their placement.

The prestige of Cézanne had never been higher than in the year following his large memorial retrospective of October 1907. At the time of that exhibition, the *Mercure de France* had published Cézanne's letters to Emile Bernard, one of which contained his admonition to "treat nature in terms of the cylinder, the sphere, the cone, all placed in perspective, so that each side of an object or plane is directed toward a central point." This famous passage was later to be considered by many, including certain minor Cubist painters, as both a sanction for Cubism and a program for its style—which they took to be essentially an extension of Cézanne's work.

But Cubism, despite its immense debt to Cézanne, is far from being simply a further development of his art. On the contrary, it represented in some fundamental ways a rejection of his methods—as, for instance, in the primacy it gave the conceptual over the perceptual. Moreover, no one who looks carefully at Cézanne's painting can believe that his instructions in the letter to Bernard have any connection with his own work. Illusions of integral three-dimensional forms such as cylinders, spheres or cones are no more to be found in his paintings —so utterly devoid of modeling in the round and closed contouring—than is the classical perspective he mentions.[1]

Fortunately, Picasso looked to Cézanne's paintings rather than his letters (which in any case contain many observations directly at odds with the unfortunate prescription he gave Bernard). He must have recognized that Cézanne's genius lay in his resolution of the disparity between the Old Master picture, its forms modeled in the round within a context of deep perspective space, and the type of "flat" modern picture which Manet had initiated (and which Gauguin, Matisse, Mondrian and others were to advance in different ways). Cézanne's was a middle-ground solution that maintained the emphatic planarity of the modern picture while reinstating the illusion of sculptural relief, which the Impressionists had dissolved. This he achieved by modeling, in effect, only the fronts of objects, thus turning the picture into a simulacrum of a bas-relief; his objects never appear to have backs, nor do they create the illusion of space behind them. It was in terms of such an accommodation of modeled forms to the two-dimensional surface, and their disposition in sequential groupings, that Cézanne seems to have interested Picasso in *Fruit and Glass*; his influence is specifically felt in the high viewpoint and the common contour of the goblet and pear.

Nevertheless, *Fruit and Glass* looks very little like a Cézanne. Absent are Cézanne's subtle inflections of color, natural light and overlapping, polyphonic contours. Rather, Picasso's still life seems to temper the sophistication of Cézanne with the simplicity of Henri Rousseau. Around the time of this picture Picasso had come upon one of the latter's paintings in the second-hand shop of Père Soulier, and his purchase of it was later celebrated at a banquet for Rousseau in Picasso's studio. While Rousseau returned Picasso's admiration for his work (he characterized Picasso as the greatest artist of the day "in the Egyptian style"), he considered Cézanne inferior to such salon heroes as Bouguereau, whose painting he judged, like his own, to be "in the modern style." Of Cézanne's pictures he said: "I could finish them."

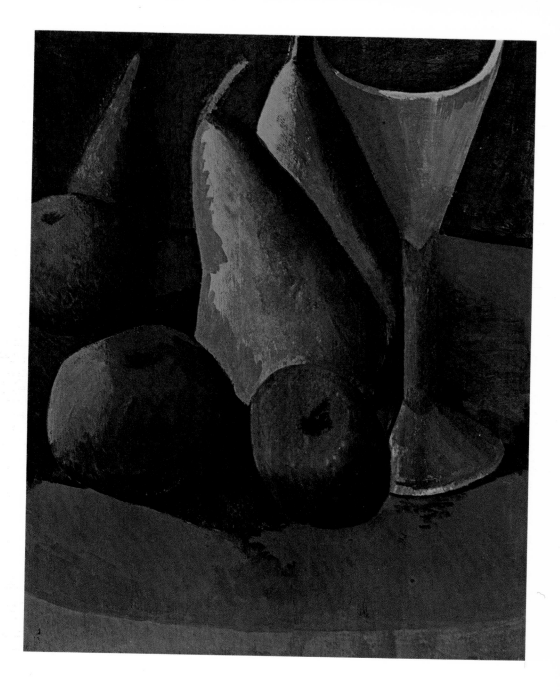

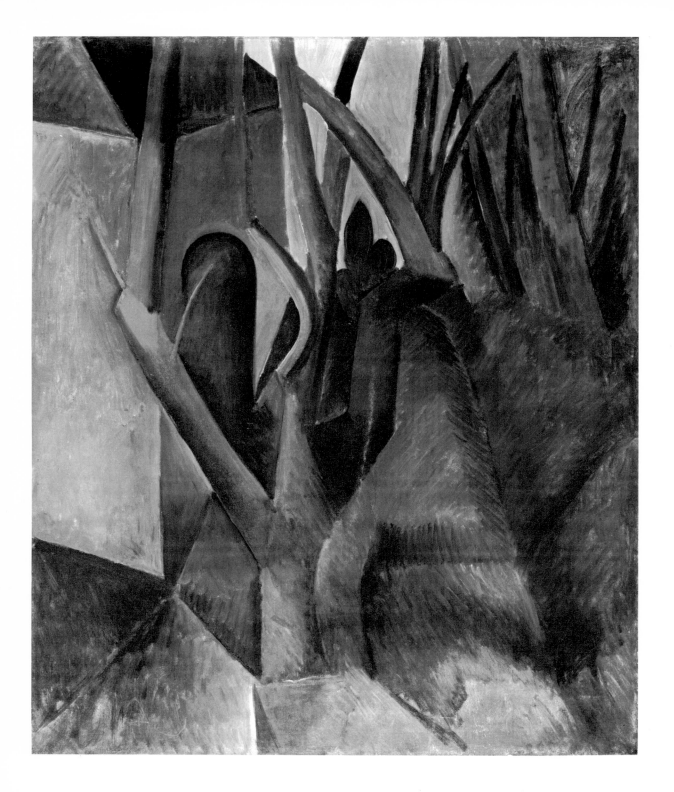

LANDSCAPE. *La Rue des Bois, fall 1908. Oil on canvas, 39⅝ x 32 inches. (C&N, pp. 200–201)*

Like most pictures executed at La Rue des Bois,[1] *Landscape* is free of African influences. And while the simplified houses and trees may owe something to Rousseau, Picasso's reduction to these quintessential notations also followed naturally from his conceptual approach to painting ("I paint objects as I think them, not as I see them").

On the other hand, close study shows *Landscape* to be a less compartmentalized composition than those that preceded or followed the stay at La Rue des Bois. And the way the discreteness of the planes of objects is modified in favor of interpenetration—at least in certain passages—reflects Picasso's continuing interest in Cézanne. This interest was probably more focused now on the latter's landscapes than on his Bathers, and it may also be symptomatic that for the first time in over two years, Picasso was once again painting from nature—at least in part.

Painting from a mental image unencumbered by the actualities and details of the visual field had allowed Picasso more readily to synthesize his compositions between 1906 and 1908, and to push them toward fantasy and abstraction. It is not by accident that his interest in Cézanne during those years focused primarily on the Bathers, for those were the most conceptual and synthetic pictures in the older painter's oeuvre. While Cézanne made much of painting before the motif, his Bathers were conceived from imagination, memory, photographs and art (mostly his own earlier drawings and paintings); they were distinguished by their more schematic, sequential compositions, their generally less colorful and often monochromatic palette, and their more radical reductions or deformations of the human figure. If Cézanne's art was usually poised between the conflicting requirements of fidelity to nature and of two-dimensional pictorial structure, then the Bathers were those of his pictures in which the balance weighed most heavily on the side of autonomous esthetic construction.

However, the stylistic trait common to all Cézanne's mature painting is *passage*, and it is to *passage* that Picasso—who had used it in a rough and rudimentary way in the blue drapery of *Les Demoiselles*—began to address himself at La Rue des Bois. Cézanne's contours were rarely closed; there was usually some point at which the planes of an object bled into or elided with one another and with those of objects contiguous on the flat surface—though these neighboring forms might represent objects at very different levels of depth in the visual field. This technique not only subordinated the integrity of individual forms to the fabric of the composition as a whole, but enabled and invited the eye to *pass* uninterruptedly from plane to plane through the whole space of the picture. In *Landscape*, the way the right branch of the central tree dissolves, or melds, into the plane of the earth near the horizon line is an elementary example of *passage*. The following summer at Horta de San Juan, Picasso would multiply instances of such elision in what were his first fully developed Cubist pictures (p. 57).

*Landscape* shows Picasso's exploration of other Cézannian techniques. With the high viewpoint tilting the forms closer to the picture plane, he was at pains to multiply nexuses where the contours of planes moving at different angles, and on different levels of depth, might touch on the surface of the canvas—as in the corner of the roof. There, the passage of a branch of the tree over the point at which four other planes meet is marked by a change to a darker value.

Cézanne's color originated in perception, and was part of his heritage from Impressionism. (Thus, the conceptual character of the Bathers may explain their limited color.) Generally he modeled or, as frequently was the case, modulated his planes through changes of hue as well as value. In focusing on the structural aspects of Cézanne, Picasso eliminated color, preferring to reduce the problem of modeling to the more conceptual terms of light and dark. Indeed, since 1901 Picasso had worked mostly in manners that approached monochromy, and when he juxtaposed bright colors, as in *Les Demoiselles* or the *Vase of Flowers*, he never modulated them (though he might roughly shade them by overpainting a wet, local color with black). At La Rue des Bois, however, Picasso began increasingly to modulate the individual planes, though still within a monochromatic context—one in which the greens of the landscape displaced the browns of the previous months' painting. These greens, which recall to some extent the coloring of Rousseau's landscapes, were no doubt suggested by the rich foliage of the countryside near Paris. Picasso actually preferred the drier, sparer landscape of Provence and Spain; while painting years later in the Ile-de-France, he would complain of "green indigestion."

51

THE RESERVOIR, HORTA. *Horta de San Juan, summer 1909. Oil on canvas, 23¾ x 19¾ inches. (C&N, p. 202)*

The summer of 1909, which Picasso spent with Fernande in Horta de San Juan (then known familiarly as Horta de Ebro), was the most crucial and productive vacation of his career. There, in the pellucid Mediterranean light of his native Spain, he distilled from the materials he had been exploring during the previous two years his first fully defined statement of Analytic Cubism. The stucco houses of the Spanish hill town especially appealed to Picasso (who, in addition to making an unusual number of sketches of them, took some photographs which he mailed to Gertrude and Leo Stein, p. 202:39). Their geometrical forms provided the simple motifs that Picasso used in his earliest paintings at Horta to clarify his structural ideas (much as Braque had used somewhat comparable architectural motifs a year earlier for those pictures that gave Cubism its name).[1] Picasso's photograph shows that the houses of Horta were then somewhat widely spaced, and indeed they so appear in another painting of the town (p. 202:40). The remarkable pyramidal configuration of interlocking houses in *The Reservoir* results partly from the perspective chosen by Picasso (looking diagonally across and upward from the so-called reservoir in the lower left of the photo, he told the author), but obviously derives much more from invention than nature.

*The Reservoir* is a paradigm of early, sculptural Analytical Cubism (even as its pyramidal configuration of verticals and horizontals anticipates the characteristic scaffolding of the more abstract, painterly Cubism of 1911–12). The word "sculptural" in this context does not refer, however, to illusions of forms modeled in the round, as the misnomer Cubism would imply. Rather, it suggests the kind of relief modeling—here, ocher for the lights, gray for the shadows—through which the structure of the composition moves stepwise downward and outward toward the spectator from a back plane that effectively closes the space. Even the "reservoir" itself—it was actually a masonry *abreuvoir*—fails to interrupt or punch a visual hole in this monumental fabric. Except for some accents of green that relieve the parchedness of the scene (occasioned, the artist recalls, by a scum that covered part of the water's surface[2]), the reflected patterns in the *abreuvoir* are continuous in character and texture with the planar forms around them.

In order that the eye might pass in a smooth but controlled way through the picture, Picasso effected numerous refinements in the painting as over and against its sketch (p. 202:41). For instance, he has aligned the sunny side of the "tower" so that its width is exactly that of the roof of the second highest building, into which it passes as if the neighboring ocher and gray were different planes of the same structure; he has adjusted the line that divides the light and shadow of the tower to continue downward through three other buildings, almost to the middle of the picture; and he has continued the left contour of the building that frames the composition in the right foreground from the bottom of the canvas to the top of the silhouette of the town.

The technique of *passage*, grasped in *The Reservoir* with a conceptual clarity that distinguishes it from its intuitive Cézannian origins, is omnipresent. In the case of the house in the middle, for example, the shaded wall elides with a diagonal plane diving downward to the left of the door; the sunlit wall spills into the plane below in a comparable manner; and the ocher plane of its gabled roof is continuous with that of the upper wall of the house to its left, while on the right the roof plane bleeds into that of the wall behind it.

These elisions provoke ambiguities as to the angles of the planes, which counterpoint the ambiguity produced by the "reverse perspective," most noticeable in the gabled roof (in front, and just to the right, of the shady side of the tower) whose orthogonals converge toward rather than away from the spectator. This effect is clearly a conscious addition to the painting, for in the drawing—and presumably in actual fact—the gable in question was disposed laterally. Such inside-out perspective is a logical coefficient of a style that gives the illusion of sculptural relief from a flat plane toward the spectator—as opposed to traditional illusionism in which objects move back from the picture plane to a vanishing point at infinity.

Picasso realized that for complete control of the surface he could not afford to isolate his sculptural mass against an unarticulated sky, but would have to ease it into that back plane by assimilating the sky to the patterning of the picture as a whole. The practice of extending the articulation and color of the landscape into the sky was familiar to Picasso from Cézanne's late versions of Mt. Ste.-Victoire. The very first landscape Picasso executed at Horta (p. 202:42) is a view of a mountain that rises above the houses in the center of the composition;

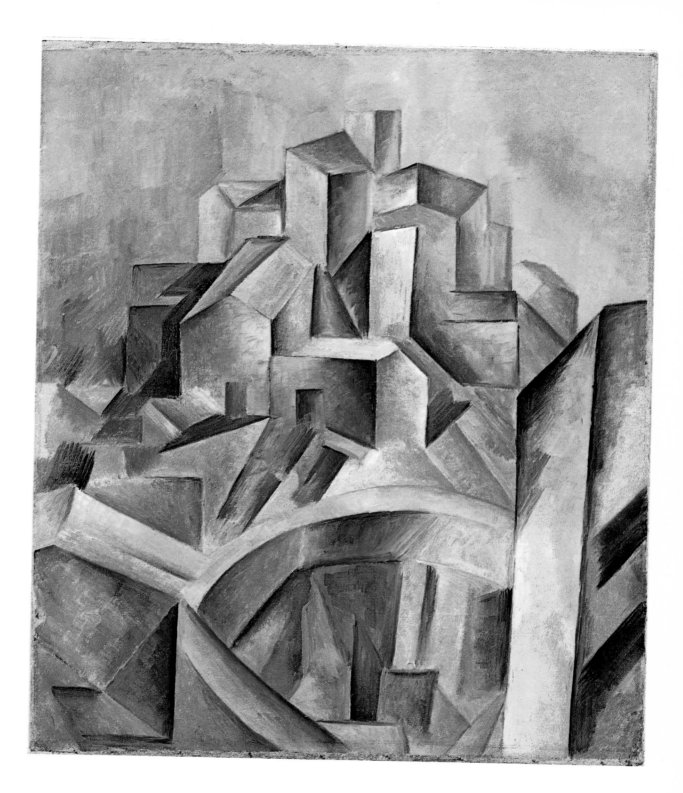

STILL LIFE WITH LIQUEUR BOTTLE. *Horta de San Juan, late summer 1909. Oil on canvas, 32⅛ x 25¾ inches. (C&N, p. 204)*

*Still Life with Liqueur Bottle* is the only still life known to date from Picasso's stay at Horta, which lasted—with intervals—from May until September, and it was one of the last paintings he executed there.[1] It shows how much Picasso's art had developed in the several months following the painting of *The Reservoir*. Here the surface is diced into small facet planes whose staccato elisions define a shallow space closed by the drapery behind. The effect is prismatic—recalling the faceting of certain late Cézannes—and the composition moves down and outward to its greatest relief at the lower center.

So abstract is Picasso's "analysis" of the motif that the reading of *Still Life with Liqueur Bottle* is not easy. For some years it was known erroneously as *Still Life with Siphon*, and was subsequently mislabeled *Still Life with Tube of Paint*.[2] To clarify it for the author, Picasso sketched some of its motifs (p. 204:46).[3] The object in the center turns out to be a large ceramic *botijo* in the form of a cock. (Another such *botijo* is held by a woman at the fountain in print No. 81 of the *Suite 347*, p. 204:48.) Wine was poured into the ceramic through the tail of the cock and was drunk from a spout in its head. The handle at the top was, in fact, round—as shown in Picasso's sketch; but it was rendered as an angular form to coalesce better with the diced planes of the painting. To the right of the *botijo* are the gray planes of a newspaper to which Picasso subscribed; it is still folded for mailing and has an address wrapper around the middle. Sandwiched between the *botijo* and the newspaper is a glass containing a straw, while below and to the left of the *botijo* are two decorative liqueur bottles, the multifaceted surface of the larger being distinctive to the Spanish anisette, Anis del Mono.

Green, which had been merely an accent among the earth colors of *The Reservoir* (though it played a more important role in *Woman with Pears*), is here the dominant tone, sometimes warmed with ocher but more often cooled with a metallic gray that emphasizes the inorganic aspects of the motif. The dull orange neck of the faience *botijo* is an unusual color accent in the work of this period, for though Picasso had tried a number of times to build passages of even stronger color into Analytic Cubist pictures, he almost always ended by painting them out. Color juxtaposition, as opposed to monochromy, involved systems at odds with the chiaroscuro modeling basic to Analytic Cubism. Only small and unsaturated accents of brighter colors could be absorbed into its shaded browns, greens, tans and grays. Substantial use of color did not occur until 1912–13 with the transformation of Cubism from an art of sculptural relief into one of flat, unmodeled planes.

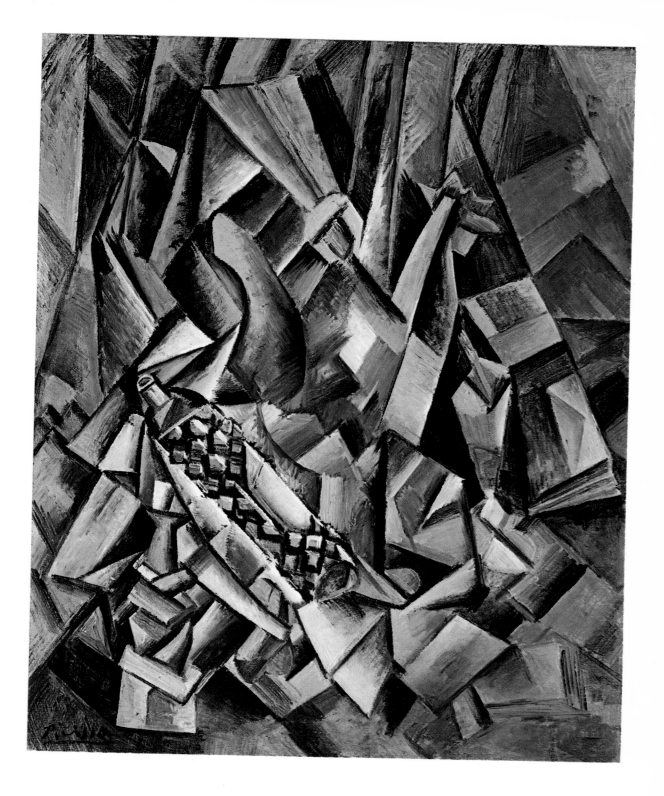

GIRL WITH A MANDOLIN. *Paris, early 1910. Oil on canvas, 39½ x 29 inches. (C&N, p. 205)*

Picasso ceased work on this superb painting when Fanny Tellier, the professional model who sat for it, became impatient with the numerous sittings it required and quit. "But who knows," the artist is reported to have said, "it may be just as well I left it as it is."[1]

Except for parts of the mandolin and the sitter's right breast, the sculptural effects in *Girl with a Mandolin* are of a more finely graduated and lower relief than in the Horta pictures. There is, to be sure, an ambiguous suggestion of deeper space behind the figure's right arm, but that arm itself has little real cylindrical projection, and the stacked picture frames that close off the background—echoing the verticals and horizontals of the support—are pressed up toward the picture plane, reinforcing the shallowness of the space.

Concomitant with this lessening of convexity, the sculptural hardness of the surface has been tempered, especially near the margins of the picture. The planes tend to dissolve into touches of pigment whose painterly finesse is matched by the sophistication of their elusive coloring: a gray warmed with ocher and faintly cooled with blue. This soft brushwork also introduces a degree of transparency into the planes, a transparency which along with the painterliness that engenders it marks the picture as a transitional work, pointing the way to high Analytic Cubism.

*Girl with a Mandolin* is also known as "Portrait of Fanny Tellier"[2]; but it is not a portrait in the same sense as others painted in 1910. Compare it, for example, with the *Portrait of Wilhelm Uhde* (p. 205:49), which dates from shortly afterward. Despite the greater fragmentation and dislocation of its planes, Uhde's face is invested by the artist with a remarkable sense of personality, and even considerable verisimilitude—according to those who knew him—through just a few key decisions. The high upper lip above the tiny mouth, the heavy brows and asymmetrical eyes are choices that remind us of Picasso's powers as a caricaturist. Fanny Tellier's face has no such endowments; on the contrary, it is reduced to a simple rectilinear schema in which the mouth is not indicated and the nose is in doubt.

The continuation of the scalloped line of Miss Tellier's hairdo confirms the plane adjoining the head to the right as the shaded (left) side of her face, thus indicating schematically a three-quarter rather than profile view. But that plane, which we would expect to be obliquely situated in space, has been swung around toward the picture surface. This is characteristic of Picasso throughout *Girl with a Mandolin*, where shapes that have been modified into largely straight-edge forms are moved toward parallelism with both the picture plane and the picture frame. To the extent this happens, the configuration announces the implied rectilinear grid that was to become firmly established in the Cadaqués pictures the following summer, and that would subsequently provide the infrastructure for Analytic Cubist painting.

*Girl with a Mandolin* is one of the earliest examples of Picasso's interest in the motif of the half-length figure playing a musical instrument; its immediate stimulus may have been a Corot (p. 205:50) exhibited in the Salon d'Automne of 1909, some months prior to Picasso's having begun the picture.[3] The increasing abstraction of Cubism in the years following made possible the multiplication of analogies between figures and instruments, and finally their fusion in whimsical and even hallucinative ways. Indeed, the musical instrument would shortly become a focus of Cubist iconography. Given its contrasts of curved and rectilinear shapes, solids and voids, lines and planes, the stringed instrument is "almost a dictionary of the Cubist language of 1910–12."[4]

Picasso's direct observation of the motif is still evident in *Girl with a Mandolin*, which retains a semiorganic morphology in aspects of both the figure and the instrument. One need only compare it to the treatment of a similar motif in the later *"Ma Jolie"* (p. 69)—painted without direct reference to a model—to see how far these vestiges of the recognizable world of human beings and objects were to dissolve into largely self-referential compositions.

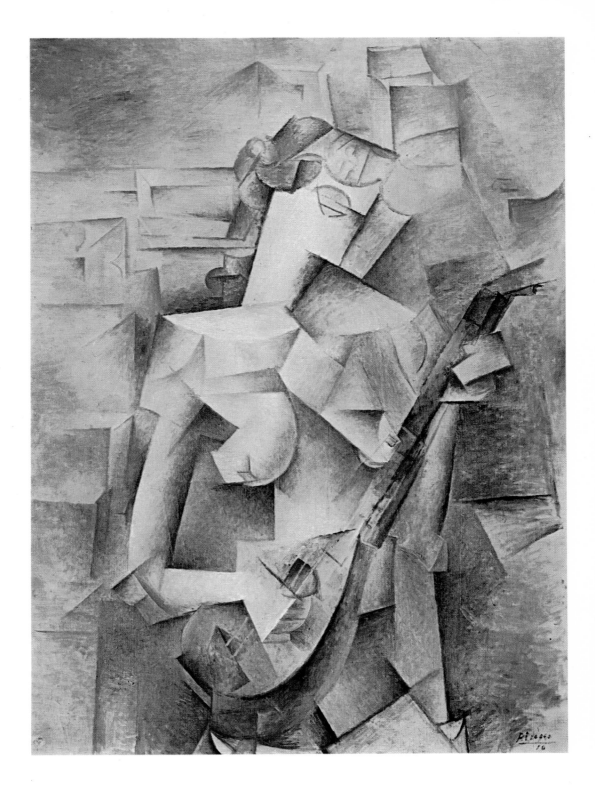

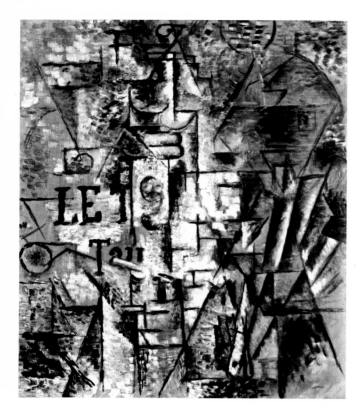

STILL LIFE: LE TORERO. *Céret, summer 1911. Oil on canvas, 18¼ x 15⅛ inches. (C&N, p. 205)*

"MA JOLIE" (WOMAN WITH A ZITHER OR GUITAR). *Paris, winter 1911–12. Oil on canvas, 39⅜ x 25¾ inches. (C&N, pp. 205–206)*

These two pictures and *The Architect's Table* (p. 73) date from the period spanning summer 1910 and spring 1912, during which Picasso and Braque, with whom he was then working closely, developed the mode we may call high Analytic Cubism. Such paintings are difficult to read, for while they are articulated with planes, lines, shading, space and other vestiges of the language of illusionistic representation, these constituents have been largely abstracted from their former descriptive functions. Thus disengaged, they are reordered to the expressive purposes of the pictorial configurations as autonomous entities.

This impalpable, virtually abstract illusionism is a function of Cubism's metamorphosis from a sculptural into a painterly art. Sculptural relief of measurable intervals has here given way to flat, shaded planes—often more transparent than opaque—which hover in an indeterminate, atmospheric space shimmering with squarish, almost neo-impressionist brushstrokes.[1] That this seems finally a shallow rather than a deep space may be because we know it to be the painterly detritus of earlier Cubism's solid relief.

The light in early Cubist paintings did not function in accordance with physical laws; yet it continued to allude to the external world. By contrast, the light in these high Analytic Cubist pictures is an internal one, seeming almost to emanate from objects that have been pried apart. Accordingly, the term "analytic" must here be understood more than ever in a poetic rather than scientific sense, for this mysterious inner light is ultimately a metaphor for human consciousness. The Rembrandtesque way in which the spectral forms emerge and submerge within the brownish monochromy and the searching, meditative spirit of the compositions contribute to making these paintings among the most profoundly metaphysical in the Western tradition.

The degree of abstraction in these images is about as great as it will be in Picasso's work, which is to say that while the pictures approach nonfiguration, they maintain some ties, however tenuous or elliptical, with external reality. Even without the advantage of its subtitle—*Woman with a Zither or Guitar*[2]—we would probably identify the suggestions of a figure in *"Ma Jolie."* The sitter's head, though devoid of physiognomic detail, can be made out at the top center of the composition; her left arm is bent at the elbow—perhaps resting on the arm of a chair whose passementerie tassels are visible just below—and her hand probably holds the bottom of a guitar whose vertical strings are visible in the center. Together with the wine glass at the left and the treble clef and musical staff at the bottom of the picture, all this suggests an ambience of informal music-making. In *Still Life: Le Torero,* too, we can make out suggestions of real objects: a liqueur bottle in the upper center; the masthead of *Le Torero,* a popular bullfight periodical, and a pipe just below it; and a folding fan to the right—a combination that alludes to the comforts of the aficionado if not to the corrida itself.

How similar are the configurations of these two pic-

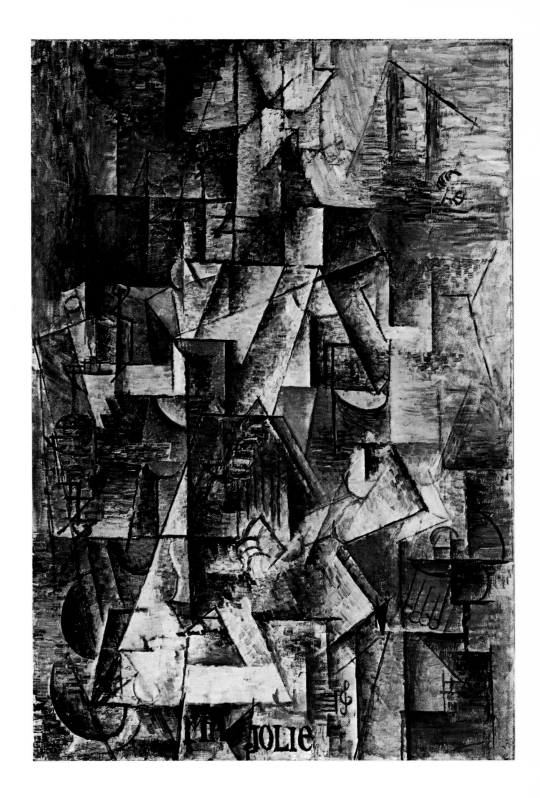

MAN WITH A HAT. *Paris, December 1912. Charcoal, ink, pasted paper, 24½ x 18⅝ inches. (C&N, p. 209)*

In the course of the eight months or so he worked in the boulevard Raspail beginning in autumn 1912, Picasso focused an extraordinary amount of his energy on *papiers collés*. Never again would this or any other form of collage interest him as much. *Man with a Hat* and *Head* (p. 80) are of the type of *papier collé* most common during that year—a severe drawing often in charcoal, in which newsprint and painted paper are employed sparingly to clarify the spatial position of key planes. Picasso did not work simultaneously with his charcoal and scissors. The composition was usually drawn in first, then the collage elements were cut as required for particular planes; the charcoal lines covered when these elements were glued down were redrawn on top.[1]

By boldly individuating certain planes and endowing them with a distinctive material existence, collage helped Picasso and Braque toward a solution to the problem they posed for themselves in 1912: how to represent three-dimensional objects on a flat surface without illusion. High Analytic Cubism, paradoxically, had retained the language of illusionism—its space and graduated shading—even as it disengaged that language from representation. Collage facilitated a new form of Cubist representation based on allusion rather than illusion.

In *Man with a Hat*, the eyes are indicated by black dots, the nose and mouth by a diagonal terminating in an arc, and the outer contour of the head by a pattern that echoes the ear and resembles the body of a guitar. (The equation of ears with the stringed instruments to which they listen is even more fully defined on the right side of *Head*, where Picasso punningly let the ear also stand for the sound hole of a guitar.[2]) The three planes of the face in *Man with a Hat*—newsprint, blue and black—are set, unmodeled, in the picture plane. However, they are *understood* to be in different positions in space, even though they are not *seen* to be so. The newsprint represents the side of the face catching the light; the blue center face is in shadow, with the black ink shaping its outer edge.

To the viewer who troubles to read the text of the newsprint a witticism is revealed: the text that covers part of the man's upper chest deals with the treatment of tuberculosis, while in the columns opposite his nose and mouth, *fosses nasales* and *dents* are mentioned.[3] Al-

though this piece of humor may have been unintentional, the fact that Picasso troubled to cut these particular passages from different pages of *Le Journal* suggests otherwise. The article, "A propos de la Déclaration obligatoire de la Tuberculose," is from page 3 of the issue of December 3, 1912; the other passage, which includes segments of "Le Bonbon dentifrice," about a breath sweetener, is from page 5 of the same issue.[4] December 3, 1912, is thus the *terminus post quem* for the completion of the work; since Picasso generally did not keep the daily papers about for extended periods, it is more than likely that this *papier collé* was executed before the end of the year.

the lower left quadrant of the picture may contain a        in his mind.

GUITAR. *Paris, spring 1913. Charcoal, wax crayon, ink and pasted paper, 26⅛ x 19½ inches. (C&N, p. 211)*

This is one of the most majestic and sumptuous of Picasso's *papiers collés*—and with its whites and ochers (and their black shadows) set in crystalline clarity against a transparent blue ground, it is one of his most "Mediterranean" as well. The artist had already stylized fragmentary front and back planes of the instrument as contrasting curvilinear and rectilinear shapes in the construction-sculpture *Guitar* (p. 75). Here the front of the guitar is represented integrally as a sinuous female form in which white paper represents the light, and flowery wallpaper the shaded parts of the instrument. The rear of the guitar is stylized into a more masculine, straight-edged, ocher shape, its shadow also represented by the ornate wallpaper. The box pattern on the ivory and gold paper that stands for the neck of the guitar serves to recall the instrument's fretwork, to which the parallel lines of charcoal and white crayon just to its right also allude; the shaded underside of the neck is displaced to the side and represented in black ink.

The curvilinear guitar body—which in *Head* and *Man with a Hat* Picasso had analogized to both the human face and ear—is here associated with the female torso, the newsprint sound hole assuming the role of navel. And since, by extension of the metaphor, the rectilinearity of the rear plane of the guitar suggests a masculine torso, the motif as a whole may be seen as expressing the union of male and female anatomies. In confirming the anatomical analogy to this author, Picasso noted with a mischievous smile that his attention had been drawn some time ago to the advertisement, prominent on the front page of the Barcelona *El Diluvio* collaged below, for Doctor Casasa, a specialist in venereal diseases. As to whether this played a role in his choice of the particular page of newsprint, the artist suggested that if it had influenced him at all, it would probably have been subconsciously. It is interesting to speculate that the advertisement for an oculist, Doctor Dolcet, at the bottom of the page might have been a whimsical prescription for the viewer who had trouble seeing what this collage was about.

The problem is knowing just how far such interpretations may be carried.[1] Picasso himself considers that when the work leaves his hand, its imagery is what its interpreters make of it. He is aware that his very reluctance

to discuss iconography encourages speculation. And while in another context he observed with regard to interpretation that *"rien n'est exclus,"* he was more bemused than persuaded by the interpretation which suggests that the white and the wallpaper halves of the female guitar-torso in this work are meant to show the body respectively as "nude" and "encased in a tight-fitting lace undergarment."[2] More in the spirit of Picasso's humor is the same authors' contention that in cutting the masthead of *El Diluvio* in a way that isolated the letters "Diluv," Picasso had transformed its meaning into a tongue-in-cheek, "Esperanto" hint as to the great French museum in which such *papiers collés*—then not even considered art beyond a small group of amateurs—would eventually find their place.[3]

Few clues as to the position of the guitar are given. It is probable that it was sitting upright in a chair like a person,[4] though the motif in the lower right corner that suggests this placement is admittedly very summarily indicated; what looks like a pipes of Pan is actually three fringed tassels hanging from the braided arm of a chair.[5] The braided motif—which can also serve to indicate the molding on a wall or the edge of a table or table runner (or a picture frame)—is frequently found in relatively realistic form in Picasso's Cubist pictures (p. 101), both with and without the passementerie tassels. The latter appear as an abstract schema very like the one here at the bottom right in *"Ma Jolie"* (p. 69) and in the upper center of *The Architect's Table* (p. 73), as well as, in more realistic form, at the right in *Man with a Guitar* (p. 85).

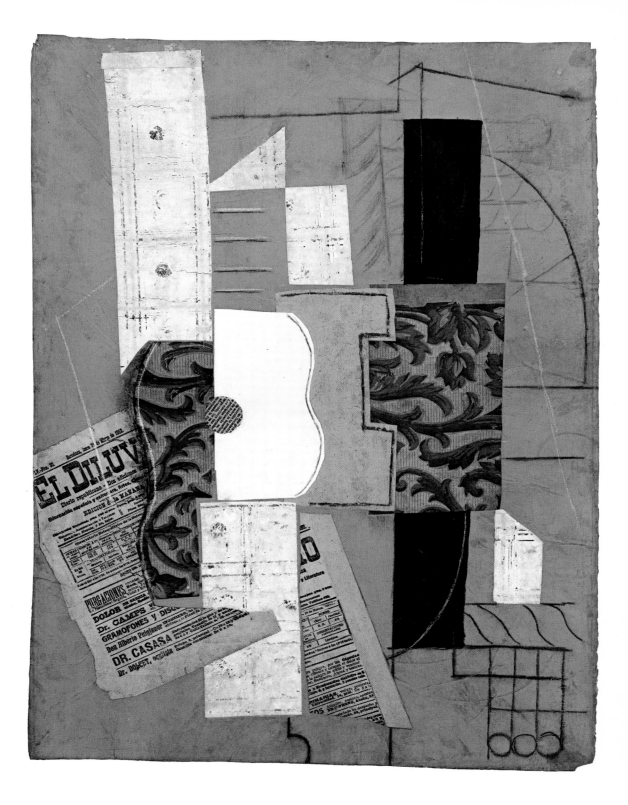

MAN WITH A GUITAR. *Céret, summer 1913. Oil and encaustic on canvas, 51¼ x 35 inches. (C&N, p. 211)*

The terms "analytic" and "synthetic," commonly employed to characterize, respectively, the Cubism of 1909–12 and that of 1913 onward, tend to suggest a radical change in style when in fact Cubism had never ceased its gradual evolution. Indeed, many Synthetic Cubist works of 1913–14 are closer as regards configuration, scale and character to their Analytic predecessors than to such subsequent Synthetic Cubist pictures as *Harlequin* (p. 99) and *Three Musicians* (p. 113). Keeping these caveats in mind, however, the conventional nomenclature can still be of value in defining Cubism's development.

The term "synthetic" has been used in two quite different ways. First, it may describe Picasso's and Braque's "synthesis" of the fragmented facet-planes and atomized motifs of Analytic Cubism into large, flat and more readable shapes; this use of the word relates it to the Synthetism of the late nineteenth century. Second, and more frequently, it has been used to indicate an invented and semiautonomous—hence "synthetic"—vocabulary of forms. In this case, the artist is understood to have arrived at the configuration not by abstraction ("analysis") of the motif, but by constructing his figures and objects directly from preexisting signs and forms.

*Man with a Guitar* is a Synthetic Cubist picture largely in the latter sense. The configuration—a bold conceit of adjacent rectangles—seems more imposed upon the motif than derived from it. Little more than the head of the figure and the pink still life with the bottle of Bass at the right are exempt from the imperatives of its grid. More typical are the black sleeve and gray right hand of the guitar player at the bottom center of the picture, which testify to the manner in which the image was required to conform to the dominant patterning. (The parallel white arcs in the upper torso of the sitter are also something of an exception in their curvilinearity, but they are no more derived from the motif than are the rectangles; and their graduated, semitransparent shading makes their visual assimilation difficult. In conjunction with the three shaded vertical rectangles with which they are paired, these arcs presumably express the convexity of the upper torso of the sitter.)

Despite its predominantly rectangular patterning, *Man with a Guitar* enjoys a considerable range of vocabulary, as exemplified in the juxtaposition of the symbolic geometry of the upper torso and the realistic drawing of the braided tassel. Another aspect of this range is the "double image"[1] by which the contours of the head and hat of the figure read also as those of a guitar—a kind of pictorial counterpart of the double entendres found in the lettering of the paintings and collages of 1911–14

The unexpected aspect of this picture's variety, however, is its coloring. Nothing in Picasso's Cubist painting prior to 1913 prepares us for its great slabs of sonorous reds, greens and ochers (some of them enhanced in their density through the use of encaustic). Nor are these carried over from collage, though the flatness of the *papiers collés* helped bring such coloring about.[2] This is not to say, however, that Picasso was suddenly reborn a colorist. Despite the rich play of color in *Man with a Guitar*—as witnessed by the subtle calibration of its five shades of red—the colors are darkened with shading and embedded within a light-dark matrix (as is always finally the case in Picasso's draftsmanly art) so that it is their rightness as values rather than as hues that makes the picture work.

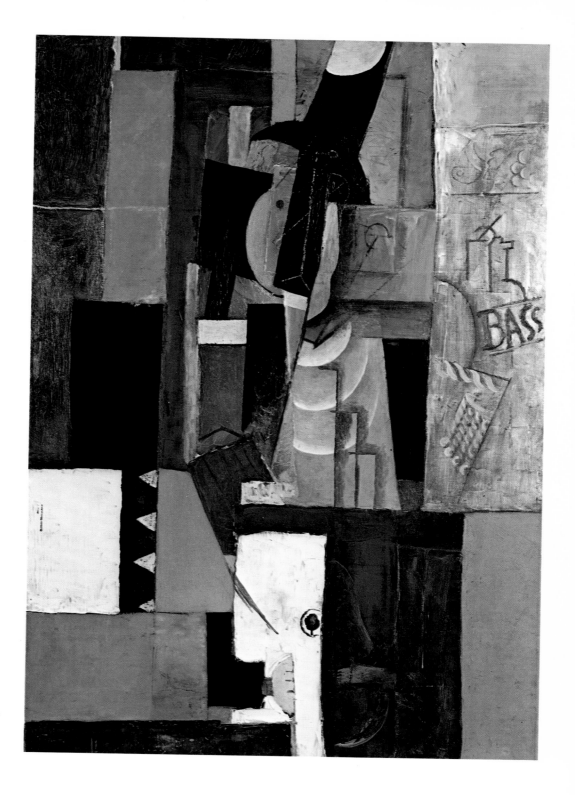

CARD PLAYER. *Paris, winter 1913–14. Oil on canvas, 42½ x 35¼ inches. (C&N, p. 211)*

Synthetic Cubism is commonly considered less abstract than its Analytic predecessor, but this is true only in a limited sense. The generally greater legibility of its images certainly makes it more representational; but its *schematic* mode of representation is more inherently abstract than the *illusionistic* mode that had prevailed in Analytic Cubism. Even where the forms in pictures in the latter style are most broken up and difficult to read, they are defined by a kind of drawing and shading and set within an atmospheric space derived ultimately from the language of pictorial illusionism inherited from the past. By contrast, Synthetic Cubism is characterized by a nonillusionist flatness, which it helped establish as central to the twentieth-century esthetic, and which is in no way undermined by representation per se.

*Card Player* exemplifies the greater legibility of Synthetic Cubism as against that of the Cubism of 1911–12. The mustachioed player is seated at a wooden table, his legs visible between those of the chair at the bottom of the picture. In his left hand he holds a playing card face up—three are face down on the table—and in his right, a pipe. On the table are a glass, a bottle behind it, and a newspaper. The newspaper masthead is truncated so as to facilitate a triple entendre, its letters serving to identify the name of the newspaper *(Le Journal)*, the objective nature of the action (JOU from *jouer*, "to play"), and the subjective nature of the experience (JOI, from *joie*, "joy"). Although the action is indicated in both pictorial and literary ways, the picture is not a narrative one, as are traditional depictions of card playing. Its centrality, frontality, flatness and motionlessness are almost Byzantine, and remind us of the persistently iconic character of high Cubist imagery.

The influences of *papier collé* are more directly evident in *Card Player* than in *Man with a Guitar*. The simulated wood graining of the table, the Greek key motif of the wainscoting, the playing cards, the fragment of *Le Journal* and the shapes of the composition in general and of the player's head in particular might each be considered, in effect, a trompe l'oeil of collage. Even the pointillist stippling that represents the shaded side of the player's neck was probably suggested by newsprint or sandpaper, although such stippling is used as a decorative convention for shading in a more freely

dosed manner elsewhere in the picture. As with the somewhat irregular edges and rough facture of *Man with a Guitar*, the collagelike effects here remind us that *papier collé* had provided Picasso with a built-in guarantee against the finessed execution that characterized the work of 1910–11. At its apogee, high Analytic Cubism enjoyed a refinement in the nuancing of values and a fluency in brushwork comparable to that in the work of the great seventeenth-century masters. As Picasso is both capable of great virtuoso painting and suspicious of it, his development is often characterized by an exploitation of this gift followed by an abrupt reaction against it. In that connection, collage played a role analogous to that of the awkward contouring of the early Blue Period and the "primitivism" of late 1906–1907; it at once delivered Picasso from the temptations of pigment and instituted a kind of drawing that would long survive collage as such, one in which the scissored, manufactured and torn edge replaced the suavely hand-drawn one. Collage also focused attention on the two-dimensionality of the picture as an esthetic object by endowing the surface with a more emphatic materiality.

The coloring of *Card Player* is more typical of Picasso's work in 1913 than that of *Man with a Guitar* insofar as the light-dark scaffolding that organizes the picture (passing from white to black through ocher, gray and blue) is more obviously dominant. The saturated red of the left arm and the green of the wainscoting are isolated, bright accents that "season" the picture and are easily absorbed into its prevailing light-dark structure.

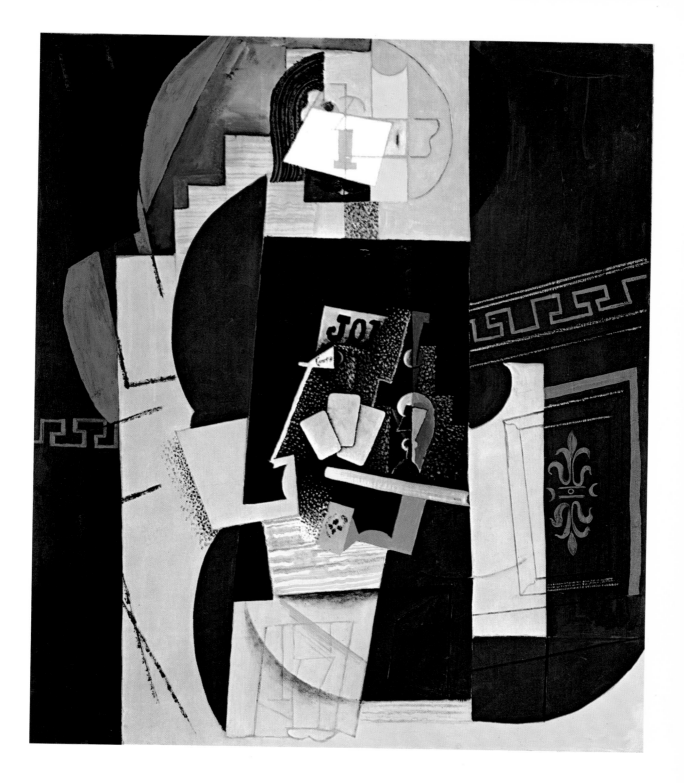

STUDENT WITH A PIPE. *Paris, winter 1913–14. Oil, char-coal, pasted paper and sand on canvas, 28¾ x 23⅛ inches. (C&N, p. 212)*

*Student with a Pipe* is one of two bust-length versions of a student wearing the traditional *faluche*, or beret, executed in the winter of 1913–14. Whereas *Student with a Newspaper* (p. 212:58) is entirely painted and drawn, though partly in simulated *papier collé*, the *faluche* and pipe in this picture are pasted paper. This particular use of *papier collé* to represent discrete objects is different from the functions we have seen it fulfill earlier. In *Man with a Hat* (p. 78) and *Head* (p. 80), pasted paper was used to define only selected planes of an object; in *Guitar* (p. 83), a page of newsprint was used descriptively (as well as plastically) to identify the newspaper as such within the iconography of the still life. In *Student with a Pipe*, Picasso provides a paper surrogate for the object. He cut the paper in the form of a *faluche*, colored it dark reddish-brown (it has since faded), and painted on the details of the headband and the clip, which identifies the student's *Faculté*. Then he creased and crumpled the paper so as to suggest the irregular surface of the *faluche*, and proceeded to attach it in such a way that it forms a kind of low relief.

The features of the student are quite easy to read. In what was probably the study for this picture (p. 212:59), Picasso had already narrowed the central plane of the head toward the top, thus indicating its slight tilt back-ward. The student's round "cheeks," executed partly in pasted paper in the study, are here contoured in char-coal, their relief indicated by the slight shadow they cast on the adjoining planes. The large, blue-gray rectangu-lar form on the left stands for the shadow of the head as a whole.

The student's ears have been turned outward forty-five degrees so that they lie flat in the picture plane, their parallel lines echoed by the four wavy lines that describe the hair. As a shorthand symbol, the black dot that indi-cates the orifice of the student's left ear mediates between the smaller black dots of his nostrils and the little round circles that stand for his eyes; the top view of the pipe bowl (superimposed on its profile) combines both circle and dot.

The circular eyes and the long flat nose—the latter stippled so as to remind us of the sandy texture of the surface—are typical of Picasso's heads of 1913–14 and

represent, as Kahnweiler pointed out,[1] a translation of the schematic features of the Wobé masks (p. 208:54) into a whimsical and personal sign language. The X by which Picasso indicates both the bottom of the nose and the ridge that descends toward the upper lip shows that he can more than equal the economy of the African artists.[2]

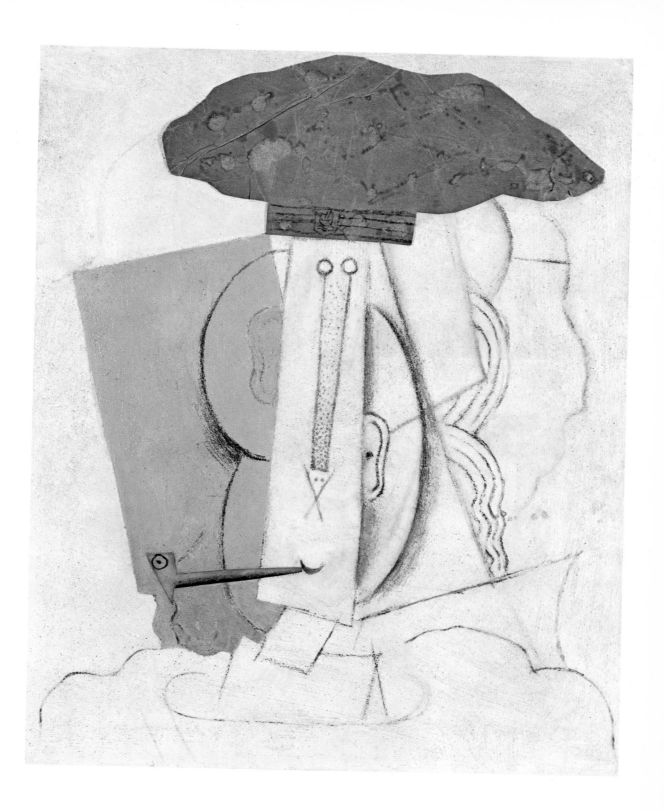

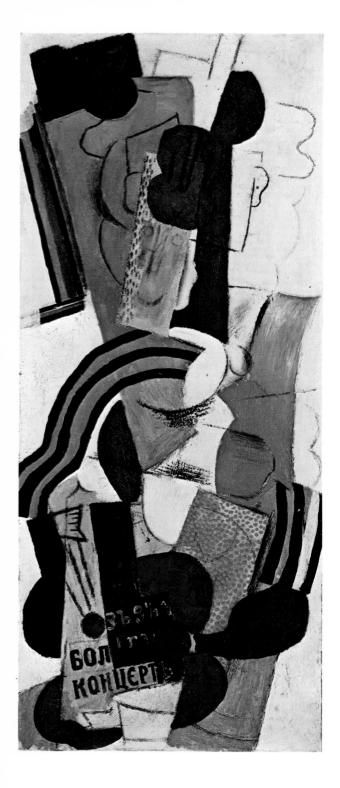

WOMAN WITH A MANDOLIN. *Paris, spring 1914. Oil, sand and charcoal on canvas, 45½ x 18¾ inches. (C&N, p. 212)*

Many forms in *Woman with a Mandolin*—among them the parallel wavy lines, red pointillist plane, blue-gray shadow and profile ear—relate closely to those of *Student with a Pipe*. However, their more disjointed syntax suggests that it was executed some months later, probably in the spring of 1914. And the almost hallucinatory way in which the anatomies of the sitter and the mandolin are confounded anticipates the "surreal" spirit of the drawings Picasso was to make still later, during his 1914 summer holiday at Avignon.

The reading of *Woman with a Mandolin* is comparatively difficult. The facial features are represented twice, once against a blue plane shaped like a musical instrument, then, just below, in charcoal, which has been partly erased, leaving a spectral "afterimage." Here the wavy hairlines serve as a bridge to the radically displaced arms. The brown sleeve of the sitter's left arm—puffed at the shoulder and tight around the forearm—makes a shape analogous to that of the mandolin; the sleeve of the right arm—from which a finlike hand emerges—goes one step further and itself forms one contour of the mandolin.

The unusually narrow format of *Woman with a Mandolin* draws special attention to the structural role of the framing edge in Synthetic Cubism. The composition is locked into and supported by the frame in a way that suggests its teetering scaffolding might collapse without it. The structures of high Analytic Cubist pictures were, by comparison, self-sufficient. While they echoed and re-echoed the stabilizing verticals and horizontals of the frame, they usually floated at a short distance from it—both laterally and recessionally—on all but the bottom edge (and even there in some paintings of 1911–12, especially in the work of Braque).

As illusionist space was squeezed out of Picasso's and Braque's pictures in 1912, the forms moved increasingly up into the picture plane, where they were no longer spatially "behind" the edges of the field. This development brought those edges—the first lines of any composition—more into play as direct components of the linear scaffolding. With these serving as a part of the scaffolding rather than a frame around it, much more instability could be tolerated in the center of the composition. In *Woman with a Mandolin*, for example, not only do curvilinear forms predominate, but even the straight lines (with one minor exception) are tilted away from the axes of the field.

It is interesting in this regard to compare *Woman with a Mandolin* to a related composition, *Man with a Guitar* (Fig. 212:60), abandoned in an unfinished state around the time *Woman with a Mandolin* was completed, but certainly begun before it—perhaps as early as in the summer of 1912 to judge by the traces of atmospheric, neo-impressionist brushwork in the upper corners. In *Man with a Guitar* the curvilinear forms are far fewer and are subordinated to the straight edges, many of which parallel the frame, which is at some distance from the scaffolding. It is clear that in opting for the less autonomously balanced, more meandering configuration of *Woman with a Mandolin*, Picasso saw the necessity of removing the spaces on the sides of the earlier image, thus allowing the framing edge to move in and give its support. Picasso's awareness of the special importance of the frame in *Woman with a Mandolin* may be reflected in a pictorial witticism whereby every form in the picture is flat except the rendering of a piece of picture-frame molding, which descends from the upper left of the composition.

The inscriptions on Picasso's Cubist paintings and collages testify to his fascination with the language of typography. According to Gertrude Stein, he learned the Russian alphabet from his friend the painter Serge Férat (*né* Jastrebzoff, whom Picasso and Apollinaire called G. Apostrophe), and began "putting it in some of his pictures."[1] As *Woman with a Mandolin* belonged to Miss Stein, she must have had this picture in mind, all the more so since it is, in fact, the only Picasso with Russian lettering. However, the presence here of the fragmentary phrase бол концерт, transliterated as Bol(shoi) Concert or the equivalent of the French "Grand Concert," may have had a different immediate inspiration than Miss Stein suggests. Kahnweiler recounts that a number of Picasso's paintings which had been sent to Russia for exhibition were returned carefully wrapped in Russian posters. "Picasso saw them," he continues, "and found the Russian characters so attractive that he carried them off and used them in his still lifes."[2]

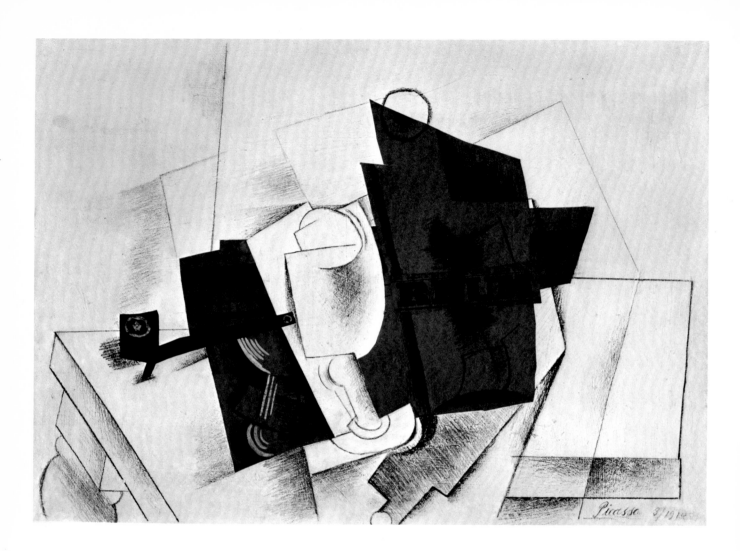

PIPE, GLASS, BOTTLE OF RUM. *Paris, March 1914. Pasted paper, pencil, gesso on cardboard, 15¾ x 20¾ inches.* (C&N, p. 212)

While most of Picasso's *papiers collés* are playful and improvisational, *Pipe, Glass, Bottle of Rum* is close to the sober spirit of Braque. Its studied elegance is epitomized by the precise, somewhat self-conscious signature, similar in its regular script letters to the "printing" on Picasso's formal calling card, as imaged elsewhere (p. 212:61). The objects are contoured and shaded with particular subtlety, their shapes almost wholly independent of the silhouettes of the two large, brown pasted papers on which they are partly inscribed. The table on which the still life is situated is extravagantly tilted, but except for the displacement of the molding of its edge to the middle of the composition, it is realized in a much less abstract manner than other parts of the work. The black accented with brown of the pipe and the black lettering on the pasted newsprint that labels the rum bottle establish the dark end of a value scale that is carefully graduated through the middle tones (the large pieces of *papier collé*) to the gessoed, white ground of the field (which has been treated in some areas as simulated collage).

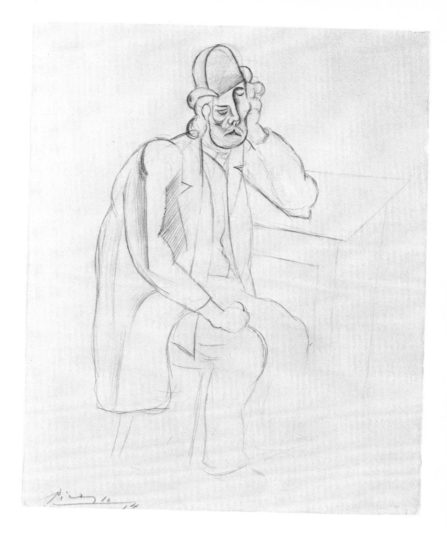

MAN IN A MELON HAT. *1914. Pencil, 13 x 10 inches.*
*(C&N, p. 213)*

The process by which Picasso abstracted his motifs from
the visible world is illuminated by a large group of draw-
ings of 1914, in which men seated at a table or leaning
on a chair or a balustrade are depicted in styles rang-
ing in varying degrees from naturalism to Cubism
(p. 213:62, 63).[1]

*Man in a Melon Hat* represents a midway point in that
spectrum. The figure is basically naturalistic. The use of
several Cubist devices, however, invests it with additional
qualities of tension, rhythmic unity and spatial control.
The rectilinear crease of the sleeve is one such device;
another is the recurring circular form that courses
through the knee, clenched fist, shoulder, hair, brim,
crown, hand, and elbow. The flattened hat and tilted
tabletop engender surface unity and a feeling of com-
pression. The displacement of the left eye, in an other-
wise conventional face, intensifies the image's power.

The naturalistic compositions in this series foreshadow
the neoclassic figure drawings that were to become an im-
portant complement to Picasso's Cubist style from 1915
onward. *(Elaine L. Johnson)*

93

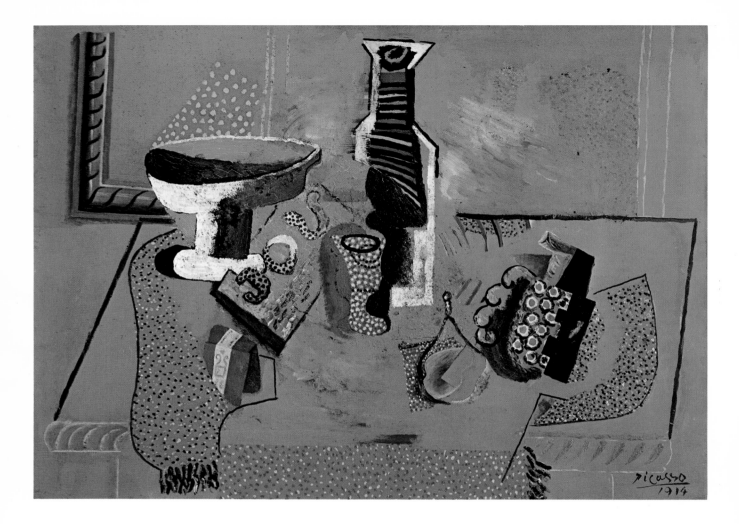

GREEN STILL LIFE. *Avignon, summer 1914. Oil on canvas, 23½ x 31¼ inches. (C&N, p. 213)*

Even in Picasso's most richly colored paintings of 1913, such as *Man with a Guitar* (p. 85), the hues tended to be dark in value, in keeping with the severe and rigorous spirit his Cubism preserved as it evolved into its Synthetic phase. However, the bright colors and uncomplicated stylizations of *Green Still Life*, executed at Avignon during the summer of 1914, announce a gay and more frankly decorative aspect of the style, the ornamental elegance of which has suggested the name "Rococo Cubism."[1] The sometimes obscure sign language of the two previous years is here temporarily suspended; the reading of the fruit dish, newspaper (with a segment of the masthead of *Le Journal*), cigarette package, glass, bottle, pear, grapes

and fragment of a picture frame requires little effort.

The omnipresent green of this picture establishes a lyrical mood and provides a continuous foil against which the staccato accents of other hues are played off. Pointillist stippling, which Picasso had been using sparingly for over a year to differentiate a plane or indicate a bit of shadow, is employed more generously here, its dots given special brightness by the use of commercial enamels. The striations of green, violet, yellow, orange and dark blue on the bottle are the stylistic counterpart of the dots—a lyrical transmutation of a shading device that goes back to the *Vase of Flowers* (p. 45). Along with the red dots and the red "shadow" of the glass, these striations focus attention on the center of the composition through their high contrast with the brilliant complementary green of the background.

GLASS OF ABSINTH. *Paris, 1914. Painted bronze with silver sugar strainer, 8½ x 6½ inches. (C&N, p. 213)*

*Glass of Absinth* is the only sculpture in the round executed by Picasso between 1910 and 1926. Its decorative pointillism makes it look of a piece with the *Green Still Life*, except that in the painting the artist dealt almost entirely with the surfaces of objects. In this little sculpture—cast in bronze from a wax model—Picasso returned to the possibilities of transparency that had concerned him in the sheet-metal *Guitar* (p. 75). Unlike the lateral, relieflike structure of musical instruments, the real absinth glass was, of course, conical and transparent—which probably prompted Picasso to attempt to fuse these two qualities in this unique experiment.

The stem and bottom of the glass are shown integrally. Above the stem, however, the glass's contours are opened to reveal its "interior."[1] The strange shapes that result were perhaps originally suggested by the levels of absinth in it, or by the planes of light passing through it. But these are less in the spirit of the objective abstraction that animated the sheet-metal *Guitar* than they are akin to the structural double entendres and fantastic mutations common to the painted works of 1913–14. Not surprisingly, therefore, the glass takes on an anthropomorphic character; for one critic, it brought to mind the "top-heavy slanting hats and the tight-fitting lace chokers of the ladies of those times."[2]

Picasso offset the weighty appearance of the bronze casts by painting them pointillistically, each with differ-

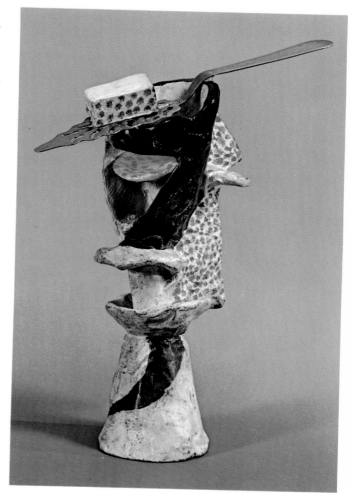

ent planar articulation and coloring with the exception of one that was covered with brown sand. This pointillism also enhanced the effect of transparency in the planes. The flatness and ornamental perforation of the real sugar strainer[3] must have especially appealed to the artist, and its juxtaposition with the painted bronze sugar cube is a three-dimensional recapitulation of the mixing of levels of reality in collage.

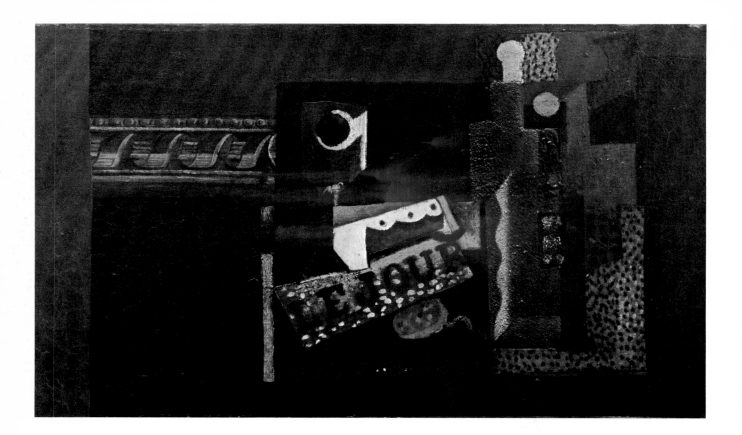

GLASS, NEWSPAPER AND BOTTLE. *Paris, fall 1914. Oil and sand on canvas, 14¼ x 24⅛ inches. (C&N, p. 214)*

This still life and those on pages 97 and 101—dating from 1914, 1915 and 1916 respectively—have much in common. All are constructed primarily with straight lines, which give way here and there to scalloped edges, braided moldings or small circles. All the backgrounds and most of the objects are dark in value—with deep reds, browns and grays predominating. Only where the forms cluster and overlap does Picasso relieve the prevailing somberness with brightly-colored pointillist planes. These stippled passages are counterpointed in *Glass, Newspaper and Bottle* and *Guitar over Fireplace* by planes heavily textured with sand. Indeed, in the latter picture it is a relieflike ridge of sand—rather than the passage from a deep blue to a still darker one—that determines the left-hand contour of the guitar.[1]

GUITAR OVER FIREPLACE. *Paris, 1915. Oil, sand and paper on canvas, 51¼ x 38¼ inches. (C&N, p. 214)*

96

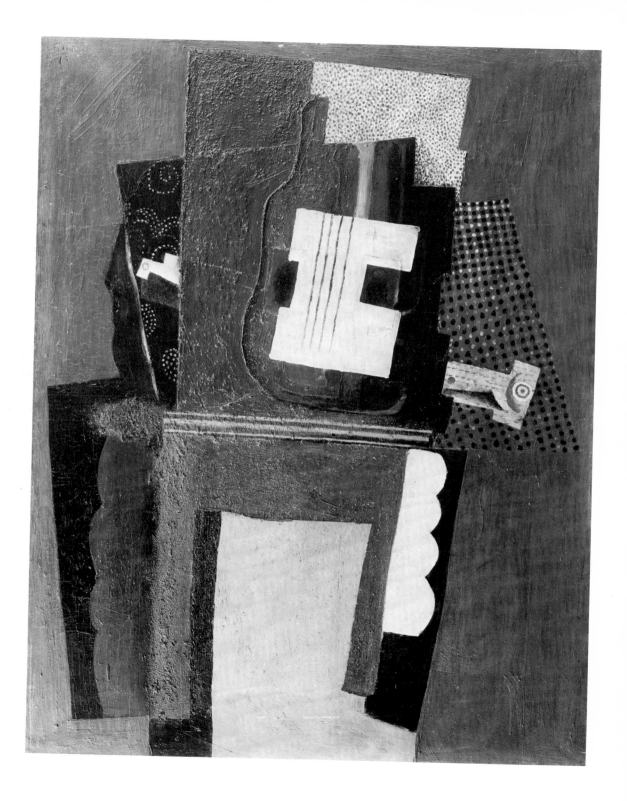

HARLEQUIN. *Paris, late 1915. Oil on canvas, 72¼ x 41⅜ inches. (C&N, pp. 214–15)*

At the end of 1915, when Picasso painted this monumental, disquieting *Harlequin*, his beloved Eva lay dying in a hospital on the outskirts of Paris. In a letter of December 9 to Gertrude Stein, the artist spoke of his anxiety over Eva's illness and described himself as having little heart for work—or even time for it, as he spent much of the day commuting to the hospital by *Métro*. "Nevertheless," he concluded, "I have done a painting of a harlequin which in the opinion of myself and several others is the best thing I have done."[1] This remark, quite uncharacteristic of Picasso, is an indication of the importance he attached to *Harlequin*, a painting which indeed marks the redirection of Synthetic Cubism on the specifically personal path that would culminate six years later in *Three Musicians* (p. 113).

In addition to personal tragedy there was the war. As a Spanish citizen, Picasso was not directly involved with World War I—nor was he profoundly affected by it. But Paris had become an anxious, gloomy city, and among Picasso's friends, Braque, Derain, Léger and Apollinaire had left for duty at the front, Cocteau was in the ambulance corps, and Kahnweiler, a German national, was forced to close his gallery. That Picasso should have chosen to paint a commedia-dell'arte figure at a time of deep personal and general social distress might seem merely a confirmation of the customary hermeticism of his imagery. But a hostile spirit that may well reflect the tenor of the times has slipped into this *Harlequin*. The decorative character of the red, green and tan costume is neutralized by the rigid rectilinearity of the configuration and the somber blacks of the background and figure, which permit chillingly stark contrasts of black and white. In this setting, Harlequin's toothy smile seems almost sinister.

The planes of *Harlequin* are flat, unshaded and broadly brushed in a manner appropriate to the scale of the work. There is, however, a purely schematic and quite whimsical contradiction of this flatness in the parody of perspective by which the diamond shapes of Harlequin's costume increase in size from right to left, a suggestion of bulging reinforced by the curve of his belt. Carried into the lower part of Harlequin's figure, this distortion of what we know to be a regular diamond pattern seems to make his legs buckle under him.[2]

The stylization of the light and shaded areas of figures as contrasting flat planes, already an established convention by the end of 1912, is freely elaborated in *Harlequin* in such a manner that the motley, the blue, the black and the brown-and-white planes all represent the figure, although they are on different levels in space and are tilted on different lateral axes. The angular white side of the head is drolly united with the round black one by their common mouth. Harlequin's white right arm—the fingers indicated by tiny black lines—leans on a piece of furniture; his left hand—articulated by white dots—holds a rectangular white plane, the freely brushed surface of which gives it an unfinished look.

Even study of the many drawings and watercolors that relate to *Harlequin* (p. 214:64–66) does not reveal what, if anything, Picasso might have originally intended for this "unfinished" area. It may have been a sheet of music, as suggested by *Pianist* (p. 215:67); or a guitar, as in *Harlequin Playing a Guitar* (p. 215:68)[3]; or perhaps a painting-within-a-painting. (Although the unpainted buff area of the rectangular plane vaguely suggests a profile, the latter reading is unlikely, and is supported by nothing in the sketches or watercolors.) Whatever Picasso's iconographic intentions here, the decision to leave the plane in its brushy, uneven state set up a pleasing dialogue between it and the flat, relatively even execution of the other parts of the picture, while introducing a note of abandon into the facture that sorts well with the breadth and boldness of the conception as a whole.

The pitching of Harlequin's figure simultaneously on four different lateral axes suggests the motion of the dance—specifically, the stiff, angular, mechanical-toy choreography in works like *Coppelia*. This reading is reinforced by the relation of the simultaneity of axes (and, indeed, by the multiplication of planes denoting the figure itself) to the images of dancing couples (p. 214:66) that date from approximately the time of *Harlequin*.[4] If these studies antedate the painting, they suggest that the configuration of *Harlequin* was arrived at by fusing two figures; at the very minimum, they confirm that Picasso thought of the multiple axiality in terms of a kind of *jaquemart*'s dance.

*Harlequin*'s size, scale and general character represent a departure from earlier Cubism. Prior Synthetic Cubism (1913–14) had retained much of Analytic Cubism's scale and configuration. And to the extent that it involved a decorative transmutation of earlier conventions — e.g.,

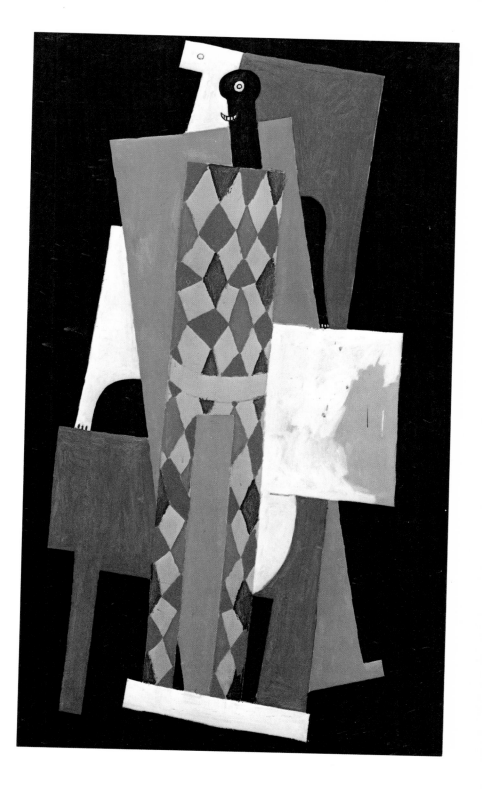

sprays of highly colored pointillist dots for the flickering facet-planes of the monochrome works—it could be considered the other side of the coin of the Analytic style. *Harlequin* breaks with such common denominators and reflects Picasso's realization that the suppression of recessional space in the years 1912–14 had facilitated—indeed, made expedient—a lateral expansion of the picture space, which naturally entailed a more monumental scale than either he or Braque had heretofore explored. The large, simple, flat planes of *Harlequin* are Picasso's entirely personal contribution to the language of Synthetic Cubism, and they pointed in a direction which Braque did not choose to follow when he returned from military service.

STILL LIFE: "JOB." *Paris, 1916. Oil and sand on canvas, 17 x 13¾ inches. (C&N, p. 215)*

*Still Life: "Job"* takes its name from a brand of cigarette papers whose label—with its curious, lozenge-shaped O—Picasso meticulously copied. The picture is notable for the marked contrast between the abstract, flat and rectilinear planes of the upper left and such trompe-l'oeil details as the high-relief, brown wood molding at the middle right. The braided rope and tassels of Picasso's table covering, which are so fragmentary and difficult to read in many earlier Cubist appearances, are here quite legible. The focus of the composition is the bright red ground of the bottle label. The bottle itself—in stippled reds, tans and blacks—already halves the intensity of this red ground, and the eye then passes through muted greens, blues and violets to the grays and browns of the outer edges.

Picasso often referred to his intimate friends—even sent them whole messages—in a kind of cryptic language full of puns, double entendres and neologisms. Proper names were studiously avoided.[1] In this regard it has been suggested that "Job" was the code name of Max Jacob,[2] whose godfather Picasso had become at the poet's baptism a year before this still life was painted. The name "Job" has a biblical connotation appropriate to Jacob's personality (and to the penury in which he and Picasso lived when they shared a room in the boulevard Voltaire in 1902–1903); its three letters not only constitute a contraction of Jacob's name but "Job" was also the brand name of the cigarette papers the poet used.[3]

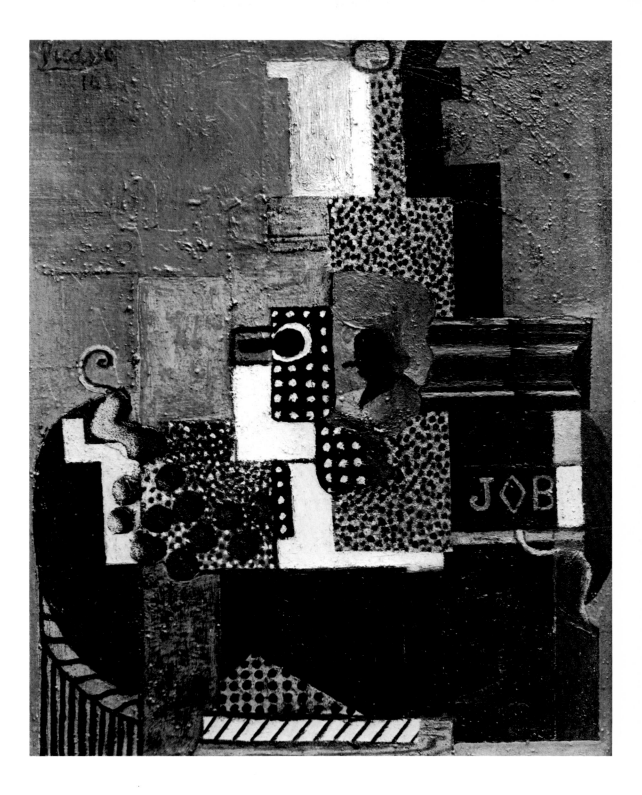

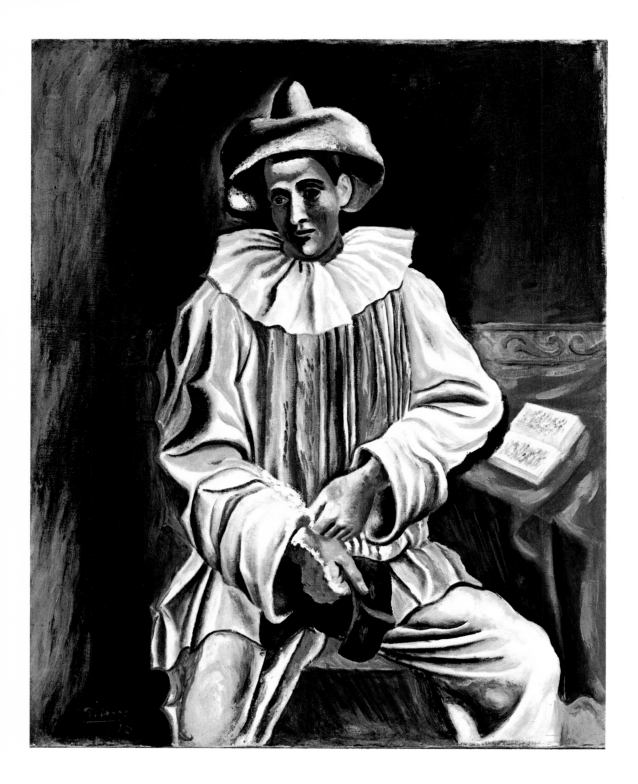

PIERROT. *Paris, 1918. Oil on canvas, 36½ x 28¾ inches. (C&N, p. 216)*

Picasso had worked in a variety of styles up to the outbreak of World War I—almost entirely successively, however. This sequential development was now to change, for the realistic imagery to which he turned in 1915 in no way signaled an end to his use of abstraction. Picasso's simultaneous exploration of many styles from that point on constituted an artistic practice previously unexampled in the history of art.

As his battery of styles diversified through the 1920s and 1930s, Picasso retained the capacity to summon up any one of them—although he usually borrowed fragmentarily from them rather than resurrecting them integrally. While a single style tended always to dominate at any given moment, Picasso could and did work in more than one manner in a single week—or day. The artist has observed that different subjects may require different stylistic means.[1] But the situation is not that simple since Picasso's preferred and rather conventional subjects—the single figure and the still life—were repeated in many different styles. On the contrary, it might be argued that style itself somewhat usurped the prerogatives of subject matter in communicating content. Thus, where an earlier artist would have chosen a battle scene or revel to express violence or sensual delight, Picasso might paint the same still life in an angular, expressionist fashion with hot, clashing colors, or alternatively, in an arabesqued manner with a rich, decorative palette.

Even within the realism with which Picasso explored the theme of Pierrot in different images of 1918 there is a considerable esthetic and expressive range. The line drawing here, for example, has a classic purity, which relates it to many of Picasso's "Ingresque" sketches of the war years. The delicacy and fragility of the line are at one with the airiness and ephemerality of the figure, who seems to exist in a poetic world remote from our own. The slight tilt of Pierrot's head and the inclination of his eyes establish a mood of reverie and nostalgia largely absent from the oil painting.

In the oil *Pierrot*, as in an elaborately modeled pencil study for it (p. 216:70), the sculptural style endows the figure with a more immediate physical presence. Here he is less the evanescent personage of the Italian Comedy than the professional dancer costumed as Pierrot. He has removed the mask that characterizes him when active in

PIERROT. *1918. Silverpoint, 14³⁄₁₆ x 10¹⁄₁₆ inches. (C&N, p. 216)*

his role (p. 216:71), and the passivity of the moment is symbolized by the book opened on the table. In both drawings, Pierrot is pensive and self-absorbed; in the painting he appears peculiarly blank and abstracted. Nor is his facial expression enlivened by the green shadow under the left eye—part of a system of sour complementary greens and reds Picasso used with curious indecisiveness to model parts of the costume, and then moderated to establish a larger contrast between the tablecloth and background. The artist seems to have been much more at home in the drawings of Pierrot than in the painting, in which the handling of the color and the patterning of the drapery on Pierrot's right arm—a scalloping almost autonomous in its shapes—introduce a note of abstraction out of harmony with the realism of the conception as a whole.

Picasso had not painted theatrical performers since 1905, when they were drawn primarily from the circus world. His collaboration with the Russian Ballet, beginning in 1917 (he was to marry Olga Koklova, one of its leading ballerinas, the following year), was the inspiration of a large number of Harlequins and Pierrots. Seen primarily as *saltimbanques* in his earlier work, they are now given the particular costumes and attributes that characterize them in the commedia dell'arte.

GUITAR. *Paris, early 1919. Oil, charcoal and pinned paper on canvas, 85 x 31 inches. (C&N, p. 216)*

This is a work of immense figural as well as formal economy. The heraldic and monumental four-colored diamond against which the paper guitar is pinned has always been read as a purely abstract, decorative motif. But it may be considered the ultimate graphic abbreviation for Harlequin—an interpretation consistent with the relative proportions and dispositions of the guitar and prismatic "figure," and reinforced by the presence, at the appropriate juncture, of the words "urinary tract" (*voie urinaire*) which appear on the band of newsprint.[1] The trompe-l'oeil frame with which Picasso surrounded the picture may also have been inspired by his desire to thwart a consideration of the image as primarily a décor.

The diamond-shaped figure, the black background from which it emerges (cf. *Harlequin*, p. 99), and the frame are executed in oil on canvas. The sheet of paper on which the guitar is drawn is attached to the canvas by real pins, which are visible only at close range. We are asked rather to imagine that this sheet is tacked at the top center by a nail, which is in actuality a paper cutout shaded in trompe l'oeil, bent out at a slight angle to "cast" a simulated shadow and pinned to the canvas in the same manner as the guitar. Braque and, soon afterward, Picasso had introduced trompe-l'oeil illusions of nails and their shadows in their high Analytic Cubist pictures. Critics have usually associated this practice with the artists' desire simply to reinvest the image with "reality," a motivation that subsequently led them to introduce lettering and then collage. But the trompe-l'oeil nails had another, more subtle purpose—that of distinguishing by contrast the special nature of Analytic Cubist space. Painted in a conventionally illusionist manner, they predicated a second, "naturalistic" spatial layer above the unconventional, ambiguous, abstract (but ultimately also illusionist) space of the remainder of the picture. In *Guitar*, the nail serves a comparable exegetical purpose within the framework of Synthetic Cubism. Since it is not a real nail, it belongs to the world of representation. Yet as a piece of paper pinned *on top* of the canvas and bent outward from it, it forces a distinction between the lateral space of the picture plane and the "relief" space in front of it.

The guitar itself is represented by a combination of three strings crossing a sound hole and a black shadow whose right contour determines the curvilinear front of the instrument and whose left defines its rectilinear back plane. The indented or "notched" pattern of the latter is echoed by the right-hand contour of the pinned paper and by the corners of the painted frame.

*Guitar* was dated 1916–17 in Zervos' catalogue raisonné, but the strip of newspaper pinned to the bottom of the guitar to represent its shadow is dated February 11, 1919.[2]

SEATED WOMAN. *Biarritz, 1918. Gouache, 5½ x 4½ inches. (C&N, p. 216)*

The seated figure—particularly the seated woman—has been a central theme in the work of Picasso since his student days in Spain. The artist has re-created the subject in a wide range of styles as exemplified by the two works on this page, both executed during the same year. The design of the small gouache is typical of many of Picasso's Synthetic Cubist works after 1915, in which the composition is articulated along two diagonal axes and planes seem to be laid lightly upon one another in shallow space.[1] Here various areas of the composition are integrated in part by the repetition of stylized motifs. In some cases, the symbolic meaning of these forms is sometimes suggested by their shape, in others, by their position or their symbolic role in Picasso's other work. Often, of course, the meaning is ambiguous or unassignable. In addition to their formal uses, the circles in this composition have a wide range of metaphorical implications—a face on dark hair or the aperture of a mask; a heart or breasts, fists or chair knobs; feet or footstools (both of the latter were explicitly drawn in previous versions of this theme). The principal colors of this work are browns, yellows, blues and oranges, relieved by olive-green and tan and accented by one red spot. *(Elaine L. Johnson)*

RICCIOTTO CANUDO. *Montrouge, 1918. Pencil, 14 x 10⅜ inches. (C&N, p. 217)*

Although an expert draftsman in the traditional sense, Picasso had rarely drawn "realistic" portraits between 1906 and 1914. This one represents a type of composition he rendered frequently in the years immediately following that period of extraordinary innovation. Many of its qualities—the sitter's pose, the gesture of his left hand, and most important, the use of fine line to delineate all forms and surface incidents—recall the work of Ingres.

Canudo (1879–1923), an Italian, had been part of Picasso's circle in Paris since 1902. He was a novelist, music and film critic, and co-founder of the Cubist-oriented publication *Montjoie!* During the war, which disbanded the Cubist group, he was a member of the Garibaldi Corps and was later in the Zouaves. *(Elaine L. Johnson)*

Two Dancers. *London, summer 1919. Pencil, 12¼ x 9½ inches. (C&N, p. 217)*

Sleeping Peasants. *Paris, 1919. Tempera, 12¼ x 19¼ inches. (C&N, p. 217)*

*Sleeping Peasants* reflects an aspect of Picasso's study of Ingres quite different from that which we see in many of his classical line drawings. Here, in the foreshortened head and upper torso of the woman's figure there are mannered effects reminiscent of the French painter's late style, as exemplified by his *Bain turc*.[1] But the effect of Picasso's drawing is more monumental, and in that respect this small gouache anticipates his more colossal "Roman" or "Pompeiian" figures of the early twenties (pp. 115, 117).

Comparison of the finished picture with its preparatory drawing (p. 217:72) provides a lesson in the functioning of a master composer. In the background, a house has been added, whose rectilinear flat planes act as a foil for the sculptural and organic forms of the peasants. A number of changes have made the painting's composition more compact, interlocking its two figures in a more mutually sustaining manner. The young man's right elbow has been extended so that it abuts the right knee of the girl, while his left leg has been placed in front of his right one and swung over to support her head. The girl's right calf and both of the boy's arms have been rendered abnormally broad. In combination with their sculptural modeling, these colossal members endow the figures with epic weight and solidity.

This bulk makes them seem very much of the earth they work, tying them closely to the cycle of nature, to which they are also bound by the sunlight that permeates the scene. The heat of the sun and the exaggeration of the figures' mass also intensify the sense of exhaustion in their sleep. It is as if the feeling of great weight in their tired bodies had found its counterpart in their shapes. We imagine their prior lovemaking—implied by the disposition of their bodies—to have been primal in nature, more procreative than erotic. (That Picasso's own associations were of this order is suggested by his use of the face of this same peasant girl, similarly foreshortened, in a *maternité* drawn at about this time, p. 217:73.)

NESSUS AND DEJANIRA. *Juan-les-Pins, September 1920. Pencil, 8¼ x 10¼ inches. (C&N, p. 217)*

In September 1920, while vacationing at Juan-les-Pins on the Mediterranean, Picasso executed five drawings and a watercolor based on the theme of the centaur Nessus' attempted rape of Hercules' bride Dejanira while ferrying her across the river Evenus. On the Riviera years later he observed: "It is strange, in Paris I never draw fauns, centaurs or mythical heroes . . . they always seem to live in these parts."[1] Picasso read and illustrated classical stories frequently during the twenties and thirties (this one is recounted in Ovid's *Metamorphoses*, which he would illustrate in 1931), but he generally used mythology as a point of departure for personal glosses and private fantasies. In the watercolor version of this theme (p. 217:74), for example, Nessus is restrained by a satyr who is entirely the artist's invention. As graphic projections of man's primitive energy and potential violence the classical combinations of man and beast such as the centaur and Minotaur especially interested Picasso; they also pleased him, as he loved to draw animals.

In the first version of this subject, dated September 11 (p. 217:75), the drawing is rapidly executed and nervously contoured; Nessus' lip-smacking leer is almost caricatural. In the Museum's more restrained drawing, executed the following day, the line is smoother and more continuous, hence more "classical" in appearance. Although the postures of the protagonists are substantially the same in the two versions, Picasso has here introduced refinements such as the foreshortening of Dejanira's right foot and the alignment of her chin with Nessus' back.

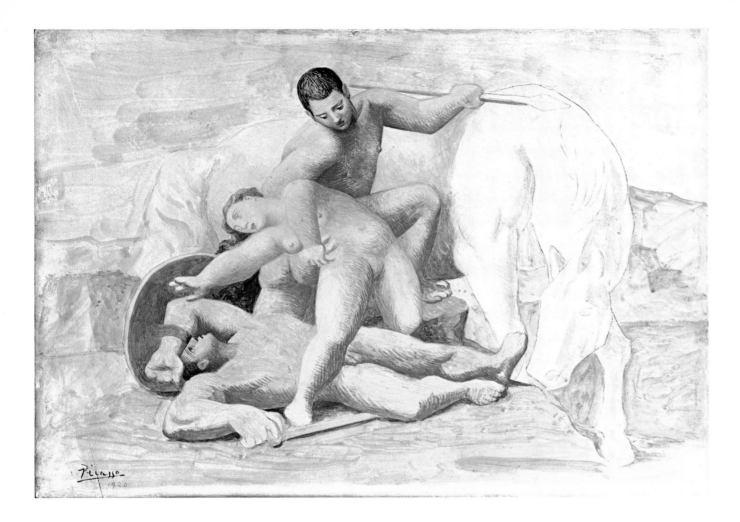

THE RAPE. 1920. *Tempera on wood, 9⅜ x 12⅞ inches.*
(*C&N, p. 218*)

We do not know if this picture was intended to illustrate
a particular ancient story such as the Rape of the Sabines,
but its monumental, triangular figure group unquestion-
ably evokes antique sculpture. The dead warrior in par-
ticular harks back to the figures in the angles of ancient
Greek pediments, even as he anticipates the soldier of
*Guernica*. The proportions of the figures are not classical,
yet it is precisely their exaggerated bulk which, like their
terra-cotta color, makes them seem more like sculptures
than living figures. The setting and background consti-
tute a somewhat dematerialized foil that projects the
plastically modeled figure group forward, the chalky
white of the horse and the pale brown and blue of the
earth and sky enhancing its terra-cotta tones by contrast.

The nature of Picasso's line cast Nessus' rape of De-
janira as a lively, psychologically animated, narrative
episode. In *The Rape*, the figures' simplified, almost "ar-
chaic" contours, insistent sculptural bulk and reserved
expressions make them seem stolid and almost inanimate
by comparison—as if frozen in the enactment of a time-
less mythological event.

THREE MUSICIANS. *Fontainebleau, summer 1921. Oil on canvas, 6 feet 7 inches x 7 feet 3¾ inches. (C&N, pp. 218–19)*

In the garage of the villa he rented at Fontainebleau for the summer of 1921 Picasso painted three very large canvases: this and another version of *Three Musicians* (p. 218:76), and their neoclassical counterpart, *Three Women at the Spring* (p. 115). The exceptional size and classical ternary form of these compositions and the solemn, almost hieratic demeanor of their figures suggest that Picasso intended these pictures not only as summations of his contrasting Synthetic Cubist and classical realist styles, but also as personal challenges to the monumental art of the past.

*Three Musicians* plays a role in Picasso's oeuvre different from that of its colossal predecessor of fourteen years earlier, *Les Demoiselles d'Avignon*. In the course of its execution, *Les Demoiselles* had evolved from a summation of earlier work to departure toward the new—an exploration left unfinished, and resolved only in succeeding paintings. *Three Musicians*, on the other hand, represented a magisterial recapitulation of the artist's powers, rather like a "masterpiece" in the old guild sense. Picasso made no studies for either version of *Three Musicians*; the whole history of Cubism, particularly that of the five preceding years, had prepared him for them.[1]

Although there are no studies for *Three Musicians*, certain of Picasso's Synthetic Cubist pictures of 1920 anticipate its pairing of Harlequin and Pierrot in frontal poses. In some of these, the two hold musical instruments (p. 219:79); in others, they are seated at a table (p. 219:80). Both motifs are combined in *Three Musicians*, where Pierrot plays a recorder (or clarinet) and Harlequin a guitar, and both are seated at a table on the brown top of which are a pipe, a package of tobacco and a pouch.[2] (These small objects and, even more, the mini-hands of the figures establish the monumental scale of the composition through their contrast with the large panels of color.) The barefooted monk, or domino, on the right—the addition of whom made *Three Musicians* Picasso's first three-figure Synthetic Cubist composition—sings from a score held in his hands.[3] The monk is totally unanticipated in prior work save for a charcoal sketch (p. 219:81) dating from shortly before the painting and showing him in a very different pose.

The three maskers are realized in flat planes whose angularity recalls the *papier collé* origin of the Synthetic Cubist morphology. Their zigzag contours, in combination with sudden transitions of value and hue, suggest the sputtering cacophony of their serenade. The colored shapes are less jigsawed in a single plane than laminated on top of one another, although the order of their layering is not wholly consistent. (The blue, for example, is in front of Pierrot's white costume above the table but behind it under the table.) Shapes overlap increasingly toward the center of the composition in a progression that recapitulates in Synthetic Cubist terms the graduated opacities from background to foreground planes in the Cubism of 1910–11. Thus, despite the similar magnitude of the three figures, there is a clear staging in the sizes of the picture's constituent shapes from the framing edge to the center of the composition.

The centrality resulting from this progression is paralleled in the quantification and location of the color. Browns govern the margins of the picture absolutely and are present throughout. Black and white, next in the order of quantity, begin only at some distance from the right and left edges of the field respectively and cut across each other. (Thus, while the monk is largely black and Pierrot primarily white, the blacks are echoed in the latter's arm, mask, pipe and pouch, while the former's sheet of music is white.) Blue panels, few in number, comprise slightly less surface area than the black or white and are concentrated closer to the center of the composition. Finally, the only bright hues—the yellow and orange of Harlequin's costume and guitar—are centered near the vertical axis of the composition (and are less dispersed than any other tones from the horizontal axis as well). Such a compositional hierarchy, in combination with the iconic frontality and frozen postures of the figures, might seem more appropriate to a Byzantine *Maestà* than a group of maskers from the commedia dell'arte; but it is precisely this structuring that informs the monumentality of *Three Musicians* and endows it with a mysterious, otherworldly air.

As there is neither modeling in the paper-thin figures nor atmospheric shading in the space around them, the picture is devoid of any illusionism that might compromise its flatness. There is, however, a purely schematic indication of space—a boxlike "room" in which the figures are understood to be standing. Its perspective orthogonals are determined by the edges of the variously lit brown planes that represent the floor, side walls and ceiling. The

system is not consistent, however, for the horizon line is higher on the left than on the right.

That this space is finally a kind of stage space recalls the theatrical antecedents of *Three Musicians*. The frequent appearance of commedia-dell'arte figures in Picasso's work of the years just previous to this picture stemmed from his collaborations, beginning in 1917, with the Russian Ballet. Of these, the most important for *Three Musicians* was the ballet *Pulcinella*—its choreography based directly on commedia-dell'arte types—which Diaghilev produced the year prior to Picasso's summer at Fontainebleau. The score was a reworking by Stra-

vinsky of music by Pergolesi, and its fusion of "antique" and modern is echoed by the hieratic mode within the Cubist orchestration of Picasso's composition.[4]

The viewer's conceptual reconstruction of the subject from the ideographs that identify its parts is readily accomplished, except perhaps in the case of the much-segmented dog under the table, who is easily overlooked. This interpolation from Picasso's domestic life is also the central motif of an important picture titled *Dog and Cock* (p. 219:82), painted in Paris either just before or just after the summer at Fontainebleau. While in the latter picture the dog strains, mouth watering, toward the cock on the table, in *Three Musicians* it lies quietly, as if charmed by the sounds of the nocturnal music.

The dog in *Three Musicians* is a whimsical motif plastically as well as iconographically. To form its gestalt we must first distinguish the particular brown tone of its head from the four other browns that adjoin it. Then this shape must be assembled with the segmented forelegs (to the left of the leg of the red-brown table), the body and rear leg (framed by Pierrot's white trousers) and the drolly isolated tail (projecting between the Harlequin's legs). The dark-on-dark treatment of the dog is reminiscent of Manet's handling of the cat in *Olympia*, where in order to distinguish the animal we must make fine discriminations at the dark end of the value scale. In the Manet, as here, the composition combines the nuancing of close values with a bold, posterlike contrast of light and dark that is made all the more dramatic by the suppression of the middle tones.

THREE WOMEN AT THE SPRING. *Fontainebleau, summer 1921. Oil on canvas, 6 feet 8¼ inches x 7 feet 3¾ inches. (C&N, p. 220)*

This capital example of Picasso's neoclassicism is as comfortable a configuration as that of *Three Musicians* is taut. Although its rhythms turn gracefully around the superb play of hands in the center, its pictorial pleasures reside less in the lateral adjustment of the composition

than in its compelling illusion of sculptural relief. Picasso's isolation of this quality through bold and simplified modeling—at the cost of complex lateral articulation and rich pictorial detail—suggests a limited kinship with the "primitive" early Cubism of 1908, as well as with certain post-Gosol works such as *Woman Combing Her Hair* (p. 37) and *Two Nudes* (p. 39). As in all such works the sculptural effects are finally, however, those of relief—as opposed to modeling in the round—as is seen in Picasso's dissolution of the solids of the three women into the patterning of the composition as a whole.

The classicism of *Three Women at the Spring* may be more one of motif and mood than of esthetic structure, though the pneumatic volumes of the women do recall—at a considerable remove—certain monumental paintings the artist saw on a visit to Pompeii in 1917. Picasso's figures do not have the ideal features or proportions of classical Greek art. Nor does their superhuman size have any kinship with the protean figures of Michelangelo—which seem to achieve their magnitude through an exteriorization of passion and energy. Michelangelo's Sibyls are muscle and sinew; Picasso's women are terra cotta and marble.[1] It is precisely their architectural character—the folds of drapery are like the fluting of marble columns—that endows the picture with its conviction of order and stability.

The theme of women at a spring or fountain was possibly suggested by the very name of the town (Fontainebleau) in which Picasso and his family were spending the summer.[2] There are at least nine drawings and paintings of this subject (p. 220:83, 84) that precede the Museum's *Three Women at the Spring*, as well as seven sketches for the hands and heads alone. In addition, there are three allegorical drawings (of which the Museum possesses one, p. 116) and a painting that proceed from the same general inspiration.

Many of the preparatory studies for *Three Women at the Spring* show the central woman standing in front of the stone fountain. But only by hiding her lower torso could Picasso clear the center space for the play of hands. As the sketches progress, both the woman on the right (whose hands hold her crossed legs in earlier versions) and the woman on the left are inclined increasingly toward the center of the field. The marvelous charcoal sketches for the former's two hands (p. 220:85, 86), one holding the jug, the other on her lap, have an even greater plasticity than the rendering in the painting.

SEATED WOMAN. *December 1926.*
*Oil on canvas, 8¾ x 5 inches.*
*(C&N, p. 222)*

SEATED WOMAN. *Paris, 1927. Oil on wood, 51⅛ x 38¼
inches. (C&N, p. 223)*

Picasso explored the potential of the "double head" from
1925 to 1927 in a series of Seated Women of which the
picture on the right is at once the most beautiful and most
unsettling. The patterns of curvilinear Cubism, exploited
for their purely decorative rhythms in such works as the
monumental *L'Atelier de la Modiste* of 1926 (p. 223:98),
are here put in the service of psychological expression to
create "an ideogram of neurosis, threat and domination."[1]
The arabesques that define the figure also enclose and in-
hibit her, producing a sense of isolation and repression
heightened by both the painted interior frame and the
manner in which the rectilinear wall molding presses in
upon her silhouette. In the coloring, whose partial trans-
parency is suggested by the changes that take place
where shapes overlap, the heretofore largely decorative
harmonies of curvilinear Cubism have soured into uneasy
dissonances (orange-red against pink, rose and deeper
red) that prepare us for the terror-filled face.

The front face of the woman disappears into shadow.
We see only her anxious inner profile which, like the
visible crescent of the moon, implies the contours of the
more remote darkened area. The terror in the face is ex-
pressed by her shrunken right eye—a tiny point as com-
pared to the circle of the left one that stares at us from
the shadows—and by her recessive mouth and chin, a
particularly expressive form of the profile within the
double head to which Picasso would return in the re-
flected image within *Girl Before a Mirror* (p. 139).

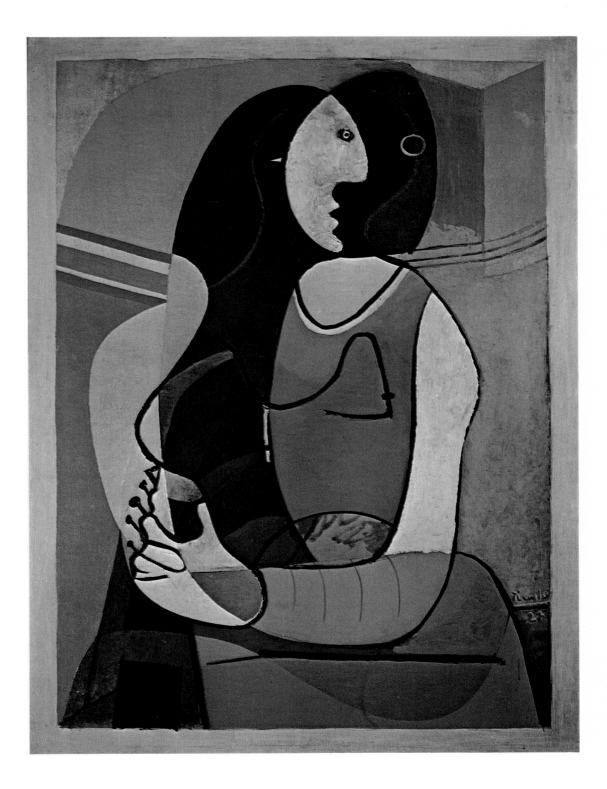

PAGE O FROM LE CHEF-D'OEUVRE INCONNU BY HONORÉ DE BALZAC. *Wood engraving by Aubert after a drawing by Picasso, 1926; published 1931; 13 x 10 inches (page size). (C&N, p. 223)*

PAINTER WITH MODEL KNITTING FROM LE CHEF-D'OEUVRE INCONNU BY HONORÉ DE BALZAC. *Paris, 1927; published 1931. Etching, 7⁹⁄₁₆ x 10⅞ inches. (C&N, p. 223)*

During 1926 Picasso filled a sketch book with ink drawings unlike any he had made before. They are constellations of dots connected by lines or, better, lines with dots where the lines cross or end. A few vaguely suggest figures or musical instruments, others seem abstract. Some are small and simple, arranged three or four to a sheet; some like the one opposite grew and spread over the page. All seem done absentmindedly or automatically as if they were doodles.

Later, sixteen of the pages were reproduced by woodcut as a "kind of introduction" to a special edition of Balzac's *Le Chef-d'oeuvre inconnu*, published in 1931 by Vollard. In this volume, one of the most remarkable illustrated books of our time, Vollard printed woodcuts of many other Picasso drawings both cubist and classic.

Picasso also made a dozen etchings especially for *Le Chef-d'oeuvre inconnu*. The one above comes nearest illustrating Balzac's story of the mad old painter who spent ten years upon the picture of a woman, little by little covering it over with scrawlings and daubings until what seemed to him a masterpiece was to others meaningless.

Curiously, Balzac's tale begins in the year 1612 before a house on the rue des Grands Augustins, the very street where Picasso was to take a 17th century *hôtel* for a studio in 1938. *(Reprinted by permission of Alfred H. Barr, Jr.)*[1]

THE STUDIO. *Paris, 1927–28. Oil on canvas, 59 x 91 inches. (C&N, p. 223)*

Although the iconography of Cubist still life sometimes reflected the ambience of the atelier, Picasso seldom painted his studio as such before 1918, and even the images of his working area executed in 1918–21 are little more than records of his surroundings.[1] Only in the mid-twenties did the motif come into its own, when the theme implicit in the methods and facture of Cubism—the process of painting—was associated explicitly by Picasso with the image of the painter at work. In a print for Balzac's *Le Chef-d'oeuvre inconnu* (p. 127) probably etched shortly before *The Studio* was begun, the artist and model were imaged realistically while the picture on the easel was abstract. In this monumental treatment of the theme —which, as an allegory of the relationship of the artist to reality, recalls Velásquez' *Las Meninas*[2]—both the painter and the still life he contemplates are abstract, and the canvas is blank.

The artist is very sparingly imaged. His legs are indicated by two parallel vertical lines; two shorter parallel horizontal lines signify his arms. The back view of his body is almost an isosceles triangle, the right edge of which is common to an inverted right triangle that denotes his body's side view. The roundness of the artist's head is summarized by a gray oval into which a shape recalling the angularity of the salient features intrudes; a third eye, which displaces his mouth, may suggest his visual perspicacity.[3] The imaging of the palette, which is indicated solely by its thumb hole, epitomizes the economy of the whole.[4]

The artist, whose right hand holds a brush, is about to draw the still life at the right, which consists of a fruit bowl and a plaster head on a table partially covered with a red tablecloth. The elements of roundness and angularity in the plaster head are abridged into straight-edged and oval shapes as in the head of the artist. And although its eyes are again vertically arranged, there are only two of them.

Although Cubism had been from the start an art of straight-edged planes that tended to echo the architecture of the frame, the extremes of rectilinearity and economy to which Picasso carried this large picture are less an extension of earlier formulations than a direct counterstatement to the curvilinear Cubism of the two preceding years as we see it in such pictures as *L'Atelier de la Mo-*

diste (p. 223:98) and *Seated Woman* (p. 125). At the same time, *The Studio* is also the two-dimensional counterpart of the pioneering rod and wire sculptures (p. 223: 100) that Picasso completed in the same year. Linear parallelism, and emphasis upon simple straight-edged polygons set off by an occasional circle or oval also characterize these sculptures; they represent the final stage in Picasso's search for sculptural transparency, achieved by delineating only the edges of planes so that the spectator, in effect, looks through them. A not unrelated transparency in *The Studio* makes the green apple visible inside the bowl and allows us to see the yellow canvas through the body of the artist. Other planes such as the darkly shaded section of the red tablecloth suggest the characteristic Synthetic Cubist "folding out" into the picture plane of forms oblique to it in actual space.

Whatever schematic clues Picasso gives for the spatial relationships of the objects in *The Studio*, he totally eschews perspective cues and modeling so as not to qualify the insistent flatness of the composition; lines that would elsewhere in his imagery have converged as orthogonals are here made parallel. The flatness of the space is further assured by the continuity of the linear network through forms which we know to be located on different planes in space. Thus, the diagonal which separates the red tablecloth from the gray tabletop continues through both planes of the fruit bowl to touch the corner of the mirror (or picture frame) on the rear wall.

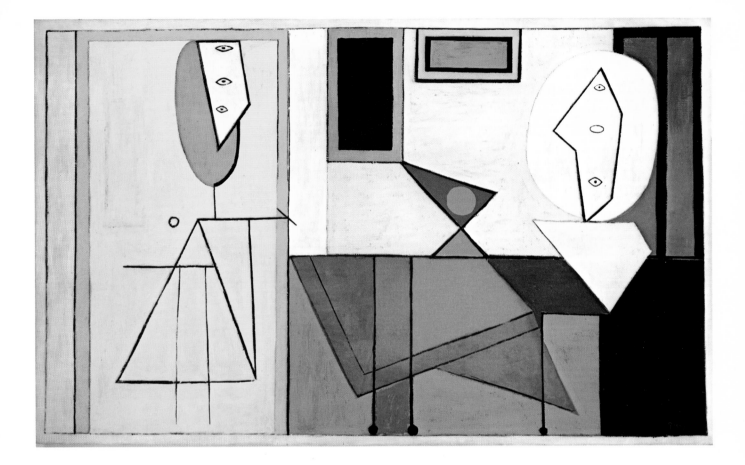

PAINTER AND MODEL. *Paris, 1928. Oil on canvas, 51⅛ x 64¼ inches. (C&N, p. 224)*

The spare rectilinear geometry of *The Studio* gives way in this elaboration of the same subject to a morphological variety that includes the organic (the painter's brown palette) and the decorative (the floral pattern of his rust-colored chair).

The artist is seated at the right on a chair, the passementerie cords of whose arm form a series of black parallel lines at the bottom of the canvas. His head bears a close resemblance to a painted metal sculpture (p. 224:101) of the fall of 1928.[1] In both works an inverted triangle is cut from the top center of the oval of the head, the apex of this negative triangle being also that of the triangle of the nose just below. In both also the oval is divided vertically to represent the light and shaded halves of the face, the light side in *Painter and Model* being turned logically toward the blue window. The features and limbs of the painter have been considerably displaced. His eyes, superimposed on his nose, are one above the other. As in a sketch for the sculpture (p. 224:102)—though not in the sculpture itself—his mouth is represented as a vertical vaginal slit with small hairs on either side. This secondary sexual double entendre is intensified by the rigidly phallic character of the painter's arm, which projects from a point as close to his waist as to his neck, and is in keeping with the general context of the hallucinatory sexuality in Picasso's work of the late twenties. The same type of mouth, in combination with the triangular nose and vertical eyes, appears in a female figure (p. 224:103) executed around the same time as *Painter and Model*.

The interchange or substitution of sexual parts within a single figure, or between male and female, is not uncommon in dreams, as Freud observed, and was already being explored by Surrealist painters, though generally in a more literal and self-conscious way. The nature of Picasso's abstract sign language facilitated such displacements,[2] and it may be that he was encouraged in this by the equation of facial features with sexual members in the art of Oceania, of which the shields, in particular, have been associated with the patterning of the heads of *Painter and Model*.[3]

The model, shown in profile at the left, is usually considered to be an integral female figure. However, the molding that traverses her at shoulder height suggests that the artist in the picture may be working from a female portrait bust propped on a stand.[4] This female face possesses the third eye—aligned vertically with the other two—that had characterized the painter in *The Studio*. As the artist studies this abstract head, the profile he draws on the canvas is realistic—a whimsical reversal of the familiar situation as we see it in the etching for *Le Chef-d'oeuvre inconnu* (p. 127). The conceit that the placid classical profile within the artist's picture disguises quite another personality was elaborated a year later in a picture where the expressionistic profile of a demonic woman is set within the serene outlines of the classical head in a picture on the wall behind her (p. 224:104).[5]

The artist's canvas is aligned vertically with the window behind it so that the white divider of the latter is prolonged as a vertical black panel into the grisaille picture-within-a-picture, and the left edge of the window frame is extended as the left edge of the stretcher. These continuities permit the artist's canvas, which is posed obliquely to the picture plane, to be locked into the flat surface design. Given the marked abstraction of this picture, Picasso's indication of the tacks on the side of the artist's stretcher—a motif of vertical dots echoed on the axis of the painter's upper torso where they suggest rivets—strikes a jocose note. The picture-within-a-picture includes, in addition to the model's profile, a schematic representation of an apple, probably the green one visible on the table to the left of his canvas. As a circle with a dot in the center it also lends itself to being read as a displaced breast. This breast-fruit symbol, together with the organic shape of the palette, emerge—in the context of the female profile—as early intimations of Picasso's vocabulary for translating the unconscious reverie of the body, which we see fully developed in *Girl before a Mirror* (p. 139).

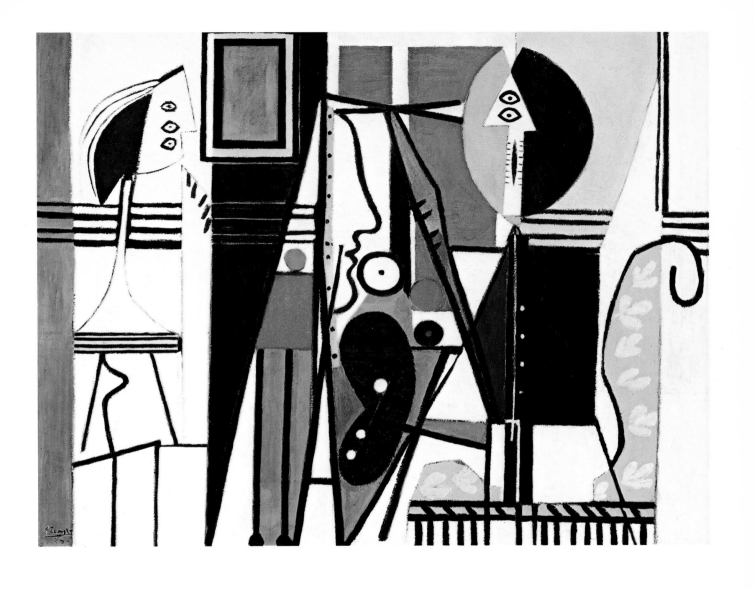

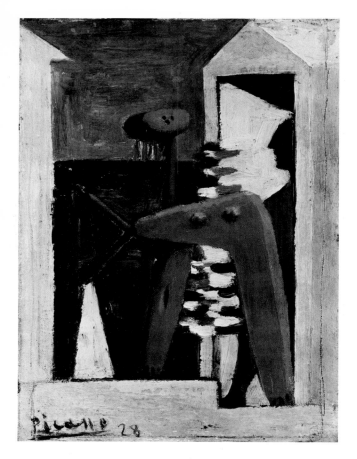

BATHER AND CABIN. *Dinard, August 1928. Oil on canvas, 8½ x 6¼ inches. (C&N, p. 224)*

At Cannes in the summer of 1927 Picasso had begun to explore biomorphism in a series of drawings of ectoplasmic female bathers (p. 225:105) that were highly sculptural in their shading and that not surprisingly culminated in the bronze (p. 225:106) executed the following winter in Paris. Picasso's responsiveness to the newly emerged Surrealist avant-garde is reflected in his adoption of this form-language, which had allowed the painters of the movement to metamorphose the body into an image of hallucinatory sexual intensity.[1] Biomorphism had already been exploited in flat patterns by Miró in painting during the three years previous, but he had not yet translated such shapes into sculpture. Picasso's forms, however, are closer in their sculptural quality (though not in their morphological particulars) to those of Tanguy, whose

earliest paintings he certainly knew, at least through reproductions in the review *La révolution surréaliste.*

By the summer of 1928 when, at Dinard, Picasso painted *Bather and Cabin,* the metamorphic, single-celled bathers of the previous year had given way to others whose monumental forms resemble great weathered dolmens assembled in Stonehengelike grandeur (p. 225:107). Although *Bather and Cabin* is of this latter series, its anecdotal character and the small size of the bather relative to the cabin make it, rather, an intimate work. The theme common to most of the Cannes drawings is revived as the female bather places her key in the cabin door. Preoccupation with insertions of keys is a Freudian commonplace, and its association with the theme of sexuality is rendered specific in this picture by the presence of a man whose silhouette is visible in the cabin opposite. The sexuality is heightened by the fact that the female bather's striped bathing suit—standing autonomously like a totem to the right of her figure—leaves her breasts and vulva uncovered as, towel in hand, she looks back apprehensively at the man while struggling to insert her key. "I like keys very much," Picasso is reported to have said much later. "It's true that keys have often haunted me. In the series of bather pictures there is always a door which the bathers try to open with a huge key."[2]

SEATED BATHER. *Early 1930. Oil on canvas, 64¼ x 51 inches. (C&N, p. 225)*

In *Seated Bather* we are confronted by a hollowed-out creature whose hard, bonelike forms are at the opposite end of the spectrum from the early Cannes Bathers; they were all rubbery flesh, she is all skeletal armor. While she sits in a comfortable pose against a deceptively placid sea and sky, the potential violence that Picasso finds in her (and increasingly in all his female figures—probably a reflection of the difficulties that had surfaced in his marriage to Olga) is epitomized by her mantislike head, which combines the themes of sexuality and aggression. The praying mantis, who devours her mate in the course of the sexual act, had been a favorite Surrealist symbol; as a number of Surrealist painters and poets collected mantises, they could hardly have escaped Picasso's notice. The menacing nature of the bather is intensified by her beady eyes and daggerlike nose, but above all by her viselike vertical mouth, Picasso's personal version of a favorite Surrealist motif, the *vagina dentata.*

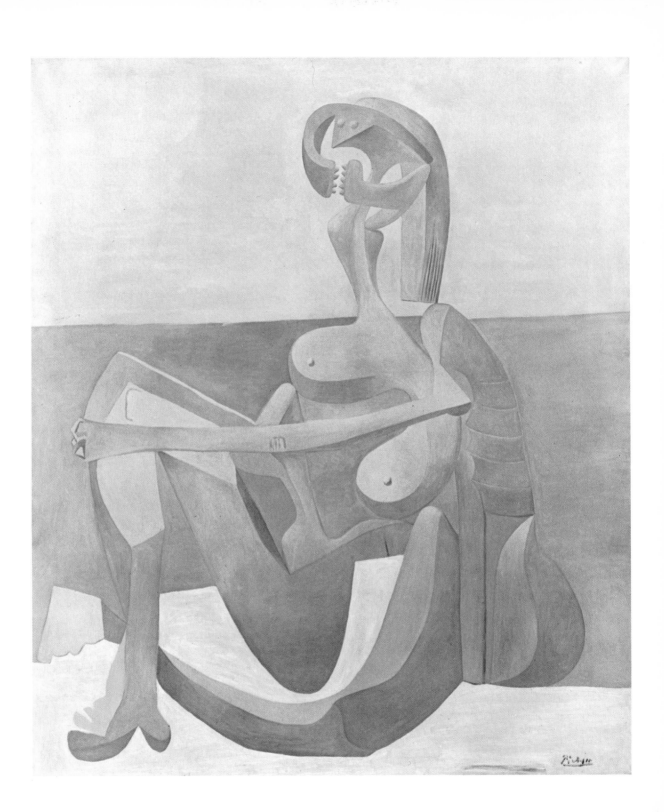

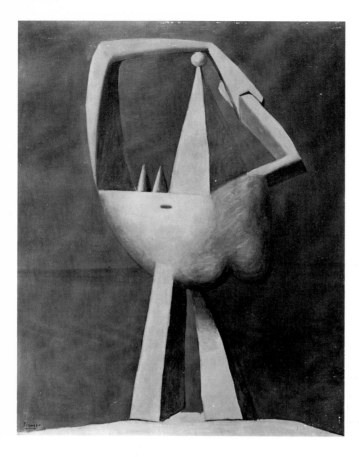

WOMAN BY THE SEA. *April 1929. Oil on canvas, 51⅛ x 38⅛ inches. (C&N, p. 225)*

The female bather in *Woman by the Sea*, a monument of cast-cement orotundity, stands with her arms over her head, like a granite nightmare of a Matisse odalisque. The tiny head and broad buttocks recall the Cannes Bathers, but the manner in which the droll conical breasts sit upon the shelf of the chest and echo the architecture of the legs belongs to the more monumental spirit of the Dinard series. The hard, erect, and pointed shapes of the breasts have obvious phallic connotations and, indeed, from their very beginnings in 1927 Picasso's Bathers, like the primordial self-sustaining amoeboid creatures they were, tended to arrogate to themselves the appurtenances of both sexes. It is perhaps Picasso's ability "to incorporate into a single form the elements of both male and female sexuality, and yet to leave each image so unequivocally itself that both separates Picasso's vision from that of the Surrealists and yet enables him to achieve some of their aims so powerfully and independently."[1]

PITCHER AND BOWL OF FRUIT. *February 1931. Oil on canvas, 51½ x 64 inches. (C&N, p. 225)*

The increasing hostility and violence in Picasso's imagery of the later 1920s, which reached its apogee in such works of 1930 as *Seated Bather*, disappeared temporarily from his art early in 1931 when he embarked on a series of colorful still lifes whose cheerfulness might reflect the artist's first contacts with Marie-Thérèse Walter.[1] It is almost as if Picasso wished to reaffirm a certain aspect of his spirit and his art in this virtuoso exercise in decorative painting—his closest approximation ever to the purely French side of the *Ecole de Paris*.

The sculpturesque effects common in Picasso's work of the three previous years give way here to flat patterning rendered all the more two-dimensional by the wide black contours that resemble the leading of stained-glass windows. Even within these black dividers, the planes of round forms such as those of the pitcher and apples are denied any illusion of convexity by the traceries of near-straight, colored lines that crisscross them. The color is laid on in a luxuriant impasto, with the light and shaded passages of objects stylized into panels of neighboring colors (the yellow and orange of the pitcher) or contrasting values of the same color (the light and dark greens of the tablecloth).

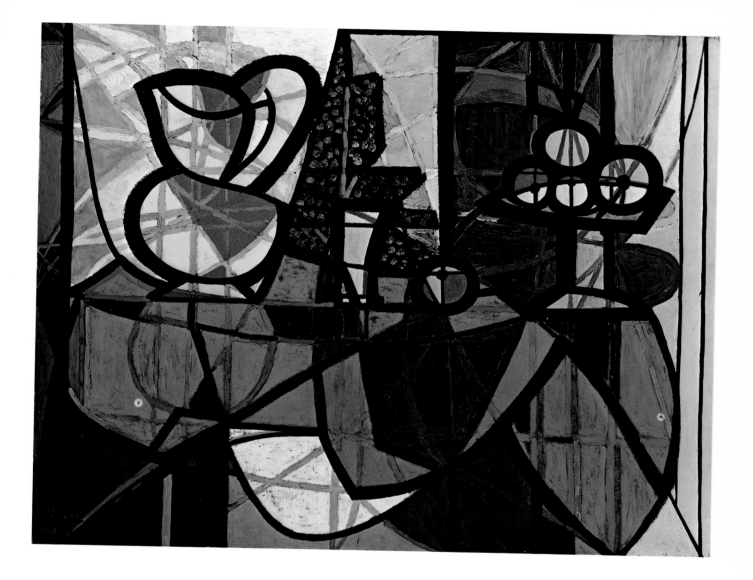

GIRL BEFORE A MIRROR. *March 1932. Oil on canvas, 64 x 51¼ inches. (C&N, pp. 226–27)*

This modern re-creation of the traditional Vanity image is as fascinating in its multilevel poetic allusions as it is coruscating in its color and design. The balance and reciprocity of the expressive and the decorative here set a standard for all Picasso's subsequent painting—indeed, for twentieth-century art as a whole.

Such equilibrium had not especially characterized Picasso's art in the years just previous. Erotic and psychological expression in the Bathers of the late twenties (pp. 133, 134) had been achieved at some cost in pictorial richness and complexity. Pure decorative virtuosity, on the other hand, had almost become an end in itself in pictures such as *Pitcher and Bowl of Fruit* of 1931 (p. 135). Picasso's resolution of these divergent tendencies in *Girl before a Mirror* did not proceed wholly from the processes of painting. In all probability, its catalyst was his love for the luxuriantly sensual Marie-Thérèse Walter, the inspiration for *Girl before a Mirror,* whose image had first appeared in paintings of the previous year.[1] None of Picasso's earlier relationships had provoked such sustained lyric power, such a sense of psychological awareness and erotic completeness—nor such a flood of images.

In *Girl before a Mirror,* Picasso proceeds from "his intense feeling for the girl, whom he endowed with a corresponding vitality. He paints the body contemplated, loved and self-contemplating. The vision of another's body becomes an intensely rousing and mysterious process."[2] To be sure, it may have been less the particular psychology of the passive Marie-Thérèse that served Picasso than her suitability as a vessel for primal feelings; indeed, that she did not have a salient personality (such as that possessed by Dora Maar who was to replace her in Picasso's affections four years later) may have facilitated the artist's transformation of her into a quasi-mythical being. Picasso has a remarkable ability to empathically displace the egos of his models, male or female. This young girl's act of self-contemplation may well have been banal. If so, the very commonplaceness of the experience contributed to the universality of the insight which Picasso's genius has distilled from it.

The head of the Girl, recognizable despite its stylization as that of Marie-Thérèse, is a variant of the "double head," which Picasso had been exploring since 1925 (pp. 121, 125). In this formulation, the profile usually receives

the light, while a darker, shadowed area completes the full face. Here both sections have about the same light value, but because of the intense saturation of its enamels, roughly brushed over its heavily built-up impastoes, the yellow and orange-red front face dominates the smoothly painted lavender profile. "This is an inversion of the expected relation of the overt and the hidden. The exposed profile is cool and pale and what is hidden and imagined, the unseen face, is an intense yellow, like the sun. . . ."[3]

By likening the front face to the sun and the cool profile to "a moon crescent,"[4] the head may be conceived as balancing in a single astral metaphor the Girl's "overt innocence"[5]—her lavender profile is surrounded by a halo of white—and "the more covert frontal view of a rouged cheek and lipsticked mouth."[6] The double head thus becomes by metaphoric extension the two faces of Eve, or that of "a contemporary Mary who is also Isis, Aphrodite. . . ."[7] But it is also a formal microcosm of the picture in its juxtaposition of warm and cool hues and its contrast of richly impastoed with thinly painted flat surfaces, all contained within a circular shape that is the leitmotif of the composition.

The vertical division of the double head is continued down through the Girl's body, where the dichotomy of overt and covert and of public and private is transposed into a contrast of the clothed and the nude. The angular black contour of the Girl's back and the horizontal black banding it encloses recall the striped bathing suits of Picasso's Bathers of the late twenties (p. 132, p. 227:113) and constitute a shorthand image of the body in costume. By contrast, the lavender surface of her curving belly and upper thigh, in repeating the color of her profile and arms, connotes bare skin. The circular "womb" inside the tumescent belly—as in an X ray—associates the sexuality of the image with procreation. Its recapitulation of the shape of the head on virtually the same axis intimates the Girl's consciousness of the biological aspects of her femininity, an awareness explored in her reflected image.

It is very possible that the vertical division of the Girl's body was prompted by memories of an unusual Vanity (p. 227:114) that Picasso almost certainly saw in the collection of his friend the poet Ramón Gómez de la Serna.[8] In this image, the woman who looks in the mirror—where, as is traditional, she is reflected as a death's head—is herself divided vertically from the head down so that while her right side is naturalistic, her left is bare bones. In the Picasso, however, the vertical division of the body distin-

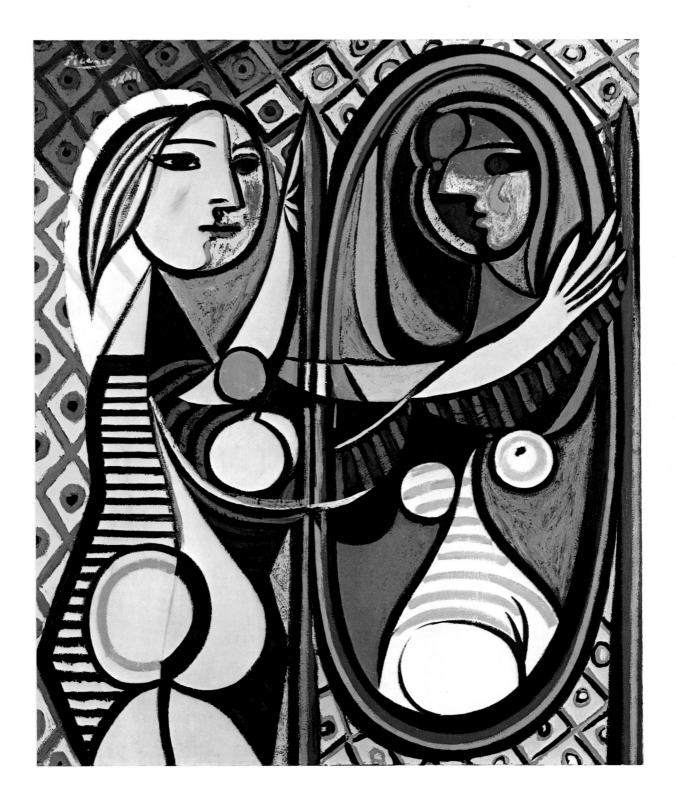

sion that characterized much of Picasso's work after 1925. In a few works, including *Two Figures on the Beach*, Picasso adapted the iconographic types and illusionist devices of Surrealists such as Ernst and Dali. This drawing is from a group Picasso executed in Cannes in 1933. Although one writer has reported that these drawings are the only works the artist considers "directly surrealist in conception,"[1] they nonetheless exhibit that conscious control characteristic of Picasso the master draftsman.

In this composition, two strange entities present themselves to each other in front of a conventional seascape. Each is composed of elements representative of several levels of reality: the practical (chair, door, shutter), the symbolic (sculpture, fork, glove), the fantastic (padded growths). The images of self they offer one to the other are guileful facades in view of their complex—sometimes disintegrating, even monstrous—reality. *(Elaine L. Johnson)*

MODEL AND SURREALIST FIGURE. *May 4, 1933. Etching, 10⁹⁄₁₆ x 7⅝ inches. (C&N, p. 228)*

Picasso's interest in classical life and mythology was heightened by his commission in 1930 to illustrate Ovid's *Metamorphoses* and paralleled his burgeoning preoccupation with his own sculpture. Before completing the plates for Ovid in 1931, Picasso bought a château at Boisgeloup. There, finally, he had the space and seclusion that allowed him to devote some of his energies to sculpture. His next spurt of printmaking activity, in 1933, closely followed this unleashing of creative activity and the simultaneous inspiration resulting from his alliance with the young Marie-Thérèse Walter.

Although Louis Fort, his printer, had installed an etching press at Boisgeloup, Picasso made few prints there. In March 1933 in Paris he embarked on a series of etchings, one hundred of which were later to fulfill an obligation to the publisher and art dealer Ambroise Vollard.[1] Not surprisingly, classic motifs and studio life were the prevailing inspirations for the first prints. Later, after his contributions to the Surrealist-oriented publication *Minotaure*, Picasso recreated this mythological being as his surrogate in compositions both of revelry and utmost seriousness.

The earliest forty prints, devoted to the sculptor in his studio, are serene, filled with light, sweet desire, and generally reflect the artist's own relaxed mood. The sculptured pieces in the first prints are those of Boisgeloup: large moon-heads of Marie-Thérèse. As variations were made on the theme, colossal Roman heads, classical groups and abstracted torsos appear. By far the most extravagant variation is the Surrealist construction shown in the etching reproduced. Here the classically simple nude model, garlands around her neck and waist, wonderingly touches an assembly of manufactured and human forms, a concoction of nineteenth-century furniture, embroidered fleurs-de-lis and objects that allude to diverse sexual possibilities.

The Vollard Suite, as it came to be called, was Picasso's first prolonged experience with printmaking in which he had complete freedom of choice of subject and execution. The dozens of plates became a refined sketchbook in which the artist gave rein to his fertile imagination and consummate draftsmanship, yet generally restricting himself to classical images and limiting the representations of his current stylistic tendencies to works of art observed by persons within the compositions. The juxtaposition of somewhat abstract sculptural forms and recognizably human spectators emphasizes a type of reality Picasso continually explores. While the sculpture could well have been part of his own space and time (either in his own transformations or in relics from the past) the artist and model who gaze upon these works are metaphors in a timeless vacuum. The drawings and prints done by Picasso during the periods of his greatest personal content are usually sensual, often witty, and almost consistently dwell on this double view of reality. *(Riva Castleman)*

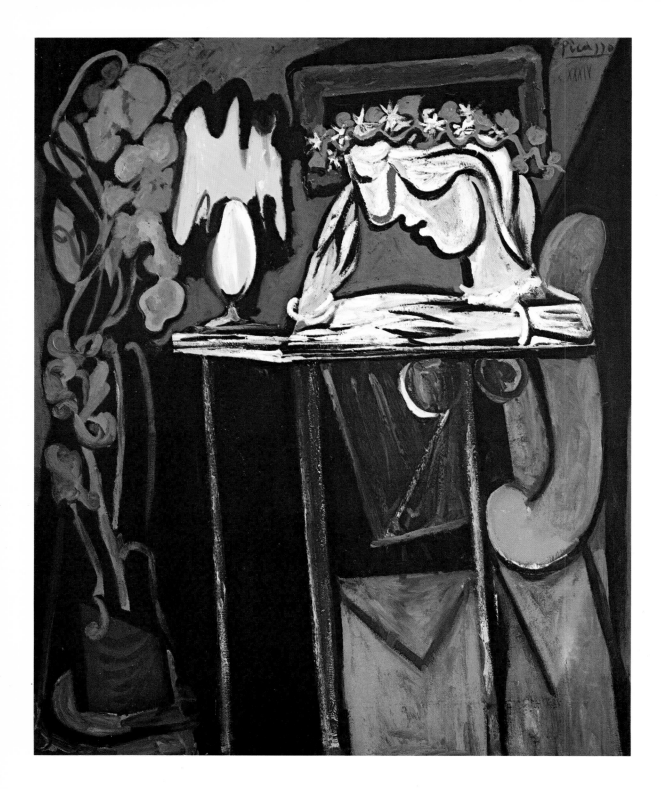

GIRL READING. *Spring 1934. Oil on canvas, 64 x 51½ inches. (C&N, p. 228)*

Each day from March 27 through March 30, 1934, Picasso completed an oil painting of Marie-Thérèse and a companion reading together from a book before them (p. 228:115).[1] Despite the intimacy implied by the proximity of their faces and the intertwining of their arms, the act of reading seems to have propelled the girls into private worlds—as is suggested by their lowered eyelids and the tilt of their heads. A month or two later that same spring, Picasso took up the motif of the open book as a point of departure for the depiction of purely solitary reverie in *Girl Reading*, a profoundly poetic picture that isolates Marie-Thérèse from her companion.

Here, she is seated at a table, her left hand holding the book before her, her right supporting her inclined head. The unexpectedly large size of her head, its predominantly chalky coloring and bulbous form—the line of the forehead running characteristically without a break into that of the nose—suggest a kinship to the monumental plaster busts of Marie-Thérèse executed at Boisgeloup during the three years previous (p. 228:116). In the painting, the largely whitish area shaded with light-blue and lavender that comprises her head and hands conveys a certain stability and repose. But the melting, organic shapes and warm, sensuous coloring of such objects as the lamp—and the juxtaposition beneath the table of the phallic chair-arm with her breasts—hint at a more passionate, perhaps sexual content for Marie-Thérèse's fantasies, which we may imagine to have been catalyzed by the book.

The wreath of flowers about Marie-Thérèse's head is consistent with the references to physical blossoming that Picasso habitually associated with her person. But it is also one of the artist's customary indications of the classical. Indeed, in many of the drawings and prints of the time this handsome girl is imaged as a *kórē* in quasimythological contexts evoking classical Greece (which frequently include the bearded proxy of Picasso himself). Possibly Marie-Thérèse is here to be imagined as reading an ancient text—Aristophanes' *Lysistrata*, for example, which Picasso was in fact engaged in illustrating at this time. The placement of the picture frame, which surrounds her head like a nimbus, is an inventive device that suggests the formation of images in her mind. Her text illuminated by a lamp that strangely metamorphoses, as

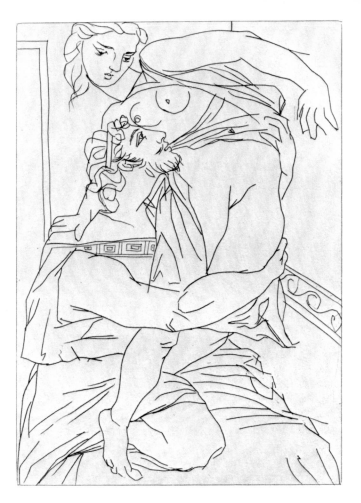

MYRRHINA AND KINESIAS FROM LYSISTRATA BY ARISTOPHANES. *1934. Etching, 8⅝ x 6 inches. (C&N, p. 229)*

if to suggest changing levels of reality, she may drowsily imagine herself transported into the ancient world, perhaps (as Picasso imaged her at that time, p. 228:117) offering her breasts to a Greek warrior, or being ravished by a lubricious Athenian as in the etching from *Lysistrata* illustrated here.

INTERIOR WITH A GIRL DRAWING. *Paris, February 1935. Oil on canvas, 51⅛ inches x 6 feet 4⅝ inches. (C&N, pp. 229–230)*

In a development of motifs that had occupied him the previous spring—aspects of which reach back to *Girl before a Mirror* and its immediate predecessors—Picasso spent much of the month of February 1935 sketching and painting variations on a composition of two girls, one of them drawing on a pad before a large mirror that rests on the floor, the other dozing with her head on a table.

Components of this new conception first appear in a series of drawings dated February 5 (p. 229:118) in which the girl drawing is represented as a quasi-surreal biomorphic pod with limblike extrusions, although the image she sees of herself in the mirror is realistic.[1] In somewhat later sketches (pp. 229:119, 120) the girl herself is represented more realistically and is moved from a chair in the middle of the composition to the floor on the right, while a second female figure, the sleeper, is introduced in the center. The arabesqued forms of the latter recapitulate aspects of the earlier biomorphic pod, but they also recall the contouring of certain Moroccan Matisses—an affinity reinforced in *Interior with a Girl Drawing* itself by the contrast of the rich lavender of this figure's costume with the saturated orange of her slippers and with the forest- and olive-greens of her hair and foot.

The opulent organic shapes of this dozing girl, which recall images of Marie-Thérèse, establish an aura of somnolence and reverie that carries over into the girl who draws. In the penumbra of the room, whose window is largely covered by a sheet tacked across it, the latter's eyelids droop. Although she sits before the mirror (which, unlike that of the earliest sketches, seems to reflect a fragment of another picture frame and painting), we feel that she is less likely to draw her own image or that of the objects about her than to exteriorize her thoughts and fantasies—perhaps as in the automatic drawing of the Surrealists, who sometimes imagined their pictures *les yeux fermés*. Indeed, about this time Picasso himself is said to have made a series of drawings, executed in darkened rooms or with his eyes closed.[2]

Sometime during the week that followed the earliest sketches of the motif on February 5, Picasso painted on this canvas a first version of *Interior with a Girl Drawing*, which was soon afterward photographed by Zervos (p. 229:122). But by the twelfth of the month that image had been entirely painted over to form the work we now see; this was itself announced by a preparatory drawing (p. 230:123) that must therefore date from the second week of the month.[3]

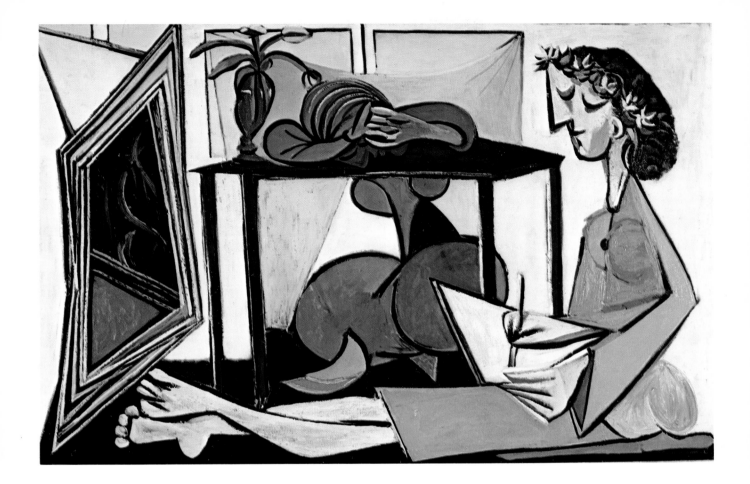

MINOTAUROMACHY. *1935. Etching and scraper, 19½ x 27⁷⁄₁₆ inches. (C&N, pp. 230–231)*

Whatever reasons may have caused Picasso to stop painting early in 1935—and they seem to have been personal and circumstantial—his creative energies for some twenty months thereafter were to find expression in graphic art and poetry, though the results were meager by comparison with any previous period of similar length.

Picasso's most remarkable composition of 1935—and possibly the most important of all his prints—is the *Minotauromachy*. This large etching is so rich in Picasso's personal symbolism and so involved with the iconography of his previous and subsequent work that it requires some analysis, however brief. The bison-headed Minotaur advances from the right, his huge right arm stretched out toward the candle held high by a little girl who stands confronting the monster fearlessly, flowers in her other hand. Between the two staggers a horse with intestines hanging from a rent in his belly. A female matador collapses across the horse's back, her breasts bared, her *espada* held so that the hilt seems to touch the left hand of the Minotaur while the point lies toward the horse's head and the flower girl. At the left a bearded man in a loin cloth climbs a ladder to safety, looking over his shoulder at the monster. In a window behind and above two girls watch two doves walk on the sill. The sea with a distant sail fills the right half of the background.

The flower girl appears several times in Picasso's earlier work—in 1903 and 1905 (p. 231:126, 127); in the large Grecoesque Composition of 1906 (p. 194:16), and its studies (p. 36; p. 194:15)—but never before in such a crucial role. The ladder, usually on the left-hand side of the composition, occurs in the 1905 paintings and etchings of acrobats; is climbed by a monkey in the curtain for *Parade* (p. 231:128); by a man with a hammer in, significantly, the *Crucifixion* of 1930 (p. 231:129); by an amorous youth in a gouache of 1933 (p. 231:130); by a shrieking woman in a *Study for the Guernica* (p. 231:131).

One of the earliest of the bull ring series of the previous years shows a female matador falling from a horse which is borne, like Europa, on the back of the bull, though her sword has been plunged, ineffectually, into the bull's neck (p. 231:132). The agonized, disemboweled horse bares his teeth in many of these same bullfights, and in 1937, after dying in *The Dream and Lie of*

*Franco* (p. 151), revives to become the central figure of *Guernica* (p. 237:151).

Minotaur himself appears as a decorative running figure in 1928 (p. 231:133) but takes on his true character in 1933 when Picasso designed the cover for the first issue of the magazine *Minotaure*, and made numerous etchings and drawings in which the monster holds a dagger like a sceptre (p. 231:134) or makes love (p. 231:135). In a drawing of April 1935 he struts with hairy nakedness across the bull ring toward a frightened horse (p. 231:136).

As a kind of private allegory the *Minotauromachy* tempts the interpreter. But explanation, whether poetic or pseudo-psychoanalytic, would necessarily be subjective. It is clear that the ancient and dreadful myth of the Minotaur which originated, together with the bull ring, on the island of Crete, has here been woven into Picasso's own experience of the modern Spanish *toromachia*. To this he has added certain motives associated with his theatre pictures and his *Crucifixion*.

Apparently the scene is a moral melodramatic charade of the soul, though probably of so highly intuitive a character that Picasso himself could not or would not explain it in words. Of three extraordinary allegories it is the first: it was followed, in 1937, by a nightmare comic strip and a great mural painting. *(Reprinted by permission of Alfred H. Barr, Jr.)*[1]

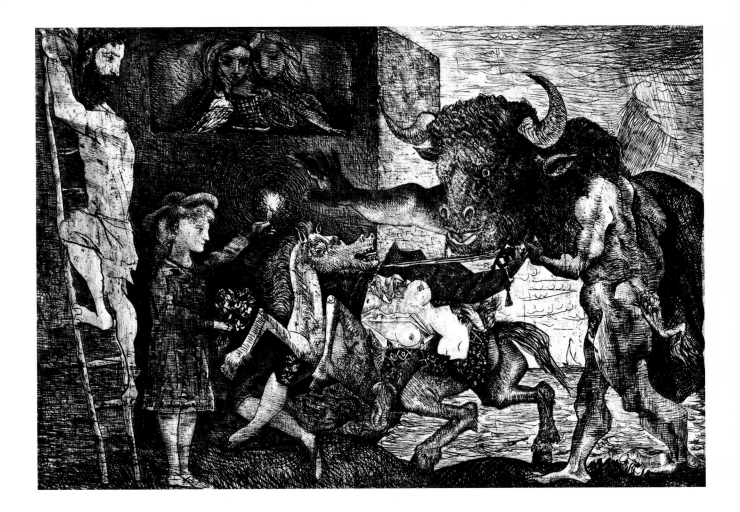

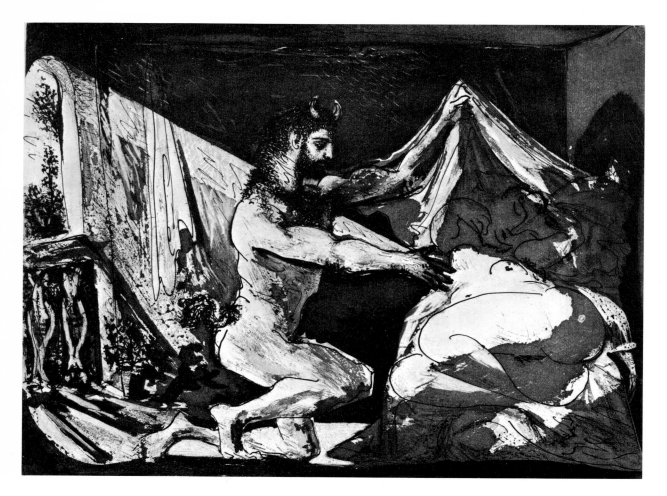

FAUN AND SLEEPING WOMAN. *June 12, 1936. Etching and aquatint, 12⁷⁄₁₆ x 16⁷⁄₁₆ inches.* (C&N, p. 230)

In June 1936 Picasso completed one of his most dramatically expressive prints and one of the last of the one hundred etchings he owed Ambroise Vollard. At this time Picasso was introduced to the technique of sugar-lift aquatint by the gifted intaglio printer Roger Lacourière. Using this medium, the artist was able to create subtle tonalities with the use of a brush. In this composition he skillfully obtains grays of such variety that a theatrically illuminated scene emerges. The triangular planes of light and dark have been considered forerunners of the structure of overlapping triangles in the painting *Guernica*.[1]

Returning again to the theme of the sleeper observed, Picasso introduces a new character, an ardent faun about to awaken a sleeping nymph. Unlike the playful flute-playing beings who entertained young maidens in earlier prints, the composite goat-man here is a serious demigod. Instead of being lustful, the faun is reverently upon his knee, one hand raised in the act of unveiling the object of his quest. The quality of momentarily suspended action recalls early Italian Renaissance annunciations, wherein the revelation is further heightened by a beam of light falling on the Virgin who stands in a loggia or gallery. The nymph, lying asleep, light pouring in upon her through an arched opening, unknowingly participates in a pagan version of one of the most mystical moments in Christian mythology. In his graphic work of the 1930s, Picasso casually introduced symbols and mythological characters that, in evoking ancient rites, extended the limited narrative of his compositions.    *(Riva Castleman)*

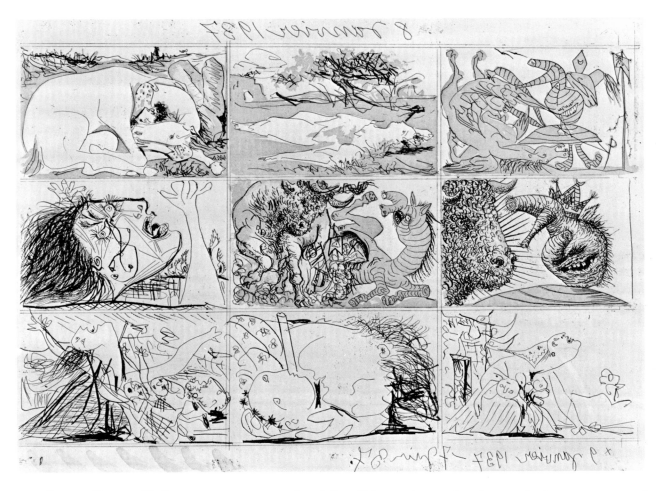

DREAM AND LIE OF FRANCO II. *January 8–9, 1937, and June 7, 1937. Etching and aquatint, 12⅜ x 16⁹⁄₁₆ inches. (C&N, p. 230)*

Early in January 1937 Picasso etched *The Dream and Lie of Franco* and wrote the accompanying poem. There are two plates, each divided into nine rectangular scenes like traditional woodcut stories or contemporary American comic strips, which Picasso admires. In fourteen scenes Picasso expresses his hatred and contempt for El Caudillo. Again the bull, the disemboweled horse appear in a story which is not as lucid as a comic strip but clear enough for dreams and lies. Franco himself is transformed into a flaccid scarecrow figure with a head like a soft hairy sweet potato—or, to borrow Picasso's phrases, "an evil-omened polyp . . . his mouth full of the chinch-bug jelly of his words . . . placed upon the ice-cream cone of codfish fried in the scabs of his lead-ox heart. . . ."[1]

The first five scenes reading from right to left continue the story of the nine scenes of the first plate. Franco has just driven his lance through the winged horse which expires at his feet (scene 10—upper right-hand corner). The dying horse gives place to a prostrate woman (scene 11) and then to a white horse whose neck rests upon the chest of a bearded man (scene 12). In a close-up (scene 13) Franco is confronted by a bull. In the final scene (central picture) Franco having been turned to a centaur-like beast with a horse's body is ripped open by the bull and dies.[2] The four remaining scenes, added later, are closely related to *Guernica* which Picasso undertook May 1st and finished in June. *(Reprinted by permission of Alfred H. Barr, Jr.)*[3]

*fandango de lechuzas escabeche de espadas de pulpos de mal agüero
estropajo de pelos de coronillas de pié en medio de la sarten en
pelotas — puesto sobre el cucurucho del sorbete de bacalao
frito en la sarna de su corazón de cabestro — la boca llena de
la jalea de chinches de sus palabras — cascabeles del plato
de caracoles trenzando tripas — menique en erección ni uva
ni prueba — comedia del arte de mal tejer y teñir nubes
— productos de belleza del carro de la basura — rapto de las meninas
en lágrimas y en lagrimones — al hombro el ataud relleno de chorizos
y de bocas — la rabia retorciendo el dibujo de la sombra que le azota los
dientes clavados en la arena y el caballo abierto de par en par
al sol que lo lee a las moscas que hilvanan a los nudos de la*

Picasso's contacts with Surrealism led him to write a
number of automatic, stream of consciousness poems,
which Sabartés helped prepare for publication. Like his
other poetry, the text for *Dream and Lie of Franco* distin-
guishes itself from the works of the Surrealists to the ex-
tent that the raw material of its imagery is not the oneiric
or marvelous, but finds its point of departure in immedi-
ate, concrete reality.

### THE DREAM AND LIE OF FRANCO

*fandango of shivering owls souse of swords of evil-
omened polyps scouring brush of hairs from priests' ton-
sures standing naked in the middle of the frying-pan—
placed upon the ice cream cone of codfish fried in the
scabs of his lead-ox heart—his mouth full of the chinch-
bug jelly of his words—sleigh-bells of the plate of snails
braiding guts—little finger in erection neither grape nor
fig—commedia dell'arte of poor weaving and dyeing of
clouds—beauty creams from the garbage wagon—rape of
maids in tears and in snivels—on his shoulder the shroud
stuffed with sausages and mouths—rage distorting the out-
line of the shadow which flogs his teeth driven in the sand
and the horse open wide to the sun which reads it to the
flies that stitch to the knots of the net full of anchovies
the skyrocket of lilies—torch of lice where the dog is knot
of rats and hiding-place of the palace of old rags—the ban-
ners which fry in the pan writhe in the black of the ink-
sauce shed in the drops of blood which shoot him—the
street rises to the clouds tied by its feet to the sea of wax
which rots its entrails and the veil which covers it sings
and dances wild with pain—the flight of fishing rods and
the alhigui alhigui of the first-class burial of the moving
van—the broken wings rolling upon the spider's web of
dry bread and clear water of the paella of sugar and velvet
which the lash paints upon his cheeks—the light covers its
eyes before the mirror which apes it and the nougat bar
of the flames bites its lips at the wound—cries of children
cries of women cries of birds cries of flowers cries of tim-
bers and of stones cries of bricks cries of furniture of beds
of chairs of curtains of pots of cats and of papers cries of
odors which claw at one another cries of smoke pricking
the shoulder of the cries which stew in the cauldron and
of the rain of birds which inundates the sea which gnaws
the bone and breaks its teeth biting the cotton wool which
the sun mops up from the plate which the purse and the
pocket hide in the print which the foot leaves in the rock.*

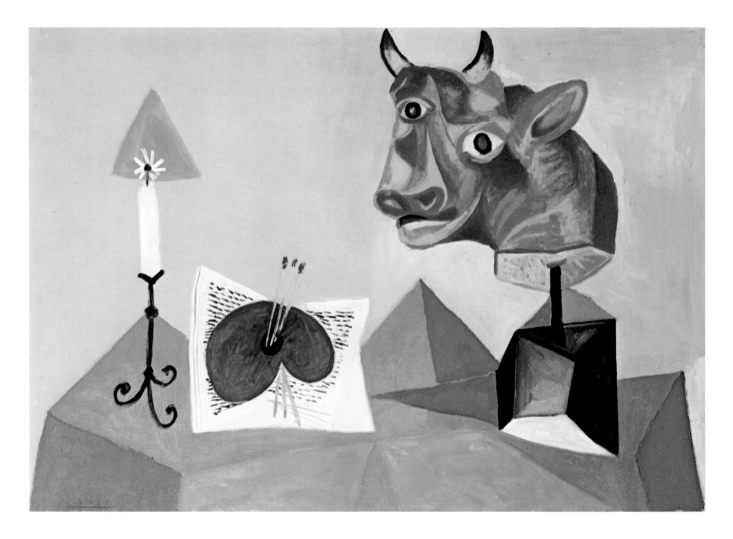

STILL LIFE WITH RED BULL'S HEAD. *Paris, November 1938. Oil on canvas, 38⅛ x 51 inches. (C&N, p. 230)*

Picasso's bulls are symbols not only of mindless power and energy but also of creative force. Here the animal is a figure of considerable pathos; the violence of the decapitation that permits its conversion into a sculptured bust is intensified by the suggestion (through the color) of its having been flayed alive.[1] It seems agonized by its confrontation with the candle, whose light, in Picasso's art, frequently betokens the power of reason (as in *Minotauromachy*, p. 149). *Still Life with Red Bull's Head* may be read as an allegory of the artist, in which the introduc-

tion of the palette and book between the bull's head and candle suggests that the artistic process is a confrontation of the unconscious, quasi-physical creative urge and the rational order with which it must be informed.

For all the violence of the beautifully executed bull's head, Picasso is careful never to let its color become literal. Indeed, its saturated reds and oranges assimilate readily to an antinaturalistic color scheme that is otherwise largely decorative. By the same token, the pointed, spiky forms around it—which echo the tips of the horns—lose their aggressiveness in becoming absorbed in a design motif that culminates in the triangular "halo" of the candle.

THE NECKLACE. *September 1938. Pen and ink, 26¾ x 17⅝ inches. (C&N, p. 232).*

Picasso often juxtaposes images representing different levels of reality in a single work. Here two nudes, disparately portrayed—one a caricature of naturalism, the other an invention of imagination—confront each other. The paradox of their meeting is compounded by the addition of a small image of equivocal meaning held in the bird-claw hands of the long-haired nude at the left. Perhaps she proudly holds a picture of herself; or, more likely—judging from Picasso's interest in the theme of the mirror—a transmuted reflection of the animal-nosed, rivet-breasted figure who is holding up the barbed necklace.

In 1938 Picasso painted and drew numerous figure pieces characterized not only by an intense psychological vitality but by an unusual linear syntax in which faceted forms, volumes, patterns, shadows and perspectives were suggested by stripes, webs, square-within-square motifs and radiating lines. In drawings such as *The Necklace,* in which all structural and decorative elements have been rendered without the aid of intermediate tonalities, the linear pattern of the surface is particularly complex.

Various sources have been suggested for the syntactical devices used in compositions of this type. Figures "which seem to be made of basketry or chair caning" may reflect an interest in the proto-Surreal compositions of the sixteenth-century Italian mannerist Arcimboldo.[1] "The dislocated figure pieces of 1938 are patterned with curious spider-web arabesques, suggestive of a mixed Andalusian-Moorish descent; indeed they often give an impression of an unresolved struggle between Arab calligraphy and Mediterranean anthropomorphism."[2] (*Elaine L. Johnson*)

RECLINING NUDE. *Mougins, September 1938. Pen, ink and gouache, 17 x 26¼ inches. (C&N, p. 232)*

Picasso's portrayal of the human figure has frequently been influenced by his regard for the styles of other artists and cultures. The elongated shapes of El Greco, the compact volumes of Iberian sculpture, and the refined renderings of Ingres have all nourished his art. The spirit of tradition is present in this drawing, too. Rarely, however, has it been parodied with such relish.

Here Picasso has used a vocabulary of abstract forms to represent parts of the anatomy, then orchestrated them into an alignment characteristic of a voluptuous harem nude. The effect is not sensuous, however, for the face combines human and canine features (see p. 162), and eyes stare from beneath tufts of bristly hair. Languor, too, is belied, for around the bulbous shapes of the throat and torso energy seems to spiral outward through blade-like limbs. The convention of opulent roundness is also betrayed, for space is punctured continually by sharp angles and edges.

The technique by which the drawing was executed adds to the incisiveness of its expression. The paper is brilliant white. The basic design was first established in a brushed gray wash, then redrawn with pen and black ink. The resulting line seems engraved into the surface. Broad sweeps of amorphous tone suggest atmosphere and counterbalance the tension of the formal structure.

The reclining nude did not play an important role in the iconography of Picasso's paintings until the 1930s and the 1940s, when it was developed more fully. The theme was, however, seen in his drawings from the time of his youth.

*Reclining Nude* was composed two days after *The Necklace* (opposite) and shares many of its characteristics. *(Elaine L. Johnson)*

NIGHT FISHING AT ANTIBES. *Antibes, August 1939. Oil on canvas, 6 feet 9 inches x 11 feet 4 inches. (C&N, pp. 232–33)*

In the summer of 1939, while temporarily occupying a bourgeois furnished apartment in Antibes which Man Ray had just vacated,[1] Picasso removed the pictures, furniture, and bric-a-brac from one of the rooms and entirely covered three of its decoratively papered walls with canvas from a very large roll. On one of these— without the aid of preparatory sketches—he executed *Night Fishing at Antibes*, which was finished toward the end of August (and sometime later trimmed to its definitive size—an unusual procedure for Picasso); the canvases on the other walls remained untouched.[2]

Picasso found the motif for *Night Fishing* in the course of his evening strolls along the quais with his then mistress Dora Maar. She is shown in the painting standing on a jetty, grasping the handlebar of a bicycle with her left hand and licking a double ice-cream cone.[3] Her companion in the scene, the painter Jacqueline Lamba,[4] wears an olive-green skirt and a green kerchief over her head. Among the rocks near the sea wall two men in a boat attempt to catch fish attracted to the surface by a powerful acetylene decoy lamp (delineated in orange and black on a yellow ground near the top center of the painting)[5]; a number of large moths and other insects, also attracted by the light, flutter around them. One fisherman, wearing a striped jersey and blue trousers rolled up near the knee, is about to spear a sole in the shallow water near the jetty; his companion, whose fishing line is tied to a toe of his right foot,[6] peers into the water, perhaps at the fish that has just swum by. On the partially submerged rocks in the lower left corner of the painting rests a crab whose soulful eyes seem to focus on the viewer. Above these rocks, in the distance, rise the towers and battlements of Grimaldi Castle (now a Picasso museum).

This largest of Picasso's paintings of the decade following *Guernica* is characteristic of much of the artist's work of the 1930s, insofar as it accommodates expressionist and biomorphic forms within a compositional armature derived from Cubism. Here, the latter is particularly loosely structured—certainly as compared to the scaffoldings of the last wholly Cubist works of the early twenties —permitting the individual forms considerable autonomy, and facilitating the illusion of their metamorphic expansion and contraction.

As was his tendency in many large compositions of his earlier years, Picasso adopted a centralized, broadly tripartite arrangement in *Night Fishing*. Although the middle area is recessed, it dominates the composition by dint of its lighter values and its marked contrast of warm and cool (the yellow and orange of the lamp against the gray and unsaturated blue of the more prominent of the two fishermen); it is also the region of greatest structural stability as a result of the scaffolding of verticals and horizontals formed by the fisherman's leg, arms and spear. The upper torso and head of the fisherman who peers into the water epitomizes the "internal" or "felt" image of the body[7]; the feeling of distention in his limbs and face as he strains to see into the water is translated by Picasso into an elongated chest and neck that are almost as equine as human, and a face that quite literally swells toward the water. The brown rocks at the left and the sea wall at the right, its reflected green light passing into the gray of the shadow, form the arms of a semicircle that swings around the arc-shaped boat, bringing the sides of the composition close up to the picture plane.

It has been suggested that the disposition of certain forms and accents within this centralized arrangement reflects Picasso's experience of a seventeenth-century Dutch *Bathers* in the Louvre.[8] That picture (p. 232:139), sometimes attributed to Nicolas Maes, shows a group of young boys swimming in the nude from a boat situated in the pictorial field in a manner very similar to the one in *Night Fishing*. The extended arm of the boy about to dive from the far side of the boat suggests that of Picasso's fisherman; it almost reaches the vertical oar, which might be considered the counterpart of the fisherman's four-tined spear. Other possible affinities between the pictures include the position of the whimsical child in the water on the lower left, who looks out at the viewer like Picasso's crab; the precarious posture of the boy with his back toward us in the center—half in, half out of the boat—whose imbalance recalls that of Picasso's crouching angler; the relation of the promontory on the right to Picasso's jetty, and that of the sails of the turning windmill to the wheel spokes of Dora Maar's bicycle. It is unlikely that Picasso was thinking of the Dutch picture as he composed *Night Fishing*. But it is not inconsistent with his artistic processes that a visual experience of spearfishing—either a momentary conjunction of forms or the very nature of the scene itself—should resuscitate if only subliminally the image of one of the multitudinous

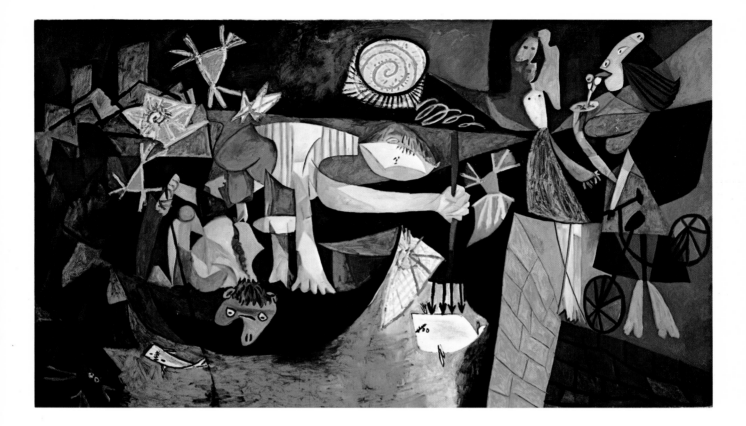

paintings his mind had "photographed" through the years, and that he should adapt the configuration of that work for his own purposes.

The ambience of *Night Fishing* is fundamentally one of physical pleasure, of play. Although fishing may be a livelihood for the men in the picture, we, the viewers—like the girls on the jetty—experience it as a sport; the bicycle, too, has its recreational allusions, and the double ice-cream cone attests to the pleasures of a stroll in the port. This festive mood is sustained by a certain whimsey in the figuration—especially in the contouring of the bicycle, moths, fish and crab, to say nothing of the double cone—and by the panache and bravado of the execution. Indeed, spearfishing "shares with the act of painting, for Picasso, the successful and suspenseful verve of marks-manship and balance, total absorption and intense in-volvement. . . ."[9]

As the scene is nocturnal, Picasso not surprisingly used a greater range and variety of dark hues—notably purple—than elsewhere in his work. This somewhat exotic col-oring enhances the possibility of dalliance implicit in the confrontation of the two couples, for whom the lantern might serve as a surrogate moon and the flickering moths as stars. However, interpretations of this picture as a vast metaphor for sexual activity (in which the spear becomes "a violent sex symbol"[10] and the bicycle "sug-gests the motion of . . . sexual intercourse"[11]) or as a polit-ical allegory ("a prophetic vision of the impending years of darkness"[12] in which the central motif becomes "the murder of fishes")[13] are certainly the fruit of over-reading.

WOMAN DRESSING HER HAIR. *Royan, June 1940. Oil on canvas, 51¼ x 38¼ inches. (C&N, pp. 234–35)*

This awesome image derives its extraordinary plastic intensity from a series of polar contrasts. The extreme of sculptural relief in the nude's anatomy—shapes "like petrified fruit . . . both swollen and hard"[1]—is opposed to the unbroken flatness of the walls, whose deep green and purple serve, in turn, as foils for the virtual colorlessness of the modeled areas. The tensions are maximal within the nude herself. Her conflict, her divergent impulses are expressed in a head whose features literally turn left and right—and even up and down—at the same time. The gesture of reaching back to arrange a coiffure, which years earlier had inspired some of Picasso's most lyrical pictures, has here occasioned an image of immense strain and discomfort, communicated through the systematic displacement of the nude's tumescent forms. Thus, her left arm projects directly from the left side of her rib cage and her left breast from the right side of her rib cage; her right breast is located under her arm while her buttocks have been swung around almost under that breast.

The purpose of these transpositions is to suggest psychic conflict through somatic dislocation. To express the fullest possible range of such tensions the artist makes aspects of the figure's front, back and sides simultaneously visible. Picasso had hinted tentatively at this fuller visual possession of his subject in such 1909 pictures as *Woman with Pears* (p. 60), where the sides of the sitter's neck and shoulders were pulled around into the picture plane. But nothing in his Cubist work—certainly not the infrequent instances where he conflated different *discrete* perspectives of objects (a formulation given undue importance by Cubism's early popularizers)—foretells the *continuous* revolving of the figure into the picture plane which we see here.[2]

The hardness of flesh and bone in *Woman Dressing Her Hair*, and the disquieting shapes of the near-monochrome anatomy, recall the monumental Bathers of 1929–30 (pp. 133, 134). But potentially violent as were those figures, they were nevertheless posed in a serene and stable manner against backgrounds of infinite space and light. Here the nude is contorted and unbalanced, and her windowless cell is claustrophobic. This oppressiveness is intensified by our unusual proximity to the figure, carefully enforced by Picasso through the foreshortening of her left leg and foot (the underside of which cannot but be

inches from the picture plane and, hence, from the viewer).

*Woman Dressing Her Hair* was painted in Royan in mid-June 1940,[3] by which time the town had been overrun by the invading Germans. The sense of oppression and constraint Picasso must have felt in the face of the curfew, the restrictions on travel and, above all, the presence of the alien occupying army doubtless played a role in motivating it. But this anguished image of a human being unable to cope transcends its immediate context to become a universal image of dilemma.[4] Although the animalistic elements in the figuration—the hooflike hands and snoutlike nose—have led to an interpretation of the protagonist as a "ruthless" being,[5] she seems rather more brutalized than brute, a person whose predicament has reduced her to a less than human state.

The genesis of the nude's head is to be found in a series of portrait sketches inspired by Dora Maar that probably date from the early spring of 1940 (p. 234:141).[6] Although the head is ovoid in these, the mouth has been swung abnormally to the left—as in the painting—which makes the nose appear to be in contrapposto. A sketch dated March 14 (p. 234:140) has numerous affinities with the painting in regard to the posture of the body, particularly the position of the arms, breasts and buttocks. Finally, in a series of sketches dating from June 3 to June 8, Picasso began to elaborate the rib cage and the position of the legs (pp. 234, 235:143–148). A deeply-felt portrait of Dora Maar in oil on paper (p. 235:150) is very close as regards the head to *Woman Dressing Her Hair;* except for the coiffure, the only significant difference is the presence in the portrait of eyebrows, whose handling makes the image resemble Dora Maar more and invests it with a melancholy not present in the larger picture. The intimacy of this more particularized private statement, dated June 16 and thus executed concurrently with *Woman Dressing Her Hair*, descants the bolder and more uncompromising qualities of the larger, public image.

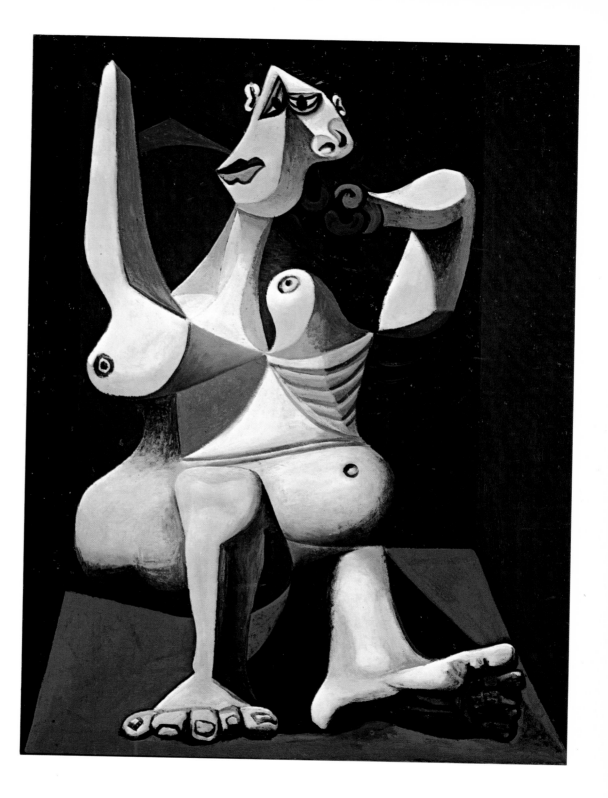

HEAD OF A WOMAN. *July 1941. Pen and ink on brown-gray paper, 10⅜ x 8¼ inches. (C&N, p. 236)*

FEMALE HEAD. *May 1940. Pencil, 8⅞ x 7⅜ inches. (C&N, p. 236)*

Many of the drawings and paintings Picasso executed during the early months of World War II in Royan near Bordeaux were characterized by a sculptural volume that contrasts with the flatness and angularity of the works of the immediately preceding years. This new tendency may have resulted from the impracticability of undertaking works of sculpture in his temporary quarters in Royan.[1] *Female Head,* which dates from this period, has antecedents in the anguished women Picasso drew as studies and postscripts for *Guernica.*

In this composition the intensity of the image is heightened by the short, strong curvilinear rhythms with which it is drawn. The basic form of a woman's head and bust are radically altered by dislocation and elision—such as is seen in the illogical extension of the ears and the metamorphosis of a shoulder into an upturned breast—as well as by the introduction of a subhuman iconographical motif. The latter is evident in the omission of a human nose in favor of the proboscis that emerges from the side of the woman's head and shares with it eyes and forehead contours.

Picasso has habitually kept a number of domestic animals around him, and the animal-snout motif, which appears in many of the artist's portraits in the late 1930s and early 1940s, may have been inspired by Kasbek, his pet Afghan hound.[2] (See also p. 155.)  *(Elaine L. Johnson)*

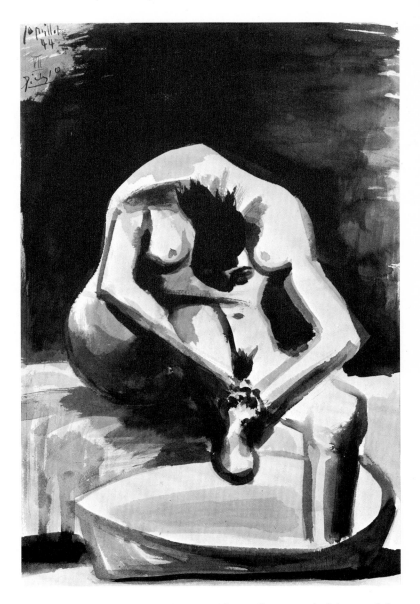

WOMAN WASHING HER FEET. *Paris, July 1944. Wash, brush and ink, 20 x 13¼ inches. (C&N, p. 236)*

The powerful and unsettling *Woman Washing Her Feet* exploits aspects of three styles. The basic form of the composition, which recalls the positions of the bending dancers and bathing women of Degas, is realistic. The unifying devices of the design, such as the line that continues from arm to leg and the geometric space between the arms, derive from Cubism. The extended form of the back and the placement of the head between widely spaced breasts recall the expressionist distortions and dislocations that had dominated Picasso's work in the late 1930s. The artist had drawn earlier several other studies of the same theme in which the neck and back contours were explicitly articulated.[1] The summary forms of this drawing are, perhaps, abstracted from them. *(Elaine L. Johnson)*

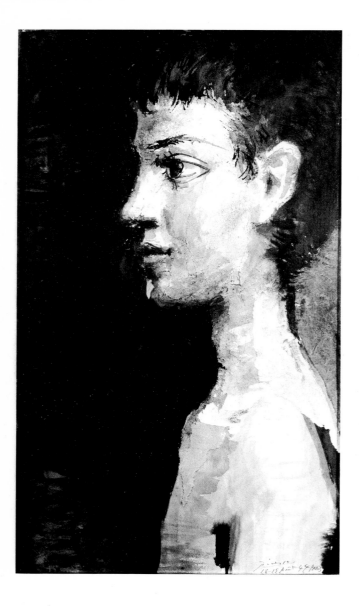

HEAD OF A BOY. *Paris, August 1944. Brush and ink wash, 19¾ x 11¼ inches. (C&N, p. 236)*

*Head of a Boy* continues a tradition of portrayals of idealized youth, begun by Picasso some forty years before in works such as *Boy Leading a Horse* (p. 35). In this draw-ing a sense of sculptural solidity is achieved, remarkably, through overlaid patches of freely brushed tone. The model, whose fully developed head overbalances his immature body, was also used by Picasso in some early studies for the monumental sculpture of 1944, *Man with a Lamb*.[1]  (*Elaine L. Johnson*)

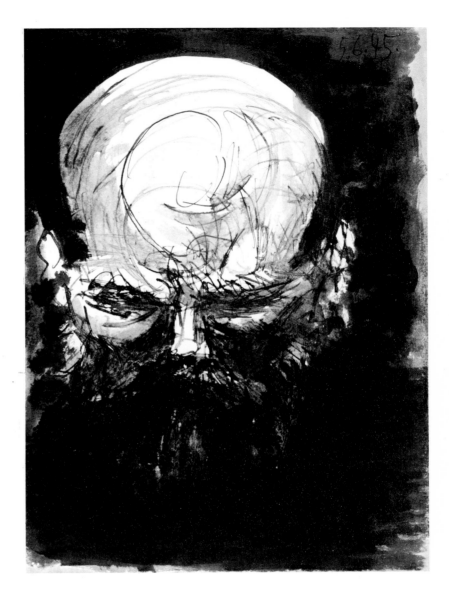

PAUL VERLAINE. *Paris, June 1945. Wash, pen and ink, 11⅝ x 8¼ inches. (C&N, p. 236)*

Throughout his career, Picasso sought the stimulus and friendship of poets, often in preference to painters. Among the friends he portrayed were Max Jacob, Guillaume Apollinaire and Paul Eluard. Although he could never have met Verlaine, the poet was a favorite of Picasso's during his early years in Paris, when the Symbolist's works shared his bookshelf with books by eighteenth-century philosophers and stories about Sherlock Holmes, Nick Carter, and Buffalo Bill.[1]  *(Elaine L. Johnson)*

THE CHARNEL HOUSE. *1944–45. Oil on canvas, 78⅝ x 98½ inches. (C&N, pp. 236–41)*

Picasso usually relies on personal experience and the given of his immediate environment as the point of departure for his art. The pressures of external circumstances tend to be communicated indirectly—in terms of style and mood—the subjects remaining nominally familiar, even conventional.[1] "I have not painted the war," Picasso was quoted as saying in autumn 1944, "because I am not the kind of painter who goes out like a photographer for something to depict."[2]

However, in the months following that remark, precisely under the impact of photographs of concentration-camp abominations, Picasso began his awesome *Charnel House*. It represented only the second time that the urgency of collective social distress had drawn him from the more familiar, personal paths of his art.[3] One of his largest and most searingly intense pictures, *The Charnel House* transcends the pure horror in the photographs, converting reportage into tragedy.[4] Its grisaille harmonies distantly echo the black and white of newspaper images but, more crucially, establish the proper key for a requiem.

Like *Guernica*, *The Charnel House* is a Massacre of the Innocents—an evocation of horror and anguish amplified by the spirit of genius. It marks the final act in the drama of which *Guernica*—with which it has affinities of style as well as iconographic cross-references—may be said to illustrate the beginning. Both works submit their vocabulary of contorted and truncated Expressionistic shapes to a compositional armature derived from Cubism. *The Charnel House*, in particular, derives its visual tautness from the acute contention between these antagonistic modes. Its forms twist, turn, bulge and buckle but finally adjust themselves to what is almost an inner frame of whitish priming and to the rectilinear accents that echo this device in the interior of the composition. This ultimately endows the picture—for all its turbulence—with a kind of classical Cubist "set," absorbing the screaming violence of the morphology into the silent and immutable architecture of the frame.

*The Charnel House* depicts a pile of dead bodies on the floor of a room that also contains a table with a pitcher and casserole on it. From the tangled bodies the forms of a man, a woman, and a child can be disengaged. Flamelike patterns rising toward the upper right corner of the com-

position allude to death by fire. The man, whose head hangs as if his elongated neck were broken, is stretched almost horizontally across the picture space. His feet emerge from the mass of limbs at the left of the picture field; his rib cage has been rotated clockwise in relation to his chest and navel; and his wrists have been tied behind him, keeping his arms suspended in a kind of enforced rigor mortis. The woman is stretched in the opposite direction, her feet emerging in the lower right corner of the canvas. Both of the man's eyes are open; one of hers is closed while the other—displaced to her chin—is open and seemingly alive. Blood pours from a gash above her breast into one and then the other hand of the child, who lies obliquely to the picture plane, his body foreshortened. Although the child's eyes are closed, his right arm and open hand, raised as if to stanch his mother's wound, suggest that he might still be living.

The lifeless man is reminiscent of the dead soldier of *Guernica* as that figure was laid out in the mural's first stage (p. 237:152), i.e., with his feet in the lower left of the canvas. Indeed, the raised arm of the dead man in *The Charnel House* also recalls that of the dead soldier; his clenched left fist echoes the soldier's Loyalist salute; and the open fingers of his right hand recapitulate the petal pattern of the "sunflower" radiance that haloed the soldier's fistful of grain in *Guernica*'s second stage (p. 237: 153). But the raised hand of the dead man of *The Charnel House* is empty, and his arm is not self-supporting like the *Guernica* soldier's phallic limb, which symbolized rebirth; it remains aloft only through its fastening to the other arm.

This latter motif is directly related to the bound legs of the lamb in the many studies for the *Man with the Lamb*, which Picasso executed during 1942–43 (p. 238:154, 155). The pathos expressed by this motif is reinforced by the manner in which the lamb's head is turned in contrapposto to its bound legs, and by the elongation of its neck—both of which characteristics also appear in the figure of the man in *The Charnel House*. That the artist had associated such a binding of limbs with the killing of innocents was already evident in 1938 when he drew a similarly bound animal (resembling a goat) at the moment of its sacrifice (p. 238:156). There, a frenzied "priestess" holds its body with her left hand while the dagger in her right is plunged through the neck of the animal, its blood pouring into a basin below. However, the idea of innocent sacrifice is only one of several implications of this animal

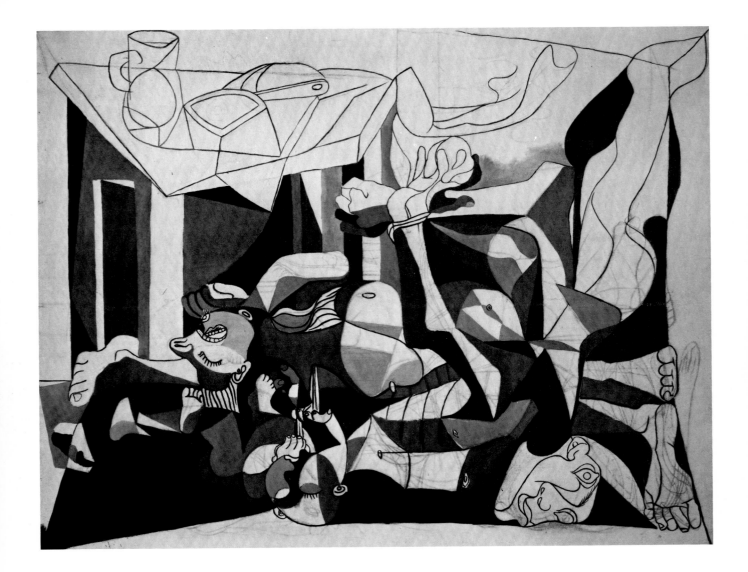

when it reappears as a lamb in *Man with a Lamb*. While its anguish in that work may suggest a prescience of death, the animal may be considered as much a lost sheep rounded up by the Good Shepherd as a sacrificial lamb.

Among Picasso's many drawings of the bound lamb are some (p. 239:157) in which its head resembles that of the horse in *Guernica*. Indeed, the horse's neck and head in the finished mural (p. 237:151) acquire expressiveness from the same kind of stretching and turning. By these indirect but characteristically Picassoid associations, the man of *The Charnel House* becomes linked to the suffering equine innocent of *Guernica*. As with the lamb, the symbolism of the *Guernica* horse is potentially both pagan and Christian, for he is at once the innocent but often slaughtered member of the corrida and, by virtue of the spear thrust into his side, also the crucified Christ.[5] Moreover, the horse in some studies for *Guernica*, which show him stretched out horizontally across the field (p. 239: 158), bears a family resemblance to the man in *The Charnel House*.

The association of the man in *The Charnel House* to the bound lamb, and to the soldier and horse of *Guernica*, may be said to endow the work with secondary symbolic dimensions. But unlike *Guernica*, which is openly symbolic, these are never made explicit, and remain subordinate to the more directly given realism of the work. That realism is rooted in the commonplace associations of the imagery of *The Charnel House*, which revolve around the immediate aspects of Picasso's daily life and work. The presence of a family group, for example, relates to the many intimate images central in his painting during the two years prior to *The Charnel House*—especially those of children, including his own daughter Maïa.[6] Nor are we surprised that the face of the man in *The Charnel House* should bear a strange resemblance to Picasso's own, while that of the woman has its antecedents in pictures inspired by Dora Maar.

This immediate and personal dimension of the iconography of *The Charnel House* is most obvious in the still life in its upper left, whose pitcher and casserole are virtually identical in design with those in *Pitcher, Candle and Casserole* (p. 239:159), painted in February 1945 while work was under way on the larger canvas. *Pitcher, Candle and Casserole* is one of numerous still lifes that recall the darkest days of the occupation—the lack of electricity and the meager meals cooked in Picasso's studio on the rue des Grands Augustins. In transposing it into *The Charnel House*, Picasso suppressed the candle, probably lest it be read as a symbol of optimism. Other still lifes painted while *The Charnel House* was being elaborated significantly include a series in which Picasso juxtaposed a pitcher, some leeks and a skull (p. 239:160). Here, the equation of "still" life with death implied in *The Charnel House* is rendered explicit in a manner well expressed by the French term *nature morte*. Taken together, these references to Picasso's intimate world give a sense of the iconography of *The Charnel House* that might be expressed as: I am this man; these are the woman and child I have loved and painted here during the last few years; these are our pitcher and casserole; it is incredible that we human beings should be as dead as these objects—reduced to the state of things.[7]

Picasso began *The Charnel House* in the last months of 1944 and worked on it over a period of at least a year and perhaps much longer.[8] In the earliest state in which it was photographed (by Zervos) in February 1945, it already contained numerous pentimenti (p. 240:165). Some of these erasures, such as the flamelike form in the upper right, would be reinstated. Not destined to appear in the final version was a cock, whose indistinct form may be made out in the upper left quadrant.[9] The cock appears frequently in Picasso's post-*Guernica* art, particularly in the winter just preceding *The Charnel House* (p. 239: 162). Its contexts vary, but it usually conveys an air of triumph, and it was perhaps as a symbol of resurrection that Picasso first envisioned it in *The Charnel House*. But just as he eliminated the soldier's phallic arm, his fistful of grain and its solar halo from *Guernica*, so he eventually deemed the cock inconsistent with the finality of the tragedy depicted here.

The second progressive photograph of *The Charnel House* (p. 240:166), made in April 1945, shows changes that are primarily local. The head of the man, which in the earlier state had been a near oval with an interior profile, has now been given its definitive form, the expressionist twisting of the nose and mouth nevertheless echoing the earlier "double head." The child's head and limbs have been radically altered into very nearly their present contouring, and the right foot of the mother has also found its final position. Erasures at the left of the painting show that sometime after the first photograph was made in February Picasso had enlarged the cock and depicted him crowing, but again decided to eliminate him—this time for good.

In the third progressive photograph, of May 1945 (p. 241:167), the pole to which the man's wrists had been tied at the outset has been suppressed, the flamelike forms reinstated and the table with its still life introduced. The details of the man's feet have been filled in, and Picasso seems to have worked a great deal over the region of the woman's upper torso and the child's legs without making, finally, more than marginal changes.

Up to this point Picasso had worked exclusively in charcoal. In all probability it was sometime in July that he began to heighten certain of the lines with black paint and to fill in the planes with unshaded black and gray. The photographer Brassaï saw *The Charnel House* during or just after these changes. He reports Picasso as saying: "I'm treading lightly. I don't want to spoil the first freshness of my work. . . . If it were possible, I would leave it as it is, while I began over and carried it to a more advanced state on another canvas. Then I would do the same thing with that one. There would never be a 'finished' canvas, but just different states of a single painting. . . . To finish, to execute—don't those words have a double meaning? To terminate, to finish but also to kill, to give the *coup de grâce?*"[10] Only one change was made in the conception: the introduction of the woman's second hand, which seems to be reaching for her child's right foot. We see all these alterations and additions in Zervos' last photograph, regrettably undated but certainly made after mid-July 1945 (p. 241:168). He published it in 1963, long after the work had left Picasso's studio, and identified it as "the present [hence, necessarily, the final] state" of the picture.

Zervos was wrong, however, in thinking that his last photograph represented the definitive state of *The Charnel House*. He was apparently unaware that Picasso had made a number of small additions at some point during the many years that he continued to keep the picture in the studio (see note 8). These primarily involved filling in some previously white areas (i.e., primed canvas sometimes shaded with erased charcoal) with a light blue-gray. In certain sections (the child's left face and right eye, the mother's breasts, the father's upper chest) these additions followed extant contours; in others (the mother's belly, the father's right hand) previous contours were modified and new ones added. The addition of the blue-gray panels added a fourth value—between the gray and white in intensity—to the light-dark arrangement of the picture, making smoother the visual assimilation of its often abruptly contoured shapes; the blueness also gave a mortal chill to the tonality, distinguishing it from the somewhat warmer gray of *Guernica* without fundamentally changing its funereal noncolor scheme.[11]

Like *Girl with a Mandolin* (p. 67), *The Charnel House* is nominally unfinished in the sense that it was abandoned short of Picasso's having carried all its parts to the standard of finish prevailing in his work at the time. (*Les Demoiselles d'Avignon* is unfinished in yet another sense, since certain contradictions of style were left unresolved.) However, we may presume that since Picasso kept *The Charnel House* about him for some time and then signed and released it, he felt that the work was, in its own interior terms, as good and as complete as he could make it. Indeed, the incompleteness at the top of the picture adds to its poetry by giving the still life a different level of reality; its spectral quality makes it like a fugitive thought, a passing association to the main subject of the work. The unpainted areas also enhance the picture's composition by making it more open and unexpected, sidestepping a patness that might have resulted from filling out the patterning (as, indeed, was the case with *L'Atelier de la Modiste*, p. 223:98, up until that time Picasso's only other very large grisaille picture aside from *Guernica*). It is no doubt true, as has been observed with acuity, that *The Charnel House* "was finished and brought off by being left unfinished."[12]

As they could easily have been removed, there is no doubt that Picasso wanted us to see the many charcoal traces of the pentimenti which haunt *The Charnel House* like ghosts, thus allowing us to recapitulate, in a sense, the integration of the image. Picasso's manifest and titanic struggle to *realize* the work pictorially becomes a metaphor for the difficulty of realizing emotionally and intellectually the enormity of the event depicted.

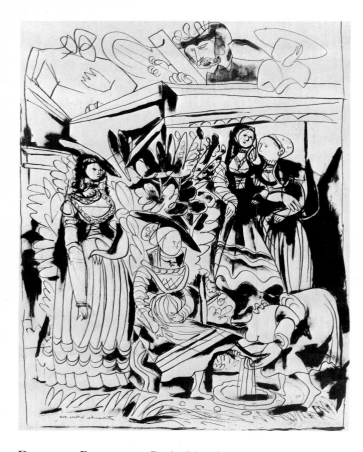

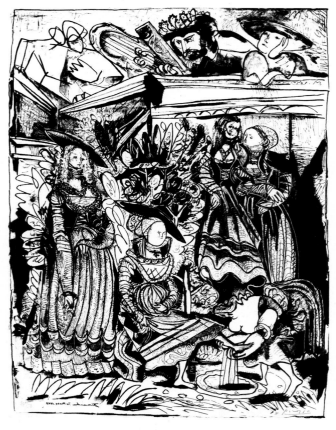

DAVID AND BATHSHEBA. *Paris, March 30, 1947. Lithograph, 25⅝ x 19¼ inches. (C&N, p. 242)*

DAVID AND BATHSHEBA. *Paris, March 30, 1947. Lithograph, 25⅞ x 19¼ inches. (C&N, p. 242)*

In 1935 Picasso told Christian Zervos that "a picture is a sum of destructions" and that "it would be very interesting to preserve . . . the metamorphoses of a picture."[1] The four states shown here of Picasso's lithographic variations on Lucas Cranach the Elder's *David and Bathsheba* (p. 242:170) offer some insight into the artist's manner of composing. In lithography there are infinite possibilities for making changes, dependent mainly on the time, skill and energy of the artist and printer. As the only way the artist can see what he has changed is to have the stone or plate proofed, the resulting prints often form simultaneously a set of preliminary drawings toward the final realization of the composition as well as a series of related and completed works. Because Picasso sees the process in terms of metamorphosis, each state becomes autonomous.

Picasso became deeply involved in lithography only after World War II. At the atelier of Fernand Mourlot he discovered the intricate pleasures of creating prints with the materials and techniques of lithography: transfer paper, crayon, tusche, washes, scraping, transferring images from plate to stone, etc. Never interested in adapting his drawing to the medium (he rarely attempted to "mirror write" the dates he invariably includes in his compositions), he prefers to adapt the medium to himself.

He began to work on *David and Bathsheba* on March 30, 1947.[2] By the end of that day the composition had gone through six states, three of which are shown here. Cranach's composition shows David and his men as a sort of frieze at the top of a wall overlooking Bathsheba's garden while the adulteress sits somewhat enclosed in a foliaged bay formed by the receding wall. Picasso puts her

DAVID AND BATHSHEBA. *Paris, March 30, 1947. Lithograph, 25½ x 19¼ inches. (C&N, p. 242)*

DAVID AND BATHSHEBA. *May 29, 1949. Lithograph, 25¹¹⁄₁₆ x 18¹⁵⁄₁₆ inches. (C&N, p. 242)*

directly below the forward jutting corner of the wall, and emphasizes the figure of David by increasing his size. According to the Biblical tale, it was at the moment of seeing Bathsheba at her bath that David's goodness and good fortune began to wane. As Picasso proceeds with his adaptation of Cranach's composition, David becomes less a seriously regal personage than a lascivious voyeur, and the agitation of the impending romance permeates the entire composition.

Each state directs the eye to a different aspect of the artist's graphic agility. After the first two states, in which the balance of the composition and the essential outlines of the figures were established, Picasso blackened the plate and redrew the picture with a uniformly thin line. From this very rigid point Picasso, in the subsequent states, scraped away at the black faces and inserted more

and more linear detail. The earliest states are almost literal drawings after Cranach, while some of the final states, although divested of most of the exact references to Cranach, closely echo the rhythm of light that enlivens the sixteenth-century composition.

Picasso's use of the compositions of other artists is faithful to his philosophy that "we must pick out what is good for us where we can find it—except from our own works."[3] Paintings have been directly inspired by works by El Greco, Velásquez, Poussin and Delacroix, among others, but in his prints Picasso has turned almost exclusively to the Cranachs.[4] His first work based on a Cranach painting was a drawing after *Venus and Cupid as a Honey Thief*[5] done in August 1942. He began the *David and Bathsheba* series in March 1947, returning to work further on it in March 1948 and March 1949. During the lat-

171

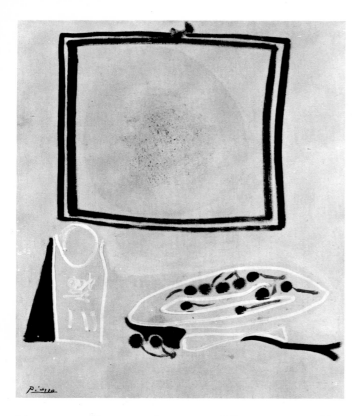

PREGNANT WOMAN. *Vallauris, 1950. Bronze, first version,* *41¼ inches high. (C&N, p. 243)*

The *Pregnant Woman*, descendant of a long line of fertility goddesses that goes back to the Venus of Willendorf, may have had very specific totemic connotations for Picasso. He had already had two children by Françoise Gilot; according to her, he wished to have a third, and the sculpture represented "a form of wish fulfillment on Picasso's part."[1] The metaphor of the woman as vessel is literally incorporated into the work, since the bronze was cast from a model in which the forms of the belly and breasts were those of large ceramic jars partially imbedded in plaster that had been used to fill out the other parts of the anatomy.

Picasso tinkered with the model of this work after the edition was cast, adding nipples to the breasts and changing other details. A second edition of bronzes (p. 243: 171) was made from this revised version in 1959.

MIRROR AND CHERRIES. *June 1947. Oil on canvas, 23⅞ x 19⅝ inches. (C&N, p. 243)*

ter period he also produced a color lithograph after Cranach the Elder's portrait of *Princess Sibylle von Cleve as a Bride*[6] and several versions of *Venus and Cupid*.[7] Picasso's best-known work after Cranach, this time the Younger, is the linoleum-cut portrait done in 1958 after the *Female Portrait* of 1564.[8]

Picasso seems to have been interested in the costumes, decorative motifs and particularly the meticulous stylization of Cranach's work. He may also have been attracted by the awkward spatial resolution in the *David and Bathsheba* picture, in which the sixteenth-century artist had some difficulty making Bathsheba appear properly enclosed in her garden. Picasso further embellishes on the quantity of detail and in the end establishes through this superficial embroidery a flattening of the last vestiges of Cranach's perspective. *(Riva Castleman)*

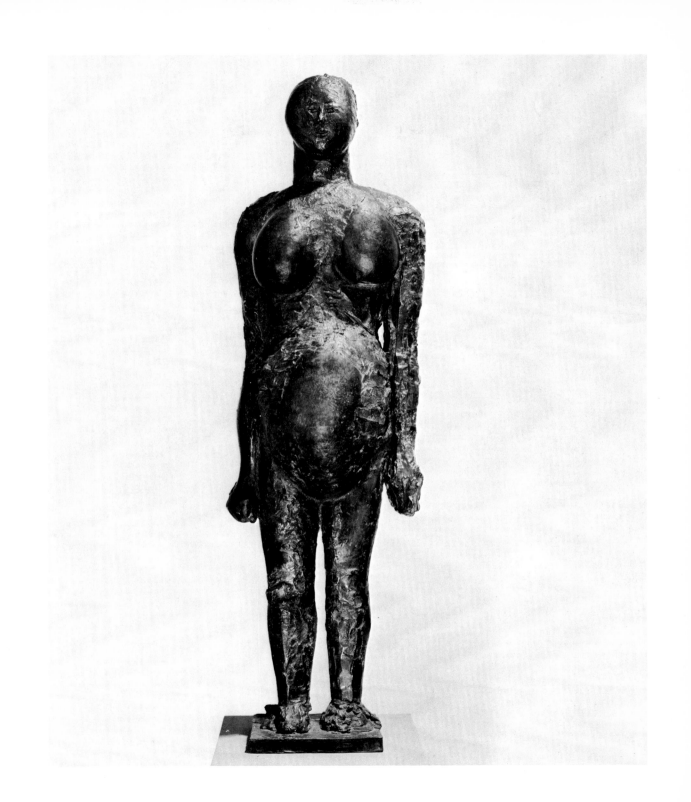

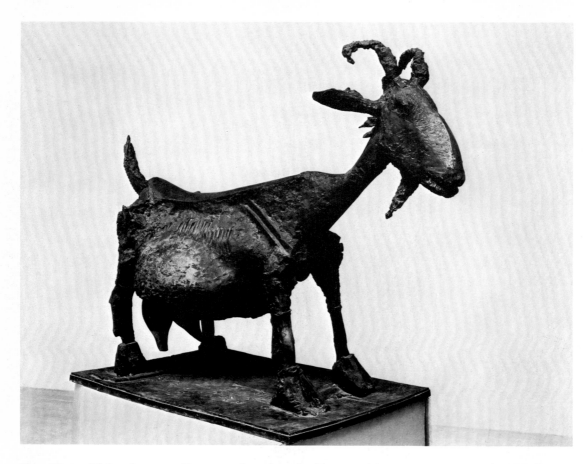

SHE-GOAT. *Vallauris, 1950. Bronze, after found objects,* $46\frac{3}{8}$ x $56\frac{3}{8}$ x $27\frac{3}{4}$ *inches. (C&N, p. 243)*

In his sculptures of the forties and early fifties Picasso eschewed the openwork, planar and linear esthetic of Cubist construction in favor of effects of mass. But this did not signal his return to simple modeling. The collage technique common to many of the earlier constructions is at the origin of most of these later works insofar as the models from which they are cast were built up additively with diverse objects and materials. The back of the *She-Goat*, for example, is cast from a palm leaf, her udder is formed from two earthenware jugs, the patterns of the rib cage are the impression of a wicker hamper and the shoulders are shaped by bits of scrap iron. These and other elements of the composite were joined by plaster, which filled out the piece to provide its silhouette and unifying surface texture (p. 243:172). Before choosing

the incorporated objects, however, Picasso had already established much of the sculpture's general character and contouring in drawings (p. 243:173).

In spite of the debt to Cubist collage in the procedures for making such sculptures, the composite structures they constitute prior to being cast in bronze are less related to Cubism than to the kind of Surrealist hybrids Picasso drew and painted in the early thirties (pp. 141, 143). Indeed, the rapid assembling of a sculpture from the forms of integral, "Readymade" objects might be considered a variant of Surrealist automatism (Max Ernst, for instance, used this technique in making the models for his bronzes). When the plaster-and-object sculptures are cast, the bronze unifies the sculpture while tending to obscure the real objects. But if these linger primarily as echoes, the loss of surreal cross-references is compensated for by a greater formal coherence.

The concupiscence traditionally associated with goats

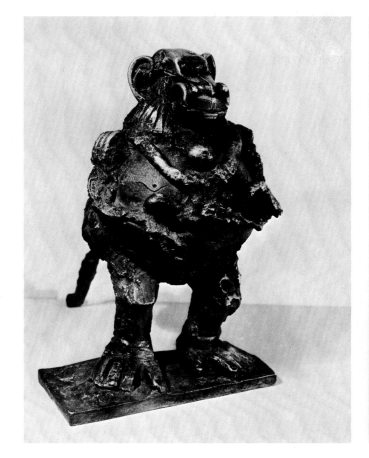

BABOON AND YOUNG. *Vallauris, 1951. Bronze, after found objects, 21 x 13¼ x 20¾ inches. (C&N, p. 244)*

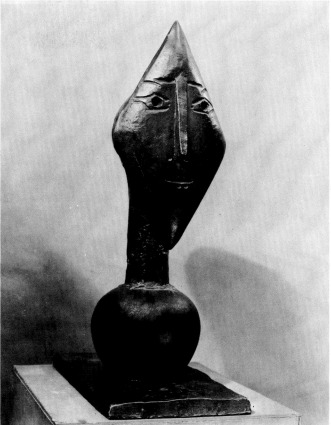

HEAD OF A WOMAN. *Vallauris, 1951. Bronze, 19⅞ x 8⅝ x 14½ inches. (C&N, p. 244)*

makes them symbols of sin in Western Christian imagery —indeed, they provide part of the anatomy of the Devil. This same trait is a virtue in Picasso's pagan view; his goats are usually symbols of Arcadian fertility and joy (as in the pictures of the Antibes period of 1946, for example, where goats caper with nymphs and fauns). But the choice of the *She-Goat* as a subject is also testimony to Picasso's lifelong love of animals. A few years after the casting of this work, he kept a pet goat which had free run of the house and grounds at La Californie.

*Baboon and Young* is exceptional for the ease with which the baboon's head is recognized as having been cast from two toy motor cars set bottom to bottom; the found objects in the remainder of the work—the steel automobile spring which formed the backbone and tail, for

example—are more fully subsumed by the reality of the baboon. The use of the toy cars here is more than just a witty plastic transformation demonstrating Picasso's ability to envision two such objects as a baboon's head. Their very choice is not without emotional and inferential meanings. On the broadest level the toy cars belong to the world of make-believe and play—which has direct analogies to the process of making an assemblage sculpture. More specifically, they are the toys of Picasso's children Claude and Paloma, whom the artist had more than once affectionately imaged playing with them (p. 244:174). Thus, as objects, the toy cars were associated in Picasso's mind with his feelings about his children, a theme expressed, in turn, in this sculpture as an image of parental tenderness.[1]

MOONLIGHT AT VALLAURIS. *Vallauris, 1951. Oil on ply-wood, 54 x 41¼ inches. (C&N, p. 244)*

In 1948 Picasso settled in Vallauris where a year earlier he had begun to work in ceramics with the assistance of the master potter Georges Ramié. Until his departure for Cannes in 1955, he was much occupied with the making and decorating of a large variety of vases, plates (see p. 178) and ceramic sculptures. His accomplishments in this field singlehandedly revitalized the town's chief industry, which had begun to atrophy in the years following World War I, and which was in full decline by 1948.

This view of the outskirts of the town, one of his rare nocturnes, is largely a draftsmanly picture. The artist laid in a terra-cotta ground up to the horizon line, and a blue one above it. The forms of the trees, electrical stanchion and house are contoured for the most part in black. (A few patches of bright green illuminate the foreground, and blackish green fills in an occasional reserved area of the background.) The objects thus take on a disembodied, transparent appearance in the light of the green and white moon.

176

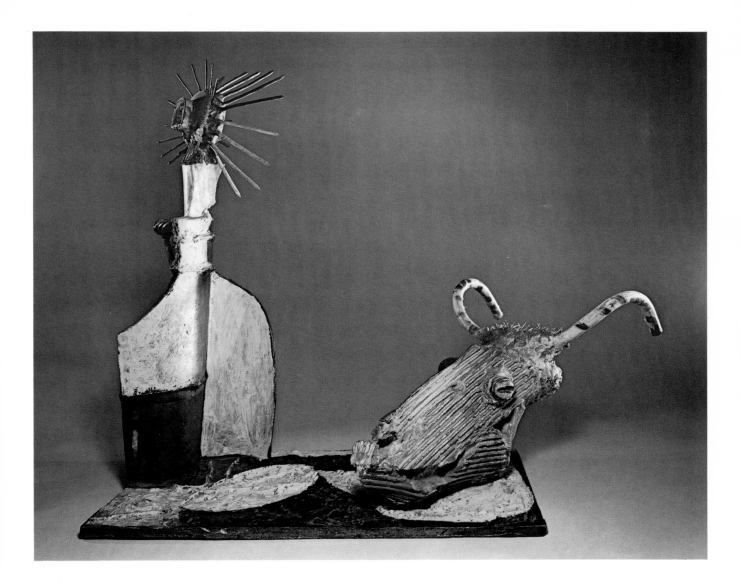

GOAT, SKULL AND BOTTLE. *1951–52. Painted bronze, 31 x 37⅝ x 21½ inches. (C&N, p. 244)*

This sculpture relates to a number of Picasso's paintings of the late thirties, forties and early fifties in which a candle is juxtaposed to a severed head or skull of an animal. Here the candle and the splayed "transparent" contours of the bottle from which it projects were cast from scrap metal, with nails and spikes representing its rays of light. The goat's skull was formed largely by bent corru-gated board with nails of different sizes representing the teeth and the residual fur between the horns. The horns themselves were made from the handlebars of a child's bicycle and the eyes were made with the heads of giant bolts.

The animal, which in *She-Goat* had been a symbol of life and fertility, is here converted into a memento mori. The "Spanish" coloring of earth tones, grays and blacks—each of the three bronze casts was painted somewhat differently—reinforces the funereal aspect of the whole.

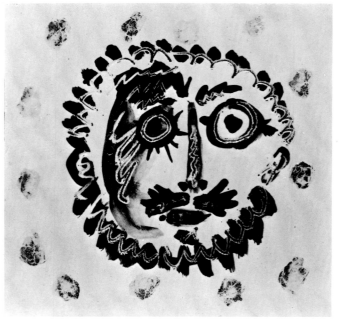

HEAD OF A FAUN. *1956. Painting on tile, 8 x 8 inches. (C&N, p. 244)*

BEARDED FAUN. *1956. Painting on tile, 8 x 8 inches. (C&N, p. 244)*

PLATE WITH STILL LIFE. *1954. Modeled polychrome glazed ceramic, 14¾ x 12½ inches. (C&N, p. 245)*

STUDIO IN A PAINTED FRAME. *April 1956. Oil on canvas, 35 x 45⅝ inches. (C&N, p. 245)*

*Studio in a Painted Frame* is, I believe, the finest of Picasso's series of recent [1956] paintings of the interior of his villa at Cannes. In it the artist has transformed the fantastic, though functioning, disorder of his studio into a beautifully controlled design suggesting at first glance his decorative late Cubist style. Yet, once one has seen the room itself, the objects in the picture are easily recognizable: the tall, heavy-mullioned window with the palm tree beyond, the squat brass stove from North Africa, his bronze bust of a woman with the diamond-shaped face (p. 175), one canvas on the easel ready for work and others scattered about on the floor, leaning every which way.

Four colors—tan, black, brown and the unpainted white of the canvas itself—make an austere harmony, singularly Spanish. When I mentioned this to Picasso he laughed, glanced down at the picture and said, half in self-mockery, "Velázquez." In the same spirit he has painted an "old-master" frame around the margins of the canvas and put his signature below, like a museum label. *(Reprinted by permission of Alfred H. Barr, Jr.)*[1]

WOMAN BY A WINDOW. *Cannes, June 1956. Oil on canvas, 63¾ x 51¼ inches. (C&N, p. 245)*

*Woman by a Window* is a salient work in the continuing farrago of images, based directly and indirectly on Jacqueline Roque, which Picasso began in 1954. A woman who "has the gift of becoming painting to an unimaginable degree,"[1] she continues to be his central subject. *Woman by a Window* was executed about two months after *Studio in a Painted Frame,* and its scene is likewise set in one of the rooms that Picasso used as an atelier in his villa, "La Californie," at Cannes. The beautiful, large-eyed Jacqueline, whom the artist was to marry two years later, sits in a rocking chair before a French window. To her right we see a fragment of a stretcher, apparently on an easel, and farther to the right, a balcony with its railing. A palm tree is silhouetted against the lawn.

The remarkably assured drawing of the head captures the serene classicism of Jacqueline's face, which seems to circulate around an all-seeing frontal eye. Her left hand, its contours among those scratched into the pigment, falls easily over the arabesque of the bentwood rocker whose shape—especially in this context of relaxed contemplation in a Riviera ambience—calls to mind Matisse.[2] The grisaille of Jacqueline's head and breasts informs her serene detachment with a sculptural coolness. The browns warm the tonality of the space around her, which is given freshness and luminosity by the transparent, thinly brushed green of the landscape.

*Woman by a Window* represents a fusion of the motif of a woman in a rocking chair, explored in a painting executed in the last week of March 1956 (p. 245:176), with that of the empty studio, four versions of which were completed between March 30 and April 2 (the date of the Museum's *Studio in a Painted Frame,* p. 179). The very next day (April 3) Picasso painted Jacqueline in a rocking chair (p. 245:177) sitting before a picture of the atelier that resembles the right side of *Studio in a Painted Frame,* with which it has in common Picasso's bust of the woman with a diamond-shaped face (p. 175), the canvas on the easel and the French window with its view of the palm tree in the garden. The latter motif appears in roughly the same position in *Woman by a Window,* though it is no longer part of a picture-within-a-picture.

After the paintings mentioned above, Picasso made a number of variations on the theme of Jacqueline looking at a canvas, of which a group of notebook drawings (p. 245:178–180) made on June 7—just four days before the completion of *Woman by a Window*—are particularly pertinent. Common to all these is the large frontal eye that is so striking in the painting. They also explain the curious brown and black triangle that projects toward Jacqueline from the right side of the stretcher that sits on the easel in *Woman by a Window.* This turns out to be a vestige of a motif clearly stated in the drawings, where the picture on the easel seems to project out to Jacqueline's eye (p. 245:179)—perhaps a graphic symbol for a kind of direct projection into the mind's eye (p. 245:180). Although this inventive element was not incorporated as such into *Woman by a Window,* it tends to explain not only the brown and black triangle, but also the other lines in the space between Jacqueline and the picture on the easel, and above all, the triangular form of her profile eye, which may be said to be as focused on that picture as the other is upon the man who is painting her.

WOMAN IN AN ARMCHAIR. *Mougins, 1961–62. Oil on canvas, 63⅞ x 51⅛ inches. (C&N, p. 246)*

This picture shows Jacqueline seated on a red velvet chair playing with her pet Afghan, Kaboul, in the garden of Notre-Dame-de-Vie, the villa at Mougins into which she and Picasso moved in June 1961. Despite the informal motif and setting, *Woman in an Armchair* has the air of a seventeenth-century court portrait—a formal study of the consort of *le roi des peintres*. The antique chair, the manner in which Kaboul stands at attention, the pose of Jacqueline's body—her arms disposed at right angles paralleling the frame—and the focus of her glance at the painter-viewer rather than at the dog all reinforce this effect. In order to suggest a frontal position for Jaqueline's face—so that she might seem to look outward more than toward Kaboul—Picasso has used a cunning variant of the interior profile: Jacqueline's lips and chin are portrayed as if they were part of a profile facing the dog, while her nose belongs to a silhouette facing in the opposite direction. The result is a facial image whose profiles cancel out, as it were, into frontality.

Large in size and highly worked over its entire surface, *Woman in an Armchair* is a special work, a major set piece that Picasso distinguished from the rest of his production. No known Picasso of the last fifteen years is more *travaillé*; few approach its degree of elaboration. Picasso indulges his love of paint in this picture with sensuous abandon; in the bravura of its execution he pits himself against the great Spanish court painters Velásquez and Goya.

There is a great variety from point to point in the brushwork of *Woman in an Armchair*, but the common denominator of the notation is painterliness. The shaggy coat of Kaboul, for example, is realized in long streaks of gray seasoned with green, blue and brown, while the scumbling of the predominantly dark-green area around his snout serves as their foil. It is, however, in the long tresses of Jacqueline, where the extended curvilinear strokes form an intricate maze of blue, green and red highlights within the mass of black, that the stylistic richness of the conception most beautifully crystalizes. The patterning of the hair—capped by the accent of the brilliant yellow ribbon—is, above all, a color microcosm of a picture in which Picasso has used a larger number of saturated colors than is his habit, and brought it off with a superb decorative effect.

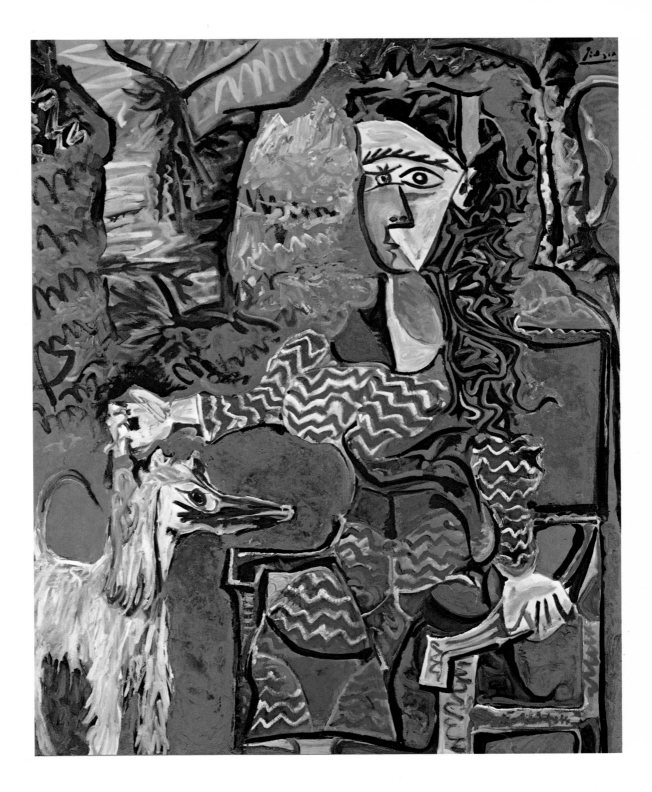

FIGURES. *Mougins, March, 1967. Wash, brush, pen and ink, 19½ x 25½ inches (sight). (C&N, p. 246)*

Picasso, always a prolific draftsman, has used drawing in many ways—in the development of styles such as Cubism, in the perpetuation of modes (such as neoclassicism) he no longer emphasized in painting, and in the elaboration of themes that have engrossed him. Such an elaboration of themes is apparent in the thousands of drawings created between 1966 and 1968, where many subjects long familiar in the artist's work—man with sheep, bathers, dancers, grandees—are recapitulated, often in surprising social and historical combinations. Many of these works are erotic; most are humorous. The richness of their invention is often astonishing, as is the occasional eschewal of technical elegance.[1]

This sheet of studies, which seems to be a private allegory, comes from that period. Here, figures are depicted in various scales and in several spatial realms. The dark eyes and rounded nose of the stubble-headed figure at the center resemble features of the aging Picasso himself. A woman's silhouette and body are united with his own. She dangles a puppetlike form. At her left, a corpulent dwarf (or dissolute Bacchus), antithesis of the godlike males of earlier works, is drawn in grotesque detail. He seems to advance mindlessly ahead. At the right, a simply clad young man, a type seen in Picasso's youthful work, observes the scene. Two couples are also shown. At the top, a pair whose relationship is equivocal is enveloped in a mesh of dark lines. Kneeling at the bottom, a beast-like male reaches for a graceless partner. He seems to parody the beauty and revelry of similar encounters between the Minotaur, or artist, and model that Picasso etched more than thirty years before. *(Elaine L. Johnson)*

THE POOL. *Mougins, January 1968. Pencil, 22¹³⁄₁₆ x 30¹¹⁄₁₆ inches. (C&N, p. 246)*

Several drawings in the large group that Picasso created between 1966 and 1968 depicted women at leisure in a pool-side setting.[1] The deployment and attitudes of the figures had precedent in works such as Ingres' *Bain turc*, 1862 (p. 246:181), as well as in Picasso's own earlier compositions, such as *The Harem* of 1906, and the neoclassic and mannerist drawings and paintings of bathers of 1918.

Line had been Picasso's preferred means for depicting neoclassical subjects in his earlier drawings. Here, it has also become a tool of his humor. Idiosyncrasies of the flesh are carefully traced, and proportions are willfully caricatured. Two figures are at odds with the style and scale of the composition: the capped swimmer whose past motions are sketched, and the dreaming nude, top right, whose large size belies her implied distance. Two other figures stand pillarlike, framing the scene: a tall woman in an academic pose and a child observer.

The simple, unmodeled rendering of this drawing befits the uncomplicated, sun-flooded scene. Most of the contours are curvilinear and soft. Tension is provided by the long, taut line that describes the back of the central, turbanned figure, as well as by the horizontal indications of the pool's edge.    *(Elaine L. Johnson)*

# CATALOG AND NOTES

WORKS ARE LISTED in the order in which they appear in the book. A date is enclosed in parentheses when it does not appear on the work. Dimensions are given in feet and inches, height preceding width; a third dimension, depth, is given for some sculptures. For prints, references are given to the following standard catalogs:

G – Geiser, Bernhard, *Picasso: Peintre-Graveur*. 2 vols. published to date. Vol. 1 (1899–1931), Berne, Chez l'auteur, 1933; Vol. 2 (1933–1934), Berne, Kornfeld et Klipstein, 1968.

M – Mourlot, Fernand, *Picasso Lithographe*. 4 vols. published to date. Vol. 2 (1947–1949), Monte Carlo, André Sauret, 1950.

B – Bloch, Georges, *Pablo Picasso: Catalogue of the Printed Graphic Work*. 2 vols. published to date. Vol. 1 (1904–1967), Berne, Kornfeld et Klipstein, 1968.

1. *Self-Portrait: Yo Picasso*, 1901. Private collection, Los Angeles

SELF-PORTRAIT
Paris, (late spring or summer 1901)
Oil on cardboard mounted on wood, 20¼ x 12½ inches
Signed bottom right: "Picasso"; inscribed top left: "Yo"
Provenance: Private Collection, Nice; Paris art market
Promised gift of Mr. and Mrs. John Hay Whitney, New York
Ill. p. 25

1. There are two partial exceptions to this statement—both unfinished oils, dating from 1895 and c. 1896–97 respectively. Others possibly exist among the as yet unpublished works in Spain. The 1895 picture is a double portrait (Fig. 2) in which the principal sitter is in the right foreground. Behind him, turning toward the viewer, is an image of the fourteen-year-old Picasso. The other (Fig. 3), which shows the painter in a seventeenth- or eighteenth-century wig and costume, is not without interest for the iconography of *Suite 347* and related works, where the artist transposes himself and his father into court gentlemen.

2. Picasso, in conversation with the author, July 1971.

Although Jaime Sabartés (*Picasso: Documents iconographiques*, Geneva: Pierre Cailler, 1954, n.p., No. 63) identifies *Self-Portrait* as the first such image of 1901, it was certainly painted after *Self-Portrait: Yo Picasso* (Fig. 1), if the artist's recollection is correct. He may also have confirmed this order to Pierre Daix and Georges Boudaille (*Picasso: The Blue and Rose Periods*, Greenwich, Connecticut: New York Graphic Society, 1967, pp. 160–61), who argue convincingly that *Self-Portrait* is the later of the two; they publish a hitherto unknown pastel and charcoal sketch for *Self-Portrait: Yo Picasso*, on the verso of which is a figure that can be definitely connected with a painting, *At the Races*, probably identifiable as No. 32 in the catalog of the Vollard exhibition in June.

2. *Double Portrait*, 1895

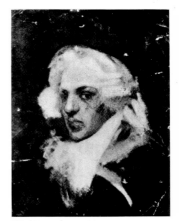

3. *Self-Portrait in Seventeenth- or Eighteenth-century Costume*, c. 1896–1897

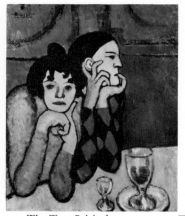

4. *The Two Saltimbanques*, 1901. The Pushkin Museum, Moscow

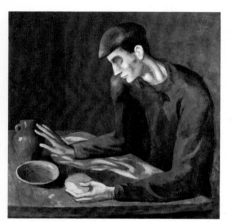

5. *The Blind Man's Meal*, 1903. The Metropolitan Museum of Art, Gift of Mr. and Mrs. Ira Haupt, 1950

THREE CHILDREN
Paris, (1903–04)
Watercolor, 14½ x 10⅝ inches
Signed bottom left: "Picasso"
Verso: *Brooding Woman*
For provenance and donor, see below: *Brooding Woman*
Acquisition number: 4.56b
Ill. p. 26

BROODING WOMAN
Paris, (1904)
Watercolor, 10⅝ x 14½ inches
Signed on recto: "Picasso"
Recto: *Three Children*
Provenance: André Level, Paris; Leperrier, Paris;
  Max Pellequer, Paris; George Eumorphopoulos, London;
  Justin K. Thannhauser, New York
Gift of Mr. and Mrs. Werner E. Josten, 1956
Acq. no. 4.56a
Ill. p. 27

SALOME
(1905)
Drypoint, 15⅞ x 13¾ inches
G.17b/b
Lillie P. Bliss Collection, 1934
Acq. no. 89.34
Ill. p. 28

THE FRUGAL REPAST
(1904)
Etching, 18³⁄₁₆ x 14¹³⁄₁₆ inches
G.21Ib/IIb
Gift of Abby Aldrich Rockefeller, 1940
Acq. no. 503.40
Ill. p. 29

1. Zervos, Christian, *Pablo Picasso*, 23 vols. published to date (Paris: Editions "Cahiers d'Art," 1932–1971), I, 78.

2. Zervos, I, 100.

3. Zervos, I, 96.

4. Zervos, I, 129.

5. Kahnweiler, Daniel-Henry, with Francis Crémieux, *My Galleries and Painters*. The Documents of 20th Century Art (New York: Viking, 1971), p. 37. "One day I was in my shop when a young man came in whom I found remarkable. He had raven-black hair, he was short, squat, badly dressed, with dirty, worn-out shoes, but his eyes were magnificent."

6. Geiser, Bernhard, *Picasso: Peintre-Graveur* (Berne: Chez l'auteur, 1933), preface.

7. Daix and Boudaille, *Picasso*, p. 254.

8. Zervos, I, 113.

MEDITATION (also known as *Contemplation*)
Paris, (late 1904)
Watercolor and pen, 13⅜ x 10⅛ inches
Signed lower right: "Picasso"
Provenance: Raoul Pellequer, Paris; Jules Furthman,
  New York; Vladimir Horowitz, New York
Collection of Mrs. Bertram Smith, New York
Ill. p. 31

1. Steinberg, Leo, "Sleep Watchers," *Life*, Vol. LXV, 26, December 27, 1968 (special double issue on Picasso)—a deeply sensitive study of this theme throughout Picasso's work.

2. Although Jean Sutherland Boggs (*Picasso and Man*, catalog of an exhibition at the Art Gallery of Toronto and the Montreal Museum of Fine Arts, January–March 1964, p. 10) had stated that the female figure "was, of course, his first mistress, Fernande Olivier," this identification is not found in Steinberg, "Sleep Watchers," Daix and Boudaille, *Picasso*, or elsewhere to my knowledge. In fact, Daix and Boudaille specifically identify (p. 257) the two pencil heads of Fernande in the somewhat later sketch for *The Actor* as "probably" the first images of Fernande in Picasso's work. Nevertheless Boggs' intuition did not contradict what relatively few intimate biographical facts are known of that period, and Picasso has recently confirmed to this author that the sleeping figure was, indeed, Fernande.

TWO ACROBATS WITH A DOG
Paris, (early) 1905
Gouache on cardboard, 41½ x 29½ inches
Signed and dated lower right: "Picasso / 1905"
Provenance: Galerie Thannhauser, Paris; Wright Ludington,
  Santa Barbara, California
Promised gift of Mr. and Mrs. William A. M. Burden,
  New York
Ill. p. 32

1. See Peter H. von Blanckenhagen: "Rilke und 'La Famille des Saltimbanques' von Picasso," *Das Kuntswerk* (Baden-Baden), v. 4, 1951, pp. 43–54. Theodore Reff ("Harlequins, Saltimbanques, Clowns, and Fools," *Artforum*, New York, x, 2, October 1971, pp. 30–43), sorts out the various typological sources for Picasso's casual mélange of attributes in his entertainers of the Rose Period. He also provides an invaluable survey of the pertinent late nineteenth-century art and literature Picasso may have seen and read.

2. For example, *Two Acrobats* in the Hermitage, Leningrad. I am indebted here to Meyer Schapiro in whose lectures at Columbia University the various implications of *saltimbanques* and entertainers in the early iconography of Picasso were discussed at length, especially in regard to the literary tradition spanning Baudelaire's prose poem *Le Vieux Saltimbanque* and Edmond de Goncourt's *Les Frères Zemganno*. Although I attended the Schapiro lectures only in the late 1940s, this Picasso material had formed part of his course when it was first elaborated some fifteen years earlier.

6. *Sleeping Nude*, 1904. Jacques Helft, Paris

7. *Family of Saltimbanques*, 1905. National Gallery of Art, Washington, D.C.

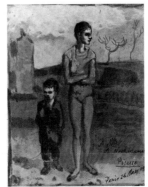

8. *Young Acrobat and Child*, 1905. Justin K. Thannhauser Foundation, The Solomon R. Guggenheim Museum, New York

9. *Boy with a Dog*, 1905. The Hermitage, Leningrad

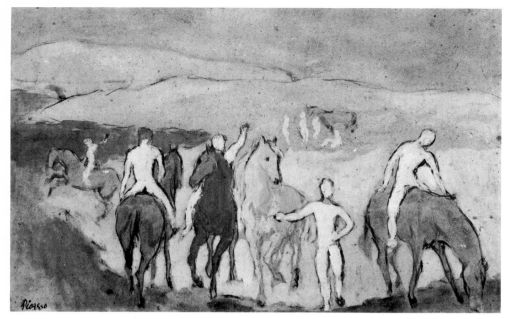

10. *Study for The Watering Place*, 1906. The Dial Collection, Worcester Art Museum

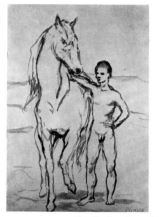

11. *Study for Boy Leading a Horse*, 1905. The Baltimore Museum of Art

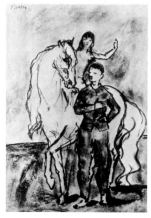

12. *Girl on Horseback, and Boy*, 1905–06

Picasso identified himself most directly with Harlequin in *At the Lapin Agile*, 1905 (Zervos, I, 120), in which he himself wears Harlequin's motley. For background on the Harlequin theme, see A. Blunt and P. Pool, *Picasso: The Formative Years* (Greenwich, Connecticut: New York Graphic Society, 1962), pp. 21–22.

3. Zervos, I, 134.

FAMILY WITH A CROW
Paris, (1904–05)
Crayon, pen and ink, 12⅞ x 9½ inches
Signed lower right: "Picasso"
Provenance: Alfred Flechtheim, Berlin; Private Collection, Basel; Heinz Berggruen, Paris; The Donor, Grosse Pointe Farms, Michigan
The John S. Newberry Collection, 1960
Acq. no. 384.60
Ill. p. 33

BOY LEADING A HORSE
Paris, (1905–06)
Oil on canvas, 86½ x 51¼ inches
Signed lower right: "Picasso"
Provenance: Ambroise Vollard, Paris; Gertrude and Leo Stein, Paris; Thannhauser Gallery, Lucerne
Gift of William S. Paley (the donor retaining a life interest), 1964
Acq. no. 575.64
Ill. p. 35

1. The various sketches which came to be summarized in the study for *The Watering Place* extend from the last months of 1905 to early summer 1906. One cannot be sure where *Boy Leading a Horse* fits into this order. Alfred H. Barr, Jr. (*Picasso: Fifty Years of His Art*, New York: The Museum of Modern Art, 1946, p. 42) accepted Zervos' dating of 1905 (Zervos, I, 118). I have adopted that of Daix and Boudaille (*Picasso*, p. 286).

2. *Boy Leading a Horse* has particular affinities with Cézanne's *Bather*, c. 1885 (Fig. 14); while this picture was probably not in the Salon d'Automne of 1904 and certainly not in that of 1905, it was in Vollard's possession in 1901 when Picasso exhibited with him, and the artist very probably saw it at that time.

3. Meyer Schapiro, lectures at Columbia University.

4. Blunt and Pool, *Picasso*, pp. 26–27.

5. "Rosewater Hellenism" is a term employed in the literary criticism in the late nineteenth century; Meyer Schapiro was the first to apply it to the painting of Puvis.

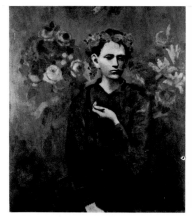

13. *Boy with a Pipe*, 1905. Mr. and Mrs. John Hay Whitney, New York

14. Cézanne, *Bather*, c. 1885. The Museum of Modern Art, New York

15. *Peasants*, 1906

16. *Peasants and Oxen*, 1906.
Barnes Foundation,
Merion, Pennsylvania

17. *Negro Attacked by a Lion*,
stone bas-relief from Osuna.
Museo Arqueológico Nacional,
Madrid

18. *Horse and Rider*, Iberian
bronze from Despeñaperros.
Museo Arqueológico Nacional,
Madrid

19. *Woman Combing Her Hair*,
1905–06

20. *Study for Woman Combing
Her Hair*, 1906. Mr. and Mrs.
George E. Seligmann, New York

THE FLOWER GIRL
Gosol, (summer); or Paris, (fall 1906)
Pen and ink, 24⅞ x 19 inches
Signed lower left: "Picasso"
Provenance: The Donor, Greenwich, Connecticut
Gift of Mrs. Stanley B. Resor, 1950
Acq. no. 99.50
Ill. p. 36

1. Daix and Boudaille, *Picasso*, p. 308, xv. 58, state that *The Flower Girl* was executed in Gosol or Paris, summer 1906.

2. Barr, *Fifty Years*, p. 256. Daix and Boudaille, *Picasso*, p. 308, xv. 57, believe that the sketch was indeed drawn from life.

3. See Barr, *Fifty Years*, p. 256, for information concerning publications on El Greco that came to Picasso's attention during 1906, as well as for a detailed discussion and reproductions of the compositional sources in El Greco and Cézanne for *Peasants and Oxen*.

WOMAN COMBING HER HAIR
Paris, (late summer or fall 1906)
Oil on canvas, 49⅝ x 35¾ inches
Signed lower left: "Picasso"
Provenance: John Quinn, New York; Mrs. Edward A.
  Jordan, New York; Marie Harriman Gallery, New York
Extended loan of the Florene May Schoenborn and
  Samuel A. Marx Collection
Ill. p. 37

1. The classic discussion of this influence in Picasso's work in 1906–07, which was first noted by Zervos following a conversation with Picasso, is James Johnson Sweeney's "Picasso and Iberian Sculpture," *The Art Bulletin* (New York), XXIII, September 1941, pp. 191–198. Sweeney notes the importance of the installation of the Osuna sculptures in the Louvre in the spring of 1906. Observing the differences between the *Woman Combing Her Hair* and Picasso's earlier sculpture of the motif, he attributes them in part to the intervention of Iberian sculpture, especially of the type exemplified by the votive bronze illustrated here.

2. This in no way contradicts the influence of Iberian sculpture. Picasso's assimilation of other art has always been generalized, so he would have considered the stylizations of Archaic Greek sculpture interchangeable with the stiff and simplified versions of Classical Greek art that issued at a later date from the provincial ateliers of Iberia after the Archaic had given way to the Classical and early Hellenistic styles in Greece itself.

TWO NUDES
Paris, (fall 1906)
Charcoal, 24⅜ x 18½ inches
Signed lower right: "Picasso"
Provenance: Jacques Sarlie, New York;
   Marlborough-Gerson Gallery, Inc., New York
Extended loan of the Joan and Lester Avnet Collection
Ill. p. 38

TWO NUDES
Paris, (late fall 1906)
Oil on canvas, 59⅜ x 36⅜ inches
Signed lower left: "Picasso"
Provenance: Paul Rosenberg, Paris; Rosenberg and Helft,
   London; John Quinn, New York; Keith Warner, Vermont;
   E. and A. Silberman Galleries, New York; The Donor,
   Pittsburgh
Gift of G. David Thompson in honor of Alfred H. Barr, Jr.,
   1959
Acq. no. 621.59
Ill. p. 39

1. Golding, John, *Cubism: A History and an Analysis 1907–1914,* 2d ed. (London: Faber and Faber, 1968), pp. 52–53. Golding's book is recommended as the most thorough and scholarly account of the period 1907–14.

LES DEMOISELLES D'AVIGNON
Paris, (1907)
Oil on canvas, 8 feet by 7 feet 8 inches
Provenance: Jacques Doucet, Paris; Jacques Seligmann &
   Co., New York
Acquired through the Lillie P. Bliss Bequest, 1939
Acq. no. 333.39
Ill. p. 41

[The only text of scholarly importance to have appeared on *Les Demoiselles d'Avignon* since the publication of Barr's *Picasso: Fifty Years of His Art* is an article by John Golding of the Courtauld Institute, London, in the *Burlington Magazine* (London), C, 145, May 1958, pp. 155–63, which deals most convincingly with the problems of style and chronology that are raised by this painting. This material was subsequently incorporated with slight changes and additions into the second edition of Golding's *Cubism* and is probably more accessible to the student there.

   The book—or rather booklet—by Günther Bandmann, *Pablo Picasso: Les Demoiselles d'Avignon* (Stuttgart: Philipp Reclam jun., 1965) contains a few interesting observations on the moralizing character of the first sketch for the painting, but is otherwise a superficial résumé of the discussions of the picture as they stood before the publication of Golding's article, of which Bandmann seems unaware.

   Pierre Daix ("Il n'y a pas 'd'art nègre' dans 'Les Demoiselles d'Avignon'." *Gazette des Beaux-Arts* (Paris), series 6, vol. 76, October 1970, pp. 247–70) has returned to the dis-

21. *Study for Woman Combing Her Hair,* 1906. City Art Museum of St. Louis

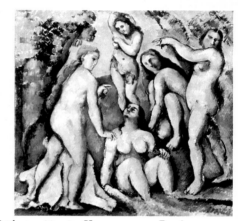

22. Cézanne, *Five Bathers,* 1885–87. Kunstmuseum, Basel

23. El Greco, *Assumption of the Virgin* (lower half), 1577. The Art Institute of Chicago

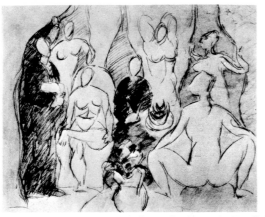

24. *Study for Les Demoiselles d'Avignon*, 1907

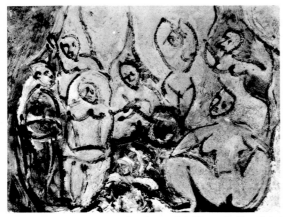

25. *Study for Les Demoiselles d'Avignon*, 1907

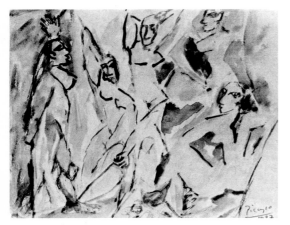

26. *Study for Les Demoiselles d'Avignon*, 1907. Philadelphia Museum of Art

cussion of whether there is any influence of Negro art in *Les Demoiselles*. His argument for the negative is not convincing — at least to this author — in part because he does not adequately confront the facts and reasoning pointing to the contrary conclusion put forth by Golding and others. In regard to the chronological questions raised by this dispute, the student will find "A Note on the Discovery of African Sculpture" in Edward Fry's *Cubism* (London: Thames and Hudson, 1966, pp. 47–48) especially valuable for review. W.S.R.]

1. Besides these composition studies for *Les Demoiselles d'Avignon* reproduced on page 41, Zervos illustrates fourteen more (II, part 2, 629, 632–644). These do not include dozens of figure studies. [Since the publication of Barr's text, later supplemental volumes in the Zervos catalogue have included at least 14 drawings which relate closely to *Les Demoiselles* as well as others that may have some connection with it. (See Zervos, VI, 980 and 981, and XXII, 461; also VI, 977–979, 982–987, 990, 992)]

2. Several of Cézanne's paintings anticipate *Les Demoiselles d'Avignon* either in composition or in single figures. Compare nos. 94, 261, 265, 273, 276, 543, 547, 726 in Venturi, Lionello, *Cézanne, son art, son oeuvre*, II, Paul Rosenberg, Editeur (Paris, 1936).

3. The lower half of El Greco's *Assumption of the Virgin* is reproduced (p. 195:23) to illustrate his "compact figure composition and angular highlights."

4. Other studies for the figure at the left, pulling back the curtain, occur not only in the composition studies and in the *Two Nudes* (p. 39) but also in works reproduced in Zervos (I, 165, 166, 173).

5. This mask from the Itumba region of the French Congo may be compared with the upper right-hand face of *Les Demoiselles d'Avignon*.

6. Picasso's statement about his interest in Iberian sculpture and his discovery of African Negro art is reported by Zervos (II, part 1, p. 10) as follows:

"On a toujours prétendu, et Mr. Alfred Barr Jr. vient de le répéter dans le Catalogue de la magnifique exposition d'oeuvres de Picasso qu'il a organisée à New York, sous le titre *Quarante ans de son art*, que les figures des *Demoiselles d'Avignon* dérivent directement de l'art de la Côte d'Ivoire ou du Congo Français. La source est inexacte. Picasso a puisé ses inspirations dans les sculptures ibériques de la collection du Louvre. En ce temps, dans le milieu de Picasso, on faisait un grand cas de ces sculptures, et l'on se souvient peut-être encore du vol d'une de ces pièces commis au Louvre, affaire à laquelle Apollinaire fut à tort mêlé.

"Picasso qui, dès cette époque n'admettait pas que l'on pût se passer, sans niaiserie du meilleur que nous offre l'art de l'antiquité, avait renouvelé, dans une vision personnelle, les aspirations profondes et perdurables de la sculpture ibérique. Dans les éléments essentiels de cet art il trouvait l'appui né-

cessaire pour transgresser les prohibitions académiques, dé-passer les mesures établis, remettre toute légalité esthétique en question. Ces temps derniers Picasso me confiait que ja-mais la critique ne s'est donné la peine d'examiner son tableau d'une façon attentive. Frappée des ressemblances très nettes qui existent entre les *Demoiselles d'Avignon* et les sculptures ibériques, notamment du point de vue de la construction générale des têtes, de la forme des oreilles, du dessin des yeux, elle n'aurait pas donné dans l'erreur de faire dériver ce tableau de la statuaire africaine. L'artiste m'a formellement certifié qu'à l'époque où il peignit les *Demoiselles d'Avignon,* il igno-rait l'art de l'Afrique noire. C'est quelque temps plus tard qu'il en eut la révélation. Un jour en sortant du Musée de Sculpture Comparée qui occupait alors l'aile gauche du Palais du Trocadéro, il eut la curiosité de pousser la porte en face, qui donnait accès aux salles de l'ancien Musée d'Ethnogra-phie. Aujourd'hui encore, à plus de trente-trois ans de dis-tance et en dépit des événements actuels qui le tourmentent profondément, Picasso parle avec une profonde émotion du choc qu'il reçut ce jour là, à la vue des sculptures africaines."

7. At the request of the writer, Paul Rosenberg asked Picasso whether the two right-hand figures had not been completed some time after the rest of *Les Demoiselles d'Avignon.* Pi-casso said, yes they had (July 1945). Later when asked whether he had painted the two figures before or after the summer of 1907, Picasso was noncommittal (questionnaire, October 1945).

8. J. J. Sweeney ("Picasso and Iberian Sculpture," p. 197) first proposed the case of the Gertrude Stein portrait as a precedent for Picasso's possibly having finished the two ne-groid heads considerably later and after his discovery of African Negro art.

9. Ardengo Soffici (*Ricordi di vita artistica e letteraria,* 2d ed., Vallecchi, Editore, Florence, 1942, p. 370) writes of seeing *Les Demoiselles d'Avignon* in Picasso's studio on the rue Schoelcher where the artist lived between 1913 and 1915.

Early books on modern art very rarely if ever reproduce the picture. Reproductions are common only after 1925, and it was apparently not until 1938 that a monograph on Picasso included a reproduction (Stein, Gertrude, *Picasso,* Paris: Li-brairie Floury, 1938, p. 65). The earliest reproduction known to the writer was published in *The Architectural Record,* XXVII, May 1910, in an article called "The Wild Men of Paris" by Gelett Burgess.

The painting seems to have been publicly exhibited for the first time in 1937 at the Petit Palais during the Paris World's Fair. That was after the death of the collector Jacques Doucet who years before had had it set like a mural painting into the wall of the stairwell of his house.

10. An analytical comparison of *Les Demoiselles d'Avignon* with Matisse's *Joie de Vivre* would be rewarding. Both were completed in the year 1907, the Picasso probably later than the Matisse. Both are very large compositions of human fig-ures in more or less abstract settings, the Picasso a draped in-terior, the Matisse a tree-bordered meadow. In both, color is freely used with a broad change of tone from left to right. The Picasso is compact, rigid, angular and austere, even frightening in effect: the Matisse open, spacious, composed in flowing arabesques, gay in spirit. The Picasso was the begin-ning of cubism; the Matisse was the culmination of fauvism. The Picasso lived a "private life" for thirty years; the Matisse made a sensation at the Salon des Indépendants in 1907 and has been famous ever since. Both canvases were epoch-making.

11. For earlier compositions of nudes which point toward *Les Demoiselles d'Avignon* see Zervos (1, 147, 160, 165). As already noted Zervos illustrates altogether 14 composition studies besides the three reproduced on page 196.

12. According to Zervos, Picasso recalls that André Salmon gave *Les Demoiselles d'Avignon* its title (Zervos, II, 1, p. 10). Kahnweiler, in a letter of 1940, writes that the title was given the picture shortly after the war of 1914–18, possi-bly by Louis Aragon who was at the time advising the collec-tor Jacques Doucet to whom Picasso sold the painting.

In his *Der Weg zum Kubismus* (Munich: Delphin Verlag, 1920), Kahnweiler calls the painting simply "a large painting with women, fruit and curtains," but gives it no title, an omission which confirms his opinion that the name is post-World War I. Fernande Olivier writing of the period 1904–14 does not mention the picture by name in her memoirs first published in 1931 (*Picasso et ses Amis,* Paris: Librarie Stock, 1933. The text is abridged from the author's articles in *Mer-cure de France* 227:549–61; 228:558–88; 229:352–68, May 1–July 15, 1931). The painting was reproduced for the first time with its present title in *La Révolution Surréaliste* (Paris), 4, July 15, 1925. André Breton, the editor of this magazine, says that it was he who, around 1921, persuaded Doucet to buy the picture, but he cannot recall who invented the title.

13. Barr, Alfred H., Jr., *Picasso: Fifty Years of His Art* (New York: The Museum of Modern Art, 1946), pp. 54–57.

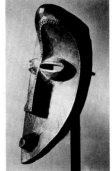

27. *Self-Portrait,* 1906
Philadelphia Museum of Art

28. Wooden Mask. Itumba.
The Museum of Modern Art, New York

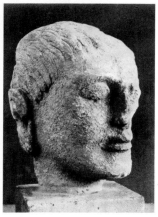
29. *Head of a Man*. Iberian. Museo Arqueológico Nacional, Madrid

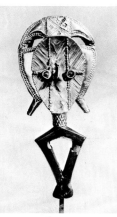
30. Reliquary Figure. Bakota, Gabon. Museum of Primitive Art, New York

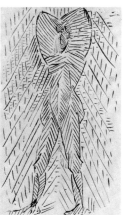
31. Drawing, 1907

**HEAD**
Paris, (late 1906)
Watercolor, 8⅞ x 6⅞ inches
Signed lower left: "Picasso"
Provenance: The Donor, Grosse Pointe Farms, Michigan
John S. Newberry Collection, 1960
Acq. no. 383.60
Ill. p. 42

**HEAD OF A MAN**
Paris, (spring 1907)
Watercolor, 23¾ x 18½ inches
Signed lower left: "Picasso"
Provenance: Pierre Loeb, Paris; Justin K. Thannhauser, New York
A. Conger Goodyear Fund, 1952
Acq. no. 14.52
Ill. p. 43

1. Despite its distortions and asymmetries the watercolor *Head of a Man* dates from early spring 1907, prior to any possible influence of African sculpture and before the elimination from *Les Demoiselles* of the male figure which was described by Picasso (Barr, *Fifty Years*, p. 57) as entering from the left bearing a skull as a memento mori in the earliest conceit for the composition. Golding (*Cubism,* plates 96a, 96b) juxtaposes it with a three-quarter view of one of the two Iberian heads (Fig. 29) that came into Picasso's possession in March 1907, and stresses the exaggerated, scroll-like ears common to both works. These heads, more primitive in character than the Osuna sculptures that were put on exhibition with considerable fanfare by the Louvre that spring, had in fact been stolen from the little-known Salle des Antiquités Ibériques of the Louvre by a Belgian adventurer named Géry-Pieret, whom Apollinaire had hired as a secretary. At the suggestion of Apollinaire, who was unaware of their provenance, the heads were offered to Picasso, and he bought them for a modest sum. In the fall of 1911, in the dénouement of a grotesque comedy of errors, the works were returned to the Louvre and later found their way back to Spain, where they are now in the Museo Arqueológico Nacional in Madrid. As Golding's comparison is convincing, it provides the date March 1907 as *terminus post quem* for the watercolor.

VASE OF FLOWERS
Paris, (fall 1907)
Oil on canvas, 36¼ x 28¾ inches
Signed lower left: "Picasso"
Provenance: Purchased from the artist in 1910 by Wilhelm
  Uhde, Berlin and Paris; Paul Edward Flechtheim, Paris;
  Mrs. Yvonne Zervos, Paris; Pierre Loeb, Paris; Mrs. Meric
  Callery, New York; Galerie Pierre, Paris
Gift of Mr. and Mrs. Ralph F. Colin (the latter retaining a
  life interest), 1962
Acq. no. 311.62
Ill. p. 45

1. In Vol. II, part I, of his catalogue raisonné of Picasso's work
Zervos states that *Les Demoiselles* was completed at the end
of spring 1907. He dates *Vase of Flowers* summer 1907, thus
indicating, no doubt correctly, that it was painted after the
larger work. It is most likely, however, that the repainting of
the right-hand figures of *Les Demoiselles* was completed in
late summer or early autumn; I have adjusted the date of
*Vase of Flowers* accordingly.

2. This motif was identified by Picasso in conversation with
the author.

3. For the best account of Picasso's much-argued relation to
African art, see Robert Goldwater, *Primitivism in Modern
Art*, rev. ed. (New York: Random House, 1967), Ch. V.

4. While such striated patterning is frequently compared to
the surface ornamentation of African sculpture, Roland Pen-
rose (*Picasso: His Life and Work*, London: Victor Gollancz,
1958, p. 132) has suggested the additional possibility of a re-
lationship to fronds of a palm. Possibly he had in mind such a
drawing as Fig. 32. Fig. 33, one of the few Picassos that (in its
central head) seems to be a direct copy of a primitive mask,
is dated by Zervos 1906 or 1907. (Were 1906 correct, it
would indicate an interest in primitive art on Picasso's part
long before his "revelation" at the Ethnographic Museum of
the Trocadero described by Zervos in Vol. II, part I.) Our
chief concern in this drawing, however, is with the ancillary
figures whose heads seem, Klee-like, to be composed of the
contours and veining of leaves. In Fig. 32, Picasso uses mark-
ings resembling palm fronds to articulate the back of a seated
nude and then extends them in Fig. 34 to shade the entire
figure.

BATHERS IN A FOREST
1908
Watercolor and pencil on paper over canvas,
  18¾ x 23⅛ inches
Signed lower right: "Picasso 1908"
Provenance: Rosenberg Gallery, New York;
  Mrs. Eleanor Rixson Cannon, New York
Hillman Periodicals Fund, 1957
Acq. no. 28.57
Ill. p. 46

32. Drawing (red ink), 1907

33. Drawing, 1906–07

34. Drawing (ink), 1907

35. *Seated Woman*, 1908. The Hermitage, Leningrad

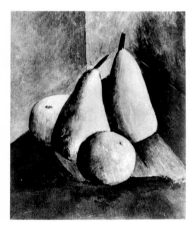

36. *Pears and Apples*, 1908

REPOSE
Paris, (spring or early summer 1908)
Oil on canvas, 32 x 25¾ inches
Signed upper right: "Picasso"
Provenance: A. Lefebvre, Paris; Galerie Beyeler, Basle
Acquired by exchange through the Katherine S. Dreier
  Bequest, and the Hillman Periodicals, Philip Johnson,
  Miss Janice Loeb, and Mr. and Mrs. Norbert
  Schimmel Funds, 1970
Acq. no. 575.70
Ill. p. 47

FRUIT AND GLASS
Paris, (summer 1908)
Tempera on wood panel, 10⅝ x 8⅜ inches
Provenance: Gertrude and Leo Stein, Paris
Promised gift of Mr. and Mrs. John Hay Whitney,
  New York
Ill. p. 49

1. Theodore Reff ("Cézanne and Poussin," *Journal of the Warburg and Courtauld Institutes*, London, XXIII, January 1960, pp. 150–169) observed that in the context of the letter in question "Cézanne was not reducing the visual world to a few ideal forms . . . but merely illustrating a method of achieving solidity in the representation of an object. . . ."
  Cézanne's formulation, a kind of art-school catechism for elementary studies in perspective, may have been inspired by a desire on Cézanne's part to have Bernard—who oppressed the old painter with his constant theorizing—return, in effect, to simple art-school practices before going on to more complex procedures. However, given Cézanne's impatience with and ridicule of Bernard, as expressed in letters to his son Paul, Jr., it seems more likely that Cézanne, who evidently felt obliged to carry on with Bernard the kind of theoretical discussions he abhorred, simply fobbed him off with a homespun "theory."

LANDSCAPE
La Rue des Bois, (fall 1908)
Oil on canvas, 39⅝ x 32 inches
Provenance: Gertrude and Leo Stein, Paris
Promised gift of Mr. and Mrs. David Rockefeller, New York
Ill. p. 50

1. Zervos (II, part I, 83) assigns *Landscape* to Picasso's return to Paris from La Rue des Bois, presumably because of its less saturated greens and the absence of leaves on the trees. Yet there are landscapes with equally bare branches that he locates at La Rue des Bois. Moreover, we do not know how long into autumn Picasso stayed there. As it was not his practice while in Paris to go to the countryside to paint, this picture—if, indeed, it was painted in Paris—would have been based on a recollection or a sketch of La Rue des Bois. Maurice Jardot, however, assigned it to La Rue des Bois in his catalog of the retrospective at the Musée des Arts Décoratifs (*Picasso,*

*Peintures 1900–1955*, Paris: Musée des Arts Décoratifs, 1955), and Picasso has since confirmed the accuracy of that attribution in conversation with this author.

BUST OF A MAN
Paris, (fall 1908)
Oil on canvas, 36¼ x 28⅞ inches
Signed upper left: "Picasso"
Provenance: Galerie Kahnweiler, Paris; M. Roche, Paris; Galerie Pierre, Paris; Galerie Vavin-Raspail, Paris; Walter P. Chrysler, Jr., New York and Warrentown, Virginia
Extended loan of the Florene May Schoenborn and Samuel A. Marx Collection
Ill. p. 53

Zervos' date of fall 1908 for *Bust of a Man* (II, part 1, 76) seems plausible. Whether it was indeed painted after Picasso's return from La Rue des Bois or, as Kahnweiler believes (see Barr, *Fifty Years*, p. 63), during the summer prior to his departure is impossible to prove on the basis of external evidence, and Picasso's fluctuations of style in 1908 make close dating on purely internal grounds somewhat perilous.

1. Golding (*Cubism*, p. 55) observes that Salmon, in his *Jeune Peinture Française*, speaks of Picasso's having temporarily abandoned *Les Demoiselles*, painted another series of pictures, and taken it up again after returning from a holiday. This holiday Golding logically locates in the summer of 1907, which would reinforce the assumption that the two right-hand figures of the painting date from late summer or early fall.

It is not impossible that the many small studies related to the last stages of *Les Demoiselles* and the *Nude with Drapery*, studies executed by Picasso in oil, tempera, gouache, and watercolor on paper from a single block (12¼ x 9½ inches) in the summer of 1907, date precisely from the holiday of which Salmon speaks. Had the holiday been long, it would certainly have been noted elsewhere in the Picasso literature. For a week or two outside Paris, the painter would not have bothered with canvases and stretchers but might well have brought along a block of paper and some colors.

2. Goldwater, *Primitivism in Modern Art*, 2d ed., p. 154.

SHEET OF STUDIES
(Late 1908)
Brush, pen and ink, 12⅝ x 19½ inches
Signed lower right: "Picasso"
Provenance: Pierre Loeb, Paris; Albert Loeb and Krugier, New York
A. Conger Goodyear Fund, 1968
Acq. no. 22.68
Ill. p. 54

FRUIT DISH
Paris, (early spring 1909)
Oil on canvas, 29¼ x 24 inches
Signed upper right: "Picasso"
Provenance: H. S. Southaw, Esq. C.M.G.; Bignou Gallery, Paris; E. and A. Silberman Galleries, New York
Acquired through the Lillie P. Bliss Bequest, 1944
Acq. no. 263.44
Ill. p. 55

1. Zervos (II, part 1, 121) dated this picture winter 1908, which Kahnweiler amended to spring 1909. Golding considers it "probably of early spring." Since the crayon drawing (Fig. 37) is dated 1908 and probably postdates the *Sheet of Studies*, it is not impossible that the painting, albeit a variant view of the motif, dates from the mid-winter months.

2. Golding, *Cubism*, p. 72.

3. In conversation with the author, July 1971.

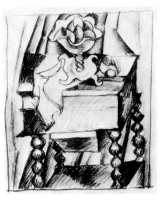

37. Study for *Fruit Dish*, 1908

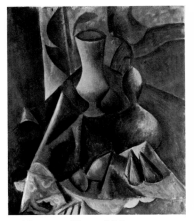

38. *Vase, Gourd and Fruit on a Table*, 1909. Mr. and Mrs. John Hay Whitney, New York

39. Photograph of Horta de San Juan by Picasso, 1909

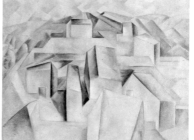

40. *Houses on the Hill, Horta,* 1909. Nelson A. Rockefeller, New York

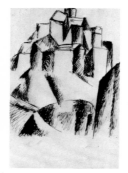

41. *Study for The Reservoir, Horta,* 1909

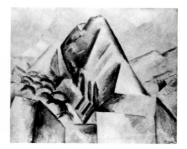

42. *Landscape, Horta,* 1909

THE RESERVOIR, HORTA
Horta de San Juan, (summer 1909)
Oil on canvas, 23¾ x 19¾ inches
Provenance: Gertrude and Leo Stein, Paris
Promised gift of Mr. and Mrs. David Rockefeller, New York
Ill. p. 57

1. Compare Braque's *Houses and Trees,* 1908 (Fig. 43) with the photograph of the motif (Fig. 44). This is one of a group of pictures painted at l'Estaque during the summer of 1908 and offered to the Salon d'Automne. When some were rejected, Braque withdrew the entire entry and showed the pictures soon afterward at Kahnweiler's gallery. Matisse is said to have commented on the "little cubes" in these paintings. But the name Cubism probably owes its existence to a review of the Kahnweiler show by Louis Vauxcelles, in which he described how Braque "reduces everything, sites and figures and houses to geometric complexes, to cubes." (*Gil Blas,* November 14, 1908).

2. What is always referred to as the "reservoir" at Horta was, in fact, a very large trough or *abreuvoir.* The townspeople did not draw water from it. Picasso recalls asking how they could even let their animals drink its rancid waters.

HEAD
(Spring 1909)
Gouache, 24 x 18 inches
Signed upper left: "Picasso"
Gift of Mrs. Saidie A. May, 1930
Acq. no. 12.30
Ill. p. 59

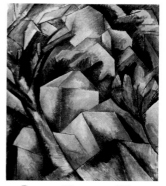

43. Braque, *Houses and Trees,* 1908. Kunstmuseum, Bern

44. Photograph by D.-H. Kahnweiler of the motif of Fig. 43

WOMAN WITH PEARS
Horta de San Juan, (summer 1909)
Oil on canvas, 36¼ x 28⅞ inches
Signed reverse: "Picasso"
Provenance: Alfred Flechtheim, Berlin; Alex Reid & Lefèvre
  Ltd., London; Pierre Matisse Gallery, New York; Douglas
  Cooper, Argilliers, France; Walter P. Chrysler, Jr.,
  New York and Warrentown, Virginia
Extended loan of the Florene May Schoenborn and
  Samuel A. Marx Collection
Ill. p. 60

TWO HEADS
Horta de San Juan, (summer 1909)
Oil on canvas, 13¾ x 13¼ inches
Signed lower left: "Picasso"
Provenance: Galerie Käte Perls, Paris; Walter P. Chrysler, Jr.,
  New York and Warrentown, Virginia; Dr. Albert W. Bluem,
  Short Hills, New Jersey; Peter W. Lange, Esmont, Virginia
A. Conger Goodyear Fund, 1964
Acq. no. 197.64
Ill. p. 58

45. *Apple*, 1910

This painting was originally the right section of a larger study
of three heads. According to Daniel-Henry Kahnweiler, it
was divided by André Level of the Galerie Percier. As repro-
duced in 1942 by Zervos (II, part 1, 162) the two sections
appear cut but mounted together (both sides were then in the
Walter P. Chrysler, Jr., collection). The Zervos reproduction
shows the left side of the picture signed, but the signature at
the lower left of the right section does not appear.

WOMAN'S HEAD
Paris, (fall 1909)
Bronze, 16¼ inches high
Incised at back of left shoulder: "Picasso"
Provenance: Weyhe Gallery, New York
Purchase, 1940
Acq. no. 1632.40
Ill. p. 61

There are two authorized editions of this bronze. The first,
unmarked and probably few in number, was cast by Vollard
sometime shortly after Picasso executed the piece. The sec-
ond, marked from one to nine, was cast—with Picasso's per-
mission—in 1960 from the original plaster in the collection of
H. Ulmann, Paris, by Berggruen, Editeur. The Museum's cast
is from the original Vollard edition.

1. Goldwater, Robert, *What Is Modern Sculpture?* (New
York: The Museum of Modern Art, 1969), p. 42.

2. The exceptions are a terra-cotta *Head* probably made not
long after *Woman's Head* and a plaster *Apple* (Fig. 45), made
early in 1910 but never cast. The apple in *Casket, Cup and
Apple* (p. 64) probably relates to this sculpture.

46. *Documents contre nature*, 1971

47. Diagrammatic sketch of *Still Life with Liqueur Bottle*

48. No. 81: *Suite 347*, 1968

STILL LIFE WITH LIQUEUR BOTTLE
Horta de San Juan, (late summer 1909)
Oil on canvas, 32⅛ x 25¾ inches
Signed lower left: "Picasso"
Provenance: Wildenstein Gallery, New York; Perls Galleries,
  New York; Walter P. Chrysler, Jr., New York and
  Warrentown, Virginia
Mrs. Simon Guggenheim Fund, 1951
Acq. no. 147.51
Ill. p. 63

1. Zervos (II, part 1, 173) placed this picture in Horta, and Picasso has subsequently confirmed that the picture was executed at the end of his stay there, though it might have received finishing touches shortly afterward in Paris.

2. When this picture was in the Walter P. Chrysler Collection, it was titled *Still Life with Siphon*. During its first years at The Museum of Modern Art it was called *Still Life with Tube of Paint* until a Spanish visitor pointed out that what had been taken for a tube of paint was actually a bottle of Anis del Mono (which brand name had figured in the title given it earlier by Zervos, II, part 1, 173).

3. Picasso had some years ago drawn a very summary sketch of the layout of the picture (Fig. 47) indicating the ceramic cock (which until now was not known to be a *botijo*). The title he has given Fig. 46 is a play on the term *d'après nature*.

CASKET, CUP AND APPLE
(Late 1909)
Ink wash, 9½ x 12⅜ inches
Signed on reverse: "Picasso"
Provenance: The Donor, New York
Gift of Justin K. Thannhauser, 1949
Acq. no. 691.49
Ill. p. 64

WOMAN IN A CHAIR
Paris, (late 1909)
Oil on canvas, 28¾ x 23⅝ inches
Signed upper right: "Picasso"
Provenance: Mlle Pertuisot, Paris; Paul Rosenberg & Co.,
  New York
Gift of Mr. and Mrs. Alex L. Hillman, 1953
Acq. no. 23.53
Ill. p. 65

GIRL WITH A MANDOLIN
Paris, (early) 1910
Oil on canvas, 39½ x 29 inches
Signed and dated lower right:
  "Picasso/10" and on reverse: "Picasso"
Provenance: Daniel-Henry Kahnweiler, Paris; René Gaffé,
  Cagnes-sur-Mer; Roland Penrose, London
Promised gift of Nelson A. Rockefeller, New York
Ill. p. 67

1. Penrose, *Picasso*, p. 156. Penrose's interesting account of
the execution of this picture suggests that Fanny Tellier posed
clothed, which Picasso has told the author was not the case.

2. When this picture was in the collection of Roland Penrose
it was often reproduced with the caption-title *Girl with a
Mandolin (Portrait of Fanny Tellier)*. Jardot, *Picasso*, no. 22,
accepts this as a portrait, though he notes that Kahnweiler has
questioned his view.

3. Robert Rosenblum (*Cubism and Twentieth-Century Art*,
New York: Harry N. Abrams, 1960, p. 40) referred to *Girl
with a Mandolin* as "a Corot-like studio portrait." At his in-
stigation, my search has turned up *La Femme à la Toque*
(Fig. 50), which is disposed in a manner not unrelated to the
Picasso. It was exhibited in the Salon d'Automne (October 1–
November 8, 1909), which Picasso almost certainly saw. John
Richardson (*Georges Braque*, London: Penguin Books, 1959,
p. 11) had stated: "Indeed, I think that the Cubists' *penchant*
for figures with musical instruments can be traced to the im-
portant pioneer exhibition of Corot's figure paintings organ-
ized in Paris in 1909. It is at any rate significant that Braque
should still recall these works with enthusiasm."

4. Rosenblum, *Cubism*, p. 64.

STILL LIFE: LE TORERO
Céret, (summer 1911)
Oil on canvas, 18¼ x 15⅛ inches
Signed on reverse: "Picasso/Céret"
  (no longer visible as canvas has been lined)
Provenance: Paul Eluard, Paris; Rene Gaffé, Cagnes-sur-Mer;
  Roland Penrose, London
Promised gift of Nelson A. Rockefeller, New York
Ill. p. 68

"MA JOLIE" (WOMAN WITH A ZITHER OR GUITAR)
Paris, (winter 1911–12)
Oil on canvas, 39⅜ x 25¾ inches
Signed on reverse: "Picasso"
Provenance: Daniel-Henry Kahnweiler, Paris;
  Paul Guillaume, Paris; Marcel Fleischmann, Zurich
Acquired through the Lillie P. Bliss Bequest, 1945
Acq. no. 176.45
Ill. p. 69

1. This type of brushwork originated in Signac's basket-weave
variation on Seurat's *points*. But unlike Picasso, the Neo-

49. *Portrait of Wilhelm Uhde*, 1910. Joseph Pulitzer, Jr., St. Louis

50. Corot, *Femme à la Toque*, c. 1850–55

Impressionists had used it in the form of a consistent, molecular screen. Matisse, too, frequently used such neo-impressionist brushwork with varying degrees of consistency until about 1905.

The choice of rectangular strokes that echo the framing edge and almost resemble a kind of brickwork is consistent with the architectural nature of Cubist pictures. The texture of the strokes varies with the solidity of the planes they articulate. Compare, for example, those in the center of "*Ma Jolie*" with those in its upper corners.

2. With the exception of *Guernica* and perhaps a few other pictures, Picasso has never titled his works. Kahnweiler (*The Rise of Cubism*, New York: Wittenborn, Schultz, 1949, p. 13. Translated from the German *Der Weg zum Kubismus*) stresses the importance of providing Cubist pictures with descriptive titles so as to "facilitate" the viewer's "assimilation" of the image. This was, in any case, his common practice. Zervos accepted the tradition, cataloguing the picture the Museum has called "*Ma Jolie*" as *Woman with a Guitar* (II, part 1, 244). An early inscription on the stretcher—though not in Picasso's handwriting—identifies the picture as *Woman with a Zither*. Picasso told the author he is no longer sure what instrument was intended; he thinks it was a guitar.

3. Braque described the letters as "forms which could not be distorted because, being themselves flat, the letters were not in space, and thus by contrast their presence in the picture made it possible to distinguish between objects situated in space and those that were not." "La Peinture et nous, Propos de l'artiste, recueillis par Dora Vallier," *Cahiers d'Art* (Paris), XXIX, 1, October 1954, p. 16.

4. Greenberg, Clement, "The Pasted-Paper Revolution," *Art News* (New York), LVII, 46, September 1958, reprinted as "Collage" in *Art and Culture* (Boston: Beacon Press, 1961), p. 73. This brilliant formal analysis is devoted to the crucial transitional period of 1912–14.

5. Statement by Picasso, 1923, as reprinted in Barr, *Fifty Years*, pp. 270–71.

6. The refrain of *Dernière Chanson* begins "O Manon, ma jolie, mon coeur te dit bonjour." Jardot, *Picasso*, no. 28, identifies it as a well-known song of 1911 composed by Fragson and based upon a motif from a dance by Herman Frink.

7. Letter to Kahnweiler dated June 12, 1912, cited in Jardot, *Picasso*, no. 30. In some paintings of 1912 Picasso went beyond the allusion involved in the inscription "Ma Jolie," writing *j'aime Eva* on the surface.

8. See Robert Rosenblum, "Picasso and the Typography of Cubism," in *Picasso/An Evaluation: 1900 to the Present* (London: Paul Elek, 1972).

9. Picasso told the author that this picture was painted from the imagination and that while it was in no way a portrait, he had Eva "in mind" when he painted it.

STUDY FOR A CONSTRUCTION
(1912)
Pen and ink, 6¾ x 4⅞ inches
Signed lower left: "Picasso"
Provenance: Pierre Loeb, Paris
Purchase, 1943
Acq. no. 754.43
Ill. p. 71

CUBIST STUDY
(1912)
Brush and ink, 7¼ x 5¼ inches
Signed lower left: "Picasso"
Provenance: The Donor, Paris
Gift of Pierre Loeb, 1943
Acq. no. 753.43
Ill. p. 71

THE ARCHITECT'S TABLE
Paris (spring 1912)
Oil on canvas, oval, 28⅝ x 23½ inches
Signed on reverse: "Picasso"
Provenance: Gertrude Stein, Paris
Promised gift of Mr. and Mrs. William S. Paley, New York
Ill. p. 73

1. This picture is identified in Zervos (II, 321) as *La Bouteille de Marc (Ma Jolie)*. Margaret Potter (catalog of the exhibition *Four Americans in Paris*, New York: The Museum of Modern Art, 1970, p. 171) points out that in a letter to Gertrude Stein, Picasso called it simply "*votre nature morte (ma Jolie)*" while Kahnweiler's letter to Miss Stein regarding the sale of the painting referred to it as *The Architect's Table*.

2. Margaret Potter has drawn to my attention the passage in Gertrude Stein's *Autobiography of Alice B. Toklas* (New York: Harcourt, Brace, 1933, p. 136) that mentions a visit of the Misses Stein and Toklas to Picasso's studio on the rue Ravignan early in 1912. As the painter was not at home, Miss Stein left her calling card, and a few days later discovered that Picasso had worked a reference to it into *The Architect's Table*, then in progress. Her subsequent purchase of this picture was the first Picasso acquisition she made independently of her brother.

3. The image of pictorial reality as perfume—which though it can be sensed is insubstantial and cannot be located in space—seems particularly appropriate to some of the spectral forms of the pictures from the winter of 1911–12. Picasso would not have used such an image for the more tactile Cubism of 1908–10.

4. In conversation with John Richardson in 1952.

GUITAR
Paris, (early 1912)
Sheet metal and wire, 30½ x 13⅞ x 7⅝ inches
Provenance: Until 1971, this sculpture was owned
  by the artist.
Gift of the artist, 1971
Acq. no. 94.71
Ill. p. 75

51. Picasso's studio, boulevard Raspail, 1912–13

1. There is no firm external evidence for the dating of *Guitar*, which Zervos (II, part 2, 773) and Penrose (*The Sculpture of Picasso*, New York: The Museum of Modern Art, 1967, p. 58) place in 1912. The *terminus ante quem* for its cardboard maquette is summer 1913, since it figures in a photograph (Fig. 51) of the studio on the boulevard Raspail that Picasso occupied for about a year, ending with his return from Céret where he vacationed during the summer of 1913. Sometime in the course of 1913, Picasso added a new bottom element to the maquette so as to incorporate it better into a *Still Life* of cut paper (Fig. 52); the whole ensemble was pinned for some months to the wall of his studio, where Kahnweiler had it photographed. That additional bottom element still exists, along with the other (disassembled) parts of the original cardboard maquette, though the ancillary paper forms which were added to make up the *Still Life* of 1913 have been lost.

Picasso has told the author that, while he cannot remember the year in which *Guitar* was executed, he recalls that this first of his construction-sculptures antedated his first collage, *Still Life with Chair Caning* (Fig. 53), "by many months." The date of that collage is itself the subject of some controversy. In 1945, Picasso indicated to Alfred Barr that it may date from 1911 (*Fifty Years*, p. 79). As a result of what Douglas Cooper described as a three-way discussion between himself, Picasso, and Kahnweiler ("The Making of Cubism," a symposium at the Metropolitan Museum of Art, New York, April 17–19, 1971), he proposed in 1959 (*Picasso*, an exhibition catalog, Marseille: Musée Cantini, May 11–July 31, 1959, no. 19) the date of spring 1912 (later refined to May 1912) for the collage—a date in keeping with the painted parts of the image. As this first collage, in which oilcloth was glued to the surface, antedated both Braque's and Picasso's first *papiers collés*, the date of November 9, 1912, given for it by David Duncan (*Picasso's Picassos*, New York: Harper and Brothers, 1961, p. 207) and repeated elsewhere cannot be correct. Picasso had already begun to make *papiers collés* in late September 1912, taking his lead from Braque, who made the first *papier collé* (p. 209:55) early in that month during Picasso's short absence from Sorgues, where the two had been vacationing together.

Cooper's dating for *Still Life with Chair Caning* is entirely logical; accepting it means dating *Guitar* near the beginning of 1912 or late in 1911—assuming that Picasso's recollection of the order of the two works is correct. On that score, it should be noted that the order of pivotal works is far easier for an artist to remember years afterward than is their particular dating.

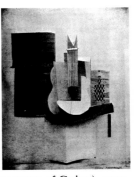

52. *Still Life* (containing the cardboard maquette of *Guitar*), 1913

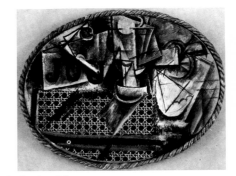

53. *Still Life with Chair Caning*, May 1912.

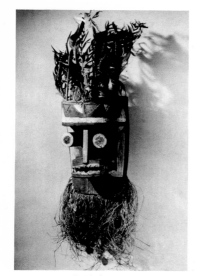

54. Wobé Ceremonial Mask. Sassandra, Ivory Coast. Musée de l'Homme, Paris

2. Douglas Cooper (*The Cubist Epoch,* London: Phaidon Press, 1970, p. 58) states that in the summer of 1912 Braque made paper and cardboard models (since lost) of objects, and that Picasso "followed his example." These 1912 models were "primarily investigations of form and volume, objects existing in paintings transposed for study in three dimensions" (p. 234). Cooper thus sees them as utilitarian objects which "became important forerunners of *papiers collés.*" Braque may indeed have thought of them that way—which would explain why he failed to preserve them or translate them into more durable materials. That Picasso, on the other hand, thought of them as a new form of sculpture is evident from the way he treated them—and from what he subsequently developed out of them. (Cooper, in minimizing these works, would seem unaware of their immense impact on twentieth-century sculpture.)

As to whether Cooper is right in his contention that Picasso followed Braque in this matter, one can only choose between his and Picasso's version of events. Picasso had all along shown himself a more sculpturesque painter than Braque and would later confirm himself as a great sculptor, whereas Braque was a very timid and mediocre one. If, indeed, Braque made his cardboard models earlier, it was Picasso who saw their possibilities as sculpture.

3. In "Negro Art and Cubism" (*Horizon,* London, XVIII, 108, 1948, p. 418), Kahnweiler stated that such masks were "the decisive discovery *which allowed* painting *to create* invented signs, freed sculpture from the mass, and led it to transparency." In a later interview (*Galleries,* p. 63) he took a more conservative position, saying: "It would be wrong to suppose that the Cubists were led to these solutions (openwork sculpture) by Negro art, but in it they found a confirmation of certain possibilities. . . ."

4. See note 1, above. Picasso told the author that the mode of planar sculptural relief in a single material he initiated with *Guitar* "had nothing to do with collage." By 1913, however, construction and collage were in a reciprocal relationship.

VIOLIN AND GRAPES
Sorgues, (summer or early fall 1912)
Oil on canvas, 20 x 24 inches
Signed on reverse: "Picasso" and inscribed: "Céret/Sorgues"
Provenance: Daniel-Henry Kahnweiler, Paris; Alfred
  Flechtheim, Berlin; E. and A. Silberman Galleries, Inc.,
  New York; The Donor, New York
Mrs. David M. Levey Bequest, 1960
Acq. no. 32.60
Ill. p. 77

1. Schapiro, lectures at Columbia University.

MAN WITH A HAT
Paris, (December 1912)
Charcoal, ink, pasted paper, 24½ x 18⅝ inches
Provenance: Galerie Kahnweiler, Paris; Tristan Tzara, Paris
Purchase, 1937
Acq. no. 274.37
Ill. p. 78

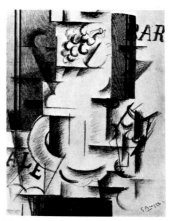

55. Georges Braque, *The Fruit Dish*, 1912. Private collection, France

1. The photograph of the boulevard Raspail studio wall (p. 207:51) is especially interesting in this regard. While the *papiers collés* of the bottom row are already in the state in which Picasso finally left them (except for some refining and darkening of the drawing), *Violin* (Fig. 56), second from the left in the upper row (and marked number 2 by the artist), has not yet received its collage elements. Sometime after the photograph was taken, Picasso added to it panels of newsprint and simulated wood-graining. Notice that the lines covered by the upper panel in that operation have been redrawn on top of the newsprint in their same positions, as have the violin's decorative sound holes on the panel below. Picasso also added a newsprint panel at the right, which is not indicated in the drawing; the absence of such a plane—necessary to the balance of the composition—might not have impressed Picasso so long as the drawing was partly covered over by the cardboard maquette for *Guitar*.

56. *Violin*, 1912–13

2. Observed by Sidney Janis, donor of *Head*; see *Three Generations of Twentieth-century Art: The Sidney and Harriet Janis Collection of the Museum of Modern Art* (New York: The Museum of Modern Art), forthcoming.

3. Murray, J. Charlat, "Picasso's Use of Newspaper Clippings in his Early Collages," master's essay, Department of Fine Arts and Archeology, Columbia University (New York), 1967, p. 21 (microfilm in the files of the Library of The Museum of Modern Art).

4. The date of December 3, 1912, is not found on any newsprint Picasso actually used for this *papier collé*. It was proffered in a memorandum of January 18, 1954, by Margaret Miller, then Associate Curator of Museum Collections. Robert Rosenblum has confirmed that the newsprint does indeed come from *Le Journal* of that date, and has provided the titles of the articles and their pagination.

57. *Chair*, 1961.

HEAD
(Spring 1913)
Collage, pen and ink, pencil and watercolor, 17 x 11⅜ inches
Provenance: Daniel-Henry Kahnweiler, Paris;
  Cahiers d'Art, Paris; Theodore Schempp, Paris;
  The Donors, New York
The Sidney and Harriet Janis Collection (fractional
  gift), 1967
Acq. no. 640.67
Ill. p. 80

1. Lionel Prejger, "Picasso découpe le fer," *L'Oeil* (Lausanne), LXXXII, October 1961, p. 29.

2. In conversation with the author, July 1971.

3. The identification of the coronation text and the redating of a number of collages of this period, including *Head*—dated winter 1912–13 by Zervos (II, part 2, 403)—are to be found in Rosenblum's remarkable "Picasso and the Coronation of Alexander III: A Note on the Dating of Some *Papiers Collés*," *The Burlington Magazine* (London), CXIII, 823, October 1971, pp. 604–607, along with interesting speculations as to extra-plastic reasons why the artist might have used this particular thirty-year-old newspaper.

GLASS, GUITAR AND BOTTLE
(Spring 1913)
Oil, pasted paper, gesso and pencil on canvas,
  25¾ x 21⅛ inches
Provenance: Daniel-Henry Kahnweiler, Paris;
  Pierre Loeb, Paris; Marie Harriman, New York;
  The Donors, New York
The Sidney and Harriet Janis Collection (fractional
  gift), 1967
Acq. no. 641.67
Ill. p. 81

1. Picasso described the use of *pochoir* in this picture to the author.

2. Murray, "Picasso's Use of Newspaper Clippings." Murray also reads the MA and OR in the upper right as references to "Ma Jolie" and the "Section d'Or."

3. Suggested by Robert Rosenblum in conversation with the author.

4. The exact duration of Picasso's stay at his previous studio at 242 boulevard Raspail is not known. He installed himself at 5 bis rue Schoelcher after his return from Céret where he spent the summer of 1913, but this studio was probably rented in the previous spring prior to his departure for Céret.
   The puns and double entendres posited in my interpretation of this picture are consistent with Picasso's love of *jeux de mots* in communications with his friends (see fn. 1 under *Still Life: "Job,"* p. 215).

GUITAR
Paris, (spring 1913)
Charcoal, wax crayon, ink and pasted paper,
26⅛ x 19½ inches
Signed lower left: "Picasso"
Provenance: Daniel-Henry Kahnweiler, Paris;
 Mme Lise Deharme, Paris; Sidney Janis Gallery, New York
Promised gift of Nelson A. Rockefeller, New York
Ill. p. 83

1. For the most fascinating, balanced and convincing account of this aspect of Picasso's iconography see Rosenblum, "Picasso and the Typography of Cubism." Murray ("Picasso's Use of Newspaper Clippings") gives a variety of penetrating interpretations along with what seem to this author a number of instances of overreading, largely related to Murray's mistaken assumption of "Picasso's total self-consciousness" (p. 9). For direct confirmation of Picasso's love of punning, see fn. 1 under *Still Life: "Job,"* p. 215.

2. Blesh, Rudi, and Janis, Harriet, *Collage: Personalities, Concepts, Techniques* (New York and Philadelphia: Chilton, 1961), pp. 23–24.

3. *Ibid*, p. 24.

4. Picasso enjoyed "sitting" stringed instruments in chairs, like personages; it was a favorite position for the sheet-metal *Guitar* (p. 75), which because of its large size took on an especially anthropomorphic appearance.

5. Picasso evidently began this *papier collé* as a horizontal composition; the erased forms of the tassels are visible in the upper right, and the way they hang indicates that the right side was originally the bottom of the composition. The change from horizontal to vertical may also explain the fact that the neck of the guitar is shown twice, both above and below its body.

MAN WITH A GUITAR
Céret, (summer) 1913
Oil and encaustic on canvas, 51¼ x 35 inches
Signed on reverse: "Picasso" and inscribed: "Céret 1913"
Provenance: Gertrude Stein, Paris
Promised gift of André Meyer, New York
Ill. p. 85

1. The "double image" as it was later to be exploited by illusionist Surrealists such as Dali was basically an optical trick. The artist had to discover a group of forms that could realistically represent two distinct objects at the same time (objects that were theoretically related on a psychological or poetic level). Picasso's fantasies in the pictures of 1913–14 were more of the order that would later be explored by the "abstract" Surrealists. His forms remain purposefully ambiguous, suggesting more than one object but literally describing none.

2. Braque ("La Peinture et nous," p. 17) observed that "the problem of color was brought into focus with the *papiers collés.*"
 By emphasizing a flatness that obviated the graduated modeling in space characteristic of Analytic Cubism (a flatness which was then carried over into painting) collage pointed to the use of pure color. It should be kept in mind, however, that Matisse and other painters had been handling color that way—though within a different kind of compositional matrix—for some years.

CARD PLAYER
Paris, (winter 1913–14)
Oil on canvas, 42½ x 35¼ inches
Provenance: Léonce Rosenberg, Paris; Paul Guillaume, Paris;
 Dr. G. F. Reber, Lausanne; Francis B. Cooke, London
Acquired through the Lillie P. Bliss Bequest, 1945
Acq. no. 177.45
Ill. p. 87

58. *Student with a Newspaper*, 1913–14

59. *Head*, 1913

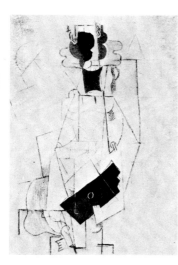

60. *Man with a Guitar*, 1914

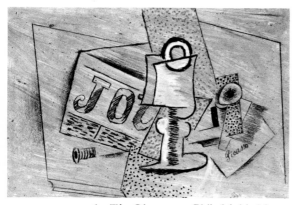

61. *The Glass*, 1914. Philadelphia Museum of Art

STUDENT WITH A PIPE
Paris, (winter 1913–14)
Oil, charcoal, pasted paper and sand on canvas,
28¾ x 23⅛ inches
Provenance: Gertrude Stein, Paris
Promised gift of Nelson A. Rockefeller, New York
Ill. p. 89

1. Kahnweiler, *The Rise of Cubism*, pp. 15–16.

2. Boeck (Boeck, Wilhelm, and Sabartés, Jaime, *Picasso*, New
York and Amsterdam: Harry N. Abrams, Inc., 1955, p. 169)
reads the lower half of the **X** as a sign for a mustache, but
reference to the *Student with a Newspaper*, where Picasso
has added a mustache, makes it clear that this form charac-
terizes the ridge above the upper lip.

WOMAN WITH A MANDOLIN
Paris, (spring 1914)
Oil, sand and charcoal on canvas, 45½ x 18¾ inches
Provenance: Gertrude Stein, Paris
Promised gift of Mr. and Mrs. David Rockefeller, New York
Ill. p. 90

1. Gertrude Stein, *The Autobiography of Alice B. Toklas*,
p. 195.

2. Transcript of a conversation on Picasso between Daniel-
Henry Kahnweiler and Hélène Parmelin, *Oeuvres des musées
de Leningrad et de Moscou et de quelques collections parisi-
ennes* (Paris: Editions Cercle d'Art, 1955) p. 20. Picasso cast
doubt on Kahnweiler's explanation in conversation with this
author, saying that a Russian musical group was concertizing
in Paris and the lettering in question was visible all around the
city on their posters.

PIPE, GLASS, BOTTLE OF RUM
Paris, March 1914
Pasted paper, pencil, gesso on cardboard, 15¾ x 20¾ inches
Signed lower right: "Picasso 3/1914"
Provenance: Daniel-Henry Kahnweiler, Paris;
  Mrs. Julianna Force, New York; The Donors, New York
Gift of Mr. and Mrs. Daniel Saidenberg, 1956
Acq. no. 287.56
Ill. p. 92

**MAN IN A MELON HAT**
1914
Pencil, 13 x 10 inches
Signed lower left: "Picasso/ 14"
Provenance: Valentine Dudensing, New York;
  Walter P. Chrysler, New York and Warrentown, Virginia;
  Kleeman Galleries, New York; The Donor, Grosse Pointe
  Farms, Michigan
The John S. Newberry Collection, 1960
Acq. no. 385.60
Ill. p. 93

1. See especially Zervos, II, part 2, 507, 858; VI, 1189–1191, 1194–1201, 1204–1216, 1218, 1223, 1227–1229, 1232, 1233, 1243.

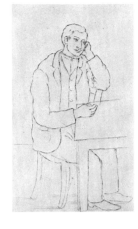

62. Figure, 1914

**GREEN STILL LIFE**
Avignon, (summer) 1914
Oil on canvas, 23½ x 31¼ inches
Signed lower right: "Picasso/ 1914"
Provenance: Paul Rosenberg, Paris; Dikran Kahn Kelekian,
  New York; The Donor, New York
Lillie P. Bliss Collection, 1934
Acq. no. 92.34
Ill. p. 94

1. Barr, *Fifty Years*, pp. 90–91.

**GLASS OF ABSINTH**
Paris, (1914)
Painted bronze with silver sugar strainer, 8½ x 6½ inches
At bottom: raised letter "P" in bronze
This piece is one of six bronzes cast from the original wax.
  Five are painted differently, while the sixth is covered
  with sand; all incorporate a real sugar strainer.
Provenance: Daniel-Henry Kahnweiler, Paris;
  Fine Arts Associates, New York
Gift of Mrs. Bertram Smith, 1956
Acq. no. 292.56
Ill. p. 95

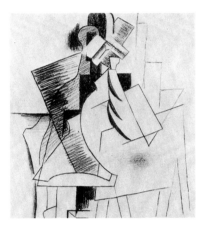

63. Figure, 1914

1. Kahnweiler, Daniel-Henry, *Les Sculptures de Picasso* (Paris: Les Editions du Chêne, 1948), n.p.

2. Penrose, *Picasso*, p. 179.

3. In preparing a glass of absinth, a cube of sugar is placed on a strainer of this type and held over the glass. Iced water is then poured over the cube of sugar to dissolve it.

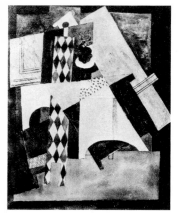

64. *Harlequin next to Buffet with Compotier*, 1915

65. *Dancing Couple*, pencil, 1915–16

66. *Dancing Couple*, watercolor, 1915–16

GLASS, NEWSPAPER AND BOTTLE
Paris, (fall 1914)
Oil and sand on canvas, 14¼ x 24⅛ inches
Signed lower left: "Picasso"
Provenance: Léonce Rosenberg, Paris; Valentine Dudensing,
  New York; The Donors, New York
The Sidney and Harriet Janis Collection
  (fractional gift), 1967
Acq. no. 643.67
Ill. p. 96

1. Lippard, Lucy R. *The School of Paris: Paintings from the
Florene May Schoenborn and Samuel A. Marx Collection*
(New York: The Museum of Modern Art, 1965), p. 22.

GUITAR OVER FIREPLACE
Paris, 1915
Oil, sand and paper on canvas, 51¼ x 38¼ inches
Signed upper left corner: "Picasso/ 15"
Provenance: Galerie Pierre, Paris
Extended loan of the Florene May Schoenborn and
  Samuel A. Marx Collection
Ill. p. 97

HARLEQUIN
Paris, (late) 1915
Oil on canvas, 72¼ x 41⅜ inches
Signed lower right: "Picasso/ 1915"
Provenance: Léonce Rosenberg, Paris; Alphonse Kann, Paris;
  Paul Rosenberg, New York
Acquired through the Lillie P. Bliss Bequest, 1950
Acq. no. 76.50
Ill. p. 99

1. Stein archives, Collection of American Literature, Beinecke
Rare Book and Manuscript Library, Yale University. The
identification of the Museum's picture with the *Harlequin*
mentioned in the letter was made by Alfred Barr in 1950.

2. Boggs, *Picasso and Man*, p. 78.

3. Unlike most of the other works illustrated here, *Pianist*
(Fig. 67) does not relate directly to *Harlequin*; but the par-
ticular character of its two-part head and the general config-
uration of its protagonist suggest that painting's ambience.
*Pianist* is also the only image even distantly related to *Harle-
quin* in which the hand of the figure holds a rectangular plane.
  *Harlequin Playing a Guitar* (Fig. 68) is also not immedi-
ately related to the Museum's painting, but its combination of
a round and angular head above a diamond-patterned costume
place it within *Harlequin*'s orbit. The likelihood that Picasso
planned at any time to make the unfinished rectangle into a
guitar is not considerable. But neither is it totally obviated by
the lack of guitarlike indentations in the rectangle. Apart
from the fact that Picasso could have chosen to add them
later, he did, on occasion, envision strictly rectangular guitars
(e.g., Zervos, II, part 2, 955 of a little over a year later).

4. There are at least ten drawings and watercolors that relate directly to *Harlequin*, though it is possible that most of them postdate the painting. This was Zervos' opinion. Because one of them (Zervos II, part 2, 557) is inscribed to André Level and dated 1916, Zervos presumably also dated numbers 556, 558 (Fig. 66) and 559 in that year. But Picasso dated his gifts when he inscribed them. Thus, the Level picture could have been executed late in 1915—either before or at the time of the painting of *Harlequin*—and dated a few months later when Picasso gave it away. In any case, it is probable that some of the related drawings and watercolors antedate the oil.

The *Bottle of Anis del Mono* (Fig. 69) has obvious affinities with *Harlequin*. The prismatic cut-glass bottle characteristic of Anis del Mono, so beautifully expressed in a relief manner in *Still Life with Liqueur Bottle*, 1909 (p. 63), is here stylized in Synthetic rather than Analytic Cubist terms, producing a flat diamond-shaped pattern analogous to the traditional motley of Harlequin. Picasso has tilted the bottle, which seemingly has legs, in a manner comparable to the Harlequin in the Museum's painting, and has stylized the round hole in the rectangular neck of the bottle so as to recall the latter's head.

STILL LIFE: "JOB"
Paris, 1916
Oil and sand on canvas, 17 x 13¾ inches
Signed upper left: "Picasso/ 16"
Provenance: Rolf de Maré, Stockholm; Carroll Carstairs
  Gallery, New York
Promised gift of Nelson A. Rockefeller, New York
Ill. p. 101

1. Speaking of this practice years later, Françoise Gilot observed: "One never referred directly to an event or a situation; one spoke of it only by allusion to something else. Pablo and Sabartés wrote to each other almost every day to impart information of no value and even less interest, but to impart it in the most artfully recondite fashion imaginable. It would have taken an outsider days, weeks, to fathom one of their arcane notes. It might be something relating to Monsieur Pellequer, who handled Picasso's business affairs. Pablo would write (since Monsieur Pellequer had a country house in Touraine) of the man in the tower *(tour)* of the château having suffered a wound in the groin *(aine)* and so on and on, playing on words, splitting them up, recombining them into unlikely and suspicious-looking neologisms, like the pirates' torn map that must be pieced together to show the location of the treasure. . . . He worked so hard at being hermetic that sometimes even Sabartés didn't understand and they would have to exchange several more letters to untangle the mystery." (Gilot, Françoise and Lake, Carlton, *Life with Picasso* (New York: McGraw-Hill, 1964), p. 177.

2. Murray, "Picasso's Use of Newspaper Clippings," pp. 26–27.

3. *Ibid*. Observed by Murray on the basis of a photograph of Jacob in Jean Oberlé's *La Vie d'artiste* (Paris: Editions de Noël, 1956), plate 12.

67. *Pianist*, 1916

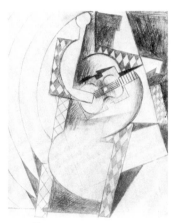

68. *Harlequin Playing a Guitar*, 1915–16

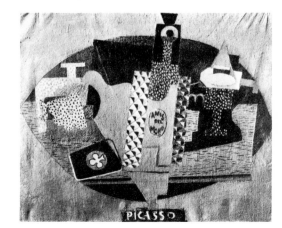

69. *Bottle of Anis del Mono*, 1915

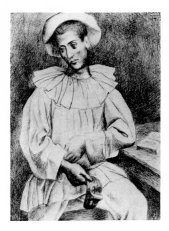

70. *Pierrot au Loup*, 1918

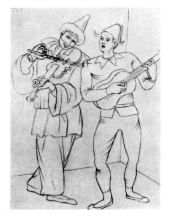

71. *Pierrot and Harlequin*, 1918

PIERROT
Paris, 1918
Oil on canvas, 36½ x 28¾ inches
Signed lower left: "Picasso/18"
Provenance: Bourgeois Gallery, New York; The Donor,
   New York
Sam A. Lewisohn Bequest, 1952
Acq. no. 12.52
Ill. p. 102

1. "If the subjects I have wanted to express have suggested different ways of expression I have never hesitated to adopt them." Statement by Picasso to Marius de Zayas, cited in Barr, *Fifty Years*, p. 271.

PIERROT
1918
Silverpoint, 14³⁄₁₆ x 10¹⁄₁₆ inches
Signed lower left: "Picasso/18"
Provenance: Alexander Iolas Gallery, New York
Extended loan of the Joan and Lester Avnet Collection, 1970
Ill. p. 103

GUITAR
Paris, (early 1919)
Oil, charcoal and pinned paper on canvas, 85 x 31 inches
Signed lower right: "Picasso" (signature added in 1938)
Provenance: Pierre Loeb, Paris; The Donor, Old Westbury,
   Long Island, New York
Gift of A. Conger Goodyear, 1955
Acq. no. 384.55
Ill. p. 105

1. I am indebted to Robert Rosenblum who offered this observation in support of my contention that the large diamond is to be read symbolically as a Harlequin.

2. *Guitar* has a number of affinities—the most important being the trompe-l'oeil nail—with a painting of the same motif made by Picasso in 1918 at the studio in Montrouge (Zervos, III, 140). While it is possible that the Museum's picture was executed there and that the strip of newspaper was therefore an afterthought, it is more likely that *Guitar* was executed early in 1919 after Picasso had moved to the rue de la Boétie.

SEATED WOMAN
Biarritz (1918)
Gouache, 5½ x 4½ inches
Signed lower right: "Picasso"
Provenance: Downtown Gallery, New York; The Donor,
   New York
Gift of Abby Aldrich Rockefeller, 1935
Acq. no. 127.35
Ill. p. 106

1. See Zervos, III, 166–178, 183, 203–206, 208–210, 212, 213, which are related to this composition.

RICCIOTTO CANUDO
Montrouge, 1918
Pencil, 14 x 10⅜ inches
Signed and inscribed lower right:
  "A mon cher canudo/Le poète/Picasso/Montrouge 1918"
Provenance: Ricciotto Canudo, Paris; Galerie Louise Leiris,
  Paris; Buchholz Gallery, New York
Acquired through the Lillie P. Bliss Bequest, 1951
Acq. no. 18.51
Ill. p. 107

TWO DANCERS
London, summer 1919
Pencil, 12¼ x 9½ inches
Signed lower left: "Picasso/Londres 19"
Provenance: Sergei Diaghilev, Paris; Léonide Massine, Paris;
  E. V. Thaw, New York
The John S. Newberry Collection, 1963
Acq. no. 178.63
Ill. p. 108

SLEEPING PEASANTS
Paris 1919
Tempera, 12¼ x 19¼ inches
Signed lower right: "Picasso/19"
Provenance: John Quinn, New York; Paul Rosenberg, Paris;
  Baron Shigetaro Fukushima, Paris; Mme Belin, Paris
Abby Aldrich Rockefeller Fund, 1951
Acq. no. 148.51
Ill. p. 109

1. Observed by Barr, *Fifty Years*, p. 106; also by Boggs,
*Picasso and Man*, p. 82.

NESSUS AND DEJANIRA
Juan-les-Pins, September 12, 1920
Pencil, 8¼ x 10¼ inches
Signed upper left: "12-9-20/Picasso"
Provenance: Galerie Louise Leiris, Paris;
  Curt Valentin Gallery, New York
Acquired through the Lillie P. Bliss Bequest, 1952
Acq. no. 184.52
Ill. p. 110

1. Penrose, *Picasso*, p. 144.

72. *Study for Sleeping Peasants*, 1919

73. *Maternité*, 1919

74. *Nessus and Dejanira*, watercolor, 1920

75. *Nessus and Dejanira* (first version), 1920

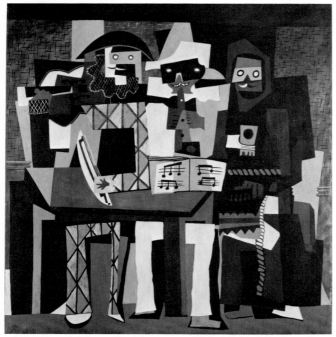

76. *Three Musicians*, 1921. Philadelphia Museum of Art

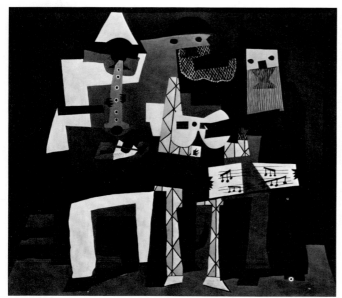

77. *Three Musicians*, 1921. The Museum of Modern Art, New York

THE RAPE
1920
Tempera on wood, 9⅜ x 12⅞ inches
Signed lower left: "Picasso/1920"
Provenance: Wildenstein & Company, Inc., New York;
  The Donor, New York
The Philip L. Goodwin Collection, 1958
Acq. no. 106.58
Ill. p. 111

THREE MUSICIANS
Fontainebleau, (summer) 1921
Oil on canvas, 6 feet 7 inches x 7 feet 3¾ inches
Signed lower right: "Picasso, Fontainebleau 1921"
Provenance: Purchased from the artist in 1921 by
  Paul Rosenberg and owned by him until its acquisition
  by the Museum
Mrs. Simon Guggenheim Fund, 1949
Acq. no. 55.49
Ill. p. 113

1. Henri Hayden's *Three Musicians* of 1919–20 (Fig. 78) has often been identified as a possible source for Picasso's versions of the subject and, indeed, insofar as it portrays—on a large canvas and in Synthetic Cubist style—three carnival-type musicians distributed evenly across the field of the composition, it certainly anticipates the later works. But the fabric of the Picasso pictures is very different and seems more related to Picasso's own work of 1920 and earlier than to Hayden's picture (itself unquestionably painted under the influence of the post-1914 Picasso).

2. The identity of these objects was confirmed by Picasso in conversation with the author.

3. The version of *Three Musicians* in the Philadelphia Museum (Fig. 76) shows the monk playing a kind of keyed harmonium or accordion. The music he holds in The Museum of Modern Art version has been put before the recorder-playing Pierrot, who has been shifted to the center of the composition. Harlequin, now playing a violin, closes the composition on the left.

The Philadelphia version is more subdivided into small shapes, and the middle of the value scale is much more in evidence. While generally more ornamental, it lacks the dramatic contrasts of light and dark, large and small, and what is finally the mysterious poetry of The Museum of Modern Art version.

4. Stravinsky's choice of Pergolesi also reflects his neo-classical interests in those years, the counterpart in Picasso being such pictures as *Three Women at the Spring* (p. 115).

218

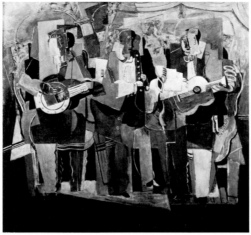

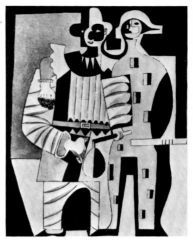

78. Henri Hayden, *Three Musicians*, 1919–20. Musée National d'Art Moderne, Paris

79. *Pierrot and Harlequin*, 1920

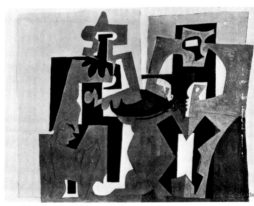

81. *Monk*, 1921

80. *Pierrot and Harlequin*, 1920

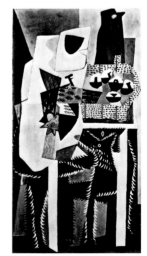

82. *Dog and Cock*, 1921

83. *Three Women at the Spring*, 1921

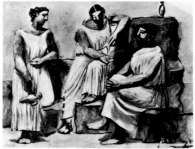

84. *Three Women at the Spring*, 1921

85. *Study for Three Women at the Spring*, 1921

86. *Study for Three Women at the Spring*, 1921

THREE WOMEN AT THE SPRING
Fontainebleau, (summer) 1921
Oil on canvas, 6 feet 8¼ inches x 7 feet 3¾ inches
Signed lower right: "Picasso/21"
Provenance: John Quinn, New York; Mrs. Meric Callery,
  New York; Carlo Frua de Angeli, Milan; J. B. Neumann,
  New York; The Donors, New York
Gift of Mr. and Mrs. Allan D. Emil, 1952
Acq. no. 332.52
Ill. p. 115

1. The gray and terra-cotta tones of this picture have frequently suggested building materials to its interpreters. Schapiro (lectures at Columbia University) spoke of stone and brick; Barr (Barr, Alfred H., Jr., *Masters of Modern Art*, New York: The Museum of Modern Art, 1954, p. 80) wrote of poured concrete.

2. This suggestion was first made by Jardot (*Picasso*, no. 54) and seconded by Boggs (*Picasso and Man*, p. 90). Jardot's text was read by Picasso who took no exception to the assertion.

LA SOURCE
Fontainebleau, July 8, 1921
Pencil, 19 x 25¼ inches
Signed lower left: "Picasso/8-7-21"
Provenance: Paul Rosenberg, New York; The Donor,
  Grosse Pointe Farms, Michigan
The John S. Newberry Collection, 1960
Acq. no. 386.60
Ill. p. 116

1. See Zervos, IV, 302–304 for two other drawings and a painting related to this theme and also executed during 1921.

2. The possible source of this image in the art of Fontainebleau was suggested to the writer by William Rubin.

87. "Nymph of Fontainebleau," 1860. Cartoon by Couder, painted by Alaux, based on an engraving of the original composition (c. 1532–41) by Rosso. Château of Fontainebleau.

88. Dog from the Fountain of Diana, Barthélmy Prieur, 1603. Incorporated into the present fountain in 1684 by the Kellers.

## NUDE SEATED ON A ROCK
(1921)
Oil on wood, 6¼ x 4⅜ inches
Provenance: Purchased from the artist in 1934 by The Donor
Promised gift of James Thrall Soby,
  New Canaan, Connecticut
Ill. p. 117

## THE SIGH
Paris, 1923
Oil and charcoal on canvas, 23¾ x 19¾ inches
Signed lower right: "Picasso/23"
Provenance: M. Knoedler & Co., Inc., New York
Promised gift of James Thrall Soby,
  New Canaan, Connecticut
Ill. p. 118

1. Soby, James Thrall, in *The James Thrall Soby Collection*,
New York: The Museum of Modern Art, 1961, p. 63.

## STILL LIFE WITH A CAKE
May 16, 1924
Oil on canvas, 38½ x 51½ inches
Signed lower right: "Picasso/24"; dated: 16 mai
  (acc. Zervos, v, 185)
Provenance: Alphonse Kann, London
Acquired through the Lillie P. Bliss Bequest, 1942
Acq. no. 190.42
Ill. p. 119

## STUDIO WITH PLASTER HEAD
Juan-les-Pins, (summer) 1925
Oil on canvas, 38⅝ x 51⅝ inches
Signed on lower right: "Picasso 25" and dated on the
  stretcher: "Juan-les-Pins/1925"
Provenance: Dr. G. F. Reber, Lausanne;
  James Johnson Sweeney, Houston
Purchase, 1964
Acq. no. 116.64
Ill. p. 121 and on cover

1. Picasso told the author that the toy theater in this picture
is an absolutely accurate representation of the one he had
made for Paul except for the omission of a human figure
originally placed at stage right.

2. Robert Rosenblum, in conversation with the author, has
drawn attention to an exceptional early Cubist painting of late
1908 (Fig. 90) in which the shading within the oval head
unquestionably anticipates the kind of interior profile which
Picasso was to isolate subsequently in the "double head."

3. The double head in Fig. 91 is claimed as an exception in
Robert Melville's "The Evolution of the Double Head in the
Art of Picasso," *Horizon* (London), vi, 35, November 1942,
p. 343, but it shows the convention in still a rather unformed
state.

89. Set for the ballet *Pulcinella*, 1920

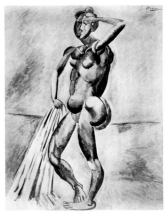
90. *Bather*, 1908

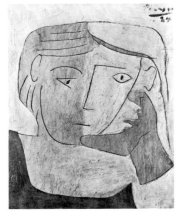
91. *Head of a Woman*, 1924

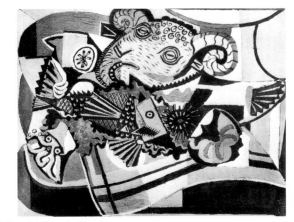
92. *Still Life with Ram's Head*, 1925

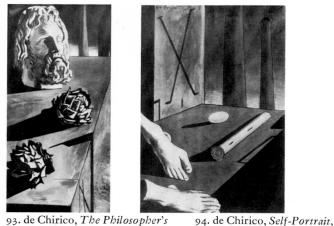

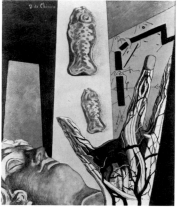

93. de Chirico, *The Philosopher's Promenade*, 1914

94. de Chirico, *Self-Portrait*, 1913

95. de Chirico, *The Span of Black Ladders*, 1914. Mr. and Mrs. James Alsdorf, Chicago

96. de Chirico, *The Scholar's Playthings*, 1917

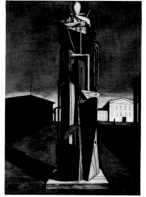

97. de Chirico, *The Great Metaphysician*, 1917. The Museum of Modern Art, New York

4. This motif occurs in two other oil paintings of 1925 (Zervos, v, 375, 444); however, it is most fully developed in *Studio with Plaster Head*.

5. Schapiro, lectures at Columbia University.

6. Picasso was unquestionably familiar with de Chirico's painting in the years prior to World War I when the Italian painter was being championed by Picasso's friend Guillaume Apollinaire. But none of the forms of Picasso's neoclassicism of 1915–24 reflects any special awareness of the Italian painter's art. In the two years prior to the painting of *Still Life with Plaster Head*, however, Picasso had been quite friendly with André Breton and was no doubt aware that the poet considered de Chirico (Surrealism's "fixed sentinel") along with Picasso himself ("Surrealism . . . has but to pass where Picasso has already passed, and where he will pass in the future") as the two artists most instrumental in the development of his movement. Indeed, in the First International Surrealist Exhibition held at the Galerie Pierre in November 1925, de Chirico and Picasso were (with Klee) the only non-Surrealists represented. This was, significantly, the first time Picasso had ever consented to participate in a group show.

7. In such pictures as *The Great Metaphysician*, 1917 (Fig. 97), de Chirico used a carpenter's square in conjunction with other forms resembling the tools of a designer or engineer (as well as suggestions of painting stretchers) to form scaffoldings that were inspired in part by the abstract structures of high Analytic Cubism. *The Great Metaphysician* is especially interesting in regard to *Studio with Plaster Head* in its juxtaposition of the carpenter's square with the white bust of what reads as a classical statue.

FOUR DANCERS
Monte Carlo, (spring) 1925
Pen and ink, 13⅞ x 10 inches
Signed lower right: "Picasso/25"
Provenance: Dikran Kahn Kelekian, New York; The Donor, New York
Gift of Abby Aldrich Rockefeller, 1935
Acq. no. 128.35
Ill. p. 123

1. See Douglas Cooper, *Picasso: Theatre* (New York: Abrams, 1968) for a discussion of the role of the theater in Picasso's life and work, a list of theatrical productions in which he has collaborated, and numerous illustrations of costumes, decor, and other compositions related to his theatrical experience.

SEATED WOMAN
December 1926
Oil on canvas, 8¾ x 5 inches
Signed upper left: "Picasso"; dated on the stretcher: "Decembra [*sic*] 26"
Provenance: Acquired from the artist in 1932 by The Donors, New York

The Sidney and Harriet Janis Collection (fractional
  gift), 1967
Acq. no. 643.67
Ill. p. 124

SEATED WOMAN
Paris, 1927
Oil on wood, 51⅛ x 38¼ inches
Signed lower right: "Picasso/27"
Provenance: Mary Hoyt Wiborg, New York; Valentine
  Gallery, New York; The Donor, New Canaan, Connecticut
Fractional gift of James Thrall Soby, 1961
Acq. no. 516.61
Ill. p. 125

1. Hamilton, George Heard, *Painting and Sculpture in
Europe 1880 to 1940* (Baltimore: Penguin Books, 1967),
p. 305.

PAGE 0 FROM LE CHEF-D'OEUVRE INCONNU BY
  HONORÉ DE BALZAC
Wood engraving by Aubert after a drawing by Picasso
  (1926); published Paris: Ambroise Vollard, 1931;
  13 x 10 inches (page size)
The Louis E. Stern Collection, 1964
Acq. no. 967.64
Ill. p. 126

PAINTER WITH MODEL KNITTING FROM LE CHEF-D'OEUVRE
  INCONNU BY HONORÉ DE BALZAC
Paris (1927); published Paris: Ambroise Vollard, 1931
Etching, 7⁹⁄₁₆ x 10⅞ inches
G.126
The Louis E. Stern Collection, 1964
Acq. no. 967.64
Ill. p. 127

1. Barr, Alfred H., Jr., *Picasso: Fifty Years of His Art* (New
York: The Museum of Modern Art, 1946), p. 145.

THE STUDIO
Paris, 1927–28
Oil on canvas, 59 x 91 inches
Signed lower right: "Picasso/28"; inscribed on
  stretcher: "1927–28"
Provenance: Valentine Gallery, New York; The Donor,
  New York and Warrentown, Virginia
Gift of Walter P. Chrysler, Jr., 1935
Acq. no. 213.35
Ill. p. 129

1. Richardson, John, "Picasso's Ateliers and other recent
works," *The Burlington Magazine* (London), XCIX, 651, June
1957, pp. 183–84.

2. Rosenblum, *Cubism*, pp. 289–290.

98. *L'Atelier de la Modiste*, 1926. Musée National d'Art
Moderne, Paris

99. Infrared photo of left section of *The Studio*, 1927–28

100. *Project for a Monument*, 1928

223

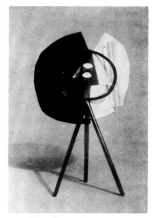

101. *Head,* 1928.

102. *Sketch for Head,* 1928

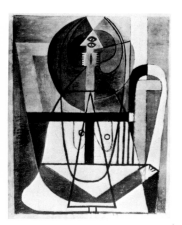

103. *Woman,* 1928

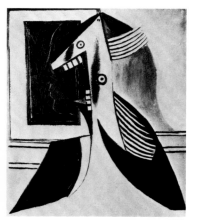

104. *Woman's Head and Portrait,* 1929

3. The analogy between eyes and mouth, though not their displacement, was well advanced in 1908 in such pictures as *Bust of a Man* (p. 53), where the inspiration in that respect was almost certainly African art.

4. Picasso had originally considered giving the artist a rectangular palette (clearly visible in the infrared photograph, Fig. 99) but subsequently painted it out.

PAINTER AND MODEL
Paris, 1928
Oil on canvas, 51⅛ x 64¼ inches
Signed lower left: "Picasso/28"
Provenance: Paul Rosenberg, Paris; The Donors, New York
The Sidney and Harriet Janis Collection (fractional
  gift), 1967
Acq. no. 644.67
Ill. p. 131

1. Barr, *Fifty Years,* p. 157.

2. For an extensive discussion of such displacements, see Robert Rosenblum, "Picasso and the Anatomy of Eroticism," in T. Bowie and C. Christenson, eds., *Studies in Erotic Art* (New York: Basic Books, 1970).

3. Golding, John, "Picasso and Surrealism," *Picasso/An Evaluation: 1900 to the Present* (London: Paul Elek, 1972).

4. Observed by Lucy Lippard in the forthcoming catalog of The Sidney and Harriet Janis Collection (New York: The Museum of Modern Art, 1972).

5. Penrose (*Picasso,* p. 235) considers the classical silhouette against which the angry woman's head is seen to be a self-portrait.

BATHER AND CABIN
Dinard, (August 9, 1928) (acc. Zervos, VII, 211)
Oil on canvas, 8½ x 6¼ inches
Signed lower left: "Picasso 28"
Provenance: Valentine Gallery, New York; Oliver B. James,
  New York
Hillman Periodicals Fund, 1955
Acq. no. 342.55
Ill. p. 132

1. For the origin and development of Surrealist biomorphism see the author's *Dada and Surrealist Art* (New York: Harry N. Abrams, Inc., 1968), pp. 18–22 and *passim.*

2. Vallentin, Antonina, *Pablo Picasso* (Paris: Club des Editeurs, Hommes et Faits de L'Histoire, 1957), p. 85.

SEATED BATHER
(Early 1930)
Oil on canvas, 64¼ x 51 inches
Signed lower right: "Picasso"
Provenance: Mrs. Meric Callery, New York
Mrs. Simon Guggenheim Fund, 1950
Acq. no. 82.50
Ill. p. 133

WOMAN BY THE SEA
(April 7), 1929 (acc. Zervos, VII, 252)
Oil on canvas, 51⅛ x 38⅛ inches
Signed lower left: "Picasso/29"
Provenance: Aline Barnsdall, Santa Barbara, California
Extended loan of the Florene May Schoenborn and
  Samuel A. Marx Collection
Ill. p. 134

1. Golding, "Picasso and Surrealism."

PITCHER AND BOWL OF FRUIT
(February 22), 1931 (acc. Zervos, VII, 322)
Oil on canvas, 51½ x 64 inches
Signed lower left: "Picasso/XXXI"
Provenance: Paul Rosenberg, Paris;
  Henry P. McIlhenny, Philadelphia
Promised gift of Nelson A. Rockefeller, New York
Ill. p. 135

1. See below, p. 139, note 1 under *Girl before a Mirror.*

THE SERENADE
Paris, October 22, 1932
Brush, pen and ink, 10¼ x 13⅛ inches
Signed lower right: "Picasso/Paris 22 octobre XXXII"
Provenance: Daniel-Henry Kahnweiler, Paris; Curt Valentin,
  New York; Perls Galleries, New York;
  The Donor, New York
Gift of Miss Eve Clendenin, 1961
Acq. no. 315.61
Ill. p. 136

1. See Zervos, VIII, 33–36, 38, 39, 41, 42, 44, 45, 46, 48 for
compositions that are closely related.

105. Drawing from a sketchbook, 1927

106. *Bather,* 1928

107. Page from a sketchbook, 1928

225

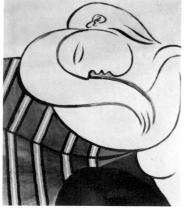

108. *Woman with Blond Hair,* 1931

109. Photograph of Picasso by
Cecil Beaton, 1931

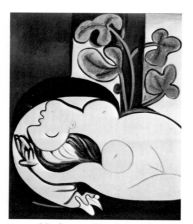

110. *Nude on a Black Couch,* 1932

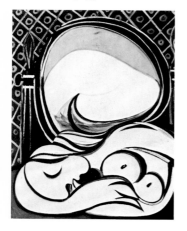

111. *The Mirror,* 1932

THE ARTIST AND HIS MODEL
Cannes, July 23, 1933
Gouache, pen and ink, 15⅞ x 20 inches
Signed lower right: "Picasso/ Cannes 23 juillet XXXIII"
Extended loan of Mr. and Mrs. Arthur Wiesenberger
Ill. p. 137

1. Boeck and Sabartés, *Picasso,* pp. 314ff.

GIRL BEFORE A MIRROR
(March 14), 1932 (acc. Zervos, VII, 379)
Oil on canvas, 64 x 51¼ inches
Signed upper left: "Picasso XXXII"
Provenance: Paul Rosenberg, Paris; Valentine Dudensing,
  New York
Gift of Mrs. Simon Guggenheim, 1938
Acq. no. 2.38
Ill. p. 139

1. Although 1932 is the year traditionally given for the begin-
ning of Picasso's liaison with Marie-Thérèse Walter, there are
a few pictures dated 1931 by Zervos (Fig. 108) that were
almost certainly inspired by her. Brassaï (*Conversations,* p.
28) speaks of Picasso's first image of Marie-Thérèse having
been painted in December 1931, but there is good reason to
think that these images go back to autumn of that year at the
very least. There is a photograph of Picasso (see Rosenblum,
"Picasso and the Anatomy of Eroticism," p. 347, fn. 23.)
made by Cecil Beaton in 1931 in which the artist stands be-
fore a painting (Fig. 109) not catalogued by Zervos, in which
the reclining nude is obviously of the series of images of
Marie-Thérèse that continued in 1932 with *Nude on a Black
Couch* (Fig. 110) and *The Mirror* (Fig. 111). The painting
includes a representation of a sculptured bust that is quite
clearly a portrait of Marie-Thérèse and no doubt represented
one of the earliest of the series of her heads Picasso was to
model in the studios he had made out of the stables of the
seventeenth-century Château de Boisgeloup, near Gisors,
which he had purchased in 1930 or early in 1931.

It seems probable that the first images of Marie-Thérèse
date from the summer of 1931. Indeed, the remarkable change
in mood in Picasso's painting as early as February and March
1931—as reflected in *Pitcher and Bowl of Fruit* (p. 135; dated
February 22) and *Still Life on a Table* (Fig. 112; dated March
11)—suggests that his first contacts with her date from the
beginning of the year. In view of the extraordinarily anthro-
pomorphic character of *Still Life on a Table,* and its anticipa-
tions of *Girl before a Mirror* (see text, p. 140), it is perhaps
not too far-fetched to consider this picture a metaphoric
tribute to the seventeen-year-old girl who had just entered
Picasso's life.

2. Schapiro, Meyer, cited in "A *Life* Round Table on Modern
Art," *Life* (New York), XXV, 15, October 11, 1948, p. 59.

3. *Ibid.*

4. *Ibid.*

5. Rosenblum, "Picasso and the Anatomy of Eroticism," p. 349.

6. *Ibid.*

7. Sypher, Wylie, *From Rococo to Cubism* (New York: Random House, 1960), p. 280.

8. Gottlieb, Carla, "Picasso's *Girl Before a Mirror*," *Journal of Aesthetics and Art Criticism*, XXIV, 4, Summer 1966, pp. 509–18. Gottlieb asserts (p. 510) that "Picasso must have known *The Living-and-Dead Lady*, which was one of Gómez' prize possessions. In his autobiography published in Madrid as appendix to *La Sagrada Cripta de Pombo* in 1923, the poet dedicated two pages to it, illustrating it with a print. The main text of the same volume contains a photograph of Picasso, taken at the banquet which was given by Ramón in his honor at the Sacred Crypt of the Pombo (the meeting place for Gómez and his followers) in 1917, when Picasso stopped over in Madrid enroute from Rome to Paris. It is most probable that a copy of the book featuring his photograph would have reached Picasso."

9. Rosenblum, "Picasso and the Anatomy of Eroticism," p. 349.

10. Marion Bernadik uses the X-ray image in relation to the figure and reflection in an essay written in January 1945 for a class of Meyer Schapiro's at The New School, New York (copy in the Library of The Museum of Modern Art). She paraphrases Schapiro in referring to the Girl's body as "simultaneously clothed, nude and X-rayed," a passage cited in Barr, *Fifty Years*, p. 176.

11. Gottlieb, "Picasso's *Girl Before a Mirror*," p. 510, observes: "It has not been noted so far that the artist has introduced into his picture a clue which tells the beholder what the young beauty is discovering when studying her image. This clue is the form of the looking-glass—a figure-length, freestanding plate fitted with an adjustable inclination. Although known since the time of Louis XVI, this type came into popular use only during the nineteenth century—to disappear shortly afterwards in the twentieth. Such a mirror is called *psyché* in France and Austria, *psiche* in Italy, and *psiquis* in Spain. The English translation of this Greek word is "soul." Its meaning is commonly known since the words *psychology, psychoanalysis, psychosis,* etc. derive from this root. Scholars are furthermore familiar with it from the story of *Eros and Psyche*, where the soul is personified as a young and lovely girl who searches for divine love. As regards the transference of the name *psyche* to a mirror, it is founded upon the popular belief that the plate does not reflect the outward likeness of the person who is consulting it but his/her soul."

12. *Girl before a Mirror* is dated March 14, 1932. *Nude on a Black Couch* is dated March 9, 1932, and *The Mirror* is dated March 12, 1932.

112. *Still Life on a Table*, 1931

113. *Bathers with a Ball*, 1928

114. *The Living and Dead Lady.* Formerly Collection Ramón Gómez de la Serna

115. *Two Girls Reading*, March 29, 1934

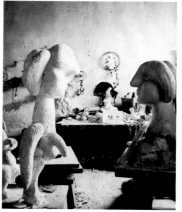

116. Picasso's studio at Boisgeloup, early 1930s

117. *Nude and Warrior*, April 30, 1934

TWO FIGURES ON THE BEACH
Cannes, July 28, 1933
Pen and ink, 15¾ x 20 inches
Signed lower right: "Picasso/ Cannes 28 juillet XXXIII"
Provenance: Galerie Robert, Amsterdam;
  Galerie Simon, Paris
Purchase, 1939
Acq. no. 655.39
Ill. p. 141

1. Cited in Leymarie, Jean, *Picasso Drawings* (Geneva: Skira, 1967), p. 58.

MODEL AND SURREALIST FIGURE
(May 4, 1933)
Etching, 10⁹⁄₁₆ x 7⅝ inches
G.346IIC.
Purchase, 1949
Acq. no. 221.49
Ill. p. 143

1. Bolliger, Hans, *Picasso for Vollard* (New York: Harry N. Abrams, 1956), p. x. Although one hundred plates were finished in 1937, the tirage was not completed until 1939, shortly before Vollard's death in an auto accident July 22. The prints were not made available until 1949. William S. Lieberman (*The Sculptor's Studio: Etchings by Picasso*, New York: The Museum of Modern Art, 1952) was the first to mention that the plates were "acquired" by Vollard, not commissioned, as Bolliger insists, because of the "success" of the Balzac and Ovid books. Neither of these books was, in fact, a financial success, and it is more probable that Vollard accepted a set number of plates in trade for several paintings Picasso acquired from him.

GIRL READING
Spring 1934
Oil on canvas, 64 x 51½ inches
Signed upper right: "Picasso/XXXIV"
Provenance: Peter Watson, London
Promised gift of the Florene May Schoenborn and
  Samuel A. Marx Collection
Ill. p. 144

1. In addition to Fig. 115, of March 29, Picasso executed Zervos, VIII, 191, 192 and 194 on March 27, 28 and 30 respectively. Zervos, VIII, 193, although not dated, almost surely comes from the same period. From early in April—to judge by the relation of its surreal biomorphism and its setting to a *Still Life* dated April 7—comes still another version of the motif of two girls reading, which Zervos (VIII, 197) has mistakenly identified as a still life.

MYRRHINA AND KINESIAS FROM LYSISTRATA BY ARISTOPHANES
New York, The Limited Editions Club, 1934
Etching, 8⅜ x 6 inches
The Louis E. Stern Collection, 1964
Acq. no. 970.64
Ill. p. 145

INTERIOR WITH A GIRL DRAWING
Paris, February 12, 1935
Oil on canvas, 51⅛ inches x 6 feet 4⅝ inches
Inscribed on stretcher: "Paris 12 février xxxv"
Provenance: Mrs. Meric Callery, New York
Promised gift of Nelson A. Rockefeller, New York
Ill. p. 147

1. Of the three sketchbook drawings of February 5, 1935, Fig. 118 and one other, Zervos, VIII, 250, show the girl before a mirror that reflects her image. In Zervos, VIII, 252, she confronts an easel with a picture painted on it. The easel had appeared on the right side of the other two sketches but in those cases supported only a blank canvas.

2. Brassaï, *Conversations avec Picasso* (Paris: Gallimard, 1964), p. 268.

3. Painting over an entire picture, as opposed to making a new version on a separate canvas, is a relatively unusual procedure for Picasso after the Blue Period. It may well be that the painter called in Zervos between February 5 and 12 precisely because he knew he was going to paint over Fig. 122. This still leaves the conundrum of the date—February 17—which appears on the drawing for that first version (Fig. 121), and no explanation for that drawing's remarkable labyrinthine web of color identification lines. This author's surmise is that it actually preceded the making of Fig. 122—except for the color indications—and that only after having overpainted that picture did Picasso add the color notations from memory, possibly as a form of record, as well as the date of February 17.

The reader should keep in mind that in referring to the "first version" in the last paragraph of the text, the author has in mind the first painting executed on the very canvas which is now the Rockefeller picture (Fig. 122). That picture, in turn, may well have been preceded by a wholly different version now in the Musée National d'Art Moderne, Paris (Fig. 125), on which Picasso apparently did not inscribe a particular date. In the Paris picture, the girl drawing seems more awake, more outwardly oriented, and the picture reflected in the mirror is more clearly a still life.

118. *Girl Drawing*, February 5, 1935

119. *Girl Drawing*, 1935

120. *Girl Drawing*, 1935

121. *Girl Drawing*, February 17, 1935

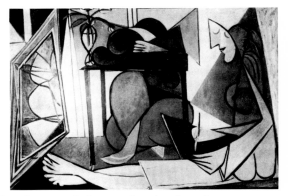

122. *Girl Drawing*, 1935 (subsequently painted over)

229

123. *Girl Drawing*, 1935

124. *Girl Drawing*, February 17, 1935

125. *Girl Drawing*, 1935. Musée National d'Art Moderne, Paris

137. *Still Life with Black Bull's Head*, November 19, 1938

MINOTAUROMACHY
(1935)
Etching and scraper, 19½ x 27⁷⁄₁₆ inches
B.288
Purchase, 1947
Acq. no. 20.47
Ill. p. 149

1. Barr, Alfred H., Jr., *Picasso: Fifty Years of His Art* (New York: The Museum of Modern Art, 1946), pp. 192–193.

FAUN AND SLEEPING WOMAN
(June 12, 1936)
Etching and aquatint, 12⁷⁄₁₆ x 16⁷⁄₁₆ inches
B.230
Purchase, 1949
Acq. no. 267.49
Ill. p. 150

1. Bolliger, *Picasso for Vollard*, p. XIV.

DREAM AND LIE OF FRANCO II
(January 8–9, 1937, and June 7, 1937)
Etching and aquatint, 12⅜ x 16⁹⁄₁₆ inches
B.298
Gift of Mrs. Stanley Resor, 1958
Acq. no. 424.58.2
Ill. p. 151

1. J. J. Sweeney has suggested that the figure of Franco might have been inspired by Jarry's famous character, Ubu. When asked about this possibility Picasso replied—with Jarry's vocabulary—that he had been *"inspiré par l'étron"* (questionnaire, October 1945).

2. The interpretation of the etching owes much to the careful analysis of W. S. Lieberman.

3. Barr, Alfred H., Jr., *Picasso: Fifty Years of His Art* (New York: The Museum of Modern Art, 1946), pp. 195, 196.

STILL LIFE WITH RED BULL'S HEAD
Paris, November 26, 1938
Oil on canvas, 38⅛ x 51 inches
Signed at lower left center: "Picasso"; dated lower right: "26.11.38"
Provenance: Galerie Louise Leiris, Paris
Promised gift of Mr. and Mrs. William A. M. Burden, New York
Ill. p. 153

1. Exactly one week earlier (November 19, 1938), Picasso completed *Still Life with Black Bull's Head* (Fig. 137) where, despite the presence below the animal of what appears to be a socle, the bull's head—powerful and self-assured, as in *Guernica*—seems to materialize from out of the walls of the room.

126. *The Mistletoe Seller*, 1903

131. *Woman with Dead Child on a Ladder*, 1937

127. *Young Girl with Basket of Flowers*, 1905. Mr. and Mrs. David Rockefeller, New York

132. *Bullfight*, 1933

128. *Curtain for Parade*, 1917. Musée National d'Art Moderne, Paris

133. *Running Minotaur*, 1928    134. *Minotaur* (with dagger), 1933

129. *Crucifixion*, 1930

135. *Minotaur*, 1933

130. *The Balcony*, 1933

136. *Minotaur*, 1935

140. Page from a sketchbook,
March 14, 1940

141. *Woman's Head*, 1940

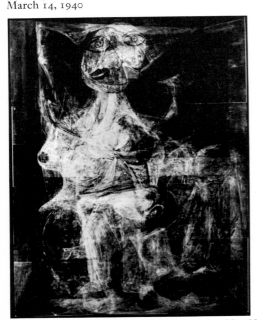

142. Radiograph of *Woman Dressing Her Hair*. (Made at the
Conservation Center of New York University)

143. Page from a sketchbook,
June 3, 1940

144. Page from a sketchbook,
June 4, 1940

WOMAN DRESSING HER HAIR
Royan, (2nd–3rd week, June 1940)
Oil on canvas, 51¼ x 38¼ inches
Signed upper right: "Picasso";
  inscribed on stretcher: "5–3.1940"
Provenance: Owned by the artist until summer, 1957
Promised gift of Mrs. Bertram Smith, New York
Ill. p. 159

1. Penrose, *Picasso*, p. 296.

2. In an essay, "The Women of Algiers and Picasso at Large," to be published in his forthcoming book, *Other Criteria* (New York: Oxford University Press, 1972), Leo Steinberg argues that simultaneity of aspects as a structural mode is unrelated to Cubist goals, even though the loosened facets of Cubism suggested some of the means. However, in the artist's later work the "weave of aspects" becomes "the efficient principle of a new consolidation."

3. Although the stretcher is inscribed March 5, 1940 (incorrectly cited in certain publications as March 6), Jardot (*Picasso: Peintures*, no. 95) was undoubtedly right in surmising that this painting was executed in June. Since the earliest drawing to approximate the pose of the whole figure dates from March 14 (Fig. 140; see last paragraph of text, p. 158), Picasso evidently began a related picture on this canvas at that time, and later painted over it. This is confirmed by a recent radiograph (Fig. 142), which gives some idea of the earlier picture. It shows that the head then took approximately the form we see in Fig. 141, undated but executed after March 2 (to judge by its place in a notebook begun January 10, 1940; see Zervos, x, 202–297).

It is highly unlikely that the execution of *Woman Dressing Her Hair* antedates the closely related sketches of early June (Figs. 143–148). As Jardot is again probably correct in suggesting that Fig. 149, dated June 19, was executed *after* the painting (related sketches of that date deal with comparable pictures-within-pictures), we may surmise that *Woman Dressing Her Hair* was executed some time during the second and third week of June 1940.

4. John Berger (*The Success and Failure of Picasso*, Baltimore: Penguin Books, 1965, p. 151), in a glaring example of the intentional fallacy, assumes that the political situation is the subject of *Woman Dressing Her Hair* and pronounces it a failure because "a woman's body by itself cannot be made to express all the horrors of fascism." But even in *Guernica* and *The Charnel House*, Picasso transcended immediate circumstantial motifs to create more generalized, more universal images, and based these, moreover, primarily on the human body, which remains for him capable of communicating the fullest range of content.

5. Penrose, *Picasso*, p. 296.

6. The date(s) of these four sketches (Fig. 141, and Zervos, x, 284–286) is not known. The sketchbook containing them

was begun January 10, 1940. They occur a few pages after a drawing dated March 2 and are immediately followed by others dated May 26.

145. Page from a sketchbook, June 4, 1940

146. Page from a sketchbook, June 5, 1940

147. Page from a sketchbook, June 7, 1940

148. Page from a sketchbook, June 8, 1940

149. Page from a sketchbook, June 19, 1940

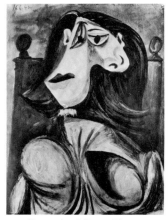

150. *Portrait of Dora Maar*, June 16, 1940

MARTIN FABIANI
Paris, July 17, 1943
Pencil, 20 x 13 inches
Dated lower right: "17 juillet 43"
Provenance: Martin Fabiani, Paris; The Donor, New York
Gift of Sam Salz, 1954
Acq. no. 249.54
Ill. p. 160

THE STRIPED BODICE
September 20, 1943
Oil on canvas, 39⅜ x 32⅛ inches
Signed upper right: "Picasso"; inscribed on stretcher:
 "20 septembre 43"
Provenance: Durand-Ruel Gallery, New York
Promised gift of Nelson A. Rockefeller, New York
Ill. p. 161

HEAD OF A WOMAN
July 16, 1941
Pen and ink on brown-gray paper, 10⅜ x 8¼ inches
Signed lower right: "16 juillet 41/Picasso"
Provenance: Pierre Loeb, Paris
Purchase, 1945
Acq. no. 9.45
Ill. p. 162

FEMALE HEAD
May 1940
Pencil, 8⅞ x 7⅜ inches
Signed upper left: "mai 40/Picasso"
Provenance: The Donor, New York
Gift of Justin K. Thannhauser, 1948
Acq. no. 7.48
Ill. p. 162

1. Barr, *Fifty Years*, p. 227.

2. Penrose, *Picasso*, pp. 278, 296, 330. A number of writers
describe the animal head as "horse-faced."

WOMAN WASHING HER FEET
Paris, July 10, 1944
Wash, brush and ink, 20 x 13¼ inches
Signed upper left: "10 juillet/44/VII/Picasso"
Provenance: Galerie Louise Leiris, Paris
Purchase, 1953
Acq. no. 186.53
Ill. p. 163

1. See Zervos, XIII, 290, 291, 316–319, 325, for reproductions
of the other drawings. This entire group of drawings relates
to a figure in the painting of 1944, *Reclining Nude and
Woman Washing Her Feet*, Zervos, XIII, 273.

HEAD OF A BOY
Paris, August 13–15, 1944
Brush and ink wash, 19¾ x 11¼ inches
Signed lower right: "Picasso/13–15 août 44 Paris"; and on
 reverse upper left: "13 août 44" and "15 août 44"
Extended loan of the Florene May Schoenborn and
 Samuel A. Marx Collection
Ill. p. 164

1. See Penrose, Roland, *The Sculpture of Picasso* (New York:
The Museum of Modern Art, 1967), pp. 106, 107, for photo-
graphs of this sculpture.

PAUL VERLAINE
Paris, June 5, 1945
Wash, pen and ink, 11⅝ x 8¼ inches
Signed, on reverse: "Pour/Paul Eluard/Picasso/le mardi 6
 juin 1945"; dated, front, upper right: "5.6.45"
Provenance: Paul Eluard, Paris; M. Knoedler & Cie., Paris
Extended loan of the Joan and Lester Avnet Collection
Ill. p. 165

1. Penrose, *Picasso*, p. 135.

THE CHARNEL HOUSE
1944–45
Oil on canvas, 78⅝ x 98½ inches
Signed lower left: "Picasso/45"
Provenance: Walter P. Chrysler, Jr., New York and
 Warrentown, Virginia
Mrs. Sam A. Lewisohn Bequest (by exchange) and
 Purchase, 1971
Acq. no. 93.71
Ill. p. 167

1. See the discussion of *Woman Dressing Her Hair*, p. 158.

2. Whitney, Peter D., "Picasso Is Safe," *San Francisco Chron-
icle*, September 3, 1944. Cited in Barr, *Fifty Years*, p. 223.

3. Following Picasso's entry into the Communist party at the
end of World War II, images bearing directly on collective
social and political issues multiplied, e.g. *Massacre in Korea,
War and Peace*. (He also contributed a poster and numerous
drawings to the International Peace Movement.) Such images
remain, however, numerically infinitesimal in his immense
output.

4. As in *Guernica* where Picasso eschewed such details as
contemporary weapons, which might have attached the image
directly to the time and place of the Fascists' bombing, or
even more generally to modern war (Schapiro, lectures at
Columbia University), so he ensured the universality of *The
Charnel House* by avoiding those references which would
link it specifically with the concentration camps.

5. For a discussion of these interlocking iconographic layers
in *Guernica*, see the author's *Dada and Surrealist Art*, pp.
290–309. A case is made there for a direct parentage of the

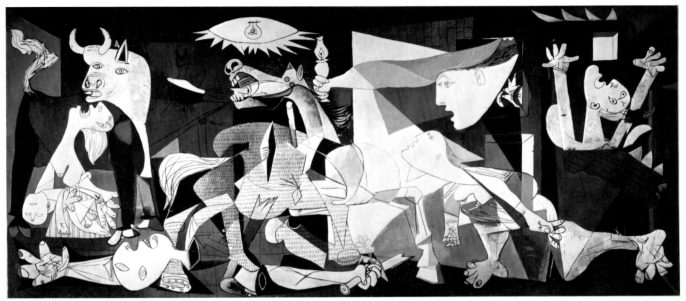

151. *Guernica*, 1937

152. *Guernica:* first progressive photograph (detail of left half),
by Dora Maar

153. *Guernica:* second progressive photograph (detail of center),
by Dora Maar

154. *Study for Man with a Lamb*, 1942

155. *Bound Lamb*, 1943

156. *The Sacrifice*, 1938

configuration of the horse in certain of Picasso's Grünewald paraphrases of 1932, especially one in which the head of Christ resembles a snouted animal, its mouth open and tongue emerging.

6. In addition to such well-known examples as *First Steps* of 1943 (Zervos, XIII, 36) the reader is referred especially to the following pictures: Zervos, XI, 78, 79, 200; XII, 70–85, 157, 160; XIII, 74, 94, 95, 98, 207; XIV, 39, 89, 90.

7. Robert Rosenblum has pointed out an affinity in regard to the juxtaposition of dead bodies and still-life objects between *The Charnel House* and Goya's "Ravages of War" from *The Disasters of War*. The latter image (Fig. 161), certainly familiar to Picasso, contains six dead figures in a wrecked house in which a chair plays a role somewhat analogous to the still life in *The Charnel House*.

8. The date Picasso ceased work on *The Charnel House* is not known. The work could not possibly have been halted before July 1945, when Brassaï reports his painting it (see text, p. 169). It was first publicly exhibited in February 1946 in *Arts et Résistance*, a show sponsored by organizations of *maquis* and partisans at the Musée National d'Art Moderne in Paris. According to Sidney Janis, who was seeing Picasso at that time, the picture was not in its present state. Assuming Janis is correct, the final light blue-gray additions (see text, p. 169) were made well over a year after the work was begun, and possibly even later. When the picture was exhibited—in its present state—in the large Picasso retrospective at the Palazzo Nazionale of Milan in 1953, the catalog entry indicated that those final changes were made as late as 1948. The picture was purchased in 1954 by Walter P. Chrysler, Jr., from whom the Museum acquired it.

9. In the Zervos catalog this cock may be discerned in different form in both the first and second progressive photographs (XIV, 72, 73) where the gravure process gives maximal definition. However, the cock is barely visible in our smaller reference photographs (Figs. 165, 166) printed in offset.

10. Brassaï, *Conversations*, p. 224 (entry for Tuesday, July 10, 1945). These connotations of the French verbs *achever*, *exécuter* and *terminer* have been observed by Picasso in other contexts to make essentially the same point.

11. "It seems to me," writes Clement Greenberg ("Picasso Since 1945," *Artforum* Los Angeles, V, 2, October 1966, p. 29), "that in *Charnel House* Picasso also makes a specific correction of the color of the earlier picture [*Guernica*] by introducing a pale grey-blue amid the blacks and greys and whites. This works, along with the use of priming instead of applied white, to give the later painting more ease of space, more air."

12. *Ibid*, p. 28.

157. *Study for Head of a Lamb*, 1943

158. *Study for Guernica*, 1937

159. *Pitcher, Candle and Casserole*, 1945. Musée National d'Art Moderne, Paris

160. *Skull, Leeks and Pitcher*, 1945

161. Goya: *Ravages of War*, c. 1810–1815. The Metropolitan Museum of Art, Dick Fund, 1932

162. *Cock*, 1944

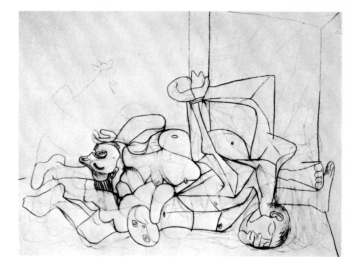

163. *The Charnel House*: detail, first progressive photograph, February 1945

165. *The Charnel House*: first progressive photograph, February 1945

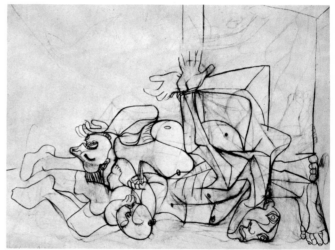

164. *The Charnel House*: detail, second progressive photograph, April 1945

166. *The Charnel House*: second progressive photograph, April 1945

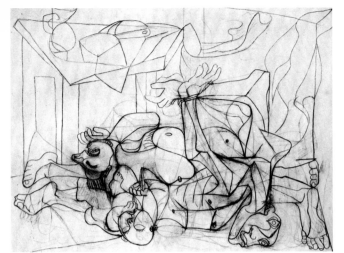

167. *The Charnel House*: third progressive photograph,
May 1945

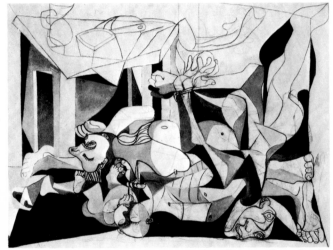

168. *The Charnel House*: fourth progressive photograph, undated

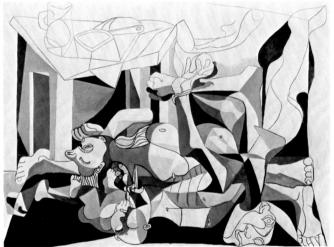

169. *The Charnel House* (final state). The Museum of Modern
Art, New York

170. Lucas Cranach the Elder, *David and Bathsheba*, 1526.
Preussischer Kulturbesitz, Staatliche Museum, Berlin

DAVID AND BATHSHEBA
Paris, March 30, 1947
Lithograph, 25⅝ x 19¼ inches
M.109I/X
Louise R. Smith Fund, 1956
Acq. no. 776.56
Ill. p. 170

DAVID AND BATHSHEBA
Paris, March 30, 1947
Lithograph, 25⅞ x 19¼ inches
M.109II/X
Acquired through the Lillie P. Bliss Bequest, 1947
Acq. no. 254.47
Ill. p. 170

DAVID AND BATHSHEBA
Paris, March 30, 1947
Lithograph, 25½ x 19¼ inches
M.109IV/X
Acquired through the Lillie P. Bliss Bequest, 1947
Acq. no. 255.47
Ill. p. 171

DAVID AND BATHSHEBA
May 29, 1949
Lithograph, 25¹¹⁄₁₆ x 18¹⁵⁄₁₆ inches
M.109 bis I/I
Curt Valentin Bequest, 1955
Acq. no. 363.55
Ill. p. 171

1. Cited in Barr, *Fifty Years*, p. 272. See also Picasso's statement to Brassaï (p. 169) made shortly before his deep involvement with lithography.

2. Daniel-Henry Kahnweiler, introduction to *Cranach and Picasso* (Nürnberg: Albrecht Dürer Gesellschaft, 1968, n.p.): "The plates after *David and Bathsheba* were from a small reproduction of this painting in a Berlin catalog that I brought to him."

3. Barr, *Fifty Years*, p. 273.

4. Unpublished etchings based on Delacroix's *Women of Algiers* and a linoleum cut after Manet's *Luncheon on the Grass* are the only clear-cut exceptions.

5. Preussischer Kulturbesitz, Staatliche Museum, Berlin.

6. Staatliche Kunstsammlungen, Weimar. Picasso's lithograph is titled *Young Girl Inspired by Cranach* (Mourlot, 176).

7. Germanisches National Museum, Munich. In May 1949 Picasso made three lithographs of the subject (Mourlot, 182–184) and an etching and aquatint (Bloch, 1835).

8. Kunsthistorisches Museum, Vienna. Picasso's print is titled *Bust of a Woman after Cranach the Younger* (Bloch, 859).

MIRROR AND CHERRIES
June 23, 1947
Oil on canvas, 23⅞ x 19⅝ inches
Signed lower left: "Picasso"; dated on stretcher "23 juin 47"
Provenance: Kootz Gallery, New York
Promised gift of Mr. and Mrs. William A. M. Burden,
  New York
Ill. p. 172

PREGNANT WOMAN
Vallauris, (1950)
Bronze; first version; cast number two of an edition of six,
  41¼ inches high
Provenance: Galerie Louise Leiris, Paris
Gift of Mrs. Bertram Smith, 1956
Acq. no. 271.56
Ill. p. 173.

1. Gilot and Lake, *Life with Picasso*, p. 295.

SHE-GOAT
Vallauris, (1950, cast 1952)
Bronze; after found objects; 46⅜ x 56⅜ x 27¾ inches
According to Daniel-Henry Kahnweiler, this is one of
  two casts of this version.
Provenance: Galerie Louise Leiris, Paris
Mrs. Simon Guggenheim Fund, 1959
Acq. no. 611.59
Ill. p. 174

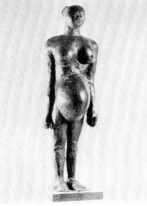

171. *Pregnant Woman*, second version, cast 1959

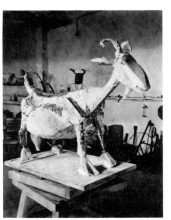

172. Plaster model for *She-Goat*, 1950

173. *Study for She-Goat*, 1950

BABOON AND YOUNG
Vallauris, 1951
Bronze; after found objects; cast number five of an edition
 of six, 21 x 13¼ x 20¾ inches
Dated on base: "1951"
Provenance: Galerie Louise Leiris, Paris
Mrs. Simon Guggenheim Fund, 1956
Acq. no. 196.56
Ill. p. 175

1. Picasso, who has had a monkey among his many other pets,
associated primates with scenes of family intimacy as early as
the Rose Period (Fig. 175).

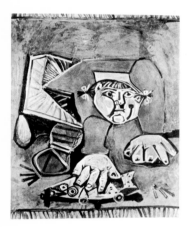

174. *Paloma Playing*, 1953

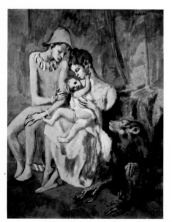

175. *The Acrobat's Family with a Monkey*, 1905. Konstmuseum,
Göteberg, Sweden

HEAD OF A WOMAN
Vallauris, (1951)
Bronze; cast number two of an edition of six,
 19⅞ x 8⅝ x 14½ inches
Provenance: Galerie Louise Leiris, Paris
Benjamin Scharps and David Scharps Fund, 1956
Acq. no. 273.56
Ill. p. 175

MOONLIGHT AT VALLAURIS
Vallauris, (1951)
Oil on plywood, 54 x 41¼ inches
Signed upper left: "Picasso"
Provenance: Galerie Louise Leiris, Paris;
 Justin K. Thannhauser, New York
Promised gift of Mrs. Werner E. Josten, New York
Ill. p. 176

GOAT, SKULL AND BOTTLE
(1951–52)
Painted bronze; one of three casts, unmarked, and
 each painted differently, 31 x 37⅝ x 21½ inches
Provenance: Galerie Louise Leiris, Paris
Mrs. Simon Guggenheim Fund, 1956
Acq. no. 272.56
Ill. p. 177

HEAD OF A FAUN
1956
Painting on tile, 8 x 8 inches
Signed on reverse: "Picasso/24.1/56 VI/6.2.56"
Provenance: Galerie Louise Leiris, Paris
Philip Johnson Fund, 1956
Acq. no. 275.56
Ill. p. 178

BEARDED FAUN
1956
Painting on tile, 8 x 8 inches
Signed on reverse: "Picasso/15.2.56/II"
Provenance: Galerie Louise Leiris, Paris
Philip Johnson Fund, 1956
Acq. no. 274.56
Ill. p. 178

PLATE WITH STILL LIFE
(1954)
Modeled polychrome glazed ceramic, 14¾ x 12½ inches
Signed reverse before glazing: "Picasso"
Provenance: Saidenberg Gallery, New York
Gift of R. Thornton Wilson, 1967
Acq. no. 2511.67
Ill. p. 178

STUDIO IN A PAINTED FRAME
April 2, 1956
Oil on canvas, 35 x 45⅜ inches
Signed lower center: "Picasso"; dated on reverse: "2.4.56/II"
Provenance: Galerie Louise Leiris, Paris
Gift of Mr. and Mrs. Werner E. Josten, 1957
Acq. no. 29.57
Ill. p. 179

1. As quoted in a Museum of Modern Art press release, "Museum of Modern Art Acquires Recent Painting by Picasso" (August 11, 1957).

WOMAN BY A WINDOW
Cannes, June 11, 1956
Oil on canvas, 63¾ x 51¼ inches
Signed upper left: "Picasso"; dated on reverse: "11.6.56"
Provenance: Galerie Louise Leiris, Paris
Mrs. Simon Guggenheim Fund, 1957
Acq. no. 30.57
Ill. p. 181

1. Parmelin, Hélène, *Picasso dit . . .* (Paris: Gonthier, 1966), p. 80.

2. Richardson ("Picasso's Ateliers," p. 190) is "reminded—if anything to Picasso's advantage—of Matisse's *Portrait of Yvonne Landsberg* (Museum of Fine Arts, Philadelphia) of 1914."

177. *Woman in the Studio,* 1956

178. Notebook sketch, June 7, 1956

179. Notebook sketch, June 7, 1956

176. *Nude in a Rocking Chair,* 1956

180. Notebook sketch, June 7, 1956

245

181. Ingres, *Bain turc*, 1862. Louvre, Paris

**WOMAN IN AN ARMCHAIR**
Mougins, 1961–62
Oil on canvas, 63⅞ x 51⅛ inches
Signed upper right: "Picasso"; dated on reverse:
  "N.D. de Vie/13 . . . [illeg.] 12.61/1 14.15.16.17.18.19.
  20/21.22.23.24.25./26.27.28.29.30./1.1.62.2.3.4.5.6.10"
Provenance: Galerie Louise Leiris, Paris
Gift of David Rockefeller (the donor retaining a life
  interest), 1964
Acq. no. 329.64
Ill. p. 183

1. Richardson ("Picasso's Ateliers," p. 184) suggests a relationship between Picasso's increasing use of his studio as a subject in the late fifties and sixties and his consciousness of himself as *le roi des peintres*. The association of the studio with the court was probably one aspect of the motivation for the 1957 series after Velásquez' *Las Meninas*.

**FIGURES**
Mougins, March 9, March 14, March 15, 1967
Wash, brush, pen and ink, 19½ x 25½ inches (sight)
Signed upper left: "9.3.67/1/14.3.15.3/Picasso"
Provenance: Galerie Louise Leiris, Paris
Extended loan of the Joan and Lester Avnet Collection
Ill. p. 184

1. For reproductions of other works in this series, see Feld, Charles, *Picasso: His Recent Drawings, 1966–1968*, preface by René Char (New York: Harry N. Abrams, Inc., 1969).

**THE POOL**
Mougins, January 30, 1968
Pencil, 22¹³⁄₁₆ x 30¹¹⁄₁₆ inches
Signed upper left: "9.3.67/1/14.3.15.3/Picasso"
Provenance: Galerie Louise Leiris, Paris
Extended loan of the Joan and Lester Avnet Collection
Ill. p. 185

1. For other drawings directly related to this theme, see Feld, *Picasso: His Recent Drawings*, especially catalog nos. 344–353, 367, 369, 371.

PHOTOGRAPH CREDITS

Courtesy Mr. and Mrs. James Alsdorf, Chicago, 222 left middle; courtesy The Art Institute of Chicago, 164, 195 bottom; courtesy The Baltimore Museum of Art, Cone Collection, 192 left bottom; Copyright (1971) by The Barnes Foundation, 194 right top; Cecil Beaton (copy negative), 226 left middle; Rudolph Burkhardt, New York, 101; courtesy City Art Museum of St. Louis, 195 top; Robert Crandall Associates, Inc., New York, 32, 113; George Cserna, New York, 16 bottom, 17 top; Cyr Color Photo Agency, Wilton, Connecticut, 125; David Douglas Duncan (copy negative), 18; John Evans, Ottawa, 49, 73, 90; Thomas Feist, New York, 59, 107, 160; A. E. Gallatin, 228 middle; Alexander George, Pomona, New York, 17 bottom; David Gulick, courtesy Joseph Pulitzer, Jr., 205 top; Kempachiro Iwasaki, Fukuoka-shi, Japan, 27; courtesy Sidney Janis, 8; D.-H. Kahnweiler (copy negative), 202 right bottom, 207 middle; courtesy Konstmuseum, Göteborg, 244 top; courtesy Kunstmuseum, Basel, 195 middle; Galerie Louise Leiris, 204 bottom; Alexander Liberman, New York, frontispiece, 21; courtesy the Louvre, 233 bottom; James Mathews, New York, 38, 50, 54, 57, 75, 80, 81, 85, 89, 96, 124, 137, 162 left, 165, 167, 170 left, 178 bottom, 201 bottom, 202 right top, 204 top, 223 middle, 241 right bottom; Herbert Matter, New York, 61; courtesy The Metropolitan Museum of Art, 190 bottom, 239 left bottom; courtesy Musée de l'Homme, Paris, 208; courtesy Musée National d'Art Moderne, 219 left top; courtesy National Gallery of Art, Washington, D.C., 191 middle; Rolf Petersen, New York, 95, 234 middle; courtesy Philadelphia Museum of Art: A. E. Gallatin Collection, '52-61-103, photograph by A. I. Wyatt, 196 bottom, '50-1-1, 197 left, '52-61-104, 212 bottom, '52-61-96, 218 top; Jacqueline Roque Picasso, 24; Eric Pollitzer, New York, 183; Percy Rainford, New York, 231 fourth row, left; courtesy Hermann and Margrit Rupf Foundation, Kunstmuseum, Bern, and Permission A.D.A.G.P. 1971 by French Reproduction Rights Inc., 202 left bottom; Sandak, Inc., New York, 144; courtesy Mr. and Mrs. George E. Seligmann, 194 right bottom; courtesy State Pushkin Museum of Fine Arts, Moscow, 190 top; Walter Steinkopf, Berlin, 242; Adolph Studly, New York, 143; Soichi Sunami, New York, 14, 15, 16 top, 26, 28, 29, 33, 36, 43, 46, 53, 55, 58, 64, 65, 68, 71, 87, 92, 93, 103, 106, 108, 110, 116, 117, 118, 123, 126, 127, 132, 134, 136, 141, 149, 150, 151, 154, 162 right, 163, 170 right, 171, 173, 174, 175, 178 right top, 178 left top, 179, 189 top, 193 top, 193 bottom, 197 right, 207 bottom, 218 bottom, 222 right middle (courtesy Pierre Matisse Gallery), 222 bottom, 226 right middle, 226 bottom, 230 bottom, 231 second row, 237 top, 239 right top; Duane Suter, Baltimore, 35; Thannhauser Collection (by courtesy Thannhauser Foundation), 191 left bottom; Charles Uht, New York, 67, 147, 155, 161, 184, 185, 198 middle, 231 first row middle; Malcolm Varon, New York, 25, 31, 37, 39, 41, 45, 47, 60, 63, 69, 77, 78, 83, 87, 94, 99, 102, 105, 109, 111, 115, 119, 121, 129, 131, 133, 135, 139, 145, 153, 157, 159, 177, 181; John Webb, London, 194 left bottom; courtesy Worcester Art Museum, 192 top.

TRUSTEES OF THE MUSEUM OF MODERN ART

David Rockefeller, *Chairman of the Board*
Henry Allen Moe, *Vice Chairman*
John Hay Whitney, *Vice Chairman*
Gardner Cowles, *Vice Chairman*
William S. Paley, *President*
James Thrall Soby, *Vice President*
Mrs. Bliss Parkinson, *Vice President*
Willard C. Butcher, *Treasurer*
Robert O. Anderson
Mrs. Douglas Auchincloss
Walter Bareiss
Robert R. Barker
Alfred H. Barr, Jr.*
Mrs. Armand P. Bartos
William A. M. Burden
J. Frederic Byers III
Ivan Chermayeff
Dr. Mamie Phipps Clark
Mrs. W. Murray Crane*
John de Menil
Mrs. C. Douglas Dillon
Mrs. Edsel B. Ford
Gianluigi Gabetti
George Heard Hamilton
Wallace K. Harrison*
John B. Hightower
Mrs. Walter Hochschild*
James W. Husted*
Philip Johnson
Mrs. Frank Y. Larkin
Eric Larrabee
Gustave L. Levy
John L. Loeb
Ranald H. Macdonald*
Mrs. G. Macculloch Miller*
J. Irwin Miller
Mrs. Charles S. Payson*
Gifford Phillips
Mrs. John D. Rockefeller 3rd
Nelson A. Rockefeller
Mrs. Wolfgang Schoenborn
Mrs. Bertram Smith
Mrs. Alfred R. Stern
Mrs. Donald B. Straus
Walter N. Thayer
Edward M. M. Warburg*
Clifton R. Wharton, Jr.
Monroe Wheeler*

*Honorary Trustee for Life*

W9-BVS-970

ERIC HERSHBERG AND KEVIN W. MOORE: INTRODUCTION: PLACE, PERSPECTIVE AND POWER—INTERPRETING SEPTEMBER 11. ACHIN VANAIK: THE ETHICS AND EFFICACY OF POLITICAL TERRORISM. MAHMOOD MAMDANI: GOOD MUSLIM, BAD MUSLIM: A POLITICAL PERSPECTIVE ON CULTURE AND TERRORISM. LUIS RUBIO: TERRORISM AND FREEDOM: AN OUTSIDE VIEW. DIDIER BIGO: REASSURING AND PROTECTING: INTERNAL SECURITY IMPLICATIONS OF FRENCH PARTICIPATION IN THE COALITION AGAINST TERRORISM. WILLIAM WALLACE: LIVING WITH THE HEGEMON: EUROPEAN DILEMMAS. LUIZ CARLOS BRESSER PEREIRA: AFTER BALANCE-OF-POWERS DIPLOMACY, GLOBALIZATION'S POLITICS. KANISHKA JAYASURIYA: SEPTEMBER 11, SECURITY, AND THE NEW POSTLIBERAL POLITICS OF FEAR. KAMRAN ASDAR ALI: MISTAKE, FARCE, OR CALAMITY? PAKISTAN AND ITS TRYST WITH HISTORY. SAID AMIR ARJOMAND: CAN RATIONAL ANALYSIS BREAK A TABOO? A MIDDLE EASTERN PERSPECTIVE. FRANCISCO GUTIÉRREZ SANÍN, ERIC HERSHBERG, AND MONICA HIRST: CHANGE AND CONTINUITY IN HEMISPHERIC AFFAIRS: LATIN AMERICA AFTER SEPTEMBER 11. TARIQ MODOOD: MUSLIMS AND THE POLITICS OF MULTICULTURALISM IN BRITAIN. RIVA KASTORYANO: THE REACH OF TRANSNATIONALISM. WANG GUNGWU: STATE AND FAITH: SECULAR VALUES IN ASIA AND THE WEST.

ERIC HERSHBERG AND KEVIN W. MOORE: INTRODUCTION: PLACE, PERSPECTIVE AND POWER—INTERPRETING SEPTEMBER 11. ACHIN VANAIK: THE ETHICS AND EFFICACY OF POLITICAL TERRORISM. MAHMOOD MAMDANI: GOOD MUSLIM, BAD MUSLIM: A POLITICAL PERSPECTIVE ON CULTURE AND TERRORISM. LUIS RUBIO: TERRORISM AND FREEDOM: AN OUTSIDE VIEW. DIDIER BIGO: REASSURING AND PROTECTING: INTERNAL SECURITY IMPLICATIONS OF FRENCH PARTICIPATION IN THE COALITION AGAINST TERRORISM. WILLIAM WALLACE: LIVING WITH THE HEGEMON: EUROPEAN DILEMMAS. LUIZ CARLOS BRESSER PEREIRA: AFTER BALANCE-OF-POWERS DIPLOMACY, GLOBALIZATION'S POLITICS. KANISHKA JAYASURIYA: SEPTEMBER 11, SECURITY, AND THE NEW POSTLIBERAL POLITICS OF FEAR. KAMRAN ASDAR ALI: MISTAKE, FARCE, OR CALAMITY? PAKISTAN AND ITS TRYST WITH HISTORY. SAID AMIR ARJOMAND: CAN RATIONAL ANALYSIS BREAK A TABOO? A MIDDLE EASTERN PERSPECTIVE. FRANCISCO GUTIÉRREZ SANÍN, ERIC HERSHBERG, AND MONICA HIRST: CHANGE AND CONTINUITY IN HEMISPHERIC AFFAIRS: LATIN AMERICA AFTER SEPTEMBER 11. TARIQ MODOOD: MUSLIMS AND THE POLITICS OF MULTICULTURALISM IN BRITAIN. RIVA KASTORYANO: THE REACH OF TRANSNATIONALISM. WANG GUNGWU: STATE AND FAITH: SECULAR VALUES IN ASIA AND THE WEST. ERIC HERSHBERG AND KEVIN W. MOORE: INTRODUCTION: PLACE, PERSPECTIVE AND POWER—INTERPRETING SEPTEMBER 11. ACHIN VANAIK: THE ETHICS AND EFFICACY OF POLITICAL TERRORISM. MAHMOOD MAMDANI: GOOD MUSLIM, BAD MUSLIM: A POLITICAL PERSPECTIVE ON CULTURE AND TERRORISM. LUIS RUBIO: TERRORISM AND FREEDOM: AN OUTSIDE VIEW. DIDIER BIGO: REASSURING AND PROTECTING: INTERNAL SECURITY IMPLICATIONS OF FRENCH PARTICIPATION IN THE COALITION AGAINST TERRORISM. WILLIAM WALLACE: LIVING WITH THE HEGEMON: EUROPEAN DILEMMAS. LUIZ CARLOS BRESSER PEREIRA: AFTER BALANCE-OF-POWERS DIPLOMACY, GLOBALIZATION'S POLITICS. KANISHKA JAYASURIYA: SEPTEMBER 11, SECURITY, AND THE NEW POSTLIBERAL POLITICS OF FEAR. KAMRAN ASDAR ALI: MISTAKE, FARCE, OR CALAMITY?

# CRITICAL VIEWS OF
# SEPTEMBER 11

# CRITICAL VIEWS OF SEPTEMBER 11

## ANALYSES FROM AROUND THE WORLD

EDITED BY ERIC HERSHBERG AND
KEVIN W. MOORE

PROJECT COORDINATED BY THE
SOCIAL SCIENCE RESEARCH COUNCIL, NEW YORK

THE NEW PRESS
NEW YORK

© 2002 by the Social Science Research Council
All rights reserved.
No part of this book may be reproduced, in any form, without written permission
from the publisher.

Published in the United States by The New Press, New York, 2002
Distributed by W. W. Norton & Company, Inc., New York

ISBN 1-56584-771-7(pbk.)
CIP data available

The New Press was established in 1990 as a not-for-profit alternative to the large,
commercial publishing houses currently dominating the book publishing industry.
The New Press operates in the public interest rather than for private gain, and is committed
to publishing, in innovative ways, works of educational, cultural, and community value
that are often deemed insufficiently profitable.

The New Press, 450 West 41st Street, 6th floor, New York, NY 10036
www.thenewpress.com

Printed in Canada

2   4   6   8   10   9   7   5   3   1

# CONTENTS

## PART III. AFTERSHOCK(S): REGIONAL PERSPECTIVES

## PART IV. THE INTERSECTION OF RELIGION AND POLITICS

# ACKNOWLEDGMENTS

Preparation of an edited volume invariably entails contributions from many individuals whose names are not recorded in the table of contents but who nevertheless were essential to producing the book. That principle applies in this instance even more than is normally the case, since contributors were scattered around the world, our deadlines were tight, and we both found ourselves commuting between our office in New York and various other places. At the risk of overlooking someone whose name should be mentioned, we take this opportunity to recognize the intellectual, editorial, and administrative support of a number of people whose prodding, skills, and efficiency were absolutely essential to this endeavor.

Many of the chapters in this book are expanded versions of essays prepared for a Web site that the Social Science Research Council (SSRC) established soon after the September attacks in the United States. Our concern during those disorienting weeks was that the deluge of writings and statements purporting to address what had taken place and what to do about it would fail to convey insights that social scientists could supply if only they had a venue in which to do so. In hindsight, we believe this hunch was justified, and we are grateful to Andre Schiffrin and Marc Favreau at the New Press for their enthusiasm about expanding and honing a selection of those essays, along with some new contributions, in order to make available high-quality analyses of these issues. The contributors to the book made extraordinary adjustments in their duties and priorities in order to finish their chapters to meet an accelerated publishing schedule.

We are particularly indebted to a number of our colleagues at the SSRC who worked diligently to recruit authors to the Council's Web site and whose efforts allowed us to produce this book quickly. Using the bully pulpit provided by the SSRC presidency, Craig Calhoun was tireless in both of these regards. His engagement enriched and accelerated both the Web site and this book. Paul Price and Ashley Timmer were equally indefatigable, and helped to recruit to the Web site leading scholars who eventually contributed chapters to this book and to others that will be included in a series undertaken jointly by the Council and the New Press.

Marcial Godoy-Anatavia offered insightful comments and editorial suggestions in response to drafts of several chapters. Eve Duffy helped to shape the introductory chapter. Amy Withers provided editorial help, Mara Goldwyn assisted with formatting text, and Elissa Klein was extremely efficient in tracking down facts and references. Thorough and insightful copy editing by Kate Scott improved the manuscript significantly.

A special note of appreciation is due to Anne Lally, who worked with us on virtually all aspects of this project from its inception to the final assembly of the manuscript. In addition to offering her valuable substantive input, she helped to secure contributions from several authors, independently handled correspondence when one or both of us were beyond reach of e-mail, and coordinated production with staff at the New Press.

Finally, Kevin Moore would like to thank Judith Farquhar and the department of anthropology at the University of North Carolina, Chapel Hill, for their hospitality.

Eric Hershberg and Kevin W. Moore
New York City, February 22, 2002

# CRITICAL VIEWS OF SEPTEMBER 11

# INTRODUCTION: PLACE, PERSPECTIVE, AND POWER— INTERPRETING SEPTEMBER 11

## ERIC HERSHBERG AND KEVIN W. MOORE

During the weeks and months after September 11, commentators from across the political spectrum declared that the terrorist attacks marked a turning point in history. September 11 was unprecedented, of such magnitude and significance that it could only be compared to such events as the two world wars and the end of the Cold War. A book published before the year was out proclaimed that the world had entered an "Age of Terror."[1] September 11, it has been repeatedly asserted, was either the end or the beginning of something momentous—a watershed event of world-historical importance. What all such pronouncements have in common is the assumption that the United States is the epicenter of global transformation: if the United States would never be the same again after September 11, such reasoning implies, neither would the rest of the world. This line of thought bears examination, for it reveals crucial aspects of the events themselves, and of the diversity of responses that they have elicited, both inside the United States and beyond.

There is no disputing that the underlying significance of September 11 can only be comprehended when placed in its full context, yet the boundaries of that context are themselves hotly contested. For some observers, the frightening shock of that day is the consequence of actions taken by followers of a charismatic religious fanatic, Osama bin Laden, whose peculiar brand of Islamic fascism has taken hold of the imagination of a growing number of people exposed to his message of resentment in the streets and mosques of Muslim communities around the world. Failing to recognize the severity of the threat—or failing to suppress it sufficiently—Western governments and various states in the Middle East and South Asia are now paying the high price of inadequate vigilance, according to this interpretation.[2] Whether categorized as atrocious crimes or as politico-military acts, the attacks carried out by the hijackers, like those undertaken by bin Laden's associates over the past decade against a variety of U.S. targets in the Middle East and Africa, are in this view a matter calling for prosecution and eradication. The perpetrators must be sought out and eliminated, at which point the immediate problem (though not necessarily all possibilities of terrorism) will have been resolved.

One alternative perspective is also based on the conviction that the most immediate policy response to the September 11 attacks must be to eradicate bin Laden's network through improved policing. But it attributes the origins of his rise and appeal to the shortcomings of numerous political regimes in the Islamic world and/or to misguided foreign policies pursued by Western governments. For these observers, bin Laden is but a symptom of a deeper malaise affecting the Muslim world, and attenuation of this malaise is seen as a sine qua non for minimizing the likelihood of additional and perhaps even worse tragedies during the years to come. Of course, advocates of such positions differ notably in their identification of the relevant political problems at hand.[3] Frequent candidates for blame include the exclusionary and/or fundamentalist nature of the Saudi monarchy and similar (mostly oil-exporting) states in the Middle East, the shortsighted decision of the United States and its allies to arm religious extremists as part of their campaign against the Soviet occupation of Afghanistan, or the enduring conflict between Israel and the legitimate aspirations of the Palestinian people for a fully sovereign state of their own.

Still other observers of today's global landscape perceive September 11 as a different sort of wake-up call, one that interrogates fundamental underpinnings of the geopolitical and security order of the post–World War II period, particularly since the end of the Cold War. According to this view, the realist conception of international relations, which held that states should structure foreign policies and alliances on the basis of their power and influence relative to other states, must now give way to the realization that nonstate actors can wield power and inflict damage on a scale that was formerly the sole province of states.[4] These observers predict that U.S. unilateralism will necessarily yield to a more multilateral and cooperative foreign policy, even if, as is likely, U.S. military superiority remains unchallenged for the foreseeable future.

One can certainly make a compelling argument that the virtually unrivaled position of the United States in the international system of power and exchange is unique in world history. Since the collapse of the Soviet Union, the global reach and unilateral freedom of action of the lone remaining superpower has grown far beyond that of previous world powers. No Roman caesar or British monarch could have imagined the scope of U.S. influence. That this "empire" is not constituted in formally territorial terms in the manner of previous imperial systems—whether Greek, Roman, Byzantine, Ottoman, Spanish, Dutch, or British—diminishes neither the force of its military authority nor its economic and cultural influence. To say that the United States is an "imperial" power is not to take an ideological, polemical, or controversial position; it is simply to state a

fact. How one interprets this reality is an entirely different matter, however, and has everything to do with where one sits—politically and geographically.

The sheer facticity of American supremacy is impressive enough in its own right, but one of the things September 11 made clear is that the United States wields more than just historically unprecedented power. It is, after all, the "City on a Hill,"[5] and as such holds extraordinary symbolic significance; this is one reason why the attacks had such a profound emotional impact abroad. But this status is double-edged. Many people around the world look to the United States as a place where achievement trumps ascription, where religious and cultural diversity is tolerated, where economic opportunity is available to all, and where the positive achievements of modernity have reached their apogee. For others, however, the United States embodies the evils of globalization, the gross disparity in wealth and power between the West and the developing world, and the reckless use of military force. Surely we knew this already: around the world, McDonald's restaurants are routinely sacked when angry crowds gather to demonstrate against some perceived American wrong. But September 11 brought home with renewed force the importance of the United States as symbol. The World Trade Center and the Pentagon represented more than *American* economic and military dominance. They also symbolized the global economic, military, and cultural ascendancy of the West, and the comparative marginalization of much of the rest of the world. As the terrorists of September 11 knew and many others have since learned, to attack the symbols is to strike at the heart of power. Here again, brute geopolitical facts give way to questions of perspective, of interpretation, of geography—and of ideology. If one's geographic perspective is from the margins and one's interpretive schema reflects this position, how does one respond to Western preeminence differently than if one is at home in the core?

Just as the extraordinary violence of September 11 was interpreted in a few much-publicized instances as an appropriate and righteous response to the violence of American global supremacy, so too the sheer symbolic force of the attacks rivaled the symbolic stature of the targets. The United States was suddenly no longer invulnerable, its power no longer unassailable. One important lesson to be learned from this clash of symbols is that American "hegemony" has never been truly hegemonic. As William Wallace points out in his contribution to this volume, a crucial and usually overlooked aspect of hegemony is the element of *consent:* a hegemonic power maintains its position of dominance not simply by force but also by the willingness of those in subordinate positions to accept the hegemon's leadership. The German sociologist Max Weber called this aspect of rule "belief," and asked "upon what inner justifications and upon what external

means does domination rest?" [6] Without some element of consent, of belief—in other words, of legitimacy—hegemony can deteriorate into coercion and domination. The events and aftermath of September 11 graphically demonstrated that the U.S. position as the world's sole superpower hardly rests upon the consent of all of the world's countries and populations. The authors of most of the chapters in this volume attempt in various ways to address this crucial issue.

Even in the absence of legitimacy, the most common response to Western preeminence, at least at the level of international relations, is accommodation: most of the world has tried to come to terms, either willingly or grudgingly, with the contemporary global order. Especially since the end of the Cold War, many countries have had to adjust their economies and their political facades in order to satisfy the West and the international financial institutions that govern the world economy and control the flow of Western largesse. Accommodation, however, is no guarantee of success, as demonstrated by recent economic crises in countries from South Korea to Argentina. And of course some countries are so profoundly marginalized—their economies and their polities so completely undone—that accommodation is not an option. This is the case in most of sub-Saharan Africa and Central Asia, and much of the Middle East.

But the attacks of September 11 were not perpetrated by states disgruntled by their weakness vis-à-vis the West. Moreover, the small group of men who planned the attacks and flew the planes were not the products of refugee camps. To the contrary, they were the sons of relative privilege, well educated and widely traveled. Their worldviews, however, appear to have been shaped by a profound sense of powerlessness and resentment. Even if they acted as individuals or as isolated groups, these men and their actions cannot be disentangled from the broader configurations of international power touched upon above. For if September 11 was indeed a watershed of historical significance, if what happened in New York and Washington really did change the world, then we had best try to understand the international context in which the events took place. We should, furthermore, bring a diverse range of analyses to bear on the political, economic, and cultural factors which shaped that broad context.

This book is about September 11, but it is also about analytic perspective, about how the position one occupies in the world, geographically, ideologically, and/or interpretively, affects how one tries to make sense of what has happened. That the kinds of questions one asks upon being confronted with events of profound significance are influenced by perspective may seem an obvious or even trivial point, yet it deserves to be reiterated in the present context, when so many in the United States follow President Bush's lead in saying, "You're either with us or against us." This book offers a sampling of interpretations of contemporary

trends from leading intellectuals around the world, whose vision is shaped in part by the locations from which they live their lives and engage the world of scholarship and civic affairs. Obviously, neither geography nor ideology nor analytic method defines exclusively how one thinks about the world, but in this book we seek to illustrate how each of these dimensions matters. Our contributors span a range of academic disciplines, from anthropology, economics, and history to political science and sociology. The points they choose to emphasize as crucial are strikingly different, as are the historical and conceptual referents to which they turn in an effort to make sense of complex and troubling phenomena. This is as we intended: we did not aspire to present each and every view of the issues, from each and every place on the intellectual or geographic map, but we have endeavored to elicit contributions from a diverse group of leading scholars.[7]

## THEMATIC EMPHASES

An adequate assessment of the consequences of the changed reality for different parts of the world must encompass several interrelated but potentially distinguishable clusters of issues. Operating on multiple levels—global, regional, and national—these include security-related concerns, a variety of significant shifts in the landscapes of economies and polities across much of the globe, and the threat posed by terrorism to liberal democratic norms.

### SECURITY

Clearly, the security implications of September 11 include but go well beyond the increasingly assertive U.S. stance toward terrorists in the Middle East or Afghanistan, or toward those who seek to target Western interests. Indeed, a variety of global and regional security arrangements not directly related to the September attacks are being reshaped by responses to those attacks. The winds of change issue not only from the United States but also from other governments, as evidenced by India's renewed assertiveness in its tense relationship with Pakistan (particularly over Kashmir) and by the growing confidence of the Putin administration in Russia's ability to impose its objectives in Chechnya. As is typical of national security emergencies everywhere, in each of these cases decisiveness in the battle against external threats has become a more potent currency in domestic political affairs than was the case prior to September 11. The aggressive American response to the September attacks has lent a veneer of legitimacy to crackdowns on domestic "subversive" opponents both past and present. In China, for example, there have been signs of increased repression of secessionist Muslim groups in the western hinterlands.[8] Likewise, former Uruguayan military leaders have

reemerged after many years of silence to justify the repression carried out during the 1970s "dirty war" against internal opposition.

It is perhaps in part for this reason that six months after the attacks in the United States, the predominant trend in American policy is clearly in the direction of increasingly unilateral rather than multilateral approaches to conflict resolution and governance. American righteousness is affecting the international behavior not only of the United States itself, but of many of its allies as well. It is widely believed, for example, that the increasing polarization of the Israeli-Palestinian conflict owes much to the Sharon government's confidence that it can count on unambiguous support from Washington, regardless of European misgivings. Analogous cases are cropping up in such distant contexts as Colombia, as analyzed in Chapter 10 of this volume. Despite concerns among Colombia's neighbors and United Nations agencies, the beleaguered Pastrana government abandoned peace negotiations in February 2002 and resumed attacks against Colombian guerrillas. Pastrana's decision was triggered by a guerrilla kidnapping of a senator seized from a hijacked civilian airplane, and was consistent with growing antiguerrilla sentiment within Colombian public opinion, but it also reflected the preferences of his American allies.

The political fallout from post–September 11 American unilateralism is nowhere more apparent than in western Europe, where NATO, the world's preeminent multilateral military alliance, has been relegated to the shadows by American distaste for consultation. Indeed, the support of mainstream European politicians for U.S. policy in the months after September 11 masked potentially profound and long-term repercussions for both transatlantic relations and European politics, and was often at odds with European public opinion, which clearly differentiated between sympathy for the United States and criticism of its response in Afghanistan. In Britain, Tony Blair gambled his political future on unstinting support for American policy, for which he faced ferocious domestic criticism. In France, where even official support was somewhat more muted than elsewhere on the continent, responses to U.S. policy grew more strident as the war in Afghanistan progressed, and as the Bush administration kept upping the rhetorical ante.[9] And in Germany, the governing alliance between the Social Democrats and the Green Party was deeply shaken by disagreement about whether and to what extent Germany should support the war in Afghanistan, the conduct of which they would not be able to influence. For the traditionally anti-war Greens, most of whose legislators Chancellor Gerhardt Schröder ultimately pressured into supporting the American war campaign, a deep rift has opened between politicians and their electoral base, as a result of which the next federal

elections may see the Greens fall beneath the 5 percent threshold needed to gain parliamentary representation.

Over the medium term, however, many observers think that the Americans' need to secure allies in the war on terrorism is likely to encourage greater flexibility in Washington, and perhaps even a significant degree of multilateralism. Substantial concessions have been granted already to Pakistan, to cite but the most striking example, and it is reasonable to expect this sort of scenario to become more frequent over time. Further down the road, presumably with a different U.S. administration in office, it is conceivable that we will see a full-fledged shift toward multilateralism. Some of the key incentives for an eventual move in that direction are laid out by Luiz Carlos Bresser Pereira in his contribution to this volume (Chapter 6), which emphasizes the increasingly nonstate and transnational character of threats to security, as well as the imperative to reorient understandings of security to encompass social and economic as well as military factors.

Colombia is but one of numerous instances where the significance of the label "terrorist" has taken on renewed force in the aftermath of the September attacks. The boundaries between those whose grievances may be considered legitimate and those who must be neutralized at all costs have shifted accordingly in locations as distant as Kashmir and Northern Ireland, with long-term consequences that remain highly uncertain. Similarly, as U.S. officials, most notably President Bush himself, defined an increasingly broad range of threats as analogous to terrorism—in his State of the Union speech Bush referred to Iran, Iraq, and North Korea as an "axis of Evil" and accused these countries of undermining efforts to contain weapons of mass destruction—prospects diminished for avoiding open hostilities with numerous established governments with which the United States had until that point coexisted with varying degrees of discomfort.

That the terrorist label is not solely a matter of semantics is evident in the case of American intervention in the war against Islamic rebels in the Philippines. Jungle warfare between the Philippine state and guerrilla organizations has gone on intermittently for decades, but not since the late days of the Cold War has there been even a remote suggestion that it was appropriate for the U.S. government to become involved in such conflicts. That changed after September, and presumably not only in the Philippines but also in other faraway locations where proscribed Islamic organizations are said to make up part of the Al Qaeda network that carried out the September 11 attacks.

## GLOBALIZATION AND ECONOMIC DEVELOPMENT

The months that followed the terrorist attacks also triggered a series of important shifts in the economic landscape and, more generally, in the climate of debates concerning economic globalization. For the American public, a sharp (though brief) decline in stock markets and in the pace of economic activity reinforced a climate of pessimism about future prospects for growth. Reeling from the shock of the attacks themselves, Americans could no longer harbor any doubt that the boom years of the 1990s had ended.[10] October witnessed a sharp surge in unemployment, particularly in New York City and in the low-skill, underpaid segments of the labor market. The impact on hotel and restaurant workers reverberated far beyond the city, and indeed beyond the country's borders: many of those left jobless were undocumented migrants whose families had remained in their countries of origin, and who now needed to make do without the remittances to which they had grown accustomed.

As signs of deepening recession dampened U.S. confidence in the inexorable expansion of market capitalism, they also influenced perceptions around the world concerning the inevitability of continuing economic globalization. Ironically, evidence that supported many of the claims of globalization's skeptics—declining consumer and enterprise demand, rising unemployment and protectionism, decreasing flows of investment and trade—did not necessarily empower antiglobalization activists. For the latter, dramatic acts of protest against the symbols of worldwide capitalist domination became far riskier in the aftermath of the attacks on the World Trade Center. The biggest international news story during the summer of 2001 concerned the bloody July demonstrations in Genoa against globalization, which drew some 150,000 people. The absence of more than sporadic and peaceful demonstrations on the occasion of the World Economic Forum meetings in New York City six months later testified to how much had changed for globalization's foes, as well as for its champions.

Meanwhile, in Washington policy circles the attacks transformed debates on fundamental questions of domestic economic affairs. The partisan battle was no longer about how to spend the surplus, for the surplus was no more, and a bewildered nation was treated to a return of Reagan era military Keynesianism. Arriving in New York a week after the attacks, President Bush abandoned his anti–big government rhetoric, pledging to spend "as much as it takes" to rebuild the damaged city and coughing up an initial $20 billion, to the surprise of the state's two Democratic Senators.[11] The federal budget put forth for the coming fiscal year contained even greater increases for security-related expenditures than had been anticipated by the hawkish administration.[12]

Republican reticence about big government proved less intractable than one might have expected. Reacting to the prospect of widespread anthrax contamination, the Bush administration moved quickly to strongarm the multinational pharmaceutical company Bayer to slash prices of the antibiotic Cipro on the grounds that the United States faced a public health emergency. Yet, as Norman Girvan, the distinguished Caribbean economist, pointed out, how one interpreted the significance of this policy shift hinged on one's location in the world.[13] For him, as for many other developing country leaders, the contrast was with U.S. intransigence regarding price breaks on pharmaceutical products to treat devastating tropical diseases in countries that lacked resources to pay market prices. It turned out that some were more equal than others when it came to the inviolability of free market principles.

The willingness to suspend economic orthodoxy in the interest of the war against terrorism extended beyond the U.S. borders: billions of dollars of Pakistan's debt were rescheduled during the last months of 2001, and hundreds of millions more were simply forgiven. Of course, if in Islamabad it seemed that a new day had dawned—in the economy as well as in many other respects analyzed by Kamran Asdar Ali in Chapter 8—the picture changed in quite different ways in such places as Argentina, where security considerations were not in play. To be sure, the Washington consensus was never applied equally to all developing countries, but that longstanding practice was all the more evident in the wake of September 11: depending on where one stood, orthodoxy was being demanded with new vigor, or flexibility took on unprecedented dimensions.

Economic expectations and preferences were affected in other ways as well, as governments of developing countries recalculated—in different directions, depending on their geographic location and strategic significance to the alliance-building strategies of Western countries—expectations for economic growth and for flows of private capital and development assistance. Some observers speculated that proximity to developed-country markets would take on renewed significance in an international environment in which goods would physically cross borders less seamlessly than was the case prior to September 11. The notion that mobility would be constrained significantly in a new world order in which security is paramount directly undermines a fundamental pillar of the hyperflexible capitalism that advocates of globalization had deemed irreversible in light of technological, organizational, and political transformations of the late twentieth century. Ironically, if this scenario proved even partially plausible, history would conclude that the apogee of global capitalism had been brought to earth by an equally transnational antagonist. In this case the victors would be a small band of ideological extremists, similarly dispersed around the world and organized in

technologically enabled, virtually invisible networks, rather than the high-flying investors and traders who spearheaded the 1990s boom.[14]

## TERRORISM AND PUBLIC LIFE

Globalization is also about movements of people across borders, and one of the frightening aspects of the September 11 attacks was the ease with which the perpetrators had moved around the world during the years, months, and days leading up to their operation. Many of the hijackers had lived in the United States for long periods. This fact, combined with the Middle Eastern origins of the terrorists and a pervasive climate of fear in the United States after the attacks, led to an extraordinary and discriminatory use of law enforcement prerogative in rounding up "foreign" suspects, a move that to many observers seemed to undermine American standards of judicial fairness.[15] Others have asked whether the space of diversity and individual freedom that distinguishes liberal democracies from the values of their antagonists might not be reasonably contracted in the hopes of securing that space against terrorism.[16] How much tolerance can be allowed at this juncture, when fanatics who regard tolerance itself as an evil possess the means to inflict mass violence and are willing to deploy it against the liberal democracies in which they themselves often live? This raises a vexing problem: even if one accepts certain restrictions on the civil liberties of noncitizens, on the assumption that the threat is "external," what of "internal" enemies? Lest we forget, prior to September 11 the most lethal act of terrorism in U.S. history, the 1995 Oklahoma City bombing, was perpetrated by an American.[17] Sources of terror and violent extremism reside within as well as without. The logic of suspecting noncitizens of terrorist intentions implies that such a threat would disappear upon naturalization.

Even though it has become increasingly difficult to monitor and control flows of people across national borders, many countries nevertheless have reflexively sought to restrict these flows in the aftermath of the attacks. And as in the United States, some of these actions raise troubling questions. A powerful example of the backlash effects of the violence of September 11 on liberal democratic states can be found in Europe. Seyla Benhabib has argued that the manner in which liberal democracies deal with questions of immigration is a fundamental test of their core values, that these policies are the "pivotal social practices through which the normative complexities of human rights and sovereignty can be most acutely observed."[18] Prior to September 11, with some variation among states, European social policy and immigration statutes were arguably more inclusive than in any other part of the world; even Germany was making moves to liberalize its naturalization laws. Now, it seems, hopes for an inclusive form of transnational citi-

zenship are being dashed on the ground of rising popular fears and new restrictions on immigration. Extreme right-wing parties, which base their appeal in large part on anti-immigration rhetoric, are gaining in popularity throughout western Europe, even in the famously tolerant societies of Scandinavia and the Netherlands.[19] As with the other clusters of issues discussed above, existing trends were exacerbated after September. In Germany, for example, the notion that "foreigners" should accept the "leading ideas" of German culture (*Leitkultur*), a sentiment that was formerly expressed only on the fringes of political discourse, is now finding its way into respectable public discourse. Moreover, anti-immigrant polemics that before September 11 were limited primarily to extreme right-wing circles are now influencing policy formation, under the guise of combating terrorism.[20]

Some observers ask whether it might not be more productive to examine the norms of inclusion and their impact on public life in liberal democracies, as Tariq Modood does in Chapter 11, than to exclude from full incorporation into society persons and practices regarded as foreign. The ways in which religious diversity finds expression in the public sphere is a key indicator of how societies define themselves. We often speak of the "core values" of liberal democracies, one of which is secularism—the separation of religion from state functions, combined with private freedom of worship. One of the "core values" of Islam, in contrast, is the public and indeed state incorporation of faith. How can these two seemingly opposing standards coexist, particularly in multicultural societies? What, if any, modifications should be made to secularism in the West, given increasing religious diversity? Should Muslims who live in the West, for example, be forced to accept secular norms, or might a new form of secularism be instituted that is less hostile to political religion? These questions have become crucial, given the nature of the grievances that motivate bin Laden and his followers.

Modernity has long been equated directly with post-Enlightenment notions of secularism. It was also seen as culturally nonspecific: though a construct of the West, modernity, it has been supposed, would look largely the same wherever it occurred. Weber defined the modern state as binding together the principles of territoriality, a monopoly on military power, and the legitimate use of violence. Modernity, he argued, combines this aggrandizement of state power with a structural differentiation of society that separates religion from politics. When states fall apart, when the integrity of state functions decays (as has been the case in many parts of the developing world), these guiding principles of stateness no longer obtain. And in many of these decaying states, fundamentalist religious movements gain a foothold.

But the persistent penetration of the public sphere by religion even in nomi-

nally quite secular countries, such as the United States,[21] has precipitated a shift in interpretations of the relationship among modernity, religion, and politics. Secularization theory predicted that religion would become increasingly marginalized in society with the advance of modernity, but this theory has been called into question by the seemingly paradoxical fact that economic development and religious fundamentalism have been advancing hand in hand in much of the developing world. In parts of the "advanced" world, meanwhile, the religious right has gained ascendancy during the latest wave of globalization. Recent research (including that reported by Wang Gungwu in this volume) suggests, moreover, that neither modernity nor secularism is a uniform construct.[22]

All of these developments highlight the need to reexamine the animating principles of liberal democracies with an eye both to dealing with the very real threat that terrorism poses and to continuing to uphold the norms that have guided public life. It has been widely asserted since September 11 that the West is distinguished from those who revile and attack it by its embrace of tolerance and individual freedoms. This constitutes an ethic of public practice, the sternest tests of which come at times like these, when this ethic finds itself directly under attack.

## ORGANIZATION OF THE VOLUME

The thematic clusters sketched out above correspond loosely to the organization of the book. Part I is devoted to interpretations of the relationship between terrorism, security, and social values. Without diminishing the horrors of events in the United States last September, the chapters by Vanaik and Mamdani point to the all too frequent tendency of Western observers to overlook the waves of terror that have been visited on colonized people for decades, and that account in part for their sometimes jaded reaction to America's post–September 11 cries for exceptional sympathy. Indeed, the fact that terrorism is a routine aspect of life in many parts of the world is part of what leads to fundamentally different understandings of the world. Values of respect for human rights—particularly that most fundamental of human rights, the right to live (free from fear of sudden and arbitrary attack)—emerges for both Achin Vanaik and Mahmood Mamdani as a common ground in reading relationships between terror and security, wherever one happens to be looking.

Both contributors write from the perspective of the global South, and share an underlying premise that the United States has, through acts of both commission and omission, had a hand in creating the political and economic conditions that can nourish terrorism. Many American readers will be shocked by this un-

spectacular claim, though it is a common assumption in many parts of the world. It is a misreading to jump to the conclusion, as many commentators have done since September 11, that those who share this point of view "blame" the United States for what happened last September. What is at stake, rather, is coming to terms with the global context in which these attacks took place. Addressing the political and historical context, Mamdani argues that the presumed equivalence between Islam and terrorism that has been so prevalent in public discourse since September 2001 is based not only on an ethnocentric and polemical interpretation of religion, but also on a highly selective memory of the post–World War II history of terrorism. He reminds us that much of the terrorism of this period had nothing to do with religious, or "cultural," battles, and that the United States itself has supported terrorist political organizations in many parts of the world in an effort to further its strategic and political agenda. Vanaik, too, is concerned with terrorism as a political phenomenon, but suggests that we must understand its ethics and its efficacy, as well as apply strict limits to how we define it. Only by arriving at an evaluatively neutral definition that distinguishes the diverse political uses to which terrorism has been put, Vanaik says, can we begin to comprehend the "singularity" of September 11.

The question of human rights and their relationship to the changing security climate is a common theme of the contributions by Luis Rubio and Didier Bigo (discussed also by Kanishka Jayasuriya in Part II). Writing from Mexico and France, respectively, both authors consider it appropriate for Western allies to support the U.S. counterterrorism effort. However, they emphasize the need to continue to privilege civil liberties that, in Rubio's view, are precisely those features of Western civilization that the attackers are most determined to destroy and that must be protected if democratic societies are to emerge as the victors in the struggle against terrorism. The legacy of September 11, he argues, will be determined in large part by whether and how notions of democracy in the U.S. evolve as a result of the attacks. Echoing concern with these principles, Bigo notes that the presence of substantial Muslim minorities, citizens and noncitizens alike, in France and in Europe as a whole dictates that Western states exercise extreme caution in adopting measures that would single out such groups for repressive actions. He suggests that the United States, less accustomed than European countries to dealing with the real threat of terror on its soil, has exhibited signs of naiveté in its response to the attacks, both in exaggerating its capacity to do away with terrorism altogether and in downplaying the costs of combating it without adequate intelligence.[23] Security responses that are not appropriate to the actual danger faced, he argues, can be counterproductive, and have the potential to increase the public sense of insecurity.

Part II, addressing the changing configuration of the world after September 11, begins with a chapter by the British international relations scholar William Wallace, whose concerns about the temptation toward U.S. unilateralism resonate with those of his colleague across the Channel, Didier Bigo. Wallace does not question basic European solidarity with the United States, whether with regard to the attacks themselves, the need for a credible response to them, or the broader governance of the international order. But he is concerned that the more the United States opts to act on its own, the more fragile the European-American coalition will become. The grounds for potential dispute include the willingness or capacity of the United States to act as a genuine partner in a coalition with the Europeans, rather than play the role of unilateral sovereign imposing decisions on members of a bloc in which it seeks outright domination. Europe's dilemma, from this perspective, is how to calibrate the imperative for continued transatlantic cooperation in the economic realm against Europe's increasing uneasiness with the growing unilateralism of U.S. foreign policy. Wallace insists, however, that the future of the transatlantic alliance is not one in which Europe is the only partner that must make adjustments. The United States, too, must come to realize that its own economic and political interests, both within the alliance and beyond it, lie in cooperating with Europe in a "liberal democratic"–led world order.

For Luiz Carlos Bresser-Pereira, the long-term prospects for international cooperation are highly promising: absent an institutional environment conducive to transnational cooperation in the management of many sorts of issues, the process of economic globalization under way in recent decades would be imperiled. And, Bresser-Pereira points out, most of the developing world is as committed as are the Western powers to avoiding that outcome. He cautions, however, that for this global consensus to hold, markets must be governed and regulated: the possibility of economic development with justice operates simultaneously as a source of political legitimacy. These twin factors reinforce the need to develop new and predominantly nonstate mechanisms for articulating consensus around issues relating to the governance of global transactions and at the same time to strengthen existing international institutions. In this regard, while the "war against terrorism" in Afghanistan is an appropriate and legitimate response by the American state to an attack on its soil, Bresser-Pereira considers it an outlier in an environment in which states will have to give way increasingly to what he labels "globalization's politics." For Bresser-Pereira, as for several other contributors to the volume, the future international order ought to be defined by cooperation, with states articulating their concerns with others through the work of multilateral organizations and,

presumably, new transnational organizations of various kinds. Contributors vary, however, in their degree of confidence that such change is likely to come about.

Kanishka Jayasuriya engages several themes from Part I, especially the balance between security and liberty, but analyzes them in the context of an international order that he regards as excessively dominated by security concerns and by widespread fear of truly open political structures. This fear is pervasive, he claims, and global in its reach. Terrorists fear the contestation that is essential to liberal democracy, yet the Western response accelerates a process already apparent prior to September 11: we see restrictions being imposed, under the guise of security, on the civil liberties and free flow of ideas without which liberal democracies lose their core values. Even if extraordinary events do sometimes necessitate extraordinary responses, Jayasuriya argues, these conditions of "exception" must be carefully delimited and subject to the constraints of liberalism's key political institutions—legislative approval, judicial scrutiny, and public debate.

Part III contains three chapters in which the implications of September 11 are analyzed from various regional perspectives. We begin with the part of the world that was, along with the United States, most directly affected by the events, namely Afghanistan and Pakistan. It is worth noting that many estimates of Afghan civilian casualties since the U.S.-led bombing campaign began are now roughly the same as estimates of lives lost in the collapse of the Twin Towers and the attack on the Pentagon. The long-term impacts of this assault, on both Afghanistan and its neighbors (Iran, Uzbekistan, Tadjikistan, and especially Pakistan), will go a long way toward determining how this significant loss of life is remembered by historians and others.[24]

Kamran Asdar Ali provides a cogent assessment of the history of Pakistan's political and military place in the region. At least since the Afghan war against the Soviet Union, he demonstrates, Pakistan has been the key geopolitical player in the region, and a proxy for the United States in its Cold War efforts against the USSR. The Afghan-Soviet war and the American money that funded it, as both Ali and Mamdani document, created the mujahideen as a transnational fighting force; the war was both the political and the military launching pad for Osama bin Laden's jihad. September 2001 inaugurated another watershed moment in Pakistani history, in which the state once again faced an international environment that had the potential to redirect Pakistani domestic politics in constructive or pernicious directions. Ali's case study is a textbook example of how distant the effects of those airplanes have been.

For Said Amir Arjomand, who viewed the horror of the Trade Center collapse on a television screen in Beirut, that impact was also direct and enduring, and

was fundamentally shaped by his location. In the Middle East, the events of September 11 are seen through the prism of the Israeli-Palestinian conflict. Indeed, as Arjomand shows, since at least 1998 bin Laden has cited this conflict, and the American support for Israel that many Muslims think perpetuates it, as one of two central points that justify his "holy war" against the United States. The "taboo" referred to in the title of the chapter—"Can Rational Analysis Break a Taboo?"—is the unwillingness of virtually all politicians, policy makers, and members of the mainstream media in the United States to question the virtually unconditional support that the United States provides Israel, or to examine the role that support may have played in the events of September 11. Arjomand argues that neither the religious nor the nonreligious motivations of the terrorists can be comprehended without acknowledging the crucial importance of the Palestinian question. Nor, in his view, can the United States hope to win its "war" against terrorism without assessing the costs of its policies in Israel and elsewhere in the Middle East.

Finally, we shift our gaze beyond parts of the world conventionally thought of as directly touched by either the attacks themselves or the war against terror, and inquire into the consequences of September 11 for a variety of issues in contemporary Latin America. Francisco Gutiérrez Sanín, Eric Hershberg, and Monica Hirst make clear that the consequences of September are not entirely new, but rather have dovetailed with and intensified several trends that were already under way. In a part of the world where terrorism and counterterrorism have long been a part of everyday life, and where the effects of narcotics trafficking, political and economic instability, and U.S. intervention in intensely bloody conflicts have characterized the political landscape for decades, September 11 both complicates and exacerbates extant problems. In Chile, to cite the most powerful symbolic example, September 11 happens to be the highly charged anniversary of the U.S.-supported coup that overthrew the democratically elected government of Salvador Allende in 1973 and installed General Augusto Pinochet in power. Gutiérrez, Hershberg, and Hirst consider Colombia to be the Latin American country in which the stakes of September 11 may prove highest, and they devote a substantial portion of the chapter to assessing the pre– and post–September 11 situation in that beleaguered country.

The concluding section of the book directly engages concerns that have been touched on throughout earlier chapters, namely the relationship between religion and politics. Tariq Modood writes from Britain, where there is a large Muslim population and where the politics of Islam was a crucial public issue long before September 11. Modood argues that how societies nominally committed to political pluralism and racial, ethnic, and religious diversity deal with crises that

threaten these core principles is crucial for their identity. To assert, furthermore, that Muslims represent a culturally and politically "alien" presence in the West (as many commentators have since September 11, including some Muslims themselves) is not only to derogate liberal democracies' essential values, but also to ignore the central contribution that Muslims in Britain have made to the expansion and strengthening of those very ideals. Modood shows that Muslims have been at the center of efforts in Britain to redress "racial" and religious discrimination, to extend to Muslim schools the public funding that was already available to Christian and Jewish schools, and in general to give religious and other markers of cultural difference full expression in the public sphere. This positive role that Muslims have played in Britain, Modood concludes, can be extended in the effort to bridge the widening gap between the West and the Islamic world.

Riva Kastoryano also addresses the role Muslims play in European and international politics. Drawing on transnationalism, a key concept from contemporary social science work on immigration, she examines the network of social, economic, and political ties that Muslims in Europe have established at multiple levels: between countries in Europe, between these countries and the European Union, with their countries of origin, and with Islamic states in the Middle East and elsewhere in the Islamic world. The phenomenon of transnationalism, moreover, helps us understand networks such as Al Qaeda, which is constituted and operates across national borders, and takes advantage of the increasingly fluid structure of interstate relations in western Europe.

Finally, Wang Gungwu takes up the question of Islamic fundamentalism by way of a deep comparative historical analysis of the relationship between different forms of secularism, modernization, and political action. Many commentators, in both the West and the Islamic world, have argued that Islamic states have failed to modernize in part because they have failed to accept Western standards of secularism. This old and contentious debate has received renewed and wider attention since September 11. Yet, from his vantage point in East Asia, Wang suggests that all of the key terms deployed in the dispute, especially the word "secular" itself, are historically contingent and ideologically loaded. The West has no monopoly on secularism, which has a much longer history in China and South Asia. The highly charged contemporary relationship between Islam and the West, Wang argues, issues not only from enormous differences in power and wealth but also from the failure of the West to acknowledge that the form of secularism it is pushing on the developing world as a prerequisite for "modernization" is itself a form of fundamentalism and faith. In the Islamic world, the long history of opposition to Western notions of modernization and secularism has

recently found virulent forms of expression among extremists who have turned this disagreement into a holy war.

## CONCLUSION

Isolationism is a longstanding feature of American political culture, and contrary to conventional wisdom, and to many commentators assessing change during the initial year of the Bush administration, the projection of U.S. military power to faraway corners of the earth does not contradict the underlying impulse upon which isolationism depends. The September 11 terrorist attack provoked renewed U.S. awareness of the importance of the world beyond its borders, and indeed a willingness to attempt to influence events elsewhere, but it did not necessarily occasion fundamental reflection about the quality of American interactions abroad. The renewed emphasis on foreign policy has not been occasioned by concern about security in the world as a whole but rather by the understandable desire to achieve "homeland" security. A stance that appears proactive on the surface is thus fundamentally defensive in its underlying psychology, if not in its methods or consequences.

While this book is written primarily by analysts who are not from the United States, it aims to speak to debates that are very much about the ways in which the United States engages the world and the importance for humankind of the Americans' getting it right, as it were. One consequence of the enormous power wielded by the United States at this moment of world history is that the costs of its adopting fundamentalist postures, in Wang's sense of the term, are potentially enormous, even more so than was the case during the Cold War era.

The contributors to this volume come from many different places and perspectives, and their views do not always converge. But they share an aspiration for a less violent world, a world in which transnational communities can coexist peacefully, diverse religious and ethnic groups tolerate (and even learn from) one another, and individuals are protected and empowered by states, rather than oppressed by them. To forge such a world, Western powers will have to cooperate with one another, and they will have to do so in ways that take into account the impact of their actions on nations that lack the resources that historically have been associated with the capacity to influence events beyond their borders (and sometimes, within those very borders). They will also need to act judiciously, to avoid trampling on individual and collective rights, and indeed to recognize the legitimate aspirations of different peoples and states to seek their own paths. Consistent with the future envisioned by writers such as Bresser Pereira, they will

have to coalesce, however reluctantly, behind an international order in which "globalization's politics" can flourish.

The key question for our time is whether the United States will elect to pursue this course into the future, or whether instead it will in effect remain isolationist, focused on its own narrow interests even while it exercises influence over the life chances of peoples far beyond its borders. Contributors to this collection may differ in the degree to which they are hopeful about the American capacity to play this role—one that would be highly unusual for a superpower—yet if this book serves to foster reflexive debates within the United States, it will have made a minor contribution to that end. That is what we believe is needed in order to create the conditions for a substantial reduction in terror, wherever and however it might take place.

PART I

## TERRORISM, SECURITY, AND VALUES

# 1. THE ETHICS AND EFFICACY OF POLITICAL TERRORISM[1]

## ACHIN VANAIK

Terrorism has become a routine part of our era. But the events of September 11—the horrific terrorist assaults in New York and Washington—and the U.S. war on Afghanistan in its aftermath galvanized global public attention to such an extent that as social scientists we are compelled to reexamine the phenomenon of terrorism as such, and to disembed it from the highly charged atmosphere surrounding the events of that day. As one step in this direction, a clearer understanding of the ethics and efficacy of terrorism would be an important contribution to the public debate and to social science itself.[2]

The complexities and difficulties of understanding a phenomenon as multifaceted as terrorism, let alone of finding an adequate definition of it, are so great that without clear analytical boundaries one risks sinking into a morass of contradictions. As in the case of many other complex "cluster" concepts, it is better to delimit the terrain of one's investigation so as to maintain clarity in a restricted field, rather than risk confusion and uncertainty in a larger domain of inquiry.[3]

My approach is not concerned primarily with an etymological emphasis on the word "terror," with its connection to a psychological state of mind in the victim. Such is the main foundation for many provisional definitions of terrorism (I shall return to this below). I concentrate, rather, on a restricted notion of terrorist acts, and on the relationship between terrorism's *means* and its *agents,* namely, between violence and its perpetrators. Three additional elements of the analysis further delimit my focus. First, with respect to terrorist acts, I restrict myself to *political* terrorism, and exclude criminal terrorist behavior or what some might feel are expressions of "economic" terrorism. Second, within the sphere of political terrorist acts, I focus primarily on the "international" domain. (The distinction I make between domestic and international terrorism will be made clear in the course of the exposition.)[4] And third, with respect to perpetrators, I want to distinguish carefully between *state* and *nonstate* actors.

The difference between state and nonstate actors is so crucial, and state-perpetrated terrorism is so frequently overlooked, that it deserves close attention at the outset. Terrorism perpetrated by states as a matter of normalized rule is of an institutionalized type quite distinct from the noninstitutionalized form char-

acteristic of individual acts of terrorism. Any discussion of terrorist regimes, as compared to other agents of terrorism, must include an etymological focus on the word "terror" itself, precisely in order to draw attention to terrorism as something that causes and sustains psychological terror. This leads to a broader definition of terrorism than one used to assess those terrorist acts perpetrated by nonstate actors. One problem with too broad a definition of terrorist regimes, however, is that if "terror" itself is the main criterion, then one is unlikely to draw sufficient distinctions between democratic and undemocratic regimes or even between different kinds of authoritarian regimes.

All regimes invoke terror in one way or another. One could easily fall into the unhelpful ideological posture of labeling all regimes, states, or countries "terrorist."[5] Indeed, the sustainability, diversity of forms, and sheer scale of state terrorist acts and campaigns is qualitatively greater and more dangerous than that of substate actors. Culpable states include Pakistan (in Kashmir and Afghanistan), India (in Kashmir and the Northeast),[6] Russia (in Chechnya), China (in Tibet), Israel (in Palestine), Indonesia (in East Timor), and a host of others, with the United States itself being the worst offender. The American record here is simply awesome to contemplate, both in number of victims and scale. It includes the nuclear bombing of civilians in Hiroshima and Nagasaki, the use of chemical weapons in Vietnam, where the United States killed over 2 million civilians, and the use of sanctions since the Gulf War which have led to the deaths of 1.2 million Iraqis, of whom approximately 500,000 were children.[7] Given the prevalence of state-executed terror, I believe it is necessary to make a distinction between terrorist regimes and democratic ones. The latter, by this reckoning, are not terrorist governments or states, but they can and do carry out terrorist acts and campaigns internationally and at times domestically.

## TERRORISM AND ETHICS

At first glance, to speak of the ethics of a terrorist act might seem peculiar. Is not terrorism by its very nature ethically wrong? It seems to me that only if a terrorist act can be defined or understood in an evaluatively neutral way can there be a serious discussion of the ethics pertaining to it. There is much to be said, in fact, for just such a morally neutral definition of the terrorist act. The problems of a nonneutral definition are considerable. For example, the old saw about one person's terrorist being another person's freedom fighter is not without significant merit. How would we get out of this relativist trap? Did Bhagat Singh engage in a terrorist act or did he not?[8] Since so many Indians are justifiably proud of Bhagat

Singh, seeing him as a heroic revolutionary and martyr, the temptation would be strong for them to deny that he was a terrorist or that he engaged in what could legitimately be described as a terrorist act. However, this is a temptation that should, in my view, be resisted. It makes more sense to recognize and clearly identify certain behavior, including that of Bhagat Singh, as terrorist and yet nevertheless be prepared to defend it, even on moral grounds. To do this is precisely to enter the terrain of discourse about the ethics of terrorism or of the terrorist act.

Similarly, why should I or anyone else necessarily regard the assassination of President John F. Kennedy with moral shock or horror, rather than with justified indifference or even a certain relief, if not approval? What if one believes, by no means unreasonably, that all U.S. presidents since the Second World War have behaved like political criminals in their foreign policy and bear principal responsibility for events that in some cases (such as Vietnam) even reach the scale of being considered attempts at genocide? It does not, of course, follow that one is justified in condoning or applauding the assassination of Kennedy or the attempted assassination of Ronald Reagan. The conditions under which condoning or applauding such acts as morally legitimate are strict, and depend on whether one belongs to a society which is a direct victim of U.S. policy. Final moral judgment can also be influenced by the presence or absence in that society of other avenues for seeking justice. But the point is that there is a serious issue regarding the ethics of terrorism that is deserving of more thoughtful discussion.

Is it possible to have an evaluatively negative definition of terrorism and yet arrive at a judgment that certain terrorist acts could be deemed morally defensible? If so, exceptions might apply to certain acts of hostage taking where there are no eventual casualties or injuries, or of assassinations, provided the political consequences were extremely positive. Two examples that come to mind are the Officers' Plot to kill Hitler, and the Sandinista capture of the Somoza-dominated National Assembly in Nicaragua, when legislators were held hostage in 1978. The political consequences of the latter action were very positive indeed: no one was hurt, and the act marked the moment when the Sandinistas moved from being a guerrilla organization with some support to becoming a much more powerful force channeling mass support against the Somoza dictatorship, which collapsed within a year.

If it is possible to have an evaluatively negative definition and yet allow for a small number of exceptions, then such an approach would seem far superior to the effort to have an objectively neutral definition. This is because the vast majority of acts deemed terrorist are morally unjustifiable and our definition could be geared to accommodating this majority situation rather than having to gear it

to accommodate the small minority of exceptional cases. However, I have yet to be convinced that this intellectual approach is consistent and appropriate. I prefer to work toward an ethically neutral working definition of the terrorist act.

## DEFINING THE TERRORIST ACT

Perhaps the best way to begin the search for a proper definition of terrorism is to first be clear about how not to go about defining it. I started off by taking down all the dictionaries I had on my shelf and looking at their entries for "terrorism."[9] This was itself quite revealing. Two 1950s American dictionaries I had, *Webster's* and *Funk & Wagnall's,* clearly reflected the dominant Cold War perspectives then prevailing, and were written before the worldwide eruption of combat-group terrorist events from the sixties onward (combat group terrorism is distinct from state-sponsored terrorism, and is often directed at states; it is typically carried out by a dedicated group, in combat with a perceived enemy). Here, terrorism was defined with regimes in mind, specifically those of the "totalitarian" Soviet, Communist, and East Bloc, in implicit contrast to the democratic regimes of the United States and the West. Terrorism was defined as a negative form of governance or system of rule. My other dictionaries, one from the 1970s and the rest from the 1990s, British rather than American, did not have definitions of terrorism that linked it to any particular system of rule. Freer from Cold War reflexes, these definitions are broader in character, theoretically speaking, and are capable of being applied to any part of the world. But these definitions are, in fact, too broad.

Since any sensible definition of the terrorist act must link it to a notion of violence, defining the latter in an appropriate way also becomes necessary. If terrorism is to be linked to violence, it is important for our purposes not to use a notion of violence that is too broad. A broad definition can be appropriate in certain contexts where one may wish to address the violence of poverty, racism, or sexism, etc.—in other words, of injustice as itself a form of violence. But such a broad understanding is not helpful in the present context, where we wish to investigate the efficacy and ethics of terrorist acts. For our purposes a stricter definition of violence has to be used, namely, "the exercise of force such as to physically harm, injure, pain, or kill humans." Such a definition excludes damage to property and is independent of the ends or intentions or subjective perceptions of the agents of such violence. It is therefore an objective definition appropriate to the search for an ethically neutral and objective definition of terrorism itself.

Our perusal of dictionaries shows four approaches to a working definition, all

of which should be rejected. Terrorism is understood as having one or a number of the following characteristics: (1) organized intimidation; (2) violence against civilians or noncombatants; (3) indiscriminate use of violence; (4) illegitimate use of violence.

Each of these understandings carries grave problems. Intimidation is too loose and broad a concept. There are many forms of organized intimidation, including systems or structures of psychological intimidation of various degrees. Would these qualify as a form of terrorism? Terrorism need not only have civilians and noncombatants as targets. Terrorist acts can be inflicted on combatants as well. The 1985 assassination of General Vaidya in Pune in western India was still a terrorist act, in spite of Vaidya's military position.[10] Similarly, when indefensible or extremely disproportionate violence is used against opposing combatants, such as the use of nuclear or chemical or biological warfare, this too can count as terrorism. One does not have to go so far as to use weapons of mass destruction. Simply using tanks or bombers to destroy a militant hideout where the defenders are known to only have rifles can also count as an indefensible terrorist act. Furthermore, certain civilians such as presidents or prime ministers, given their own responsibilities for conducting warfare, can be seen with justice by the opposing side as legitimate targets for terrorist efforts at assassination.

As for terrorism being the indiscriminate use of violence, this fails to account for those terrorist acts that involve the very specific, indeed highly discriminate, use of violence, selective assassinations being the most obvious example.

Finally, assigning the label of terrorism only to those acts deemed illegitimate begs all questions about the legitimacy of the "officially" legitimate wielders of violence, namely, states.[11] Such an approach is far too narrow, for it definitionally excludes even the possibility of state terrorism. Given the prevalence not just of state-sponsored but also state-organized and state-executed terrorism, we must be wary of definitions in which such behavior is made unrecognizable as terrorism, and therefore remains unrecognized and unpunished.[12]

An appropriate and serviceable definition of the terrorism of a political act must possess the following properties: (1) it should be evaluatively neutral; (2) it should not be too broad or too narrow; (3) it should be objective. In regard to objectivity, the judgment of whether an act is terrorist or not should be made independent of, and without reference to, the motives or self-perceptions of the perpetrators. For example, the agents of state terrorism rarely see themselves as engaged in terrorist acts. Even the more open-minded and morally sensitive of state officials will concede only that the state (especially if it is a liberal democratic state) is sometimes guilty of unfortunate and condemnable "excesses" or human rights "abuses," but never of terrorism. Such a view would effectively ex-

culpate the liberal democratic state of the United States from the charge of nuclear terrorism in dropping bombs on the overwhelmingly civilian populations of Hiroshima and Nagasaki. The untenability of such an exculpation should be obvious. Once we arrive at a definition of terrorism that is balanced, neutral, and objective, we can more intelligently discuss its efficacy and ethics.

I propose the following as a working definition of the political terrorist act: "the calculated or premeditated use, or threat of use, of violence against an individual, group, or larger collectivity in such a manner that the target is rendered physically defenseless against that attack or against the effects of that violence." What makes this form of terrorism political, as distinguished from, say, criminal terrorism (i.e., murder), is that the act is harnessed to some political intent or purpose and carries a political meaning. The defenselessness can be the result of (1) surprise outside of a battle or war zone; (2) the nature of the target chosen, for example, its civilian status; (3) the nature of the weapons used; or (4) enormous disproportion in the violence exercised between the two sides even within a battle or war zone, in other words, a gross violation of the principle of *minimal or reasonable force*. The agents of the terrorist act can be individuals, combat groups, or larger entities like the apparatus of states.

## DOMESTIC AND INTERNATIONAL POLITICAL TERRORISM

Domestic political terrorism is easy to recognize. It is carried out by domestic agents for domestic purposes, such as the Oklahoma City bombing, or the Bader-Meinhof campaign of the 1970s. What about international political terrorism? Again, let us start off by pointing out what is not meant by this. The simple fact of outside support for domestic agents does not make an act one of international political terrorism. If the February 1993 bomb blasts in Bombay, for example, were the handiwork of an outside agency, say the Inter-Services Intelligence (ISI) of Pakistan, then this would be an example of international terrorism.[13] But if there was only ISI help for domestic agents perpetrating the act for domestic-related purposes, such as supposed retaliation for the police-abetted communal riots in Bombay in the aftermath of December 6, 1992, then this would not be a form of international terrorism. After all, one state can accept assistance from another and use it to carry out terrorist acts against its domestic population. Specific acts of brutality carried out within the context of American support for the Somoza or Pinochet regimes in Latin America, the Shah of Iran, or Mobutu in Zaire were nevertheless forms of domestic terrorism.

Nor do we mean by international political terrorism the mere fact that an act, such as the assassination of Kennedy, has international repercussions. Nor do we

mean the phenomenon of the increasing international spread of terrorism. Rather, the existence of any of the following properties defines an act of political terrorism as international: (1) It is carried out by "outside" actors owing allegiance to or residing in another country. (2) The cause to which the act is related is extra-national; the purpose is to reorder the existing international system of states, as, for example, in a war of national liberation. (3) The act is primarily directed against an external power or involves direct defiance of an external power or powers. This last category would apply to the 1986 U.S. bombing of Qaddafi's palace in Libya (in which his daughter was killed) in retaliation for his alleged role in the bombing of a German disco in which two U.S. servicemen were killed.[14] It would also apply to the famous 1979 U.S. hostage crisis in post-Shah Iran when revolutionary guards declaring allegiance to Ayatollah Khomeini captured the U.S. embassy and held its employees hostage; or the more recent hostage crisis involving the Japanese embassy in Peru.

Although the failure of any group to acknowledge responsibility for the September 11 attacks could suggest ambiguity about whether it constituted an international act according to the above conditions, it is difficult to see how it could have been motivated by anything other than an attempt to "punish" the United .States for its foreign policy behavior. The targets chosen symbolized U.S. military, political, and economic might. What evidence there is about those who boarded and hijacked the planes points to people of Saudi and Egyptian origin, none of whom were U.S. citizens. The properties outlined in points one and three above would seem to apply to the September 11 attacks.

Though not all forms of international political terrorism are linked to perceived "wars of liberation" (as perceived by one side), this is the most frequent connection. That is to say, international political terrorist acts are quite often connected to wars declared or undeclared, wars small or large, termed "wars of liberation" by one side and "counterinsurgency wars" by the other.[15] This connection provides important grounds for helping us to judge both the efficacy and the ethics of the international political terrorist act.

## THE EFFECTIVENESS OF INTERNATIONAL POLITICAL TERRORISM

To judge the effectiveness of terrorism generally is to ask and answer the question of how successful it is in helping to realize the cause or overall political goals to which a terrorist act is dedicated. This applies as much to evaluating an act of an insurgency combat group as it does to an act of the state committed to counterinsurgency operations. But important differences between state terrorism and

combat-group terrorism must be grasped.[16] International terrorism today is usually a form of warfare. Discussion of its efficacy must itself be located in a discussion of the nature of *modern* warfare, or, more precisely, how modern warfare differs from war in the past.

Throughout the twentieth century there was an inescapable trend toward the greater "democratization of war." Mass movements, popular guerrilla wars, and political and social revolutions emerged on a scale, depth, and frequency never seen before. Popular mass struggle, whether violent or nonviolent, became a crucial factor in shaping the politics of the twentieth century. It was reflected in decolonization, the rise and fall of Communist regimes, and the extraordinary defeats of militarily far more powerful opponents by those much weaker: the United States in Vietnam (1963–75) and the USSR in Afghanistan (1979–89).

What is relevant for our purposes about this "democratization" is not so much the greater extent to which there was citizen mobilization in the larger-scale wars of the twentieth century when compared to those of the eighteenth and nineteenth centuries, but that popular support for a war has become much more important. Popular perceptions about the role and aim of a war, its continuation, and the means to be used, all have much greater impact on the conduct of war and even on its political effects and outcome than was the case in the past. One important criterion for judging the effectiveness of a terrorist act related to a larger war, therefore, is whether or not it increases popular legitimacy or support for the war on the side of the perpetrators of the act or acts in question. Here the differences between state terrorism and the combat-group terrorism of its opponents become important.

State terrorism has little flexibility. It has one primary aim: to intimidate the opposition; to show, through promoting a fear of the consequences of fighting such a war, the *futility* of the cause to which its opponents are attached. State terrorism against an enemy force runs the risk of alienating the state's own popular base, but the state may be prepared to pay this price if it feels it has succeeded in getting its message of futility across. State terrorism is also relatively inflexible in that it must be directed primarily at the enemy population or armed rebels. The state must protect itself from accusations of inhumanity or lack of respect for the rights of its population. The more democratic the state in question is, the more worried it is likely to be about such accusations. It usually makes every effort to cover up such acts from domestic or foreign public scrutiny, to deny the existence of such acts, to minimize the degree to which human rights have been violated if such acts become public, or to attack the patriotic credentials of those who uncover or are horrified by the revelation of such acts. Such routine reflexes have, of

course, been very much in evidence in regard to the Indian state's reaction to critics of its human rights behavior in Kashmir and the Northeast.

The contrast with combat-group terrorism is striking. Such terrorism is politically aimed not only at the enemy government or strike force but also at its home population. The primary purpose of the terrorist act here is symbolic; the last thing the combat group wants is for the act not to be known to a wide public. In most cases the combat group or movement responsible for the act wants to make that responsibility publicly known. However, in some cases where the primary purpose is revenge and the perpetrators fear negative political repercussions—for example, a weakening or loss of legitimacy even among the home population—responsibility may not be acknowledged. This might well have been the case with regard to the assassination of Rajiv Gandhi and the behavior of the Liberation Tigers of Tamil Eelam (LTTE), if that group was responsible for the assault.[17] But as a general rule, combat group terrorism wants public awareness of its act because the act is aimed simultaneously at enhancing the legitimacy and support for its cause with the home population and demoralizing the enemy force and its popular support base.

Revolutionary Marxists have hit the nail on the head when they say such terrorist acts are "propaganda by the deed" or "reformism with a gun." The traditional Marxist critique of terrorism is not moral but rather tactical/strategic: terrorism is not, on balance, efficacious. Terrorism is condemned because it is seen as a substitution of individualist or small-group action for mass activity or for efforts to generate such mass activity. It is further condemned for being based on a false premise: that the assassination or elimination of supposedly key individuals can somehow bring about a dramatic transformation of the system or of a government's basic orientation or policies.[18]

The Marxist view, then, makes two claims concerning the ineffectiveness of terrorism: (1) terrorism is the politics of the weak; and (2) it perpetuates this weakness. However, this view is not fully correct and needs to be substantially qualified. Terrorism is often the weapon of the strong—of the strong counterinsurgency state. The stronger side can and does resort to terrorism although the weaker side is more likely to make terrorism a matter of strategy rather than just tactics. This does not, of course, preclude the stronger side from resorting to systematic and regularized terrorism.

One obvious but nonetheless very important distinction between state terrorism and combat-group terrorism is that the scale of terrorism perpetrated by the former can be, and often is, much greater than that perpetrated by the latter. Although the state has more powerful means for engaging in large-scale

terrorism, the issue of "availability of means" is not the primary reason why the scale of state terrorism is so much greater. The determining factor is, rather, the contrasting *ends* of states vis-à-vis those of other, much smaller, entities. For example, in spite of all the talk over the decades (talk that has become louder after the end of the Cold War and the breakup of the USSR) about the danger of combat-group nuclear terrorism, for decades the real danger has come from state actors. The sarin nerve gas attack by an esoteric Buddhist cult, the Aum Shinrikyo, on March 20, 1995, in a Tokyo subway was really the first time a terrorist group not connected to a state used a chemical agent, potentially a weapon of mass destruction.[19]

This act may turn out to be a historical marker. But there remains a lesson to be learned from the stubborn historical fact that as far as combat-group terrorism is concerned, even much more easily available capacities to cause mass destruction, such as poisoning a city's water supply, have not been exercised. This is in striking contrast to the scale of mass killings of civilians perpetrated by states, from the killing fields of Kampuchea to Hiroshima/Nagasaki to American saturation bombings and use of chemical warfare in Vietnam, or the chemical warfare in the war between Khomeini's Iran and Hussein's Iraq.

For the combat group the terrorist act is a dramatized statement of political intent or commitment and has a very specific purpose, such as release of prisoners or fulfillment of specific and limited demands. Therefore, there has to be a strong relationship of *proportionality* between the ends sought by that act and the means used in it. The act itself should not be of such a nature as to alienate popular home support or to rationalize or justify enemy-state retaliation against the combat group's home population on a scale involving thousands, let alone tens or hundreds of thousands. This is precisely what a terrorist act involving weapons of mass destruction would invite. In short, there is usually inherent in the very political character of combat-group terrorism a powerful factor of self-limitation regarding the means to be used. The main purpose behind the act is the symbolic impact it will have, not the material damage it will cause. Thus, it has never made sense for the combat group to even think of competing with states when it comes to upping the scale of destruction, either threatened or carried out.

This brings us to the nub of the issue. Only the pursuit of "grandiose" objectives can justify or rationalize the possession, use, or threat of use of "grandiose" means, like weapons of mass destruction, or justify large-scale killings in a single act. A struggle for national liberation, to which combat-group terrorism is often harnessed, is certainly a grand ultimate goal, but each particular act of terrorism has much more limited and specific objectives, even as it is part of the larger pur-

suit of the overall goal. Only states can convincingly claim to be pursuing grandiose objectives as a matter of *regularized actions.*

These can range from "defending national security," "defending the free world," "defeating world imperialism," "behaving like a world power," "shifting the balance of power in one's favor" by sending a political message to one's perceived rivals (almost certainly the main purpose behind the nuclear bombing of Hiroshima and Nagasaki), to whatever other grandiose aim the state sees as its cause, role, or responsibility. That so many people should not wish to face up to the potential and actual dangers of state terrorism and prefer to see the state as capable only of "excesses" represents a deep insensitivity to universalist and state-transcending principles of human rights.

But before more fully exploring the issue of ethics, we have still to dispose properly of the issue of efficacy. Contrary to the traditional Marxist claims about the inefficacy of combat-group terrorism, such acts can and have been politically effective. (This is also true of a great deal of state terrorism.) The Marxist failure to adequately factor in the dimension represented by the democratization of warfare leads to a characteristic underestimation of the importance of the symbolic dimension, and therefore of the potentials possessed by the terrorist act. The Marxist tradition simplifies the relationship between the generation of mass consciousness in the home population and the terrorist act as an external stimulus to it. It also underestimates the potentially demoralizing or delegitimizing impact a terrorist act can have on the direct enemy agency and its relationship to its own support base.

It also should be said that states, too, have learned something in the course of the history of modern counterinsurgency operations worldwide. States have become more intransigent when faced with terrorist demands. This seems particularly so in hostage scenarios where an attritional strategy of "waiting it out" is often seen as providing the best option available to the side (the state) opposing the hostage capture and authorized to negotiate with the captors. In short, most states have much greater resources than they previously had to deal with even strongly implanted and well-armed liberation movements, and though unable to inflict decisive defeats in the short or medium term, are more confident of success in the longer term through the pursuit of sustained attritional warfare.

From the late seventies onward, states began to engage in and learn from prolonged counterinsurgency operations. Usually, though not always, the passage of time and ensuing war weariness have a stronger negative effect on the more weakly armed side even when it enjoys deep and wide political support from its home population. This is true of the Naga struggle for independence in India's Northeast. It is a factor in the LTTE struggle in Sri Lanka for Tamil Eelam. This

general trend has also had its impact in diminishing the political value of the terrorist act when carried out by the combat group. This is not to say, however, that we have reached the stage where such acts are never or only rarely efficacious. Precisely because we live in an era of mass communications and in a context where popular perceptions have become more important than ever, the temptation to engage in symbolic politics or to pursue the "low-cost" and politically high impact of terrorism has become stronger. Terrorism is here to stay.

## THE SINGULARITY OF THE SEPTEMBER 11 ATTACKS

There is a marked singularity about the September 11 terrorist attacks that seems to overturn the relevance of the distinctions earlier made between combat group and state terrorism. In particular, there are the dimensions of unacknowledged responsibility, and of scale. Until September 11, 2001, one cannot think of a single terrorist act by a nonstate entity that had killed more than a few hundred people, and that was very rare. Here, in contrast, the scale of an act by a nonstate actor/agency (regardless of whether or not it had some state support or help) was comparable to acts of states in wartime. True, there have been acts and campaigns by states that easily dwarf the death toll of September 11. But outside of wartime contexts, and in terms of instantaneousness of damage caused by acts of terror, the scale of the attacks of September 11 was exceptional. Also, like the case of the assassination of Rajiv Gandhi by a human suicide bomber suspected to belong to the LTTE, here too, no one acknowledged responsibility for the attacks.[20] What conclusions should we draw about this break from the normal pattern of terrorist acts by nonstate actors?

The fact of nonacknowledgment suggests not merely a concern for avoiding specific and focused retribution but a confidence that acknowledgment was not necessary because the home constituency to which the act was addressed was large and wide enough that no overt signal through acknowledgment of the deed was required. That is to say, there was already a presumption that there existed such a widespread bitterness against the United States that there is already a huge and widely spread population, not congruent with any "national" population, real or aspiring, which will in some way judge the September 11 attacks as a form of punishment for presumed American iniquities against that home constituency. The scale of the attack is apparently connected to the much grander size of the anticipated home constituency that might applaud the attacks. Thus the goal of the September 11 attacks would appear to be much wider than has ever been the case for combat-group terrorist acts in the past. Here a blow was being struck not for some specific purpose related to some specific end, like na

tional liberation of a specific entity from a specific oppressor through an act of pressure, but rather for a more diffuse, general, and wide aim such as avenging a pan-Islamic community against a more general and sustained suffering on it imposed by the United States.

One can easily reject Samuel Huntington's clash of civilizations thesis for the false picture of the world it presents, yet still recognize that stoking pan-Islamic sentiments may well have been a crucial part of the September 11 perpetrators' motives. Precisely the approximation in magnitude of the goal to that of state terrorist acts—the "grandiosity" of the apparent political goals behind September 11—best explains the scale of the attacks. It also suggests that bitterness against the United States, especially since the emergence of its exceptional dominance after the end of the Cold War, now runs so deep that along with a sense of much greater frustration against the awesome power of an otherwise unrivaled United States, there is now a greater determination to impose a much higher scale of suffering on it.

It is as if deep frustration that the United States cannot be militarily weakened or even politically undermined through symbolic acts of defiance has promoted a desire and attempt to strike at its weakest point, its unguarded and unguardable civilian population and society, irrespective of how provocative this might be. In short, that sense of proportion commonly found in combat-group terrorist acts—the wish not to provoke the "enemy" into attacking with far greater might—has been lessened if not lost altogether. This would also mean that whereas earlier acts by combat groups were essentially symbolic and caused comparatively minor material damage, in the case of September 11 the dimension of planned material damage was a much more important factor in deciding the nature of the act.

It is still the case that nonstate terrorist actors from Ireland and Spain to those in Kashmir and Sri Lanka and elsewhere remain overwhelmingly within the classical pattern and do not seek to compete with states in the scale of damage caused by the terrorist act. But if there are now even one or a few nonstate agencies that do seek to break this mold, it would suggest that after September 11 a new threshold has been crossed that is a source of deep future worry (while it still does not alter the fact that state terrorism remains the single biggest component of the problem of global terrorism, something too easily forgotten otherwise). What do we now say about the possibility of not just states but at least a few nonstate actors using weapons of mass destruction or resorting to chemical, biological, and nuclear forms of attacks on enemy targets, territories, and populations?

Hitherto, most alarmists warning about the danger of nuclear terrorists have had combat groups in mind, not states. This attitude will be reinforced after Sep-

tember 11. But it is still an exaggerated alarmism that has three objective effects: (1) It helps to justify the possession of nuclear weapons by states, for example, to provide deterrence against such nonstate nuclear terrorism. (2) It diverts attention away from the behavior, attitudes, and thinking of state elites. The implicit assumption that such terrorists are frighteningly irresponsible when compared to those who run states or influence their policies is simply nonsense and is belied by all historical evidence. (3) It lets the concept of nuclear deterrence, as advocated, defended, or practiced by state elites, off the hook. Deterrence is simply a way of rationalizing the adoption of a fundamentally terrorist way of thinking about nuclear weapons. In spite of the changed circumstances and dangers we face after September 11, it is not some distinctive breed of footloose or insane nuclear terrorists that is the source of the greatest nuclear danger, but the routinized and disguised terrorism of deterrence thinking by otherwise ordinary, sane, humane, and ethical people.[21]

But having said all this, there still remains the question of how we now judge the possibilities of nuclear, chemical, or biological terrorist acts by nonstate actors. Technically, many barriers exist that make it extremely difficult for combat groups to handle such agents of destruction. Politically, there are various factors that promote self-limitation in such groups and individuals, as distinct from state actors. Nevertheless, we can no longer rule out with the same confidence or equanimity the possibility of such "grandiose" acts of terrorism in the future, such as the bombing or other destruction of a civilian nuclear energy plant.

## THE ETHICS OF INTERNATIONAL POLITICAL TERRORISM

We now move from the terrain of terrorism's efficacy to the troubling question of its ethics. Many of the arguments in this section will have general relevance; when discussing ethics for example, there is less need to make a distinction between international and domestic political terrorism. But focusing on international political terrorism does make matters a little easier since so much of this kind of terrorism is linked to wars of liberation. Insofar as domestic political terrorism can be linked to "righteous" revolutionary struggle to overthrow oppressive regimes, the present discussion of ethics would apply to these cases as well. Clearly, in talking of the ethics of such kinds of political terrorism we are operating on the terrain of the age-old discourse about the relationship between ends and means.[22]

To begin with, any possibility of claiming that a terrorist act is just and should therefore be supported must assume that the cause to which that act is harnessed is itself good and just. This is a necessary even if not a sufficient condition for one

to defend such an act. If the cause is itself not believed to be just, as one side will usually consider it not to be, then the act cannot be justified. The justice of using terrorist methods, therefore, is related to the justice or justness of the cause itself. Indeed, to rebel against an "unjust" system can itself be considered a fundamental right of the individual in the Lockean sense. But even when we accept this, it still doesn't answer the question of *how* to rebel.

There are two ways of ethically justifying all violence in the aid of a supposedly just cause. The first is to do so in the name of efficacy. Here the question of what means or methods to be used in pursuit of the given end is no longer a moral but a practical one. It is a question of effectiveness, of tactics and strategy. This is how revolutionaries usually rationalize the use of terrorist threats or acts of violence. Since the end striven for constitutes such a profound transformation of existing society and its values, including its moral ones, why then should the struggle against it be bound by such values, the revolutionary asks, especially when the enemy will not feel bound, even by existing values, in defense of its power? Of this last point there are many examples, but a particularly important one was the 1973 U.S.-supported military coup in Chile to overthrow the democratically elected Popular Unity government of Salvador Allende.

Chile had perhaps the longest history of representative democratic government of any Third World country. Nonetheless, although Allende's coalition was reelected in 1973 with a larger plurality of the popular vote than it had received in presidential elections three years earlier and had remained steadfast in its respect for constitutional rule, this did not prevent ruling classes that felt deeply threatened by his policies from resorting to the most brutal and undemocratic methods to overthrow him. Allende refused to listen to his own supporters who, in anticipation of the coup and in clear recognition of the turmoil in the country, were clamoring for arming the general civilian public to prevent the coup, which so many saw was coming.

The point is not a trivial one. It is what lies behind, for example, Malcolm X's famous dictum concerning the liberation of black people in the United States "by any means necessary." That is to say, such revolutionaries claim that their struggle to achieve a just end must by not be weakened by a renunciation, *in advance,* of certain means.

The second way of justifying all violence in the name of a just cause is by means of an approach that Barrington Moore has aptly called the "calculus of suffering." [23] Here the claim is that oppression can be so extreme that no amount of terrorism by the oppressed and suffering by the oppressor can change the overall balance sheet of suffering. In the remarkable film by Gilo Pontecorvo, *The Battle of Algiers,* this particular approach to justifying terrorist violence was

dramatized most effectively. The French authorities had captured one of the principal leaders of the FLN, Ahmed Ben M'Hidi, and were parading him in front of an international press conference. One reporter for a French newspaper said: If he thought the cause of Algerian independence was so just, then how could he justify placing home-made bombs in baskets, then in public places, which blew up innocent French women and children? M'Hidi replied that it was terrible that French women and children were killed in this way, but then went on to remind the reporter and the others at the press conference that French planes which flew over Algerian villages and dropped their bombs killed many, many more Algerian women and children. He exclaimed, "I tell you what! Give us your planes and we will give you our baskets."

However, neither of these two rationalizations—on the basis of efficacy or by a balance sheet of suffering—is fully acceptable. Each begs a crucial question: Can certain forms of violence ever be justified, including cruelty, torture, and the killing of children? Merely to ask the question should, one hopes, be enough to elicit the proper reply. No, it cannot. "By all means necessary" is an utterly unacceptable dictum. One must accept that there are some individual rights and social norms that are all but inviolable. Certain norms—no cruelty to children, no torture—are, if not absolute, nearly so. If we accept this, as we should, then it becomes possible to formulate general rules regarding the use of permissible or acceptable means in pursuit of just ends.

However, much discussion in India on the relationship between means and ends has been strongly influenced by the Gandhian tradition, whose approach has been insufficiently subtle, to say the least. Ends, we are repeatedly reminded, cannot justify means. Good ends cannot justify bad means. But another question is rarely if ever asked within the Gandhian tradition: Do means justify ends? Do good means justify bad ends? Does building schools and hospitals, for example, justify or even lessen the evil end of maintaining colonial rule?

The idea that means must prefigure ends has to be handled carefully. There is genuine merit in the view that the goodness or worth of the ends achieved bears some significant relationship to the integrity of means used in pursuit of those ends. But what is this relationship? To what extent can means prefigure ends? Any claim that means *must* prefigure ends, which is the basic thrust of the Gandhian approach, is ridiculously and unjustifiably rigid. For means cannot only reflect or presage their ends, they also unavoidably reflect their beginnings. Means are doubly determined by both their putative goals and their starting points, namely the extant conditions of injustice and suffering (in variable forms of brutality and repression) confronting victims. For example, in the struggle to overthrow slavery or fascism, to expect that the means used will not bear some definite rela-

tionship to the character and system of this repression is quite unrealistic. Such means can certainly differ significantly from those used to overthrow other kinds of oppression operating in much milder contexts of physical repression and brutality.

There is, however, another claim within the Gandhian tradition. Terrible or unacceptable means, it is argued, can negate or nullify ends. What are we to make of this line of argument? Clearly, it depends on what we mean by negating or nullifying ends. All too often this is misunderstood to mean that the very *justice* of the end sought can be negated or nullified by the injustice of the means used in its pursuit. However, the justice of a cause is never contingent on the means used in pursuit of that cause, but is determined independent of those means. This may be a trivial point of logic but it is surprising how often it is forgotten.

Nor does this mean that a sympathizer or supporter of that cause cannot condemn or oppose the use of a whole range of means. Of course, one can. But it is to insist that, for example, the justice of the Palestinian cause cannot be negated or nullified or even altered in any way by the iniquity of means, however terrible, that may be used in its pursuit. This does not mean, however, that the justice of that cause stands eternally. That justness is historically constituted and can therefore be historically altered in that it might no longer be a meaningful cause whose value must be adjudicated or placed on the political agenda. So it is historically and theoretically conceivable, for example, that at some future time, few Palestinians will remain concerned about securing a Palestinian nation.

If, however, by negating or nullifying one is suggesting that the *worth* of the achievement or of the realized form taken by the goal desired can be diminished or even fully nullified by the character of the means chosen to pursue it, then this is obviously correct. If the overthrow of South African apartheid had resulted in the institutionalization of, say, a reverse apartheid, then many would certainly question the value of the form that the final achievement—the goal of overthrowing apartheid—had taken. The value, many would feel, was significantly diminished even if not fully negated or nullified. Or, to take another example, the use of nuclear weapons against civilian populations in the service of some cause (e.g., the defeat of fascism) could nullify the value of that final achievement however just the goal and the struggle for it might be.

Any judgment of the possible indefensibility of the use of certain means is connected not so much to the concrete effect of those means on the form in which the just cause is realized, but on the grounds of other general principles, namely ethical principles concerning individual human rights. This is the basis of the well-known and very important distinction between the justice of a war and justice in the conduct of a war. Even if opposing sides cannot agree on the

justice of a particular war—for example, the Indian state and its supporters are not likely to accept the justice of the Naga struggle for independence—both sides can still accept the necessity of justice in the conduct of that war.[24] Thus there can be certain *rules of warfare* that pertain even to terrorist acts, and that can be accepted and respected by all.

Following Norman Geras, two such rules would seem to be particularly pertinent.[25]

## RULE 1

There has to be a distinction between legitimate and nonlegitimate targets. This does not have to correspond strictly to the distinction between civilians and noncivilians. Certain kinds of civilians, depending on the particular context, have real responsibility for the conduct of warfare on one side and from the perspective of the other side are entirely legitimate targets. There is, moreover, an unavoidable gray area: blowing up an ordnance factory can result in killing nearby civilians, but that does not mean the factory is not a legitimate target. Despite the inescapable generality of this rule, it can still serve as an important guideline to proper moral conduct. It is one thing to target, say, Golda Meir for assassination, or to target senior defense officials, or to attack a military or strategic installation. It is another thing altogether, and ethically unacceptable, to bomb a public space wherein ordinary Israeli citizens will be killed or injured. To take a different example, IRA public bombings that damage property and cause severe disruption in everyday life but are preceded by adequate warning to relevant British authorities to allow them to clear people from the targeted area need cause no serious moral dilemma or anguish to supporters of the Irish Republican cause.

## RULE 2

Even for legitimate targets there have to be rules for *how* they are attacked. Certain vital principles have to be respected. One is that only minimum or reasonable force be applied. You don't use a hammer to kill a fly. To put it another way, every effort must be made to avoid the imposition of gratuitous suffering. A serious and genuine commitment of this kind would outlaw torture, the infliction of humiliation, or the use of other unwarranted interrogation methods. There may be exceptional circumstances in which such restraint does not apply, but these are much more likely to be found in the abstract peregrinations of moral philosophers or in the fiction of films and books than in life. Forms of fairly brutal interrogation methods used by the police and army on captured suspects or militants or terrorists as a matter of routine are not justified by the argument that extraction of information from such captives is nec-

essary to preserve the larger good and the protection of the public over which the state exercises its sovereignty.

A second principle is that there has to be a distinction between the "combatant," who can be attacked, and the "person," whose rights have to be respected. One can attack a combatant, even kill him or her. In a combat situation one can hardly avoid this. But this does not give the right to calculatedly disfigure or maim an opponent. Moreover, once the situation changes and the status of the opponent is no longer that of combatant, then his or her new role must be recognized and the rights associated with that new role, or the rights associated with his or her being a "person," must be respected. Thus, prisoners have definite rights that must be fully respected.

Of course, these rules are general. They can hardly be expected to cover all contexts, contingencies, or situations. But they nonetheless provide real practical guidelines. When so much of current practice, even in democracies like India, constitutes a standing violation and contempt for even these very elementary principles, we will be accomplishing a great deal if we can generalize respect for such principles and institutionalize their practice regardless of whether our support and loyalty is extended to the combat group in question or to its opposing state or to other power structures.

## CONCLUSION

To arrive at an ethically neutral view that opposes international terrorism, regardless of the cause in whose name it is perpetrated, it is essential not only to adhere to the rules proposed above but also to be vigilant in identifying state-executed terrorism. Protective layers of state power and rhetoric too often make such acts unrecognizable. The double standards involved here are not only morally shameful but also politically counterproductive. They lead to more widespread bitterness and alienation, thereby reinforcing the appeal of those who, like bin Laden, claim that terrorism is the only effective form of political retribution against the strong, to whom, it would appear, uniform principles of international justice do not apply.

In this regard, a central issue that must not be avoided pertains to the nature of the U.S. military assault on Afghanistan. Is this a terrorist war of revenge and imperial expansion, as many a longstanding critic of U.S. foreign policy would aver, or is it a just war? In India, the United States, and elsewhere, many have argued that this is a just war. Certainly, the Western and Japanese media, and much of the media in India, have treated it as such. If this is accepted, it still does not mean the United States was not guilty of terrorist acts in Afghanistan. But the na-

ture of its culpability would be *qualitatively* diminished as compared to a situation where its claim of waging a just war is itself deemed false and unacceptable.

In the first case, the focus would shift to the issue of whether the United States, in waging this just war, was using just means, and was taking sufficient care not to cause suffering to "innocents" (i.e., civilians, but not Taliban soldiers, even if they had no connection whatsoever to the events of September 11). We have no consensually accepted account of casualties, civilian or military.[26] But the use of "daisy cutters," the most indiscriminate bombs in the conventional, non-nuclear arsenal, and cluster bombs and the fact that there were considerable civilian casualties and hardship to hundreds of thousands if not millions of refugees already in a pitiful condition would provide ammunition to those who believe there was a misuse of means, and that persistent aerial bombing in a country with no capacity whatsoever to resist such action is hardly the exercise of minimal, reasonable, or proportionate force.

There would, however, also be others who argue that in such a full-scale and justified war, civilian casualties were sufficiently restricted to warrant an overall balance-sheet assessment quite favorable to the United States, even with regard to the means used in pursuit of the war. The fact that a repressive Taliban regime was overthrown, to the approval of many or most Afghans, would be a consequence that is seen as reinforcing the U.S. case. Indeed, since Osama bin Laden has apparently escaped capture in spite of the U.S. war on Afghanistan, the primary justification given to the public for having dealt retributive justice for September 11 in this manner now rests on the fact that the Taliban has been overthrown and that Al Qaeda cells in Afghanistan have been eliminated or have shifted elsewhere. Others, of course, would see this outcome as the replacement of one ruthless and authoritarian regime by another regime, one comprising the forces of the Northern Alliance and others, that is also likely to be ruthless and authoritarian, based on a past record that is both better and worse than that of the Taliban.[27] They would also point out that the failure to capture the presumed perpetrator-in-chief, Osama bin Laden, despite the military assault, gravely weakens the consequentialist argument in favor of the war.

The United States declared it would make no distinction between suspected terrorists and the country that harbors them—an extraordinary claim not supported by international law. It also declared that the United States was henceforth engaged in a "war against global terrorism" that would last indefinitely. In short, the United States disregarded all existing international laws and norms. It declared what was, in effect, a unilateral right to define who "global terrorists" were or are, and to pursue them wherever they may be and in whatever manner the United States saw fit. The United States gave itself the right to attack any deemed

"enemy," which could be countries and regimes as well as groups or individuals, since no distinction was to be made between terrorists and countries or governments harboring them. Since this is a "war," any U.S. action in the future does not have to await the actual perpetration of a terrorist act, but can, as in any war, take the form of surprise and preemptive attacks on a continuous and repeated basis against any perceived enemy.

In short, the United States has not only demanded that its war on Afghanistan be considered just, but also that its declared "war on global terrorism"—the goals, forms, methods, targets, scale, and duration of which are all to be determined solely by the United States—be seen and endorsed as a just war. The political scope of this claim is nothing short of breathtaking, and all in the name of fighting a selectively defined terrorism. Both intellectual clarity and moral scrupulousness must now be regarded as vital inputs into the contemporary discourse on international terrorism. Without them, we risk either failing to understand or, worse, legitimizing global political projects whose purposes go well beyond the issue of how best to cope with the problem of terrorism.

# 2. GOOD MUSLIM, BAD MUSLIM: A POLITICAL PERSPECTIVE ON CULTURE AND TERRORISM

## MAHMOOD MAMDANI

Media interest in Islam exploded in the months after September 11. What, many asked, is the link between Islam and terrorism? This question has fueled a fresh round of culture talk—the predilection to define cultures according to their presumed "essential" characteristics, especially as regards politics. An earlier round of such discussion, associated with Samuel Huntington's widely cited but increasingly discredited *Clash of Civilizations*,[1] demonized Islam in its entirety. Its place has been taken by a modified line of argument: that the terrorist link is not with all of Islam, but with a very literal interpretation of it, one found in Wahhabi Islam.[2] First advanced by Stephen Schwartz in a lead article in the British weekly *The Spectator*,[3] this point of view went to the ludicrous extent of claiming that all suicide couriers (bombers or hijackers) are Wahhabi and warned that this version of Islam, historically dominant in Saudi Arabia, had been exported to both Afghanistan and the United States in recent decades. The argument was echoed widely in many circles, including the *New York Times*.[4]

Culture talk has turned religious experience into a political category. What went wrong with Muslim civilization, asks Bernard Lewis in a lead article in the *Atlantic Monthly*.[5] Democracy lags in the Muslim world, concludes a Freedom House study of political systems in the non-Western world.[6] The problem is larger than Islam, concludes Aryeh Neier, former president of Human Rights Watch and now head of the Soros-funded Open Society Foundation: it lies with tribalists and fundamentalists, contemporary counterparts of Nazis, who have identified modernism as their enemy.[7] Even the political leadership of the antiterrorism alliance, notably Tony Blair and George Bush, speaks of the need to distinguish good Muslims from bad Muslims. The implication is undisguised: whether in Afghanistan, Palestine, or Pakistan, Islam must be quarantined and the devil exorcized from it by a civil war between "good" Muslims and "bad" Muslims.

I want to suggest that we lift the quarantine for analytical purposes, and turn the cultural theory of politics on its head. This, I suggest, will help our query in at least two ways. First, it will have the advantage of deconstructing not just one protagonist in the contemporary contest—Islam—but also the other, the West.

My point goes beyond the simple but radical suggestion that if there are "good" Muslims and "bad" Muslims, there must also be "good" Westerners and "bad" Westerners. I intend to question the very tendency to read Islamist politics as an effect of Islamic civilization—whether good or bad—and Western power as an effect of Western civilization. Further, I shall suggest that both those politics and that power are born of an encounter, and neither can be understood in isolation, outside the history of that encounter.

Second, I hope to question the very premise of culture talk. This is the tendency to think of culture in political, and therefore territorial, terms. Political units (states) are territorial; culture is not. Contemporary Islam is a global civilization: fewer Muslims live in the Middle East than in Africa or in South and Southeast Asia. If we can think of Christianity and Judaism as global religions—with Middle Eastern origins but a historical flow and a contemporary constellation that cannot be made sense of in terms of state boundaries—then why not try to understand Islam too in historical and extraterritorial terms?[8] Does it really make sense to write political histories of Islam that read like political histories of geographies like the Middle East, and political histories of Middle Eastern states as if these were no more than the political history of Islam in the Middle East?

My own work leads me to trace the modern roots of culture talk to the colonial project known as indirect rule, and to question the claim that anticolonial political resistance really expresses a cultural lag and should be understood as a traditional cultural resistance to modernity.[9] This claim downplays the crucial encounter with colonial power which I think is central to the post–September 11 analytical predicament I described above. I find culture talk troubling for two reasons. On the one hand, cultural explanations of political outcomes tend to avoid *history* and issues. By equating political tendencies with entire communities defined in nonhistorical cultural terms, such explanations encourage collective discipline and punishment—a practice characteristic of colonial encounters. This line of reasoning equates terrorists with Muslims, justifies a punishing war against an entire country (Afghanistan), and ignores the recent history that shaped both the current Afghan context and the emergence of political Islam. On the other hand, culture talk tends to think of individuals from "traditional" cultures in authentic and original terms, as if their identities are shaped entirely by the supposedly unchanging culture into which they are born. In so doing, it dehistoricizes the construction of political identities.

Rather than see contemporary Islamic politics as the outcome of an archaic culture, I suggest we see neither culture nor politics as archaic, but both as very contemporary outcomes of equally contemporary conditions, relations, and conflicts. Instead of dismissing history and politics, as culture talk does, I suggest

we place cultural debates in historical and political contexts. Terrorism is not due to the residue of a premodern culture in modern politics. Rather, terrorism is a modern construction. Even when it harnesses one or another aspect of tradition and culture, the result is a modern ensemble at the service of a modern project.

## CULTURE TALK

Is our world really divided into the modern and premodern, such that the former makes culture and the latter is a prisoner of culture? This dichotomy is increasingly prevalent in Western discussions of relations with Muslim-majority countries. It presumes that in one part of the world (the one called *modern*), culture stands for creativity, for what being human is all about; while in the other part (the part labeled *premodern*), culture stands for habit, for some kind of instinctive activity whose rules are inscribed in early founding texts, usually religious, and mummified in early artifacts. When I read of Islam in the papers these days, I often feel I am reading of museumized peoples, of peoples who are said not to *make* culture, except at the beginning of creation, as some extraordinary, prophetic, act. After that, it seems that they—we Muslims—just *conform* to culture. Our culture seems to have no history, no politics, and no debates. It seems to have petrified into a lifeless custom. Even more, these people seem incapable of transforming their culture, the way they seem incapable of growing their own food. The implication is that their salvation lies, as always, in philanthropy, in being saved by agents from the outside.

If the premodern peoples are said to lack a creative capacity, they are conversely said to have an abundant capacity for destruction. This is surely why culture talk has become the stuff of front-page news stories. It is, after all, the reason, we are told, to give serious attention to culture. It is said that culture is now a matter of life and death. To one whose recent academic preoccupation has been the institutional legacy of colonialism, this kind of writing is deeply reminiscent of tracts from the history of modern colonization. This history assumes that people's public behavior, specifically their political behavior, can be read from their religion. But could it be that a person who takes his or her religion literally is a potential terrorist? And that only someone who thinks of a religious text as not literal, but as metaphorical or figurative, is better suited to civic life and the tolerance it calls for? How, one may ask, does the literal reading of sacred texts translate into hijacking, murder, and terrorism?

Some may object that I am presenting a caricature of what we read in the press. After all, is there not less talk about the clash of civilizations, and more about the clash inside Islamic civilization? Is that not the point of the articles I re-

ferred to above? After all, we are now told to distinguish between *good Muslims* and *bad Muslims.* Mind you, not between good and bad persons, nor between criminals and civic citizens, who both happen to be Muslims, but between good Muslims and bad Muslims. We are told that there is a fault line running through Islam, a line that divides moderate Islam, called genuine Islam, from extremist political Islam. The terrorists of September 11, we are told, did not just hijack planes; they also hijacked Islam, meaning "genuine" Islam!

I would like to offer another version of the argument that the clash is inside—not between—civilizations. The synthesis is my own, but no strand in the argument is fabricated. I rather think of this synthesis as an enlightened version, because it does not speak only of the other, but also of self. It has little trace of ethnocentrism. This is how it goes. Islam and Christianity have in common a deeply messianic orientation, a sense of mission to civilize the world. Each is convinced that it possesses the sole truth, that the world beyond is a sea of ignorance that needs to be redeemed.[10] In the modern age, this kind of conviction goes beyond the religious to the secular, beyond the domain of doctrine to that of politics. Yet even seemingly secular colonial notions such as that of "a civilizing mission"—or its more racialized version, "the white man's burden"—or the nineteenth-century American conviction of a "manifest destiny," have deep religious roots.

Like any living tradition, neither Islam nor Christianity is monolithic. Both harbor and indeed are propelled by diverse and contradictory tendencies. In both cultures, righteous notions have been the focus of prolonged debates. Even if you should claim to know what is good for humanity, how do you proceed? By persuasion or force? Do you convince others of the validity of your truth or do you proceed by imposing it on them? Is religion a matter of conviction or legislation? The first alternative gives you reason and evangelism; the second gives you the Crusades and jihad. Take the example of Islam and the notion of *jihad,* which, roughly translated, means "struggle." Scholars distinguish between two broad traditions of jihad: *jihad akbar* (the greater jihad) and *jihad asgar* (the lesser jihad). The greater jihad, it is said, is a struggle against weaknesses of self; it is about how to live and attain piety in a contaminated world. The lesser jihad, in contrast, is about self-preservation and self-defense; more externally directed, it is the source of Islamic notions of what Christians call a just war.[11]

Scholars of Islam have been at pains since September 11 to explain to a non-Muslim reading public that Islam has rules even for the conduct of war: for example, Talal Asad points out that the Hanbali school of law practiced by followers of Wahhabi Islam in Saudi Arabia outlaws the killing of innocents in war.[12] Historians of Islam have warned against a simple reading of Islamic practice from Is-

lamic doctrine: after all, coexistence and toleration have been the norm, rather than the exception, in the political history of Islam. More to the point, not only religious creeds like Islam and Christianity but also secular doctrines like liberalism and Marxism have had to face an ongoing contradiction between the impulse to universalism and respective traditions of tolerance and peaceful coexistence. The universalizing impulse gives us a fundamentalist orientation in doctrine, just as the tradition of tolerance makes for pluralism in practice and in doctrine.

Doctrinal tendencies aside, I remain deeply skeptical of the claim that we can read people's political behavior from their religion, or from their culture. Could it be true that an orthodox Muslim is a potential terrorist? Or, the same thing, that an Orthodox Jew or fundamentalist Christian is a potential terrorist and only a Reform Jew or a Christian who has converted to Darwinian evolutionary theory is capable of being tolerant of those who do not share his or her convictions?

I am aware that this does not exhaust the question of culture and politics. How do you make sense of politics that consciously wears the mantle of religion? Take, for example the politics of Osama bin Laden and Al Qaeda, both of whom claim to be waging a jihad, a just war against the enemies of Islam. To try to understand this uneasy relationship between politics and religion, I find it necessary not only to shift focus from doctrinal to historical Islam, from doctrine and culture to history and politics, but also to broaden the purview beyond Islam to include larger historical encounters, of which bin Laden and Al Qaeda have been one outcome.

## THE COLD WAR AFTER INDOCHINA

The late Pakistani scholar and journalist Eqbal Ahmad draws our attention to the television image from 1985 of Ronald Reagan inviting a group of turbaned men, all Afghani, all leaders of the mujahideen, to the White House lawn for an introduction to the media. "These gentlemen are the moral equivalents of America's Founding Fathers," said Reagan.[13] This was the moment when official America tried to harness one version of Islam in a struggle against the Soviet Union. Before exploring its politics, let me provide some historical background to the moment.

I was a young lecturer at the University of Dar-es-Salaam in Tanzania in 1975. It was a momentous year in the decolonization of the world as we knew it: 1975 was the year of American defeat in Indochina, as it was of the collapse of the last European empire in Africa, the Portuguese. In retrospect, it is clear that it was

also the year in which the center of gravity of the Cold War shifted from Southeast Asia to southern Africa. The strategic question was: Who would pick up the pieces of the Portuguese empire in Africa, the United States or the Soviet Union? As the focal point of the Cold War shifted, there was a corresponding shift in U.S. strategy, based on two key influences. First, the closing years of the Vietnam War saw the forging of a Nixon doctrine which held that "Asian boys must fight Asian wars." The Nixon doctrine was one lesson that America learned from the Vietnam debacle. Even if the hour was late to implement it in Indochina, the Nixon doctrine guided U.S. initiatives in southern Africa. In the post-Vietnam world, the United States looked for more than local proxies; it needed regional powers as junior partners. In southern Africa, that role was fulfilled by apartheid South Africa. Faced with the possibility of a decisive victory in Angola by the Popular Movement for the Liberation of Angola (MPLA),[14] the United States encouraged South Africa to intervene militarily. The result was a political debacle that was second only to the Bay of Pigs invasion of a decade before: no matter its military strength and geopolitical importance, apartheid South Africa was clearly a political liability for the United States. Second, the Angolan fiasco reinforced public resistance within the United States to further overseas Vietnam-type involvement. The clearest indication that popular pressures were finding expression among legislators was the 1975 Clark amendment, which outlawed covert aid to combatants in the ongoing Angolan civil war.

The Clark amendment was repealed at the start of Reagan's second term in 1985. In its decade-long existence it failed to forestall the Cold Warriors, who looked for ways to bypass legislative restrictions on the freedom of executive action. The CIA chief, William Casey, took the lead in orchestrating support for terrorist and proto-terrorist movements around the world—from the *contras* in Nicaragua to the mujahideen in Afghanistan, to RENAMO in Mozambique[15] and UNITA[16] in Angola—through third and fourth parties. Simply put, after the defeat in Vietnam and the Watergate scandal, official America decided to harness, and even to cultivate, terrorism in the struggle against regimes it considered pro-Soviet. The high point of the U.S. embrace of terrorism came with the *contras.* More than just tolerated and shielded, they were actively nurtured and directly assisted by Washington. But because the *contra* story is so well known, I will focus on the nearly forgotten story of U.S. support for terrorism in southern Africa to make my point.

South Africa became the Reagan administration's preferred partner for a policy of "constructive engagement," a term coined by Reagan's assistant secretary of state for Africa, Chester Crocker. The point of "constructive engagement" was to bring South Africa out of its political isolation and tap its military potential in

the war against militant—pro-Soviet—nationalism.[17] The effect of "constructive engagement" was to bring to southern African regional policy the sophistication of a blend of covert and overt operations: in Mozambique, for example, South Africa combined an official peace accord, the 1984 Nkomati Agreement, with continued clandestine material support for RENAMO terrorism.[18] Tragically, the United States entered the era of "constructive engagement" just as the South African military tightened its hold over government and shifted its regional policy from détente to "total onslaught."

I do not intend to explain the tragedy of Angola and Mozambique as the result of machinations by a single superpower. The Cold War was fought by two superpowers, and both subordinated local interests and consequences to global strategic considerations. Whether in Angola or in Mozambique, the Cold War interfaced with a civil war. An entire generation of African scholars has been preoccupied with understanding the relation between external and internal factors in the making of contemporary Africa and, in that context, the dynamic between the Cold War and the civil war in each case. My purpose is not to enter this broader debate. Here, my purpose is more modest. I am concerned not with the civil wars, but only the Cold War, and, furthermore, not with both adversaries in the Cold War, but only the United States. My limited purpose is to illuminate the context in which official America embraced terrorism as the United States prepared to bring the Cold War to a finish.

The partnership between official America and apartheid South Africa bolstered two key movements that used terror with abandon: RENAMO in Mozambique, and UNITA in Angola.[19] RENAMO was a terrorist outfit created by the Rhodesian army in the early 1970s and also patronized by the South African Defense Forces. UNITA was more of a *proto-terrorist* movement with a local base, though one not strong enough to have been able to survive the short bout of civil war in 1975 if it had not received sustained external assistance. UNITA was a contender for power, even if a weak one, while RENAMO was not—which is why the United States could never openly support this creation of Rhodesian and South African intelligence and military establishments. Because the 1975 debacle in Angola showed that South Africa could not be used as a direct link in U.S. assistance, and the Clark amendment barred U.S. covert aid in Angola, the CIA took the initiative to find fourth parties, such as Morocco, through which to train and support UNITA. Congressional testimony documented at least one instance of a $15 million payment to UNITA through Morocco in 1983. Jonas Savimbi, the UNITA chief, acknowledged the ineffectiveness of the Clark amendment when he told journalists, "A great country like the United States has other channels. . . . The Clark amendment means nothing."[20]

By any reckoning, the cost of terrorism in southern Africa was high. A State Department consultant who interviewed refugees and displaced persons concluded that RENAMO was responsible for 95 percent of instances of abuse of civilians in the war in Mozambique, including the murder of as many as 100,000 persons. A 1989 United Nations study estimated that Mozambique suffered an economic loss of approximately $15 billion between 1980 and 1988, a figure 5.5 times its 1988 GDP.[21] Africa Watch researchers documented UNITA strategies aimed at starving civilians in government-held areas, through a combination of direct attacks, kidnappings, and planting land mines on paths used by peasants. The extensive use of land mines put Angola in the ranks of the most mined countries in the world (alongside Afghanistan and Cambodia); currently the number of amputees is conservatively estimated at over 15,000. UNICEF calculated that 331,000 died of causes directly or indirectly related to the war. And the U.N. estimated the total loss to the Angolan economy from 1980 to 1988 at $30 billion, six times the 1988 GDP.[22]

The CIA and the Pentagon called terrorism by another name: "low-intensity conflict." Whatever the name, political terror brought a kind of war to Africa that the continent had never seen before. The hallmark of terror was that it targeted civilian life: blowing up infrastructure such as bridges and power stations, destroying health and educational centers, mining paths and fields. Terrorism distinguished itself from guerrilla war by making civilians its preferred target. If left-wing guerrillas claimed that they were like fish in water, right-wing terrorists were determined to drain the water, no matter what the cost to civilian life, so as to isolate the fish. What is now called collateral damage was not an unfortunate by-product of the war; it was the very point of terrorism.

Following the repeal of the Clark amendment at the start of Reagan's second term, the United States provided $13 million worth of "humanitarian aid" to UNITA, then $15 million of "military assistance." Even when South African assistance to UNITA dried up following the internal Angolan settlement in May 1991, the United States stepped up its assistance to UNITA in spite of the fact that the Cold War was over. The hope was that terrorism would deliver a political victory in Angola, as it had in Nicaragua. The logic was simple: the people would surely vote the terrorists into power if the level of collateral damage could be made unacceptably high.

Even after the Cold War, U.S. tolerance for terror remained high, both in Africa and beyond. The callousness of Western response to the 1994 genocide in Rwanda was no exception. Or consider what happened in Sierra Leone in the aftermath of January 6, 1999, when Revolutionary United Front (RUF) gunmen maimed and raped their way across Freetown, the capital, killing over 5,000

civilians in a day. The British and American response was to pressure the government to share power with RUF rebels.

## AFGHANISTAN: THE HIGH POINT IN THE COLD WAR

The shifting center of gravity of the Cold War was the major context in which Afghanistan policy was framed during the Reagan administration, but the Iranian revolution of 1979 was also a crucial factor. Ayatollah Khomeini anointed America as the "great Satan," and pro-American Islamic countries as "American Islam." Rather than address itself to specific sources of Iranian resentment against the United States, the Reagan administration resolved to expand the pro-American Islamic lobby in order to isolate Iran. The strategy was two-pronged. First, with respect to Afghanistan, it hoped to unite a billion Muslims worldwide around a holy war, a crusade, against the Soviet Union. I use the word "crusade," not "jihad," because only the notion of "crusade" can accurately convey the frame of mind in which this initiative was undertaken. Second, the Reagan administration hoped to turn a doctrinal difference inside Islam between minority Shia and majority Sunni into a political divide. It hoped thereby to contain the influence of the Iranian revolution as a minority Shia affair.

The plan went into high gear in 1986 when the CIA chief, William Casey, took three significant steps.[23] The first was to convince Congress to increase support for the anti-Soviet war in Afghanistan by providing the mujahideen with American advisers and American-made Stinger antiaircraft missiles to shoot down Soviet planes. The second was to expand the Islamic guerrilla war from Afghanistan into the Soviet republics of Tajikistan and Uzbekistan, a decision reversed when the Soviet Union threatened to attack Pakistan in retaliation. The third was to recruit radical Muslims from around the world to come and train in Pakistan and fight with the Afghan mujahideen. The Islamic world had not seen an armed jihad for centuries, but now the CIA was determined to create one, to put a version of tradition at the service of politics. Thus was the tradition of jihad—of a just war with a religious sanction—nonexistent in the last 400 years, revived with American help in the 1980s. In a 1990 radio interview, Eqbal Ahmad explained how "CIA agents began going all over the Muslim world recruiting people to fight."[24] Pervez Hoodbhoy recalled, "With Pakistan's Zia-ul-Haq as America's foremost ally, the CIA advertised for, and openly recruited, Islamic holy warriors from Egypt, Saudi Arabia, Sudan, and Algeria. Radical Islam went into overdrive as its superpower ally and mentor funneled support to the Mujahidin, and Ronald Reagan feted them on the lawn of the White House, lavishing praise on 'brave freedom fighters challenging the Evil Empire.' "[25]

This is the context in which an American-Saudi-Pakistani alliance was forged, and in which religious madrassahs were turned into political schools for training cadres. The CIA did not just fund the jihad; it also played "a key role in training the Mujahidin." [26] The point was to integrate guerrilla training with the teachings of Islam and thus create "Islamic guerrillas." The Indian journalist Dilip Hiro explained, "Predominant themes were that Islam was a complete sociopolitical ideology, that holy Islam was being violated by [the] atheistic Soviet troops, and that the Islamic people of Afghanistan should reassert their independence by overthrowing the leftist Afghan regime propped up by Moscow." [27]

The CIA looked for, but was unable to find, a Saudi prince to lead this crusade. It settled for the next best thing, the son of an illustrious family closely connected to the Saudi royal house. We need to remember that Osama bin Laden did not come from a backwater family steeped in premodernity, but from a cosmopolitan family. The bin Laden family is a patron of scholarship. It endows programs at universities like Harvard and Yale. Bin Laden was recruited with U.S. approval and at the highest level, by Prince Turki al-Faisal, then head of Saudi intelligence. [28] This is the context in which Osama bin Laden helped build, in 1986, the Khost tunnel complex deep under the mountains close to the Pakistani border, a complex the CIA funded as a major arms depot, as a training facility, and as a medical center for the mujahideen. It is also the context in which bin Laden set up, in 1989, Al Qaeda, or "military base," as a service center for Arab Afghans and their families. [29]

The idea of an Islamic global war was not a brainchild of bin Laden; the CIA and Pakistan's Inter-Services Intelligence (ISI) hoped to transform the Afghan jihad into a global war waged by Muslim states against the Soviet Union. Al Qaeda networks spread out beyond Afghanistan: to Chechnya and Kosovo,[30] to Algeria and Egypt, even as far as Indonesia. The numbers involved were impressive by any reckoning. Writing in *Foreign Affairs,* Ahmad Rashid estimated that 35,000 Muslim radicals from 40 Islamic countries joined Afghanistan's fight in the decade between 1982 and 1992. He added, "Tens of thousands more came to study in Pakistani madrasahs. Eventually more than 100,000 foreign Muslim radicals were directly influenced by the Afghan jihad." [31] The non-Afghani recruits were known as the Afghan-Arabs or, more specifically, as the Afghan-Algerians or the Afghan-Indonesians. The Afghan-Arabs constituted an elite force and received the most sophisticated training. [32] Fighters in the Peshawar-based Muslim "international brigade" received the relatively high salary of around $1,500 per month. [33] Except at the top leadership level, fighters had no direct contact with Washington; most communication was mediated through Pakistani intelligence services. [34]

The Afghan jihad was the largest covert operation in the history of the CIA. In fiscal year 1987 alone, according to one estimate, clandestine American military aid to the mujahideen amounted to $660 million—"more than the total of American aid to the contras in Nicaragua."[35] Apart from direct American funding, the CIA financed the war through the drug trade, just as it had in Nicaragua. The impact on Afghanistan and Pakistan was devastating. Prior to the Afghan jihad, there was no local production of heroin in Pakistan and Afghanistan; the production of opium (a very different drug than heroin) was directed to small regional markets. Michel Chossudovsky, professor of economics at the University of Ottawa, estimates that within only two years of the CIA's entry into the Afghan jihad, "the Pakistan-Afghanistan borderlands became the world's top heroin producer, supplying 60% of US demand."[36] The lever for expanding the drug trade was simple: as the jihad spread inside Afghanistan, the mujahideen required peasants to pay an opium tax. Instead of waging a war on drugs, the CIA turned the drug trade into a way of financing the Cold War. By the end of the anti-Soviet jihad, the Central Asian region produced 75 percent of world's opium, worth many billions of dollars in revenue.[37]

The effect on Pakistan, America's key ally in waging the Cold War in Central Asia, was devastating. To begin with, the increase in heroin production corresponded to an increase in local consumption, hardly an incidental relation: the U.N. Drug Control Program estimated that the heroin-addicted population in Pakistan went up from nearly zero in 1979 to 1.2 million by 1985, "a much steeper rise than in any [other] nation."[38] There were two other ways in which the Afghan jihad affected Pakistan. The first was its impact on Pakistan's military and intelligence services, which were key to giving the CIA an effective reach in Afghanistan and, more generally, in Soviet Central Asia. The more the anti-Soviet jihad grew, the more the intelligence services, particularly the ISI, moved to the center of governmental power in Pakistan. The Islamization of the anti-Soviet struggle both drew inspiration from and reinforced the Islamization of the Pakistani state under Zia.[39] Second, the more the Afghan jihad gathered momentum, the more it fed a regional offshoot, the Kashmiri jihad.[40] The jihadi organizations were so pivotal in the functioning of the Pakistani state by the time Zia died in 1988 that the trend to Islamization of the state continued with post-Zia governments. Hudud ordinances[41] and blasphemy laws remained in place. The Jameet-e-Ulema-Islam, a key party in the alliance that was the Afghan jihad, became a part of Benazir Bhutto's governing coalition in 1993.[42]

By now it should be clear that the CIA was key to forging the link between Islam and terror in Central Asia. The groups it trained and sponsored shared three characteristics: terror tactics, embrace of holy war, and the use of fighters

from across national borders. The consequences were evident in countries as diverse and far apart as Indonesia and Algeria. Today, the *laskar jihad* in Indonesia is reportedly led by a dozen commanders who fought in the Afghan jihad.[43] In Algeria, when it became evident that the Islamic Salvation Front (FIS) would win the 1991 election and it was prevented from taking power by the Algerian military, those in the political leadership of FIS who had pioneered the parliamentary road were eclipsed by those championing an armed jihad. The Algerian-Afghans, according to Martin Stone, "played an important role in the formation of the Islamic extremist groups of the post-Chadli crisis." Though their precise numbers are not known, Stone reports that "the Pakistani embassy in Algiers alone issued 2,800 visas to Algerian volunteers during the mid-1980s." One of the most important leaders of the Algerian-Afghans, Kamerredin Kherbane, went on to serve on the FIS's executive council in exile.[44]

The Cold War created a political schism in Islam. In contrast to radical Islamist social movements like the preelection FIS in Algeria or the earlier revolutionaries in Iran, the Cold War has given us a state-driven conservative version of political Islam in countries like Pakistan and Afghanistan. In an essay on September 11 titled "Neo-Fundamentalism," Olivier Roy has usefully contrasted these tendencies: radical political Islam as against conservative "neo-fundamentalism." Islamist social movements originated in the twentieth century in the face of imperial occupation; they aimed to rejuvenate Islam, not just as "a mere religion" but as "a political ideology which should be integrated into all aspects of society (politics, law, economy, social justice, foreign policy, etc.)."[45] Though it began by calling for the building of a supranational Muslim community (*umma*), radical Islamism adapted to the nation-state and sprouted different national versions of Islamism. This shift has been the most dramatic in movements such as the Lebanese Hezbollah, which has given up the idea of an Islamic state and entered the electoral process, and Hamas, whose critique of the PLO is that it has betrayed not Islam, but the Palestinian nation. Where they are allowed, these movements operate within legal frameworks. Though not necessarily democratic, they strengthen the conditions for democracy by expanding participation in the political process. In contrast, state-driven neofundamentalist movements share a conservative agenda. Politically, their objective is limited to implementing sharia (Islamic law). Socially, they share a conservatism evidenced by opposition to female presence in public life and a violent sectarianism (anti-Shia). Though originating in efforts by unpopular regimes to legitimize power, the history of neofundamentalist movements shows that these efforts have indeed backfired. Instead of developing national roots, neofundamentalism has turned supranational; uprooted,

its members have broken with ties of family and country of origin. According to Roy, "While Islamists do adapt to the nation-state, neo-fundamentalists embody the crisis of the nation-state. . . . This new brand of supra-national fundamentalism is more a product of contemporary globalization than the Islamic past."[46]

If the mujahideen and Al Qaeda were neofundamentalist products of the Cold War—trained, equipped, and financed by the CIA and its regional allies—the Taliban came out of the agony and the ashes of the war against the Soviet Union in Afghanistan. The Taliban was a movement born across the border in Pakistan at a time when the entire Afghan population had been displaced not once but many times over, and when no educated class to speak of was left in the country. *Talib* means "student" and the student movement, Taliban, was born of warfare stretching into decades. Its members were children born in cross-border refugee camps, orphans with no camaraderie but that with fellow male students in madrassahs, madrassahs that initially provided student recruits to defend the population—women and young boys—from the lust and the loot of mujahideen guerrillas. Born of a brutalized society, the Taliban was, tragically, to brutalize it further. An old man in a mosque in Kandahar, an architectural ruin that was once an ancient city of gardens and fountains and palaces, told Eqbal Ahmad, "They have grown in darkness amidst death. They are angry and ignorant, and hate all things that bring joy to life."[47]

Both those who see the Taliban as an Islamic movement and those who see it as a tribal (Pashtun) movement view it as a premodern residue in a modern world. But they miss the crucial point about the Taliban: even if it evokes premodernity in its particular language and specific practices, the Taliban is the result of an encounter of a premodern people with modern imperial power. Given to a highly decentralized and localized mode of life, the Afghani people have been subjected to two highly centralized state projects in the past few decades: first, Soviet-supported Marxism, then, CIA-supported Islamization.[48] When I asked two colleagues, one an Afghan and the other an American student of Afghanistan, how a movement that began in defense of women and youth could turn against both,[49] they asked me to consider this development in a triple context: the shift from the forced gender equity of the communists to the forced misogyny of the Taliban, the combination of traditional male seclusion of the madrassahs with the militarism of the jihadi training, and finally, the fear of Taliban leaders that their own members would succumb to rape, a practice for which the mujahideen were notorious.[50] True, the CIA did not create the Taliban. But the CIA did create the mujahideen and embraced both bin Laden and the Taliban as alternatives to secular nationalism. Just as, in another context, the Israeli intelli-

gence services allowed Hamas to operate unhindered during the first intifada— allowing it to open a university and bank accounts, and even possibly helping it with funding, hoping to set it off against the secular PLO—and reaped the whirlwind in the second intifada.[51]

My point is simple: Contemporary "fundamentalism" is a modern political project, not a traditional cultural leftover. To be sure, one can trace many of the elements in the present "fundamentalist" project—such as opium production, madrassahs, and the very notion of *jihad akbar*—to the era before modern colonization, just as one can identify forms of slavery prior to the era of merchant capitalism. And just as transatlantic slavery took a premodern institution and utilized it for purposes of capitalist accumulation—stretching its scale and brutality far beyond precapitalist practice or imagination—so Cold Warriors turned traditional institutions such as *jihad akbar* and madrassahs and traditional stimulants such as opium to modern political purposes on a scale previously unimagined, with devastating consequences. Opium, the madrassah, *jihad akbar*—all were reshaped as they were put into the service of a global American campaign against "the Evil Empire."

When the Soviet Union was defeated in Afghanistan, this new terror was unleashed on Afghani people in the name of liberation. Eqbal Ahmad observed that the Soviet withdrawal turned out to be a moment of truth, rather than victory, for the mujahideen.[52] As different factions of the mujahideen divided along regional (north vs. south), linguistic (Farsi vs. Pashto), doctrinal (Shia vs. Sunni) and even external (pro-Iran vs. pro-Saudi) lines, and fought each other, they shelled and destroyed their *own* cities with artillery. Precisely when they were ready to take power, the mujahideen lost the struggle for the hearts and minds of the people.[53]

## THE QUESTION OF RESPONSIBILITY

Who bears responsibility for the present situation? To understand this question, it will help to contrast two situations, that after the Second World War and that after the Cold War, and compare how the question of responsibility was understood and dealt with in two different contexts.

In spite of Pearl Harbor, World War II was fought in Europe and Asia, not in the United States. Europe, and not the United States, faced physical and civic destruction at the end of the war. The question of responsibility for postwar reconstruction arose as a political rather than a moral question. Its urgency was underlined by the changing political situation in Yugoslavia, Albania, and particularly Greece. This is the context in which the United States accepted responsibil-

ity for restoring conditions for decent civic life in non-Communist Europe. The resulting initiative was the Marshall Plan.

The Cold War was not fought in Europe, but in Southeast Asia, southern Africa, and Central and South America. Should we, ordinary humanity, hold the United States responsible for its actions during the Cold War? Should official America be held responsible for napalm bombing and spraying Agent Orange in Vietnam? Should it be held responsible for cultivating terrorist movements in southern Africa, Central America, and Central Asia? Official America's embrace of terrorism did not end with the Cold War. Right up to September 10, 2001, the United States and Britain compelled African countries to reconcile with terrorist movements. The demand was that governments must share power with terrorist organizations in the name of *reconciliation*—in Mozambique, Sierra Leone, and Angola. Reconciliation turned into a code word for impunity, disguising a strategy for undermining hard-won state independence. If terrorism was a Cold War brew, it turned into a local Angolan or Mozambican or Sierra Leonean brew after the Cold War. Whose responsibility is it? Are these countries hosting terrorism, or are they, like Afghanistan, also hostage to terrorism? I think both.

Perhaps no other society paid a higher price for the defeat of the Soviet Union than Afghanistan. Out of a population of roughly 20 million, a million died, another million and a half were maimed, and another 5 million became refugees. U.N. agencies estimate that nearly a million and a half have gone clinically insane as a consequence of decades of continuous war. Those who survived lived in the most land-mined country in the world.[54] Afghanistan was a brutalized society even before the present war began.

Official America has a habit of not taking responsibility for its own actions. Instead, it habitually looks for a high moral pretext for inaction. I was in Durban at the 2001 World Congress Against Racism when the United States walked out of it. The Durban conference was about major crimes of the past, such as racism and xenophobia. I returned from Durban to New York to hear Condeleeza Rice talk about the need to forget slavery because, she said, the pursuit of civilized life requires that we forget the past. It is true that unless we learn to forget, life will turn into revenge seeking. Each of us will have nothing to nurse but a catalogue of wrongs done to a long line of ancestors. But civilization cannot be built on just forgetting. We must not only learn to forget, we must also not forget to learn. We must also memorialize, particularly monumental crimes. America was built on two monumental crimes: the genocide of Native Americans and the enslavement of African Americans. The tendency of the United States is to memorialize other peoples' crimes but to forget its own—to seek a high moral ground as a pretext to ignore real issues.

## WHAT IS TO BE DONE

Several critics of the American bombing of Afghanistan have argued that terrorism should be dealt with like any criminal act. But if terrorism were simply an individual crime, it would not be a political problem. The distinction between political terror and crime is that the former makes an open claim for support. Unlike the criminal, the political terrorist is not easily deterred by punishment. Whatever we may think of their methods, terrorists have a cause, and a need to be heard. Notwithstanding Rushdie's claim that terrorists are nihilists who wrap themselves up in objectives, but have none, and so we must remorselessly attack them,[55] one needs to recognize that terrorism has no military solution. This is why the U.S. military establishment's bombing campaign in Afghanistan is more likely to be remembered as a combination of blood revenge and medieval-type exorcism than as a search for a solution to terrorism.

Bin Laden's strength does not lie in his religious message, but rather in his political one. Even a political child knows the answer to Bush's incredulous question, "Why do they hate us?" When it comes to the Middle East, we all know that the United States stands for cheap oil, and not free speech. The only way of isolating individual terrorists is to do so politically, by addressing the issues in which terrorists "wrap themselves up." Without addressing the issues, there is no way of shifting the terrain of conflict from the military to the political, and drying up support for political terror. If we focus on issues, it should be clear that September 11 would not have happened had the United States ended the Cold War with demilitarization and a peace bonus. The United States did not dismantle the global apparatus of empire at the end of the Cold War; instead, it concentrated on ensuring that hostile states, branded "rogue states," not acquire weapons of mass destruction. Similarly, the United States did not accept responsibility for the militarization of civilian and state life in regions where the Cold War was waged with devastating consequences, such as Southeast Asia, southern Africa, Central America, and Central Asia; instead, it just walked away.

In the first weeks after September 11, the leaders of the United States and Britain were at pains to confirm aloud that theirs was a war not against Islam, nor even just Islamic terror, but against terrorism. To be convincing, though, they will have to face up to the relationship between their own policies and contemporary terrorism. A useful starting point would be to recognize the failure of U.S. Iraq policy, give up a vendetta that refuses to distinguish between the Iraqi government and Iraqi people, and to pressure Israel to reverse its post-1967 occupation of Palestinian lands. It is the refusal to address issues that must count as the *first* major hurdle in our search for peace.

For their part, Muslims need to break out of the straightjacket of a victim's point of view. This too requires a historical consciousness, for at least two good reasons. One, only a historical consciousness can bring home to Muslims the fact that Islam is today the banner for diverse and contradictory political projects. Not only anti-imperialist Islamist movements but also imperialist projects, not only demands to extend participation in public life but also dictatorial agendas, carry the banner of Islam. The minimum prerequisite for political action today must be the capacity to tell one from the other. The second prerequisite for action is to recognize that just as Islam has changed and become more complex, so too has the configuration of modern society. More and more Muslims live in societies with non-Muslim majorities. Just as non-Muslim majority societies are called upon to realize an equal citizenship for all, regardless of cultural and religious differences, so Muslim-majority societies face the challenge of creating a single citizenship in the context of religious diversity. In matters of religion, says the Koran, there must be no compulsion. Islam can be more than a mere religion—indeed, a way of life—but the way of life does not have to be a compulsion. Islamist organizations will have to consider seriously the separation of the state from religion, notably as Hezbollah has in Lebanon. Instead of creating a national political Islam for each Muslim-majority state, the real challenge faced by Muslims is to shed the very notion of a nation-state. Whatever the terms of the nation-state—territorial or cultural, secular or religious—this political form exported by the modern West to the rest of the world is one part of Western modernity that needs to be rethought. The test of democracy in multireligious and multicultural societies is not simply to get the support of the majority, the nation, but to do so without losing the trust of the minority—so that both may belong to a single political community living by a single set of rules.

# 3. TERRORISM AND FREEDOM: AN OUTSIDE VIEW

## LUIS RUBIO

Nothing is more telling about the recent terrorist attacks in the United States than the nature of their targets. The Twin Towers in New York City represented the future, modernity, America's optimistic outlook on the world, and, more recently, globalization. The terrorist attacks constitute a direct hit against those values, which is the main reason why the whole Western world immediately rallied in support. But that is not the whole story. Certainly many people around the world outside the traditionally defined Western nations also showed profound consternation, but others clearly did not. Many citizens of Third World nations did not jump up in solidarity with America, and most of their governments, even when outwardly supportive, were less than wholeheartedly behind their words.

The purpose of this essay is to look into the rationale that lies in the minds of many of those peoples and governments. The idea is to create a framework that may help the reader understand another perspective on the events of September 11. This approach does not attempt to diminish the gravity of the attacks or in any way to justify them, but rather to analyze the nature of those responses and explore their meaning. Ultimately, only analysis and understanding can lead to knowledge and thus to better policy responses in the future.

Even if not directly affected by the attacks, most governments felt compelled to take a position on them. Some, like the Canadians, did not even blink. If anything, their complaints had to do with being taken for granted for help they were already giving anyway. Others strongly condemned the attacks, expressed deeply felt solidarity, and led major acts of support in their own nations, including stepped-up investigations of terrorist cells. Even while holding old grudges, most of the western European nations fell into this pattern, setting aside whatever differences they might have with the United States and recognizing what was at stake. Still others reacted strongly or less so, but largely paying lip service to the cause against a common international enemy, without giving too much weight to their response inside their societies. In some cases, public opinion, for or against supporting the United States, forced governments into action. Either way, the intellectual, political, and academic debate in many of those societies concentrated on three issues: the culprits, the more profound causes of the events, and the the-

ories and hypotheses that attempt to explain the complexity of present world reality as well as to propose alternative future scenarios.

Probably the most difficult thing to understand, but also, paradoxically, the most obvious, is that a terrorist is a profoundly rational individual. His or her motivation may be religious or political, ideological or metaphysical, but the terrorist act itself is profoundly rational. A terrorist uses an attack as a means to attain something else. A terrorist's strategy almost by definition involves the use of propaganda, which is further evidence of both its rationality and its political nature. For example, Osama bin Laden's Al Qaeda has made extremely effective use of various grievances that affect its main target audience: from resentment of dictatorships in various Islamic nations to the Arab-Israeli conflict. The political nature of terrorism further complicates matters, for one person's terrorist is often another person's freedom fighter. An individual who blows up a building in New Delhi on behalf of a Kashmir extremist group is a terrorist in India but a freedom fighter in Pakistan. Something similar but even more complicated happens when one enters Kurd territory: since Turkey is a NATO ally, a Kurdish saboteur is a terrorist when he or she attacks in Turkey, but his cousin is a freedom fighter when attempting to advance exactly the same cause in Iraq, an enemy of the West.[1]

If one accepts the premise that the attacks were planned and carried out by rational political actors, then it has to follow that the United States, and I would add the West in general, is confronting not a bunch of religious fanatics (even if many of their cohort could be so defined), but a well-developed organization that has global capabilities and enjoys extraordinary freedom of action. The literature on Mr. bin Laden and the Al Qaeda network is extensive.[2] It shows a pattern of organization, escalation, and learning that was clearly dismissed or misunderstood by U.S. and Western intelligence services over the past decade. Each one of their actions constituted a test of American capabilities, as well as of its responses. The evidence shows that there was much less learning on the American side than there was on the Al Qaeda side. This fact may well explain why the United States was caught so unprepared for the attacks.

The nature of the enemy that the United States began to seriously confront after September 11, 2001, was not well understood in the U.S., and much less so elsewhere in the world. In fact, even many of the nations that immediately and wholeheartedly jumped in solidarity with the United States seriously doubted the assertion that the attacks had been carried out by such an organization. Discoveries of Al Qaeda cells in various European nations after September 11 attest to this fact: nobody was paying attention, or, at the very least, none of the Western governments recognized the nature of the Al Qaeda threat. This is why it is criti-

cal to understand not only the nature of the Al Qaeda network, but also the sentiment of support that existed elsewhere around the world when the attacks took place.

Seen from afar, many observers thought that the attacks, as bloody and heinous as they were, were justified. Their views ranged from the specific to the abstract, but all coincided in at least one factor: they manifested a profound resentment of, even hatred toward, the United States. These positions immediately led to a very peculiar form of moral relativism. Terrorism is to be condemned, many of them said, but sometimes it may be justified.

## GLOBALIZATION, MODERNITY, AND THE AMERICAN IMPERIUM

The first thing that was noticeable in the attacks was the symbolism of the chosen targets. Although the terrorists did not directly claim responsibility for their acts (even if further evidence left no doubt about their authorship), their actions and subsequent videotapes made clear they are against globalization and modernity and what they see as godlessness in the way that modern society (the archetype of which is undoubtedly the United States) has come about. It is not coincidental that the favorite targets of Hamas and other fundamentalist terrorists in the Middle East have not been religious schools, synagogues, or—what would be far more symbolic—settlements in the occupied territories, but shopping malls, discos, and fast-food outlets like McDonald's and Sbarros. Al Qaeda could find no better expression of globalization and modernity than New York City, the hub of worldwide finance, with its Twin Towers reaching for the sky.

This resentment of modernity and world integration resonates widely. One thing that has become quite obvious over the past several years is that the world has split, and not in the way many politicians and analysts of globalization had assumed, by means of an objective widening of the gap between rich and poor, but rather according to the *perceptions* of where modernity is going. One side emphasizes modernity's positive aspects while the other focuses on the increased exploitation of the poor by the wealthy and the destruction of traditional ways of living.

Hard evidence shows that globalization has opened up opportunities for development and growth throughout the world, creating vehicles for progress that were completely shut in the past. Peasants in Sri Lanka have dramatically improved their lot simply by having access to telephone lines that allow them to find out market prices for their crops. Producers of parts and workers at assembly lines in the Dominican Republic and Bangladesh have access to jobs that their

forefathers could never have imagined possible. Certainly, low wages run parallel to many of those jobs, but low wages are simply a reflection of extremely low levels of education, poor infrastructure, and the like. Many a nation, particularly in Southeast Asia, has recognized the challenge and the opportunity and turned modernization into a competitive advantage. For every argument about low wages there is an example of transformation: only forty years ago most Koreans were poorer than the average Bangladeshi.

But perceptions do not always match reality and realities don't necessarily alter perceptions. The rejection of progress as a good in and of itself is almost as old as history. Christopher Lasch, in *The True and Only Heaven: Progress and Its Critics,* made an exceptional assessment of how societies have perceived progress over time and how moral traditions have existed that do not embrace a vision of men and women released from outward constraints.[3] More recent studies have shown how views opposing modernity are advancing around the world. None of the authors of these studies has even imagined how deeply resentful many people are of progress, change, and world integration or, worse, about how far a few extremist radicals are willing to go to avert what they perceived to be a catastrophic demise of their civilization. But they do show a growing cleavage around the world. The titles of three such books speak for themselves: *One World: Ready or Not,* by William Greider;[4] *Jihad vs. McWorld,* by Benjamin Barber;[5] and *The Lexus and the Olive Tree,* by Thomas Friedman.[6]

It was modernity that was attacked by the Islamic radicals on September 11. Notwithstanding this, the debate in many intellectual and political circles took a different slant. Some thought that the Americans had earned the attacks because of their support of Israel or their indifference toward the plight of the Palestinians; another approach was that the events of September 11 were justified because America has sustained and continues to sustain illegitimate regimes all over the globe. From these perspectives, the other target of the attacks, the Pentagon, became as apt a symbol as the Twin Towers.

The peculiarity of the charges against the United States is that they don't match with either the way America normally behaves or with the way Americans see themselves. There can hardly be any question that the United States has often been an arrogant power, sometimes hypocritical and frequently unwise.[7] As *The Economist* argued, "America defends its interests, sometimes skillfully, sometimes clumsily, just as others countries do. Since power, like nature, abhors a vacuum, it seeps into places where disorder reigns."[8] What separates the United States from all previous major powers in history is that it is the least territorial and the most idealistic of them all. Americans see themselves as a benign power that seeks to keep order in a disordered world and are often embarrassed by the

use of power and, much more so, by the use of force; hardly the behavior that was the trademark of the Greek, Roman, British, or Soviet empires in their times. In stark contrast with those hegemons, Americans like to be loved as they project their power. There's no question Americans have an uphill selling job to do.

Lukewarm, even negative reactions in many places around the world are not difficult to fathom. For good or ill, American foreign policy has not done a good job in winning the hearts and minds of people at large. Also, expediency, particularly during the years of the Cold War, frequently meant supporting, and often sustaining, unpopular, illegitimate governments in power. It is easy to see this as a cause for resentment, as the sentiments of millions of Asians, Africans, and Latin Americans endlessly exhibit. But what the terrorist strikes showed was that some people go well beyond resentment. While many Latin Americans or Asians responded to the attacks by paying lip service to the United States and then going back to their business of criticizing it, the hatred shown in the attacks themselves is another story.

Anti-Americanism goes back a long way; it did not begin just before September 11. A hundred and fifty years ago, Pierre Buchez, a French socialist, said, "America is solidly organized egoism, it is evil made systematic and regular."[9] America's success, as well as the resulting hubris, has created a contemporary anti-Americanism driven by feelings of humiliation, worthlessness, and hopelessness in many places, particularly in Islamic nations. Nevertheless this deep anti-Americanism can only explain perceptions and attitudes, not terrorism.

The main difference between those who resent the United States and those who actually attacked it seems to involve the religious component. As the history of the Taliban shows in Afghanistan, the Islamic radicals merged politics and religion to an extent not seen in the West since the time of the Inquisition.[10] Religion and religious zealotry became the driving force of politics in a context in which the United States was reviled anyway: "From one end of the Arab world to the other, the drumbeats of anti-Americanism had been steady. . . . The American imperium in the Arab-Muslim world hatched a monster."[11] The growing politicization of Islam, directed particularly against the United States, is nothing new. Many Muslim and Arab governments, most of them semi-authoritarian in nature, have become promoters of a negative view of America in order to survive. In order to appease their populations and avoid the harsh issues raised by their authoritarian rule, many Arab governments have allowed the United States to become an icon of evil and its ills to become the only image of America those societies receive. Inevitably, not only the image but also perceptions of the United States end up being distorted. Furthermore, there has long been a noticeable split between moderate political leaders and radical citizens in several nations of that

region. Fundamentalist Islamic groups have plagued key countries for years, and their governments have catered to them. The United States cannot be perceived as an honest broker in the Middle East peace negotiations or as a liberal society when it is seen as sustaining illegitimate governments such as those, most prominently, of Egypt and Saudi Arabia. In accommodating internal opposition, Middle Eastern regimes sustained by Washington end up biting the hand of their benefactor.

## INTERPRETING HISTORY

Many have tried to explain these dynamics in a broad context. A massive study on fundamentalism carried out by the University of Chicago analyzed the broad currents that have led human society into fundamentalism—its sources, history, scope and impact—and offers an extraordinary perspective on fundamentalist movements, of which bin Laden's is only a recent example.[12] But closer to the subject of terrorism, over the past decade two American academics put forth their grand views of the future. In the 1989 article "The End of History?" Francis Fukuyama argued that the de facto American victory over the Soviet Union would end all ideological disputes and, thus, open up the world for a different kind of development.[13] The end of history was meant to be a metaphor for the beginning of an era free from major conflict, where the values of democracy and capitalism would reign. Fukuyama's argument, later expanded in book form, went further than the obvious: in a recent piece analyzing the events of September 11, he reminded us that he had "referred to the progress of mankind over the centuries toward modernity, characterized by institutions like liberal democracy and capitalism. . . . This evolutionary process did seem to be bringing ever larger parts of the world toward modernity. And if we looked beyond liberal democracy and markets, there was nothing else towards which we could expect to evolve; hence the end of history." According to Fukuyama, "The struggle which we face is not the clash of several distinct and equal cultures struggling amongst one another. . . . The clash consists of a series of rearguard actions from societies whose traditional existence is indeed threatened by modernization."[14]

Shortly after Fukuyama made waves with his thesis, Samuel Huntington, taking a different though equally ambitious approach wrote "The Clash of Civilizations?" Implicitly rejecting Fukuyama's benign take, Huntington's main argument was that the future would no longer be characterized by conflict among nations but among civilizations, ideas, and cultures: "It is my hypothesis that the fundamental sources of conflict in this new world will not be primarily ideological or primarily economic. The great divisions among humankind and

the dominating source of conflict will be cultural. Nation states will remain the most powerful actors in world affairs, but the principal conflicts of global politics will occur between nations and groups of different civilizations. . . . The fault lines between civilizations will be the battle lines of the future." [15] Over the years, many observers thought that Huntington had won the intellectual argument and the recent terrorist attacks seemed to confirm that view.

Huntington's thesis is extremely powerful and attractive and in fact seemed to be confirmed. Despite appearances, however, the events of September 11 tend to undermine his argument. The nature of those attacks and the multiplicity of reactions that they have produced around the world suggest that the clash and confrontation is less among civilizations than within them. Just as there are profound differences within the West, the Islamic world is besieged by conflict about the past and about the future. Although the specifics might be different, the disputes in the Muslim world, Europe, and Latin America are about the same things: capitalism and globalization, the environment and industry, democracy and freedom, regulation and free markets. Within Western societies, antiglobalization activists oppose many features of modern civilization; meanwhile, members of the Egyptian middle classes aspire to live in a modern, advanced nation surrounded by every consumer gadget available. Ambivalence toward a modern and progressive vision is to be found everywhere.

Does this restatement of Huntington's thesis change the debate? In a way it does. Fukuyama's thesis was very simplistic at first sight but more sophisticated if one delved into it carefully. If one accepts the hypothesis that most societies are split into different cultures (using Huntington's terminology), then Fukuyama may ultimately be right: after all, the core of his argument was that liberal society would win out. In this sense, he could easily argue that in many Muslim nations there is a modern, liberal society in the making that will ultimately prevail. In fact, the September 11 attacks show that the fight is between the borderless proponents of democracy and capitalism and its equally borderless enemies. Whichever it may be, the fact remains that the causes and culprits of these events are more complex than it would appear at first sight and have deep historical roots.

Another major breach that the September 11 attacks exposed is one that Francis Fukuyama also brought to the picture. His second major thesis over the past several years was that some societies work better than others and that these are typically based on trust. In other words, where there is trust in people and in institutions, people thrive and the economy works better. [16] The Unites States had long operated on the basis of trust and openness, which is one of the reasons why many people around the world visit and admire the country and its institutions.

September 11 has thrown a big bucket of cold water on that, and the consequences have yet to become clearly visible. To begin with, the September 11 hijackers obtained their boarding passes from an electronic machine that asked them whether they had packed their own bags! Maybe such an extreme level of trust will vanish altogether, but what is key is to find a way to maintain security without destroying what America is all about—and admired for. That balance between trust and security will become paramount.

## THE FUTURE

In light of the attacks, there are two ways to see the future. Someone who accepts the clash of civilizations thesis would predict an all-out assault against the alleged culprits and the nations that harbor them. Someone who recognizes the complexity of September 11 and its inherent shades of gray would take a far more parsimonious view of the future. Military action against Al Qaeda was clearly necessary, not only to exact retribution—ultimately, a great power does not need to prove its strength in so obvious a fashion—but also, more practically, to dismantle the Al Qaeda network and to dislodge its foothold in Afghanistan. But military action is not all that is required. Military action tends to destabilize because it alters the existing structures of power. This effect is relevant not only in obvious places such as Afghanistan, where everything has changed, but also in neighboring Pakistan, where many of the former Taliban and Al Qaeda members may have gone, and in plenty of other places too. China, India, and the Middle East have all been changed as a result of military action in Afghanistan, as has the Horn of Africa. A New World Order may not be any more in the cards now than it was a decade ago, at the end of the Cold War, but politics and diplomacy will ultimately have to replace military action in order to reconstitute a viable foundation for long-term stability in affected regions around the world.

On another level, the consequences of September 11 will ultimately be measured by the way the United States evolves as a society. How can the "success" of the American response be assessed? Nobody can deny the need to introduce major security precautions in order to avoid future attacks. But what has historically differentiated the United States from other societies has been its commitment to freedom, justice, and the rule of law. At the end of the day, maybe American success will rest less on military might than on the nature of the society that emerges from the struggle. Those who espouse a more complex reading of events following September 11 point to the damage that might occur to the values that inspire American democracy—among them freedom, justice, and due process of the law—and to the rights of innocent civilians who could suffer

from domestic surveillance, ethnic profiling by law enforcement, or long-term detention and mistreatment of those who may know something about suspected terrorists or their activities. Though there has to be greater room for dealing with issues of justice and due process in war, the minute America forgets where its essence lies it will have lost everything.

In fact, as Israel has learned to its peril, history has shown that one of the strongest root causes of terrorism lies in the abuse, torture, and violation of rights of innocent people, which turn them into blind fanatics or radicals seeking revenge. One way to guarantee future terrorist attacks lies in creating and multiplying its seeds by abusing innocent populations.

Terrorism cannot be dealt with by force alone, but force is a necessary component of any policy that aims to address it. There may be legitimate grievances that have to be dealt with, but violence will not end just because those grievances have been addressed. In fact, the opposite may be true. As the escalation of attacks against U.S. interests over the past decade shows, terrorism tends to develop a momentum of its own. In that context, compromise cannot produce the desired result. Hence, once legitimate grievances have been addressed, criminal prosecution becomes the only viable option. Terrorists need to lose their legitimacy for terrorism to wither away; as long as it is considered a legitimate course of action, new terrorists will keep on emerging. This is why the United States will not be able to disengage easily from its effort to end terrorism and why it is so important that it doesn't. It has to learn to be a strong power, albeit a humble one. The question is whether, once the perceived threat has diminished, Americans will have the stomach for such a transformation.

The attacks changed America. Americans have every right to feel attacked, violated, and abused. And they have been. Punishment of the culprits should be exemplary. But that punishment ought not to be at the expense of the values that are the mainstay of the West and of the United States. The reason for this is not only moral but also essentially practical. The best way to nurture the hatred and the nihilism that were shown in these events is by responding with more hatred in the form of unjustifiable destruction, violation of the dignity and rights of innocent people, and the abandonment of the basic features of the rule of law, which is what differentiates an autocracy from a democracy, of which the United States is the world's prime example.

Terrorism has as its prime objective not only to destroy and demoralize, but also to foster a sense of chaos. This was well understood by Lenin, the leader of the Russian revolution, who once observed that the main purpose of terrorism is to terrorize. It seeks to destroy the spine of a society by undermining its values and generating forces willing to sacrifice its very democratic nature in order to

confront the enemy. In this sense, as bin Laden's statements exemplify, the terrorists' main aim is political: they use terror to advance a cause. In this, counter to conventional wisdom, terrorists are absolutely rational: they know what they want and have found a way to advance their interests. What these terrorists may not have counted on is that their own front is not unanimous about their cause. The deep social divisions that are obvious in Algeria and also Egypt are at least as profound as those in Western nations. Given this, it is critical to fight terrorism with weapons that could ultimately defeat it, rather than running the risk of further nurturing it with the wrong measures.

For many years, the very nations that have become the largest source of conflict, and now terrorism, have often been those where the United States decided not to pursue the case of liberal democracy and economic reform. In these countries the United States ended up in bed with the autocratic governments whose countries provided most of the members of Al Qaeda and the terrorist teams that attacked on September 11.[17] It is impossible to tell whether a different policy would have averted those attacks. But it is clear that the United States has not been a strong promoter of its own core values in the region where terrorism has brewed. It surely would be impossible to turn around every Arab nation overnight, and the United States is in no position to force such an outcome. But a process of gradual change, akin to the process of democratization that took place in the South of Europe in the 1970s and in much of Latin America later on, could well be a place to start: American policy in the Muslim nations ought to be legitimized and associated with peaceful change that benefits the majority.[18]

Ultimately, the war on terrorism will end up weakening or fortifying the essence of America. Either way, Americans will have to resolve this conflict within their own legal and political process. The problems of open and democratic societies are not new. Decades ago, an eminent philosopher, Karl Popper, wrote an exceptional essay about the unique difficulties that liberal societies confront. In *The Open Society and Its Enemies*,[19] Popper argued that in liberal societies there are always remnants of the tribalism from which they came and that the shock of transition to modern society frequently creates reactionary movements that attempt to return to their origins. Modernity and tribalism thus enter into conflict, each trying to have its way. The fanaticism that motivates the terrorist may be explained by these tensions. Events on and after September 11 prove that these fights can be extremely bloody and violent.

The successful military campaign in Afghanistan constituted a clear-cut response to the terrorist attacks, and it may have also succeeded in dismantling the foundation of the Al Qaeda network. The question of what follows is as complex as the root causes of the conflict. One big thrust will surely be to develop intelli-

gence networks, early-warning mechanisms, and an appropriate security struc-
ture. The other will be to rebuild Afghanistan, restructure America's foreign pol-
icy in the region, and above all, develop a strategy aimed at helping develop a
process of gradual change in the Muslim nations. The balance among these two
thrusts is going to be difficult to achieve, but it will be critical to the crucial out-
come of strengthening stability and peace as well as security.

The easy response is to deal with every future challenge in an indiscriminate
fashion, targeting as suspect everything and everybody that looks like a terrorist
or that fits some profile. Some of this profiling will inevitably have to be incorpo-
rated into security procedures at airports, immigration entry points, and the like.
The key challenge will be precisely to preserve freedoms without introducing un-
manageable risks. But the risk of abusing the rights of individuals, whether citi-
zens or not, is extraordinary and should not be taken lightly.

The problem with liberal societies is that in order to remain liberal they have
to act within the framework of the rule of law above and beyond the expedient
use of authority or firepower. Power has its uses, and it must be employed when it
is warranted and in a way that furthers the broader objective of sustaining hu-
mane and democratic values. The battle against terrorism has to be won with the
appropriate weapons, those that will produce a better place in which to live. To
paraphrase John Womack of Harvard: democracy does not produce, by itself,
a decent way of living; rather, it is decent ways of living that make democracy
possible.[20]

# 4. REASSURING AND PROTECTING: INTERNAL SECURITY IMPLICATIONS OF FRENCH PARTICIPATION IN THE COALITION AGAINST TERRORISM

## DIDIER BIGO

From a French perspective, the security repercussions of the September 11 attacks in the United States assume two distinct dimensions. The first one is the most obvious, but also the most dubious. It is to relate security only to danger and to the strategies of the clandestine organizations that targeted New York and Washington. In the wake of the American military response, these clandestine organizations might undertake similar actions against those who supported such responses, particularly if their backing included sending troops abroad. A second set of repercussions emerges from the relation between security and freedom, and prompts us to examine the response strategies of different governments, as well as the consequences of the surveillance and control measures they have implemented, at home and/or abroad. If these policies against terrorism are poorly conceptualized and managed, they have the potential to accentuate internal cleavages within the different societies and to reveal vulnerabilities within the body politic itself. Although these issues undoubtedly carry less significance in terms of immediate threats to human life than the threat of direct retaliation against France, over the medium and long haul they could prove crucial for French society.

This chapter considers these issues separately, but in practice they may become intertwined. Such would be the case, for example, if in reacting against specific controls perceived as discriminatory, domestic groups opted to support—actively or passively—the operation within France of networks that until then had lacked a significant domestic social base. I try to demonstrate that security is not the opposite of insecurity. It is not a zero-sum game. On the contrary, security is like a sphere wrapped in an envelope of virtual insecurity. The more the security sphere increases, the more virtual insecurity increases. The process of securitization is also a process of (in)securitization. The relation between bombings and the fight against terrorism needs to be analyzed in such a way as to understand the effects of the measures taken in the struggle against terrorism. Security is a relational process. It is not a phenomenon linked to survival, a historic value, or a behavior, a right, or a norm. Security is a concept that is always contested, because it is positive if one looks at the relation be-

tween security and danger, but negative if one looks at the relation between freedom and security.

## DANGER AND INTERNAL SECURITY

France has been affected many times by attacks aimed at anonymous civilians as part of efforts to destabilize the government or to influence its foreign policy. Attacks during 1985–86 and 1995 had enduring effects on the public consciousness and at the level of public institutions, as administrative and legislative measures were elaborated to combat terrorism. Thus, issues that in the United States appear unprecedented following September 11, 2001, actually have been relevant in France for at least the past five or ten years. Nonetheless, both the number of victims of September 11 and the choice of symbols that were targeted mark a difference in scope that suggests limits to the analogy.

French policy in Lebanon, its support for Iraq, and its training of agents of the Algerian government were the focus of the 1985–86 attacks claimed by the Comité de Solidarité avec les Prisonniers Politiques Arabes et du Proche-Orient (CSPPA). That network may or may not have been linked to the Iranian government or factions associated with it, but it operated transnationally, with members present in Germany and the Ivory Coast.[1] The organization was relatively simple, however, with a weak social base and made up of individuals who had known one another for a long time and who were all fully apprised of preparations for attacks against civilians.

The series of attacks in 1995 claimed by the Groupe Islamique Armé–Commandement Général (GIA–CG) also targeted France, this time specifically because of its support for the generals and officials in Algeria.[2] This organization was somewhat more complex, with four separate cells operating in at least two countries: a London cell complemented efforts of three France-based units by arranging transfers of funds. The number of people directly involved nevertheless remained minuscule, and though evidence suggests support in some domestic quarters, this hardly approached the "uprising of the Paris *banlieues*" implied by alarmist statements that were issued at the time by security agencies and repeated in the media. Nor does the evidence show much in common between the attackers of 1985–86 and those who emerged a decade later, despite officials' attempts to invoke the same nebulous Arab-Muslim terrorist threat. It should nevertheless be noted that the "Afghan" group soldiers of the GIA and Osama bin Laden's organization were evoked in 1995. But it was clear at the time that the issues at stake were Franco-Algerian.

By contrast, those behind the September 11 attacks targeted the symbols of

international capitalism, the World Trade Center, and of American superpower status, the Pentagon and, presumably, the White House. The impression conveyed by this choice of targets is that France is less likely to be in the terrorists' sights than the city of London, Germany, or for that matter Berlusconi-led Italy. French overestimation of its own rank in the international order may lead to an exaggeration of its risk as a target of future attacks. If the source of the September 11 attacks is indeed the bin Laden network and Al Qaeda, or even the ultraradical clandestine organization Hamas, there is little reason to think that France would be a priority target. Its policy with regard to Palestine is more balanced than that of the United Kingdom or the United States, making France less susceptible to the anger of radicalized Muslims. This is all the more true given France's comparatively temperate discourse regarding worldwide financial liberalization, the increasing prevalence of which is associated primarily with Anglo-American interests. Finally, French reservations about the occasionally messianic character of U.S. cultural and linguistic advance make it even less likely that France would be perceived as a "great Satan" (or even a little one).

It is nevertheless possible to imagine some local radicalized groups—remaining perhaps from the 1995 conflict with the GIA—undertaking copycat actions, independent of any general coordination, aimed at smaller-scale symbols such as American or British enterprises in France. It is also conceivable that clandestine nationalist groups within France could try to take advantage of the present situation, when all eyes are turned to international crisis, to reconstitute their domestic bases of support through thefts of explosives, bank robberies, or the collection of "revolutionary taxes." Conversely, the increased mobilization of security forces might well motivate these groups to act prudently in order to avoid being portrayed by the media as being on the same plane as international terrorists. Indeed, the contemporary role of the media complicates the situation for all actors involved, in ways that are impossible to predict: even minor attacks can be considered part of a war in the shadows and thus take on importance beyond what would otherwise be justified by their limited scale.

The situation would of course change significantly if France, whether in an effort to assert its rank in the world or for reasons of conviction, were to provide massive troop support on behalf of a punitive action undertaken by the Americans and the British. But if its participation is limited to a modest contribution to such a response, it would be unwise to publicize this excessively to satisfy the media or to play domestic politics. As Germany has shown, declarations of solidarity can be strong without taking on a clearly bellicose character. It is only in the context of a global escalation of violence in which France participated to as-

sert its status as a world power that France would find itself designated a target of clandestine organizations seeking to "respond to the response."

It may be worth reflecting on what should be done in the event that France were faced tomorrow with an attack that resulted in hundreds of deaths. Under such catastrophic circumstances, the first steps to be taken would need to be preventive in nature, taking their cue from the errors of the Americans who, while keeping track of bin Laden, failed to anticipate the September 11 attacks. French diplomats, as well as representatives of police, intelligence, military, academic, and legal sectors, would appropriately convene regularly to assess the long-term implications of policies and practices that might stoke frustrations and grievances among populations at risk, particularly those from the Magreb. Foremost among the policies that would merit such analysis are French support for the Algerian government, its laxity toward Tunisia, and the refusal to offer asylum to members of the Algerian opposition. Secondly, and still at the level of preventive measures, consideration would be needed of the effects on governmental legitimacy of the new European security architecture and related restrictions on immigration: what, in a society of risk, are the rights and obligations of a new "European citizen"? I shall return to this point below.

A third preventive measure would be to determine the operational response to such a hypothetical attack. Inevitably, an extremely lethal attack would elicit a military as well as a legal response, but it would be essential that these be coordinated to ensure that the courts could conduct effective investigations. The waiting period would best be prolonged as much as possible, even while forces were being amassed to convey unequivocally the intention to employ military action. This was the strategy that the Americans seemed to be pursuing in the weeks following September 11. They then abandoned it by unleashing the war in Afghanistan, which in turn demonstrated a flawed military strategy, its immediate apparent success notwithstanding. Instead of air strikes, would not ground troops have been more appropriate? The war in Kosovo showed that one does not fight against paramilitary groups with cruise missiles, or at any rate that in doing so one does not resolve the conflict. Implied here is a need to promote cooperation among intelligence agencies and special forces, both in the conduct of their missions and in their respect not only of civil liberties but also of international standards of human rights and the conduct of war.

A more likely scenario, however, is analogous to the present, when France, without having been affected directly by attacks, is still compelled to maintain high levels of alert against attack without undermining social cohesion or aggravating tensions with Muslims living in France. A key objective in this instance

must be to avoid labeling these groups as the source of the problem. It is also essential to maintain distance from the symbolic and military confrontation between the United States and Afghanistan to retain room for maneuver in the event that polarization becomes more extreme. This means affirming solidarity with the United States and perhaps participating in specific actions, but not trying in the process to take on the role of mediator. Consultations should be planned between organs of the Quai d'Orsay (the foreign office) and Defense Ministry, as well as Interior and Justice ministries, and these ministries should be participants in an enlarged Internal Defense Council, which would make clear that potential responses are not limited to military options.

To be sure, French diplomats charged with overseeing relations with NATO and the European Union tend to emphasize the need for France to act as mediator in the international arena. The efforts by some U.S. officials to take advantage of the September attacks to restructure in their favor the balance between the EU and NATO have been flagrant, and require a diplomatic response from Europe.[3] French efforts to mediate in this situation, however, are complicated by the post–World War II history of French transatlantic diplomacy. In moments of crisis France tends to combine elements of Atlanticism and Gaullism, insisting simultaneously on solidarity and autonomy, and is thus in a more delicate diplomatic situation vis-à-vis the United States than are other countries of the NATO alliance. French diplomats, caught in their own game of international self-importance, should be reminded that their statements and actions carry real risks for the civilian population in France. Nonsecurity professionals—in this case, diplomats—must come to understand that it is now necessary to assume the possibility of attacks in the overall political diplomatic calculus. As we argue in the next section, extreme official statements about securitization run the risk of exaggerating public perceptions of unlimited dangers that are far out of proportion with actual statistical risk, and thus reinforce the sense of insecurity.

## TO REASSURE AND PROTECT AFTER SEPTEMBER 11

Security, as Jean Delumeau points out, consists of reassuring and protecting the public, not disturbing and worrying them.[4] But sometimes in seeking to achieve the former we unintentionally produce the latter. Reassuring does not consist of conjuring up every possible danger in order to "sell" security, or of denying or minimizing genuine dangers. Rather, reassuring entails reestablishing the symbolic order—not by retaining its original form, but by managing its transformation.[5]

The myth of the impunity of the United States and the centers of interna-

tional capitalism fell with the Twin Towers, and we must adjust to that. Everyone is equally vulnerable to determined attackers, and though technical measures can always be employed to counter this type of attack (strengthened air security, arming civilian aircraft personnel with lethal weapons, etc.), contemporary societies simply cannot be protected by impenetrable physical and electronic barriers. We must abandon the delusion of *maximum security* that always follows a murderous terrorist attack.[6] Antiterrorist measures that aspire to form an impenetrable "technological" shield imply a Northern Irelandization of Western societies, which runs counter to the real goal of security. Reassuring consists of demonstrating the political impotence of such attacks and their counterproductive impact on those who initiate them.

## REASSURING

While Western politicians join families in mourning the victims of September's attacks, they also must explain why the attacks occurred and resist the temptation to respond on a purely emotional level. If it was tactically important at the outset to avoid adopting a logic of revenge and to calm the situation to prevent domestic unrest, it soon became appropriate to explain how these attacks served counterproductively to paralyze negotiations in the Middle East, to the detriment of the Palestinians. Bin Laden may have resided in Afghanistan, but the core of his discourse is articulated around the liberation of sacred sites in Palestine, and it is not possible to isolate the situation in Afghanistan from the Israeli-Palestinian conflict. At the same time, it became imperative to insist that the context created by the attacks in no way justifies security measures aimed at limiting immigration and asylum. To revive myths of absolute sovereignty and border impenetrability or to pretend that technical solutions can completely prevent new attacks is to ignore the powerful trends in contemporary societies toward the multiplication of flows (capital, ideas, information, goods, people) and the growing speed of their circulation. Not only are attempts to reverse these trends likely to fail, they also jeopardize important liberties by suggesting a hierarchy of rights, and invite a situation in which limits imposed by extraordinary laws become increasingly portrayed as ordinary.

Rather than the ambiguous discourse of politicians or experts who, in trying to reassure the public, conjure up an impressive list of vulnerabilities never imagined by this very public, we would do well to adopt the slogan of "living with terrorism." As employed by General Carlos Alberto Dalla Chiesa to describe Italian policies in reaction to the *anni di piombi,* this was not a sign of fatalism, but of realism.[7] Dalla Chiesa was determined to avoid changing lifestyles radically and sought to mobilize citizens in their everyday lives against what he called the

image of the "great antiterrorist masses" invoked by politicians who typically had little of substance to say.[8] Reassurance requires a communications policy that does not deny the rationality of clandestine organizations, but demonstrates their contradictory (and often superfluous) nature, as well as the illusions they have about their own power. The social and political pointlessness of their acts, which will not move things in the direction they desired, must be pointed out. A more detailed study of the political management of "black terrorism in Italy" and of public reactions at the time could be very helpful in thinking about current events, despite the differences of scale and context.

## PROTECTING

Protecting is even more complex than reassuring. Protection, like security—being both warlike and humanitarian—is ambiguous and its meaning is rapidly changing.[9] The framework of "war between nations" used by Raymond Aron and other thinkers to explain past forms of conflict is outdated in a postbipolar context. Huntington's "clash of civilizations" is no more pertinent to today's crisis.[10] In contemporary societies of risk, protection must rather be viewed from three interrelated perspectives: (1) the relation of the individual to the state and to transnational actors; (2) the relation of risk to fear and uncertainty; and (3) the relation of security to danger and freedom.

This means that protection can no longer be understood as static or as operating on purely territorial or national levels. Protection is not limited to the defense of national interests against those of neighboring states, nor is it necessarily the protection of territory and infrastructures. Protection has to be understood in relation to solidarity and responsibility. It can entail the protection of individuals or of endangered social groups, of public or private actors, located within or outside national boundaries. It can be implemented via international collaboration. Essential questions—concerning who must be protected; by whom, against what threats, and why—force us to reconsider traditional conceptions of protection and move us away from an exclusive reliance on barriers, on strict border controls, or on the quest for a hypothetical "safe zone" located behind impermeable borders.

We must also transcend traditional intellectual frameworks that equate protection with prevention of territorial invasion. The idea of a Maginot Line against clandestine actions, requiring total security of air space and of sea and land borders, is not only illusory; it is also prohibitively expensive in both human and monetary terms, and these resources would be better spent on more flexible and preemptive approaches. Clandestine organizations cannot be stopped by

physically closing all borders, for borders must reopen sooner or later unless there are deep changes in the economic and political status quo.

The proliferation of border controls, the repression of foreigners, and so on has less to do with protection than with a political attempt to reassure certain segments of the electorate who long for evidence of concrete measures taken to ensure safety. But protection must now be achieved differently, through modes that are more akin to the locks of a dam, which "channel and monitor flows," than to the fortress logic that underlies reliance on blockading borders. The technologies that regulate flows are often less visible than those that block flows, but they also can be more effective. Thus, public education needs to be conducted by the media on the "limits of the visible." We must distinguish between visibility and the needs of democracy, and to ensure accountability we must reinforce the role of the judiciary to monitor application of these new techniques. The answer is not to eschew judicial oversight or to relegate it to a post-facto validation of faits accomplis, as seems to be the present Spanish option. Judges must work cooperatively with the information and security services and understand their needs without giving them carte blanche to undertake whatever measures they please.

In a world of flows and constant movement, protection requires both a proactive capacity to anticipate these movements and the creation of mechanisms that enable individuals and groups with different value systems to coexist in the same territory despite their diverse ways of life. This is one lesson to be drawn from the experience of Bosnia and Kosovo, and it can also apply where antagonisms are less acute or are limited to the potential explosion of tensions among social groups located within a single country rather than across national frontiers.

Protection now requires mediation between groups and energetic insistence on the values that are fundamental to democratic socialization, rather than the never-ending quest to identify and isolate possible internal enemies, as the fortress approach of sealed borders would imply. Protection has to be mobilized every day, but appropriate roles of security professionals and the citizenry must be distinguished in order to avoid the twin threats of vigilantism and the uncontrolled proliferation of private security agencies. Protection must be understood as a dynamic, relational framework, but with no confusion of tasks. Finally, protection is not limited to national territory. One useful image is the Möbius strip, on which there is a border between the interior and exterior, but it is contingent rather than fixed.

Transnational protection can be exercised either geographically (for example, by EU cooperation in granting visas) or through other means, such as by devel-

oping profiles or "morphing" activities.[11] This latter method is already used by some security agencies, and its use can determine the level of influence and importance of different information agencies. It is not new, being connected to technologies and ideas developed at the beginning of the 1970s. The point is that the development of these techniques is not simply a consequence of transformations of violence over the last 30 years, but has accompanied them. The emphasis on remote surveillance technologies and the accumulation and filtering of information by database, sometimes to the exclusion of other technologies, is relevant to what happened in New York and Washington, D.C.—particularly if the bin Laden network is behind these attacks. After all, bin Laden had been identified five years earlier as a primary threat, yet was nevertheless able to carry on with his activities. We must therefore reevaluate the methods of protection used and compare their strengths and weaknesses. One of the weaknesses could be hyper-technology.[12]

The most acute problem encountered by protection agencies in a risk society is being able to differentiate between an accident and the malevolent or strategic intentions of an adversary. Identifying adversaries who refuse to claim responsibility for or comment on their acts because they are not looking to develop "propaganda by the deed" is technically and politically difficult. From a technical point of view, this problem highlights the importance of human intelligence, long subordinated to high-technology means of intelligence gathering.[13] Politically, it complicates the situation because popular opinion demands the quick identification of a recognizable enemy, while the genuine enemy might hide behind silence or "false colors."

Given the furtive nature of clandestine actions and the long-term situation that must be managed, it is inappropriate to react to every attack as if we were in a period of "international crisis," namely with a high-visibility response that tries both to dissuade the adversary and allow a quick return to the previous state of affairs.[14] The methods of foreign intervention that prevail during an intense and short crisis simply cannot be transposed to the emergent context of conflict, which is characterized by a number of features: asymmetry, depolarization and/or proliferation of conflicts, suicide attacks, the tactical invisibility of adversaries, the organization of transnational terrorist networks, and deeply antagonistic long-term conflicts.[15] In this context of "permanent crisis," the appearance must be kept up of the stability and composure of governmental institutions.[16]

Thus, contingency must be managed while at the same time symbolic overreaction combined with tactical impotence is avoided. In the constant oscillation between different antiterrorist responses, ranging from militarization of the response to criminalization of terrorists, the emphasis placed on military options

must correspond to the danger presented by the terrorist organizations in question.[17] The militarization of policing in Europe with the aim of increasing antiterrorist cooperation among governments must be accompanied by judicial protection for individuals and their civil rights, as well as by the judicial accountability of security agencies. In the case of September 11, the secretiveness of the response is reasonable, both in terms of immediate actions of special services and long-term actions (infiltrations). However, this policy is tenable only if it is ultimately overseen by the judiciary, so as to avoid generalizing these kinds of actions beyond the organizations to be infiltrated such as to the surveillance of sympathizers far removed from them.

The effectiveness of the post–September 11 response will also depend on ending excessive dependence on information technologies like satellites and the Internet, and a return to human forms of intelligence gathering. If we are going to allow for the application of exceptional counterterrorist measures, then we must also employ a very restricted definition of the types of clandestine organizations against which such measures may be used. This emphasis on judicial oversight, even in international cases, has the disadvantage of constraining responses to an act of terrorism, but it also helps ensure targeting the real perpetrators rather than taking revenge or merely dealing a blow to a convenient enemy. This oversight must accompany, or even limit, the militarization of action. Militarization alone, especially against an invisible enemy, can engender diagnostic errors and create conditions for counterpropaganda from the adversary.

In spite of these dangers, militarization seems to be the trend. Beefed-up technology is increasingly touted as the solution to terrorism, whether in the form of surgical air strikes or intelligence-gathering techniques based on wire tapping, expansion of databases, and the like. Yet excessive reliance on such measures probably accounts for the failure of American intelligence services, which abandoned infiltration in favor of "high-tech" methods.[18] By prolonging these trends, we are confusing the activities of domestic policing, antiterrorism, and intelligence, thereby increasing bureaucratic competition between agencies instead of setting limits on their actions and establishing a precise framework for their collaboration. If everyone is equally involved in antiterrorism, the resulting confusion will lead to greater loss of confidence, not to greater collaboration. The definition of terrorism is currently being expanded so that everyone can include their closest enemies in it, and thus develop a "consensus." This is being done in such a way that the legal definition of terrorism, which was already problematic, is becoming ridiculous, including both supporters of bin Laden and youth groups that participate in antiglobalization demonstrations.[19] What is needed is to study the impact of these new definitions of the antiterrorist struggle on orga-

nized crime, on clandestine immigration and asylum, on the surveillance of certain social groups (Muslims, Sikhs, Kurds, antiglobalization movements, hackers, etc.), and on public freedoms.

So far we have analyzed risks of attacks in France and the appropriate stance to be taken with respect to clandestine organizations. But if we wish to understand fully the domestic repercussions of French participation in antiterrorist efforts, we must assess how the application of exceptional measures is likely to affect social cohesion in France over both the short and long run.

In analyzing the relationship among risk, security, and liberty, we have up to now emphasized primarily the first two components. But what about the relationship between security and liberty? Some measures taken in the name of the struggle against terrorism may themselves place social stability at risk by reinforcing existing social cleavages in French society. It would be ironic if carefully calibrated measures that enabled France to overcome the challenges that directly affected it in 1986 and 1995 were now supplemented by a flood of legislative and regulatory initiatives intended to show its solidarity with and goodwill toward the United States. Such wholesale changes may be expected in settings that have not experienced terrorism and thus lack legal means for addressing it. That is not the case in France, which wields one of the world's most comprehensive arsenals of judicial means for combating terrorism. And while some may disagree with the balance it establishes between security and liberty, many observers believe that it addresses simultaneously the need for efficiency and for judicial authority to limit possible abuses by intelligence services. To be sure, reforms are needed to diminish the excessive dependence of the French judicial system on the actions of individual judges. Nonetheless, if every terrorist attack in the world reinforced the trend toward heightening security and expanding powers of exception, the balance between security and liberty would be upset.

## TEMPORALITY AND EXCEPTIONAL MEASURES

Since the events of September 11 the balance among liberty, security, and risk has been modified throughout the European Union.[20] This reassessment of risk has taken place in a climate in which security has taken on an entirely positive connotation, and liberty has been portrayed as its opposite. Rather than conceiving of security as a process, authorities work on the assumption "The more security the better." In this context security expands in ways that suppose that new measures can be implemented temporarily, to be eliminated once the source of threat has been eliminated.

As British home secretary, Roy Jenkins led efforts to enact the 1974 Prevention of Terrorism Act in response to a wave of bloody attacks; the act restored most powers of exception that had been abolished in Northern Ireland during the previous year. Subsequently Jenkins wrote that "the Terrorism Act helped both to steady opinion and provide some additional protection. I do not regret having introduced it. But I would have been horrified to have been told at the time that it would still be law nearly two decades later. . . . It should teach one to be careful about justifying something on the ground that it is only for a short time."[21] Jenkins continued his reflection by noting the difficulty of being a policy maker under such circumstances, where one "must" act decisively to "survive" politically, even when one knows that the best course of action is simply to improve enforcement of existing safeguards. There is, then, a tendency among politicians to allow exceptional measures to become part of everyday life, with the result of jeopardizing the very civil liberties and social contract that the state is supposed to uphold.

Reflecting on Jenkins's book and the experience of Northern Ireland, Laura Donahue emphasizes the dangers of a "permanence of the temporary" and the inability over the long term to resist the temptation to add more and more security measures. Each measure is expected to be more effective than the last, and each is presented as temporary, but none do anything to fix the problem of violence. Especially with the sort of violence these measures aim to combat because, in contrast to the violence of conventional warfare, its targets change over time, and its perpetrators do not have as their objective the seizure of state power.[22]

Donahue insists that by reinforcing an existing religious cleavage, emergency measures imposed since 1922 have strengthened and radicalized a political cleavage between loyalists and nationalists, preventing reconciliation and afflicting Northern Irish society with a climate of permanent exception in which "temporary" suspensions of civil liberties have gone on for 80 years. By responding to the events of September 11 with attempts to harmonize laws of exception across countries along lines that privilege security, regardless of the historical trajectories of states and their internal balance between liberty and security, is there not a risk of exacerbating religious cleavages and fostering growing political radicalization among competing camps? What this terrible paradox suggests is that it is not the attacks themselves but rather the responses to them that could undermine social peace.

This possibility needs to be considered seriously in France, where Islam now represents the second most widely practiced religion in the country and where there is a risk that control measures will be directed almost exclusively toward the

Arab and Muslim populations. If this were to occur, it would result in the prolif-
eration of feelings of discrimination and the radicalization of substantial groups
that already see themselves as excluded.

Surveillance focusing on small, highly militant and radical minorities of par-
ticular groups should not be allowed to expand under the pretense of efficiency
to encompass surveillance of large groups, nor should it become more visible. To
the contrary, it is essential that the sort of spiral, whereby measures that are ini-
tially deemed temporary and localized become generalized over time, which
beset Northern Ireland, not become generalized across Western societies. It is
easy to start down that road, but very difficult to get off of it.

## A SPIRAL EFFECT

One example of this spiral effect can be seen in France, after the *vigipirate* plan
was passed in 1995. This plan was enacted in the wake of the terrorist attacks dis-
cussed at the beginning of this chapter, provided for the use of the army in main-
taining public security. It allowed local officials wide latitude in implementing its
provisions, based on "concentrations of foreign populations" in their areas.

If the experience under France's *vigipirate* plan is typical, it is imperative to re-
flect on the risks incurred in extending antiterrorist measures beyond their initial
purposes, such as using them to reduce petty crime or to police neighborhoods
deemed vulnerable to crime. Since 1995 the *vigipirate* plan has remained in effect
in some such locations, and no French politician is eager to run the risk of sus-
pending it and then to be blamed for imprudence if a serious crime occurs soon
afterward. This routinization of exceptional measures can be cumulative, with
each new round of controls supplementing preceding ones. If this phenomenon
takes place in France, we could face an array of tensions leading to groups tar-
geted by emergency measures subsequently using the existence of those measures
to justify new violence.

The United Kingdom offers another example of this spiral effect. For many
years, England, Scotland, and Wales experienced an everyday situation very dif-
ferent from that of Northern Ireland. But measures originally enacted to combat
the IRA were generalized to the fight against clandestine organizations from the
Middle East that have aspired to unleash attacks in London, with the result that
Great Britain has become one of the most security-ridden countries in Europe.
Quite suddenly there has been a shift in security regimes, as exceptional proce-
dures taken to deal with the specific problem of Northern Ireland have come to
be accepted as part of everyday life. Facing internal criticism from lawyers and

judges, and amidst recent moves to reopen the debate about introducing a national identity card as part of the struggle against terrorism, the British government has tried to justify its stance by alluding to "European pressures" and by asserting that it had "fortunately" anticipated the September 11 events by enacting the "Terrorism Act 2000."[23]

Yet the Blair government is encountering internal opposition within the Labour Party as well as from the House of Lords. The latter have insisted in committee discussions that, given the range of measures being contemplated in the United States following September 11—controls of illegal immigration, increased use of wiretaps and Internet surveillance, etc.—as well as the European Union's expansion of the definition of terrorism, it is necessary to reflect on the timeliness and efficiency of additional measures, as well as their impact at the national level. France would do well to heed this advice as well.

To avoid such a spiral, it is essential to distinguish those measures that constitute indispensable support for the struggle against terrorism from those whose nebulousness, generality, or dubious relevance jeopardize civil liberties without offering an iota of support for the struggle against terrorism. Between these two extremes is an intermediate category of measures that indeed may be effective but that come at the expense of one or another liberty. Only a careful adjudication of this tension will bring about a new symbolic order that can be accepted by all and that will not render social relations more fragile.

## ANTI-TERRORIST MEASURES AND THEIR EFFECTS ON SOCIAL COHESION

In *Constructing the Political Spectacle* Murray Edelman wrote, "Sometimes political enemies hurt their opponents, and often they help them. Because the evocation of a threatening enemy may win political support for its prospective targets, people construct enemies who renew their own commitment and mobilize allies."[24] There is, then, a tendency in every country and in every international institution to apply longstanding fears to new contexts and to try to make linkages between the past and the present. In Western democracies this tendency in the political game is magnified by analogous processes in bureaucracies and in the media. It is rarely perceived, because it is born of a discourse of consensus and hegemony, and it is dangerous in several respects. Measures that encourage a proliferation of disparate declarations and norms may soon enter into contradiction with one another, and become ineffective. Moreover, some of these measures may produce side effects that counter the intent of other elements of policy.

If managed poorly by the government, this dynamic has the potential to undermine social cohesion instead of strengthening the symbolic pact between state and society upon which such cohesion depends.

In the current context, in which the global, regional, bilateral, and national levels are intertwined, it is increasingly difficult for a government to remain engaged in international diplomacy while preserving the security of its population and conducting an autonomous policy. Governments are no longer masters of the political agenda or of the media and find themselves compelled to position themselves rapidly in response to initiatives that are not theirs but their allies'. As a consequence, foreign policy and internal security are increasingly in contradiction with each other.

## IMPACT OF AMERICAN POLICIES ON FRENCH INTERNAL SECURITY

The September 11 attacks call for a review of the entire system of rules governing French civil aviation and security aboard aircraft. Contrary to what some NGOs would like, it is not possible to ignore what occurred and to return to normal as if the attacks had not taken place. Specific changes will be needed to assure a new equilibrium in the air-travel system. At a technical level, steps can be taken to inspect passenger baggage, better equip and train security personnel, and so on. Discussion of changes on the ground and their impact on the financial profitability of airlines is somewhat more complex, and it would be appropriate to study possibilities for privatizing baggage security and passenger control services now undertaken by public officials.

A series of measures can also be taken to analyze the movements of clandestine organizations linked directly to recent attacks. These include the movements not only of people but also of the funds used to support them. These measures will no doubt strengthen the effectiveness of monitoring efforts, but will come at the cost of significant intrusions into the private affairs of individuals and companies. It is difficult to see how it could be otherwise. Thus, there is a need to reach agreement that the mechanisms of this surveillance must be employed by people who will be accountable, and to enlist the cooperation of judges working at an international level with intelligence services. As for the tracing of funds, efforts to enlist the cooperation of banks and the business world have languished for many years. Perhaps the shock they experienced with the attack on the World Trade Center will change attitudes in this regard.

It cannot be denied that such measures will affect internal security in France, or that citizens who travel frequently will be troubled by practical constraints on

their speed of movement, which may demonstrate that restrictions on "free" circulation will be more than just theoretical. With regard to the circulation of capital, one can imagine that banks will yet again seek out new strategies for taking advantage of existing laws, whether through the use of facilities located in microstates or in tax havens operating within the borders of numerous countries. Most likely they will do so with the implicit backing of political parties and enterprises that also seek to take advantage of the "lieux d'exceptions."[25]

Yet in the United States the antiterrorist struggle has quickly become a catchall category justifying policies that affect a wide range of society, ranging from the Internet to the movements of social protesters to immigration policy. Herein lies the greatest risks of destabilizing internal security and social cohesion in France if France opts simply to follow the American strategy.

To cite Murray Edelman once again, "Enemies become whatever claim works for the situation and the moment. . . . The displacement of resentments onto personified targets who are vulnerable and available for political and psychological use is pervasive in enemy construction."[26] Edelman highlights as well the bureaucratic tendency to present old solutions that have been rejected in the past as if they were the solution to "new problems," to the point where one redefines the very nature of the problem as a function of the solutions that one already has on hand.

Following this line of thinking, one can see how the question of asymmetric and deterritorialized forms of violence that struck the United States have been reconfigured through a discourse of war and military strikes that require identification of a territorial enemy, in this case Afghanistan. This policy may be skillful to the extent that it engages the sentiments of the American population, but over the medium and long terms its effectiveness is very much in doubt. One can multiply enemies and create heterogeneous coalitions simply by having the illusion of addressing the problem, but the implementation of consensus created in this manner may, as Graham Allison has pointed out in the Cuban Missile Crisis context, antagonize allies and ultimately weaken the coherence of the alliance itself.[27] The capacity of some American think tanks to profit from the context created by September 11 by undertaking an effort to impose new alliances, to structure to their advantage relations within old alliances, and to push at the world level a number of their initiatives that had been blocked for years shows that we are far from the continuous emotional response of the United States. The rapid mobilization of bureaucratic resources inside the United States and the maintenance of a strategy of steadily increasing tensions after more than a month's pause after the attacks (instead of an instant reaction) permitted them to structure the international political game to their advantage, and this has serious

repercussions for security both in France and at the EU level: it creates an "obligation" to adopt or to adapt to national conditions a set of measures that assist the Americans but that do not necessarily favor internal European social cohesion. Yet the longer and more intensively the United States pursues this policy, the greater will be the doubts instilled in allied governments, as well as in critical segments of public opinion that from the outset expressed their disagreement. One sees here as well the effects of American communications policy during the Gulf War and, later, in the former Yugoslavia. Many criticize the Americans for having delivered biased and incomplete information to their allies, and there is fear that this could occur again in the present context.

It is certainly too early to predict the full range of effects that will result from this partial restructuring of relations among forces. U.S.-U.N. relations are being modified, but it is still not clear whether, after the shock of September 11, there will emerge in the United States a greater acceptance that norms exist that transcend their own national interests, which they ought to accept, or whether instead they will attempt to impose their own cultural norms universally. It appears as if dialogue, including with the English, is becoming more and more difficult for the American government. For example, they seem to have trouble accepting the idea that the British, Germans, and French might have some lessons to offer them with regard to the struggle against terrorism, and that they could teach the Americans methods and technologies that are even more effective than their own.

Relations within NATO between the United States and its allies are changing as well. The United States vacillates between a strategy of alliance and go-it-alone policies. The Americans do not wish to be constrained by NATO's juridical norms, yet they insist on obtaining NATO's support. The Americans want NATO member states to fully believe their evidence and the accuracy of their lists of people, companies, banks, and governments that they suspect of having ties with terrorism. Yet these lists can be fabricated to fit American bureaucratic and commercial interests; this reality, as well as real dangers, obligates other governments not to follow the American lead blindly. It is no surprise that there has been all along an American tendency to subordinate the role of European institutions, which have their own capacities for analysis, and to embed them in a coalition directed unequivocally by American services. The geographic expansion of NATO's missions is less problematic if the discussion is about sending troops outside Europe, whereas the enlargement of its mission to new areas of activity within European states touches directly on Europe's autonomy in matters of its own defense.

The struggle between the FBI, the CIA, and the Defense Department as to which agency should take the lead in the field of Internet surveillance, on the as-

sumption that "he who controls the Internet today controls the world tomorrow," is being precisely reproduced in the debates about antiterrorism at the global and European levels. This undoubtedly explains the blindness of these agencies with regard to the far lower-tech instruments that were known to be available to clandestine organizations. The three agencies above concentrated surveillance on nuclear, biological, and chemical weapons and on missiles, encrypted communications, and high technologies, on the assumption that only these vectors represented significant threats. Yet after the 1983 suicide attacks in Lebanon, in which truck bombs were used, studies conducted by the Rand Corporation and by English and French agencies emphasized the potential use of similar methods in combination with airline hijackings. But security agencies ignored these studies and instead focused on expense of such high-budget areas as the threat of nuclear terrorism or cyberterrorism. This tendency was especially pronounced in the United States, with its belief in technological sophistication as a source of power, and this belief is reinforced further in its present crusade.

Much the same can be said concerning the link between terrorism, migration, and Islam. The accession of the Republicans to power has revived certain think tanks that had been isolated under Bill Clinton. Their nativist and anti-immigrant thinking, combined with the promotion of specifically American cultural values, have found an echo abroad in discussions of "menaces from the South" and "clashes of civilizations." The thesis of Samuel Huntington hinged on the difficulties of Latino assimilation and the association of American culture with the defense of Western values in contrast to those of the Confucian and Islamic traditions. Such thinking has had an impact outside the United States, as exemplified by the post–September 11 statements by Italian President Silvio Berlusconi. In France as well, the none too subtle linkage made in the United States between terrorism and Islam tends to prevail in international discussions, even though the French and the Europeans have for years presented analyses that sharply contradict these linkages. Europe has seen a concerted effort in democratic circles to counter these alarmist discourses, yet they carry a certain media appeal, which is unfortunate because they serve to justify forms of racism and xenophobia that have an extremely negative impact on social cohesion. One can imagine without difficulty that if Islam were the second religion in the United States and if Muslims represented a similar percentage of the U.S. population as they do in France, the American discourse would be less aggressive.

The need to distance Europe from American messianic statements was understood immediately after September 11. Nevertheless, through collaboration among intelligence services, with their built-in tendency to want to monitor entire social groups, we could now find ourselves having to accept an enlargement

of surveillance of the sort that has been proposed in the United States. For example, Judd Gregg, a member of the U.S. Congress, has called for electronic and satellite surveillance and for staking out all mosques. The eventual effects may prove, at least in France and England, to be counterproductive and radicalizing of moderate individuals. The French and English governments need to take into account their own internal needs in terms of social and national cohesion. They cannot accept an expansion of surveillance that would affect a significant percentage of their populations; they must insist on a highly focused and humane use of surveillance and resist the generalized technological surveillance proposed by the Americans.

Despite sympathy for the victims and widespread indignation, it is not clear how pro-Atlantic European societies in general, and Greece and France in particular, are. Many Europeans openly criticize the policies of various American governments and their often cynical motivations, such as the CIA's role in creating the bin Laden network. Sympathy for the American population doesn't necessarily carry with it acceptance of its government's policies. It would not be surprising, then, if European protests resulted from an extension of American military strikes to countries whose ties to the attacks are indirect. These would bring together groups of the extreme left, the antiglobalization movement, and humanitarian NGOs, as well as enraged Muslim groups and community organizations from the congested suburbs surrounding large French cities.

One should not succumb to the temptation to lump these diverse groups together and label them all "anti-American." Such labeling would only serve to polarize French society. Even protests creating modest difficulties for public order should not be equated with acts of terrorism or support for terrorism. France must reject the argument of the U.K. Terrorism Act 2000, which went so far as to condemn the acts of Kurds in their own land. Too rapid an alignment with the policies of the Republican administration in Washington in the name of solidarity could accentuate expressions of anti-Americanism. It is important, then, to resist the demand to standardize policy responses in the name of effectiveness, a demand that would lead to the application of American norms in other countries. The French must take into account the specific circumstances in France and also share the knowledge that France has accumulated through experience with terrorism. In the best of circumstances, France can assist American governments to better recognize their own limitations. Only by maintaining a discourse of distance with the American government can France avoid waves of anti-American feeling and protests that would undermine French social solidarity.

France has avoided the latest wave of attacks, and it is undoubtedly not among the primary targets of the clandestine organizations responsible for them. Con-

fronted with an enemy that is best understood as elusive rather than invisible, that is able to maintain its presence in the media and the discourse of individuals and institutions even when it is physically absent, society must respond in a manner that takes into account the long-term horizon that this crisis will entail. Intense, short-term mobilizations are not necessarily the best methods to deal with a conflict that continues over time and that is unlikely to result in a clear victory or defeat. Conventional notions of warfare should not be allowed to blind us to realities: scenarios very different from those of high-intensity crises and states of emergency require their own responses. It is essential to avoid extreme responses and to resist calls to declare emergencies and the temptation to express panic. It would also be foolish to believe in the possibility of a definitive military triumph over terrorism. By keeping the situation in perspective, it is possible to take steps that over the medium and long term call into question the seriousness and competence of clandestine organizations; highlight the contradictions between their actions, their stated objectives, and their results; and restore symbolic asymmetry in power and legitimacy among actors. Societies can protect themselves with discrete and consistent actions, rather than highly visible but intermittent responses, thus avoiding giving this elusive enemy the opportunity to create situations of permanent crisis that would undermine political, economic, and social life and jeopardize the balance between liberty and security. It is imperative to insist on measures that are strictly necessary to the struggle against terrorism and adapted very specifically to these particular clandestine groups, and to refuse to equate these with forms of delinquency with which they are linked at most indirectly. Further, we must structure a new symbolic equilibrium that safeguards social cohesion and avoids discourses of polarization; these only augment the vulnerability of French society. Placing emphasis on the equality of exposure to danger, and calling upon values of civic solidarity ensures internal security in the broadest sense and creates a pact for the protection for all individuals, rather than a mere set of techniques that control territory along one's borders.

# PART II

## THE FUTURE INTERNATIONAL ORDER

# 5. LIVING WITH THE HEGEMON: EUROPEAN DILEMMAS

## WILLIAM WALLACE

The tragedy of September 11, 2001, demonstrated that the United States now shares the vulnerability that globalization had long since brought home to Europe's more densely packed states. The American response—the skillful application of military power, backed by active diplomacy, leading to the rapid collapse of the Taliban regime—demonstrated that America nevertheless remains the dominant global power, militarily, economically, diplomatically: capable of responding to a distant threat through instruments unavailable to any other state, without more than marginal assistance from any other state. The immediate impact of the American success in Afghanistan—achieved without significant assistance from other states, through carefully calibrated projection of force from the continental U.S.A.—has, indeed, strengthened the perception of global American supremacy, both inside and outside the United States.

West European states, the closest allies and formal "partners" of the United States in the Western international order established after 1945, found themselves sympathetic spectators, in spite of their immediate gestures of alliance, solidarity, and subsequent offers of military assistance. The United States dispatched the Taliban regime with the assistance of forces within Afghanistan and of a number of neighboring states. The Bush administration resisted any repetition of the experience of Bosnia and Kosovo, where the need to consult with allies—so it seemed to U.S. policy makers—needlessly inhibited American freedom of action for little compensating gain in military contribution from partner states. In the wake of this immediate triumph, which confirms longer-term trends in American approaches to foreign policy, the United States' European allies are thus faced with a range of strategic and tactical choices. Do they assume that American dominance within the post–Cold War global order is likely to remain unchallengeable for the foreseeable future? Do they accept, and work within, a global framework of American hegemony, to *bandwagon* as far as they can on established ties to the United States through pursuing influence at the margin; or should they seek to *balance* American dominance by building up European institutions as a competing center of power? In either case, do their relations with the United States depend on the European provision of particular

types of power—military, as well as economic—or is it possible (and acceptable to their American ally) to maintain mutual trust and cooperation between the self-consciously "civilian power" of institutionalized Europe and the militarily dominant United States? Is "partnership" within the framework of multilateral institutions that have been established over the past half century—in almost all cases on American initiative, and with active American support—still meaningful, when the historical circumstances that underpinned these transatlantic institutions have now disappeared?

## HEGEMONY—AND LIBERAL HEGEMONY

Antonio Gramsci's concept of hegemony, now widely accepted in conventional political discourse, emphasized the combination of coercion and consent that maintains structures of dominance, both within states and within systems of states. Stable structures of power depend on both material resources and ideology-dominant systems of belief. States can secure temporary supremacy over their neighbors through the use of overwhelming force and the utilization of superior technology, underpinned by the expenditure of the necessary economic resources; longer-term supremacy, however, depends upon at least a degree of acceptance by those dominated of the legitimacy of the dominant power. All formal or informal empires have proclaimed legitimizing ideologies, with greater or lesser degrees of success. Islam provided the motivating force and rationale for Arab conquest of North Africa, Persia, and Central Asia, and maintained a succession of regional orders over the centuries that followed. Napoleon Bonaparte's modification of the ideology of the French Revolution into a doctrine of popular mobilization and administrative modernization provided the legitimacy that recruited divisions of German, Polish, and Dutch troops to march with the Grand Army to Moscow in 1812. The absence of a broader rationale for German hegemony was a crucial weakness in the Nazi regime: apart from a handful of would-be collaborators, it could depend only on coercion outside its borders, provoking resistance that tied down its forces and dissipated its resources.

Theories of liberal hegemony—from Arnold Toynbee, Charles Kindleberger, Robert Gilpin, and others—have provided a rationale for American engagement in the construction and maintenance of global order since 1945. Toynbee looked back to a succession of previous international orders in which dominant powers had established structures of custom, law, and institutionalized diplomacy, which prolonged dominance and enabled the dominant power to maintain its position through prestige and authority as well as through the distribution of resources and the threat, and use, of force.

Kindleberger and Gilpin focused more directly on the nineteenth-century period of British dominance as a historical precursor for the American role after World War II. The English-defined gold standard and the English doctrine of free trade briefly nurtured global (or at least European) economic expansion, while the British navy suppressed piracy and the slave trade, and British political leaders and lawyers laid down rules for international diplomacy and crisis management. Competing imperialist ideologies—Russian, French, German, Italian, Japanese—brought a reversion to economic protection and international rivalry; Germany's rapid growth to industrial and scientific leadership in the final decades of the nineteenth century, followed by a military and naval expansion which was a clear challenge to Anglo-Saxon preeminence, then brought the long peace of nineteenth-century Europe to a catastrophic end in the Great War of 1914–18.

Nineteenth-century Britain, however, was never as unchallengeable in terms of economic or military supremacy as the United States is today. Militarily, the collapse of the Soviet Union has left the United States without any competitor in terms of investment in advanced technology or in deployable forces. The long time scale of military research, development, and deployment implies that no serious challenger to the United States is likely to emerge within the next 15 to 20 years, at least not in terms of the provision of conventional, organized forces. "Asymmetric" warfare by state-sponsored terrorist groups remains, of course, an active threat; but America's ability to project military force across the globe is likely to remain unique. There is no indication of any other state, or group of states, willing to make the sustained investment needed to acquire such capabilities, or with the resources to support such sustained investment.

British hegemony was undermined partly by its loss of markets and of industrial and technological leadership to Germany. After the sustained economic growth of the 1990s, which was supported by technological innovation across a range of sectors, the United States appears unchallengeable within the global economy, at least within the medium term. With the country skirting recession in 2001–2, however, it is worth remembering the rapidity with which economic recession has brought shifts from optimism to pessimism in the past, and might do so again. In the late 1980s, budgetary and trade deficits, accompanied by slow growth, provoked a succession of studies of American "decline" and of the dangers of imperial "overstretch," of which Paul Kennedy's *The Rise and Fall of the Great Powers* (1988) was the most widely read. The Japanese economy, widely seen as the strongest and most technologically advanced national economy in those years, has since then fallen back to apparent stagnation, remarkably rapidly.

There *are* a number of structural weaknesses in the American economy, most notably the scale and persistence of its trade deficit and its increasing dependence on imports of energy. A shift in the balance of economic growth between the United States and Europe, accompanied by a shift in the dollar-euro exchange rate, might well bring a parallel shift in perceptions of economic strength and weakness. European governments would be wise not to assume that such a shift will follow the introduction of the single currency; it may however be noted that the last period of European optimism and American pessimism accompanied (and in part reflected) the surge in economic integration launched by the Single European Act in 1986. Continued economic growth within China may also have a cumulative impact on American economic competitiveness and confidence. Over the medium term, U.S. economic hegemony is thus not as secure as U.S. military supremacy.

Liberal hegemony, however, also heavily depends on the consent that comes from acceptance of the legitimacy of systemic leadership. The Western international system established under U.S. leadership after 1945 embedded political and economic values in multilateral institutions accepted as authoritative by America's allies and partners. The U.S. administration at the end of the Second World War engaged, as John Ikenberry (1998) has put it, in "constitutional politics in international relations." Washington officials deliberately encompassed America's dominant position in military and economic terms within the constraints of an institutional order, which reassured its dependent allies that the United States would remain committed to multilateral cooperation and to political and economic stability. Through these institutions those dependent allies were provided with a voice to influence American decisions. American dominance was to some extent diffused through the United Nations, the International Monetary Fund, the World Bank, the Atlantic Alliance, and the many other global and regional agencies established under U.S. leadership. For 20 years after 1945, it was almost unthinkable for American policy makers to find themselves outvoted within any of these institutions; American assumptions and perspectives continued to set the agenda, while allowing political leaders from other states a sense of participation in joint decisions. Western European economies recovered under benign American guidance and economic assistance; western European armed forces were rebuilt with transferred U.S. technology, within NATO guidelines. American prestige retained its aura of distinction as the countries of "the free world" in western Europe and East Asia became less dependent, more plausible partners who might share America's global burdens in resisting Communist expansion and assisting the economic development of the Southern Hemisphere. The Kennedy administration launched its "grand design" for a

strengthened Atlantic Community, its transformation of the Organization for European Economic Cooperation into the broader Organization for Economic Cooperation and Development, and its declaration that the 1960s were to be "the decade of development," in the confident expectation that America's partners would accept the rationale for its initiatives and continue to follow its lead.

By the early 1960s American economic domination had weakened, as a consequence of U.S.-assisted dynamic growth within western Europe and Japan. The challenge to its international *political* leadership came from outside these close allies, however, as the new states whose case for independence U.S. diplomacy had vigorously supported flocked into international institutions, caucused as the Nonaligned Movement (and later as the G-77), and allied with the Soviet Bloc in challenging the U.S.-led multilateral agenda. The deepening U.S. involvement in Vietnam further weakened U.S. confidence and its balance of payments and international reputation. Nevertheless, Robert Keohane's classic study, *After Hegemony* (1984) was mistitled. American leadership persisted through the 1970s and 1980s, in spite of the decline of U.S. economic dominance and the apparent post-Vietnam decline of U.S. military supremacy, because American ideas about governance and markets retained their authority, both within international institutions and within other advanced democracies. Within the Third World, authoritarian governments and revolutionary movements rejected U.S. domination as they saw it, looking to Soviet or Chinese models for alternative inspiration. As the sclerosis of the Soviet system became apparent, however, and the Chinese themselves rejected the brutalities of the Cultural Revolution, even the flawed qualities of the American model regained their appeal. Joseph Nye, in *Bound to Lead: The Changing Nature of American Power* (1990) rightly drew attention to America's reserves of "soft power," reflected in the wide international acceptance of "Western" values and market principles, the prestige and influence of American universities and research institutions, and the broader cultural influence of the largely American English-language media. American power might be more effectively exerted indirectly than directly, through the half-conscious acceptance by elites within other states of American assumptions about domestic and international order.

Part of the paradox of the resurgence of American economic and technological supremacy in the 1990s, together with the demonstration (first in the Gulf War and then again in the intervention in Afghanistan) of American military dominance, is that these have been accompanied by a weakening of American "soft power." American prestige, both abroad and at home, has suffered from domestic political and economic scandals (as in the 1970s). The disappearance of the Soviet Union deprived the United States of its most-easily accepted rationale

for global engagement, which also legitimized American leadership of the Atlantic Alliance and the broader "free world." Between the Gulf War of 1991 and the Afghan intervention of 2001, the visible hesitancy with which American policy makers approached the deployment of U.S. power in Somalia, Bosnia, and Kosovo, and the preoccupation with "exit strategies" from the point of entry on weakened the respect of America's allies for its military and political leadership. A further paradox of American supremacy is that what is perceived within the United States as "resentment" at its liberty and prosperity, as "anti-Americanism" on the part of hostile outsiders, has partly flowed from the spill-over of domestic controversies onto the international stage. The "global" NGOs that demonstrated against U.S. domination of the global economy at the WTO meeting in Seattle were largely American-led. The narratives of antiglobalization and the corruption of free market capitalism have drawn upon American critiques as well as on diatribes from other countries, and have been disseminated across the world through English-language media.

A further paradox is that the collapse of state socialism, and the apparent "victory" of market democracy as the model for political and economic order has led not to the "end of history" that Francis Fukuyama proclaimed but to a greater emphasis on the differences among approaches to market democracy. The Malaysian prime minister Mahathir bin Mohamad and others laid great stress in the immediate post–Cold War period on the claimed superiorities of the "Asian model." The most delicate and difficult dialogue on the values which underpin market democracy has, however, been across the Atlantic: between an American model that emphasizes free markets and a limited role for government in social welfare and European "social market" models, which—in differing ways—lay greater stress on the regulation of employment and on the provision of welfare. American charges that European social democracy has led to "Eurosclerosis" have been met by European charges that American-style capitalism carries unacceptable social costs. The symbolic importance of capital punishment as an issue in transatlantic relations is that it encapsulates the differences of approach: the American belief in a more vigorous culture of success and failure, of reward and punishment, against the European concern with social harmony and community as necessary components of a liberal economy—or the Old Testament certainties of good and evil, reward and punishment, within America's religious culture against the secular culture of urban Europe. Here again, the division of opinion is partly a reflection of differences *within* the United States, as well as between the United States and other democratic states. The Republican attack on "big government," which has in many ways defined the issues of American politics during the 1990s, attracted limited support within Europe. Most European right-wing

parties remained closer to the traditions of Christian Democracy and state-centered conservatism. Furthermore, from the mid-1990s onward the majority of European governments were center-left rather than center-right. The international spillover of the Republican attack on Democratic "big government" and Democratic "internationalism" was that American "values" have come to be rhetorically presented, not only by leading senators and congressmen but also by the Washington intellectuals who dominate the Op-Ed pages—as distinctive from those of America's partners and allies, rather than as universal.

Geir Lundestad has described the U.S.-led Atlantic "community" of the past half century as *Empire by Invitation* (1998). The United States, as a self-consciously liberal hegemon, operated through multilateral institutions that disguised, legitimized, and moderated its dominance and provided a narrative (or rationale) of common values shared by the "free world," which were declared to be universal in their application. A central difficulty for the United States' European partners, in responding to the current reestablishment of American military and economic dominance, is that the rhetorical justification for this dominant position is more often couched in realist than in liberal terms: with reference to U.S. national interests rather than to shared global values and concerns, with self-conscious unilateralism rather than U.S.-orchestrated multilateralism. The consensus within Congress and within the Washington think-tank community had turned against global institutions in the course of the 1980s, as images of corruption and anti-American bias replaced earlier assumptions about cooperation in pursuit of shared values in the face of Communist obstruction (Luck, 1999). In the 1990s the consensus appears to have been moving also away from cooperation with allies, away from disguising the hard realities of U.S. dominance within the softer clothes of multilateral partnership, toward a determined—even hard-nosed—assertion that U.S. interests come first and that there was nothing that America's partners had to contribute in defining America's short-term or long-term interests.

## BANDWAGON OR BALANCE?

European governments are therefore faced with a harsher choice in responding to the reassertion of American leadership than their predecessors were in responding to President Truman's formulation of shared values across the "free world," or to President Kennedy's grand design for "Atlantic partnership," or even to President George Bush's 1991 evocation of shared values within a "new world order." The current rhetoric of "American values" and "national interest" is far less inclusive. European governments are offered a choice between "follower-

ship" behind assertive American leadership or resistance to American leadership—which necessarily implies a search for an alternative focus for power and influence sufficiently strong to demand American attention.

Over the past 40 years, British governments have characteristically adopted a "bandwagonning" stance: declaring their firm support for American strategic goals while attempting from within that overall stance to influence American policy at the margin. French governments, on the other hand, have characteristically resisted American strategy, while at the same time attempting to persuade their European partners to combine in a caucus, which could collectively hope to counterbalance American dominance of Western diplomacy. The dependence of western European states on American military commitment during the Cold War limited the attractions of this balancing strategy for other states, the German government most of all. European governments deliberately diverged from the line set by American leadership for Middle East policy in 1973–74 and again in 1981, which provoked sharp transatlantic disagreements and resulted in a retreat by these countries from the autonomous approaches they had briefly adopted. Even before the outbreak of transatlantic differences on the Middle East in 1973, Henry Kissinger's "Year of Europe" speech had spelled out to America's European allies the Realist doctrine that military power and economic cooperation were intrinsically linked and that western Europe's continuing dependence on the United States to provide security required its governments to bend their international economic policies to fit American preferences.

British and French approaches to U.S. leadership have to some extent converged since the end of the Cold War. For example, both were determined to provide ground, air, and naval forces to support the U.S.-led coalition to expel Iraq from Kuwait in 1991, in order to demonstrate their significance as American allies. The experience of Bosnia, however, demonstrated to both British and French policy makers that a greater capacity for autonomous military operation was needed to avoid being forced to follow U.S. policy without gaining significant influence over its direction: that a balancing caucus was needed to counter U.S. domination. This led to the 1998 Franco-British initiative on European defense, which set out the objective of achieving not only a much greater degree of integration among European military forces but also of establishing a degree of "autonomy" for EU member states within NATO—an objective that successive U.S. administrations had firmly resisted. At the Helsinki European Council in December 1999 the EU heads of government committed themselves to a series of "headline goals" for deployable military forces, to be operational by 2003. By the end of 2001, however, the progress toward achieving these goals in practice appeared very modest.

In the wake of the attacks of September 2001, not only the British but also the French and German governments chose explicitly to bandwagon rather than to balance: to declare their active support for the American response, and to offer military contributions toward it. (It should be noted that the French government, in particular, took this stance in the face of considerable opposition in the domestic media.) Tony Blair, the British prime minister, went furthest in declaring active sympathy for the American predicament and support for the American response; he gained considerable popularity from this within the United States, although it remains unclear to what extent he gained any significant influence over aspects of American policy. All three of these major European governments appear to have chosen explicit support for current U.S. policy in the hope of gaining some degree of constraint over future American options. Their calculation has been that the threat of withdrawal of support by the United States' most active allies might serve to tip the balance among Washington policy makers considering the range of possibilities, over further military action against Iraq, for example—bandwagoning now in the hope of improving the chances of successful balancing later.

Transatlantic economic relations have of course been for many years much more a matter of balance among relatively equal powers than of leadership and followership. The EU is an effective force in global trade negotiations, a standard setter in international regulation, and a challenge to the extraterritorial reach of American antitrust policy as applied to multinational companies—and it is therefore a necessary partner in developing global competition policies. World trade negotiations through successive trade rounds have revolved around transatlantic bargains between the EU and the United States, to rising discontent from other parties to the negotiations. The supremacy of the dollar and the close links between the Washington-based international financial institutions and the U.S. Treasury have, however, maintained American dominance over crucial areas of global economic management. In the shadow of the attacks on the World Trade Center and the Pentagon, it is possible that the successful launch of the euro as a tangible currency across 12 of the 15 EU member states, now visibly available as an alternative reserve currency and store of value, may prove in the long term to give the EU the capacity to balance the United States in another major area of global public policy.

## CURRENCIES OF POWER

One of the most difficult issues for America's European partners to address is what balance to strike between military power, diplomatic activity, and economic

influence, and how to respond to the greater emphasis American policy makers characteristically place on military power. West European governments depended on the United States for security throughout the Cold War. The United States maintained 12 divisions, two fleets, and substantial air forces in and around the European theater, backed by strategic and tactical nuclear weapons. Within this Atlantic security framework, institutionalized European integration developed as a self-consciously "civilian" power, using the instruments of financial assistance and trade concessions to persuade its neighbors and partners to cooperate.

The enlightened self-interest that led U.S. administrations to underwrite the economic and political recovery of western Europe after 1945 and to extend an American security guarantee, lay partly in the expectation that the rebuilding of European state structures and economies would in time enable those states to shoulder a larger share of the "burden" of global order and global development. American policy makers saw burden sharing both in military and in economic terms: anticipating that within NATO the European allies would progressively replace the conventional U.S. contribution to the common defense, and that within the U.N. system and through bilateral economic assistance they would provide a progressively larger financial contribution to the pursuit of shared Western objectives. The question of potential linkages between burden sharing and policy sharing remained unexplored; U.S. policy makers appear to have assumed that their European partners would continue to accept the rationales for American policy and thus to follow American leadership, even as they shouldered a larger and larger proportion of the costs of the defense and promotion of Western values.

In practice, the United States continued to provide by far the largest contribution to Western defense throughout the 1970s and 1980s, while becoming more and more discontented with its contributions to economic development in other countries and to international institutions. Since then the continuing shrinkage of U.S. aid programs and congressional resistance to contributions to multilateral institutions and its active support of high levels of military expenditure even after the Soviet threat had disappeared have tipped the budget for American foreign policy heavily toward military power at the expense of instruments for exerting economic influence. European governments, in contrast, took their "peace dividend" in the form of deep cuts in military expenditure, while largely maintaining expenditure on nonmilitary aspects of foreign policy. As a result, the United States now accounts for some 40 percent of global military expenditure, while the EU collectively accounts for 25 percent. The United States is battling to reduce its 25 percent contribution to the budgets of the United Nations and U.N.

agencies, while EU states collectively contribute 40 percent to the U.N.'s regular budget and 50 percent to agency budgets and the costs of peacekeeping.

There is, however, no basis for mutual understanding across the Atlantic on the appropriate exchange rate between these different currencies of power and influence. The Realist conception, which underpins the Bush administration's foreign policy, emphasizes the determining importance of military power, which it effectively demonstrated once again in its projection over Afghanistan. The logic of this position is that European states must invest a great deal more in deployable military forces if they wish either to balance American dominance or to exert greater influence over the direction of American policy; that the instruments of "civilian power" are the small change of global influence. There is, however, little domestic support within any European state for significant increases in defense spending, while at the same time there is frustration among political elites that substantial expenditure on international economic development, even when (as in Palestine) in support of declared U.S. objectives, has not earned these states significant influence over the policies which the hegemon pursues.

In summary, the United States has moved toward a foreign policy biased toward coercion, while European states have moved further toward dependence on foreign policy instruments focused on the generation of consent. The perspective predominant in Europe is that American policy makers overemphasize the politico-military dimension of international politics; the predominant American perspective is that European governments place far too much faith in diplomacy and economic aid. Divergent attitudes to the threat posed by a new wave of revolutionaries who reject the Western model of modernization reflect these opposing biases in their approaches to world politics. The rhetoric of the Bush administration, of the Congress, and of the U.S. media is that the United States is "at war" with global terrorism: that there is a clear target, which must be attacked and defeated. The understanding of European governments, informed by the bitter experiences of combating terrorism within Europe over the past generation—in Ireland, in Italy, in Germany, and in Spain—is that terrorism cannot be defeated through military means alone: that a combination of state reconstruction, economic development, negotiation, policing, intelligence, and military power is necessary to "drain the swamp" within which terrorism breeds.

## IS PARTNERSHIP POSSIBLE?

American rhetoric about transatlantic partnership was always a little disingenuous, offering junior partnership within an American-led community rather than an effective partnership of equals. Nevertheless, multilateral rhetoric and multi-

lateral institutions made it easier for European governments to accept American leadership and to persuade their domestic publics that they had gained a degree of influence over American policy in return. From the 1960s through to the 1990s, the United States resisted any moves toward an autonomous European group within NATO, but successive U.S. presidents did pay lip service to the multilateral quality of NATO, participating in regular summits and bilateral consultations of a quality which persuaded all but Gaullist France that the consultative partnership offered was a bargain worth maintaining. With the partial exception of global financial regulation, where U.S. administrations have remained determined to maintain their key role within the IMF, partnership in global economic policy has become much more substantial. Thus, the most difficult test for continuing hegemony—for continued acceptance by America's dependent partners of the legitimacy of its dominant role—lies in the politico-military domain.

In Afghanistan, the United States has now demonstrated that it can go it alone in managing a crisis and defeating a distant but weakly armed opponent. American policy makers were determined to prevent their Afghan operations from becoming entangled in the multilateral coils of NATO and thus permitted only a handful of forces from a small number of allies to assist the American-led effort. But the United States has not yet demonstrated that it can build a stable peace within western, central, and southern Asia without a broader coalition to sustain a longer-term strategy. The implication of administration rhetoric and requests for assistance from allies has been that the long-term process of rebuilding domestic order and a working economy can be shouldered primarily by others, after the United States has defeated the immediate military threat. Such a division of responsibilities is unlikely to be welcome or acceptable, however, without both some appearance of continuing consultation and some definition of shared objectives and values sufficient to legitimize the demands the United States wishes to make. A world in which American policy makers proclaim that "superpowers don't do windows" or that "it is not the job of the 101st Airborne to help children across the road," while expecting their allies to shoulder the burden of these essential but subordinate nation-building tasks, is one in which American power is likely to be increasingly resisted rather than welcomed. U.S. power can be successfully exerted in a crisis without waiting for the consent of other friendly states; but if the consent of those friendly states is taken for granted over an extended period, it will cease to be offered so willingly, and may in time be withdrawn.

The dilemmas European governments face in the aftermath of September 11, 2001, in responding to the expectations of their American hegemon are acute. They have to recognize that Europe as a region now matters far less to the United

States than it did during the previous half century, as American attention has turned to the Western Hemisphere and Asia. They have to weigh up the arguments for greater investment in military power, partly in response to U.S. expectations and partly as a means of counterbalancing U.S. power. They have to pursue opportunities to influence the direction of U.S. policy in circumstances where American tolerance for multilateral channels of consultation have declined. They have to respond to American requests for support and assistance without having had the opportunity to share in formulating the policy that has set the context within which those requests are made.

There are, however, dilemmas for the United States as well. Hegemony rests on consent as well as on coercion, as has been argued above; and consent has to be generated and maintained through the provision of persuasive leadership and through reference to a universal set of values. Liberal hegemony requires dominant powers to present the pursuit of their enlightened self-interest as being in the common interests of civilization as a whole. Explicit references to direct and immediate national interests, a rationale for foreign policy that stresses the exceptional and exclusive interests of the United States compared to those of its partners, resistance to multilateral regimes that diffuse American leadership within frameworks of shared rules and obligations—all of these weaken the "soft power" of American prestige and reputation on which the informal empire of this hegemonic world order depends.

The Founding Fathers recognized that "a decent respect for the opinions of men" outside the North American continent required them to frame the rationale for independence in terms that foreign as well as domestic audiences might accept. U.S. political leaders and intellectual elites in the post–Cold War world have found it easier to address their domestic audience than their partners and allies beyond North America when they describe their framework for foreign policy, not recognizing that in the long term this may threaten the ability of the U.S. to generate the "coalitions of the willing" needed to support American objectives across the globe. Where economic and financial instruments are required, America's European partners are essential to such coalitions; where peacemaking and nation building operations follow the resolution of immediate crises, they have greater resources and skills than any other group of states. Those instruments and resources will continue to be readily available in support of American interests only if American policy makers continue to invest in a multilateral rationale for U.S. dominance, rather than asserting that U.S. dominance is a reality that other states must—willingly or unwillingly—accept. Hegemony rests upon a range of resources: hard military power, economic weight, financial commitments, and the "soft currency" of hegemonic values, cultural influence,

and prestige. Rather than requiring a massive expenditure of budgetary resources, soft power costs political time and investment and imaginative leadership, to persuade the states in the shadow of the hegemon that they share in a common enterprise, and that they are not being coerced to follow an agenda set over their heads.

# 6. AFTER BALANCE-OF-POWERS DIPLOMACY, GLOBALIZATION'S POLITICS

## LUIZ CARLOS BRESSER-PEREIRA

The Cold War was not all that ended with the September 11 events. The centuries' old balance-of-powers diplomacy was also eclipsed. While the conflict between the United States and the Soviet Union ended in 1989 with the collapse of one of the contenders, international policy makers and analysts continued to behave as if the world remained divided between two conflicting superpowers. After the September 11 tragedy, however, it became apparent that the foreign policies of the remaining superpower, as well as those of intermediate powers, required substantial revision; a new international order must be conceptualized and developed. The basic premise upon which the old order was built—that conflicts can be resolved through war or the threat of war—no longer made sense. While military power continues to be a relevant factor in international relations, it has become clear that the history of diplomatic relations could no longer be reduced to a chronicle of wars or threats of war between empires or nation-states.

September 11 demonstrated that other nation-states are no longer the source of major threats faced by the United States and other major powers. These nation-states are now merely competitors in the global marketplace. The real threats now come from terrorism, from diverse kinds of religious fundamentalism, from the drug trade, from climate change, from financial instability due to uncontrolled international money flows, from situations of extreme poverty coupled with stagnation still existent in some parts of the globe, particularly in Africa, and from the perception of long-term economic decadence and exclusion that haunts some regions and ethnic groups, particularly in the Middle East.

The new obvious enemy that emerges from the events of September 11 is international terrorism, although it is unlikely that any country will dare to harbor and support terrorism in the aftermath of the U.S. attack on Afghanistan. Some countries may be quite friendly to U.S. leadership in the world while others may be less so, but no nation is in a position to become a real threat to the United States or to other major democratic countries in the world. Balance-of-powers or conflicting-powers diplomacy is over. The question now is, what kind of international order will replace it, given the changing nature of threats facing the world powers. My guess is that globalization—up to now an economic phenomenon

with powerful consequences in the arenas of development and distribution—will require more political guidance than ever. I suggest that under these circumstances, the old idea of international governance, which always seemed utopian to Realist theorists and politicians, is now an actual possibility. We will continue to witness resistance to it in the United States, but isolationist policies as well as pure hegemonic behavior will conflict more and more with true national interests.

The central problem faced by nation-states with respect to foreign affairs is no longer war or the threat of war, but how to take better advantage of the opportunities offered by international trade and finance. The issue facing political leaders is how to win rather than lose in an international arena essentially characterized by win-win trade games, but in which some tend to gain more than others. Thus, instead of diplomacy being defined by political-military conflict, what we will increasingly see is a global diplomacy in which the central issues are the rules of international trade and finance, as well as those for immigration and multicultural life within nation-states.

In other words, a new international order, which has been emerging since the end of World War II and the foundation of the United Nations, became dominant after the September 11 events. The old international order was the conflicting-powers diplomacy; the new order that is emerging I call in this essay globalization's politics. The substitution of the word "politics" for "diplomacy" is not accidental: it has a meaning that I will discuss below. Conflicting major nation-states required diplomatic activity, and a global world will continue to require diplomacy, but more than that, it will demand political action. Diplomacy and politics were never opposite activities, but they will be increasingly related, if not identical, in the new international order.

## NATION-STATES CEASED TO BE ENEMIES

International relations have been viewed in terms of actual or potential clashes of superpowers for centuries: France vs. England, Spain vs. France, Spain vs. England, Germany vs. France, England vs. the Ottoman Empire, the Austro-Hungarian Empire vs. Napoleonic France, the Ottoman Empire vs. the Austro-Hungarian Empire, and so on. The Cold War was the last chapter of this conflicting-powers diplomacy—a period in which the conflict remained "cold" and did not turn into war. However, the many regional wars of the second half of the twentieth century are generally attributed to the displacement into Third World settings of the U.S.-Soviet conflict. When the Berlin Wall came down and the Soviet Union fell apart, analysts immediately acknowledged that only one superpower remained, but this did not keep them from searching for the new great

world power that would become the United States' next competitor. China was the most obvious candidate, because of its size and the dynamism of its economy. Others were also suggested. Yet given China's manifest interest in peaceful trade and the violence implicit in the clash-of-civilizations hypothesis, international relations analysts had to look for new threats. The category of "rogue nations" was introduced as the new enemy from which the United States had to protect itself, and the National Missile Defense strategy was put forth to accomplish that.

These analyses made little sense since they inappropriately applied Cold War logic to changed international situations. Scholars and policy makers were unable to consider the new historical circumstances or uninterested in doing so and insisted on applying traditional intellectual frameworks in their attempts to understand changing realities. In the wake of September 11 there was an incentive to determine that current realities were linked to military interests. Yet although dramatic events like those of September 11 may not change entrenched interests and dogmatic views, they may have the power to clarify the nature of historical change.

After September 11 it became clear that the United States no longer has enemies among nation-states. Today, no country in the world represents a real military, economic, or ideological threat to the United States. Some countries are friendlier than others. Certain small countries, like Iraq or North Korea, and Afghanistan before the Taliban's defeat, may be regarded as unfriendly, but though they may be threatened by American power, none of them represents or represented a real danger to the United States. They know very well that if they initiate an attack against the United States, legitimate retaliation will be immediate and overwhelming. They were well aware of this before the defeat of the Taliban regime. On the day of the terrorist attacks on the Twin Towers and the Pentagon, Afghanistan was the first government to declare it had nothing to do with the attacks. Although war may have been the first response to the terrorism, it will not be the major strategy for fighting and defeating it.

It would be misleading to conclude that the United States has ceased to have real enemies among nation-states because of its military strength. I suggest that there is a more general and relevant reason for the end of the conflicting-powers politics that is also valid for the intermediate powers such as China and Russia; France, Germany, and Britain; Italy and Spain; or Brazil and Mexico. Among the intermediate powers, only India and Pakistan still see each other as enemies, or potential enemies, owing to the Kashmir conflict. As soon as this is resolved, they will join the prevailing category of competitors instead of war-threatening countries. Among the small nations, the Israeli-Palestinian conflict remains the most dangerous one. There are other territorial conflicts among small nations, partic-

ularly in Africa, but the new emerging diplomacy will have to tackle them in reasonably impartial terms.

Regional conflicts represent an unacceptable threat to economic security. In a global world, where respect for property rights is essential, such conflicts have to have a solution—in most cases, some form of compromise. International arbitration to resolve such conflicts should be reasonably impartial because parties would not accept decisions unless they are based on impartial principles, and they would continue to challenge them. States would rely on force, and, sooner or later, new conflicts would arise. The fact that the arbitrators would impose their decisions does not represent a problem—courts, which are in principle impartial, impose their decisions—but it is essential that the imposed decision have some legitimate reference to the concept of justice.

## WAR CEASED TO BE THE WAY OF RESOLVING CONFLICTS

Among major nations of the world today, it is unthinkable to consider war as an acceptable way of resolving conflicts. This is not so much due to fear of retaliation as to other factors. First, classical imperialism—the strategy of subjugating other people by force and colonizing or taxing them—is implausible today. Second, following a long and difficult process, territorial conflicts, which had previously been resolved only through wars, are now mostly settled. Finally, the common economic interest in participating in global markets far outweighs any remaining conflicting interests.

War was the standard "international" behavior among precapitalist tribes, city-states, and ancient empires. It was the mechanism that traditional dominant groups used to appropriate economic surplus, which they did by collecting war booty, enslaving the defeated, or imposing heavy taxes on colonies. On the domestic front, dominant classes always depended on the control of the state to appropriate economic surplus from peasants and merchants. Religious legitimacy was always an essential part of the process, but the very existence of empires and dominant oligarchies depended on their capacity to hold political power and wage war.

With the capitalist revolution, consolidated in England with the Industrial Revolution, a new and enormously significant factor emerged. The internal appropriation of economic surplus ceased to depend on the control of the state, as it now took place in the market, through the realization of profits. Markets, wage labor, profits, capital accumulation, technological progress, and innovation became the key economic elements that a new polity was supposed to assure. The modern state began to emerge in twelfth-century Italian republics in order to

organize and guarantee long-distance trade. The first nation-states material-ized three or four centuries later as an outcome of the alliance of kings with a bourgeoisie seeking to make markets free and secure within large territories previously divided among feudal lords. State institutions—essentially the legal system—which had already been highly developed in the Roman Empire, gained importance as a guarantor of merchants' property rights and contracts.

In this new historical context, military power continued to play an essential role, as it was required to defend the nation against external enemies, and, fur-ther, it supported the strategy of the new nation-states to open new markets and to assure access to strategic inputs. During the nineteenth and the first part of the twentieth centuries, history was essentially the story of how capitalist countries defined their national territories and developed modern empires to assure mar-ket monopoly over large territories. In this period, the first nation-states were able to consolidate their capitalist revolutions, to assure the rule of law, to de-velop liberal institutions, and, finally, to transform their authoritarian regimes into modern democracies. These are the developed countries of today. Some of the countries left behind, such as Brazil, Mexico, Argentina, India, China, the Asian tigers, and South Africa, were able to achieve a capitalist revolution in the twentieth century, and today are the intermediate developing countries. A third group of countries has not yet been able to complete a capitalist revolution and remains mostly at the margin of global economic growth.

As countries evolved into modern and wealthy democracies or into interme-diate developing economies, their national territories became well defined. Con-currently, their interest in maintaining imperial power decreased as newly independent countries opened their markets to foreign trade and colonies in-creasingly resisted foreign rule.

Conversely, the moment when a country's territory is well defined and further imperial expansion no longer makes sense as a national strategy, war ceases to be an affirmative way of achieving economic development. It is not by accident that Japan and Germany, the two major countries defeated in World War II, devel-oped extraordinarily in the postwar period without being tempted to rebuild their military power. One may argue that this was a condition imposed by the United States in the aftermath of World War II, but what we see presently is just the opposite. The United States is pressing these two countries to rebuild their military capacity in order to participate more actively in international security actions.

Thus, in a world in which economic surplus is achieved through profit in markets, and where markets are open all over the world, war or the threat of war has lost most of its classical appeal in the life of nations. The last "war"—the Cold

War—may be interpreted alternatively as a conflict between statism and capitalism, which capitalism won, or as the attempt by some underdeveloped countries to speed up industrialization through bureaucratic control, or as the last chapter of resistance from some large countries (particularly Russia and China) to opening their economies to global capitalism. It is likely that all three interpretations shed light on some aspects of the Cold War, but here I would like to highlight the last one. The resistance of the Soviet Union and China to opening their economies was not solely rooted in the classical protectionist arguments. They also sought legitimacy in distorted socialist ideas. Soviet statism was designed to be an economic and ideological alternative to capitalism and liberalism. In fact, it was just a protectionist and statist industrialization strategy that closed a large portion of the globe to international trade for decades. While the Soviet Union still existed, and while China was under Mao Zedong's rule, their economies remained separate from global capitalism.

## GLOBALIZATION IS THE NEW GAME

It is not a mere coincidence that the word "globalization" gained dominance after the Soviet Union collapsed and China made overtures to the world and to capitalism under Deng Xiaoping. They were the two major countries that had remained closed to global markets. As soon as they opened up, globalization became a fait accompli, and wars to open markets lost meaning. Furthermore, the collapse of the Soviet Union completed the process begun in World War II of defining most national borders. For centuries, war was extensively used as a tool for national consolidation, but now we have to look for other instruments and different behaviors if we expect to understand the emerging patterns of international relations among nation-states. The era of conflicting-powers diplomacy is over. It is true that the events of September 11 were followed by a war, but it has been an entirely different kind of war that more resembles an extreme form of international policing.

The configuration of global capitalism took centuries and was marked not only by technological change and economic growth but also by the consolidation of two basic and complementary institutions, the nation-state and the market. Nation-states emerged in the sixteenth century in France, England, and Spain, a period of mercantilism and absolute monarchies. The liberal revolution against excessive market regulation by the state began with political revolutions, first in England in the seventeenth century and in the United States and France in the following century. It reached a high moment in the late eighteenth century with the American and French revolutions. The fact that political revolutions made

room for civil rights and liberalized markets is indicative of the complementarity of market and state. The nineteenth century was the century of competitive capitalism and liberalism, which, just as mercantilism previously had been exhausted, came to a crisis. However, the basic reason for the crisis of capitalism and liberalism was uncontrolled markets, not excessive market regulation. After the Great Depression in the 1930s, the new capitalist pattern that emerged was the welfare or social democratic state. For some time there was a dispute between centralized economic planning and Keynesian economic policies, but the latter proved to be more sensible and durable.

Like the mercantilist and liberal phases, the social-democratic phase (that spanned roughly from the 1930s to the 1980s) witnessed the continuous emergence of new nation-states and the consolidation of existing ones. Economic growth, which gained full historical significance in the liberal period, achieved momentum in the social-democratic phase. Cyclical crises continued to characterize capitalist development, but crises ceased to have devastating economic consequences. Nevertheless, a much longer cycle consisting of waves of state intervention manifested itself in the mid-1970s. Given the excessive and distorted growth of the state apparatus during the preceding decades, an endogenous crisis of the state emerged, a fiscal crisis and a crisis in bureaucratic management, and space was opened for liberal, market-oriented reforms. Concurrently, the growth of world markets at a faster pace than GDPs, the explosive rise of global financial markets, and, more broadly, the emergence of an increasingly strong net of international relations not only among nations but also among individuals, firms, associations, and NGOs led to globalization.

Today we see the effective dominance of global markets. Trade in goods, services, technology, money and credit, and direct investing abroad is not the only game in town, but it is the one that really counts. All sorts of international rules protect markets, making them open and increasingly secure. Only labor markets have not yet become global. Yet, even there, strong immigration flows toward rich countries point in this direction.

Several new historical circumstances contributed to the growth of globalization. The acceleration of technological progress, the information-technology revolution, and the reduction in transportation costs combined with the end of the Cold War, the increasing pressure from the dominant U.S. economy for trade liberalization, and the increasing acceptance that international trade may be a win-win game, were the factors that changed the world in the last quarter of the twentieth century.

Globalization is a set of economic relations, institutions, and ideologies that are mostly controlled by rich countries. Globalization is different from "global-

ism." Globalization is an economic and technological fact with political conse-
quences, whereas "globalism" is just one of these political consequences: an ide-
ology that asserts, first, that there is now an international community that exists
independent of nation-states, and second, that the nation-states have lost the au-
tonomy to define their national policies and have no alternative but to follow the
rules and restrictions imposed by the global market. Although there is a grain of
truth in the second assertion, nation-states remain powerful and retain a sizable
degree of independence in defining their policies. Contrary to certain naïve per-
spectives, developed democracies do not follow a single economic model, the
American model. There are three additional models: the Japanese, the Continen-
tal European, and the Scandinavian.

## GLOBALIZATION REQUIRES STRONG STATES

Both the endogenous crisis of the state and globalization, which implied a rela-
tive reduction in nation-states' autonomy to define policies, led ultraliberal ana-
lysts to predict or to preach the reduction of the state to a minimum. This was
just nonsense. Strong markets need a strong state. Globalization, to be com-
pleted, demands stronger, not weaker, nation-states. The balance between state
organization and market coordination may obey a cyclical pattern, as I suggested
in a previous work,[1] but it is not difficult to see that the countries with more free
and active markets are also the ones with more effective state organizations and
state institutions. Since the mid-1990s, when the ultraliberal ideological wave
lost momentum, this truth became increasingly clear. After September 11, how-
ever, it gained full significance. The times of small government were over.

The United States, a repository of ultraliberal strength and also the direct tar-
get of the terrorist attack, is experiencing clearly changed attitudes toward the
role of government. Confidence in government, which had been declining since
the 1960s, has rebounded powerfully. It is in times of crisis that people remember
how important government is. According to public opinion surveys in the 1960s,
confidence in government (measured by responses to questions like "Do you be-
lieve that government will do what is right?") was above 60 percent, it fell to less
than 20 percent in the 1990s. After the September 11 events it returned to 1960s
levels.[2]

However, as a sad trade-off, some civil rights were summarily eliminated in
the United States under the rubric of fighting terrorism. The Bush administra-
tion secretly detained more than 600 foreigners, suspended attorney-client right
to secrecy, instituted racial profiling, and extended powers of government sur-
veillance and trial by special military tribunal. *The Economist* characterized these

"disturbing" executive decisions as "not quite a dictatorship."[3] Indeed, we cannot speak of dictatorship, but there is no doubt that the measures threaten freedom. The fight for civil rights has a long history. Americans, from the time of their Founding Fathers, always played a major role in this battle. The last relevant episode was President Carter's fight for human rights. Just as there is a necessary, although ever-changing, balance between state intervention and market allocation of economic resources, there must be a balance between civil rights and national security. Yet, as we know well in Latin America, where military regimes prospered from the mid-1960s to the mid-1980s, the first argument that authoritarians use to justify limits to civil and political rights is the need for national security. The September 11 events had the positive effect of reminding us of the importance of government and good governance, but represented a dangerous retreat from the consolidation of civil rights. I believe that this is a temporary problem and that the tradition of protecting civil rights and democracy will eventually prevail, but it is clear that it will be just as necessary to fight for civil rights as it is important to fight against international terrorism.

If we look carefully at the direction of market-oriented reforms that have taken place since the 1980s, the more successful ones were able not only to liberalize markets but also to increase government capacity. This was consistently the case in developed countries. In Britain, for instance, we may disagree with Thatcher's reforms, but we have to admit that rather than weaken the state, they made it stronger. In developing countries this was not always true. Argentina is a case in point. This country followed, or tried to follow, all the directions coming from Washington and New York, and yet met with disaster. Privatization was chaotic and ruinous, although it may be claimed that this was a problem of implementation, not of conception. In the case of macroeconomic policy, however, this excuse does not apply. Given an obviously overvalued currency, badly needed fiscal adjustment proved unfeasible, because expenditure cuts were not accompanied by GDP growth and increased revenues as long as entrepreneurs showed no confidence in investing, nor wage earners in consuming. The IMF demanded fiscal adjustment but accepted the currency overvaluation. In sum, reforms and fiscal adjustment were poorly designed and coupled with incompetent macroeconomic policies: they weakened the Argentine state instead of making it stronger, and led the country to a severe economic and political crisis in late 2001.

Argentina's crisis came to a head just after the September 11 events and served to draw attention to the need for stronger states that are fiscally sound and administratively competent in an era of globalization. The nation-state remains the basic political unit where collective interests and citizenship are guaranteed.

Globalization makes states more interdependent, not weaker. An orderly and secure globalization requires competent and strong state organizations.

If we can historically distinguish the rise of republican, liberal, democratic, socialist, and, again, republican ideals not as conflicting but as concurrent political values, we can also define what we mean by a strong liberal, democratic, social, and republican state. A strong liberal state is a political system that protects freedom, property rights, and respects each gender, race, and culture. A strong democratic state is the polity that assures representative and legitimate government. A strong social-democratic state seeks full employment and equality of opportunity, and assures social rights. A strong republican state is organized to protect the environment and public economic patrimony against corruption and rent seeking. The process of globalization does not dismantle nation-states and their respective state organizations. Globalization just makes markets global, necessitating international-level regulation. Only the support of strong nation-states will make this international regulation possible.

## TERRORISM THRIVES IN WEAK, FRUSTRATED STATES

The September 11 events took place in the context of an already global world where most nation-states still remained weak and underdeveloped. The states where fundamentalism thrives and terrorism is born are poor and weak states where modernization has been frustrated. In these states, civil society is nonexistent, elites are rapacious, and government only represents elites. In the twentieth century, a number of countries, such as Japan and Italy, modernized and joined the club of rich capitalist nations. Others, like Korea, Brazil, Russia, and South Africa, completed their capitalist revolutions and became intermediate developing countries. A group of very large countries, like India and China, although remaining on average very poor, were able to develop, industrialize, undergo a partial but effective modernization or capitalist revolution, and build strong states.

A large number of countries, however, were definitely left behind. Among them, I would distinguish two types: those that never experienced real economic development and a capitalist revolution, and those that attempted to develop and modernize but failed. The former, among which are most of the sub-Saharan countries, remain outside the globalization process; they have weak states and a population unable to protest. The latter are a different case in that they are mostly Middle Eastern Islamic countries. In these countries, fundamentalism and terrorism are principally the result of frustration with the failed modernization attempts of the last 50 years. The only country in the region that successfully

modernized was Turkey. Iran made significant strides toward modernization in the 1960s and 1970s, but because of a corrupt elite, space was created for fundamentalism. Now, Iran appears to be slowly moving toward a secular society. Other countries each exhibit a different situation, but the fundamentalist threat is most pronounced where frustration with modernization and national consolidation is clearest. This is why Jürgen Habermas remarks that "despite its religious language, fundamentalism is, as we know, an exclusively modern phenomenon."[4]

This is not the place to delve into why so many modernization attempts fail. The basis of the problem is the lack of an educated people and an active civil society that can control elites, but this is precisely the definition of precapitalist societies. Original or primitive capital accumulation and successful national and capitalist revolutions require enlightened business and political elites that exist only by chance. For some time, developed countries thought that World Bank and IMF experts, armed with superior knowledge and financial clout, would be able to demand action from elites and control their performance. But in most cases they failed miserably, mostly because international technocrats are unable to understand the specific economic and political conditions in each country. Since the mid-1980s, however, developed countries have been adopting two appropriate conditions for assistance to the poorest countries: investments in education and adoption of democratic political regimes. These policies enable elites to govern and make them more accountable to their own people.

It is quite clear that countries that are excluded from economic growth are also excluded from globalization. As Clive Crook argues, "Far from being the greatest cause of poverty [globalization] is its only feasible cure."[5] In other words, only countries that participate in globalization, adopting the new technologies and institutions that globalization requires, will create conditions for economic growth. The problem that became clear after the September 11 events is that populations in countries not able to accomplish this are increasingly restless. These countries are not able to participate in global markets, or, when they participate, they do so under such disadvantageous conditions that no real growth or increase in standards of living are achieved. In several studies using regression analysis, Dani Rodrik has shown that poor countries are not profiting from international trade.[6] However, one should not confuse "international" trade with "free" trade. International trade can privilege manufactured against primary goods, as Raul Prebisch showed a long time ago;[7] local production in poor countries may be organized in such a way that the benefits from international trade accrue only to a small elite or to foreign interests.

Thus, the fight against terrorism and all kinds of fundamentalism involves in-

creased efforts from the international community to help developing countries whose modernization was frustrated by corrupt and alienated elites. Such help, however, will only be successful if it is concentrated in enabling the citizens and elites of these countries to protect their national interests and to resolve their own problems, instead of imposing modernizing policies that do not necessarily fit their needs.

Unlike the frustrated modernizers, the poor sub-Saharan countries do not pose the threat of terrorism. However, the devastation of infectious disease in that region is an increasingly global issue. In a global world, communicable diseases travel quickly and easily, and rich and intermediate countries cannot afford to ignore this reality. If they were not able to act before out of solidarity, they will have to act now from self-interest. For many years, rich countries have been discussing the conditions for debt relief to these countries. It is time to accelerate this process, because even if the loans were largely captured by corrupt local elites, responsibility for this misdeed does not only lie with the transgressors. The technocrats that devised a growth strategy for them based on foreign loans are also at fault.

## TO ASSURE SECURITY, GLOBALIZATION MUST EMBRACE POLITICS

The international order essential to global markets includes a strong United States as well as a strong economic and military association among developed countries, like the G-7 and NATO; but this is not enough. Involvement of intermediate countries through, for instance, the G-20 or an enlarged United Nations Security Council would help but would still be insufficient. It is critical to design strategies to reduce poverty in poor countries and limit elites' corruption in countries that are beginning their modernization or capitalist revolutions. But attaining these objectives requires strategies that international institutions have proved unable or poorly equipped to define. The essential task is to make the leading countries understand the new characteristics and the new requirements posed by the new diplomatic paradigm that is emerging: globalization's politics.

We can compare the new challenge faced by the world as a whole in the twenty-first century with that faced by the new nation-states when they arose from the feudal order. The first challenge faced by monarchs and the bourgeoisie and, subsequently, by politicians and civil societies was to establish order and security within their national borders—which would enable the constitution of national markets. Yet slowly but inevitably, societies understood that order could not depend only on force, but also required the rule of law and the gradual con-

solidation of civil, political, social, and finally, republican rights. It also became clear that such goals involved first elite and later popular participation in political affairs. Argumentation, development of secular ideologies, and public debate were required, and some degree of cooperation and solidarity alongside competition had to develop. In other words, the attainment of social order involved politics, in the noble sense that Aristotle and, in modern thought, Hannah Arendt understood the term. Nation-states may arise from violence, from war and revolution, but they have no alternative but to become political, to build up a polity, to cultivate some degree of solidarity and mutual respect within their societies. Civil, political, and social rights were the outcome of successful political demands coming from below, but they also were responses to the intrinsic needs of the new economic and social order in the making.

As Arendt wrote in *On Revolution,* politics is the alternative to war and violence. She remarks, "The two famous definitions of man by Aristotle, that he is a political being and a being endowed with speech, supplement each other." In addition, she concludes: "The point here is that violence itself is incapable of speech, and not merely that speech is helpless when confronted with violence. Because of this speechlessness, political theory has little to say about the phenomenon of violence. . . . As long as violence plays a predominant role in wars and revolutions, both occur outside the political realm, strictly speaking, in spite of their enormous role in recorded history." [8]

Politics was central in the Greek *polis* and the Roman republic, where speech and arguments played a pivotal role. Yet those were exceptional instances in a precapitalist world dominated by violence and war more than by politics. With the emergence of modern nation-states, politics progressively prevailed with the governed, who concurrently became citizens. Through argument and persuasion, citizens established methods for deciding on collective action, regulated elections and representation, set common goals, defined rights and obligations; and made agreements and comprises. Coercion lost ground, unless one considers the money spent in political campaigns as a form of coercion. Yet, with this money, the rich merely try to persuade the poor: they are no longer able to threaten them. It is still not a fair or democratic way of conducting politics, but it is still politics rather than brute force.

Thus, politics is an alternative to brute force. It existed tentatively in the ancient Greek and Roman republics, and reappeared in modern times, with the rise of nation-states, which were established in the midst of violence but which gradually turned to politics, becoming pacific and democratic. In the international domain, the first manifestation of politics was diplomacy. Negotiations preceded wars and, in certain cases, prevented them. Yet diplomacy and politics are dif-

ferent things. In classical diplomacy, conflict resolution was not achieved with persuasion or elections, but with the threat of violence. The international order that has been in retreat since World War II, the balance-of-powers diplomacy, worked in accord with this principle.

Now, the challenge faced by individual countries in the global world is similar to the challenge that nation-states faced in their consolidation process. Just as nascent nation-states slowly built political institutions to guarantee domestic order and security, global order and security will require the development of mature political institutions. Thus, diplomacy is being transformed into globalized politics. Modern diplomacy, which is essentially economic diplomacy, is already a form of politics. But a strictly political diplomacy, aimed at creating political institutions at the international level, is becoming increasingly important. The first major step in the twentieth century was the creation of the United Nations. Moving forward, we can expect stronger international political institutions in the United Nations and new or related entities, such as the International Criminal Court and the multiple international agreements protecting human rights and the environment and fighting drugs and international crime.

The great international challenge today, now that balance-of-powers diplomacy has lost most of its meaning, is to transform globalization into globalization's politics, which is a politics that supports the global economy through the establishment of political institutions. Globalization per se is not an international order. However, to the extent that specifically international political institutions gain force and representational status alongside international economic institutions like the WTO and IMF, globalization will cease to be the manifestation of wild global markets and become the civilized, political means for nation-states and individuals to relate to one another in the international domain.

## GLOBALIZATION'S POLITICS REQUIRES SOLIDARITY

If institutions at the international level are strengthened in the same way that nation-states were consolidated, international cooperation will cease to be a slogan, and a certain degree of international solidarity can begin to be constructed. This solidarity may be explained either as the  manifestation of the altruistic bent that counterbalances self-interest in each one of us, or as Tocqueville's "well-understood self-interest." Simply put, maintaining a society that organizes itself politically requires solidarity among its members. At the moment the global economy tends to transform itself into a global society, some degree of solidarity becomes a necessity. When there is a global society, there are global enemies to be fought—enemies like fundamentalism, terrorism, drug traffic, disease, and ex-

treme poverty. Global society will only be able to fight these enemies if it is able to develop some degree of solidarity. Self-interest and competition will remain dominant, but cooperation and solidarity will necessarily have a role. Recently, in a *Washington Post* article with the self-explanatory title, "Why We Must Feed the Hands That Can Bite Us," a physiology professor from UCLA articulated the interest of the American people in helping poor nations.[9] Globalization has reduced distances between people not only economically and culturally but also in health terms. Rich countries now have a well-understood self-interest in demonstrating solidarity with the poorest ones.

Solidarity already exists among rich countries. They may compete economically among themselves, but they know they are part of a single game—a game whose sum is greater than its parts. Consequently, they build solidarity nets among themselves, their business enterprises, and their citizens. As long as developing countries complete their capitalist revolutions, achieve an intermediate level of development, and become democratic, they are admitted to this club as junior members. The problem is with the very poor countries and with those developing countries where modernization was frustrated.

These are the two categories of countries that need the most solidarity but receive the least. It is more difficult to express solidarity with those who are different. Mass immigration transformed the multicultural problem into one of the central political questions faced by rich countries. At the international level, the rich often view frustrated and poor nations as a threat, making solidarity problematic. When rich countries try to demonstrate their solidarity, it often takes the form of setting "civilizing" conditions as a quid pro quo for charitable help.

There is no easy solution to this problem. The international institutions created to promote growth, such as the World Bank, have been more successful in intermediate countries than in frustrated and poor countries. The international technocrats are full of good intentions, but good outcomes depend much more on the capacity of local officials and local entrepreneurs to make good use of resources received as aid or finance than on imposed conditionalities. In the case of sub-Saharan Africa, for instance, the World Bank's decision in the early 1970s to base the regional development strategy on international finance eventually proved a major mistake. Corrupt local elites wasted the borrowed money, and 30 years later, income per capita remained about the same while the impoverished nations had to service large foreign debts.

Building some degree of solidarity in a global world takes place not only because such behavior corresponds to the self-interest of rich countries. It also stems from the moral values of their citizens, concretely expressed in the international NGOs and social movements that they lead as well as from the demands of

the poor countries. These two factors are leading to the rise of a global civil society and a global citizenship, which began with the United Nations' Declaration of Human Rights. The Declaration made clear that men and women had the right to have rights. Globalization is speeding up the process whereby human rights are universally acknowledged. The concrete possibility of a global citizenship and of a global civil society is part of the global dynamics.[10] This is yet another aspect of globalization's politics.

## GLOBALIZATION'S POLITICS PRESUMES FAIR REGULATION

Globalization is a historical fact that is here to stay. It is a technological and economic phenomenon promoting societies' capacity to increase productivity and generate wealth while it facilitates the advance of the international division of labor and the application of Ricardo's law of comparative advantages. Yet markets, when uncontrolled or regulated in a biased way, may be as blind and unjust in distributing income and wealth as they are efficient in allocating factors of production and promoting economic growth.

Globalization made all countries interdependent. Before globalization, large and increasing inequalities among nations were a moral challenge for the developed countries and were the major problem faced by developing ones. Now they are challenges for all. Inequalities are dangerous, and if we remember Hirschman's tunnel effect, we will realize that increasing inequalities are still more dangerous.[11] Globalization involves opening markets and increasing levels of productivity and wealth, but it also generates increasing inequalities when the poor and the weak are unable to profit from the opportunities globalization offers. We know well that markets are efficient but blind. Thus, like national markets, globalization requires regulation, fair regulation.

Market liberalization represented a great advance for the developing countries, as import-substitution development strategies pursued by developing countries throughout most of the post–World War II era had ceased to make sense. However, this is not true for the frustrated modernizers and the poor countries. These countries are far from having completed their capitalist revolutions, and do not have a modern business class or a competent professional middle class. Their insertion into the globalization process often involves economic risks. The groups or regions unable to modernize are destined not only to stay in their present situation, but also to lose income and social prestige.

In their attempt to reform the economies of precapitalist countries, rich countries established the priorities according to their interests. For instance, opening of financial markets and full protection of intellectual property rights

were instituted in many countries over the past decade or so at a time when these countries were not yet prepared for such reforms. With few exceptions, the opportunities offered by global international markets worked against the developing countries, not in their favor. In the 1970s, developing countries took the initiative in economic international affairs for the first time. They were involved in an international effort to build a New International Economic Order based on preferential trade relations, but this effort failed. They suddenly gained access to large amounts of private international credit and became highly indebted. Subsequently, however, growth rates dropped substantially and developing countries lost the precarious gains they had achieved in the international arena. Since the end of World War II, most developing countries engaged in state-led import-substitution strategies. These countries (with the classical exception of the Asian tigers, which were able to switch to export-led growth at the right time) expanded too rapidly, which generated serious distortions in their economies. The foreign debt crisis as well as a fiscal crisis of the state made their economic fragility manifest.

The initiative was now American, and the instruments were the World Bank and the IMF. After the Baker Plan in 1985,[12] fiscal adjustment and market-oriented reforms became the new domestic guiding principle. At the international level, the United States advanced with the 1986–1994 Uruguay Round and the creation of the World Trade Organization out of the General Agreement on Tariffs and Trade (GATT), which included major provisions related to property rights and protection of direct investments. All these policies went in the right direction, responding to the demand for badly needed reforms and indicating the establishment of global markets that in principle are in the interest of all. Yet today it is widely accepted that the Uruguay Round agreements benefited rich countries more than their poor counterparts, that financial liberalization happened too soon and too widely and provoked repeated financial crises and diminished economic growth rates, and that property rights agreements were more beneficial to developed countries than to developing ones.

The critique that contemporary globalization is excluding large parts of the world from the benefits of growth comes from these three factors, which help to account for the inability of most poor and developing countries to profit from the opportunities offered by globalization, and which led to increasing differences in rates of per capita growth between rich and poor countries. In the end, poor countries were left with frustrated modernization. At the same time, the acceleration of technological progress increased the demand for skilled labor and reduced the demand for unskilled workers, and this led to further concentration of wealth within each country. Discontent in relation to globalization origi-

nates not only from left-wing groups in developed countries, but also from significant social segments in developing countries. The Porto Alegre Social Forum, which met for the second time in January 2002, is a serious expression of these concerns.

Developing countries like Brazil are already competing successfully in the international arena, and the growth challenge they face depends on their capacity to advance democratization, so that public debate can reduce the policy mistakes that government administrations are otherwise inclined to make. A fair regulation of global markets is important to them, but more important is their ability to think independently and make the decisions that their situation requires, which are not necessarily the ones recommended by international organizations. By contrast, poor countries and frustrated modernizers are in very different situations. A central challenge rich countries and international institutions face in order to achieve global security is to develop some solidarity initiatives that create conditions that will allow such countries to participate in and profit from global markets.

## TRANSITION TO GLOBALIZATION'S POLITICS REMAINS DIFFICULT

If the new global order that is emerging is a political order where argument and persuasion rather than war and the threat of war are the guiding principles, and if this order tends to be based on the rule of law and on competition mitigated by solidarity, how can we explain that the immediate response to the September 11 events was war?

The September 11 assault was an attack directed at the United States. The world's hegemonic nation immediately understood this attack literally as an act of war, compared it to the Pearl Harbor attack, and decided to respond to war with war. For a few days, the problem was to figure out who the enemy was. The American media and the U.S. administration immediately defined international terrorism as the enemy, but they knew that this was too diffuse an agent to be isolated as the enemy. Defining all countries that harbor terrorism as enemies was also too broad. The United States would have to include among its enemies some traditional friends, such as Saudi Arabia. Afghanistan, however, proved perfect to take the role of the enemy, since the fundamentalist group that was in power did more than harbor terrorists; it was itself hostage to them. The Taliban used and was used by the chief paramilitary terrorist organization in the world, Al Qaeda, in such a way that it was difficult to distinguish the Taliban from Al Qaeda itself.

The Taliban has been defeated, and perhaps Al Qaeda has been defeated as well, but we are far from being able to say that terrorists in general have been defeated, because no war will ever defeat this kind of evil. To the contrary, when civilized nation-states decide to fight uncivilized terror with war, the danger is that they also become uncivilized. Jürgen Habermas, writing on the consequences of the September 11 events, said: "The 'war against terrorism' is no war, and in terrorism is expressed also—and I emphasize the word 'also'—the ominously silent collision of worlds that must find a common language beyond the mute violence of terrorism against military might." [13]

The monstrous attack on the American people caused manifestations of solidarity from the civilized world because all felt threatened. In the short run, it led the American government to a punitive war, but the major long-term consequence for the hegemonic nation will be a radical reexamination of its international policy. The objective will be to increase American and international security by reducing hate. As is gradually being recognized, generalized retaliatory actions against unfriendly Arab countries and the maintenance of a Cold War policy of dividing the world into friends and enemies will worsen the present insecurity instead of improving it.

At present, the obvious enemies are terrorist groups. Motivated by hate, their actions are not rational—there is no trace of the use of adequate means to achieve specific ends. In contrast to governments of nation-states, terrorist leaders do not fear widespread retaliation. They may even look forward to it, since it will only breed more hatred.

Why did hatred become so intense and so strongly directed against the United States? Is it solely because the United States is the hegemonic country in the world? Although many will be tempted by this explanation, I am sure that it is wrong.[14] The United States may not be the "benevolent hegemon" that it likes to consider itself,[15] but it is the first democratic country in the history of humankind to become hegemonic, and consequently some degree of anti-Americanism will exist everywhere, even in countries that are friendly with the United States. This sentiment should not, however, be confused with the deep hatred that animated the September 11 terrorist acts.

Hate is clearly not rooted in the Islamic religion itself. Of the 1.3 billion Muslims worldwide, it is primarily among Middle Eastern fundamentalists that this hatred is widespread. It makes somewhat more sense to designate the increased economic inequality wrought by globalism as the underlying cause. However, there are many poor and excluded groups throughout the world who do not express the same level of hatred as the perpetrators of the September 11 attack. Another explanation is that American international policy has been unable to

assimilate the end of the Cold War, and the U.S. government continues to act in a biased way toward countries deemed friends, particularly the state of Israel. This explanation is not comprehensive, but the nurturing of anti-U.S. sentiment among so many in the region, including among non-Arabs such as Afghans and Iranians, probably emanates from this American policy mistake. More broadly, the answer to this question is directly related to my basic claim in this essay. It is time to change from balance-of-powers diplomacy to globalization's politics. The international order in which participants divide themselves into friends and enemies needs to be transformed into an order where participants compete among themselves at the same time that they have some say in international political institutions.

Isolationism is definitely dead. The events of September 11 had the effect of clarifying for Americans why they need to engage the rest of the world on a sustained basis. To advocate an isolationist policy for the United States is as unrealistic as expecting that nation not to intervene in regional conflicts. Thus, if the United States is the all-powerful hegemonic country in the world, if it no longer faces enemy-countries but enemy-terrorists, its strategy of limiting terrorism and assuring national and international security should change. Instead of siding with friends against enemies, which was rational in Cold War times, it should move to a new policy of acting as an unbiased arbiter in regional conflicts.

The American government grasped this new reality when it intervened in the former Yugoslavia. In its joint action with NATO, it did not favor Bosnians, Serbs, or Croats. It acted in favor of peace. Thus, even if many were unhappy with the American action, in the end most people in the region developed a positive stance toward the United States. In the case of Israel, we may already be seeing a clear change in American policy. The United States does not consider its national interest to be alignment with just one side. Israel's security must be assured, but peace in the region is now essential. It may take some time. At the moment, Israeli and Palestinian terrorist groups are behaving in a more radicalized fashion. American efforts have been fruitless. But the logic of the new international order that is emerging indicates that the United States will have a major role in achieving peace in the region, and that it will perform its role by adopting an impartial attitude toward the parties. This change in policy will eliminate a major source of hate.

In the new global world that has been emerging from the end of the Cold War, the medium-term objectives will be to maintain effective order and security, to guarantee freedom, and to reduce inequality among people and nations. I do not say this only because it is consistent with my personal values, but also because

global markets will require it. Global markets will require new international institutions, new international behaviors, in short a new international order: globalization's politics or globalization's diplomacy instead of a conflicting-powers politics.

The United States will remain the hegemonic country for decades to come, but it will have to limit its unilateral actions and play according to the international rules that it is actively helping to build. Before September 11, the United States rejected the Kyoto Protocol, refused support to the International Criminal Court, and resisted joint action against tax havens. Now it is reviewing these policies. Changes will take time, will face opposition, and will require debate. Interest and ideologies will continue to play their classical roles. Yet, a new comprehension of how these issues affect the U.S. national interest will lead to new approaches. Two major changes are already evident. U.S. support for the United Nations is less ambiguous, and gone is the U.S policy of automatic alignment with Israel. Europe, for its part, will also have to change. European society is more internally balanced, but multicultural problems originating in immigration require more appropriate responses than those heretofore undertaken. Additionally, the European Union's protectionism, particularly for agriculture, will have to be eased. In relation to this last issue, change is already under way, as could be seen in the WTO 2001 meetings in Doha, Qatar.

## CONCLUSION

We live in a global world where market competition is central, but cooperation and solidarity must counterbalance competition. Yet instead of global solidarity we are experiencing global hatred. The world's nations must undertake consistent action to countervail this tendency. A democratic world requires international security, and the United States can count on other democratic nations to contribute. In the short run, the question is how to punish the terrorist organizations. In the medium run, it is how to define the U.S. role as international arbiter. Both short and medium term, the challenge will be to reduce hate and to establish civilized relations among all.

This challenge and the efforts to face it are not new, but the September 11 events showed that it must be tackled more consistently. My prediction is that a new international order is emerging as a response to the new realities. A new globalization's politics will substitute the old balance-of-power diplomacy. Great nations will no longer see each other as enemies but as competitors. This new game may become a win-win scenario if international political institutions tem-

per blind market actions, if competition is mitigated with solidarity, and if the leading countries in the world, through the United Nations, take on the role of neutral arbiters in regional conflicts.

In this new international order, nation-states will remain powerful and more autonomous than globalist ideology suggests. Yet in order to achieve security in global markets, they will have to cooperate and accept greater interdependence in economic as well as in political terms. The transition from threat of war and diplomacy to world politics, from balance-of-power diplomacy to globalization's politics, will involve concrete steps toward world governance. Secure and equitable markets demand political institutions. Markets and politics are the alternative to brute force and war. Markets are the realm of competition; politics, the domain of collective action. Markets are apparently self-regulated, but they require political regulation. Political decision making involves arguing and persuading as well as compromising and voting. While markets are supposed to be competitive, politics is essentially cooperative. Politics acknowledges conflicting interests, but it is impossible without some degree of solidarity. The September 11 events showed that no one is secure alone, and definitively opened the window to international politics.

The intrinsic combination of markets and politics, of self-interest and cooperation, of the profit motive and the republican responsibility for the common good, of citizens' rights and multicultural respect, are at the core of modern, secular, liberal, social, and republican democracies. For the first time in the history of humankind, politics instead of force will start to be the major factor in international relations. Military power will continue to play a role, but a diminishing one. Through competition and free markets, mutual benefits may be achieved, but it is only through politics that the necessary values and international institutions will be created. It is through a modern diplomacy, now transformed into politics, that international governance will someday emerge. I will probably not see this day, but the historical facts that I have analyzed in this essay make me confident that my sons and daughters, or at least my grandchildren, will. Global governance is not yet a reality, but it has ceased to be a utopia.

# 7. SEPTEMBER 11, SECURITY, AND THE NEW POSTLIBERAL POLITICS OF FEAR

## KANISHKA JAYASURIYA

### SEPTEMBER 11 AND THE POLITICS OF EMERGENCIES

When two airliners loaded with jet fuel crashed into the Twin Towers of the World Trade Center (WTC), we witnessed not just a terrible human tragedy but one of those events, like the collapse of the Berlin Wall, that we can bookend as signaling the altered circumstances of both global and domestic governance. At the outset it needs to be to acknowledged that the importance of the events of September 11, 2001 lies in that they accentuate tendencies already evident in the political structures and practices of liberal democracies. The argument of this chapter is that the motif of security and its associated antipolitical rationality which underpin the emerging transnational and domestic orders predate the WTC attacks. But these events have offered a window of opportunity for a range of political interests and forces around the world to consolidate the construction of new forms of political reasoning that seek to conceal real political struggles and conflict under the cover of the wide-ranging rubric of security. The problem, as Mark Neocleous notes, is that "the corollary of the focus on (in)security is the perpetual mystification of the processes of social power."[1]

Security and fear have become the dominant chords in the politics of liberal democracies. Hence one objective of this essay is to explore schematically how the dramatic events of September 11 and the still unfolding aftershocks have significant ramifications for the nature of global governance, as well as for the institutions of liberal democracy. The unmistakable fact is that the events of September 11 and their aftermath are still reverberating around us, thereby robbing us of the necessary distance to produce a full accounting of the impact of the terrorist attacks.

Nevertheless, it is possible to discern the broad contours of the dents inflicted on the shape of political life in a range of advanced liberal democracies. These are most visible in the damage done to the very notion of "politics" and political argument, and in this context, the most serious danger arising from the events of September 11 is likely to be a form of "anti-politics." This may well portend, under the seductive cloak of "security," a debilitating form of politics that marginalizes

the constructive conflicts—the debate and discussion—that animate the public sphere in liberal polities. In short, it has exacerbated a process of depoliticization that has been one of the most important consequences of globalization.

Although my principal focus here is on this new antipolitics and the response of states to the September 11 attacks, I do not want to lose sight of the fact that the terrorist attacks and the motives that prompted them are deeply inimical to democratic politics. The blanket label of terrorism is, of course, misleading. After all, Gandhi and Mandela were at various times accused of terrorism. What is disturbing about the recent attacks is not that Al Qaeda is devoid of a political program, but that this program is based on a fundamentalist morality (founded in this case on some transcendental religious essence) that allows no room for any real debate or argument. Moreover, Al Qaeda fails to focus this program on combating any real sources of structural power or a broader array of economic and social institutions. It seeks instead to direct its terror at persons, events or—as with the attack on the WTC—on buildings or monuments of symbolic value (at least to the groups involved). Wendy Brown, in an incisive analysis of the moralism and antipolitics of contemporary identity movements that could equally be applicable to many neofascist movements, observes:

> Moralism so loathes overt manifestations of power—its ontological and epistemological premises are so endangered by signs of action or agency—that the moralist inevitably feels antipathy towards politics as a domain of open contestation for power and hegemony.[2]

Over and above all these facets of moralistic antipolitics, there remains the insistent denial of the artificial or contingent nature of politics—i.e., that there is no fundamental truth to be discovered therein—which is an essential part of the practice of political liberalism. In the rush to identify these attacks as symptomatic of the irrational nature of political Islam, the common moralistic political rhetoric that drives a range of neofascist movements of various hues—be they white supremacist, extreme antiabortion movements, or the Shiv Sena of India—is often ignored.[3]

Even more troubling, the response to the attack by various governments and intellectuals has exhibited the same tone of moralism. Thus, Charles Krauthammer, an influential neoconservative columnist in the United States, declares:

> This is no time for obfuscation. Or for agonized relativism. Or, obscenely, for blaming America first. (The habit dies hard.) This is a time for clarity. At a time like this, those who search for shades of evil, for root causes, for extenuations are, to borrow from Lance Morrow, "too philosophical for decent company."[4]

While this may stand out as a particularly inane bit of commentary on recent events, it nevertheless reflects a broader self-censorship apparent in the United

States that has made public and media discussion of the politics of terrorism very difficult. This strident moralistic tone of many neoconservatives is not confined to the United States but is also evident in other countries such as Britain and Australia, where there is deep hostility to any discussion of these events in political terms—in terms of power and conflict. But a greater cause for concern is the fact that liberal democratic governments in a number of countries, particularly Britain, Canada, the United States, and Australia, have hastily introduced punitive legislation that seeks to suspend fundamental rights in some cases, and/or expand law enforcement powers. What is more, the legislation serves to enhance the discretionary powers of the executive while diminishing the role of the judiciary.

As occurred during the Cold War, the present crisis has also exposed the precarious position of civil liberties as this "new war" gathers steam. Congress has passed the USA PATRIOT Act, which enacts far-reaching changes—including the preventive detention of immigrants on suspicion of terrorism and the expansion of telephone and Internet surveillance—which severely curtail civil liberties.[5] Further, the U.S. president has signed an order for special military tribunals to try those charged with terrorism. These tribunals have lower standards of proof and admissibility of evidence than ordinary judicial processes.[6] All these measures pose serious problems for those concerned with basic rights.

Similarly, the British home secretary has proposed tough antiterrorist legislation that includes extending already substantial powers to detain suspected terrorists and the extensive use of surveillance powers. Among the more disturbing clauses in the British antiterrorism legislation is the proposal to remove from the system of judicial review the commission overseeing detention without trial.[7] Britain has also sought since September 11 to opt out of Article 5 of the European Convention on Human Rights, which bans detention without trial—something that no other European country has seen fit to request. Likewise, in Australia, the ruling Liberal and National Coalition, with the support of the opposition Labour Party, has enacted draconian laws on border security that effectively curtail judicial review for asylum seekers and give wide discretionary powers to designated ministers of state.[8] A common thread running through these measures is the effort to enhance executive discretion on a range of issues and block off, wherever constitutionally possible, scrutiny by the legislature or the judiciary.

Thus we find that in surprisingly short order several liberal democracies have sought to offer political leaders and other public officials a legislative framework for acting outside normal constitutional and representative institutions. It is significant that these broad emergency powers have been based on the concept of

"exceptions," according to which, in "states of emergency" or great peril, liberal democracies need to undertake special actions to safeguard security.

This argument bears close affinity with the political and legal theorizing of Carl Schmitt.[9] Well known as a trenchant critic of the Weimar Republic, Schmitt later lent his theorizing in support of the Nazi regime. He was also an important critic of positivistic legal thinking,[10] and is perhaps the most preeminent theorist of the "exception." The notion of "exception" refers to the capacity of the sovereign to make decisions in terms of its political will rather than be constrained by normative "law." Schmitt suggests that "exception" is

> codified in the existing legal order, [and] can at best be characterised as a state of peril, a danger to the existence of the state, or the like. But it cannot be circumscribed factually and made to conform to preformed law.[11]

One of Schmitt's central concerns was with the particular problems that emergencies and exceptions pose for liberal theory and practice.[12] His argument is that liberalism particularly fails to adequately theorize states of emergency or states of exception and is unable, therefore, to provide for the emergency measures to be undertaken in times of peril. For Schmitt, it is during periods of state emergency that "sovereign decision making" emerges as the true center of politics. This, in effect, makes the executive the center of state sovereignty. This form of "exceptional state," as Ingebourg Maus points out,

> corresponds to the principle that Schmitt projects upon the absolutist state seen as capable of bringing civil war to close "a state of the executive and the government" exclusively aimed at a achieving a maximal degree of effectiveness; he describes it as a state that produces "public order and security."[13]

Schmitt sharply distinguished between the various elements of the "constitutional state" (*Rechtsstaat*) and its political *essence,* namely the political identity of the "people," which he argued has priority over the liberal components of the constitution.[14] For Schmitt to make this argument congenial to the emergent fascist order, the substance or essence of *political identity* had to be represented in terms of the cultural and social homogeneity of the "people."[15] The significant inference to be drawn from this argument is that all legal orders need to have an external foundation, and that the constitutional state is not identical with the state as such. Therefore, for Schmitt, elements of the normal legal order could be waived under conditions of peril where there were internal or external threats to order. Clearly, this analysis constitutes an attack on the liberal constitutional Weimar regime and provides a juridical framework for the fascist legal and political order.[16]

Schmitt was certainly no friend of political liberalism.[17] But as a number of keen observers have noted,[18] he identified a crucial problem for liberalism,

namely that all legal orders have an "outer core," and that in the context of emergencies, delineating the nature of this "outer core" poses a number of challenges. Foremost among them is how liberalism can defend and maintain its own basic presuppositions, including respect for civil rights and tolerance, during a time of significant external threat. Schmitt was clearly wrong about the inability of liberal democracies to respond to emergencies such as the events of September 11. Indeed, while there are troubling indications that many of the measures taken have increased executive power and curtailed civil liberties in Britain and the United States, none of this approaches the suspension of the liberal constitutional order advocated by Schmitt. Schmitt has also been proved wrong on another score. Liberalism has responded to the events of the September 11 by employing new forms of statecraft and practices that—borrowing a term from Judith Shklar, but using it in a somewhat different sense—I refer to as a new "postliberal politics of fear."

However, the key contention of this chapter is that although liberalism has responded and adapted to these new emergencies, this new political practice not only fails to provide a political justification for the liberal constitutional order but also actively seeks to depoliticize areas of economic and social life. In short, it is a politics of "antipolitics." In this sense, Schmitt seems to be on target in suggesting that liberalism's failure to justify its fundamental precepts remains especially acute during emergencies. What is more problematic is that recent changes in the public sphere and political life of advanced liberal democracies such as the United States, Britain, and Australia point to the emergence of an antiliberal understanding of the "exception."

This in no way suggests that anything like what Schmitt advocated in terms of "exception" is replacing the structures and institutions of liberal democracy. Rather, the argument advanced below is that the emergence of a new postliberal politics of fear in many liberal democracies is driven in part by the process of globalization where political practices invoke security and "public order" as their guiding motifs. The crucial point is that security is understood as being outside of the public sphere of democratic life, and is instead framed in terms such as "risk reduction," economic order, or the fundamental values of the nation.

## GLOBALIZATION, ANTIPOLITICS, AND THE NEW "POSTLIBERALISM OF FEAR"

One of the most pervasive effects of the phenomena that we group under the term globalization is to amplify "risk" in the global community. What is perhaps most distinctive about this new risk is that it further strengthens the link between

the domestic and the international; no longer can various sources of risk be quarantined from the safe harbors of domestic societies of many advanced industrial countries. Nothing more starkly illustrates this amplification of risk than the events of September 11, which have brought home more effectively than anything to date the extent to which the new risks are global in nature. And the source of these new forms of risk is not just terrorism; they extend to a whole range of economic and social activities. After September 11 the economic collapse of Argentina, following earlier crises in East Asia, Russia, Brazil, and Turkey, reveals the deep-seated nature of economic risk in the new global political economy. This is not all: consider the familiar issues such as climate change, global health epidemics underlined by the anthrax scare, global movements of people, and transnational criminal networks.[19]

In terms of the argument of the social theorist Ulrich Beck, these phenomena may well be suggestive of a shift toward a risk society that is increasingly global.[20] But it is clearly something more than this. First, these new risks have to be seen as emerging out of a constellation of economic and social interests. This change in the understanding of risk needs to be placed in the context of the globalization and transformation of capitalism that emerged in the last two decades. As Davis has aptly noted, we live in an age where there has been a "globalization of fear," and this reaches outward from a sense of individual insecurity toward more generalized social forces.[21] In short, it is not simply the amplification of risk and fear but the very particular manifestation that it takes on in a globalized environment that we need to recognize.

Second, and this is more critical, we need to consider how these new forms of risk have been turned into a *new politics of fear*. Indeed, as these new fears of globalization have been amplified, national governments have resorted to security as a key component of their political practice. Risk itself becomes currency in the political process. Moreover, even before the New York terrorist attacks, the increased valorization of security—already apparent as one of the distinctive signposts of the domestic political order, and readily evident in the rise of the law and order state in the United States[22]—was being paralleled increasingly in the transnational arena, as exemplified by heightened surveillance along the U.S.-Mexican border.[23] The events of September 11 have accelerated these practices in a way that blurs the boundary between the domestic and the global. The accentuation of a "globalization" of fear has been met by what could be a new form of statecraft, i.e., modes and practices of political rule, of which security is the dominant motif: a process that is leading to the creation of a new postliberal state of fear.

A useful starting point in coming to terms with this new statecraft is Judith Shklar's notion of a liberalism of fear. Shklar's singular analysis of liberalism

identified a desire to tame the impulses of human cruelty that have been such an enduring aspect of the twentieth century. A liberalism of fear is the liberalism of negative politics that places "damage control" at its center and that belongs, Shklar suggests, using Ralph Waldo Emerson's words, to a "party of memory" rather than a "party of hope." As Shklar conceives it, a liberalism of fear is tempered not by an optimistic account of human self-development, rationality, or personality, but is grounded instead in a memory of a history of cruelty inflicted by the powerful on the weak.

Unlike a traditional rights-based view of liberalism, this analysis accentuates a conception of liberal practice that focuses on the consequences of diminishing the fear that arises out of public cruelty. According to Shklar, rights become instrumental rather than ends in themselves, because a liberalism of fear

> cannot base itself upon the notion of rights as fundamental and given, but it does see them as just those licenses and empowerments that citizens must have in order to preserve their freedom and to protect themselves against abuse.[24]

What makes Shklar's work especially useful in seeking to articulate the security motif that increasingly underpins the new statecraft of fear is the emphasis placed on liberal political practice as a means of tempering the sources of fear and cruelty that mark the often tragic history of the twentieth century. Shklar's "liberalism of fear" resonates with the notion of the politics of fear being argued here. This is clearly seen when she argues that "the fear we fear is of pain inflicted by others to kill and maim us, not the natural and healthy fear that merely warns us of avoidable pain."[25] She emphasizes that one cannot and should not ignore evidence of systematic governmental brutality, in both liberal and illiberal states. It follows that a fundamental norm of liberal practice must be that "one must put cruelty first and understand the fear of fear," and defend the institutions of democracy that protect its citizens from state cruelty.[26]

Yet this interpretation of the negative politics of "damage control" does not fully account for the new antipolitics of fear that is driving politics in many liberal democracies. Shklar pits the weak against the cruelty inflicted by public governmental agencies. Of course, as we have seen, states now identify the sources of fear as emanating from nonstate actors such as terror networks represented by Al Qaeda. Indeed, it needs to be added that states ranging from Russia to China and India have used the recent terror attacks to inflict cruelties on minorities. Furthermore, and related to Shklar's emphasis on this "liberalism of fear," the high priority given to constitutionalism—the institutional separation of power as an antidote for public abuse of power—is now threatened. Current political practices invoking enhanced security lead to a concentration of executive power and discretion; they tend to depart from rather than reinforce liberal constitutional-

ism. At root, whereas Shklar's liberalism of fear espouses a form of negative politics, recent political practices around fear are more congruent with an *active version of antipolitics*. For this reason this new statecraft of security and fear is better understood as a new "postliberal politics of fear."

Another aspect of the genealogy of this new antipolitics that informs the postliberal politics of fear is the nineteenth-century notion of "police." To police in this context does not refer to the activities of any specialized agency of law enforcement but rather to a generalized concern with the detailed and comprehensive regulation of urban life in order to create a well-ordered and secure environment for trade and commerce. The police as public agency was designed as one endowed with security as its dominant objective; it was concerned with regulating all aspects of social and personal life. In early modern Germany, as Marc Raeff observes, new urban ordinances provided the framework within which new forms of bureaucratic practice and professionalized administrative functions started to develop. What is significant about these routines of politics was the emphasis they placed not only on the provision of order but also on "a government's ability to reach out to local communities and subordinate institutions, through effective channels of communication." [27] As Raeff points out, these older notions of police reflect a particular hybrid of liberalism and security that has come to play an important role in a range of domestic programs, including those associated with various notions of "third way" social policy.[28] Indeed, recently both David Garland and Mark Neocleous have drawn attention to the importance in many recent social-reform programs of the work of the early-nineteenth-century British magistrate Patrick Colquhoun and his broader concept of the social policing of poverty.[29] This is not to suggest that that there has been a reversion to these kinds of practices, but it does highlight the fact that, as observed by Garland, current notions of "security" and ideas of the diffusion of sovereign power or managing "sites" of potential danger in the pursuit of order have an important antiliberal lineage.[30]

This lineage informs the current postliberalism of fear, which depoliticizes important areas of social and economic life. Complex social and economic changes in the structure of modern capitalism, of which globalization is the most prominent, have amplified a sense of insecurity and risk and moved a wide range of public issues beyond the review and control of national and popular political processes. In turn, states and political actors—particularly those on the right—have responded by making security, or the attempt at security, a central motif of their political programs. This emphasis on security is antipolitical for a variety of reasons: (1) It criminalizes social problems at both the domestic and transnational level, thereby obscuring the underlying relations of power and conflict

that underpin a range of social phenomena; (2) It promotes, under the guise of border control, a highly exclusionary form of citizenship; and (3) It relocates power away from deliberative and representative assemblies in a wide range of social and economic areas. In the next section we will see how this works out in three key areas: securitization, border control, and the relocation of power within the state.

## 1. SECURITY AND THE TRANSNATIONAL LAW-AND-ORDER STATE

One of the clearest ways in which globalization is shaping the new security order is through what international relations theorists awkwardly call securitization.[31] The term refers to the expansion of the framework of security to encompass aspects of transnational politics previously unrelated to it, and the ability of governments to invoke emergency measures in its name. After September 11, examples of this securitization abound, in public health, the environment, and even the financial system, through efforts to combat money laundering and to seize the assets of suspected terrorist organizations and their alleged supporters. There are good reasons for concluding that even before the events of September 11, the criminalization of various issues in the transnational system was well in train. The massive intensification of border and immigration controls in most liberal democracies, alongside the existing war on drugs, for example, point to the development of a new transnational "law-and-order state."[32]

An analogy for the present crisis can be found in the anti-Communist and Cold War rhetoric that dominated U.S. domestic and international politics in the decades after 1945. The obvious parallels are to be found in the increasing importance attached to issues of security in both domestic and international politics. The decisive shift in the political climate initiated by Truman and consolidated by Eisenhower lay not in the increasing salience of security to public policy and political language, but in how the U.S. state apparatus came to be dominated by Cold War imperatives. The pursuit of these imperatives was often at the expense of broader civil liberties, as exemplified by the infectious spread of McCarthyism.[33]

However, the analogy with the Cold War "national security state" remains somewhat limited because it obfuscates the way in which globalization has transformed the very notion of security in recent years so that it is increasingly understood in terms broader than merely "guns and bombs." The language of security now permeates every sphere of life. Globalization does not just weaken the state; it transforms the state.[34] The standard account of how globalization affects sovereignty maintains that the rapid integration of the global economy or the increasing intensity of trade and financial flows serves to limit the functions of sovereign

states. But the problem with this "flow" model is that it leaves untouched the fundamental binary divide between the external and the internal.[35]

The binary divide has produced an unhelpful debate over the extent to which state power has been lost as a consequence of globalization. Susan Strange, in a sophisticated analysis of these changes in the global political economy, argues that all states have had their authority and functions greatly diminished because of the integration of states into the global economy.[36] In particular, she draws attention to the role and power of financial markets in constraining the ability of states to effectively intervene in large areas of economic life. While offering a valuable and perceptive analysis of the impact of globalization on the state, this account suffers from a kind of zero-sum conception of state power and autonomy. It neglects the degree to which sovereignty is being transformed from *within* the state as well as by its interactions with external actors. What is most evident in the securitization of domestic issues is that most drivers of change are to be found in the changes to the internal structure and organization of the state.

In recent years, the Anglo-American democracies of the United States, Britain, and Australia, spurred on by a climate of fear, have developed harsh penal regimes to combat so-called law-and-order problems. The emergence of the new law-and-order state has led to a very different conception of security, one that increasingly places less emphasis on the social causes of individual behavior that were dominant within what Garland terms the older understanding of penal welfarism, in favor of an approach to criminal activity that places emphasis on the issues of public order and control. In this new penology very different approaches may be taken, ranging from "zero tolerance" to community policing, but the underlying theme running through them is that "they share a focus upon control, an acknowledgement that crime has become a normal social fact, and a reaction against the criminological ideas and penal policies associated with penal-welfarism."[37] More important, in English-speaking liberal democracies this new postliberal state of fear has also come to dominate other areas of social policy such as welfare reform. For example, under the new paternalism of the U.S. workfare or Britain's New Deal or Australia's policy of mutual obligation, a significant increase in the surveillance and punishment of welfare seekers has a strong confluence with ideas of the new political penology.[38]

In this new postliberal state, new forms of risk management involve applying risk profiles to a set of relationships, institutions, and even geographic sites, rather than endeavouring to manage or transform the behavior of individuals. This emphasis on the *management of risk* at the level of populations rather than individuals is critical. It is reflected in the high priority given to issues such as border control and the use of identity documents. This approach to risk control

and management strips away the social and legal context of individual behavior as governments and other organizations seek to manage the "sites" of criminal activity such as terrorism, international drug trafficking, or panic over so-called "people smuggling." In short, such risk-management measures construct a transnational law-and-order that converges with the new model of "control" that underpins the new penology, which in turn is a distinctive feature of the new postliberal state of fear. *Again, the events of September 11 force us to confront the way in which globalization is changing the very form of the state.*

This language of security is not confined to state security agencies. It has also become an intrinsic rationale of the program of development agencies like the United Nations Development Program (UNDP).[39] For these international agencies and many other nongovernmental organizations, the notion of "human security" now includes such areas as poverty and the environment; this is the transnational analogue of "community policing." This new perspective embodies the more expansive understanding of security employed by establishment security agencies.

This new version of human security presents the same difficulties as the "hard" definitions of securitization because ideas of human security are premised on the view that in some way "communities of security" can be constructed in isolation from systems of power.[40] Perhaps these difficulties are even more acute for theorists of human security as these understandings explicitly theorize security without an adequate recognition of the social and political relations of power that constrain individual behavior. As Neocleous aptly points out:

> Far from being unimportant, the "insecurities" in fact raise the central questions of social and political power; the central questions, that is, of critical theory. And this is the point: in the process of being securiticized these questions are being depoliticized.[41]

As with the new political penology, approaches to human security are based on a "culture of control,"[42] which is one of the key elements of the new law-and-order state.[43]

The expansive definition of security, whether used by the UNDP or the Pentagon, has disturbing consequences. It is reflected in the depoliticization of complex problems and issues, as transnational problems are disembedded from the politics of power and interests and situated within the *antipolitical* framework of security and risk. Within the framework of the new security language, whether it is the "hard" security of Bush's National Security Council or the "soft" security of some international development agencies, conflict and debate—the raw materials of *politics*—get submerged in the search for *policies* of risk management and control. This "politics of antipolitics" is an important component of the new postliberal state that has been strongly reinforced by the events of September 11.

It is inimical to the institutions and values that sustain and animate the public sphere of liberal democracies.

## 2. BORDER CONTROL AND EXCLUSIONARY CITIZENSHIP

Equally important for this new postliberal politics of fear is the increasing salience attached to border control. Again, this is intimately linked to the process of globalization because one of the key aspects of current forms of globalization is that it not only accentuates the free flow of capital but also attenuates the movement of people, both migrant labor and refugees, to advanced industrial countries.[44] In fact, in comparison with previous periods of internationalization, the current phase of globalization is marked by its distinctively lopsided nature; on the one hand are policies that accelerate the free movement of capital, and on the other, increasingly harsh barriers that constrain the free movement of people. Admittedly, these policies of border control were previously prominent in the policies of a number of countries. This is evidenced, for example, by the extensive surveillance and control of the U.S.-Mexican border or the development of wide and significant arsenals of border enforcement measures in Europe, where border controls were scrapped within the European Union but the external borders of the EU were more tightly policed and the rights of non-EU nationals were viewed differentially.[45]

What is significant after the events of September 11 is that these policies are now clearly overlaid by the kind of security motifs that have become such an important component of the new postliberalism of fear. These policies of border control as well as policies relating to illegal immigration tend to exclude significant groups of people from the public sphere of the liberal polity. Hence, an exclusionary form of citizenship becomes another key element of the new political order. The gradual inclusionary development of citizenship that has historically driven liberal democratic societies has now been reversed so that citizenship becomes an ever more exclusive privilege.[46] Consequently, when these issues of border control are looked at in a more comparative perspective, it is apparent that welfare reform in several countries—such as the United States, the United Kingdom, and Australia—has sought increasingly to link the rights to benefit and entitlement to the performance of various obligations such as the work test.[47]

Nothing is perhaps more illustrative of these issues of border control than the so-called *Tampa* issue in Australia. In early July 2001 the Norwegian ship M.V. *Tampa* picked up a number of asylum seekers from an unseaworthy vessel and, for safety reasons, headed to disembark at the nearest available port, which was in Australia. The Liberal-National Coalition government of Australia, in defiance of time-honored international conventions, refused to accept the *Tampa* and its

human cargo of refugees and asylum seekers, and a crisis was ensured. It was only resolved after the asylum seekers, now branded "illegal immigrants," were placed on harsh detention conditions under Australian government supervision on the small South Pacific island of Nauru. It was the so-called "Pacific solution" to infringements of border security.

In short order, the events surrounding the *Tampa* in July–August were conjoined with and compounded by the subsequent events of September 11. The end result was draconian legislative measures: first, the passing of "border protection" legislation, which in effect enabled the Australian government first to circumscribe its migration zone and place the mainland off-limits to certain migrants, thereby denying access to the protection of international conventions; second, legislatively curtail some existing powers of judicial review pertaining to a whole range of refugee issues[48]; and, finally, astutely engineer in the highly volatile atmosphere of a general election a political culture and climate of fear whose net result was a new kind of punitive right-wing populism that foreclosed any serious political discussion or debate.[49]

The *Tampa* issue in Australia is one striking example that highlights the fact that (1) there has been a growing convergence between the new domestic and international political penology—one that vividly portrays the emergence of the new postliberal politics of fear, and (2) the new policies of border control seek to restrict access to the public sphere, reinforcing a new exclusionary citizenship.[50] However, it needs to be understood that the issue of border protection is not just an external one. One of the consequences of this new postliberalism of fear is to create internal enemies who are perceived to be threatening or dangerous, and whose civil liberties are thereby curtailed.

Mary Douglas, for instance, points to the way certain groups or categories of people come to be labeled dangerous within the political process.[51] Clearly, in this political era of constructed fear, exactly this process—namely, the creation of internal enemies—is under way. For example, one of the most striking elements of the policy response to this crisis is that many ethnic and minority groups are now deemed to pose a threat to national security. Against this background, many Cold Warriors in the United States have given extraordinarily generous airplay to Samuel Huntington's thesis of a clash of civilizations.[52]

Although these threats to national security, unlike those of the Cold War, are now framed in terms of ethnicity rather than ideology, the outcome poses the same challenge to basic rights. More interesting, these dangers are not seen as external but as inhabiting the center of the domestic sphere, and this has been reflected in the post–September 11 growth of racial profiling in the United States directed mainly at Muslim citizens.[53] Again, it needs to be stressed that this type

of political construction reflects the extent to which the domestic law-and-order state has begun to rely on constructing the image of certain groups as being especially prone to criminal actions of the sort that threaten national or international security.[54] The essential point to be drawn from this is to recognize how this new emphasis on border control has become subtly manifested in exclusionary policies of citizenship, i.e., the exclusion from the public sphere of citizens and residents on the basis that they pose a threat or a danger to the political community. Indeed, the rise of this exclusionary citizenship has emerged as one of the problematic aspects of the new postliberal politics of fear.

## 3. RELOCATING POWER WITHIN THE STATE

One of the major implications of globalization has been the relocation of power within the state. Put simply, in a globalized world, the state loses some of its traditional capacities and functions—such as autonomy in national economic policy making—only to emerge increasingly as a *regulatory state* providing economic and social order. One important dimension of this new regulatory state is the move toward a kind of *institutional order* which attempts to insulate key economic policy-making institutions, such as independent central banks, from the politics of bargaining.[55] In this process, central banks have become key players because they provide the link between international regimes and the domestic state. Some domestic state institutions and agencies are seen as being more critical than others for the implementation of international regimes. In this context, central banks are at the interstices of the engagement between the international economic order and the domestic state. As a result, the increasingly juridical character of central banks turns out to be a key feature in the management and regulation of the international economic order. In other words, this insulation of certain agencies, such as central banks, from the processes of democratic politics, serves to depoliticize economic management.

One of the consequences of the September 11 events has been to reinforce these trends in a whole range of new sectors to such an extent that even some of the economic institutions will be increasingly framed in terms of security. We have noted above clear evidence of the growth of executive power, the serious curtailment of civil liberties, and the limitations placed on judicial oversight. In fact, in this context, the emergence of certain aspects of a "state of exception" should be a cause for concern for those interested in the protection of fundamental political rights. But one of the important characteristics of this new form of state is that it relocates power both within the state as well as in new types of transnational governance networks.[56]

In brief, the language of security serves to frame facets of transnational gover-

nance in terms of "risk," thereby occluding important issues of conflict and power. Take, for example, the way these broader trends in transnational governance are reflected in approaches to border control and security, which now require increased cooperation between executive agencies of various countries. The United States has pressured the Canadian government to impose "perimeter continental security," with the objective of establishing common entry and exit policies for visitors, immigrants, and refugees.[57] What is significant in this proposal is that it will not only relocate power within the state (toward immigration and border enforcement agencies) but increasingly requires the establishment of networks of specialized agencies.[58] This raises substantive issues of democratic accountability. Posing the movement of people as primarily a security risk submerges the political questions of exclusion and inclusion, all of which raise issues of power within the broad motif of security.

It is worth recalling that one of the central arguments of the Frankfurt school legal theorist Franz Neumann is that the development of capitalism leads to the development of nonformal instruments of law.[59] In fact, the last century has seen a gradual acceleration of legal fragmentation and dissolution. Legal deformalization, Neumann argued, is rooted in a fundamental transformation of capitalist economies over the greater part of the twentieth century. William Scheuerman has built on Neumann's work and has developed a persuasive argument of great importance, namely that the process of globalization is leading to the institution of those very nonformal instruments of law perceived by Neumann as a threat to a democratic conception of law.[60] In some respects, this deformalization process has been accelerated by the events of September 11 at both the international and domestic levels. These tendencies toward deformalization, and I would stress *depoliticization*, need to be situated in the context of the rapid structural transformation of global economic institutions.

## CONCLUSION

Globalization and its social consequences have changed the internal architecture of the state. This is evident in the emphasis given to indirect forms of regulation and the shift away from the structures of democratic accountability toward more independent economic institutions such as independent central banks. However, at the same time, globalization and its attendant social changes have also transformed the nature of politics and the public sphere of liberal democracies. The amplification of risk that it has created has led to the increasing dominance of security, embedded in the language of politics as well as in the programs, policies, and institutions of government—all contributing to a new postliberalism of fear.

Clearly, Carl Schmitt erred in arguing that liberal states are unable to re-spond to states of emergency. Nevertheless, the contention that liberalism is unable to articulate a political defense of liberal politics may have some just-ification in the light of governmental responses to the events of September 11 in several democratic states. Instead, what has emerged is a constant appeal within liberal democratic polities—especially in the United States, Britain, Canada, and Australia—to "pre-political" elements such as cultural or, now, civilizational notions of the nation; or, even more problematically, to concepts of security. It needs to be emphasized here that the events of September 11 have only served to accelerate an already existing trend. Ira Katznelson has drawn pointed attention to the illiberal temptations of liberalism by observing that

> liberalism also remains vulnerable to illiberal temptations by virtue of its principled thinness. Precisely those features many of us consider liberal virtues—its low-key ap-proach to patriotism, its reticence in officially sanctioning communal origins, its com-mitments to individual autonomy—deprive liberalism of the resources with which to construct satisfying political and communal identities or normatively grounded guides to public policy.[61]

Though I agree with Katznelson's diagnosis of the illiberal temptations of liberal-ism, I disagree with his analysis. These illiberal temptations spring not from what Katznelson refers to as the "thinness" of liberalism but from a failure, as Schmitt pointed out, to delineate a political justification of the liberal politics of conflict and contestation. This failure results in a "fallback" to "thick" nonpolitical con-structions of community and agency. In what I have called the postliberal politics of fear, one such prepolitical element is the notion of security. In the contempo-rary context, security becomes a means of removing issues from the political arena. In this language of security and in the political programs that resonate with its assumptions, there is an occlusion of the relations of power and conflict that animate politics. In this new antipolitics individual agency becomes disem-bedded from the larger social context and relocated within the framework of se-curity and risk. Additionally, the relocation of power, both within the state and through various forms of international cooperation, poses difficult questions about the process and structures of democratic accountability. George Monbiot underlines these concerns when he points out that "while those who seek to deny liberties claim to defend individualism, in truth they engineer conformity of be-lief and action that is drifting towards a new fundamentalism."[62]

This emphasis on risk management and reduction is one of the defining features of the new postliberal politics of fear. As we have seen, it operates in a variety of areas, ranging from welfare reform in countries such as the United States and Britain to the rise of the law-and-order state. Clearly, though, while

these forms of antipolitics have been evident for some time, the overall impact of September 11 has been to accelerate and reinforce the trends all tending toward the new postliberal politics of fear. The events of September 11 have not just reinforced these trends, but internationalized them. The influence of the new transnational law-and-order state is underlined by the shift toward the securitization of civil society in a number of countries.

Quite apart from deleterious consequences for civil liberties, what is a matter of greater concern is that the new language of security may prove to be a significant hindrance to developing a truly global rule of law and cosmopolitan democratic governance. And yet precisely this surely must be the most effective means of dealing with the terrorism witnessed on September 11. And make no mistake, these problems have to be forcefully confronted by the global community. Without doubt, neofascist fundamentalism (of Islamic and other hues) poses a threat to politics and to the discussion that is vital to politics' survival. But we should not allow this crisis to be used to threaten the very politics that the neofascist movements so abhor. These movements can only be combated by articulating the rationale and principles underlying a *global rule of law,* which in turn means we need to acknowledge the elements of conflict and power that pervade modern politics. It forces us to return to the politics that the new expansive conception of security so clearly eschews. Above all, the liberalism of fear fails to recognize the public spaces and practices we have in common. As Arendt so eloquently put it:

> To live together in the world means essentially that a world of things is between those who have it in common, as a table is located between those who sit around it; the world, like every in-between, relates and separates men at the same time.[63]

PART III

# AFTERSHOCK(S): REGIONAL PERSPECTIVES

# 8. MISTAKE, FARCE, OR CALAMITY? PAKISTAN AND ITS TRYST WITH HISTORY

## KAMRAN ASDAR ALI

Five months after the September 11 tragedy, Pakistan seems like another country. President General Pervez Musharraf has become the darling of the Western press. In January 2002, in a major address to the nation (and to the world at large) the general promised to curtail Islamist groups' activities and to reform madrassah (Islamic schools) education. He positioned himself as a moderate Muslim ruler who had heeded the wishes of the silent majority in Pakistan that was against extremism and fanatical Islam. His desire to rid Pakistan of extremist elements was affirmed when he invoked the secular, modernist father of the Pakistani nation, Mohammed Ali Jinnah. Jinnah, a highly westernized British-trained lawyer from a minority Muslim sect, successfully led Indian Muslims in their struggle to establish an independent Pakistan. His speeches and writings emphasize a vision of a secular, democratic, and modern national entity populated primarily by Muslims but providing equal citizenship rights to all religious groups that lived within its boundaries. It is this vision of a modern, moderate, and Muslim Pakistan in which the general is seeking to wrap himself.

Musharraf's speech marks an important reversal in Pakistan's political history, a history replete with changing allegiances among the ruling elite. Yet for a military man who came to power through a coup (as most do) and who was essentially committed to the Pakistani military's involvement in Talibanized Afghanistan and to its incursions into Indian-held Kashmir, this was indeed a major policy change. While the rest of the world focused on his personality and praised him for the brave decision to confront extremists, which surmounted grave threats and domestic pressures—a decision that some say will bring Pakistan back into the fold of civilized nations—Pakistanis themselves knew that they may have been witnessing nothing more than another performance in the country's ongoing political theater, directed and produced by the military's General Headquarters Central.

The Pakistani military leadership needs to rehabilitate itself, just as it needed to work its way out of another major crisis of legitimacy in 1971. Marx's often repeated quip that great historical events appear twice, the first time as tragedy, the second time as farce, is appropriate in this case. After embroiling the country in a

brutal civil war, in December of 1971 the Pakistani army surrendered to the Indian Forces in East Pakistan/Bangladesh.[1] As a result of its defeat and the subsequent division of the country, the Pakistani military finally handed over power to a civilian administration after governing for 13 years. Drawing on the memory of that national turmoil, the present military ruler of Pakistan, Musharraf, has drawn an analogy between the events of 1971 and the present crisis in the region. In so doing, he has underscored the relevance of that year for Pakistan's more recent history. Just as it was 30 years ago, the Pakistani military has again been exposed for its failed policies and its adventures in neighboring states. The liberation of Kabul may not be the end of misery for the long-suffering Afghani population. Yet the genuine rejoicing in most parts of Afghanistan and the sense of freedom that the Afghan people feel should remove all doubt that in the Taliban the Pakistani state and specifically its military was supporting an undemocratic, obscurantist, and oppressive regime. This policy would have continued with disastrous aftereffects for the people of the region but for the tragedies in the United States on September 11.

Nineteen seventy-one was a crucial year for Pakistan. The disgraced military handed power over to Zulfikhar Ali Bhutto, who became the president and the first civilian martial-law administrator of Pakistan. Perhaps the post–September 11 political crisis reminded Musharraf of the 1971 turmoil because of the potential scenario in which Benazir Bhutto might come to power as her father did in 1971.[2] Musharraf may have thought that such a possibility could become a reality if the United States and European states remained jittery about Pakistan's nuclear warheads falling into the hands of Islamist forces in the region, as they remained suspicious of Pakistan's security agencies' strong ties to radical Islamist groups. In such a situation, if Bhutto continued to play her cards well, she could become a consensus choice for the West. Moreover, her unqualified support for the Pakistani military's post–September 11 policies offered clear signals to assure some in the military itself that she was not a threat to its political authority, social influence, and budgetary demands. She could, like her father before her, who reestablished and reaffirmed the military's authority, become the civilian face that maintains the status quo in Pakistani politics and saves the military from the latest imbroglio it has created for itself. But learning his lesson from the events of 30 years ago, Musharraf's reversal has personally as well as institutionally enabled him, at least for the time being, to outmaneuver Benazir Bhutto's attempts to regain power. His credentials have become solidified in the international arena, where he is now considered trustworthy, as evidenced by his being invited to the White House.

Musharraf's analogy to the 1971 crisis is limited in some respects, for there are

important differences between then and now. In 1971 the threat to the state structure was primarily from the left. The long rule of the military, which had deep links to industrial and feudal interests, had led to a popular mobilization that demanded democratic reform, economic redistribution, social justice, and rights for ethnic minorities. Now, in contrast, after a period of military rule, the threat to the governing junta is from the more militant Islamist forces in Pakistan. Ironically, these forces are to a large extent the product of a longer legacy of military rule in Pakistan.

## THE AFGHAN CONNECTION

General Musharraf's transformation can be traced directly to the evening of September 14, 2001, when the he met with his cabinet and national security team in a marathon session lasting until the early hours. The task was to decide whether the Pakistani government would accede to the demands made by the United States in the aftermath of the September 11 terrorist attacks. Pakistan was reportedly asked to provide logistical support to the U.S. military along with the use of Pakistani airspace, if the need arose, and to share up-to-date intelligence on the suspected terrorist leader Osama bin Laden and his followers in Afghanistan.

By now Pakistan's decades-long involvement in Afghanistan is known by most who follow the news. It is seldom recalled, however, that in the late 1970s another general, Zia ul Haq, then ruler of Pakistan, convened a meeting similar to Musharraf's. At that time the military junta was asked to play a crucial role in support of the U.S.-financed resistance to Soviet forces occupying Afghanistan. That decision was undoubtedly easier for the dictator Zia ul Haq and his advisers than the one faced by Musharraf. Zia had been in power for two years, and his religiously conservative regime was already unpopular both at home and abroad. Supporting the United States would give his government badly needed legitimacy on the world stage. Zia also anticipated a U.S. aid package to help Pakistan deal with its perpetual social and economic problems. However, Zia was a master tactician. He did not immediately agree to the terms of support offered by the Carter administration and rejected the initial offer as "mere peanuts."[3] It was not until the early Reagan years that the Pakistani government finally accepted the first installments of the nearly $3 billion that flowed into the region in the 1980s. To the skeptical Pakistani population, the military regime portrayed its intervention in Afghan affairs as humanitarian and political assistance to fellow Muslims. But the junta's decision to play ball with the United States also was taken for strategic reasons.

Since Pakistan's independence in 1947, relations between Afghanistan and

Pakistan had been strained because of boundary disputes and the feared spillage of ethnic Pashtun nationalism across the common border. Afghan rulers disputed the nineteenth-century division of Pashtun-dominated areas by the British colonial authorities. The Durand Line, the boundary between colonial India and Afghanistan, was inherited by Pakistan as its own border with the neighboring state. Successive Afghan governments were supportive of nationalist Pashtun movements that called for regional autonomy or independence from Pakistan. These struggles were a source of anxiety to the centralizing Pakistani state. With openly hostile India on their eastern flank, Pakistani military strategists regarded their not-so-friendly western neighbor with suspicion. Tensions were aggravated by the Communist-led coup in Afghanistan in 1978 and the subsequent Soviet invasion of that country in 1979. The U.S.-backed resistance to the pro-Soviet Afghan regime guaranteed, at least in the minds of the Pakistani military leaders, a somewhat concrete resolution of their Afghan problem.

The fall 2001 campaign in Afghanistan is fresh in our minds, but the mass displacement of the Afghan population, the destruction of their homes, and the loss of 1.5 million Afghan lives during their two-decades-long civil war had by September 2001 vanished from the consciousness of Western news media. Nor did many outside Pakistan remember the Afghan war's impact on Pakistani civil, cultural, and political life. The Pakistani military used part of the international aid that poured into Pakistan during the Afghan war in the 1980s to strengthen its Inter-Services Intelligence Directorate, or ISI. The ISI was the principal liaison between U.S. intelligence agencies and the varied factions of the Afghan resistance against Soviet occupation, known as the mujahideen. The ISI created a range of shell, covert, and legitimate companies that were used as fronts for the war effort in Afghanistan. Unknown to the Pakistani public, these companies became the major conduits for supplying arms to the "freedom fighters." The ISI also assumed a leading role in suppressing democratic dissent within Pakistan. To date, even after Musharraf's recent supposed move against hard-liners and Islamist elements within the army (exemplified by the forced retirement of General Mahmud Ahmed, the director-general of the ISI, in October 2001), there are no constitutional checks and balances on ISI's operations. Its ranks remain filled with highly motivated ultranationalist and religiously zealous officers who are concerned with safeguarding what they consider to be the boundaries—geographic and ideological—of the Pakistani state.

Another important result of the U.S. economic and development aid in the 1980s, combined with assistance from Saudi Arabia, was the implementation of Zia's plans for the Islamization of Pakistan. Development funds were used to establish and maintain Islamic religious schools (*deeni madaris*) in different parts

of Pakistan. Zia and his junta considered the students and graduates of these schools as the foot soldiers who would support the dictator as he pressed ahead with his agenda to build an Islamic polity and a theocratic state.

A third legacy of the Afghan war was the unprecedented infiltration of drugs and weapons into Pakistani society. Profits from drug and weapons trafficking partly helped to finance the covert war in Afghanistan, while also funneling enormous wealth to a section of the upper echelons of Pakistan's military and bureaucratic elite.

The triumph of the Afghan resistance forces in 1992 did not result in what Pakistan's military had always desired: a stable Afghanistan following the dictates of Islamabad. With the Cold War already a fading memory, the United States and other Western countries virtually abandoned the victorious mujahideen, making only vague promises of development aid to rebuild the war-ravaged country. In subsequent years, infighting among the new Afghan leadership, and its growing independence from the ISI, led Pakistan to intensify its involvement in Afghanistan's affairs. The Taliban, a radical faction of madrassah students under the guidance of Mullah Mohammed Omar of Kandahar, was bankrolled by the Pakistani military in 1995–96 on its path to victory in Afghanistan. From the perspective of the generals in Islamabad, the Taliban's loyalty to and dependence on them guaranteed a safer and less volatile western border. In addition, Pakistan was interested in secure routes to the landlocked Central Asian states. A stable, Taliban-led Afghanistan was an element of a larger geopolitical strategy wherein Pakistan, the United States, and international petroleum companies envisioned multiple pipelines transporting oil and natural gas from resource-rich Central Asian countries to Pakistani ports on the Persian Gulf. But the strongly independent and unpredictable nature of the Taliban, and the continuing civil war in northern Afghanistan, dampened the initial excitement these schemes had generated.

It should be noted that Pakistan's involvement in Afghanistan and its support for the Taliban were regionally unpopular. Iran strongly opposed the Pashtun-dominated Sunni Taliban and blamed it for the systematic killing of the Hazara Shi'a minority in Afghanistan. Similarly, other Central Asian states backed the Northern Alliance, which was constituted primarily of non-Pashtun ethnicities. India too played its role and gave diplomatic and monetary sustenance to non-Taliban forces against the Pakistan-supported regime. Even prior to the Taliban, Pakistan's intelligence services had historically given assistance to Pashtun Afghan groups and had continuously sabotaged the multi-ethnic Afghan government that came into power after the Communist regime of Najibullah fell in 1992. All through the 1980s Pakistan supported Gulbadeen Hekmatyar (one

of the most brutal and undemocratic of mujahideen commanders), whose radical Islamist party, Hizb-e Islami, received more than 60 percent of the aid that went to the mujahideen through Pakistani channels.[4]

Pakistan's support for Pashtun groups may partly be a result of geography, since Pashtun-populated areas in southern Afghanistan are contiguous with the Pakistani border. This proximity has historically shaped the region and resulted in cross-border kin and group ties. Earlier solidarities had at times been exploited by Pashtun nationalist forces, but in the 1990s the Pakistani security agencies, charged with running a covert war against the Soviet presence in Afghanistan, were successful in turning these ethnic bonds into ones of Islamic resistance. How Pakistan's North West Frontier Province, the area that borders Afghanistan and has a majority Pashtun population, went from being a hub of nationalist and leftist politics to being now identified with radical Islamic movements is a still unwritten and underanalyzed part of Pakistani history.[5] The change clearly reflects how in the last two decades the use of Islamic symbols and political discourse has helped the Pakistani state successfully diffuse a progressive, nationalistic, and at times separatist movement within its borders, and to assert its influence over Afghan national politics that threatened its control over this region.

Musharraf inherited a Pakistan in which Zia ul Haq's ghost, more than a decade after his death in an airplane explosion, lingered on. Even after an interim experiment in democratic politics, Zia's legacy permeated Pakistani cultural life, which shifted to embrace orthodox Islamic values under the growing influence of Islamist political factions. One of the most important components of this legacy is the madrassah system of education. In a state that has forsaken responsibility for providing its people with educational and employment opportunities, the madrassah system became an avenue for a large percentage of the rural and urban poor to seek social advancement. Many such *madaris*,[6] linked to a more orthodox Wahhabi tradition of Islam, had a militant edge to their training and became recruiting grounds for the conflict in Afghanistan or in Kashmir. The Taliban themselves were a product of such *madaris*. They also intensified sectarian rivalries in Pakistani society. Saudi Arabian–funded *madaris*, for example, professed an anti-Iran and anti-Shi'a ideology, and their graduates have been responsible for widespread violence against Pakistan's Shi'a minority. Iran, meanwhile, has aided Shi'a militancy by providing resources to Shi'as in Pakistan.[7] In a sense, Pakistan in the 1990s became a space where, along with its own violent ethnic rivalries, the Saudis and the Iranians engaged in a turf war on Pakistani soil and at the expense of Pakistani lives. One consequence of such involvements is that Pakistan remains politically unstable, rife with growing ethnic and sectar-

ian violence. This violence, although it challenges the authority of the Pakistani state and military, has also been cynically deployed *by* the state against internal opposition. The government has used some of the Islamist groups for external purposes as well, for example, in its covert war in Kashmir.

## THE OTHER WAR: KASHMIR

The 1971 roots of the present crisis in Pakistan spread to its east and to its west. In that year, India gave support and sustenance to the Bengali liberation struggle in East Pakistan. The ruling Pakistani military junta saw India's aid to the Bengali freedom fighters as abetting Bengali "terrorists." Yet the then-reigning international opinion, influenced by the wave of anticolonial struggles, was clearly in favor of Bengali self-determination. India, therefore, never faced censure in the court of world opinion; instead it was congratulated by many as the liberator of the Bengali people.

In December of 2001, three decades to the month after Bangladesh won its freedom, Pakistan and India were again at the brink of war. This time it was over the right to national self-determination and independence from India demanded by the Muslim population of Kashmir. The thirty-year cold peace between the neighbors has been punctuated by low-intensity warfare along their long common border and maintained by the supposed deterrence that their nuclear potential proffers. Within this context—perhaps as a way of overcoming the memory of its earlier defeat, and in a clear reversal of 1971 roles—Pakistan has since the late 1980s ideologically, logistically, and militarily supported an armed struggle in Indian Kashmir. This undeclared war, which is nominally about supporting the rights of the Kashmiri Muslim population, also serves strategically to tie down a large contingent of the Indian defense forces, while simultaneously causing a drain on the Indian exchequer. India has responded to this provocation with massive force and brutality, as did Pakistan in 1971. It has spurned dialogue with the legitimate representatives of the Muslim independence movement and has obstructed any third-party involvement in mediating the process. In doing so it has further fueled the conflict and been guilty of human rights abuses against the civilian population, including torture, rape, summary executions, and disappearances of innocent Kashmiris.[8]

These measures have intensified the response of armed Kashmiri resistance groups like the Lashkar-e-Taiba and Jaish-e-Mohammad, which, sustained and aided by the Pakistani military, took center stage within the struggle. These groups, violently or otherwise, also forced to the margins those Kashmiri political groups that were more inclined toward nonviolent struggle, civil disobedi-

ence, and political dialogue. India's militaristic intrusion and Pakistan's support of armed struggle have left the Kashmiri people caught between two belligerent states that are engaged in a proxy war, at a tremendous cost to the people of the region.

Pakistan's involvement in Kashmir came at a moment when international opinion was shifting on the issue of aid to violent insurgencies, even those perceived as struggles for national liberation. During the 1990s national boundaries became more porous to international trade and global finances, yet more restrictive of cross-border aid by individual states to wars of national liberation or to political insurgencies. The stabilization of Central America under the Arias plan had led to the end of conflict in that region,[9] and became a harbinger of an international consensus against such aid. The Pakistani military may have a deep memory of humiliation, but it has seldom possessed the flexibility to understand changing international trends.

As suggested above, Pakistan's major external policy initiatives in the last two decades, under its military's directions, have consisted of two elements: nurturing a Pakistan-friendly regime in Afghanistan to guarantee strategic depth on its western border, and encouraging armed resistance against India in Kashmir. Both interlinked policies also guaranteed the preservation of the military's high demands on the national budget, and provided the ideological justification for the growth and consolidation of its role in Pakistan's social and political life. Yet these policies expose the political miscalculations of the Pakistani state. The military may feel betrayed by world censure of its policies in the region, yet it has continuously misread the diplomatic tolerance of its regionally isolated policy on these issues as acceptance of its stand.

Even after its about-face on the Taliban issue after September 11, which laid bare the serious flaws of its previous policies, the Pakistani military continued to think that it could still intervene in Kashmir. However, the December 2001 attack on the Indian Parliament may drastically limit Pakistan's support for Kashmiri separatists. India, with or without proof of official Pakistani involvement in this particular deed, pointed to the pattern of support that the Pakistani military had offered to armed groups that targeted civilians. Pakistan failed initially to understand the emerging atmosphere of zero tolerance toward any form of terrorist activities as the definition of the term expanded post-September 11. The Indian government, in contrast, taking its cue from the United States, pushed hard to win the international public relations war, if not the hearts and minds of Kashmiri Muslims.

India, perhaps compensating for its hurt pride in the Kargil incident—in the

summer of 1999 (in an action masterminded by General Musharraf himself) Pakistani-trained insurgents and army regulars caught the Indian security forces by surprise and occupied Indian-held territory in Kargil—has threatened Pakistan with dire consequences for the attack on Parliament. It is the return of 1971, this time in reverse. The neighbors, now armed with nuclear arsenals, remain involved in a game of dangerous brinkmanship. This is not simply a regional issue, but should be a matter of grave concern to the international community as well. Yet the final responsibility for the outcome rests with the belligerents themselves. The two countries, with their immense social and economic problems, need to resolve the Kashmir issue by means of a meaningful dialogue that takes seriously the legitimate concerns of the Kashmiri Muslims.

Unfortunately, successive Pakistani civilian governments in the last decade have been unable to influence the country's policy on Kashmir. That has been the purview of the military, which has periodically sabotaged any movement toward a negotiated settlement. Yet civilian governments have also neglected domestic issues of democratic governance, economic distribution, and social needs. This, along with their rampant corruption, has eroded people's faith in civilian rule. Within this context, the military has portrayed itself as the stable social institution that can save Pakistan from its corrupt and inept civilian representatives. As mentioned above, the ISI and the military have been involved in all major domestic and international decisions made in the past two decades, even when nominally out of power. Hence, the peculiar impasse that Pakistan faces in a post–September 11 world is entirely the military's responsibility.

## THE FUTURE

The Pakistani military understands this responsibility at a fundamental level. This is one reason why its institutional face, General Musharraf, condemned Islamist violence in his January speech. Musharraf's move was also intended to reduce the international pressure on his government, and to systematically refurbish the tarnished image of the Pakistani military among Pakistanis themselves. The military remains the largest and most organized, most modern and technologically sophisticated political group in Pakistani society. As much as it nurtures its constituency by an immensely sophisticated use of the national media, it is also cognizant of the social, economic, and political implications that its long-term policies have had on the country. It is aware that to continue to rule it needs to create a new consensus and it therefore seeks to recast the memory of the recent past as an aberration. It is willing to play the liberal secular card to retain its hold on power. Instead of the Islamists, its new allies are the large majority of

Pakistanis who had found themselves unwillingly trapped in a society that was turning toward more extreme forms of Islamic practice and polity. The liberal intelligentsia has heaved a sigh of relief at this turn of events. Long the target of Islamist attacks, sometimes instigated by the state security apparatus itself, liberals are now circling their wagons around Musharraf, seeing him as the savior that will release the country from the Islamists' grip. In their unrestrained acclaim they perhaps forget the military's ability to manipulate history. Musharraf is willing to hold elections to the national parliament, but he will remain in power as the head of state for another five years. The military will not risk civilian scrutiny until it can guarantee the continuation of its own entrenched power in Pakistani society.

By accepting the post–September 11 U.S. demands in exchange for fresh promises of international largesse, the Pakistani military has for the time being saved itself from the wrath of the U.S.-led coalition. But in the process, the regime may have plunged Pakistan into an uncharted future, with no regard for such stability as remains in Pakistani social life. The promise of U.S. aid in exchange for strategic support, moreover, falls on deaf ears among most Pakistanis (and Afghans). They remember a series of broken Western promises, most recently when the United States and its allies failed to provide much-needed development assistance in the early 1990s. And during the 1980s, when billions of dollars did pour into Pakistan, the impact on development was minimal, since a large percentage of the money was used by the government to purchase military hardware and support mujahideen groups. Accusations of corruption and pilferage were also common. Given the past performance of Pakistan's ruling elite, the Pakistani public might rightly be skeptical about any meaningful impact on their lives from the promised aid.

Pakistan is at a difficult crossroads. Yet like many such crisis moments, this moment could be seized to rethink a range of options. The opportunity could be used to put forward workable solutions for Pakistan's political and social problems. Otherwise Pakistani society will continue to be riddled with social chaos and violent strife. The suffering population of this land of rivers, mystic poets, and ancient history deserves far better than its elites have offered in the five decades of its existence. As a first step, the international community should make clear that its present support for the military regime is not a green light for the latter to perpetuate its rule indefinitely.

International pressure, using economic aid as a tool, should be increased on the present junta to hold free and fair elections. It should be persuaded to revoke all Zia-era amendments to the constitution, including laws that uphold separate electorates (in which Muslims and non-Muslims vote for separate candidates),

those that discriminate against religious minorities, and those that suppress the rights of women. All political parties, irrespective of their affiliation and ideology, should be allowed to participate in the elections. The elections could be held under the auspices of the United Nations, which has by now gained considerable experience in monitoring elections. The U.N. has, in the last decade, intervened in states that have already witnessed protracted civil war or social strife. Pakistan could be an experiment in avoiding such a calamity before it occurs. Within the context of a democratically elected government a sincere reprioritizing of national resources should be instituted. The military's budgetary demands, which stand at almost 30 percent of the annual budget, need to be curtailed in favor of funding vital social needs in primary and postsecondary education, health, rural and urban infrastructure, job creation, and the strengthening of the legal system.

The Pakistani liberal media is comparing Musharraf's answer to this crisis to a Kemalist secular transformation. While selectively remembering the modernizing and secularizing impulse of that Kemal Atatürk–led process, these commentators tend to forget that the Turkish experiment in nation building featured draconian laws, centralized power, oppression of ethnic minorities, and extreme brutality against its population by a police state. Those affected by such a process will continue to resist its imposition. It is absolutely crucial to understand that if the social and political framework within the country does not fundamentally change, we may witness the dissolution of Pakistan, as we have seen occur in Somalia and elsewhere. The geostrategic location of Pakistan, along with its nuclear capability, should make the international community think seriously before it allows such a future to unfold. The primary task should remain that of national integration, socioeconomic development, and the strengthening of democratic norms. Pakistanis will need international support and encouragement but, more important, selfless leadership from within to attain this goal.

# 9. CAN RATIONAL ANALYSIS BREAK A TABOO? A MIDDLE EASTERN PERSPECTIVE

## SAID AMIR ARJOMAND

I happened to be in Beirut in mid-May 2001, when the Israeli retaliatory raids began to escalate. My host called me at midnight, after I had gone to bed, to come and see what was happening. I saw on the TV screen, as did millions in the Middle East, pictures of the continuing fire caused by the bombing. I saw the rubble of destroyed buildings and the human suffering that went with them. The next day it was evident that these pictures had evoked not only deep revulsion among Lebanese but also the fear of another Israeli invasion of Lebanon. With very good reason, nobody believed the Americans would do anything to stop the Israelis if they decided to invade. When I returned to the United States, none of that horror and tragedy experienced in the Middle East had registered with my fellow Americans, who had the luxury of ignoring it in the false security of their different world.

These images provide a starting point for studying the appeal of terrorism to desperate young men and, more rarely, women in the Middle East. Viewing recent Israeli-Palestinian developments from the perspective of the Muslim world, as did my friends in Beirut at that time, the inability of the American superpower to stop the expansion of Jewish settlements in Palestinian territory even during the period of peace accords and negotiations is incomprehensible. Such incomprehension doubtless facilitated the spread of the conspiratorial rumor, widely current in the Arab Middle East, that it was not bin Laden but the Jews who destroyed the World Trade Center. On the other hand, what is impossible to miss is the Israelis' conspicuous use of American weapons, especially of F-16 fighter jets and smart bombs, since May 2001. Those who see our weapons used to destroy Palestinian civilian targets on their television screens throughout the Middle East are more likely to hate our destructive power than to consider us champions of freedom and democracy. It is true that the mind-set of the Islamic fundamentalists has been formed over a long period, and that the September 11 terrorist operation must have been planned by bin Laden some time ago. But the intensity of commitment to the goals of the movement at the moment of decisive suicidal action may be influenced by more immediate events. Who is to say that if the F-16s had not been so visible in the destruction of Palestinian targets a short while ago,

some of the plotters in the highly improbable and risky project to destroy the World Trade Center and a wing of the Pentagon would not have wavered and caused its failure in 2001, as happened in the attempt to destroy the WTC in 1993? This speculation aside, if the point is to reduce the likelihood of another attack, removing the cause that fuels suicide bombings is not irrelevant. But let us leave these speculations for more solid empirical grounds.

Of the two evident factors that can explain the terrorist attacks of September 11, one has been blown to distorted proportions and misleadingly simplified; the other was at first studiously avoided and then increasingly denied. The first factor is Islamic fundamentalism in general, and its terrorist offshoot, Al Qaeda, in particular. The second is our unconditional support for the policies of the state of Israel. In addition to the U.S.-Israel connection, there are some less important causes of violent opposition to the United States in the Middle East: our action in Iraq since the Gulf War and our support for Saudi Arabia and a number of other repressive Arab regimes. There is a tendency to grossly oversimplify the first factor in such a way as to obviate the need for thinking of the second set of factors altogether. The constantly repeated simplistic explanation of the motive of terrorists as crazy and fanatical hatred of freedom and democracy eliminates the need for any further explanation and thus obscures the real causes of terrorism. In this chapter I will try to demonstrate that the social sciences can offer a more rational ordering of the causally relevant factors through a nuanced assessment of the religious motivation of terrorism, on the one hand, and the Middle Eastern political situation, on the other.

Let us first examine the nonreligious causes of terrorism and their implications for U.S. policy. These raise some uncomfortable questions about the accountability and deeds of our government and those of our close allies. At the end of the Gulf War in 1991, President George Bush countermanded General Norman Schwartzkopf's expected march on Baghdad to finish Saddam Hussein off fair and square. Many Iraqis who had risen against Saddam in anticipation of an American capture of Baghdad were let down, and slaughtered by his remaining armored forces. The population of Iraq has since suffered a decade of siege and bombing by our aircraft, with occasional advertisement of "covert" operations to overthrow Saddam by the CIA. There has been no historical judgment or public debate on the decision by President Bush senior of the kind that is necessary for a healthy democracy. Nor did we, in the false security of our supposedly invulnerable world, show any concern that the suffering of the Iraqi civilian population, including the injury, deforming, and death of a few hundred thousand Iraqi children, might tarnish our image as the haven of freedom and democracy. Immediately after September 11 we heard of renewed plans to "punish Saddam"

in our war against terrorism.[1] The fateful 1991 Bush decision, however, was completely forgotten. Nor was there any change in the total indifference of the U.S. government to the suffering of Iraqi civilians.

Rethinking our relationship with Saudi Arabia is not emotionally painful either, and does not meet any deep psychological obstacles. The fact that Osama bin Laden comes from a prominent Saudi family and most of the 19 September 11 highjackers were from Saudi Arabia has provoked broad questioning of our support for the Saudi regime. On the far right, for instance, retired Colonel Ralph Peters envisions running the Saudi oilfields for the benefit of civilization: "we must be prepared to seize the Saudi oilfields and administer them for the greater good. Imagine if, instead of funding corruption and intolerance, those oil revenues built clinics, secular schools, and sewage systems throughout the Middle East. Far from being indispensable to our security, the Saudis are a greater menace to it than any other state, including China."[2] Elsewhere along the political spectrum, commentators and policy analysts are beginning to consider the uncomfortable consequences of the potential overthrow of the Saudi monarchy.

Level-headed thinking about the U.S.-Israeli connection is much more difficult, however, as it runs counter to a long-standing taboo against criticizing the Israeli government—all the more so because the taboo is understandably reinforced in adversity. To reassess U.S. policy toward Israel in the post–September 11 context is to point a finger at an ally, which is just what the terrorists would have wanted, and we would be cowards to let them have that satisfaction as well as the horrendous destruction of American lives and property. Nevertheless, as we shall see presently, this taboo is the source of major distortions in our understanding of September 11.

## CONTENTIOUS CONSTRUCTION OF THE REALITY OF SEPTEMBER 11

The shock and disorientation of September 11 created an urgent demand to make sense of what had happened and set in motion a contest for shaping the public discourse designed to make sense of it. Terrorism, so dramatically manifested, had to be explained; and the kind of explanation that prevailed would obviously not be neutral in its consequences. Two groups—American Muslim organizations, especially the Arab American groups, and the American Jewish groups, especially the pro-Israel lobby—were immediately drawn into this contest, which revolved around the two above-mentioned factors adduced to explain the motivation of terrorism. These two groups competed in the enterprise of constructing reality in a great crisis, seeking to frame the discourse around

September 11, which would in turn henceforth constitute the objective facts of terrorism.

The contest for the control of reality and constitution of objectivity through the forging and appropriation of the emerging consensual discourse was highly mismatched. The well-organized Jewish groups and Israeli lobby stepped into the business of defining reality and shaping public discourse fully prepared. The minimally organized Arab and Muslim Americans, by contrast, found them-selves totally on the defensive against guilt by association and the general moral outrage of American society. The media did perform credibly and responsibly in publicizing and protesting the acts of racism and hate crimes against Arab and Muslim Americans. The *New York Times* even reported a shift by some Arab American organizations from cautious restraint to public expressions of disap-proval of American foreign policy,[3] and a month into the new year, 2002, we were told that "Arab students rediscover voices silenced on September 11."[4]

This sympathetic performance of the media was made easy, since it drew on the dominant American ethos of pluralism and the rule of law. The same, how-ever, cannot be said about more difficult issues in public debate on our policy op-tions. In the face of psychologically uncomfortable questions related to policy, demonology tends to displace rational analysis. This is especially the case when it comes to thinking about the U.S.-Israeli connection, for there is a long-standing taboo against criticizing the Israeli government, and it was greatly reinforced by the stress of the crisis of September 2001. This basic lay of the land in American politics, slanted even more by the devastation at Ground Zero, gave a tremen-dous advantage to pro-Israel organized groups attempting to frame the post-crisis public discourse.

The strategy that readily suggested itself to these groups was to deny the rele-vance of the Israeli-Palestinian conflict while singling out Islamic fundamental-ism and blurring its distinctness from Islam as a whole. On the day that Prime Minister Sharon canceled the talks with the Palestinians, for instance, a *New York Times* article by Serge Schmemann, "Israel as Flashpoint, not Cause"; quoted our former ambassador to Israel, Martin Indyk, as stating that "Israel will not pay the price in its blood for such a coalition [that includes Arab and Islamic states]. There is real concern that Israel's enemy will be the U.S.'s friend." (Mr. Indyk does not appear to measure Israeli and American blood on the same scale.) The words "The Target" were printed above the headline, accompanied by an enigmatic pic-ture of shadows of men engaged in the politically innocuous act of praying on the Western Wall of Jerusalem.[5] In other words, business as usual for the pro-Israel stalwarts, as if nothing had happened. Or perhaps even better than usual. Boosted by the likes of Schmemann and Indyk, Prime Minister Sharon, just be-

fore ordering the attack some two weeks later on two Palestinian neighborhoods with American-made tanks and Apache helicopters, warned the Americans not to "appease Arabs" as the Western democracies had appeased Hitler on the eve of World War II. The *New York Times* cycle of Op-Ed restoration of consensus was completed with Dennis Ross's reassurance that, bin Laden's clear and unequivocal words notwithstanding, "Bin Laden's Terrorism Isn't About the Palestinians."[6] With irrelevance of the Israeli-Palestinian issue to September 11 so clearly established, the shaping of public discourse on behalf of Israel could move from the defensive to the offensive, and tackle Islam as the sole remaining cause of terrorism.

The *New York Times* led the way once more, identifying Islam as the cause of terrorism. In its November 13, 2001, Arts & Ideas section, a review of a polemical book by Martin Kramer, an Israeli political scientist described as an expert "who teaches in the United States and Israel," occasioned the appearance of the lead article, "Many Experts on Islam Are Pointing Fingers at One Another," and provided advance publicity for the accusation against academic specialists on Islam of failing to warn the American public about the dangers of Islamic extremism.[7] Having thus commandeered the *New York Times,* which obligingly established him as an expert (without quotation marks), Mr. Kramer then moved his offensive onto the editorial page of the *Wall Street Journal* ("Terrorism? What Terrorism?!" 11/15/01) on the occasion of the annual convention of the Middle East Studies Association.[8] Those of us who are members of MESA were referred to as the 2,600 "experts" on the Middle East (in quotation marks), and excoriated for "helping to lull America into complacency" and for calling the terrorist attacks "crimes—not acts of war." Having expressed concern over the gullibility of "some pliant senator or congressman willing to propose additional budgets for Middle Eastern studies," Kramer offered his advice to Israel's supporters with a flourish: "Mr. President, don't waste your time. The professors don't meet the course prerequisites. Members of Congress: There is no justification for an additional penny of support for this empire of error—and no better time to reexamine the federal subsidies it already enjoys." The exaggerated pretense of concern about "some pliant senator" was unnecessary. As if to oblige Mr. Kramer, 89 senators sent a letter to the president the next day, urging him "not to restrain Israel from retaliating fully against Palestinian violence."[9]

The pro-Israel interpretation easily won the uneven struggle, and by now constitutes the objective reality of terrorism for the vast majority of Americans. Yet this refabricated consensus can easily mislead us into the trap of an American crusade against the Muslims. Bin Laden would have been delighted to hear Kramer's opinion that the September 11 attacks were not crimes but had the dig-

nity of acts of war, and could not wish for greater help with his apocalyptic war than the assistance given by Sharon and his allies in the press. Nothing would give bin Laden and the Islamic terrorists greater satisfaction (on whichever side of the grave they happen to be) than an unending war against the Arabs or Muslims that would sooner or later precipitate a revolution in Saudi Arabia and the Persian Gulf and pit the United States against Islam.

With the spectacular military success in Afghanistan, the moment was opportune for declaring a victory in the war against terrorism and bringing it to an end. Once more, however, the pro-Israel lobby came to bin Laden's help to assure that the war would be extended and remain open-ended until such time that our hubris brought self-destruction. Already in July 2001, before the terrorist attacks, the American Israeli Public Affairs Committee (AIPAC) flexed its muscle by isolating Iran and blocking a U.S.-Iran rapprochement. It lobbied to change the administration's proposal to extend economic sanctions against Iran from two to five years in order to send a clear message to the Iranians. AIPAC's great success was reflected in the nearly unanimous approval of the measure (490–6 in the House, 96–2 in the Senate). The vote also reflected the continued prevalence of the demonized image of Iran that began with the hostage crisis of 1979. Yet immediately after the invasion of Afghanistan in October 2001, the Iranians took the initiative and rushed to help us, both on the basis of common interests in Afghanistan and with the hope of improving relations with the United States, and continued to use their considerable influence with the Northern Alliance cooperatively to install the new Afghan government.[10] President Bush's sudden extension of the war against terrorism to the production of weapons of mass destruction by Iran, announced by his reference to the "axis of evil" in his State of Union message of January 29, 2002, was said to have come out of the blue. In fact, however, on January 25, AIPAC had written to the president: "We applaud your leadership on working to halt Iranian proliferation. Iran's continued support for global terrorism and their aggressive weapons of mass destruction program make their pursuit of chemical, biological and nuclear weapons a grave concern to the United States, Israel and all states that value democracy."[11] This letter had in turn followed allegations by the Mosad (denied by the Iranian government) that 50 tons of weapons had been loaded onto the ship *Karin A,* bound for the Palestinian Authority in Iran, with Persian documents or inscriptions as an obliging trace. This story was accompanied by a sudden upsurge of reporting, in the *New York Times* and other newspapers, on Iran's support for terrorism, an upsurge that took place alongside an Israeli campaign "to turn Iran into an outcast."[12] The success of these efforts was evidenced by President Bush's demonization of Iran as a part of the axis of evil. Rational assessment of our previous

policy of "dual containment" (which by all reasonable accounts had failed to achieve its objective of ghettoizing Iran) and of the cost of depriving ourselves of any presence and influence in Iran were swept aside by this new post–Cold War demonology. This sweeping rhetorical shift has badly damaged the prospects for Iran's troubled reform movement, which had been highly demonstrative in its sympathy after the tragedy of September 11. The irony is that, within a quarter of a century, Ayatollah Khomeini's demonological virus has infected the superpower he called the Great Satan.

It goes without saying that Islam is the subtext of the extension of the war against terrorism to the Iran of the ayatollahs, and we must now turn an assessment of the explicit as well as implied place of Islam in the constructed reality of September 11.

## ISLAMIC TERRORISM: A CLASH OF CIVILIZATIONS OR THE CLEFT CIVILIZATION OF MODERNITY?

The spread of suicide bombings beyond the Islamic Hamas into the adherents of other groups make their easily accepted explanation in terms of purely religious motivation questionable. Other facts make such explanations even more dubious. It is well known that the Palestine Liberation Organization is a secular organization, as is its affiliate, the Popular Front for the Liberation of Palestine, which claimed responsibility for the assassination of the Israeli tourism minister, Rehavam Zeevi, on October 17, 2001. It is also well known that some of the PLO's leading figures in its radical wing are Christian rather than Muslim Arabs. But with the advent of Islamic fundamentalism a quarter of a century ago, the recruiting base for terrorism in opposition to U.S.-backed Israel expanded from the ethnic Arabs in the Middle East to the entire Muslim population of the globe. This larger Muslim population, within which Islamic fundamentalist movements of varying strength have grown in the last two decades, stretches into Central Asia as far as Afghanistan, where bin Laden began his political venture against the Soviet Union in the 1980s with substantial support from the U.S. policy organs, including the Central Intelligence Agency. Within the Islamic fundamentalist movement emerged the ideology of "political Islam" (I prefer this term to "Islamism," which has also gained currency). As a form of nativism, political Islam employed a reified view of the West that had been aptly characterized as "Occidentalism" (the reverse of Orientalism) in a study of Muslim intellectuals in contemporary Iran.[13] In addition, political Islam adopted the revolutionary justification of violence from the modern myth of revolution, backing it with a new reading of the Koran that diverged radically from the conservatism of tradi-

tional Islamic political thought. The original targets of the Islamic militants in their revolutionary struggle were the secular states and rulers of the Middle East.[14] In the 1990s, Osama bin Laden extended the Islamic justification of violence to the realm of international terrorism.

This bare sketch of Islamic terrorism's historical development suggests that the increasing vitality of religion in the Muslim world explains why the militants justify their political goals in terms of Islam and that in so doing they induce total commitment and willingness to die for the cause. Despite this, however, Islamic fundamentalism does not inherently include anti-U.S. terrorism among its goals. As groups like bin Laden's broaden the recruitment base for terrorism and attempt to appropriate Islam, it is tempting to see not just Islamic fundamentalism, or political Islam, but Islam itself as responsible for terrorism. Such a backward reading of history obfuscates the multiply mediated causation of the terrorist attacks. It can easily give rise to the blunt or subtle deduction of terrorism from allegedly essential characteristics of Islam. Such misconceptions lead to allegations of the inevitable "clash of civilizations," which amount to the advocacy of war against over a billion Muslim people (including many loyal citizens of the United States and some of the victims of September 11). Those who see Islam as the sole or overwhelming cause of terrorism include a few academic pundits, but also some prominent writers. Salman Rushdie thus affirms: "Yes, This Is About Islam!"[15] V. S. Naipaul believes that, given the importance of the idea of paradise in Islam, "no one can be a moderate in wishing to go to paradise. The idea of a moderate [Muslim] state is something cooked up by politicians looking to get a few loans here and there."[16]

The complex internal factors determining both the growth and the decline of Islamic fundamentalism in different countries are largely unaffected by United States policy. Urbanization and a variety of other social and political processes, such as the spread of literacy, higher education, and the media in the last half century have resulted not only in the rise of Islamic fundamentalism in some countries—and within it, of political Islam based on the cloning of the pre-1989 Marxist, anti-imperialist revolutionary ideology—but also in a general increase in the vitality of religion in the Muslim world.[17] Internal processes can also account for the decline of Islamic fundamentalism and of political Islam, as in Iran, where there were highly visible demonstrations of sympathy in the days following September 11. In any event, the animus of Islamic fundamentalism need not necessarily be directed against the United States but can be directed elsewhere. One need only think of the United States' alliance with Saudi Arabia, the first Islamic fundamentalist state of the twentieth century, and the target of much of bin Laden's wrath. In other words, the undoubted relevance of the growth of Is-

lamic fundamentalism, and especially the rise within it of the political Islam that fuels terrorism, does not by itself provide an adequate explanation for the disaster of September 11 and does not eliminate the need for understanding its other mediating causes. To get from fundamentalism to terrorist attacks we must look for additional causes, such as hatred animated by the use of American weapons against Palestinian civilians, our continued bombing of Iraq, and our support for repressive Arab regimes that maintain our oil supply.

Let us see how bin Laden blended these nonreligious causes of anti-Americanism with Islam into the manifesto of Islamic terrorism which was put into practice in a somewhat improbable alliance with a reactionary formation on the periphery of the Muslim world. Between 1982 and 1992, the United States, Saudi Arabia, and Pakistan supported the training of some 35,000 men from 43 Muslim countries to join the Afghan mujahideen in the jihad against the Soviet Union. These included the young Osama bin Laden, who in the course of anti-Soviet operations became friends with Prince Turki of Saudi Arabia and General Hamid Gul of Pakistan. He secured large donations from Saudi princes for a service center (*makhtab al-khidmat*) set up in Peshawar in 1984 by his Jordanian-Palestinian mentor, Abdullah Azam; it was taken over by bin Laden himself after Azam's assassination in 1989. At that time, he also set up Al Qaeda. Bin Laden returned to Saudi Arabia in 1990 to work in his family business, and founded a welfare organization for the Arab veterans of the Afghanistan war, which also served as a financial structure for Al Qaeda. After Iraq's invasion of Kuwait, he offered to raise an Arab-Afghan force to fight Iraq, but turned against the Saudi royal family when his offer was rejected in favor of American troops. He left for the Sudan in 1992, and elaborated his ideas for a "global Islamic revolution" in 1995. In 1996, he was reportedly training a second generation of some 1,000 Arab-Afghans for an Islamic revolution in Arab countries. He returned to Afghanistan with his bodyguards and three wives and 13 children in May 1996 and issued his first declaration of jihad against the Americans in August 1996.[18]

Meanwhile, another U.S.-Saudi-Pakistani-fostered cancerous growth had spread over Afghanistan. The koranic schools (madrassahs) had mushroomed around the Afghan border in Pakistan to assure the continuous supply of mujahideen in the holy war against the Soviet Union. (By 1988, there were some 8,000 registered and perhaps 25,000 unregistered madrassahs, which offered free board to over half a million poor boys.) A force of these koranic students (Taliban) had conquered Kandahar in November 1994, and within a month, some 12,000 Afghan and Pakistani students had joined them. From Kandahar, the Taliban picked up most of the pieces of an Afghanistan shattered by nearly two decades of civil war. The supply of students from the madrassahs continued to the

end of Taliban rule. When the Taliban were defeated in Mazar-e-Sharif in 1997, for instance, a group of madrassahs, from one of which the Taliban leader, Mullah Omar, had graduated, were closed down, and their 5,000 students were sent to replenish the Taliban forces.[19] By the time bin Laden returned to Afghanistan in 1996, Mullah Omar had established an Islamic government, duly styled the Islamic Emirate of Afghanistan, and called himself the commander of the faithful (*amir al-mu'minin*). It was the most primitive form of government imaginable. According to one Taliban leader, "The Sharia does not allow politics or political parties. That is why we give no salaries to officials or soldiers, just food, clothes, shoes, and weapons.[20] We want to live a life like the prophet lived 1,400 years ago and jihad is our right." [21] The supreme *Shura* (council) in Kandahar, an advisory body to the commander of the faithful, was at the apex of the Taliban authority structure, and a military *shura* and a *shura* in Kabul were subordinate to it. Mullah Omar, however, consulted the Supreme *Shura* less and less. As the same Taliban leader explained, "For us consultation is not necessary. We believe this is in line with the Sharia. . . . General elections are not compatible with the Sharia and therefore we reject them." [22] There was a rudimentary judiciary to enforce the Sharia under the Chief Kadi of Kandahar, but the Taliban rule was overwhelmingly military. The Taliban regular army never exceeded 30,000 men, but there were irregular armies (*lashkar*) consisting of volunteers who joined for booty. Conscription was tried but was very unpopular, and the Taliban were forced to rely on Pakistanis and Afghan refugees who had passed through the madrassahs, on Al Qaeda, and on volunteers from neighboring countries in Central Asia. The 15,000-strong Taliban force that captured the city of Taleqan in September 2000 included 3,000 Pakistanis, 1,000 from the Islamic Movement of Uzbekistan, and a few hundred of bin Laden's Arab-Afghans.[23]

Bin Laden soon moved to Kandahar to be near the center of the Taliban power. In Kandahar he was joined by the head of the banned Islamic Jihad in Egypt, Dr. Aiman al-Zawahiri, and gathered members of Al Qaeda around him. Bin Laden ingratiated himself with the Taliban leadership by sending several hundred Arab-Afghans to take part in the Taliban offensives in the north, and to help in massacres of the Hazara Shi'ites,[24] while he himself engaged Mullah Omar and other Taliban leaders in all-night ideological discussions. These discussions raised the ideological sophistication of the Taliban slightly in the last years by adding a modern veneer of increasingly vociferous anti-American, anti-imperialist rhetoric to their Islamic atavism.[25]

What was bin Laden's revolutionary ideology that rubbed off a little on the Taliban while guiding the international terrorist operations of Al Qaeda? On February 23, 1998, he issued a manifesto, the "International Islamic Front for

Jihad Against the Jews and Crusaders." In it he added to the staple diatribe against the Jewish state the U.S. occupation of the holiest land of Islam (the Arabian peninsula) since the Gulf War. At the same meeting, a *fatwa* was issued enjoining the killing of the Americans and their allies. As the U.S. air strikes against Iraq accelerated in 1998, bin Laden called on Muslims to confront and kill the Americans and the British, and proceeded with the terrorist bombing of the U.S. embassies in Kenya and Tanzania, which killed over 200 people.[26] In the videotaped messages broadcast after September 11, bin Laden constantly repeated these two cardinal points of his revolutionary ideology and the objectives that corresponded to them: "I swear to God that America will not live in peace before peace reigns in Palestine, and before all the army of infidels depart from the land of Muhammad."[27] In the last video broadcast by Al Jazeera television in 2001, bin Laden harangued: "Our terrorism against America is a good terrorism to stop the oppressor from committing unjust acts and to stop America from supporting Israel, which is killing our children."[28]

In terms of its appeal to potential recruits to Al Qaeda outside of Saudi Arabia, the rhetoric of occupation of "the land of Mohammad" is a pale second to the Israeli occupation of Palestine. The moralistic argument that bin Laden cares little about the actual plight of the Palestinians, even though it may be factually correct, misses the point. The Israeli-Palestinian conflict is the lynchpin of the mythology of political Islam and the main source of its popular appeal. The conspiratorial view of Zionism it contains finds constant reinforcement from continuous military action by the Israeli government, which is viewed as state terrorism throughout the Middle East. *Pace* Dennis Ross and those who argue for the irrelevance of the Israeli-Palestinian conflict, reduction in acts of violence against Palestinian people and civilian targets would weaken the evidence for the mythology that underpins political Islam and thus undermine the culture that breeds terrorism.

Samuel Huntington's thesis on the clash of civilizations has been quite popular among the Islamic fundamentalists, as that of Iranian President Khatami's opposing idea of a "dialogue of civilizations" has been among the reformists.[29] A few days after the September 11 attacks, a Turkish daily sympathetic to Islamic fundamentalists quoted a professor as saying, "We have not as yet witnessed a full clash of civilizations in the concrete, though the events of September 11 constitute the beginnings of such a concretization."[30] What is more important, bin Laden and Al Qaeda militants believe Huntington. The instructions found in the luggage of the September 11 highjackers refer to "the admirers of Western civilization" as "the followers of Satan." The instructions were drawn up according to

bin Laden's jurisprudence (which he defines as that of Muhammad, in contrast to the traditional Islamic jurisprudence), and were designed to regulate the Al Qaeda militants' action at the "hour of encounter between the two camps."[31] Referring to their astounding success, bin Laden declared: "These events have divided the world into two camps, the camp of the believers and the camp of the infidels."[32]

Huntington himself, however, was at first much more cautious. In an interview with the *New York Times*,[33] he implicitly acknowledged many criticisms of his thesis, maintaining that Islam's borders are bloody because there are so many of them. He pointed out that in every other civilization, it is not Islam but demography (i.e. the large number of males in the 16–30 age bracket) that accounts for militancy and terrorism, that there are as many intra- as inter-civilizational conflicts (he claimed to have made the point with reference to Islam), and that it is bin Laden who wants a clash of civilizations and not Huntington. Above all, Huntington denies having implied that civilizations are unified blocks, which had been taken as a basic premise for their inevitable clash, and emphasizes a lack of cohesion as the main problem with contemporary Islam. In truth, bin Laden's terrorism has many roots in the modern political tradition of revolutionary terrorism—which began with the Jacobins during the French revolution and was developed by Russian revolutionary groups in the nineteenth and early twentieth centuries—as it does in the Islamic tradition. Like the fascist movements in the interwar Europe, political Islam represents "the Jacobin dimension of modernity" in the contemporary Muslim world.[34] It is thus a phenomenon of the global interpenetration of civilizations, which has created a distinctive "civilization of modernity."[35]

As the *New York Times* signaled the end of the national crisis by downsizing the section, "A Nation Challenged," which had been a daily feature of the paper since the September attacks, *Newsweek* began the year 2002 with an article by Samuel Huntington titled "The Age of Muslim Wars," an age that, according to Huntington, "began as the cold war was winding down in the 1980s." Here, Huntington recognizes the rise of Islamic fundamentalism as a response to modernization and globalization. Furthermore, he acknowledges the causal relevance of the Israeli government's "provoking the second intifada with its settlements and ongoing military presence in the West Bank and Gaza," and concludes that "the resentment and hostility of Muslims toward the West could be reduced by changes in U.S. policies toward Israel." In fact, much of his analysis seems unobjectionable, except for the use of the terms "Muslim wars" and "Muslim violence" to refer to the incidence of violence "involving Muslims," which does not neces-

sarily have a religious cause. (Where religious causation can be established, as with "Muslim terrorism," the term is not objectionable, even though I consider "Islamic terrorism" more accurate.)

But the problem with the argument remains the unbridged gap between Islamic terrorism and Islam. This gap makes the clash of Western and Islamic civilizations meaningless. Another idea of Huntington's, however, can throw some light on the subject. In addition to his famous geological metaphor of "fault lines" between distinct and impenetrable civilizations, he also offers the idea of "cleft countries," such as the United States, which replicate these hypothesized lines within them.[36] It would be more accurate to speak of one cleft, namely that of the global civilization of modernity, in which both dialogue and clash among different elements of civilizational complexes is inevitable. From the perspective of this new global civilization and its discontents, the September 11 tragedy shows the alarming new possibilities for revolutionary violence by clandestine groups as an expression of such discontents.

The tendentious derivation of terrorism from the allegedly essential features of Islam distracts us from the really serious questions about the constituency of political Islam and the appeal of terrorism within it. The modern education of bin Laden and the terrorist pilots Atta and Jarrah gives us the best clue to the psychology of the discovery of Islam and its political use for revolutionary violence by Islamic Jacobins. To this we may add the significant departure of a few young British Muslims to fight with bin Laden and the Taliban when the American bombing of Afghanistan began. The Muslims educated abroad and the Muslim diaspora—the generation at the meeting point of the Islamic and Western civilizations—are the most important agents of the modernization of the Islamic tradition. One form this modernization can take and has taken is political Jacobinism and Islamic terrorism on the fringes, but these are not its predominant forms. It would be absurd to ignore the cultural symbiosis in the broad middle of the spectrum of those with a foot in each civilization, and be blind to the sustained efforts of Muslim intellectuals in the Middle East and in the Western diaspora to integrate a pluralistic Islamic culture into the contemporary global civilization. Nor should we ignore the broad, nonviolent sociological impact of the Muslim diaspora on their original homelands.

Terrorism in modern politics always counted on the reactionary forces of the far right to polarize society. The same unspoken and unholy alliance between terrorism and reaction is at work in today's global society, where we find the prime minister of Israel unwittingly helping to realize bin Laden's vision of a world polarized into two camps: Islam and the West. To paint all Muslim students in Europe and the United States and all the Muslim diaspora in the West with the same

brush as we paint the Taliban is to endanger the forces of moderation and doom the catalysts of modernization of Islam in the cleft global civilization of modernity. Only then may the Islamic Jacobin dream of a clash of imagined and ossified civilizations come true. Ian Buruma and Avishai Margalit close their illuminating comparison of the Occidentalism of Al Qaeda's reified caricature of Western civilization and the violent anti-Westernism of the Nazis and the Japanese fascists with the eloquent plea that "we should not counter Occidentalism with a nasty form of Orientalism. Once we fall for that temptation, the virus has infected us too."[37]

## RATIONAL CHOICE IN FOREIGN POLICY

Turning finally to policy considerations, we should not let the hubris of military success in Afghanistan restore our false sense of security. We can no longer maintain our indifference toward the events in the distant Middle East, and should insist on greater accountability of our government and its allies. After World War I, the German sociologist Max Weber argued that modern politics required its own "ethic of responsibility," which can be said to consist of taking into account the costs and consequences of our action in politics.[38] The present crisis highlights the enormous practical difficulty of such an ethic of responsibility based on a cost-benefit analysis of the kind rational choice theorists take for granted. Given the openness of our society and the vulnerability of our skyscrapers and densely populated cities to biological and other forms of terrorism, it would be irresponsible to ignore the colossal cost—in the lives and resources of the American people—of our nation's identification with the expansionist policies of the state of Israel. Yet any such cost-benefit analysis seems crass and morally repellent to the majority of Americans, and they are in no mood to be reminded of its rationality in their current mood of heady patriotism. The prospects for rational public debate and deliberation in the American republic are not made brighter by the bellicose insistence that anyone who is not with us is against us.

Al Qaeda has been destroyed, and bin Laden and his aides, if still alive, should be brought to justice. Beyond this, rational debate on our policy options requires the weighing of the costs and benefits of striving for a fairly equitable peace in the Middle East against those of the belligerent recipes for further intractable military engagement in the Middle East. Any help we can draw from the social sciences to this end through a critical examination of the shaping of public discourse and the undebated extension of the war against terrorism should be most welcome. Let us conclude with a few hints in that direction:

1. If Arab-Americans are asked to forego some of their civil liberties and im-

munities to help the U.S. government combat terrorism, the least we can do is restrain the excessive fundamentalists zeal of American Jewish fundamentalist groups, such as the Gush Emunim, and other American supporters of Jewish settlements on Palestinian lands.

2. We need a systematic cultural policy for supporting Islamic modernist elements in the Middle East and the Western diaspora instead of pushing them into the arms of Islamic terrorists. The Islamic terrorists win if their worldview appears as the only plausible one to alienated Muslim youth, and jihad as the sole path to heroism. Young Muslims should be offered convincing alternatives to political Islam. Western universities can play a critical role in this respect, as can cultural exchanges that foster a dialogue of civilizations. It goes without saying that a rational cultural policy would be the opposite of the witch hunt advocated by Mr. Kramer and the pro-Israel lobby.

3. Islamic fundamentalism may be a rampant bull, but it should be allowed to stamp in all and sundry paths until its force is spent. We should not attract it toward us by waving a red flag in the form of F-16s and Apache helicopters used against civilian targets in Palestine and Iraq.

4. We must break the long-standing taboo against mentioning the cost of our identification with Israel and be prepared to criticize its policies when appropriate.

# 10. CHANGE AND CONTINUITY IN HEMISPHERIC AFFAIRS: LATIN AMERICA AFTER SEPTEMBER 11

## FRANCISCO GUTIÉRREZ SANÍN, ERIC HERSHBERG, AND MONICA HIRST

### INTRODUCTION

The aftershock of the terrorist attacks of September 11, 2001, have reverberated throughout the globe, including in places that are geographically far removed from the conflict between Islamic fundamentalism and the United States. U.S. priorities and policies in the international arena have changed substantially since September, both as a response to the attacks and as part of the broader "war on terrorism" declared by the Bush administration. For Latin America, shifts in the U.S. agenda will have far-reaching effects, encompassing economic and trade policies, pressing issues of regional security and migration, and the continuing challenges of maintaining fragile democracies and protecting human rights. The relative importance of each of these domains varies by subregion, and indeed by country, but this chapter nevertheless identifies some broad patterns that are emerging in the region, and focuses on several especially critical changes that are underway or appear imminent.

The initial response of Latin American countries to the September 11 attacks was consistent: governments throughout the region expressed their shared grief at the loss of human life and announced coordinated efforts to combat terrorism. Brazil called for a conference of the Organization of American States (OAS), and the Inter-American Treaty of Reciprocal Assistance (IATRA) was invoked for the first time since its inception in 1947.[1] Though Brazil also cautioned against "irrational reactions," Washington accepted the Latin American response with enthusiasm. Both initiatives had their desired symbolic effects, showing that U.S. allies in Latin America were unanimous in supporting an anticipated military reaction by the wounded superpower to the north. Yet the September attacks happened to coincide with a moment in which hemispheric affairs were exhibiting fragmentation rather than coordination or integration. As events unfolded subsequently, Latin American governments increasingly dealt with the United States on a bilateral basis rather than as a cohesive regional bloc.

Indeed the initially uniform reaction masks the degree to which sentiment about the events varies widely, as do their implications for different countries in

the region and for distinct policy domains. Intraregional policy coordination was at the forefront of the agenda for many Latin American governments throughout the 1990s, yet the region demonstrated limited capacity to mobilize as a unified actor. Presidential summits and declarations of common principles have rarely translated into common positions around mutual concerns. Nowhere was this more evident than in the area of drug trafficking, arguably the most serious security problem facing the region during the 1990s, or in matters relating to external debt, which constituted the principal issue for most Latin American countries during the preceding decade. In both instances, time and again the United States imposed its preferences in bilateral interactions with (often reluctant) leaders of individual countries.[2] Repeated instances of failed coordination among Latin American governments have also reinforced the clearly dominant position of the United States in hemispheric affairs despite an overall American stance toward the region that combines elements of active engagement with tendencies toward reluctance, inconsistency, and neglect. After sketching the overall contours of U.S. relations with Latin America in recent years, this chapter analyzes several specific cases that highlight the diverse effects of September 11 on matters of economy, democracy, and security in the region.

## LATIN AMERICA AND THE UNITED STATES IN THE 1990s

To understand the effects of September 11 in Latin America one must first take into account trends in the region during the last years of the Cold War and the immediate post–Cold War era. Latin America has undergone major transformations over the past two decades, both in the political and economic arenas. In each of these domains, as well as with regard to an array of security-related issues, there were important shifts in the relationships between Latin American countries and the United States, as well as in their relationships to one another.

### DEMOCRACY AND HUMAN RIGHTS

A protracted period of authoritarian rule in most of the region came to a close with at least nominally democratic regimes governing every Latin American country except Cuba following the political transitions of the 1980s and 1990s. Although historically the U.S. commitment to democracy in the hemisphere has been highly contingent, the 1990s witnessed an unequivocal American endorsement of civilian rule and growing, if uneven, insistence on the need for governments in the region to ensure respect for human rights. At various points during the decade, challenges to constitutional government in Guatemala, Paraguay, and Venezuela were stymied in part because of coordinated opposition from

Washington and democratic Latin American governments. Similarly, when Peru's President Alberto Fujimori carried out an unconstitutional *auto-golpe* in 1992,[3] the United States lined up squarely on the side of those who demanded a prompt return to some semblance of democratic governance. Though it would be a serious mistake to downplay the American role in enabling Fujimori to prolong his repressive administration for nearly a decade after the *auto-golpe,* numerous instances arose in which U.S. pressure induced greater respect for human rights than would have been obtained otherwise. Mexico's handling of the Zapatista rebellion and Colombia's conduct of its ongoing counterinsurgency war against the FARC and ELN offer two telling examples of American influence preventing bad situations from becoming even worse.[4]

## ECONOMIC REFORMS AND DEVELOPMENT

Confronted with a legacy of economic mismanagement by dictatorships and with imposing levels of external debt that compelled a long overdue opening to the world economy, virtually all Latin American governments embarked during the 1980s and 1990s on sweeping programs of neoliberal economic reforms.[5] Although the pace of liberalization varied from one country to another, as did the depth of resistance from social and economic groups opposed to the so-called Washington Consensus, one country after another agreed to reduce barriers to foreign trade and investment, privatize public-sector enterprises, and curtail government regulation of market transactions. These measures had a significant impact on the internal structures of Latin American economies and on the region's relationship to the global economic environment. If on the whole the results were less than satisfactory,[6] much of the region benefited at least in the short term from a meaningful renegotiation of foreign debt, increased direct foreign investment, and the expansion of intra- and interregional trade. Many Latin Americans experienced economic liberalization as a source of new possibilities for achieving prosperity and for replicating at home appealing ways of life that once seemed attainable only in the developed countries. For others, however, these changes were perceived as embodying a U.S.-imposed model of development that jeopardized traditional ways of life and accentuated social polarization in a region already notorious for having the most unequal income distribution in the world.

Meanwhile, the advance of regional trade agreements breathed new life into subregional integration processes in the Americas during the 1990s. Mercosur, in the Southern Cone, was widely considered the most successful experiment to date with south-south regional integration. Tentative efforts to revive long dormant subregional integration schemes emerged as well in the Andes, Central

America, and the Caribbean, and several bilateral accords were reached to promote trade among subsets of Latin American countries. Farther north, ratification of the North American Free Trade Agreement (NAFTA) was followed by a dramatic expansion in U.S. trade with Mexico, as well as with Central America and the Caribbean. Alongside the Clinton administration's willingness to extend $40 billion worth of loan guarantees to enable the Zedillo administration to withstand the 1994 Tequila crisis, these developments highlighted the special status that Mexico had achieved in post–Cold War U.S.–Latin America relations.

If in some quarters the proliferation of subregional integration schemes encouraged the perception that Latin American governments could benefit from coordinated efforts independent of U.S. involvement, the U.S. vision of a hemispheric free-trade zone as an alternative to subregional blocs came increasingly to drive the overall development agenda. Despite reticence from some South American countries, and outright antagonism from Brazil, the Clinton administration's 1995 proposal to create a Free Trade Area of the Americas (FTAA) gained momentum across the region, particularly after the effects of the East Asian financial crisis took a serious toll on Mercosur.

## THE SECURITY AGENDA

Notwithstanding the near absence of outright military confrontations between Latin American states, a series of bilateral tensions, internal conflicts, and unconventional security threats affected the region during the 1990s. For purposes of this essay, the most significant interstate conflict was the decades-old Cold War between the United States and Cuba, both of which, despite timid nudging from third parties (both Latin American and European), showed little interest in rapprochement.

The principal internal conflicts were located in Central America and the Andes. Peace processes brought an end to enormously costly civil wars in Nicaragua, El Salvador, and Guatemala, with United Nations engagement playing a crucial role in overseeing (at times imperfect) compliance on the part of the respective states and opposition groups alike. American cooperation with these processes, and support for intervention by outside parties other than the U.S. government, surely owed much to the triumph of U.S. surrogates in each of the three countries. Nonetheless, it is noteworthy that the second half of the 1990s saw the United States adopt a reasonably even-handed approach toward Nicaraguan and Salvadoran *frentistas* against which it had waged war through proxies throughout the previous decade.[7]

In Peru, by the mid-1990s the Fujimori government had triumphed following an increasingly savage campaign against the vaguely Maoist Sendero Luminoso

insurgency, which was itself responsible for thousands of political murders during a war that had plagued the country since the early 1980s. The United States provided steady support for the government's counterinsurgency policies and for its association of those efforts with a common agenda against drug trafficking. A similar dynamic has prevailed intermittently in the American stance vis-á-vis counterinsurgency in Colombia, though for much of the Clinton administration this possibility was impeded by a combination of concern over human rights violations by the Colombian military and by U.S. anger over evidence that President Ernesto Samper (1994–98) had accepted campaign funds from drug traffickers.

Latin America's role in the international narcotics trade represented the principal unconventional threat to hemispheric security. Although the cultivation of coca and poppies was concentrated in the Andes, the consequences of illegal narcotics production were felt in most of the region, as money laundering and drug-related corruption among economic and political elites reached troublesome proportions. In Colombia, a complex scenario dominated by drug trafficking, guerrilla warfare, and paramilitary activity produced stable, though high, levels of violence. U.S. congressional approval of Plan Colombia in 2000 paved the way for a substantial increase in the U.S. military presence, which was welcomed by the Pastrana government (1998–2002) and local armed forces. At the same time, however, many neighboring countries as well as European governments believed that the plan pushed by the United States would only deepen the Colombian conflict, which was increasingly beginning to spill over into neighboring countries. How best to deal with the deteriorating situation in Colombia was at the forefront of the hemispheric agenda on the eve of the September 11 attacks, and remains so to this day.

## THE CONTEMPORARY LANDSCAPE

Latin American countries have not participated directly in the military action in Central Asia, and no serious suggestions have been made for direct military involvement in the war on terrorism outside the hemisphere. Yet the change in the international climate since September 11 has had plenty of consequences for the region. New and renewed apprehensions have emerged regarding political, economic, and security matters, particularly as they concern relations with the United States. In many countries, a disjuncture has emerged between official stances, articulated by governments, and broader public opinion. Anti-Americanism—not to be confused with anti-Western sentiment—has by many accounts become more visible across Latin America.

Reactions in the region to the attacks of September 11 and to the U.S. response often reflected concerns that were in the air beforehand, but they also point to the reemergence of cleavages that seemed to have disappeared long ago. In Uruguay, for example, military officials who had studiously avoided public discussion of the armed forces' role in the 1970s "dirty war" against "subversion" proclaimed themselves vindicated by the U.S. response to the threat posed by international terrorism.[8] In neighboring Argentina, the events triggered a definitive split between competing factions at the University of the Mothers of the Plaza de Mayo. When one prominent *madre* applauded the fact that the United States had finally experienced suffering, an opposing faction withdrew from the institution and condemned the use of random violence against innocents.[9] Most striking, perhaps, was the stunned reaction of Chileans, for whom September 11 marks the anniversary of the bloody U.S.-supported coup that overthrew the elected government of Salvador Allende in 1973 and installed a military government led by Augusto Pinochet. Throughout the 17-year dictatorship and the decade of civilian rule that succeeded it, September 11 has been a day of highly charged protests, commemorations, and vigils, with competing sides advancing diametrically opposed accounts of that momentous date in national history. This past year—with Pinochet back in Chile having been legally charged with being an international terrorist, and facing expanding investigations by Chilean courts—debate on the streets was muted. Millions of Chileans spent the day in front of their television sets. But they were mesmerized not by conflicts over how to remember their own troubled past but by the spectacle of the World Trade Center towers crumbling from an assault even more explosive than that which the Chilean air force had carried out against the Presidential Palace in downtown Santiago 28 years earlier.

While additional examples of such unforeseeable side effects of the September 11 attacks can no doubt be cited, the remainder of this chapter focuses on several specific concerns that were on the agenda before as well as after the attacks. We begin with a reflection on the painful saga of contemporary Colombia, where the quest for peace suffered a serious setback in February 2002, when the Pastrana administration effectively suspended peace negotiations with the FARC by ceasing to recognize a guerrilla-controlled zone declared off limits to the Colombian military. The emphasis placed on the Colombian conflict reflects our conviction that there, more than anywhere else, September 11 may prove a critical juncture in the evolution of a major Latin American country and its relations with the United States. Then, after briefly addressing the potential consequences of September 11 for U.S. policies toward neighboring Venezuela, and for several specific dimensions of American policy that affect different Latin American

countries to varying degrees, the chapter concludes with some tentative assessments of likely trends in hemispheric relations as a whole.

## THE WAR AT HOME? EFFECTS OF THE WAR ON TERROR ON THE CONFLICT IN COLOMBIA

Throughout the Andes, the September 11 attacks and the war in Afghanistan created fears of an escalation of violence and turmoil in Colombia. The Colombian military worried that the U.S.-led operation in Central Asia might result in diminished American funding for Plan Colombia, the initiative that President Pastrana characterized before the international community as a "Marshall Plan" for Colombia. Other observers anticipated a more aggressive American stance in response to kidnapping and other tactics used frequently by the guerrillas, and a more lax response to abuses committed against civilians by paramilitary groups. The escalation of violence geared toward affecting the outcome of elections and the search for special political deals in Washington were both deemed likely outcomes of the war on terrorism.

The Colombian civil war involves four factions: the armed forces, the FARC, the ELN, and the Autodefensas Unidas de Colombia (AUC). The FARC and the ELN appeared as leftist guerillas in the 1960s, and reflect a complicated blend of what Paul Collier has referred to as greed and grievance.[10] On the one hand they reflect massive failures of state and market to provide for the needs of Colombian citizens. On the other hand they also form part of a vast illegal economy, operating virtual protection rackets in portions of the national territory in which bribery (via coca crops, petroleum, nickel, or gold) thrives alongside only a minimal presence of the central state.[11]

The AUC, in turn, are an alliance of various paramilitary forces promoted by local and regional elites, mainly ranchers who had been victimized by the guerrillas' kidnapping industry, as well as by politicians and members of the military. After a decade in which the *autodefensas* enjoyed impunity and thrived with the complicity—or in the best of cases, impotence—of the Colombian government, paramilitary forces became a major part of the opposition to subversion. Their basic strategy has been the systematic use of massacres to create a social void around the guerrillas.[12]

When one recalls that the army itself behaves not infrequently as another irregular force, the overall picture appears hellish, and it is. However, one should resist the temptation to conclude that Colombians have nothing left to lose. The country maintains a Congress, a political system, markets, institutions, a judiciary, and democratic traditions. All of these are very imperfect, but they are not

pure window-dressing either. Indeed, as many U.S. citizens understand better today than they did before September 2001, the value of democratic goods is not destroyed but rather is enhanced in the presence of horror.

It is in this context that we pose the question of how the war against terrorism in Colombia (and in Latin America) will promote or degrade democracy, how it will affect U.S. behavior toward Colombia, and how it will affect different sectors of Colombian society. The evidence to date does not give much cause for optimism, as reflected in two basic changes in the U.S.-Colombia democratic agenda since September 11.

First, until September 11 the United States government combined its support for antiguerrilla military operations with indifference (at worst) or benevolent neutrality (at best) toward President Pastrana's peace efforts. Since the September attack, however, the United States has pressured Colombia to convert itself (in both senses) into a good and brave soldier in the antiterrorist crusade. In this regard, the official statements of the U.S. ambassador in Colombia following the attacks were as telling as they were ominous. His comparison of the FARC-ELN-AUC with Osama bin Laden was preposterous, but it had to be taken extremely seriously. Did the comparison hint that they merit analogous treatment? Moreover, was the ambassador's reference to extradition of imprisoned FARC leaders (and perhaps of AUC members as well) to stand trial in the United States simply a rhetorical gesture? Both declarations provoked quite a stir in Colombia, and even a minister of the very pro-U.S. Pastrana administration reacted with something just short of open anger.[13]

Throughout 2001 the peace process in Colombia was dying a slow death, in part because of its lack of results, and in part because of the FARC's extreme provocations. Yet several factors combined to enable the process to survive until mid-February 2002. In the first instance, it was the only possible source of political oxygen for an otherwise failed Pastrana administration, which aspired desperately to complete its mandate later in the year having achieved a meaningful settlement to the country's internal conflicts. Moreover, despite their obvious flaws, the peace talks were seen by many Colombians as the last chance to save thousands of lives that would be lost if open war were to break out again. Furthermore, the persistent efforts of U.N. agencies and various European governments to keep negotiations alive delayed the resurgence of open war, despite pressures from the United States, and increasingly from Colombian public opinion, for the armed forces to be given a free hand to stamp out the threat posed by narco-guerrillas.

Indeed, prior to September 11 it was widely believed that the United States

would run a real risk if it were perceived as having torpedoed peace talks. By crossing a threshold of "nationalist tolerance," the argument ran, the Americans could give the FARC both the rationale and the legitimacy that it desperately needed to continue its war. This view was reinforced by opinion surveys that showed Colombians' disdain for all of the armed groups in society. But by early 2002 this situation had clearly changed, and the presidential candidate who appears to be emerging as a frontrunner has called for direct U.S. involvement in an all-out war to liquidate the guerrillas. Support for this option among the electorate grows with each new hostage-taking incident and ambush.

The second change is related to the expectations of an important sector of the Colombian elite. The day after the Twin Towers fell, they began to openly voice the hope that the United States might finally adopt a more "realistic" appraisal of the Colombian war. Now that Americans know what terrorism is, went the argument, they will have to weaken or lift altogether the restrictions they have imposed on the Colombian government's conduct of the war, particularly regarding human rights.

No such shift has yet been made explicit, and the official U.S. position regarding rights violations remains intact, but there is a very real danger that it could evolve in the wrong direction. At least three factors motivate this pessimistic prognosis. First, the U.S. government has embarked on what promises to be a protracted and ugly war with no clear limits on its scope. In waging that battle it will have limited latitude with which to choose its allies, nor can it be too particular about their behavior. The government of Pakistan, to cite an obvious example, is an unelected, highly repressive, and nuclear-armed clique of military officers, who until recently provided crucial backing to the Taliban. As we have witnessed in Pakistan, and indeed inside Afghanistan itself, local actors will try to force concessions from the United States as a price for entering the antiterrorist alliance. Occasionally, such bargains will produce positive outcomes, but in Colombia, several very influential groups feel that the main concession to be wrested from the U.S. is free rein to pursue a scorched-earth policy toward insurgent groups. At the very least, many U.S. officials would feel that this is a low price to pay for attracting a staunch ally.

This highlights the strong continuity between past and present policies. During the 1990s, for example, U.S. interest in efforts to strengthen Colombian democracy was largely subordinate to strategic objectives like the drug war and neoliberal economic adjustment. Similarly, during the 1970s and 1980s, the main goal of U.S. policy was Communist containment. In each phase, democracy was considered secondary to the overarching goal. In the aftermath of September 11,

disturbing signs of this logic are emerging once again. In particular, there are signs that the United States is inclined to abandon two aspects of Plan Colombia which had distinguished the initiative from conventional counterinsurgency efforts. First, the plan explicitly rejected the Colombian military's equation of control of the narcotics traffic and suppression of guerrilla organizations, and in principle its resources were to be devoted solely to the former objective. By March 2002, it had become increasingly apparent that U.S. officials were determined to abandon this distinction. Secondly, the plan included provisions that attached release of the American funds to a U.S. determination that Colombia was making continued progress toward protecting human rights. This aspect of Plan Colombia also seems likely to be abandoned under present circumstances.

This is especially dangerous for Colombia, for U.S. involvement has had some clearly positive implications on the country's human rights performance in recent years.[14] Yet history shows us that lacking an endogenous agenda, Colombian regimes have oscillated between anti-Communist, antidrug, and (now) antiterrorist models of governance, each of which carries with it profound costs in terms of stability and the quality of democracy. Moreover, given the extreme power asymmetry between Colombia and the United States, the subordination of democracy to strategic objectives will inevitably open avenues for nondemocratic actors in Colombia to draw on U.S. resources and cite U.S. policies for justification of their actions.

It is equally crucial to recall that the war against terrorism is also taking place in the United States itself. The terrorist threat, and the continuous flow of scary events—anthrax packages, security alerts, airport searches, and so on—have fostered a pervasive climate of fear, and a continued escalation of activities by a practically invisible enemy can provoke a wave of blind fear, the worst possible milieu for democracy. As a result, a degree of deterioration in the quality of American democracy is a real possibility, though it remains premature to assess the extent to which this will occur. Yet whether it emerges at an institutional level (e.g., antiterrorist legislation) or through public opinion (e.g., increasingly hawkish positions with regard to foreign affairs), the negative impact on prospects for human rights in Colombia could prove enormous.

Last but not least, conflicts are also learning systems. Actors derive lessons from the experiences, arguments, and behaviors of others, whether they be allies or adversaries. Today the lessons being learned are that bombing errors are tolerable, that legislation limiting civil liberties may be necessary. Indeed, several Colombian legislators began to prepare measures along these lines as soon as the Afghan war began. For the U.S. government, criticizing and restricting such actions in Colombia will become increasingly difficult. The dismal perspective is

one of strengthening military and repressive intervention, and a weakening of humanitarian and pro-democratic intervention.

Colombia is the most dramatic example of a case where U.S. foreign policy could prove fundamental to the prospects for democracy and human rights in Latin America, but bilateral relationships with the United States could be pivotal elsewhere in the region. One such country is neighboring Venezuela, where the relationship between Washington and the populist administration of Hugo Chavez has been fraught with tension since the latter's rise to power in 1998. U.S. distaste for Chavez has been reinforced by several factors, aside from his close friendship and repeated public visits with Fidel Castro, with whom he has signed cooperation agreements that have provided the beleaguered Cuban government with access to low-price oil.[15] Chavez's efforts to build alliances with Libya and Iraq— where he enjoyed a much photographed limousine ride with Saddam Hussein— strike many in Washington as confrontational. Moreover, though Chavez echoed neighboring countries' words of sympathy for the United States in the immediate aftermath of the attacks, he provoked the ire of American authorities by condemning the killing of innocent Afghan children as a result of indiscriminate aerial bombing.[16] Finally, the strong and growing economic nationalism of the Chavez government has spawned deep anger among domestic as well as foreign economic elites. The polarization of Venezuelan politics and society has grown sharply since September, and the country is experiencing serious macroeconomic difficulties. Given the present climate in international affairs and the depth of American distaste for Chavez, further deterioration in the Venezuelan internal situation could trigger external as well as domestic conflict.

Trends in U.S.-Mexican relations were also disrupted as a result of the September attacks. Up until September 11 the Bush and Fox administrations were progressing smoothly through talks aimed at eventually legalizing the status of millions of undocumented Mexican migrants living in the United States. These negotiations represented major foreign policy priorities for both governments and held out the promise of legal protection for vast numbers of people for whom legal rights and political representation were limited by their clandestine status. Expectations for success were high on both sides of the border, yet the talks came to an abrupt halt with the terrorist attacks on American soil. The dialogue between the two countries has now shifted to strategies for tightening Mexico's borders, not only with the United States but also with Guatemala. One potential consequence is a rekindling of Mexican resentment toward the colossus to the north, but it is also conceivable that Mexican fears of fueling anti-immigrant sentiment during a tense period in the United States may squelch the

temptation to resort to nationalist rhetoric, and in the process may nurture a climate of constructive cooperation on both sides of the border.

## ECONOMIC RELATIONS AND SECURITY: EMERGING TRENDS AFTER SEPTEMBER 11

Two noteworthy developments in recent months testify to the likely significance of the post–September 11 environment for shaping the complex economic ties linking the United States and Latin America. Although here as elsewhere it remains a bit early to make definitive predictions about long-term trends, evidence suggests that relations on matters of trade and on financial bailouts for economies in crisis are already being affected.[17]

The inauguration of a Republican administration in January 2001 increased expectations about the prospects for successful negotiation of the FTAA, as President Bush seemed more likely than his predecessor to secure congressional approval of "fast track" authority, permitting the executive branch to negotiate trade agreements independent of congressional meddling.[18] Yet as 2001 progressed, growing fears of recession stimulated protectionist sentiments in the U.S. Congress. Well before the September attacks, Congress seemed likely to adopt a more cautious posture than the administration or many Latin American governments had hoped with regard to international trade liberalization.[19]

Despite these concerns, "fast track" was indeed approved, squeaking by with a margin of one vote in the House of Representatives. Significantly, the administration presented international trade as vital to advancing American security interests, and by some accounts this strategy saved the day in what otherwise would have been a defeat for the measure's proponents. The debate between protectionism and economic growth is likely to occupy Congress and the Bush administration for some time to come, however, since on the eve of the vote pivotal congressmen secured a number of key concessions in exchange for their support. Specific branches of textile, clothing, and agricultural industries were exempted from the legislation, to the particular dismay of Caribbean governments whose economies will be directly affected and which, like most developing countries, lack the clout that would enable them to demand analogous provisions to protect narrow national interests. Moreover, any eventual treaties will be subjected to far greater congressional scrutiny than would have been the case under the original bill. Under the circumstances, Latin American trade partners remain justifiably apprehensive concerning prospects for gaining equitable access to the American market even if their governments manage to reach agreements with the U.S. executive.

A second area of economic policy that appears to have changed concerns the likelihood of U.S. support for financial bailouts of countries facing economic collapse. American refusal to participate in rescue efforts in response to the Argentine crash in late 2001 and early 2002 does not mean it will never back rescue efforts of other countries in the future. Argentina hardly qualified as a front-line country in the war against terrorism; instead of helping, the United States could blame the victim by holding Argentina up as an example of the consequences of straying from the Washington-prescribed "hard road of reform."[20] Ironically, with the Argentine economy having crashed and with prospects uncertain for International Monetary Fund backing of a new recovery program, Argentine authorities have begun to question the country's unswerving acceptance of the Washington Consensus over the previous decade. One cannot yet estimate the likelihood of other Latin American countries following suit, but the Peruvian finance minister's bitter criticism of the IMF stance in Argentina suggests that unlimited influence by U.S. and IMF economic policy gurus may be a thing of the past.

U.S.–Latin American security ties are also being reconfigured. The expansion of FBI, DEA, and CIA operations as part of sweeping "homeland security" measures carried out inside the United States is already affecting police and intelligence activities across Latin America. This trend has the potential to open a Pandora's box of civil-military tensions regarding highly sensitive issues. Given that so many Latin American countries have only recently established civilian control over armed forces, effective mechanisms to avoid abuses and clarify blurry borders between legitimate and illegitimate repression will be crucial to the continued strengthening of democratic rule.

The push for greater regional collaboration between police, intelligence, and even military actors implies a revision of the principles of nonintervention that are still vehemently defended by such countries as Venezuela and Brazil. This topic has been a subject of debate ever since nonmilitary threats (i.e., narcotics trafficking) became a central component of the regional security agenda. Indeed, an intense debate on cooperative security took place in the early 1990s as a result of U.S. pressures to revise established Latin American foreign policy concepts on sovereignty. Under current circumstances, this pressure will most likely be renewed.

Even while doctrinal issues remain unresolved, several countries in the region exhibit a growing capacity to conduct cooperative efforts regarding security along critical borders. Improved relations between American and Mexican authorities are one aspect of the pre–September 11 landscape that seems to have survived despite the impact of the attacks on other aspects of bilateral relations.

Similarly, Argentina and Brazil have expanded cooperative measures to improve intelligence and police controls at the so-called Triple Border area (where Brazil, Paraguay, and Argentina meet), particularly between the cities of Puerto Iguazu (Argentina), Ciudad del Este (Paraguay), and Foz do Iguaçu (Brazil).[21] Since September 11, the Triple Border has become the most scrutinized area in the Southern Cone: the FBI has requested information regarding the presence of Hezbollah and Hamas members in the area, and local police forces from all three countries have intensified their presence in the area.

Brazil remains eager to play a more active role in multilateral arenas, not only in the Southern Cone and the Andes but also within the U.N. The Brazilians have insisted that a reconceptualization of world politics is needed in order to confront emerging global threats and have called for the elaboration of what could be called an "ethical diplomacy." Yet the prospects for Brazil to expand its role as a global player appear to have diminished significantly since September 11.[22] Over the past several months, the Brazilian government has expanded domestic control over money-laundering operations and exhibited less resistance than in the past to the presence of U.S. intelligence in the country.

Thus, instances of subregional cooperation operating independent of U.S. interests remain relatively infrequent, and this highlights the growing risks to Latin America of a heightened unilateralism on the part of the United States. Such a trend can only serve to deepen political fragmentation within the region. A continued reliance on strictly bilateral negotiations with Washington will discourage efforts to forge any semblance of a Latin American community. Recent difficulties encountered by the Rio Group in gathering support from other regions for a U.N. proposal to fight terrorism reveal the obstacles the region faces in achieving a voice in the international arena.[23] A continuing lack of intraregional unity will only reinforce Latin America's peripheral status in world affairs. The point is not trivial, for a successful regional approach to security issues, particularly in the relatively conflict-free Southern Cone, could underscore the fact that poor regions of the world are not by definition a source of threats to global security, and indeed that they are able to manage their affairs without external tutelage.

PART IV

# THE INTERSECTION OF
# RELIGION AND POLITICS

# 11. MUSLIMS AND THE POLITICS OF MULTICULTURALISM IN BRITAIN *

## TARIQ MODOOD

The murder and terrorization of civilians as part of a political program does not begin with the acts of September 11. It occurs regularly in a number of places in the world, sometimes executed, or at least supported, by Western states. The perception of these victim populations is often that they matter less than Westerners who are victims. This deep sense that the West exercises double standards is a source of grievance, hate, and terrorism; it is perhaps the most important lesson of September 11, not the division of the world into rival civilizations, civilized and uncivilized, good and evil. This perception has to be addressed seriously if there is to be dialogue across countries, faiths, and cultures, and foreign and security policies need to reviewed in the light of the understanding that is achieved. Our security in the West, no less than that of any other part of the world, depends upon, to adapt a phrase, being tough on terrorism and tough on the causes of terrorism.[1]

The issues are not related only to foreign policies. Over the weekend of September 15–16, a Muslim storekeeper in Dallas and a Sikh storekeeper in Arizona City (no doubt presumed to be a Muslim on account of his brown skin, turban, and beard) were killed in "drive-by" shootings. Since then, attacks, harassment, and vandalism against Muslims and their property have been reported in all parts of the United States and throughout Europe. The "clash of civilizations" thesis[2] (reprinted in the *Sunday Times* October 14, 2001, because it was thought to be especially relevant after September 11) furthers racist stereotyping and all attendant evils within societies that are attempting to be multicultural. Hence the presence of Muslims in the West in the present atmosphere may come to be seen, even by Muslims themselves, as alien. Despite official protestations to the contrary, many in the West think that the underlying problem is not terrorism or even Islamic fundamentalism, but Islam itself—a rival and inferior civilization.

* Portions of this chapter draw on Tariq Modood's article "The Place of Muslims in British Secular Multiculturalism," in *Muslim Europe or Euro-Islam: Politics, Culture, and Citizenship in the Age of Globalization,* ed. Nezar Al Sayyad and Manuel Castells (Lanham, Md.: Lexington Books, 2002).

This pointing the finger at Muslims clearly will not go away, and its repudiation—though politically important—is not believed by many Muslims throughout the world. Not just because all the countries, organizations, and individuals that are being targeted by the U.S.-led "war against terrorism" are Muslims (no one mentions the Tamil Tiger separatists in Sri Lanka, even though they pioneered the use of suicide bombers, not to mention the various groups that the CIA supports, as it used to support the Taliban). But also because Islam is so clearly evoked by many terrorist and *jihadi* organizations—bin Laden is perhaps the greatest advocate of the clash-of-civilization thesis. Hence the thesis poses a real danger of becoming a self-fulfilling prophecy in this moment when we are all trying to make sense of what is happening in the world, who is to blame, and how justice and peace can be furthered.

The idea of Islam as a "civilization" separate from that of the Judeo-Christian West is, however, as false as it is influential. Islam, with its faith in the revelations of Abraham, Moses, Jesus, and Muhammad, belongs to the same tradition as Christianity and Judaism. It is, in its monotheism, legalism, and communitarianism, not to mention specific rules of life, such as dietary prohibitions, particularly close to Judaism. In the Crusades of Christendom and at other times, Jews were slaughtered by Christians and their secular descendents, but protected by Muslims. The Jews remember Muslim Spain as a "golden age." Islam, indeed, was then a *civilization* in the true sense of the word, and a genuine geopolitical rival to the West. Yet even in that distant period Islam and Christendom were not entirely discrete, nor were they only competitors. They borrowed and learned from each other, whether it was in relation to scholarship, philosophy, and scientific enquiry, or medicine, architecture, and technology. Indeed, the classical learning from Athens and Rome, which had been lost to Christendom, was preserved by the Arabs and came to western Europe—like the institution of the university itself—from Muslims.[3] In fact, it is no exaggeration to say that the critical rationalism and humanism that lie at the heart of the Renaissance, the Reformation, and modern science, produced through engagement with ancient Greek texts, were born in Arab universities, even though they became most fully developed in western Europe.[4] That Europe came to define its civilization as a renaissance of Greece and Rome and excised the Arab contribution to its foundations and wellbeing is an example of racist myth making that has much relevance to today.

If in the Middle Ages the civilizational current was mainly one way, from Muslims to Christians, in later periods the debt has been paid back. Yet this later epoch of West-Islam relations has been marked not by the geopolitics of civilizational blocs but by a triumphant West. In terms of power, Muslim civilization collapsed under Western dominance and colonialism and it is a moot point

whether it has since been revived or suitably adjusted itself to Western modernity. Anyway, the idea of a "clash of civilizations" obscures the real power relations that exist between the West and Muslim societies. Whatever is happening in the latter today must be seen in a context of domination and powerlessness—a context in which Muslim populations suffer depredations, occupation, ethnic cleansing, and massacres with little action by "the international community." Indeed, the latter, especially American power and military hardware, is often the source of the destruction and terror. As with Iraq, it is no small irony that the United States and its allies have waged a war against a Taliban in Afghanistan with weapons—and indeed a *jihadi* ideology—that the United States itself supplied to their current opponents only a decade before.[5]

Meanwhile, the creation of Israel, as an atonement for the Holocaust and more generally for the historical persecution of the Jews by Europeans, along with ongoing Israeli military expansion, have resulted in a continuing and deepening injustice against Palestinians and others. It is a conflict that has many of the motifs of late-twentieth- and early-twenty-first-century barbarities: ethnic cleansing, state terrorism against civilian populations, and guerrilla action against civilians, increasingly in the form of "suicide bombings." All this is occurring, and yet no intervention by any international alliance for justice has taken place, because of the power of the pro-Israeli lobby. The latter cannot be challenged in the United States for domestic electoral reasons, regardless of the harm it does to American interests and a balanced policy in the Middle East. Now that the terror has come home, it must be time to review this disastrous policy and seek justice.

A crucial component of this reckoning must be to review the history and contemporary presence of large Muslim populations in the West, and to reject the idea that they are following a disruptive agenda of their own. One way of coming to see that Muslims in the West are not culturally and politically alien to the West is to study their political assertiveness and identify the values that are being appealed to in that politics. A good case for this exercise is Britain, where there is a significant number of recently settled Muslims and where Muslims are politically active.

The large presence of Muslims in Britain today (approaching 2 million, more than half of whom are of South Asian, primarily Pakistani, origin) is a result of Commonwealth immigration from the 1950s onward. This was initially male labor from rural, small farm–owning and artisan backgrounds seeking to meet the demand for unskilled and semiskilled industrial workers in the British economy, with wives and children arriving from about the 1970s on. The proportion of urban professionals among South Asian Muslims was small, though it in-

creased with the arrival of political refugees from East Africa in the late 1960s and 1970s (though the majority of this group were Hindus and Sikhs). Britain, particularly London, as a cosmopolitan center, has also been very attractive to some of the rich and the professional classes from the Middle East, especially from the 1970s onward, and many of them have large investments in businesses, banks, and property in the city. There have during this period also been waves of political refugees from other parts of the Muslim world—Somalia, Bosnia, and Afghanistan being notable recent cases. In the main, however, we are talking of immigrants from former British colonies, who arrive initially as temporary manual labor in order to improve their standard of living back home but gradually come to be settled diasporas. Muslim immigrants and their offspring in Britain differ from their U.S. counterparts by having longer residence, by having considerably less education and income, and by being more concentrated in certain neighborhoods.

## RACIAL EQUALITY MOVEMENTS

The presence of new population groups such as these made manifest certain kinds of racism in Britain, as a result of which antidiscrimination laws and policies began to be put into place beginning in the 1960s. These laws and policies, initially influenced by contemporary thinking and practice in relation to anti-black racism in the United States, assume that the grounds of discrimination are "color" and ethnicity. To this date, it is lawful to discriminate against Muslims *qua* Muslims because the courts do not accept that Muslims are an ethnic group (though oddly, Jews and Sikhs are recognized as ethnic groups by the courts). Though initially unremarked upon, this exclusive focus on race and ethnicity, and the exclusion of Muslims but not Jews and Sikhs, has come to be a source of resentment among Muslims. Muslims do, however, enjoy some limited indirect legal protection as members of ethnic groups such as Pakistanis, Arabs, and so on. Over time, groups like Pakistanis have become an active constituency within British "race relations" (Middle Easterners tend to classify themselves as "white", as in the 1991 census, and are not at all prominent in political activism of this sort, or in domestic politics generally). One of the effects of this political activism was to highlight race.

A key measure/indicator of racial discrimination and inequality has been numerical underrepresentation in prestigious jobs, public office, etc. Hence people have had to be (self-)classified and counted, and so group labels and arguments about which labels are authentic have become a common feature of certain political discourses. Over the years it has also become apparent that by these inequal-

ity measures it is Asian Muslims, and not African Caribbeans, as policy makers had originally expected, who have emerged as the most disadvantaged and poorest groups in the country.[6] To many Muslim activists the misplacing of Muslims into "race" categories and the belatedness with which the severe disadvantages of the Pakistanis and Bangladeshis has come to be recognized by policy makers means, at best, that race relations is an inappropriate policy niche for Muslims[7] and, at worst, is seen as a conspiracy to prevent the emergence of a specifically Muslim sociopolitical formation.[8] These suspicions of race-egalitarians continue to divide the politics of multiculturalism and were evident in the mixed response that some Muslim organizations gave to the landmark admission of institutional racism by the government in 1999.[9] To see how such thinking has emerged, we need to briefly consider the career of the concept of racial equality.[10]

The initial development of antiracism in Britain followed the American pattern, and indeed was directly influenced by American personalities and events. In the United States the color-blind humanism of Martin Luther King Jr. later came to be mixed with an emphasis on black pride, black autonomy, and black nationalism as typified by Malcolm X, and this occurred also in the United Kingdom (both these inspirational leaders visited Britain). Indeed, it is best to see this development of racial explicitness and black pride as part of a wider sociopolitical climate that is not confined to race and culture or nonwhite minorities. Feminism, gay pride, Québecois nationalism, and the revival of Scottishness are some prominent examples of these new identity movements that have come to be an important feature in many countries, especially those in which class politics has declined.

In fact what is often claimed today in the name of racial equality, especially in the English-speaking world, is more than would have been claimed in the 1960s. Iris Young expresses well the new transatlantic political climate when she describes the emergence of an ideal of equality based not just on allowing excluded groups to assimilate and live by the norms of dominant groups, but based on the view that "a positive self-definition of group difference is in fact more liberatory."[11] The shift is from an understanding of liberal equality in terms of individualism and cultural assimilation to a politics of recognition, to equality as encompassing public ethnicity. There seem, then, to be two distinct conceptions of equal citizenship, each based on a different view of what is "public" and "private." These two conceptions of equality may be stated as follows:

1. The right to assimilate to the majority/dominant culture in the public sphere; and to enjoy toleration of "difference" in the private sphere.

2. The right to have one's "difference" (minority, ethnicity, etc.) recognized and supported in the public *and* the private spheres.

The former represents a liberal response to "difference," and the latter is the "take" of radical identity politics. The two are not, however, alternative conceptions of equality in the sense that to hold one, the other must be rejected. Multiculturalism, properly construed, requires support for both conceptions. For the assumption behind the first is that participation in the public or national culture is necessary for the effective exercise of citizenship, the only obstacle to which is the exclusionary processes preventing gradual assimilation. The second conception, too, assumes that groups excluded from the national culture have their citizenship diminished as a result, and offers to remedy this by accepting the right to assimilate, yet adds the right to widen and adapt the national culture and the public and media symbols of national membership to include the relevant minority ethnicities.

It can be seen, then, that the public/private distinction is crucial to the contemporary discussion of equal citizenship, and particularly to the challenge to an earlier liberal position. In a complete reversal of the liberal position, it has been argued that the assumption that difference must be privatized works as a "gag-rule" to exclude matters of concern to marginalized and subordinated groups, such as their religious practice, and the political integration of these minorities on terms of equality inevitably involves their challenging the existing boundaries of publicity.[12]

Integration flows from the process of discursive engagement as marginal groups begin to confidently assert themselves in the public space, and others begin to argue with and reach some agreement with them, as well as with the enactment of new laws, policies, and so on. So the focus becomes participation in a discursive public space, and equality becomes defined as inclusion into a political community, not in terms of accepting the rules of the existing polity and its hallowed public/private boundary lines, but the opposite.[13] Muslim assertiveness has emerged as a domestic political phenomenon in this climate in which what earlier would have been called "private" matters had become sources of equality struggles. In this respect, the advances achieved by antiracism and feminism (with its slogan, "the personal is the political") acted as benchmarks for later political group entrants, such as Muslims. As will be seen below, though Muslims raised distinctive concerns, the logic of their demands often mirrors those of other equality-seeking groups.

## MUSLIM IDENTITY POLITICS

The battle over *The Satanic Verses* that broke out in 1988–89 was seen by all concerned as a Muslim-vs.–The West battle. On the Muslim side, it generated a far

more impassioned activism and mobilization than any previous campaign against racism.[14] Many "lapsed" or "passive" Muslims (i.e., those Muslims, especially the nonreligious, for whom their Muslim background hitherto had not been particularly important) (re)discovered a new community solidarity. What was striking was that when the public rage against Muslims was at its most intense, Muslims neither sought nor were offered any special solidarity by any nonwhite minority. The political embrace of a common "black" identity by all nonwhites—seen up to then as the key formation in the politics of post-immigration ethnicity—was seen as irrelevant to an issue that many Muslims insisted was fundamental to defining the kind of "respect" or "civility" appropriate to a peaceful multicultural society, that is to say, to the political constitution of "difference" in Britain.[15] It was in fact some white liberal Anglicans who tried to moderate the hostility against the angry Muslims, and it was interfaith groups rather than Christians active in antiracism, let alone black political organizations, that tried to create a space wherein Muslims could state their case without being vilified.

Why some identities are asserted rather than others is of course a contextual matter. Part of the answer as to which identity will emerge as important to a group at a particular time, however, lies in the nature of the minority group in question.[16] Pakistanis were "black" when it meant a job in a racial-equality bureaucracy, "Asian" when a community center was in the offing, "Muslim" when the Prophet was being ridiculed, "Kashmiri" when a nationalist movement back home had gained momentum and blood was being spilled. That the Caribbeans have mobilized around a color identity and the South Asians around religious and related identities is neither chance nor just a "construction," but is based on something deeper about these groups. That Muslims in their anger against *The Satanic Verses* found a depth of indignation, a "voice" of their own, in a way that most had not found in relation to events and in mobilization in the previous decades cannot be explained just in terms of issues to do with political leaderships, rivalries, tactics, etc. Certainly some individuals and organizations exploited the situation, but they could not have done so if there had not been a "situation" to exploit.

The genie, once out of the lamp, has not been recorked. In a very short space of time "Muslim" has become a key political minority identity, acknowledged by right and left, bigots and the open-minded, the media and the government. This politics has meant not just a recognition of a new religious diversity in Britain but a new or renewed policy importance for religion. The religion of one's family is the most important source of self-identity among people of South Asian origin, especially Muslims.[17] This owes as much to a sense of community as to per-

sonal faith, but the identification and prioritization of religion is far from just a nominal one. Very few Asians marry across religious and caste boundaries, and most expect that their children will be inducted into their religion. At a time when a third of Britons say they do not have a religion, nearly all South Asians say they have one, and 90 percent say that religion is of personal importance to them (compared to 13 percent of whites).

These proclaimed identities cannot be characterized as belonging to private life and therefore irrelevant to public policies and resources. For example, half of Asian Muslims want state funding for Muslim schools.[18] Moreover, religious and ethnic identities are not simply an expression of behavior, of participation in distinctive cultural practices. Across the generations and in relation to time spent in Britain, there is a noticeable decline in participation in the cultural practices (language, dress, attendance at place of worship, and so on) that go with a particular identity. Yet the decrease in self-identification with a group label (black, Muslim, etc.) is relatively small. That is to say, there are people in Britain who identify themselves as Muslim, but may not be at all religious. In one sense, there is nothing new or peculiar about this. In another sense, it marks a new conception of ethno-religious identities. For we are not talking about passive or fading identities. To do so would be to overlook the pride with which they may be asserted, the intensity with which they may be debated, and their capacity to generate community activism and political campaigns. People may still feel passionate about the public recognition and resourcing of aspects of their community identity, even though as individuals they may not wish that resource for themselves. So for example, the demand for public funding of Muslim schools has been a source of Muslim grievance, with both secular and religious Muslims highlighting the injustice of a system that funds Christian and Jewish but no Muslim schools till quite recently. Yet only half of those Muslims who support funding of Muslim schools say that if they had the choice they would prefer to send their own child to a Muslim school; once again, the young are not much less likely to want the funding but are less likely to want to take up the option for their own (future) children.[19] Muslim purists might disparage these ambivalences but in fact the success of the Muslim campaigns partly depends on the political support of the not fully religious Muslims, on the extensive mobilization of the Muslim community.[20] Hence, it would be wrong to think of the secular Muslims as only token or "symbolic" Muslims.[21]

# RELIGIOUS EQUALITY

I have given some account of what terms like "equality," "inclusion," and "recognition" mean in contemporary discourses, but what do they mean in practical terms? What kinds of specific policy demands are being made by or on behalf of religious groups when these kinds of terms are deployed? I suggest that these demands have three dimensions.

## 1. NO RELIGIOUS DISCRIMINATION

The very basic demand is that religious people, no less than people defined by race or gender, should not suffer discrimination in job and other opportunities. So, for example, a person who is trying to dress in accordance with his or her religion or who projects a religious identity, such as a Muslim woman wearing a headscarf (*hijab*), should not be discriminated against in employment. At the moment in Britain there is no legal ban on such discrimination. The legal system leaves Muslims particularly vulnerable because while discrimination against yarmulke-wearing Jews and turban-wearing Sikhs is deemed to be unlawful *racial* discrimination, Muslims, unlike these other faith communities, are not deemed to be a racial or ethnic group. Nor are they protected by the legislation against religious discrimination that does exist in the United Kingdom, for that, being explicitly designed to protect Catholics, only covers Northern Ireland.[22] After some years of arguing that there was no evidence of religious discrimination, the hand of the British government has been forced by the European Union's Article 13 of the Amsterdam Treaty (1999) including religious discrimination in the list of the forms of discrimination that all member states are expected to eliminate. In the first quarter of 2002, the U.K. government has been consulting on appropriate legislation.

## 2. PARITY WITH NATIVE RELIGIONS

Many minority faith advocates interpret equality to mean that minority religions should get at least some of the support from the state that older established religions do.[23] Muslims have led the way on this argument too, and have made two particular issues politically contentious, namely the state funding of schools and the law of blasphemy.[24] They failed to get the courts to interpret blasphemy to cover offences beyond what Christians hold sacred, but some political support exists for an incitement-to-religious-hatred offense, mirroring the existing incitement-to-racial-hatred offense. The government, indeed, inserted such a clause in the post–September 11 new security legislation, in order to conciliate Muslims, who, among others, were strongly opposed to the new powers of sur-

veillance, arrest, and detention that were being proposed. As it happened, most of the latter was made law, but the incitement-to-religious-hatred offense was defeated in Parliament.

In relation to schools, after some political battles in the 1990s, the government has recently agreed to fund four Muslim schools on the same basis enjoyed by thousands of Anglican and Catholic schools and some Methodist and Jewish schools. However, post–September 11, building on anxieties generated by riotous scenes in the summer of 2001, considerable political opposition to religious schools has been whipped up, as is mentioned below.

## 3. POSITIVE INCLUSION OF RELIGIOUS GROUPS

The third dimension is that religion in general, or at least the category of "Muslim" in particular, should be a category by which the inclusiveness of social institutions should be judged, in the same way that antiracists use "black" and feminists use "female." Employers, for example, should have to demonstrate that they don't discriminate against Muslims by explicitly monitoring appropriate policies. Similarly, local authorities should provide appropriately sensitive policies and staff, especially in relation to (non-Muslim) schools and social and health services and should, say, fund Muslim community centers in addition to the existing Asian and Caribbean community centers.[25]

These policy demands may seem odd within the terms of the U.S. "wall of separation" between the state and religion and do make secularists uncomfortable in Britain, too, but it is clear that they mirror existing antidiscrimination policy provisions in the United Kingdom and are a form of "catching-up."

Muslim assertiveness is not simply derived from Islamism. The discourse is primarily derived from contemporary Western ideas about equality and multiculturalism, though Muslim political activism has been triggered by what is seen as attacks on Islam. It is, however, increasingly being joined by Islamic evocations and Islamists, especially as there is a sense that Muslim populations across the world are repeatedly suffering at the hands of their neighbors, aided and abetted by the United States and its allies, and Muslims must come together to defend themselves. This approach is mainly nourished by despair at the victimization and humiliation of Muslims in places such as Palestine, Iraq, Bosnia, Chechnya, Kashmir, Kosovo—and now, Afghanistan. For many British Muslims, such military disasters and humanitarian horrors evoke a strong desire to express solidarity with such Muslims through the political idea of the *ummah,* the global community of Muslims, which must defend and restore itself as a global player.

# A PANICKY RETREAT TO
# A LIBERAL PUBLIC/PRIVATE DISTINCTION

If the emergence of a politics of difference out of and alongside a liberal assimilationist equality created a dissonance within liberalism, as indeed it did, the emergence of a British Muslim identity out of and alongside ethno-racial identities has created an even greater dissonance. Philosophically speaking, it should be less disruptive, for a move from the idea of equality as sameness to equality as difference is a more profound conceptual movement than the creation of a new identity in a field already crowded with minority identities. But this is to ignore the hegemonic power of secularism in Western political culture, especially on the center-left. While black and related ethno-racial identities were welcomed by, indeed were intrinsic to, the rainbow coalition of identity politics, this coalition is deeply unhappy with Muslim consciousness. Though for some this rejection is specific to Islam, for many the ostensible reason is that it is a religious identity. What is most interesting is that if this secularist position is taken at its face value—that the injection of religion as such into politics is unacceptable—then the difference theorists, activists, and paid professionals revert to a public/private distinction that they have spent two or three decades demolishing. The unacceptability, the bad odor, of Muslim identity is no doubt partly to do with the conservative views on gender and sexuality professed by Muslim spokespersons, not to mention issues to do with freedom of expression as they arose in the Rushdie affair.[26] But these are objections to specific views, and as such they can be argued with on a point-by-point basis—they aren't objections to an identity. The more fundamental stated objection to Muslim identity is that it is a politicized religious identity.

The ideological basis of this latter objection is that religion belongs to the private sphere and is not a legitimate basis for a political identity. This is a classical liberal tenet, though it has never been followed in a pure form, with the partial exception of France. The radical secularist position is of course incompatible with the politics-of-difference perspective on the essentially contested nature of the public/private distinction described above and, therefore, with a thoroughgoing conception of multiculturalism, which should allow the political expression of religion to enter public discourse.[27] The Rushdie affair made evident that the group in British society most politically opposed to (politicized) Muslims weren't Christians, or even right-wing nationalists, but rather the secular, liberal intelligentsia. Muslims are frequently criticized in the Op-Ed pages of the respectable press in a way that few if any other minority groups are. Muslims often remark that if in such articles the words "Jews" or "blacks" were substituted for

"Muslims," the newspapers in question would be attacked as racist and would indeed risk legal proceedings.[28] Just as the hostility against Jews, in various times and places, has been a varying blend of anti-Judaism (hostility to a religion) and anti-Semitism (hostility to a racialized group), so it is difficult to gauge to what extent contemporary British Islamophobia is "religious" and to what extent "racial." Even before the aftermath of September 11 it was generally becoming acknowledged that of all groups Asians face the greatest hostility, and Asians themselves feel that this is because of hostility directed specifically at Muslims.[29] In the summer of 2001, the racist British National Party began explicitly to distinguish between good, law-abiding Asians and Asian Muslims.[30] Much low-level harassment (abuse, spitting, name-calling, pulling off a headscarf, and so on) goes unreported, but the number of reported attacks since September 11 was four times higher than usual (in the United States it has increased 13-fold, including the two deaths previously mentioned).[31]

## SINCE SEPTEMBER 11

The military and civil liberties aspects of the "war against terrorism," even more so than at the time of the *Satanic Verses* affair, has seen a vulnerable and besieged group assert itself publicly and at times defiantly. The majority of Muslims, while condemning the terrorist attacks on America, opposed the bombing campaign in Afghanistan, as did many non-Muslims, and some Muslims and the left organized joint antiwar protests. (In this respect, Muslims—except for those bound by Labour Party constraints—and other British citizens were more volubly opposed to their government's military actions than their counterparts in the United States). There was a broad consensus in the Op-Ed pages of the national papers that the "price" for bombing Afghanistan was a just solution for the Palestinians, a position that Muslims of all stripes heartily endorsed, and which meant that they were on some occasions part of the political mainstream. A significant minority of Muslims voiced support for the Taliban, even for bin Laden, and there were some media reports that some young men had gone to Afghanistan to fight for the Taliban, and that some of them had been killed in the U.S. attacks, though such reports were difficult to confirm.[32] As at the time of the Rushdie affair, the media gave massive and disproportionate coverage to Muslim extremists, regardless of the limited support they enjoyed among Muslims. There was, however, at least one new feature in the media debates after September 11. Whereas in the late 1980s there were virtually no self-identified Muslims (as opposed to persons with a Muslim background) with a platform in the national media, by 2001, partly because Muslims had achieved notoriety as a political

problem, there were now a couple of Muslim broadsheet columnists. They, together with other occasional Muslim contributors, expressed collective self-criticism. This was absent in the Rushdie affair. While maintaining a strongly anti-U.S. foreign policy stance, they expressed shock at how much anger and latent violence had become part of British Muslim, especially youth, culture, arguing that West-hating militant ideologues had "hijacked" Islam and that the moderates had to denounce them.[33] The following quote from Yusuf Islam (formerly the pop star Cat Stevens, before his conversion to Islam, and now the head of the Islamia Educational Trust, who had been wrong-footed by the media in relation to Khomeini's fatwa in 1989), nicely captures this shift in the position of the moderates: "I was still learning, ill prepared and lacking in knowledge and confidence to speak out against forms of extremism. . . . Today, I am aghast at the horror of recent events and feel it a duty to speak out. Not only did terrorists hijack planes and destroy life, they also hijacked the beautiful religion of Islam." [34] Other Muslim intellectuals issued fatwas against the fanatics[35] and described the Muslim revolutionaries as "fascists" [36] and "xenophobes," [37] with whom they did not want to be united under the term "British Muslim." Whereas in the *Satanic Verses* affair moderate Muslims argued against what they took to be a bias against Muslims—a failure even by liberals to extend the ideas of equality and respect for others to include Muslims—moderates now added to this line of defense an argument about the urgency of reinterpreting Islam. This reinterpretation variously calls for a reexcavation of the Koran as a charter of human rights, which, among other achievements, abolished slavery and gave property rights to women more than a millennium before either of these was achieved in the West; a restoration of the thirst for knowledge and rational enquiry which characterized medieval Muslim societies; a recentering of Islam around piety and spirituality, not political ideology; a "reformation" that would make Islam compatible with individual conscience, science, and secularism. Ziauddin Sardar, one of the most prominent of the moderate Muslim intellectuals, said that the failure of the Islamist movements of the 1960s and 1970s was partly responsible for the contemporary distortions of Islam by the militants. Such movements, he argued, had started off with an ethical and intellectual idealism but had become intellectually closed, fanatical, and violent. Just as today's middle-aged moderates encouraged the earlier Islamic renewal, they must now take some responsibility for what came to pass and do something about it.[38]

From the non-Muslim side has come widespread questioning, once again echoing the issues raised by the Rushdie affair, about whether Muslims can be and are willing to be integrated into British society and its political values. This has ranged from anxiety about terrorist cells and networks recruiting alienated

young Muslims for mischief abroad and as a "fifth column" at home, and whether Muslims were willing to give loyalty to the British state rather than to transnational Muslim leaders and causes, to whether Muslims were committed to what were taken to be the core British values of freedom, tolerance, democracy, sexual equality, and secularism. Many politicians, commentators, letter writers and phone callers to the media from across the political spectrum, not to mention the home secretary,[39] blamed the fact that these questions had to be asked on the cultural separatism and self-imposed segregation of Muslim migrants and a "politically correct" multiculturalism that had fostered fragmentation rather than integration and Britishness.[40] The issue of "faith schools" came to be one of the central elements of this debate. Violent disturbances in some Northern English cities in the summer of 2001, in which Asian Muslim men were the central protagonists, were blamed on the fact of segregated communities and segregated schools. Some of these schools, among the most underresourced and underachieving in the country, had rolls of over 90 percent Muslims, while some neighboring schools were more than 90 percent white. The former came to be called "Muslim schools," including in official reports.[41] In fact, they were nothing of the sort. They were local, bottom-of-the-pile comprehensive schools that had suffered from decades of underinvestment and "white flight" but were run by white teachers according to a secular national curriculum. "Muslim schools" then came to be seen as the source of the problems of divided cities, cultural backwardness, riots, and lack of Britishness and as a breeding ground for militant Islam. Muslim-run schools were lumped into this category of "Muslim schools," even though all the evidence suggested that their pupils did not engage in riots and terrorism and, despite limited resources, achieved better exam results than local authority "secular" schools. On the basis of these "Muslim school" and "faith school" constructions, tirades by prominent columnists in the broadsheets were launched against allowing state funding to any more Muslim-run schools, or even to a church-run school, and demands were made once again to make the British state entirely secular. It was argued that a precondition for tackling racial segregation was that "religion should be kept at home, in the private sphere."[42] Whatever the rights and wrongs of specific analyses and diagnoses, it is clear that the behavior of no other group in Britain—including groups defined by "race"—acts as a stimulant to debates about whether that group is "British" as do Muslims.

# MUSLIMS IN THE WEST

In this highly charged debate, which is now as much *among* advocates of toler-ance and equality as it is between such advocates and their opponents, it is im-portant to continue to interpret inclusion, recognition, and respect in a way that is not biased against religious people. Religious discrimination is just as inimical to the principles of democratic multiculturalism as other forms of discrimina-tion; similarly, racial, ethnic, and sexual identities ought not to be favored over religious identities. Specifically, Muslims, now seen as an alien presence, can be a positive asset to countries such as Britain. What we need today is greater under-standing of the dispossessed and the powerless, especially when they seem cul-turally alien and mobilize around their group identities. In this, diasporas in the West can be a critical source of dialogue, understanding, and bridge building. Groups such as Muslims in the West can be part of transcultural dialogues, do-mestic and global, that might make our societies live up to their promise of di-versity and democracy. Such communities can thus facilitate communication and understanding in these fraught and destabilizing times.

Such dialogue—at personal, local, national, transnational, and international levels—seems a tall order, but there are grounds for hope. One is that, though it is certainly true that the sense of being besieged and insecure that contemporary Islam and Muslim societies feel is not conducive to dialogue, this feeling can change. The presumed "closed-mindedness" of Islam is due in large part to colo-nialism and Western dominance. When Muslims do not feel threatened and powerless, they have been outward-looking and expansive, generous and univer-sal; it is powerlessness that has made them closed-minded and repressive (espe-cially in relation to women), suspicious of new ideas and influences. Hence, dialogue is possible, but it must be under conditions of mutual respect, in a world order that addresses inequalities of wealth and power and allows Muslims the political freedom to develop their own societies rather than imitate the West or suffer dictatorships that further Western interests. (The latter dynamic grows out of Western countries' dependence on cheap oil and their failure to develop alter-native energy sources.)

When I was a student in the early 1970s, my intellectual and political forma-tion took place at a time when many intellectuals and students were attracted to and energized by an ideology committed to the overthrow of capitalism. For the most part this ideology was confined to hero worship of far-away "freedom fight-ers" (recall those ubiquitous posters of Che Guevara), dangerous utopianism, and violent slogans—as it is among many Muslim students and intellectuals today. But political activism by leftist students in that era also included physical

confrontations in the street, seizures of buildings (leading to a temporary break-down of government in Paris in 1968), and domestic terrorism in parts of Europe by groups such as the Baader-Meinhof Group and the Red Brigade. Some of my generation still look back fondly at that era, but I think most of us are relieved that the militant Marxism passed. This gives me some hope that the same can happen with militant Islamism. Still, armed resistance will often be justifiable, typically against foreign occupation or a brutal regime. For all ideologies, secular and religious, are capable of "fundamentalism," and the resort to violence is often a response to specific political and social conditions rather than an inherent element of a belief system per se.

Bridge building, however, does not simply mean asking moderate Muslims to join and support the new project against terrorism. Muslims must also ask, where are the moderate Western governments when moderate Muslims call for international protection and justice in Palestine, Bosnia, Chechnya, and Kashmir, or for the easing of sanctions against Iraq after it became apparent that it was the weak and the poor who were bearing the brunt of their effects? Western policy in relation to the Muslim world and many other parts of the world has been far from moderate. Now that a terrible tragedy has happened to the United States, the United States is asking moderate Muslims to join its campaign. The fundamental question, however, is whether there is a recognition by the West of a need to radically review and change its attitude toward Muslims.

# 12. THE REACH OF TRANSNATIONALISM

## RIVA KASTORYANO

September 11 shook the world's imagination as intensely as the attack itself. The first question many people asked was: Who would commit such a crime? Tied to this was another question: Who was capable of carrying it out? Obviously, such an "action" was the work (indeed, the "œuvre") of a well-organized and coordinated group. Its behavior and rhetoric exemplify the reality and the paradox of transnationalism.

This chapter examines the emergence of transnational communities among Muslim populations settled in Western Europe today, which have given birth to a new form of "transnational nationalism" based on religion. It analyzes the relationship of this transnational nationalism both to European nation-states and to the emerging formation of Europe itself as a supranational political unit. It attempts to show that transnationalism, as a form of political action that moves beyond national boundaries and is mobilized more specifically at the European level, still does not erase the importance of nation-states. Instead, transnational actions provide various linkages to the processes of Europeanization and more generally to that of globalization, but concurrently address political and legal claims to nation-states. Al Qaeda was able to take advantage of the opportunity structures that allow transnational networks—whether malevolent or benign—to function. By understanding transnationalism itself, we can also understand the opportunistic and pernicious use of transnationalism, as well as its legitimate manifestation.

## EUROPE AND TRANSNATIONAL ISLAM

Transnationalism is a "global phenomenon." Its contemporary context is globalization and economic uncertainty, which, combined, stimulate the construction of worldwide networks.[1] Its institutionalization requires a coordination of activities based most of the time on common references—objective or subjective—and common interests among members. With this comes a coordination of resources, information, technology, and sites of social power across national borders for political, cultural, and economic purposes.[2]

Increasing mobility and the development of communications have facilitated such transborder relations,[3] giving rise to the emergence of transnational actors—terrorists are just one type—who function in two or more countries and invent new practices and symbols mixing geographical, cultural, and political references. A new global space has thus been created, a space of participation beyond yet within territorially delimited nation-states, and a "political community" that is transnational and therefore deterritorialized has been "remapped."

Such a transnational political community is not homogeneous. The rhetoric of its mobilization, however, recentralizes the community in a nonterritorial way, creating new expressions of belonging and political engagement as well as a "deterritorialized" understanding of "nation": *a transnational nation*. The rhetoric of *ummah,* the worldwide community of believers in Islam, provides an excellent example. *Ummah* has always implied an imagined community that reframes all national diversity into one global community. But its exploitation today by fundamentalists in Muslim countries as well as in Western Muslim diasporas goes well beyond its initial religious definition. In this religiously and politically charged context, transnational nationalism arises as a species of globalizing communitarianism that reinvents crucial features of nationalism beyond the boundaries of states. It does not make claims on behalf of territorial self-determination. It does, however, fashion new power relationships with states that are engaged concurrently in the process of globalization through economy and culture. Transnational nationalism thus presents a paradox: it challenges older historical notions of territory and national boundaries—indeed, the nation-state per se—but at the same time it situates itself both toward and over states.

The events of September 11 illustrate such a transnational nationalism. Terrorism is, of course, not intrinsic to transnationalism. But the September 11 terrorists were in fact organized transnationally. The attacks elucidate the role of transnational actors in the realization of such a transnationalism. Their action is inevitably bound up with their ability to participate in at least two social, cultural, and political arenas, thus challenging the balance between the cultures, politics, and territory of nation-states. Transnational actors interact in a new global space where the cultural and political specificities of multiple national societies are combined with emerging multilevel and multinational activities. One can see this phenomenon among immigrant communities that are now settled in western Europe, especially among Muslim populations. Muslims settled in different European countries have a distinct basis for transnational organization, which generates a common and specific identification: being Muslim in Europe, a member of a religious minority who is seeking legitimacy and recognition both within Europe and the individual countries of settlement.

The extensive Muslim presence in Europe goes back to the migrations of the 1960s, when, with the end of colonialism, France, Great Britain, Germany, Switzerland, and Belgium were competing for cheap labor in order to accelerate their economic growth. There are approximately 13 million Muslims in Europe. They are settled in almost all member states of the European Union and beyond. Loyalties to their home countries and to their national identities characterize social and ethnic relations among Muslim populations in Europe and limit their identity boundaries. Within the national groups, sects, brotherhood and regional allegiances, and political ideologies provide identity repertoires for community organizations specialized in language teaching, folklore, or religion. Such organizations, subject to immigration policies and to legislation concerning the social activities of migrants in host countries, have proliferated since the 1980s in all European countries.

Since then, Islam has become an important political force in western Europe. Even if fragmented from within by various national identities, ethnicities, and doctrinal differences, Islam nevertheless increasingly represents a unifying force among Muslim immigrants. It fosters the assertion of collective interests through networks linking the local to the national and the transnational. The process of assimilating Muslims is not following the same path as that of Poles, Belgians, Italians, Spanish, and Portuguese who migrated to different European countries in the twentieth century. Public opinion in all European countries projects this difference as one of religion, namely Islam, by questioning its compatibility with the West and its ability to adopt Western "universal" values (this ignores the fact that most immigrants from Muslim backgrounds define themselves as secular).

The absence of religion from the political projects of the European Union, furthermore, combined with the lack of resources that European institutions allocate to religiously based social activities, have led religious organizations, wherever Muslims are concentrated, to extend their networks from the local to the national and transnational levels. Cultural (secular) organizations' networks are supported by European institutions for purposes of democratic pluralism, but Muslim organizations have had to turn for financial support to their countries of origin and to international Islamic organizations for purposes of religious identity. These networks of support simultaneously defend the social interests of Muslim migrants and promote Islam, the latter by ensuring its expansion in the West. They finance activities that transcend national, ethnic, linguistic, and religious cleavages. Their objective is to promote a common identification: to be Muslim in Europe.

The coordination of these various organizations to promote a transnational Islam is not an easy task. The process has to take into consideration practical as

well as theological issues. Organizations that present themselves as multinational because they represent different nationalities, and transnational because they are established in almost every European country, take over the coordination of this diversity. The best example is the Jammaat-Tabligh (Faith and Practice), an Indian organization first established in Great Britain, which has expanded since 1960 to different European cities by sending missionaries to ensure the loyalty of the believers. Their leaders proclaim a peaceful Islam. They push their members to be "good citizens" and eschew political discussion, "because," says its French representative, "politics split [divide] Islam." This approach is at odds with that of many Islamist organizations, which give expression to the political force of Islam in the world system.

Concurrently some networks assert Muslim interests, in collaboration with fundamentalist regimes that maintain close ties—mainly financial—with politico-religious Muslim groups in Europe. The Kaplan movement in Germany, for example, promotes the Iranian revolution among Muslims in Europe through its Turkish founder.[4] Even though the movement does not directly seek political power in Turkey, the European network of the Turkish Islamist Party has developed a rhetoric on international Muslim identity, the clear political target of which is Turkey. Their influence is nevertheless limited to members of the same nationality. Some are representatives of a party in their home country, but they constitute a marginal phenomenon, even though their organizations become a "sanctuary" for Islamist activists fleeing the regime of their country, against which they are fighting.

European supranational institutions whose purpose is to fight against racism help immigrants to construct these transnational networks. By encouraging the development of legal strategies with a common jurisdiction in different European countries, these institutions place immigrants' networks on the same level as other lobbies or interest groups that act in Brussels or Strasbourg, and enable them to improve their status in the countries of residence.[5] By thus structuring their action transnationally, immigrant organizations affect politics at both the national and supranational level.

Islam as a common denominator has become the core of an invented transnational, religious "ethnicity," created in part as a response to social exclusion in Europe. This identity has developed in spite of the fact that Muslims are as diverse as Christians in origin, language, nationality, ethnicity, and even denomination (Sunnites, Shi'ites, or Alawites). Despite this fragmentation from within, Islam represents a unifying force among Muslim immigrants so far as collective interests are concerned. Such a unification through Islam does not mean the reconstitution of *ummah*, even though, according to the Koran, "Every Muslim is

supposed to belong to Islamic *ummah* regardless of his her ethnicity or loca-tion";[6] it refers rather to a reconfiguration of *ummah* reinterpreted as a form of *transnational nationism* that is religious, not civic, and where old symbols look for new meanings, to use Geertz's expression.

The construction of such a unity aims at the recognition of Islam within member states as well as through European supranational institutions, with the same idea of a "mobilized diaspora" suggested by John Armstrong, defined as "an ethnic group which does not have a general status and advantage."[7] The claim follows a dual logic, calling for the fight for equal treatment within nation-states and at the same time a mobilization that gets support from "outside." But it is im-portant to distinguish between diasporas and contemporary Muslim immi-grants structuring transnational communities. The classical examples of the Jewish and Armenian diasporas do not apply to Muslims. The long history of dispersion and of minority status on the one hand and the absence of any estab-lished state and nation on the other (until the comparatively recent establish-ment of Israel, of course), historically led Jews and Armenians to assimilate in their states of residence while they maintained the myth of a return to a home-land. The Muslims in Europe, in contrast, are a minority—for the first time in the history of Islam—and their attachment is to their actual countries of origin, where for the most part the religion of the state is Islam. Their mobilization aims both at equality with other religions in the receiving countries and within pan-European institutions, and at promoting religious unity abroad.

Whereas the example of the Jews has been at the core of a "diaspora national-ism,"[8] the expectation of unity within the diversity of Islam in the West can be in-terpreted as transnational nationalism. Diasporas are organized around a shared memory of forced "exile" and the correlative myth of *return* to a homeland in order to build a nation-state, whereas transnational nationalism is a result of vol-untary emigration, of *leaving* "home" with the purpose of settling elsewhere, yet maintaining ties with home states. Contemporary diaspora nationalism may transform into nationalist movements for "reterritorialization" and statehood. Transnational nationalism takes form *after* nationalism and nation-states have become realities. Anderson refers to "long-distance nationalism," which "sug-gests taking the classical nation-state in another direction."[9] Unlike territorial-ized minority nationalism, transnational nationalism does not defend the right to self-determination; instead it presupposes a form of membership that is in-herently deterritorialized. The demand for recognition of a status with equal rights is not expressed in territorial terms.

Accordingly, "nation" is not defined in the same way for diasporas and for transnational nationalisms. Diasporas orient themselves to nations defined by

ideals vested in past symbols and project themselves into the future with the same myth, whereas the "nation" of transnational nationalism is multidimensional: it encompasses not only the states of emigration and immigration, but also the EU. As we shall see below, "citizenship" in the context of this transnational nation is also multinational.[10]

The interactions among these different levels of transnational nationalism have been significantly altered by the events of September 11. Individual states in Europe, the EU, and countries of emigration have all had to respond to September 11. And the *ummah* itself has been shaken to its core. Many of the questions that the contemporary phenomenon of transnationalism has raised with the construction of transnational networks of Muslims into Europe have been intensified by September 11: What are the implications for the link between territory and the nation-state; for the balance between community structures and the state; and for the relationship between rights and identities, politics and culture? The multiple memberships and plural loyalties upon which transnational practices rest lead to confusions by redefining the concepts of community, nationalism, and citizenship, and call into question the relevance of nation-states in a globalized world.

## THE POLITICS OF EUROPEAN TRANSNATIONALISM

In Europe, despite the fact that immigration and integration policies fall under the power of individual states, immigrants settled in different European countries foster solidarity networks across national borders on the grounds of one or several identities, linking their home countries to the countries of settlement. Some of these networks are formal, some informal, some based on identity, some on interest, some on both. They all reveal multiple references and multiple allegiances: to the host country, to the home country, to Europe perceived as a political unit, and to a constructed (Islamic) transnational community. A transnational community is composed of individuals or groups settled in different national societies who share common references—territorial, religious, linguistic—and express common interests beyond boundaries. Migrants emphasize their belonging to such a constructed unity in order to consolidate their solidarity beyond territorial settings.[11]

Transnationality is not really a new phenomenon. People who have migrated for economic reasons and who perceive immigration as temporary have long maintained close ties with their country of origin, one manifestation of which is sending remittances back home. But what is new with the transnationality that immigrants are practicing today is its organizational aspect, namely constructed

networks and structured communities. Contemporary transnationalism also implies a flexible understanding of territory: as being bounded in many respects, yet also delimited through cross-border political action—and as conferring citizenship, often dual or multiple.

Many factors influence the nature and structure of transnational communities: geographical proximity and historical ties between the sending and receiving countries, economic and political opportunity structures of the host country, and the size and degree of local concentration or dispersion of immigrant groups. Colonial ties are no longer a determining factor. Increasing mobility, standardized social relations, convergent politics of European countries toward immigration, and globalized markets generate a sort of geographical indifference: Algerians are not confined to France, and Indians and Pakistanis not to Great Britain; Turks—who were never colonized yet initially settled primarily in Germany—are spread throughout Europe. The colonial ties that once influenced immigrants in their choice of a trajectory have been replaced by different kinds of networks.

New economic and political contexts have also allowed the creation of transnational institutional structures. For example, economic liberalism has encouraged the rise of ethnic entrepreneurship, the extension of which beyond local settings is the result of the dispersion of immigrants with similar regional and/or national backgrounds across a continent, or even the world. Even more relevant to the reality of transnationalism today is political liberalism. By privileging ethnic pluralism, political liberalism has encouraged cultural activities through migrants' associations, where identities are redefined and reorganized. The politics of multiculturalism and identity that have become so prevalent in Western democracies since the 1980s have been the keys for the emergence of transnational communities. Fragments of identities—national, linguistic, religious—have been "reappropriated" by immigrants through "identity politics," which have become a cement holding transnational communities together.

On a national level, community organizations demand both cultural recognition and the political representation of diversity within the state institutions of receiving countries. Political liberalism thus allows the fragments of national identities that were suppressed in immigrants' countries of origin to find the legitimacy, recognition, and representation abroad that they lacked at home. This in turn creates a feedback effect whereby the increasing interconnection between receiving and sending countries can make these claims legitimate at home as well. In the context of the European Union, these demands pass through supranational institutions, which often directly affect sending states' decisions on their recognition. Such is the case with the Kurds in Europe: their desire for the recog-

nition of their culture and language, long repressed by the centralized Turkish state, led them to act at the European level as a "stateless" population. When Turkey was accepted as a candidate for membership in the European Union in 1999, it was told that it would have to improve its record on minority rights before it could be admitted. As a result, Turkey has recently begun to introduce into public debate the rights of the Kurdish minority within its borders. In any case, the home state provides the emotional basis—either as ally or adversary—and the country of settlement or the EU, the legal and political support for such actions. This leads to political participation in multiple spaces, allowing political norms and values to migrate from one to the other.

It is in part this very fluidity of transnationalism that the September 11 terrorists object to. Islamist extremists seek to protect their selective interpretation of the faith from the diversity that the West represents. Yet this very openness, and mobilizing opportunities afforded by transnationalism, provides an opening to organize their actions in ways that would otherwise not be possible.

Transnational communities thus aim to act as pressure groups for political, social, and cultural recognition in multiple spaces. In the host country, they try to influence the politics of immigration and integration, as well as policies regarding "minority issues." Even though the concept of *minority* is ambiguous and causes uncertainty in defining legal forms of recognition, transnational actors transpose European debates to the national level by claiming linguistic and religious recognition.[12] This is the case in France and Germany. In the home country these communities contribute to a redefinition of the "official" state nationalism by introducing into public debates identities that were suppressed in the process of nation-state building but have been "reappropriated" through the process of mobilizing and building transnational communities.[13]

Thus the transnational community takes shape through action, claims, and mobilization led by transnational actors who transfer not only economic practices and political norms, but also "ideas, behaviors, identities, and social capital" from one location to another.[14] Their economic power is sometimes used for political purposes, to support voluntary associations that claim the recognition of an identity and act beyond boundaries. For political activists this knowledge of the political "rules of the game" becomes a sign of their political acculturation and increases their capacity to negotiate with states and official institutions, the European Union foremost among them.

The European Union stands, among other things, for the idea of open-minded conciliation, for an alternative conception of accommodation and inclusion to that of the nation-states that comprise it, which, in spite of their liberal democratic heritage, have long histories of particularistic and exclusionary social

practices. According to those who fight on behalf of the integration of immigrants into national societies, the idea of universality suitable for Europe is to conceive of an arena in which foreigners resident in Europe, or European citizens who are perceived to be foreigners—by virtue of the nationality of "origin," as it is called in France (which is seen as an ethnic marker) or of color or religion—would be inscribed within a plurality of cultures for the same reasons that traditional national identities are encompassed within the broader European identity. I shall further elaborate this point below, in my discussion of European citizenship.

In 1992, at the time of the signature of the Maastricht Treaty (when the European Community had 12 member states), activists involved in transnational networks referred to themselves as the thirteenth population, the thirteenth state, or the thirteenth nation to express their solidarity on a European level.[15] By this was meant a representation of "all immigrants" settled in Europe since the 1960s. The rhetoric is based on the importance of defining a common interest formulated in terms of equality of rights.

Theoretically, such understanding of a "nation" refers to representation beyond the particular relations of Muslim immigrants with their states of residence as well as their states of origin. But its reality reveals contradictions. On one hand it declares itself to be a reaction to nationalist sentiments voiced by the member states, yet often resorts to the same official nationalist vocabulary when it confronts other immigrant groups in the transnational network. On the other hand, the construction of a political Europe is idealized as a political community where identities and interests can be expressed in terms that move beyond particularistic national frameworks. Claims are expressed in reaction to national identities as well as to public policies that affect immigration or integration, leading immigrants to define a core identity around which a community can be constructed in order to negotiate its recognition.[16] Voluntary associations participating in the transnational network therefore express widely varying interests, developed and formulated in reaction to the culture or policies of individual states. Some Muslim activists emphasize a common nationality, some a common religion, some base their argument on color as a core element of discrimination, as is the case in Great Britain. In France, the classical republican rhetoric of citizenship, a defensive and exclusive discourse on secularism (*laïcité*), and the lack of any institutional recognition of Islam have pushed immigrants to express their claims for recognition in religious terms. In Germany, the ethnic understanding of the nation clusters Muslims in terms of ethnic communities, as a minority based on a common foreign nationality who must focus their claim to citizenship rights in terms of acquired German nationality, where possible.[17]

Claims internalized in reaction to exclusion in states of residence are elevated onto the European level, where discourses on identity nominally try to move beyond national particularities. Leaders of immigrants' voluntary associations in France, for example, have adopted the republican rhetoric of a civic and unified political community, and therefore reject in their appeals to the EU any policy framed in terms of "color." In their view this concept is relevant for the British context but not the French or German one. They thus express their internalized attachment to French nationalist rhetoric, according to which policies toward immigrants are intended to prevent exclusion from the larger society by not recognizing any ethnic, cultural, or religious specificity. Similarly, ethno-racial approaches to identity developed in Great Britain and ethnic identity expressed in terms of nationality in Germany have become a way for activists resident in those countries to fight against racism and discrimination and for equality of rights in Europe.

Concretely, Muslim immigrant populations perceive their involvement in a "transnational nation" as taking place through any organization that seeks to influence national policies through action at the European level. Their transnational solidarity network, like networks of professional organizations, is part of the spider's web that covers the European space, a "space without internal frontiers in which," according to the Single European Act of 1986, "the space of the free movement of goods, of property and capital is safeguarded." Hence, new forms of solidarity evolve that place these networks beyond the "nationalization" of political action. Whether perceived as immigrants, foreigners, or blacks (to use the terminology in France, Germany, and Great Britain, respectively), they all converge in their participation in the construction of a European political space, ideally a new political space open to negotiations for representation and recognition that legitimizes their action. Increasing interactions between national societies (home and host) in the wider European space, between national institutions and supranational institutions, and among nation-state members of the European Union, generates a common social, cultural, economic, and political engagement.

## TRANSNATIONALISM AND EUROPEAN CITIZENSHIP

Liberal democratic notions of citizenship have historically been fairly unitary. Although the various functional components of citizenship in liberal democratic states can be usefully distinguished (Marshall's tripartite distinction between civil, political, and social elements is the most influential), these components have been fused in practice since at least the end of World War II. (There has been

some variation among states.) This specifically Western conception of citizenship, furthermore, has by definition been national; in other words, it has been conferred by nation-states and delimited by national borders.

Both the functional and geographical components of citizenship are now being subjected to contradictory and disintegrative pressures in Europe. European integration is creating an effectively transnational political and economic entity and corresponding form of citizenship, at least for "Europeans," with many rights and duties now accruing at the EU level. Member states, in contrast, largely retain the classically national prerogative to determine both who enters from outside the EU and how these immigrants are incorporated into national regimes, but they are now also subject to supranational, EU-level, pressures to conform to an emerging set of common immigration policies (for example, as elaborated in the Dublin and Schengen agreements). Continuing variation of standards and patterns of incorporation among member states, when combined with emerging EU institutional authority such as the European Court of Justice and the European Court of Human Rights, is allowing for the disaggregation of citizenship's functional components. Foreign nationals are sometimes allowed to vote locally, as in the Netherlands, for example, which allows even relatively recent immigrants from outside the EU to participate in local, but not national or EU, political life without changing their citizenship status. These multiple-rights regimes allow for overlapping and/or contending forms of participation and rights that challenge the formerly unitary conception of citizenship.

Transnational networks have taken advantage of the space afforded by these developments, and introduced new modes of political participation at both the national and the European level. Non-European nationals residing in Europe are now able to assert their autonomy toward nation-states. Moreover, mobilization for equality of rights, on which transnational participation is based, encourages immigrants to take part in the elaboration of the uncertain and comparatively inclusive identity of Europe as a whole, in contrast to traditional nation-state–based citizenship, which historically has been exclusive, especially with respect to those perceived as foreign. Put differently, nation-states have a "hard identity" rooted in history, and newcomers cannot change this understanding of nation or state. "Europe" in contrast has a "soft" identity, since it is a political community in formation that includes not only all the identities of its member states but also the identities that are excluded from assimilation in the nation-states. So immigrants or foreigners, and Muslims in particular through their mobilization on a European level, develop the feeling of taking part in the process of Europeanization and in its identity formation.

Citizenship is expressed by the engagement of individuals in polities, and

their direct or indirect contribution to the public good.[18] European citizenship implies, in the view of the activists involved in building transnational immigrant networks, the construction of a new "community of faith" that is supposed to represent the European Union and is expressed by the "will to live together."[19] Just as with the formation of national political communities, this implies the expression of a "will to live together" in a de facto multicultural and democratic space.[20] The transnational engagement of immigrants for equal rights necessitates a civil understanding of membership, not necessarily civic and definitely not ethnic or territorial.

Yet from a legal perspective non territoriality is joined with the very territorial notion of "citizenship of the Union." According to Article 8 of the Maastricht Treaty, "citizenship of the Union" presupposes national citizenship in one of the member states. Thus the treaty maintains a link between citizenship and nationality. Obviously the European Union as a political construction cannot require the same ideal conditions as a nation-state: the coincidence between territorial, cultural, linguistic, and political unity. Nevertheless, the EU seems to be, at least as far as the citizenship of the union is concerned, a projection of the nation-state model, where citizenship and nationality are conjoined. But at the same time, political participation at the EU level adds an extraterritorial dimension to the traditional conception of citizenship. According to the same Article 8, a citizen of the Union has the right to free circulation in and the liberty to reside and work on the territory of any member state and—more relevant to the link between territory and citizenship—the right to vote in local elections in a member state of which he or she is a resident (not necessarily a citizen).

In contrast to juridical conceptions, many normative assessments of European citizenship stress its supranational component. The most influential view is that of the German social theorist Jürgen Habermas, who argues that the process of moving from national to supranational regimes and governance should be viewed as part of the unfinished historical process of modern nation building.[21] The initial steps of nation building in Europe, Habermas asserts, are analogous to the present situation, in which national sources of solidarity and moral bases of society are eroding. Habermas suggests that pan-European attachment to a shared political culture—"constitutional patriotism"—may develop, and that it is the only alternative to increased particularism in contemporary multicultural states. The French philosopher Jean-Marc Ferry, who first developed the concept of postnational citizenship in relation to Europe as a new political community, suggests that a form of membership beyond the nation-state could be developed: citizenship should be dissociated from nationality, as a way to underline the dissociation between rights and identity.[22] Similarly, a conception of citizenship

beyond territorial boundaries leads Rainer Bauböck to elaborate the concept of "transnational citizenship" as "the liberal democratic response to the question of how citizenship in territorially bounded polities can remain equal and inclusive in globalizing societies."[23] Applying these concerns directly to the immigrant population in Europe, Yasemin Soysal uses the concept of "postnational membership" to identify a form of citizenship that is related to international norms and conventions related to human rights, and therefore different from a strictly juridical form of citizenship limited to citizenship of a nation-state.[24]

As I argued above, the participation of immigrants in a transnational nation contributes to the formation of an identity of citizen, an identity developed in the relationship of immigrants to national institutions. Nationally, participation in voluntary associations and institutions creates an identification with the political community through collective action. On the European level, "the identity of citizen" is shaped in relation to supranational institutions which contribute to the European public good and generate a new political identification for individuals involved in transnational mobilization. This participation can be considered as the second stage in the process of political socialization for immigrants, which takes place in the European public space where they exercise citizenship beyond national boundaries and beyond the political prerogatives of the state. Immigrants, whether legal citizens of a member state or not, act together in this new space, a space of communication as well as of socialization in the use of power.

This dynamic, arising from political participation in several spaces at the same time and speeding up the interaction between different political value systems and cultures, forms the basis for transnational action, or transnational nationalism. It leads to confusion in the definition of legal status as reflected in the tension between membership, citizenship, and nationality. Particularly for immigrants with non-European backgrounds, European citizenship underscores the complexity of contemporary social and political reality in Europe. By stimulating their involvement in the common good of the European Union, supranational institutions extract immigrants from their "communal ties" by taking them away from any direct political action in their home country. But European citizenship, as a more inclusive and globally oriented form of membership than that of nation-states, also reemphasizes the allegiance of immigrants to their home country precisely through encouraging participation in transnational networks.

Transnationalism, therefore, is inevitably bound up with dual or multiple citizenship, insofar as it relies on more than one national reference as well as on at least two arenas of social participation. Dual citizenship has been at the core of debates on the new German citizenship law, bringing out old and dangerous sus-

picions about membership and the necessity of allegiance to a single political community. But dual citizenship demands more flexible conceptions of a community's moral and political values, as well as of the civic duties demanded of those residing within it.[25] Some see in dual citizenship a potential source for "democratic influence," that is, the application of Western democratic values in immigrants' countries of origin, many of which are undemocratic.[26] Dual citizenship creates blurred boundaries and allows the simultaneous participation in at least two political arenas. In practice and reality, however, citizens are only citizens of the state in which they *fully* exercise their rights and obligations. Their legal status flows merely from agreements between states. But the tension between juridical membership status, increasingly influential normative conceptions of supranational citizenship, and the empirical realities of how immigrants participate in multiple spheres, also creates opportunities for entirely new forms of political action.

## CONCLUSION

The transnationalism of Muslim immigrants entails Europeanization of political action, but not the Europeanization of all of their claims. Many claims for recognition and equality remain focused on individual states. The state remains essential as a practical framework for the negotiation of rights and representation. It is, likewise, still the principle institutional framework for citizenship claims and legal protections.

In contrast, the consolidation of transnational solidarity generally aims to influence a state from "outside," from transnational space. Transnational networks impose themselves on states and public authorities as they become indispensable structures for the negotiation of collective identities and interests. Most claims on a national level now imply parallel pressures on the European level, while claims made on the European level seek to affect decisions taken nationally within each of the states. Clearly, transnational networks aim to reinforce their representation on the European level, but their practical goal is recognition on the national level. Moreover, immigrant activists, even those most active on the European level, see states as their chief adversaries. This adversarial relationship becomes particularly acute when cultural, especially religious, norms and practices clash. The last few years have seen intense conflicts across Europe between Muslim immigrants and European states on issues related to religious rights. These conflicts have contributed to the radicalization of many Muslim groups, who find that their identity as Muslims is leading to their being ghettoized by aggressively secular states, and leads them to conclude that extremist opposition to

the West is the most effective means of combating their exclusion. They are able to take advantage of transnational nationalism in this effort.

September 11 is the most extreme example of this radicalization, and reveals the paradoxes of transnationalism: (1) Transnationalism acts on multiple levels (local, national, regional, and global). (2) For Islamic activists, it reimagines *ummah* (or a version of *ummah*) in rhetorical opposition to the West, even though many of the transnational Muslim leaders studied in the West and acquired there the know-how—the political tools—to interact with states, a process through which they have been politically "acculturated." Some of these actors are highly educated and integrated into a society of residence. They often are socially and institutionally assimilated, sometimes are juridically invisible through naturalization, yet all while they keep strong ties to their home country and to a network with which they identify themselves and on whose behalf they act. (3) Transnational aims are ambiguous. They include political agendas in the countries of origin (such as in Saudi Arabia or elsewhere in the Middle East), yet are often put forward through deterritorialized forms of political action. Transnationalism can be a tool of Muslim fundamentalists seeking power or seeking to influence politics in the Middle East, and it can be a means for the assertion of a religious transnational nationalism within Western states.

Will the attacks of September 11 induce *states* to fashion new, transnational modes of action? There is no simple answer to this question, since it implies that states might, at least partly, imagine themselves in some new way as transnational actors, coordinating interests and strategies beyond simple, old-style alliances. If they do not do so, then we must ask if old styles of warfare respond appropriately to the new (terrorist) use of transnational tools. Again, we find ourselves with paradoxes. States remain the driving force of globalization. They accede to supranational norms while simultaneously maintaining their autonomy. They continue to be the dominant actors of negotiation, asserting and defining their own interests in international relations and domestically. But the "nation" here retains its relevance as the prevailing emotional unit of identification and of mobilization and resistance, just as the nation is at the basis of any transnational enterprise. So states will remain the modal unit in the process of globalization, which takes state capacity to negotiate within and without as essential. At the same time states will have to imagine new ways of acting and to adapt, both structurally and institutionally, to the new realties. In short, the reach of transnationalism accentuates the contradictory challenges faced by states in the age of globalization.

# 13. STATE AND FAITH:
## SECULAR VALUES IN ASIA AND THE WEST

### WANG GUNGWU

In the aftermath of September 11, 2001, much has been written about Islamic fundamentalism, including a great deal of speculation about why Muslim states have failed to modernize. One of the reasons given has been that they have failed to become more secular. This essay will focus on what lies behind the secular values that have been resisted strongly by some and found more readily acceptable by others. It will also consider the broader comparative question of how countries with different religious backgrounds have met the challenges of the modern and the secular.

Through social science literature as well as common usage, the scholarly community by and large accepts that being modern is a condition closely associated with being secular. Two recent views are representative. Bernard Lewis, in discussing what has made the Islamic world poor and weak and the West rich and strong in the contemporary world, says that "the standards that matter in the modern world" are economic development and job creation, literacy, educational and scientific achievement, political freedom, and respect for human rights. In the context of the role of religion, he notes, many Muslims recognize that "a principal cause of Western progress is the separation of Church and State and the creation of a civil society governed by secular laws."[1] The point about the secular foundations of modernity is even more forcefully put by Michael Howard when he writes of "the challenge to Islamic culture and values posed by the secular and materialistic culture of the West" and "the profound and intractable confrontation between a theistic, land-based, and traditional culture . . . and the secular material values of the Enlightenment."[2]

Both views link the secular directly with modernity as it has blossomed in the West. One places greater emphasis on civil society, the other on materialistic culture. But for both, the secular derives from church-state separation and the Enlightenment and would thus appear to have been the product of a unique historical experience, what David Martin calls a "Christian" phenomenon.[3] This is closely tied to the long and ongoing struggle for secularization in western Europe. The process may date its beginnings from the Renaissance and Reformation, but it reached its climax during the second half of the nineteenth century,

and is still going on, particularly in other parts of Europe, the Americas, and Australasia. Outside the Western world, the word "secular" is used most commonly in reference to the political model of the secular state that was transplanted to most postcolonial countries in Asia and Africa. The best example of this is India, where secularism has been well developed and receives close attention in the context of contemporary rival fundamentalisms that threaten state authority and public order.[4]

Farther east in Asia, the word "secular" has not been directly applied to countries like China and Japan, but many descriptions of modern progress in both those countries point to examples where they have successfully transplanted among their peoples "the secular and materialistic culture of the West." It is interesting that "secular" is not used to describe the values associated with Confucianism, or for social and political systems that have centered on being this-worldly without having a dominant religion. Confucian and Buddho-Confucian elites have considered it their greatest responsibility to bring harmony to the life of man between Heaven and Earth without reference to God or gods.

The reason why the term "secular" is not used for these eastern religions originates from a narrow definition that associates the word with the struggle against the Christian church and, therefore, places it in the context of freedom from a once totalistic religion. Hence the intense interest as to why the Muslims, with an equally totalistic religion, could not do the same. In contrast, there has been far less curiosity about ancient manifestations of secular values. All questions about comparable values in ancient Greece and Rome, as with ancient China, would turn to words like "rational" or "humanist." By using the word "secular" exclusively in the context of European intellectual liberation history, however, two important issues have been unnecessarily neglected. One is an improved understanding of why modern secular values have fared better in some parts of the world than in others, and also why East Asia has responded to some secular offerings more readily than to others coming from the West. The other is the likelihood that when the people who accept the modern and secular have different roots for what is rational and humanist in their traditions, they place different emphases on the secular values that they are prepared to accept and may eventually produce for themselves different kinds of modernity.[5]

## SECULAR AND "ASIAN" VALUES

The question of secular values was very much on my mind immediately after the September 11 attack in the United States. In my address one month later at a conference on the topic of "Asian values and Japan's options," I linked the issue of

Asian values to the future of secular values. My view about the notion of "Asian values" is that the debates that this has aroused have a long lineage. The current political references to them represent merely new versions of an older dichotomy. Their roots could be found in ideas concerning the Occident and the Orient. The Japanese made an early contribution to this dichotomy by using Toyo (Eastern Ocean) and Seiyo (Western Ocean) and influenced the Chinese to adopt the same terms, Dongyang and Xiyang. Today, the word "Asian" has been adopted as a substitute for the post–World War II revision of the word "Oriental." In any case, both sets of alternative terms in Japan and China were really derived from European usage.

The recent manifestation of "Asian values" is a reply to American-led pressure on some Asian governments following the end of the Cold War. Before that, a new dichotomy that opposed capitalist ("Western" and secular) values to communist ("Eastern" and secular) values in support of the notion of a "central balance" in world politics, had put the weight on questions about power and wealth that were obviously this-worldly. The forces arrayed against each other were armed to their nuclear teeth, and the struggle was couched in terms of irreconcilable political and economic systems. After that struggle ended in 1990, the post–Cold War pressures for world peace were accompanied by a note of triumphalism, and seemed to conceal a new mission to civilize the world in secular terms. The "Asian" response originated from some of the less free parts of East and Southeast Asia, not directly from the Islamic states.[6] It recalls the Japanese and Chinese use of ideas about Eastern foundation or substance (*ti*) and Western application or function (*yong*) prevalent at the end of the nineteenth century.[7] The original stress on the sanctity of tradition has been modified by recognizing that Western "application" (the acceptance of modern secular values) in some countries in eastern Asia is now predominant and will become the core of a new "foundation."

In the context of the attention given to the gulf between Western and Islamic values, it is understandable why Samuel Huntington's "clash of civilizations" paradigm has provoked fresh interest. When he depicted how the West might face a combined threat from the Islamic and the "Confucian" world, the outline he presented was understandable, though somewhat paranoid. He may well have asked the question, but did not, whether there could also be a conflict between Christian and Islamic civilizations in which the East Asian "Confucians" would have to choose sides. Huntington is unpersuasive in suggesting some sort of collaboration between Islam and Confucianism aimed at the West. The evidence he presents is at best circumstantial. But he is also misleading in his use of the word "civilization." As a political scientist, he was primarily describing the continua-

tion of Great Power relations in different formations. From now on, he implies, another set of Great Powers might be seeking new unifying symbols in older divisions derived from different religious traditions and value systems. The struggle that he envisaged, however, would really be driven by secular power where the West was concerned, and this would be governed by the scientific and humanist spirit that underpins modern secularism.[8]

It is this secular drive that characterizes our age. This is where the image of "civilizations" as power players in global affairs rings false. Each of the major value systems in the world today has a distinctive relationship with different kinds of secularism, and these distinctions would be better understood if the value systems were recognized as having different sources. We need to ask what the meaning of secular values is, if only to pursue the reasons why so many Muslims have found it difficult to come to terms with secularism. For comparison, we also need to explore the extent to which the peoples of Hindu India and Confucian China have been secular. Further, how are we to relate the ideas about "Asian" values to the future of secular values as such; in other words, what constitutes the secular in Asia?[9] Islam is one of the great religions of Asia. If there are questions about the troubled reception given to secularism in Islam, should there not be similar doubts about the fate of this secularism with other faiths in Asia? If not, why not? Indeed, if there are "Asian" values, would they not reflect the problems that all Asian religions face?

## ALTERNATIVE CONCEPTIONS OF SECULARISM

Prior to 1990, the world that was divided between capitalism and communism could have been portrayed as one engaged in a civil war between two secular faiths. Nevertheless, the "central balance" of potential war and terror was an important factor in giving the world relative peace for some 40 years. Since then, after the economic reforms leading to the gradual opening of China and then the fall of the Soviet Union, that balance of terror has given way to total victory for the capitalist cause. As a result, there seems to be a new mission to bring one set of secular values to a globalized world.

These modern secular values derive from the achievements of the Enlightenment project in Europe and across the Atlantic. During the past decade, their major focus shifted from anticommunism to issues of democracy, human rights, and a free global market economy as the core of a "truth" that had just been confirmed by victory. Claims have been made for how this truth is to be universalized, but many thinkers in both Asia and the West know that secular capitalism is neither a natural law that the West has discovered, nor a godgiven truth that has

been bestowed upon the West. It is, rather, the product of centuries of worldly struggle in search of wealth and power, and also of the search for a happier world at all levels of state and society. It is the hard-won result of painful experiments conducted by generations of social, political, and business leaders, not least the intellectuals who helped develop the various fields of mathematics, natural sciences, and social sciences. In East Asia, for most adult Japanese and large numbers of educated Chinese, this road to progress was not itself new. They had observed with keen interest the traumas in the West that had produced the ideals behind its progress. Some had actually sought the same ideals for their respective countries. Even when they failed, many still hoped that their own societies would ultimately progress in a similar direction.

September 11 reminds us that, apart from what the imperatives of international politics could force Asian leaders to agree on, there is nothing substantive about the values given the name of "Asian." What various Asian governments and their elites have in common were drawn from the history of battles to defend traditional values against the alien ones brought into Asia by the West. These battles opened up discussions about why traditional values seemed to clash with modern secular ones, but the debates, ironically, were largely framed by European standards of what was considered progressive and what was not. When couched in that way, the question of Japan's options where values are concerned becomes highly relevant. The choices that Japan makes are clearly relevant for China as well. How do the Japanese and the Chinese understand which values were secular?

The triumphant note of the 1990s reminds us of an ancient Confucian cosmic belief in the mandate of heaven. This was based on the simple principle that the victor must be favored by Heaven and, therefore, must be the bearer of the truth. The pragmatic lessons of history run through Chinese and Japanese history: "The victorious is king, the defeated is but a bandit." Thus, the secular mission to bring Western progressive modernity to East Asia should not meet resistance, provided it really triumphs. For the Japanese, there was a thorough defeat in 1945, and therefore, willingly or not, they accepted the winning model for a second round of modernization.[10] For the Chinese there had been many humiliations by Britain, France, Russia, by the allied forces at the siege of Peking in 1900, and then by the new imperial Japan down to 1945. China's struggles to respond to these defeats led a new generation of Chinese leaders to adopt communism, an alternative but equally alien ideology, as the true path to modernity. This did not free them from external threats. Their desire for independence and sovereignty gained them the enmity of the Soviet Union, and this forced them to turn to the United States and ultimately to revise their views about capitalism itself.[11] But,

with the long backdrop of Chinese history in mind, it could be said that the Chinese had merely lost battles but never the war. They had endured invasions of mind and body but never the comprehensive defeat experienced by the Japanese. Thus they seem to have retained, however imperfectly, some faith in the rational and humanist tradition that was at the heart of their ancient civilization. How do the values represented in this tradition compare with those identified with the modern secularism of the West?

As manifested in the triumphant West, secularism is a product of the endgame in the epic struggle between church and state. Clearly no other part of the world shared this unique experience of church-state separation, or the accompanying process of secularization that could only have occurred when a clash between God and Caesar resulted in victory for Caesar. The process may have begun with the Reformation and the French Enlightenment, but it did not really end until the middle of the nineteenth century.[12] Given this unique history, it was understandable for western Europe to see all of Asia as having never been secularized. Defined in the narrow terms of the church-state relationship, that judgment is correct. But it ignores the fact that "the secular," more broadly construed, is not confined to the West. It has wider reference points in faiths that are primarily about this world, that is, about everything that is not sacred. The idea of what is secular was strictly confined in Muslim polities, but it was more tolerable and acceptable in South Asian religions like Hinduism and Buddhism. And, farther east, China has had a distinct tradition of this-worldly faiths that wielded considerable influence among its neighbors. Indeed, when set against this broader historical and conceptual framework, the ancient Mediterranean world of Greece and Rome can also be said to have had its own kind of secular faiths before the rise of Christianity. Although these faiths were eventually crushed and displaced, the ideas behind them were similar to aspects of ancient Hindu thought and were comparable to the values underlying Chinese secular beliefs.

Since September 11, debates on whether there can be a separation of religion and state in Islamic countries have been revived. The terms of these debates have their roots in conflicts within monotheistic faiths, that is, Judaism, Christianity, and Islam. It is interesting to contrast that discussion with the fierce ongoing debates within India today. In India, Hinduism and Islam have had centuries of internal tension, and now occupy apparently irreconcilable positions in a modern nationalist framework. And, although the idea of a secular state in India has gained a surprising depth of meaning, the commitment to secularism, initially accepted by most Hindus, is now being undermined by a growing fundamentalism among the country's Muslims, Sikhs, and increasing numbers of Hindus themselves. This fundamentalism makes clear that secular values in India are dif-

ferent from those elevated in western Europe and globalized in North America and Australasia. Taken together with what was peculiar to the secular tradition in China, especially those aspects that have survived till the present day, the Indian case helps us identify the kinds of secular values active in Asia today.[13]

During the last two centuries, the dominant discourse in Asia has been cast in terms of a "hard" secularism, essentially fundamentalist in nature, that denies the spiritual life altogether, as against a "soft" secularism that co-opts the spiritual for an integrated worldview that would satisfy the needs of the largest numbers of people. A third position, in which secular values are completely subordinated to spiritual values, may still attract specific religious communities and some individuals, but among most elite groups in Asia, it is considered to be turning back the clock of progress, and the likelihood of its being fully taken up in any country today is slim. The background for the secular values on offer in Asia remains that of a choice between hard and soft secularism. Nevertheless, the choice must be made within the context of different underlying ideas of the secular.

The major ideas about what constitutes the secular in Asia today come from three distinct sources. The first was the separation of church and state in the Christian West; the second emerged from the need to establish a modern state in postcolonial countries like India and others in Southeast Asia; and the third originated from the rational and this-worldly attitudes toward religion of the ancient Greeks and Romans, and also the Chinese. To illustrate this more fully, the three sources of the secular could be distinguished as deriving from three kinds of faiths: (1) monotheistic religions; (2) South Asian religions; and (3) ancient secular faiths.

The first two are presented here only briefly because the modern secular values they stand for or reject are well known and widely debated. The secular faiths in their modern transformations will be given more attention. These have been studied mainly for their roots in ancient history, but their relevance to the contemporary world has not often been recognized. The events since September 11, coupled with disparate ideas about "Asian" values, and the possible threat of practitioners of Islam and Confucianism acting in concert against the West, suggest that the process of changing and modernizing ancient secular faiths has lessons for us today.

## THE MONOTHEISTIC RELIGIONS

The monotheistic religions of Judaism, Christianity, and Islam sprang from a common source in the Middle East. The latter two derived their spiritual power from the first, and have been its dominant variants for a long time. Their strong

missionary urges have provided them with world-conquering strength. Christianity grew steadily into a sacral imperial power and evolved into several major religious communities. Eventually, its various forms have nested in nation-states and some have been supportive of nationalist goals. Islam was more immediately successful and established a chain of military states on three continents. The religion these states espoused had at least two main divisions, the Sunni and Shi'a, but the fractured condition of the Muslim world after the fiftieth century left it with no powerful states to resist the forces of modern secularization coming from western Europe. What Christianity and Islam do still have in common is the mission to bring the only true God (that is, the only Truth) to the world. This has been the source of the continuous rivalry between them for more than 1,300 years.

In modern times, the major source of conflict has arisen from their very different attitudes toward the rise of secularism, a word that came into use during the nineteenth century. Within Christianity, which initially resisted but eventually accepted the separation of church and state, secular values first reached mainstream status during the eighteenth century with the French Enlightenment and the American Revolution, and that status was ultimately achieved among all states with Christian backgrounds. Within Islam, individual political leaders, intellectuals, and scientists since the nineteenth century have recognized the secular basis for the modern world. The words they used for what was secular were derived from the word for science and that for the world, namely *'ilmaniyah* (from *'ilm*, meaning science), and *'alamaniyah* (from *'alam*, meaning the world). Azzam Tamini suggests that an even more accurate rendering would be *dunyawiyah*, which is rooted in another word for this earth and refers to "that which is worldly, mundane or temporal." [14]

The successor states of the Ottoman Empire, especially those bordering the Mediterranean, notably Egypt and modern Turkey, but also Palestine, Syria, Tunisia, and Algeria, were consistent in adapting secular values to their needs. But there remained fierce opposition among the faithful toward the secularizing elites. The failure of the new states to solve problems of poverty and more generally to defend themselves against Western dominance was seen as proof that they had taken the wrong road. The fact that the powerful Muslim Brotherhood began in Egypt (1928), one of the secularizing states, highlights the direct relation between what was seen as imitative actions of the elites and the popular reaction from the faithful. In Turkey, Mustafa Kemal Atatürk's determination to use the nationalist state to control Islamic extremism has been an exception among modern Muslim leaders. But secularism in Turkey has by no means won the day, and the reaction against it has been increasing, both in Turkey itself and

throughout the Islamic world. Since the Iranian revolution in 1978, increasing numbers of Muslims have come to believe that to be secular without losing one's faith is a challenge, if not a hopeless contradiction. The answer for many, especially the clerics, is that protecting Islam is preferable to the material progress associated with secular values.

In sum, the key difference between the Christian and Muslim worlds today lies in different approaches to the process of secularization. Although not always spelled out in national constitutions, the relentless pressures of the scientific and industrial revolutions working in support of national survival or aggrandizement did not allow any European country to avoid that process. Its success, first in Europe and then across the oceans to the rest of the world, confirmed that secular values provided the foundations for material progress. Thus the ideas and institutions presented by a victorious West to the rest of the world have become the dominant model for most other nations to either reject or emulate.

## SOUTH ASIAN RELIGIONS

The South Asian religions, notably Hinduism and Buddhism, experienced a vastly different history. They had no church from which the people needed to secularize themselves. Among Hindus, the Brahmin priestly castes emphasized values based on concepts of inward purity, but most people in their "small communities, birth groups, and religious sects" were at the same time "secular." [15] The Brahmins served the kings of the warrior castes with loyalty and were rewarded with respect and privilege. The many gods or many manifestations of God of the Hindus, however, did not satisfy everybody, and alternate visions led to the rise of Buddhism, Jainism, and later Sikhism. In the end, a multi-ethnic and multilingual Hinduism prevailed despite the violent conquests by the Muslim armies that came out of Central Asia after the twelfth century.

For the Hindus, there was no conflict between the sacred and the profane. The question of becoming secular did not arise until the formation of British India. Out of that experience came two alternative paths to secularism. [16] One was the religious route sought after by Gandhi and his followers, which stressed the equality of all religions in their common search for God as the Infinite Truth. The other was the colonial or nation-state route. It was the latter that prevailed: the secular state model that the Western colonial powers bestowed upon their successors when they departed after the end of the Second World War. India is the best and most challenging example of this experiment in political modernization, and its Hindu leaders have carried on with this model by appealing to both secular nationalist necessity and a Gandhian rhetoric. In spite of the resurgence

of Hindu fundamentalism in the face of Muslim and Sikh fundamentalisms, India has remained firm in the defense of secularism.[17] Even with regard to Kashmir, official policy has always insisted that the issue on India's part is merely one of sovereignty in a multireligious society and not, as with Pakistan, a matter of a religious majority.

The many gods and castes in Hinduism have not stood in the way of Indian secularism. One of the major offshoots of Hinduism, Buddhism, did not fare well on its native soil but migrated to take root in Sri Lanka, Southeast Asia, and farther east in China, Korea, and Japan. In rejecting God or gods, this Buddhism may seem to have been somewhat of a heresy, but in essence, it still focused on an inner tranquillity that derives from the same source as Hinduism. Because it transplanted well away from India, and played an important part in shoring up secular values in East Asia, I shall say more about this later. The point to emphasize here about South Asian religions is that, while neither Hinduism nor Buddhism pushed for secular solutions to the world's problems, they have both been able to tolerate and even embrace certain secular values that they see as posing no threat to their core doctrines.

## ANCIENT SECULAR FAITHS

The third source of secular, this-worldly values is the two ancient faiths that were dominant in the ancient Greco-Roman world and East Asia. Both have undergone transformations during the past two millennia. The modern phase of these faiths is now led by western Europe and its extensions in the Americas and Australasia, and its offerings are being emulated to a greater or lesser extent in East Asia. But their separate origins are still important enough to create a strong tension between them. Both would claim the universality of the secularism they represent, deriving in one case from a scientific and legal spirit embodied in free individuals, and in the other from an emphasis on social morality and harmony.

### GRECO-ROMAN RELIGIONS

The worldly spirit of the ancient Greco-Roman religions flourished for centuries until the ascent of the Emperor Constantine in the fourth century. It then disappeared with the fall of the Roman Empire, when Europe was blanketed by the Dark Ages, and its secular values were replaced by a new Christian fundamentalism. With the rise of Islam, some Greek scientific texts, notably those on logic, mathematics, and astronomy, were preserved and studied, and scientific advances were made. That these writings were admired by the early Muslim elites has led to some puzzlement as to why this tension between the secular and the

sacred did not lead to a creative fusion. Of particular interest has been the re-treat from scientific experimentation and astronomical observation that had reached high standards of achievement among Muslim scholars by the thirteenth century.[18]

Christian humanists who began to look to ancient Greece and Rome from the twelfth century onward fared no better in introducing alternate views into schol-arly debates. In contrast to Islam, whose various communities stood by the words in the Koran, in the Christian world a powerful church stood in the way of any questioning of orthodox "truths." In these circumstances, the secular values ex-pounded by the Greeks were all but lost to the world. They had to wait another three centuries, until the fall of Constantinople and the division of the church it-self, before light was shone on them again. In short, they had to be rediscovered and reevaluated among new generations of Christian scholars. Thereafter, these values have modified Christian missionary values and, in turn, notably after the Reformation, have been modified by both the Catholic and Protestant heritage.

It is here that the contrast with the Islamic response is most stark. Greco-Roman secular values did not succeed in modifying Islamic missionary values despite the fact that the classical texts that represented that spirit were much ap-preciated by early Muslim scholars. Without doubt, the success of Greco-Roman values within the Christian world was stimulated by the church-state separation after the Renaissance. This provided the necessary conditions for intellectual elites to advance the scientific and technological revolution that has shaped the modern world today. But the key point that I wish to underline with respect to the Greco-Roman experience is that ancient secular values espoused by political and cultural elites could not initially resist the onslaught of a religion, whether Christianity or Islam, that met the spiritual needs of ordinary people.

## CHINESE RELIGIONS

The secular values in ancient Chinese thought had different origins and their evolution followed a different trajectory. They began not with God or gods but with a faith in the three-part continuum of heaven, earth, and man, in which man and earth had prominence and man was given a firm if not exactly equal place.[19] This essentially secular position was endorsed by Confucius when he af-firmed that he knew only of this life, and therefore had nothing to say about the afterlife. As with the Greeks and Romans, for the Chinese the measure of man was man. This rational humanist beginning became the main thrust in the Con-fucian ideals of morality and social harmony—in this world. Of course, the Chi-nese concept of the secular, as with the Greeks and Romans, had nothing to do with secularization from a church-dominated state and society. The Confucian

scholars who came to dominate the Han dynasty from the second century B.C. were convinced that the universal moral values they espoused could only be grasped and practiced by the enlightened elites. The elites were, therefore, entrusted with managing the empire and tutoring the emperors who were worldly manifestations of Heaven's approval.[20]

The modern Chinese word for "secular" reveals the tortuous history of Confucianism and the travails of later Confucian elites. The word is *shishu,* meaning "of this world," but its original meaning referred to the popular and lowly ways of the common people, and the "backward" values that they held. Their customs and practices were variously transmitted by magicians, shamans, and spirit-healers with their dubious rituals, and bore no resemblance to the rational and ethical humanism in the minds of the enlightened few. Confucian secularism was, in the end, no less corruptible than the Greco-Roman version. After dominating the imperial administration for nearly four centuries, it could not prevent the total collapse of the Later Han dynasty during the third century A.D. Not only were the overland frontiers threatened by "barbarians" and the ruling house divided by deadly rivalries, there was also a deep cultural gulf between the Confucian elites and the people they governed. That gap had become intolerable to the peasant majority, and several rebellions based on popular religions broke out throughout the empire. It was in this way that Buddhism, brought into China by a handful of dedicated priests from India, took root. It combined with some of the popular faiths of the Chinese through the common language used to translate the Sutras. The ideas about government and the sophisticated philosophical concepts found in the Sutras soon won over a new generation of rulers and their courtiers, especially those of non-Chinese origins, from the steppes, who had conquered much of North China. Eventually the Chinese rulers in the south also converted to Buddhism.

In this way, the secularism of Han Confucianism was gradually modified by the tenets of Mahayana Buddhism as well as by other faiths that remained popular among the majority of people. The Confucian-Buddhist cosmology underlying the idea of rule by virtue did not require a dichotomy between God and Caesar, rendering unnecessary a separation between Heaven and ruler. Binary centers were nonexistent, so there was no need for secularization, and this differentiated the Chinese value system from that of Europe.

Thus the Confucians survived, much chastened by their failure. For four centuries, until the beginning of the Tang dynasty in the seventh century, they were content to carve a niche for themselves as a specialized group of empire managers, but also waited for opportunities to recover their lost glories. They reformed and sharpened their concerns with moral values—making it clearer that

these were, among other things, based on respect for authority—and ideals of order and social harmony. They could seek compromises with an indigenized Buddhism as well as with the popular Taoism that had been inspired by the Buddhists to formally reinvent itself. The secularism represented by early Confucians could not be revived without a recognition that the spiritual needs of the people had to be met. Early in the Song dynasty (960–1278), several determined Confucian thinkers, thoroughly versed in Buddhist and Taoist literature, started on the road of reconstruction. For the Chinese, the emergence of a new Confucianism that culminated in the work of Zhu Xi in the twelfth century and its effects on Chinese society may be compared to the scientific "Enlightenment" for eighteenth-century Europeans. It soon became the political and moral orthodoxy that helped to legitimize the following Chinese dynasties, including those established by Mongols and Manchus, and then reached out to inspire the regimes of the Korean Li dynasty and the Tokugawa shogunate. Its confidence was not seriously shaken until the defeat in the two Opium Wars of the nineteenth century and the subsequent impact of Western ideas in China.[21]

This brief outline of the rise of early secularisms, followed by decline, compromise, and rebirth and then by ripeness and arrogance underlines the failures of secular elites to bridge the gap in values between themselves and the subject majorities they ruled over. That failure was experienced by the Greco-Romans and the Confucian Chinese alike. The later Greeks and Romans could not revivify their heritage by themselves. They had to await enlightened Christian scholars and scientists who could breathe new life into their profoundly secular ideas. There was a fecund fusion of ideals and institutions that led to a continuous struggle for supremacy between secularization and evangelical revivals. The tension so far has been a creative one, especially in the United States, but at least for the past half century, the forces of the modern secular state in Europe and in large parts of the decolonized world of new nation-states have had to fight hard to keep the challenge of fundamentalist religions under control.

The Confucian Chinese, on the other hand, reinterpreted their own classics in the light of popular Buddhist concepts and succeeded in making some of the doctrines of that religion serve their ends. But, with centuries of sustained success and overwhelming secular power through the Ming and Qing dynasties, the Neo-Confucians succumbed to corruption and degeneration. They lost their ability to respond to new foreign invasions and the challenging ideas brought to China. Their successors since the turn of the twentieth century have cast about to find ways of domesticating the modern secular values from the West that they finally decided to accept.

## CHINA'S MODERN SECULAR CHALLENGE

The Chinese experience since the fall of state Confucianism remains instructive. After the Qing dynasty fell in 1911, there was an open scramble to find a more successful replacement for the traditional secular ideals that had failed. Numerous ideologies were introduced from Europe, from nationalism to liberal and social democracy, from communism to fascism and national socialism. Significantly, there was little interest in the available religions. Both Islam and Buddhism were familiar to the Chinese intellectuals, but neither was a match for the religion of the Christian missions. Christianity was a partner of European wealth and power and should have attracted the pragmatic Chinese. But the religion was tainted not only by association with imperialism and colonialism worldwide, but also specifically with China's own humiliation. The proud young Chinese of the May Fourth Movement after 1919 chose to measure success in materialistic terms. Thus their only model had to be the secular Great Powers. In the "triumphal" tradition where victor is emperor and loser bandit, the First World War was a fateful example in at least two ways. It raised great doubts about western Europe as a model and by extension the efficacy of Anglo-American liberal democracy. The failure of the French reduced the appeal of the French Revolution, but not altogether. That had been superseded by a new and even more thorough social revolution, that of Leninist Soviet Russia.

The story of the fresh secular conversion of large numbers of young Chinese intellectuals during the 1920s and 1930s has often been told. All that needs emphasizing here is the attraction of scientism through the prism of Social Darwinism, Marx, and Freud, which led readily to radical politics, to "scientific" socialism, and ultimately to secular fundamentalism. Certainly, the basic layer of secular values that Chinese intellectuals had inherited from Confucianism eased the acceptance of the powerful modern versions of what were originally Greco-Roman tendencies to humanistic rationalism. Marx's description of religion as the opium of the people struck a deep chord. Opium was real, it was the cause of China's downfall both at war and among the paraphernalia of Chinese opium smokers. The cast-out Confucian literati were depicted as representatives of an outdated mode of production, that of feudalism, and the popular religions practiced by ordinary Chinese the worst kinds of superstition. Indeed, all religions soon became superstitions and all who believed in God or gods, spirits and ghosts, and the afterlife, were lumped together as superstitious.

Thus was born the newest replacement for the Confucianism that had failed. It was science, the basis of knowledge, that provided all criteria for what was true and worthy, and this marked the formation of a new secular faith. Although sec-

ular youths dominated in every political party and most social organizations until the 1940s, it was the Chinese Communist Party after 1949 that secured the absolute power of secularism in China. Members of the Party would have to set aside their religion. Those who still believed in religion would not be welcome to join the Party. Until the death of Mao Zedong and the end of the Cultural Revolution, the future of secular values was assured, but that of religion was fairly dim.

I suggested above that the 40 years after the end of the Second World War were mainly the years of a secular civil war fought between the capitalist states led by the United States and the communist states led by the Soviet Union. The secular state in the United States was of course never absolute in its secular policies. There was always a tension between religion and civil authority that suggested that both sides sought a balance between the sacred and the secular. It was this balance that separated the Americans from their more anticlerical contemporaries in Europe. But the Cold War, despite the Christian rhetoric the Americans used against godless communism, satanic forces, and the "evil empire," was in reality a no-holds-barred rivalry between two models of secular power. The leaders of China understood that, and clearly took the side of absolute secularism against the "sugared bullets" of capitalism. And as long as there were prospects of victory, the Chinese people followed their leaders. In fact, the word "faith" became more important than the word "secular" during the Cultural Revolution, when Mao Zedong became something of an earthly god, the *Little Red Book* a set of catechisms, and the shouted slogans nothing more than mantras.

The present leadership is not unaware of the dangers that absolute secularism could breed. About 20 years ago, Hu Qiaomu, the president of the Academy of Social Sciences, warned, "If we only engage in building a socialist civilization and do not work hard to foster a socialist spiritual civilization at the same time, people will be selfish, profit-seeking and lacking in lofty ideals. In that case, how much will our mental outlook differ from that in capitalist societies?" [22] This was not very flattering to capitalist societies. The point is that, first, he saw both capitalism and socialism as equally secular, and second, he wanted socialism to be more spiritual—if only about secular ideals. If he were alive today, he would have to acknowledge that very few of the young in China share the idealism that inspired the first-generation Communist Party leaders. On the other hand, at the popular level there is evidence that many seek spiritual sustenance that only religion can give, be it within traditional temples, mosques, and churches or in secret cells or through untried sects and cults. Although it is not clear what Hu Qiaomu meant by "spiritual," he seems to have been worried that the kind of fundamentalism that thrives on materialist and secular values could erode the high moral ground that his generation of revolutionaries sacrificed so much to attain. A gen-

eration earlier, traditional elites had confidently insisted that Western *yong* (application) could be accepted because Chinese *ti* (foundation) was universal and true for all time. But Mao's slogan, *guwei jinyong* (apply the ancient for modern use), implicitly turned modern secularism into foundation and left the ancient values, selectively and where relevant, for use and application. That this transformation was readily accepted by the educated young reminds us how ancient secular faiths and modern secular values share the same roots.

A secular China going capitalist and a capitalist America taking a secularist view of religious fundamentalism seem to make strange bedfellows, but they may not be that far apart. For example, where democracy is concerned, the ancient Greek ideal is readily accepted in China, although there are reservations about the modern version. The Chinese stress as an ideal the democracy of collectives, with or without kinship ties, whereas the West gives a higher value to democracy as expressed through individuals. With a shift in emphasis, the gap is bridgeable. It is a little more difficult where human rights are concerned, if only because the ideal comes from a deep Christian faith that has been secularized. As long as the Chinese remain fundamentalist about their secularism, they are likely to resist this. On the other hand, there are spiritual qualities drawn from older Buddhist and Taoist ideals that could narrow the gap, although their versions of what constitutes rights differ markedly from the Christian. There is, however, no reason why the differences should be regarded as absolute, why the West cannot understand the Chinese idea of placing duties above rights, and the Chinese the Western belief that rights must come first and be protected in order for duties to be accepted.[23] Neither is explicit about ways in which their views are a variety of secular faith, and how that set of differences has formed the background of a secular civil war that threatens to go on consuming us. If this were admitted, it would put the current talk about "the clash of civilizations" in context and expose the melodrama that surrounds the debate.

## CONCLUSION

September 11 was a reminder to new secular elites everywhere that there can be no sets of values that are purely secular. It challenged the religious to weigh how far fundamentalism might go if their faiths are linked with political agendas. At the same time, it puzzled most Americans, who are religious and secular in turn, how much the global reach of their secular power is resented if not hated, although it may also have convinced some to believe that only through the application of even greater power can threats to that power be removed.

A survey of the history of secular values shows that spiritual needs of many

different kinds have to be met, and that secularism has been enriched by at least two religions, Christianity and Buddhism. It is still unclear whether these secular manifestations have risen above the religions that nourished them. Will they always be divided by their different moral and spiritual roots, origins that cannot be easily ignored? And what about Islam's past and future contributions? Although early Islam declined to take the secular ideas of the Greeks further and mold them to sustain its own purer truth, it did enrich the realms of knowledge that the Greeks stimulated. Starting in the nineteenth century, Muslim elites considered the issue afresh. But now they are divided as to how much they should accept and use European secular values to achieve modern progress and regain pride in their culture. With a few exceptions, they sought compromises with secularism that are now strongly resisted by the fundamentalists among them. When their modernizing states proved unable to deliver the wealth and power hoped for and avoid being pawns in a global secular civil war, a growing number of new elites no longer believed that modernity has inevitably to follow a known formula, however successful that might have been elsewhere. Many of them are now ready to use Islam to shape a different path through Islamic states, or at least to contribute an inner strength that secular values cannot provide.

Against this Islamic return to the vigor of a primary faith, secular values in the modern West, considered to be universal by many, have been used for a series of continuous conflicts, especially by Great Powers seeking imperial dominance and fighting their world wars. Although these powers, whether in defeat or in victory, claim to be supported by the divine guidance of inherited religious traditions, their secularism has increasingly been identified with narrow nationalist or ethnic interests. As a result, the universal claims of their secular values have been steadily undermined, nowhere more so than among the Muslims who understand only too well the spiritual roots of these claims in monotheist Christianity and Judaism. This close association of secular values with Judeo-Christian dominance will remain a major obstacle to accepting any modernity that seems to be defined by these values. For the dominant West to dilute that link with their own spiritual history would be both unpalatable and very difficult to do.

That brand of secularism was so dominant that there was no credible alternative to the civil war between the two power groupings in the Cold War. For the religious, whether Christian, Muslim, Hindu, Buddhist, or other, they could only wait to see how the secularists would fare. They were asked to believe that history would prove that the side that won would hold the Truth. In pursuit of that victory, both sides drove themselves to use the maximum destructive capacities of their secular ways. Leaders in the Middle East and South Asia who were less secu-

lar were often cynically used by the secular powers to serve self-proclaimed "universal" interests. Those in East Asia who were already secular, or believed that they had to be secular in order to be modern, were impressed by the fact that global capitalism won that civil war. Clearly, to them it seems that even greater commitment to secular values is needed if they are to attain the elusive modernity they have long wanted.

But not all elites are convinced that this is the end of history. In face of the certainty and arrogance underlying that proclamation, various religions and their revivalist manifestations began to find that their previously muted voices are now being heard. What had been weak resistance for the past 200 years against the advent of the secular has found new strength in a fundamentalist defense against encroaching Western secularism. It points now to the callous results of the secular civil war that the world has just been through, notably where rich and poor seem further apart than ever, where selfish national interests have been paramount, and where the powerful exercise double standards for their own gains. Large numbers of the Muslim leadership in the Middle East are convinced that the most glaring injustice has fallen on their heads. Thus the skepticism toward the very basis of secular power has grown among them, and calls to resist that power through fundamental Islam have been most persistently made.

At present, "the West" and "East Asia" are the two nodes of modern secularism. It appears that the West has every reason to be confident of its own set of secular values. Japan and China are still trying to improve on the alternative versions they have had, Japan by continually adopting specific institutions from western Europe and the United States, China by seeking inspiration across a wide spectrum of secularisms that spans communism, capitalism, and its Confucian past. Both countries are redefining what they have accepted of modern secular values as "foundation" (*ti*) by "applying" (*yong*) what they can of their past to minimize the spiritual damage that this modern secularism might do to their peoples. As for those in South Asia, the secularists are fighting off the steady growth of fundamentalism among their Islamic and other religious communities, but they have no alternative save to select carefully the modern values that they can safely adopt into their valued traditions.

Given this new awareness of threat, what is the future of secular values? As in the past, there can be too much secularism. When Greco-Roman and Confucian values were dominant in their respective regions, they both failed. The former could have been revived by Islam, but this did not happen. Ultimately, Greco-Roman values were only rejuvenated by a divided Christianity. Similarly, Confucian values were in decline until they were reinterpreted through a unique blend

of Buddhist and Taoist ideas and thus regained a dominance that they retained until the twentieth century. These comparisons suggest that secularism by itself cannot satisfy the human psyche.

But what can soften and rescue modern secularism today? When secular values are globalized, their limitations are even more widely exposed. Thus they arouse an opposition that is also global. For the doubters, including those for whom a return to organized religion is not an option, a new dichotomy is needed to highlight the spiritual vacuum that has been revealed. Therefore, whether themselves fervently secular or not, they would focus on the values that contradict the global capitalism now most closely identified with the modern secular. Although we may be skeptical about the strength of these efforts to dramatize a growing desperation that is gathering momentum worldwide, there is little doubt that a credible response is needed to minimize the tensions that have been produced. We have seen that Christianity and the South Asian religions have contributed to a balance of secular and spiritual values, but sections of Islam have been alienated, not least by a perception of a persistent crusading bias against it. The long-standing issue of Muslim-Christian tensions itself is too complex to be dealt with here, but the need to remove that bias must be a precondition for engaging Islam in the wider quest for modernity. For that process to begin anew, it is most unhelpful to portray the Confucian East as allying with a Christian West against Islam, or allying with Islam against a Christian West.

September 11 has reminded us that a divided secularism can be challenged, hence the calls for discussion between erstwhile protagonists. Dialogue among various groups of religious modernizers is not new; they have had to defend themselves against fundamentalists among the secular and the religious alike for many decades. What is new is that the secularists need a deeper dialogue among themselves in facing a common danger. Most important of all, many of them have to admit that secularism itself can be a form of faith, prone to errors and weaknesses, and containing its *own* propensity to be fundamentalist. Wherever secularists are seen as belittling religion and dismissing the spiritual needs of most people, whenever they couch their faiths in terms of absolute nationalist interests, and when they insist that only their claim of universalism is valid and all other claims must conform to their standards, they will meet with organized opposition. The proponents of secularism must reexamine the roots of modern secularism and consider how they can eschew the fundamentalism that has divided them. For them, letting religion back in is not the answer. But if it cannot pay sufficient attention to spiritual needs, especially of people in the poorer nations of the world, secularism does not deserve the respect it has had so far.

# NOTES

**Introduction: Place, Perspective, and Power—Interpreting September 11, by Eric Hershberg and Kevin W. Moore**

1. Strobe Talbott and Nayan Chanda, eds., *The Age of Terror: America and the World After September 11.* New York: Basic Books, 2001.

2. See, for example, Thomas Powers, "The Trouble with the CIA," *The New York Review of Books,* 17 January 2002.

3. Bernard Lewis provides a good overview of these perspectives, prior to September 11, in *What Went Wrong? Western Impact and Middle Eastern Response.* New York: Oxford University Press, 2001.

4. See the overview by Robert Keohane, "The Globalization of Informal Violence, Theories of World Politics, and the 'Liberalism of Fear,' " in Calhoun, Price and Timmer, eds., *Understanding September 11: Perspectives from the Social Sciences.* New York: The New Press, 2002.

5. The phrase is from John Winthrop, the Puritan colonial leader. It refers to the example the New World colonies were meant to set for the rest of the world, and asserts God's providence for the colonial undertaking. Reagan used the phrase to contrast America to the "evil empire" of the Soviet Union.

6. Max Weber, "Politics as a Vocation," in Gerth and Mills, eds., *From Max Weber.* New York: Oxford University Press, 1946, p. 78.

7. We would have liked to have included additional perspectives in the volume, but our unusually tight publishing deadline prevented us from securing contributions from researchers based permanently in sub-Saharan Africa and in the Middle East. Thus, the book does not analyze the implications of the new international context for such questions as external aid flows or international peace-keeping efforts in Africa, nor does it explore emerging pressures on authoritarian regimes in the Middle East—to name just two of a much longer list of issues that we would ideally have included contributions on but that we omitted in order to ensure timely publication of a cohesive collection.

8. Amnesty International, "China: Fight Against Terrorism No Excuse for Repression," web.amnesty.org/ai.nsf/Index/ASA170322001?OpenDocument&of=COUNTRIES\CHINA, posted on 11 October 2001.

9. An editorialist on a French news station captured the mood when he said that Bush's State of the Union address was appropriate "to a sheriff convinced of his right to regulate the planet and impose punishment as he sees fit." Suzanne Daley, "Many in Europe Voice Worry U.S. Won't Consult Them," *The New York Times,* 31 January 2002, A12.

10. John Cassidy, "Striking It Rich: The Rise and Fall of Popular Capitalism," *The New Yorker,* 14 January 2002, pp. 63–73.

11. By early 2002 it was unclear whether the $20 billion would be delivered.

12. This is on top of the already staggering amount that the U.S. spends on the military, which for fiscal year 2002 amounts to half of all discretionary spending by the U.S. government. As William Wallace notes in his contribution to this book, the U.S. accounts for some 40 percent of *global* military expenditures. Both of these statistics are documented by the Center for Defense Intelligence, www.cdi.org.

13. Norman Girvan, "Anthrax and the World Trade Organization," syndicated column distributed to newspapers throughout the Caribbean, and available online through the *Trinidad Guardian,* www.guardian.co.tt/NormanGirvan.html.

14. If an eventual tightening of border controls on goods and services seemed plausible, new restrictions on the movement of people quickly became a certainty, altering developing-country labor markets and, as noted above, unsettling local economies in the process.

15. Ronald Dworkin, "The Threat to Patriotism," *New York Review of Books,* 28 February 2002.

16. The contributions of Didier Bigo and Kanishka Jayasuriya in this book both speak to this issue.

17. It is worth noting that after that horrific assault, the government did not, as far as is known, go around the country and detain U.S. military–trained right-wing fanatics in an effort to identify other potential Tim McVeighs.

18. Seyla Benhabib, "Citizens, Residents and Aliens in a Changing World: Political Membership in the Global Era," *Social Research* 66 (Fall 1999): 711.

19. Steven Erlanger, "An Anti-Immigrant Europe Is Creeping Rightward," *The New York Times,* 30 January 2002, A3.

20. *Human Rights Watch World Report 2002* (New York: Human Rights Watch, 2002) makes the broader point that "human rights violations in the U.S." in the aftermath of September 11 provide cover for such abuses around the world, all under the guise of fighting terrorism.

21. The putative separation between church and state in the U.S. has historically not been very secure. From its Protestant origins and anti-Catholic measures that continued well into the nineteenth century, through the Scopes trial and battles over abortion and prayer in schools in the twentieth century, to faith-based initiatives emerging from the White House in this century, the U.S. has only ambivalently embraced, and unevenly adhered to, its constitutional obligation to insulate the government from religious influence.

22. Dipesh Chakrabarty, *Provincializing Europe: Postcolonial Thought and Historical Difference.* Princeton: Princeton University Press, 2000; Rajeev Bhargava, ed., *Secularism and Its Critics.* Oxford: Oxford University Press, 1998.

23. In the sense of intelligence agencies, but also savoir faire.

24. Few sane people question the desirability of ridding Afghanistan of the Taliban, but it remains to be seen whether and to what degree a U.S.-installed alternative will be more civilized. Similar doubts prevail with regard to neighboring states, where imperfect systems may be destabilized beyond repair.

## 1. The Ethics and Efficacy of Political Terrorism, *by Achin Vanaik*

Shortened titles refer to items in "Sources," pp. 248–49.

1. This essay is a substantially revised and reworked version of an earlier article titled "The Efficacy and Ethics of the International Political Terrorist Act or Event," which appeared in *Mapping Histories,* ed. Neera Chandoke. New Delhi: Tulika Press, 2000.

2. Key studies on the ethics of terrorism and violence, secular or religiously inspired, include Walzer, *Just and Unjust Wars*; Lukes, *Marxism and Morality*; Geras, *Discourses of Extremity*; Bauhn, *Ethical Aspects of Political Terrorism*; Laqueur, *Age of Terrorism*; Rapoport and Alexander, *Morality of Terrorism*; and Juergensmeyer, *Terror in the Mind of God*.

3. Would not one's provisional definition of culture, for example, differ depending on whether one sought to distinguish between culture and nature, culture and market, culture and art, or culture and society?

4. Much of the discussion on the efficacy and ethics of such international political terrorist events, however, is of general applicability to other kinds of terrorism.

5. Thus Noam Chomsky frequently refers to the United States as a terrorist state, indeed, as being among the worst of such terrorist states. See Chomsky, "New War on Terror."

6. The northeastern states of India are for the most part populated by hill tribes that before British rule had no real connection to plains India throughout the centuries, no matter what the various ruling dynasties were. Not surprisingly, in three of the states formed after Indian independence—Mizoram, Nagaland, and Assam—there were separatist movements. Mizoram's movement was much weaker and has now largely disappeared. Separatist currents still exist in Assam, but it is in Nagaland where separatism has the deepest and strongest roots.

7. According to a 1995 study by the Food and Agricultural Organization, reported in *The Lancet*, the journal of the British Medical Society, 567,000 children had been killed by the sanctions. This was the basis of the question posed to Madeleine Albright, then U.S. ambassador to the U.N., by Lesley Stahl on the CBS television program *60 Minutes*, on 12 May 1996, in a segment called "Punishing Saddam," on the effect of sanctions. Her notorious reply was "We think the price is worth it." See also Mohamed Ali and Iqbal Shah, "Sanctions and Childhood Mortality in Iraq," *The Lancet*, May 2000. The UNICEF study of early 1999 described by Ali and Shah states that child mortality in south-central Iraq rose from 56 per 1,000 in 1984–89 to 131 per 1,000 in 1994–99. The former assistant secretary-general of the U.N. and the coordinator of the U.N. humanitarian program, Dennis Halliday of Ireland, resigned in 1998 to protest the sanctions regime against Iraq. He stated, "The results of the embargo meet the definition of genocide under the U.N. Convention of Genocide" (*Disarmament Diplomacy* [London], June 2001, p. 62). Halliday's successor, Hans von Sponeck of Germany, announced his decision to stand down for the same reasons on 13 February 2000. Two days later Julia Burkhardt of Germany, then head of the U.N. World Food Program in Iraq, took the same step.

8. Bhagat Singh was a revolutionary nationalist who, in an act of defiance of British colonial rule, threw a bomb into the Central Legislative Assembly in New Delhi on April 8, 1929. No one was killed or injured in the blast. Bhagat Singh was subsequently arrested and hanged by the colonial authorities.

9. *Webster's New School and Office Dictionary* (1957): "A system of government by terror; intimidation." *Funk & Wagnall's Standard Home Reference Dictionary* (1957): "A system that seeks to rule by terror: the act of terrorizing." *Chamber's Twentieth Century Dictionary* (1975): "An organized system of intimidation." *The Concise Oxford Dictionary of Current English* (1990): "The use or favoring of violent and intimidating methods of coercing a government or community." *Cobuild (Collin's Birmingham University International Language Database) English Language Dictionary* (1991): "The use of violence, especially murder, kidnapping and bombing, in order to achieve political aims or to force a government to do something." *Collin's Gem English Dictionary* (1993): "Use of violence and intimidation to achieve political ends."

10. In 1984, when General Vaidya was army chief-of-staff, the Indian army launched a massive attack, code-named Operation Bluestar, on the Golden Temple, the holiest shrine of the Sikhs, where the Sikh militant leader and advocate of an independent Sikh nation, J. S. Bhindranwale,

and his armed supporters had taken shelter. Vaidya's assassination the next year by Sikh terrorists in the western Indian town of Pune was an act of reprisal for Operation Bluestar.

11. Weber's definition of the modern state as one claiming a monopoly on the legitimate use of violence within a given territory is still widely accepted. See Gerth and Hills, eds., *From Max Weber: Essays in Sociology,* "Politics as a vocation."

12. We should make a distinction between state-sponsored and state-executed terrorism. The Pakistan government sponsors groups engaged in terrorism in the Indian part of Kashmir. But most such groups are autonomous entities, some indigenous to the region. State-executed terrorism is carried out directly by state apparatuses and personnel.

13. On December 6, 1992, the forces of Hindu communalism deliberately defied the law and the secular character of the Indian Constitution by destroying the Babri Masjid mosque. (The mosque was seen by these communalists as symbolizing hated Muslim rule and oppression of Hindus, since it was alleged—falsely—that the mosque had been erected in the early sixteenth century after the destruction of a Hindu temple on that site devoted to worship of the Lord-King Rama.) Immediately following this demolition there were brutal organized riots against Muslims up and down the country. Two months later there were bomb blasts in the main commercial city of Bombay, in and around the financial center of the city where the stock exchange was located.

14. In November 2001 a German court convicted four people in the case, and said the bombing had been planned by the Libyan secret service. The court also said the extent of Qaddafi's involvement was not known ("4 Guilty in Fatal 1986 Berlin Disco Bombing Linked to Libya," Steven Erlanger, *The New York Times,* 14 November 2001).

15. We must be careful here. It is not without reason that Article 51 of Section VII of the U.N. Charter, which talks of the right to self-defense in the context of wars, refers to states and official cross-border actions by states. Wars are thus related to issues of territory and territorial sovereignty. Group terrorism is a form of warfare when it is connected to disputes over territory and territorial sovereignty, where one side is seen as an illegitimate occupying force. Thus not all forms of terrorism, whether by states or nonstate actors, are "part" of a war concerning issues of territory and sovereignty. The September 11 attacks are best seen as a "crime against humanity" (which can also take place within wars) rather than an "act of war." The U.S. government sought to present the event as an "act of war" to help justify its retaliation against Afghanistan, which *was* a war.

16. The distinction between combat-group and state terrorism is obviously artificial, since the state has its own combat groups. But making the distinction between these two types of agencies, one state and the other nonstate, is essential.

17. In 1991, Rajiv Gandhi, then prime minister of India and campaigning for the Congress party's reelection, was killed by a woman suicide bomber at a public meeting. This took place in the southern state of Tamil Nadu, where the LTTE, with its base amongst the ethnically similar Tamils of the northern Jaffna region of Sri Lanka, also had sources of support. Though never conclusively proved, the act, though not acknowledged by LTTE, was nevertheless widely seen as an act of revenge by the LTTE for the (failed) Indian government attempt to crush them following the 1987 India–Sri Lanka Accord. That accord gave India the extraordinary status of being the principal arbiter in Sri Lanka's internal civil war, thus putting the imprimatur on India's desire to be the accepted regional hegemon. However, India failed to live up to its end of the bargain, which was to militarily destroy the LTTE, and the Colombo government, facing negative political fallout from continued Indian presence, after little more than a year, told the Rajiv Gandhi government to pull out its troops.

18. The classic statement in the Marxist literature on this is Trotsky's *Terrorism and Communism* and his *Their Morals and Ours.*

19. Twelve people died, but hundreds more suffered serious illnesses.

20. Video clips of Osama bin Laden, released by the U.S. government, still leave matters unclear—quite apart from charges that the tapes were doctored. It is one thing for bin Laden to welcome the September 11 attacks, which he does on the tape. It is another to read this as an acknowledgment of responsibility, especially since in interviews appearing in print media, and on the Arabic Al Jazeera television network, he has also explicitly denied culpability for organizing that specific act. If it is plausible that some cells of the Al Qaeda network may well be responsible for the September 11 attacks, it is also plausible that bin Laden was more an inspirational figure rather than the leader and director of the operation itself.

21. Hannah Arendt's famous discussion of the "banality of evil" is appropriate here. See Arendt, *Eichmann in Jerusalem: A Report on the Banality of Evil.* New York: Viking, 1963.

22. Karl Marx and Max Weber are of course relevant here. "Emancipatory ideologies" of an explicitly revolutionary character, e.g., Marxism, suffer from a consequentialist "blindness" in that they are concerned with desirable outcomes but not with necessary restrictions on the range of behavior allowable to revolutionary agencies. Some contemporary Marxists and socialists have criticized classical Marxism on this score in the effort to develop a better and subtler relationship between Marxism and morality. See in this context Marcuse, "Ethics and Revolution," and Arblaster "Bread First, Then Morals." See also Lukes, *Marxism and Morality,* Rapoport and Alexander, *The Morality of Terrorism,* and Soper, "Marxism and Morality." Weber distinguished "science as a vocation" from "politics as a vocation," and argued that the principles governing each were separate. Since politics had to address as its central feature the issue of violence, it had to be guided by a secular ethic of responsibility that judged actions by their consequences, not their intentions. So good ends could be achieved from bad means. Indeed, since politics involved violence, this would most often be the case (see Gerth and Mills, *From Max Weber*). In the Indian context, means-ends discussion obviously has as its central reference points the various writings of Mahatma Gandhi.

23. Moore, *Reflections on the Causes of Human Misery and upon Certain Proposals to Eliminate Them,* pp. 25–28.

24. Nagaland has had a sustained struggle for independence for over four decades. Through a mixture of repression and elite bribery, New Delhi has been able to keep it within the union even though the Naga people, if they could ever freely exercise a choice, would long ago have sought independence. Today, a war-weary population and a weakened insurgency are considering some kind of formal end to the war and a form of autonomous existence within the union.

25. See especially Chapter 2 in Geras, *Discourses of Extremity,* which contains an excellent summary discussion of ethical problems pertaining to revolutionary violence. I am greatly indebted to Geras and have drawn heavily on his work for my own presentation here regarding the specific issue of morality, as well as more generally. The notion of prefiguration is also taken up at some length in Geras, *Legacy of Rosa Luxemburg,* pp. 133–73.

26. There is, however, an independent and carefully "conservative" estimate by Marc Herold, a university professor of economics at New Hampshire University, of 3,767 civilian deaths in Afghanistan between October 7 and December 10, 2001. This estimate is cited by Seumas Milne, "The Innocent Dead in a Coward's War," *The Guardian* (U.K.), 20 December 2001. Regarding the number who died in the September 11 attacks, the roster of dead and missing issued by companies involved, including the airline companies and the New York Fire Department, is 2,405. Estimates from *The New York Times,* the Associated Press, and *USA Today* range from 2,600 to 2,950. See Mann, "Globalization and September 11." Milne in *The Guardian* cites a figure of 3,234 for September 11.

27. Since the assault on Afghanistan has not, as of this writing, secured the primary suspect or culprit, the justification for this "humanitarian" intervention through arms becomes similar to the claims that the United States and its supporters presented for Bosnia, Serbia, the 1991 Gulf War

against Saddam Hussein, and so on. It becomes part of that larger issue of whether and under what circumstances is a military intervention by an outside power or powers to overthrow a tyrannical, undemocratic, or oppressive regime justified. My own view on this tricky moral issue as it pertains to international relations is to be found in Chapter 5 of Vanaik, *India in a Changing World*. It is broadly similar to the view expressed by Carol Gould, in the chapter "Cosmopolitical Democracy," in *Rethinking Democracy*. Briefly stated, this perspective argues that claims of national sovereignty and self-determination cannot in principle be allowed to override universal human rights, which by virtue of being universal take precedence over nationalist claims. This justifies various forms of external intervention to promote human rights in other countries. But the question of *military* intervention does not fall straightforwardly into the category of justifiable intervention. Thus one cannot simply militarily intervene to overthrow apartheid, Stalin's Russia, the shah of Iran, etc., no matter how brutal these dictatorships. This is because a fundamental democratic right that must also be respected is the right of a people to overthrow *their own* tyrant where people are constituted politically in nation-states, as they are in our world. Therefore, one must oppose the military interventions in Afghanistan, Bosnia, Serbia, etc. However, this too is not an absolute. The conditions in which external military intervention become acceptable, indeed necessary, are when the very category of the "people" is threatened by genocide because of the large proportion of the whole population in danger. This criterion of proportion would apply to the conditions in East Timor in 1975, when one third of the population was being massacred by Indonesia, to the recent massacre in Rwanda, and to the Pol Pot regime in Kampuchea, where, proportionately speaking, more people were killed than in Hitler's concentration camps. Preventing or ending a real genocide threatening the very existence of a population—not mass expulsions ("ethnic cleansing") nor even simply massacres or "mass killings," horrific as they are—is the crucial criterion here. So genocide should not be defined or cited as casually as it so often is.

### SOURCES

Arblaster, Anthony. "Bread First, Then Morals." In David McLellan, *Socialism and Morality*. London: 1990.

——. "What Is Violence?" *Socialist Register 1975*. London: 1975.

Bauhn, Per. *Ethical Aspects of Political Terrorism*. Lund: 1989.

Bidwai Praful and Vanaik, Achin, *South Asia on a Short Fuse: Nuclear Politics and the Future of Global Disarmament*. New Delhi: 1999.

Brown, Peter G., and Douglas MacLean, eds. *Human Rights and U.S. Foreign Policy*. Lexington, Mass.: 1979.

Chomsky, Noam. "The New War on Terror." *The Spokesman* 73 (2001).

Combs, Cindy C. *Terrorism in the 21st Century*. Upper Saddle River, N.J.: 1997.

Crenshaw, Martha, and Jim Pimlott, eds. *Encyclopedia of World Terrorism*. Armonk, N.Y.: 1997.

Doppelt, G. "Walzer's Theory of Morality in International Relations." *Philosophy and Public Affairs* 8 (1978), no. 1.

Fullinwider, Robert K. "War and Innocence." *Philosophy and Public Affairs* 5 (1975–76).

Geras, Norman. *Discourses of Extremity*. London: 1990.

——. *The Legacy of Rosa Luxemburg*. London: 1976.

Gerth, Hans Heinrich, and C. Wright Mills, eds. *From Max Weber: Essays in Sociology*. New York: 1946.

Gould, Carol C. *Rethinking Democracy*. Cambridge: 1990.

Juergensmeyer, Mark. *Terror in the Mind of God*. New Delhi: 2001.

Laqueur, Waller. *The Age of Terrorism*. Boston: 1987.

Lichtenberg, J. "National Boundaries and Moral Boundaries: A Cosmopolitan View." In Peter G. Brown and Henry Shue, eds. *Boundaries: National Autonomy and Its Limits.* Totawa, N.J.: 1981.

Luban, David. "Just War and Human Rights." *Philosophy and Public Affairs* 9 (1989), no. 2.

Lukes, Steven. *Marxism and Morality.* Oxford: 1985.

Mann, Michael. "Globalization and September 11." *New Left Review,* 12, (new series) (November–December 2001).

Marcuse, Herbert. "Ethics and Revolution." In David McLellan, ed. *Socialism and Morality.* London: 1990.

Mavrodes, George I. "Conventions and Morality of War." *Philosophy and Public Affairs* 4 (1974–75).

McLellan, David. *Socialism and Morality.* London: 1990.

Moore, Barrington. *Reflections on the Causes of Human Misery and upon Certain Proposals to Eliminate Them.* Boston: 1972.

Rapoport, David C., and Yonah Alexander, eds. *The Morality of Terrorism: Religious and Secular Justifications.* New York: 1982.

Soper, Kate. "Marxism and Morality." *New Left Review* 163 (May–June 1987).

Trotsky, Leon. *Terrorism and Communism.* Ann Arbor: 1962.

———. *Their Morals and Ours.* New York: 1966.

Vanaik, Achin. *India in a Changing World: Problems, Limits and Successes of Its Foreign Policy.* New Delhi: 1995.

Walzer, Michael. "The Moral Standing of States: A Response to Four Critics." *Philosophy and Public Affairs* 9, no. 3 (1980).

———. *Just and Unjust Wars.* New York: 1977.

Wilkinson, Paul, and Alasdair M. Stewart, eds. *Contemporary Research on Terrorism.* Aberdeen: 1987.

## 2. Good Muslim, Bad Muslim: A Political Perspective on Culture and Terrorism, *by Mahmood Mamdani*

Shortened titles refer to items in "Sources," pp. 251–53.

1. Huntington, *The Clash of Civilizations.*

2. Wahhabi is a strictly orthodox Sunni sect; it is predominant in Saudi Arabia.

3. Schwartz, "Ground Zero and the Saudi Connection."

4. For an account of bad Muslims, see Harden, "Saudis Seek to Add U.S. Muslims to Their Sect"; for a portrayal of good Muslims, see Goodstein, "Stereotyping Rankles Silent, Secular Majority of American Muslims."

5. Lewis, "What Went Wrong?"

6. "While more than three-quarters of 145 non-Muslim nations around the world are now democracies, most countries with an Islamic majority continue to defy the trend, according to a survey by Freedom House, an independent monitor of political rights and civil liberties based in New York" (Crossette, "Democracy Lags in Muslim World," p. 4).

7. Neier, "Warring Against Modernity."

8. Amartya Sen has highlighted the flip side of this argument in an interesting article on Indian civilization: to think of India as a Hindu civilization is to ignore the multiple sources from which historical India has drawn its cultural resources. Conversely, to try and box civilizations into

discrete cells—Hindu, Muslim, Christian, Buddhist—is to indulge in an ahistorical and one-dimensional understanding of complex contemporary civilizations. I would add to this a third claim: to see also these discrete civilizational boxes as territorial entities is to harness cultural resources for a very specific political project. See Sen, "Exclusion and Inclusion," and ibid., "A World Not Neatly Divided."

9. Mamdani, *Citizen and Subject.*

10. Think, for example, of the Arabic word *al-Jahaliya*, which I have always known to mean the domain of ignorance. Think also of the legal distinction between *dar-ul-Islam* (the domain of Islam) and *dar-ul-harab* (the domain of war), a distinction that implies that the rule of law applies only to the domain of Islam.

11. Noor, "Evolution of Jihad in Islamist Political Discourse."

12. Asad, "Some Thoughts on the World Trade Center."

13. Ahmad, "Genesis of International Terrorism."

14. Then a rebel group backed by the Soviet Union and Cuba.

15. RENAMO stands for Mozambican National Resistance, a guerilla organization formed in 1976 by white Rhodesian officers to overthrow the government of newly independent Mozambique.

16. National Union for the Total Independence of Angola, the MPLA's main rival for power after independence from Portugal in 1975.

17. The U.S. used its leverage with a variety of multilateral institutions to achieve this objective. It successfully urged the IMF to grant South Africa a $1.1 billion credit in November 1982, an amount that—coincidentally or not—equaled the increase in South African military expenditure from 1980 to 1982 (see Minter, *Apartheid's Contras,* p. 149).

18. In less than a year after Nkomati, Mozambican forces captured a set of diaries belonging to a member of the RENAMO leadership. The 1985 Vaz diaries detailed continued South African Defense Force support for RENAMO. See Vines, *RENAMO: Terrorism in Mozambique,* p. 24.

19. On Angola and Mozambique, see Minter, *Apartheid's Contras,* pp. 2–5, 142–49, 152–68; Vines, *RENAMO,* pp. 1, 24, 39; Brittain, *Hidden Lives, Hidden Deaths,* p. 63.

20. Quoted in Minter, *Apartheid's Contras,* p. 152.

21. Ibid., p. 3.

22. Ibid., pp. 4–5.

23. Rashid, *Taliban: Militant Islam, Oil and Fundamentalism in Central Asia,* pp. 129–30.

24. www.bitsonline.net/Eqbal/.

25. Hoodbhoy, "Muslims and the West after September 11."

26. Chossudovsky, "Who Is Osama bin Laden?"

27. Hiro, "Fallout from Afghan Jihad."

28. Blackburn, "U.S. Alliance with Militant Islam," p. 3.

29. Rashid, *Taliban: Militant Islam,* p. 132.

30. Blackburn, "U.S. Alliance," p. 7.

31. Rashid, "The Taliban: Exporting Extremism."

32. Chossudovsky, "Who Is Osama bin Laden?"

33. Martin Stone, *Agony of Algeria,* p. 183.

34. Chossudovsky, "Who Is Osama bin Laden?"

35. Ahmad and Barnet, "Reporter at Large: Bloody Games." p. 44.

36. Chossudovsky, "Who Is Osama bin Laden?"

37. McCoy, "Drug Fallout"; Chossudovsky, "Who Is Osama bin Laden?," has also synthesized available information on the growth of the drug trade in Central Asia.

38. Cited in Chossudovsky, "Who Is Osama bin Laden?"

39. Hoodbhoy, "Muslims and the West."

40. Ibid.

41. The 1979 Hudud ordinance declared all sex outside marriage unlawful. It also sanctioned the flogging of women accused of adultery.

42. Chossudovsky, "Who Is Osama bin Laden?"

43. Jay Solomon, "Foreign Terrorists Are Tied to Indonesia," p. 9.

44. Stone, *Agony of Algeria*, p. 183. Colonel Chadli Benjedid was president of Algeria from 1978 until January 1992, one month after the FIS electoral victory in the first round of general elections.

45. Roy, "Neo-Fundamentalism."

46. Ibid.

47. Ahmad, "In a Land Without Music."

48. "The ideologies at war—Marxism and Fundamentalism—are alien to Afghan culture. Afghanistan is a diverse and pluralistic society; centralizing, unitary agendas cannot appeal to it." Ahmad, "In Afghanistan: Cease Fire Please."

49. Rashid, *Taliban: Militant Islam*, explains that the Taliban did not only ban women from public life, they also banned numerous activities for men, such as any game with ball, music (except drums), lest any of these entice others socially. See also Ahmad, "In a Land Without Music."

50. Discussion with J. Rubin and Ashraf Ghani.

51. A former military commander of the Gaza Strip was quoted in 1986 to the effect that "we extend some financial aid to Islamic groups via mosques and religious schools in order to help create a force that would stand against the leftist forces which support the PLO" (quoted in Usher, "Rise of Political Islam in the Occupied Territories," p. 19). Two Israeli experts on defense policy, Ze'ev Schiff and Ehud Ya'ari, give a short account of Israeli policies toward Hamas so far as bank transfers and other margins of maneuver are concerned in Ze'ev Schiff and Ehud Ya'ari, *Intifada: The Palestinian Uprising—Israel's Third Front*, pp. 233–34. Finally, Khaled Hroub acknowledges that the Israelis used Hamas and the PLO against each other but discounts any deliberate Israeli role in aiding Hamas. See Hroub, *Hamas: Political Thought and Practice*, pp. 200–203.

52. Ahmad, "Endgame in Afghanistan."

53. Ibid., "Stalemate at Jalabad"; ibid.; "The War Without End," and "Endgame in Afghanistan."

54. United Nations Mine Action Program for Afghanistan, quoted in Flanders, "Killer Food Drops."

55. Salman Rushdie, "Fighting the Forces of Invisibility."

SOURCES

Ahmad, Eqbal. "Stalemate at Jalabad." *The Nation*, 9 October 1989.

———. "In Afghanistan: Cease Fire Please." *Dawn* (Karachi), 7 April 1991.

———. "Endgame in Afghanistan." *Dawn* (Karachi), 26 April 1992.

———. "The War Without End." *Dawn* (Karachi), 30 August 1992.

———. "In a Land without Music." *Dawn* (Karachi), 23 July 1995.

———. "Genesis of International Terrorism." *Dawn* (Karachi), 5 October 2001.

Ahmad, Eqbal, and Richard J. Barnet. "A Reporter at Large: Bloody games." *The New Yorker,* 11 April 1988.

Asad, Talal. "Some Thoughts on the World Trade Center." Unpublished paper, October 2001.

Blackburn, Robin. "The U.S. Alliance with Militant Islam," *Terror and Empire,* www.counter punch.org/robin3.html.

Brittain, Victoria. *Hidden Lives, Hidden Deaths: South Africa's Crippling of a Continent.* London: Faber & Faber, 1988.

Chossudovsky, Michel. "Who Is Osama bin Laden?" Montreal: Centre for Research for Globalisation. http://globalresearch.ca/articles/CHO109C.html, posted 12 September 2001.

Crossette, Barbara. "Democracy Lags in Muslim World." *International Herald Tribune,* 24–25 December 2001.

Flanders, Laura. "Killer Food Drops." *Working for Change,* www.workingforchange.com/ article.cfm?itemid=12097, posted 8 October 2001.

Goodstein, Laurie. "Stereotyping Rankles Silent, Secular Majority of American Muslims." *The New York Times,* 23 December 2001, A20.

Harden, Blaine. "Saudis Seek to Add U.S. Muslims to their Sect." *The New York Times,* 20 October 2001.

Hiro, Dilip. "Fallout from Afghan Jihad." *Interpress Services,* 21 November 1995.

Hoodbhoy, Pervez. "Muslims and the West after September 11." South Asia Citizens Wire, Dispatch no. 2, www.mnet.fr/aiiindex, posted 10 December 2001.

Hroub, Khaled. *Hamas: Political Thought and Practice.* Washington, D.C.: Institute for Palestine Studies, 2000.

Huntington, Samuel. *The Clash of Civilizations and the Remaking of the World Order.* New York: Simon & Schuster, 1996.

Lewis, Bernard. "What Went Wrong?" *Atlantic Monthly,* January 2002.

Mamdani, Mahmood. *Citizen and Subject: Contemporary Africa and the Legacy of Late Colonialism.* Princeton: Princeton University Press, 1996.

McCoy, Alfred. "Drug Fallout: The CIA"s Forty Year Complicity in the Narcotics Trade." *The Progressive,* 1 August 1997.

Minter, William. *Apartheid's Contras: An Inquiry into the Roots of War in Angola and Mozambique.* New Jersey and London: Zed Press, 1994.

Neier, Aryeh. "Warring Against Modernity." *The Washington Post,* 9 October 2001.

Noor, Farish A. "The Evolution of Jihad in Islamist Political Discourse: How a Plastic Concept Became Harder." Social Science Research Council, www.ssrc.org/sept11/essays/noor.htm, posted October 2001.

Rashid, Ahmad. "The Taliban: Exporting Extremism." *Foreign Affairs,* November–December 1999.

———. *Taliban: Militant Islam, Oil and Fundamentalism in Central Asia.* New Haven: Yale University Press, 2000.

Roy, Olivier. "Neo-Fundamentalism." Social Science Research Council, www.ssrc.org/sept11/ essays/roy.htm, posted October 2001.

Rushdie, Salman. "Fighting the Forces of Invisibility." *The New York Times,* 2 October 2001.

Schiff, Ze'ev, and Ehud Ya'ari, *Intifada: The Palestinian Uprising—Israel's Third Front* (New York: Simon & Schuster, 1990).

Schwartz, Stephen. "Ground Zero and the Saudi Connection." *The Spectator,* 22 September 2001.

Sen, Amartya. "A World Not Neatly Divided." *The New York Times,* 23 November 2001.

———. "Exclusion and Inclusion." South Asia Citizens Wire, dispatch no. 2, www.mnet.fr/aiindex, posted 28 November 2001.

Solomon, Jay. "Foreign Terrorists Are Tied to Indonesia," *The Wall Street Journal,* 13 December 2001.

Stone, Martin. *The Agony of Algeria.* New York: Columbia University Press, 1997.

Usher, Graham. "The Rise of Political Islam in the Occupied Territories." *Middle East International* (London), no. 453 (25 June 1993).

Vines, Alex. *RENAMO: Terrorism in Mozambique.* Bloomington: Indiana University Press, 1991.

## 3. Terrorism and Freedom: An Outside View, *by Luis Rubio*

1. The literature on terrorism is vast, but a few books and recent articles and essays are particularly valuable. See Walter Reich, *Origins of Terrorism.* Washington, D.C.: Woodrow Wilson Center Press, 1990; Paul R. Pillar, *Terrorism and U.S. Foreign Policy.* Washington, D.C.: Brookings Institution Press, 2001; Timothy Garton Ash, "Is There a Good Terrorist?" *The New York Review of Books,* 29 November 2001; David L. Phillips, "Wanted, a Covenant to Define and Fight Terrorism," *International Herald Tribune,* 2 January 2002; Isabel Kershner, "The Martyr Syndrome," *The Jerusalem Report,* 8 October 2001.

2. See, for example, Simon Reeve, *The New Jackals.* Boston: Northeastern University Press, 1999; John K. Cooley, *Unholy Wars.* London: Pluto Press, 2000; Yonah Alexander and Michael S. Swetnam, *Usama bin Laden's al-Qaida: Profiles of a Terrorist Network.* New York: Transnational Publishers, 2001; Peter L. Bergen, *Holy War, Inc: Inside the Secret World of Osama bin Laden.* New York: Free Press, 2001; Adam Robinson, *Bin Laden: Behind the Mask of the Terrorist.* London: Mainstream Publishing, 2001.

3. Christopher Lasch, *The True and Only Heaven: Progress and Its Critics.* New York: Norton, 1991.

4. William Greider, *One World: Ready or Not.* New York: Simon & Schuster, 1997.

5. Benjamin Barber, *Jihad vs. McWorld.* New York: Ballantine Books, 1995.

6. Thomas Friedman, *The Lexus and the Olive Tree.* New York: Farrar Straus Giroux, 1999.

7. The literature on this subject is extensive. A few minor examples are the following: Sanford J. Ungar, *Estrangement: America and the World.* New York: Oxford University Press, 1985; Loren Barritz, *Backfire.* New York: Morrow, 1985; Donald Kagan and Frederick W. Kagan, *While America Sleeps.* New York: St. Martin's Press, 2000; David Halberstam, *War in a Time of Peace.* New York: Scribner, 2001; Stephen Barber, *America in Retreat.* London: Tom Stacey, 1970; C. J. Bartlett, *The Rise and Fall of the Pax Americana.* New York: St. Martin's Press, 1974; Henry A. Kissinger, *Nuclear Weapons and Foreign Policy.* New York: Norton, 1969; Henry Morgenthau, *Politics Among Nations.* New York: Knopf, 1967; Martin Kramer, *Arab Awakening and Islamic Revival.* New Brunswick, N.J.: Transaction Publishers, 1996.

8. *The Economist,* 22 September 2001, p. 10.

9. Quoted by Tony Judt in "America and the War," *The New York Review of Books,* 15 November 2001, p. 4.

10. See Tom Carew, *Jihad*. London: Mainstream Publishing, 2000; Robert D. Kaplan, *Soldiers of God*. New York: Vintage Departures, 2001; Ahmed Rashid, *Taliban: Militant Islam, Oil and Fundamentalism*. New Haven: Yale University Press, 2000; Larry P. Goodson, *Afghanistan's Endless War: State Failure, Regional Politics and the Rise of the Taliban*. Seattle: University of Washington Press, 2001; Peter Marsden, *Taliban*. New York: Oxford University Press, 1998.

11. Fouad Ajami, "The Sentry's Solitude," *Foreign Affairs*, November–December 2001, p. 2.

12. Martin E. Marty and R. Scott Appleby, eds., The Fundamentalism Project Book Series, vols. 1–5: vol. 1, *Fundamentalisms Observed* (1991); vol. 2, *Fundamentalisms and Society* (1993); vol. 3, *Fundamentalisms and the State* (1993); vol. 4, *Accounting for Fundamentalisms* (1994); vol. 5, *Fundamentalisms Comprehended* (1995) (Chicago and London: University of Chicago Press, 1991–95).

13. Francis Fukuyama, "The End of History?," *The National Interest*, Summer 1989, pp. 3–18.

14. Ibid., "History Is Still Going Our Way," *The Wall Street Journal*, 5 October 2001, A14.

15. Samuel P. Huntington, "The Clash of Civilizations?" *Foreign Affairs*, Summer 1993. This article was further expanded in Huntington, *The Clash of Civilizations and the Remaking of World Order*. New York: Simon & Schuster, 1996.

16. Francis Fukuyama, *Trust*. New York: Free Press, 1995.

17. The failure to understand how Muslim societies work is further evidenced in Martin Kramer, *Ivory Towers on Sand: The Failure of Middle Eastern Studies in America*. Washington, D.C.: Washington Institute for Near Eastern Policy, 2001.

18. An interesting proposal for such a policy was summarized in Fareed Zakaria, "How to Save the Arab World," *Newsweek*, 24 December 2001.

19. Karl Popper, *The Open Society and Its Enemies*. New York: Harper & Row, 1963.

20. John Womack, "México: Un diagnóstico, entrevista con John Womack" (Mexico: An Assessment—An Interview with John Womack), *Nexos*, February 1996, pp. 41–48.

## 4. Reassuring and Protecting: Internal Security Implications of French Participation in the Coalition Against Terrorism, *by Didier Bigo*

1. A team preparing a new attack against France was stopped in the Ivory Coast in 1987. For more details see Didier Bigo, "Les Attentats en France en 1986: Un cas de violence transnationale et ses implications," *Cultures & Conflits*, no. 4 (*Les Réseaux internationaux de violence*) (Winter 1991).

2. During the trial of the first team in 1998 they claimed that French were active in the civil war in Algeria by training governmental troops and backing their position against FIS and GIA. For more details see A. Laïda, "*Les Réseaux dans le procès Chalabi: Articulations des jeux judiciaires, politiques et médiatiques autour de la notion de sécurité intérieure*. Paris: IEP, 1998.

3. See, for example, the American declarations on NATO's role in the coordination of antiterrorism efforts, which if implemented would be highly destabilizing for relations between NATO members and second- and third-level states in the European Union.

4. Jean Delumeau, *Rassurer et protéger: le sentiment de sécurité dans l'Occident d'autrefois* (Paris: Fayard, 1989). See also John Mueller, "Scenarios catastrophes," in D. Bigo and J. Y. Haine, eds., "Troubler et inquiéter: Les Discours du désordre international," *Cultures & Conflits*, no. 19–20 (1995).

5. On this point, see the anthropological work of George Balandier, *Pouvoir sur scène*. Paris: Seuil, 1981.

6. On maximum security, see Gary Marx, "Société de sécurité maximale," *Déviance et société* 2 (1988); Didier Bigo, "Conclusion," *Polices en réseaux: L'Expérience européenne.* Paris: Presses de la Fondation nationale des sciences politiques, 1996.

7. General Dalla Chiesa, author interview. GROUPS, *Terrorism: Approches françaises,* report, 3 volumes, 1983. General Dalla Chiesa was responsible for an antiterrorist joint team struggling against the Red Brigades. He was killed by the Mafia when he tried the same strategy against the Sicilian Mafia.

8. General Dalla Chiesa, author interview. GROUPS, *Terrorisme: Approches françaises,* vol. 3.

9. Didier Bigo, Jean-Paul Hanon, Anastasia Tsoukala, and Laurent Bonelli, "La Fonction de protection," report. Centre de prospective de la Gendarmerie nationale, March 2001.

10. See "Nouveaux regards sur les conflits," in Marie Claude Smouts, ed., *Les Nouvelles Relations internationales, pratiques et theories.* Paris: Presses de la Fondation nationale des sciences politiques, 1998; *The New International Relations: Practice and Theory,* translated from the French by Jonathan Derrick, New York: Palgrave, 2001.

11. See Didier Bigo, Elspeth Guild, Claire Sass, and Helena Jileva, "Le Visa Schengen et la police à distance," report, IHESI, July 2001).

12. On this point, see the analyses of General Christian Delanghe of the Centre de recherche et d'étude de doctrine de l'Armée de Terre, in *L'Action des forces terrestres au contact des réalités.*

13. France, in refusing all American and German technologies, has without a doubt maintained an advantage. It is not a question of relying on more technologies, as proposed by NATO and the EU, but of defending an alternative vision.

14. On the theory of international crises, see Patrick James, *Crisis and War.* Kingston, Ont.: McGill–Queen's University Press, 1988.

15. Didier Bigo, "Guerre, conflit, transnational et territoir," in Badie and M. C. Smouts "L'International sans territoire," *Cultures & Conflits,* no. 21–22 (Spring–Summer 1996). Available online at www.conflits.org

16. Didier Bigo, *Sécurité intérieure, implications pour la défense,* report. DAS, May 1998.

17. Daniel Hermant and Didier Bigo, "Simulation et dissimulation: Les Politiques de lutte contre le terrorisme en France," *Sociology du travail,* October 1986.

18. Philippe Bonditti, "La Lutte antiterroriste aux Etas-Unis," paper presented at the IEP de Paris, September 2001.

19. See the draft proposal from the European Commission for a council framework decision on combating terrorism, in particular Article 3 and the justifying introduction.

20. It would be well worth studying systematically how each country has reacted and what specific legislative or regulatory measures have been established in name of the struggle against terrorism. One would consider whether these were already under consideration prior to September, the shifting rationales for those that had been proposed earlier, and the balance between domestic and EU actors in the decision-making processes that led to the proposals.

21. Roy Jenkins, *A Life at the Centre.* London: 1991, pp. 387 ff.

22. Laura Donahue, *Counter-terrorist Law and Emergency Powers in the UK.* Dublin: Irish Academy Press, 2001.

23. The Terrorism Act 2000 came into force on February 19, 2001. The new act provides for permanent U.K.-wide antiterrorist legislation to replace the existing, separate pieces of temporary legislation for Northern Ireland and Great Britain; a new definition of terrorism, which will

apply to all types of terrorism; new powers to seize at borders cash suspected of being terrorist funds; a new offense of inciting terrorist acts abroad from within the U.K.; new judicial (as opposed to ministerial) arrangements for extensions of detention, enabling the United Kingdom to lift its derogations under the European Convention on Human Rights and the International Covenant on Civil and Political Rights; and specific offenses relating to training for terrorist activities.

24. Murray Edelman, *Constructing the Political Spectacle*. Chicago: University of Chicago Press, 1988, p. 66.

25. See, in particular, the works of G. I. P. Justice and Pierre Lascoumes, 1999.

26. Edelman, *Constructing the Political Spectacle*, pp. 74–78.

27. Graham Allison, et al., *Essence of Decision: Explaining the Cuban Missile Crisis*, 2nd ed. New York: Pearson PTP, 1999.

## 5. Living with the Hegemon: European Dilemmas, *by William Wallace*

SOURCES

Ikenberry, John L. "Constitutional Politics in International Relations." *European Journal of International Relations* 4, no. 2 (June 1998): 147–77.

Kennedy, Paul. *The Rise and Fall of the Great Powers*. New York: Random House, 1987.

Keohane, Robert O. *After Hegemony*. Princeton, N.J.: Princeton University Press, 1984.

Luck, Edward. *Mixed Messages: American Politics and International Organization, 1919–1999*. Washington, D.C.: Brookings Institution Press, 1999.

Lundestad, Geir. *Empire by Invitation: The United States and European Integration, 1945–1997*. Oxford: Oxford University Press, 1998.

Nye, Joseph S. *Bound to Lead: The Changing Nature of American Power*. New York: Basic Books, 1990.

## 6. After Balance-of-Power Diplomacy, Globalization's Politics, *by Luiz Carlos Bresser-Pereira*

Shortened titles refer to "Sources," p. 257.

1. Bresser-Pereira, "Economic Reforms and Cycles of State Intervention."

2. "The mood of America: What September 11 Really Wrought," *The Economist*, 10 January 2002, based on data from the University of Michigan and the Gallup Organization.

3. "No Not Quite a Dictatorship," *The Economist*, 6 December 2001.

4. Habermas, "Faith and Knowledge."

5. Crook, "Globalization and its Critics."

6. Rodrik, *The New Global Economy and Developing Countries*.

7. Prebisch, *The Economic Development of Latin America and Its Principal Problems*.

8. Arendt, *On Revolution*, p. 19.

9. Diamond, "Why We Must Feed the Hands that Can Bite Us."

10. On the emergence of a global citizenship see the survey by Vargas, "Ciudadanias Globales y Sociedades Civiles Globales." Vargas surveys works by Manuel Castells, Anthony Giddens, Boaventura de Sousa Santos, David Held, and Yuval Davis.

11. When drivers face traffic congestion in a two-lane tunnel, they become frustrated, but the drivers in one lane will become much more frustrated if the other lane starts moving ahead.

12. Announced at a World Bank–IMF meeting in Seoul, South Korea in 1985, the Baker Plan's objective was to enable debtor nations to grow out of their debts by encouraging them to enact economic reforms.

13. Habermas, "Faith and Knowledge."

14. See Kennedy, "The Colossus with an Achilles Heel." Kennedy, for instance, defended this explanation in an article published immediately after the attack.

15. This expression is attributed to Larry Summers, former U.S. secretary of the treasury and now president of Harvard University.

### SOURCES

Arendt, Hannah. *On Revolution*. New York: Viking Press: 1963.

Bresser-Pereira, Luiz Carlos. "Economic Reforms and Cycles of State Intervention." *World Development* 21, no. 8 (August 1993): 1337–53.

Crook, Clive. "Globalization and Its Critics" (special survey). *The Economist* 27 September 2001.

Diamond, Jared. "Why We Must Feed the Hands That Can Bite Us." *The Washington Post*, 13 January 2002.

Habermas, Jürgen. "Faith and Knowledge." Speech given at the award ceremony for the German Book Trade's Peace Prize at the Paulskirche in Frankfurt, 14 October 2001.

Kennedy, Paul. "The Colossus with an Achilles Heel." *New Perspectives Quarterly* 18, no. 4 (September 2001).

Prebisch, Raul. *The Economic Development of Latin America and Its Principal Problems*. New York: United Nations, Department of Economic Affairs, 1950.

Rodrik, Dani. *The New Global Economy and Developing Countries: Making Openness Work*. Washington, D.C.: Overseas Development Council and Baltimore: Johns Hopkins University Press, 1999.

Vargas, Virginia. "Ciudadanias Globales y Sociedades Civiles Globales: Pistas para el Analisis." World Social Forum 2001, Biblioteca de las Alternativas, Porto Alegre, Brazil, Janeiro 2001.

### 7. September 11, Security, and the New Postliberal Politics of Fear, *by Kanishka Jayasuriya*

Shortened titles refer to items in "Sources," pp. 260–62.

1. Neocleous, "Social Police and the Mechanisms of Prevention," p. 12.

2. Brown, *Politics out of History*, p. 30.

3. Shiv Sena, founded in Bombay in 1966, is an extreme nationalist Hindu movement that has a long history of political violence and terror in pursuit of its communal ends. It is currently in political alliance with the Hindu nationalist party, the BJP.

4. Krauthammer, "Voices of Moral Obtuseness," A37.

5. Lapham, "Notebook: American Jihad."

6. Ibid.

7. Young, "Once Lost, These Freedoms Will Be Impossible to Restore."

8. Rubenstein, "Citizenship, Sovereignty and Migration."

9. For a very good recent introduction to the work of Schmitt, see MacCormick, "Democracy, Subsidiarity and Citizenship in the 'European Commonwealth,'" and Scheuerman, *Carl Schmitt*. Both accounts are particularly good on Schmitt's legal and constitutional theory.

10. Particularly as it was represented by the work of the jurist Hans Kelsen. For an excellent overview of this debate see Dyzenhaus, *Legality and Legitimacy*.

11. Schmitt, *Political Theology*, p. 6.

12. See MacCormick "Democracy, Subsidiarity and Citizenship" for a good description of Schmitt's changing attitudes toward constitutional and emergency powers.

13. Maus, "The 1933 'Break' in Carl Schmitt's Theory," pp. 202–3.

14. Schmitt, *Verfassungslehre*, and ibid., *Political Theology*.

15. Ibid.

16. And clearly, Schmitt's view of the nature of what he called "decisionism" changed to a theory of what he called "concrete normative order" in the 1930s. For a good account of these changes see Christi, *Carl Schmitt and Authoritarian Liberalism*.

17. Schmitt, *Concept of the Political*.

18. See especially MacCormick, "Democracy, Subsidiarity and Citizenship," Scheuerman, *Between the Norm and the Exception*, and Dyzenhaus, "Liberalism After the Fall."

19. For a review of the effects of globalization on the illicit economy, see Firman and Andreas, *Illicit Global Economy and State Power*.

20. For recent, somewhat varied, attempts to understand the new forms of risk see Beck, *Risk Society and World Risk Society*; Giddens (1984) *The Constitution of Society* and *Modernity and Self Identity*; and Bauman, "Social Issues of Law and Order."

21. Davis, "Flames of New York."

22. Garland, *Culture of Control*.

23. Dunn, *Militarization of the U.S.-Mexico Border 1978–1992*.

24. Shklar, *Political Thought and Political Thinkers*, p. 19.

25. Ibid., p. 11.

26. Ibid., p. 19.

27. Raeff, *The Well Ordered Police State*, pp. 45–46.

28. For an analysis of the new social policies such as workfare in these antipolitical terms, see Jayasuriya, "Capability, Freedom and the New Social Democracy," and ibid., "Autonomy, Liberalism and the New Contractualism."

29. See Garland, "Limits of the Sovereign State," and Neocloeous, "Against Security."

30. Garland, *Culture of Control*.

31. Weaver, "Securitization and Desecuritization."

32. However, it is perhaps better to view this new form of state as kind of regulatory state that has security, broadly defined, as one of its central components. On the new regulatory state see Jayasuriya, "Globalisation and the Changing Architecture of the State."

33. On the interplay of domestic and international policies in the origin of these national security policies, see Freeland, *The Truman Doctrine and the Origins of McCarthyism*.

34. See Jayasuriya, "Globalisation, Sovereignty, and the Rule of Law," and ibid., "Globalisation and the Changing Architecture of the State" for a detailed argument along these lines.

35. Clark, *Globalisation and International Relations Theory,* presents an excellent account of how holding on to this binary distinction distorts our analysis of globalization.

36. Strange, *The Retreat of the State.*

37. Garland, *Culture of Control,* p. 185.

38. For a justification and overview of the new paternalism in social welfare see Mead, "Rise of Paternalism." Especially important in this defense of the new paternalism is the idea of responsible agency, an idea that informs not only the new political penology but also the new international liberalism of fear. Consider, for example, the governance programs of the World Bank. In this respect at least, it harks back to older notions of "police" analyzed above.

39. For a flavor of these approaches see Teharanian, *Worlds Apart.*

40. See, for example, Booth, "Security and the Self: Reflections of a Fallen Realist."

41. Neocleous, "Social Police," p. 13.

42. Garland, *Culture of Control.*

43. None of this is to dismiss the potential of some version of human security in providing a more political version of security. I have elaborated on some of these issues, using the work of Amartya Sen to develop a capabilities approach to freedom which places domination at the center of its normative framework. See Jayasuriya, "Capability, Freedom and the New Social Democracy."

44. Hayter, *Open Borders.*

45. For an excellent recent analysis of the politics of border control on the U.S.-Mexico border, see Andreas, *Border Games.* This work draws attention to the symbolic assertion of border control signified by the use of a highly punitive law-and-order approach to border control.

46. Tamas, "On Post Fascism." Indeed, rather provocatively, Tamas calls this a new kind of post fascism.

47. Jayasuriya, "Autonomy, Liberalism and the New Contractualism."

48. Rubenstein, "Citizenship, Sovereignty and Migration."

49. Rundle, "John Howard and the Triumph of Reaction."

50. Cole, *Philosophies of Exclusion.*

51. Douglas, *Risk and Blame.*

52. Huntington, *Clash of Civilizations.*

53. Davis, "Flames of New York."

54. See, for example, Wilson and Harrenstein, *Crime and Human Nature.*

55. Jayasuriya, "Globalisation, Sovereignty, and the Rule of Law."

56. Ibid.

57. Golden, "Canada Must Chart Its Own Course."

58. For a good overview of the rise of specialized agencies and networks of regulatory agencies, see Slaughter, "The Real New World Order."

59. Neumann, *The Rule of Law.*

60. Scheuerman, "Economic Globalization and the Rule of Law."

61. Katznelson, *Liberalism's Crooked Circle,* p. 51.

62. Monbiot, "Taliban of the West," p. 11.

63. Arendt, *The Human Condition,* p. 52.

## SOURCES

Andreas, Peter. *Border Games: Policing the U.S.-Mexico Divide.* Ithaca, N.Y.: Cornell University Press, 2000.

Arendt, Hannah. *The Human Condition.* Chicago: University of Chicago Press, 1998.

Bauman, Zygmunt. "Social Issues of Law and Order." In D. Garland and R. Sparks, eds. *Criminology and Social Theory.* Oxford: Oxford University Press, 2000.

Beck, Ulrich. *Risk Society: Towards a New Modernity.* Newbury Park, Calif.: Sage Public, 1992.

———. *World Risk Society.* Cambridge: Polity Press, 1999.

Booth, Ken. "Security and the Self: Reflections of a Fallen Realist." In K. Krause and Michael Williams, eds., *Critical Security Studies: Concepts and Cases.* Los Angeles: University of California, Los Angeles Press, 1997.

Brown, Wendy. *Politics out of History.* Princeton University Press, 2001.

Christi, Renato. *Carl Schmitt and Authoritarian Liberalism.* Cardiff: University of Wales Press, 1998.

Clark, Ian. *Globalisation and International Relations Theory.* Oxford: Oxford University Press, 1999.

Cole, P. *Philosophies of Exclusion: Liberal Political Theory and Immigration.* Edinburgh: Edinburgh University Press, 2000.

Davis, Michael. "The Flames of New York." *New Left Review* 12 (2nd ser.): 34–50.

Douglas, Mary. *Risk and Blame: Essays in Cultural Theory.* London: Routledge, 1992.

Dunn, Timothy. *The Militarization of the US-Mexico Border 1978–1992.* Austin: University of Texas Press, 1995.

Dyzenhaus, David. "Liberalism after the Fall: Schmitt, Rawls and the Problem of Justification." *Philosophy and Social Criticism Journal* 22: 9–37.

———. *Legality and Legitimacy: Carl Schmitt, Hans Kelsen and Hermann Heller in Weimar.* Oxford: Clarendon Press, 1997.

Firman, Richard, and Peter Andreas, eds. *The Illicit Global Economy and State Power.* Lanham, Md.: Rowman & Littlefield, 1998.

Freeland, Richard. *The Truman Doctrine and the Origins of McCarthyism: Foreign Policy, Domestic Politics and Internal Security, 1946–1948.* New York: Knopf, 1972.

Garland, David. "The Limits of the Sovereign State: Strategies of Crime Control in Contemporary Society." *British Journal of Criminology* 36 (4): 445–71.

———. *The Culture of Control: Crime and Social Order in Contemporary Society.* Chicago: University of Chicago Press, 2001.

Giddens, Anthony. *Modernity and Self Identity.* Cambridge: Polity Press, 1991.

———. *Beyond Left and Right: The Future of Radical Politics.* Cambridge: Polity Press, 1994.

———. *The Constitutional of Society: Outline of the Theory of Structuration.* Cambridge: Polity Press, 1984.

Golden, Anne. "Canada Must Chart Its Own Course." *Globe and Mail,* 5 October 2001, A17.

Hayter, Teresa. *Open Borders: The Case Against Immigration Controls.* London: Pluto Press, 2000.

Huntington, Samuel P. *The Clash of Civilizations and the Remaking of World Order.* New York: Simon & Schuster, 1996.

Jayasuriya, Kanishka. "Capability, Freedom and the New Social Democracy." *Political Quarterly* 71, no. 3 (July 2000): 282–99.

———. "Globalisation and the Changing Architecture of the State: Regulatory State and the Politics of Negative Coordination" *Journal of European Public Policy* 8 (2001), no. 1: 101–23.

———. "Globalisation, Sovereignty, and the Rule of Law: From Political to Economic Constitutionalism?" *Constellations* 8 (2001), no. 4: 442–60.

———. "Autonomy, Liberalism and the New Contractualism." *Law in Context,* 18 (2001), no. 2: 57–78.

Katznelson, Ira. *Liberalism's Crooked Circle.* Princeton: Princeton University Press, 1996.

Krauthammer, Charles. "Voices of Moral Obtuseness." *The Washington Post,* 21 September 2001, A37.

Lapham, Lewis. "Notebook: American Jihad." *Harpers Magazine,* January 2001, pp. 7–9.

MacCormick, Neil. "Democracy, Subsidiarity and Citizenship in the 'European Commonwealth.' " *Law and Philosophy* (1997) 16: 331–56.

Maus, Ingebourg. "The 1933 'Break' in Carl Schmitt's Theory." In David Dyzenhaus, ed., *Law as Politics: Carl Schmitt's Critique of Liberalism.* Durham, N.C.: Duke University Press, 1998.

Mead, Lawrence. "The Rise of Paternalism." In L. Mead, ed. *The New Paternalism.* Washington: Brookings Institution, 1997.

Monbiot, George. "The Taliban of the West." *The Guardian Weekly,* 3–9 January, 11.

Neocloeous, Mark. "Against Security." *Radical Philosophy* 100 (March–April 2000): 7–15.

———. "Social Police and the Mechanisms of Prevention: Patrick Colquhoun and the Condition of Poverty." *British Journal of Criminology* 40, no. 4: 710–26.

Neumann, Franz. *The Rule of Law: Political Theory and the Legal System in Modern Society.* Leamington Spa, U.K.: Berg, 1986.

Raeff, Marc. *The Well Ordered Police State: Social and Institutional Change Through Law in Germanies and Russia 1600–1800.* New Haven: Yale University Press, 1983.

Rubenstein K. "Citizenship, Sovereignty and Migration: Australia's Exclusive Approach to Membership of the Community." Paper prepared for seminar "Boundless Plains to Share? Australia's response to the MV *Tampa* Asylum Seekers," Melbourne, Australia, October 11, 2001. ‹www.law.unimelb.edu.au/icil/tampa/kirubenstein.html›

Rundle, Guy. "The Opportunist, John Howard and the Triumph of Reaction." *Quarterly Essays* (2001): 1–66.

Scheuerman, William E. "Economic Globalization and the Rule of Law." *Constellations* 6 (1999), no. 1: 3–26.

———. *Carl Schmitt.* Lanham, Md.: Rowman & Littlefield, 1999.

———. *Between the Norm and the Exception: The Frankfurt School and the Rule of Law.* Cambridge, Mass.: MIT Press, 1995.

Schmitt, Carl. *Verfassungslehre* [Constitutional Theory]. 1928. Reprint, Berlin: Duncker & Humblot, 1965.

———. *The Concept of the Political.* Translated by George Schwab. 1932. Reprint, New Brunswick: Rutgers University Press, 1976.

———. *Political Theology: Four Chapters on the Concept of Sovereignty.* First pub. 1922. Translated by George Schwab. 1922. Reprint, Cambridge Mass: MIT Press, 1985.

———. *The Crisis of Parliamentary Democracy.* Translated by Ellen Kennedy. Cambridge, Mass.: MIT Press, 1985.

Shklar, Judith. "Political Thought and Political Thinkers." Edited by Stanley Hoffman. Chicago: University of Chicago Press, 1998.

Slaughter, Anne-Marie. "The Real New World Order." *Foreign Affairs* 76 (1997), no. 5: 183–97.

Strange, Susan. *The Retreat of the State: The Diffusion of Power in the World Economy.* Cambridge: Cambridge University Press, 1996.

Tamas, G. M. "On Post Fascism." *Boston Review,* Summer 2000, available online at bostonreview. mit.edu/BR25.3/tamas.html (accessed 4 Jan 2002).

Teharanian, Majid. *Worlds Apart: Human Security and Global Governance.* London: I. B Tauris, 1999.

*The New York Times.* "Fight Against Money Laundering Widens." 11 December 2001, C2.

Weaver, Ole. "Securitization and Desecuritization." In Ronnie Lipshutz, ed. *On Security.* New York: Columbia University Press, 1995, pp. 46–86.

Wilson, J. Q., and R. J. Harrenstein. *Crime and Human Nature.* New York: Simon & Schuster, 1986.

Young, Hugo. "Once Lost, These Freedoms will be Impossible to Restore." *The Guardian,* 11 December 2001.

## 8. Mistake, Farce, or Calamity? Pakistan and Its Tryst with History, *by Kamran Asdar Ali*

Shortened titles refer to items in "Sources," below.

1. Until 1971, Pakistan was divided into West Pakistan and East Pakistan, with 1,000 miles of Indian territory between them. Bengalis in East Pakistan demanded regional autonomy, which was finally gained after the Bengalis, with Indian help, defeated the Pakistani army in the 1971 civil war.

2. Zulfikhar Ali Bhutto was deposed by the military in 1977 and was later executed. General Zia ul Haq ruled from 1977 to 1988, when Bhutto's daughter was elected president. Her government collapsed amid charges of corruption in 1990, only to be returned to power from 1993 to 1996.

3. I credit Professor Hamza Alavi for reminding me of this historical exchange.

4. Rashid, *Taliban: Militant Islam, Oil and Fundamentalism in Central Asia.*

5. Pakistan's major peasant mobilizations and land takeovers under the direction of underground Communist groups occurred in this province in the 1970s.

6. Plural of "madrassah" in Urdu.

7. Shi'a and Sunni are the two main branches of Islam. Shi'as (or Shi'ites) are dominant in Iran. In Saudi Arabia, the Wahhabi sect of Sunni make up some 90 percent of the population. In Pakistan Shi'as make up 20 percent of the population and Sunnis, 77 percent.

8. See Amensty International, reports on India 1997–2000, and Human Rights Watch.

9. The Arias plan for ending the war in Nicaragua was approved by the presidents of Guatemala, El Salvador, Honduras, and Nicaragua in 1987. Arias won the Nobel Peace Prize that year.

### SOURCES

Ahmad, Eqbal. *Confronting Empire: Interviews with David Barsamian.* London: Pluto Press, 2000.

Amnesty International. *Annual Report: India. 1997, 1998, 1999, 2000.* www.web.amnesty.org/web/ar2000web.nsf/countries›

Gardezi, Hassan, and Jamil Rashid, eds. *Pakistan, the Roots of Dictatorship: The Political Economy of a Praetorian State.* London: Zed Press, 1983.

Human Rights Watch UK, *India's Secret Army in Kashmir,* Vol. 8, 1996.

Jalal, Ayesha. *The Sole Spokesman: Jinnah, the Muslim League, and the Demand for Pakistan.* Cambridge: Cambridge University Press, 1985.

———. *The State of Martial Rule: The Origins of Pakistan's Political Economy of Defence,* Cambridge: Cambridge University Press, 1990.

Rashid, Ahmed. *Taliban: Militant Islam, Oil and Fundamentalism in Central Asia.* New Haven: Yale University Press, 2000.

Wolpert, Stanley. *Jinnah of Pakistan.* London: Oxford University Press, 1984.

## 9. Can Rational Analysis Break a Taboo? A Middle Eastern Perspective, *by Said Amir Arjomand*

Shortened titles refer to items in "Sources," p. 64.

1. This was the so-called Wolfowitz plan. *The New York Times,* 20 September 2001; 1 October 2001.

2. *The Wall Street Journal,* 4 January 2002.

3. "In Shift, Muslim Groups Cast Themselves as Loyal Critics," *The New York Times,* 25 October 2001.

4. *The New York Times,* 28 January 2002.

5. *The New York Times,* 23 September 2001.

6. *The New York Times,* 12 October 2001.

7. *The New York Times,* 13 November 2001.

8. "Terrorism? What Terrorism?!," *The Wall Street Journal,* 15 November 2001.

9. "Senators Urge Bush Not to Hamper Israel," *The New York Times,* 17 November 2001.

10. Hersh, "The Iran Game."

11. "AIPAC Praises the President's Leadership on Impending Iranian Weapons Proliferation." Letter to President Bush, 25 January 2002, www.aipac.org/result.cfm?id=1260.

12. *Los Angeles Times,* 2 February 2002.

13. Boroujerdi, *Iranian Intellectuals and the West.*

14. Arjomand, "Unity and Diversity in Islamic Fundamentalism."

15. Rushdie, "Yes, This is About Islam," *The New York Times,* 2 November 2001.

16. Shatz, "The Way We Live Now: 10-28-01 Questions for V.S. Naipaul, Literary Criticism," *The New York Times Magazine,* 28 October 2001.

17. Arjomand, "Unity and Diversity in Islamic Fundamentalism."

18. Rashid, *Taliban: Militant Islam, Oil and Fundamentalism in Central Asia,* pp. 130–33, and 256, notes 6 and 9.

19. Ibid., pp. 28–29, 59, 89–91.

20. And, he could have added, concubines from among Shi'ite prisoners of war.

21. Cited in Rashid, *Taliban,* p. 43.

22. Ibid. p. 102.

23. Rashid, *Taliban,* p. 80.

24. The Hazara make up approximately 19 percent of the Afghan population.

25. Rashid, *Taliban*, pp. 136–40.

26. Ibid., 134.

27. "Bin Laden's Statement: "The Sword Fell," *The New York Times*, 8 October 2001.

28. "Bin Laden's Deathly Boasts" *The Boston Globe*, 24 December 2001.

29. Arjomand, "From the Editor."

30. *Zaman*, 18 September 2001.

31. Makiya and Mneimeh, "Manual for a 'Raid.' "

32. "Bin Laden's Statement" *The New York Times*, 8 October 2001.

33. "Q & A: A Head-On Collision of Alien Cultures?" *The New York Times*, 20 October 2001.

34. Eisenstadt, *Fundamentalism, Sectarianism, and Revolution.*

35. Tiryakian, "The Civilization of Modernity and the Modernity of Civilizations."

36. Huntington, *Clash of Civilizations*, p. 209.

37. Buruma and Margalit, "Occidentalism," p. 7.

38. Weber, "Politics as Vocation."

### SOURCES

Arjomand, S. A. "Unity and Diversity in Islamic Fundamentalism." In M. Marty and R. S. Appleby, eds. *Fundamentalisms Comprehended.* Chicago: University of Chicago Press, 1995, pp. 179–98.

———. "From the Editor," *International Sociology* 16 (2001), no. 3 (Special Issue, "Rethinking Civilization Analysis").

Boroujerdi, M. *Iranian Intellectuals and the West: The Tormented Triumph of Nativism.* Syracuse, N.Y.: Syracuse University Press, 1996.

Buruma, I., and A. Margalit. "Occidentalism." *The New York Review of Books*, 17 January 2002.

Eisenstadt, S. N. *Fundamentalism, Sectarianism, and Revolution. The Jacobin Dimension of Modernity.* Cambridge: Cambridge University Press, 1999.

Hersh, S. M. "The Iran Game: How Will Tehran's Nuclear Ambitions Affect Our Budding Partnership?" *The New Yorker*, 3 December 2001.

Huntington, S. P. *The Clash of Civilizations and the Remaking of World Order.* New York: Simon & Schuster, 1996.

Makiya, K., and H. Mneimeh. "Manual for a 'Raid.' " *The New York Review of Books*, 17 January 2002.

Rashid, A. *Taliban: Militant Islam, Oil and Fundamentalism in Central Asia.* New Haven: Yale University Press, 2000.

Tiryakian, E. A. "The Civilization of Modernity and the Modernity of Civilizations." *International Sociology* 16 (2001), no. 3.

Weber, M. "Politics as Vocation." 1918. In H. Gerth and C. W. Mills, eds., *From Max Weber.* London: Routledge, 1948.

## 10. Change and Continuity in Hemispheric Affairs: Latin America After September 11, *by Francisco Gutiérrez Sanín, Eric Hershberg, and Monica Hirst*

1. Ironically, Mexico had recently called for dismantling the IATRA as obsolete. A general analysis of the reach and limits of the recent reactivation of the Inter-American system has been writ-

ten by Juan Tokatlian. See Spanish edition of *Foreign Affairs* 1, no. 4 (November 2001). See also Farid Kahat on the Social Science Research Council web site (www.ssrc.org/sept11).

2. The region has proved equally incapable of presenting a unified front regarding efforts to open the U.N. Security Council to broader participation from developing countries. Most recently, the South American presidential summit convened by the Brazilian government raised more doubts about than support for Brazil's efforts to assume the mantle of regional leadership.

3. An *auto-golpe* is a peculiarly Latin American phenomenon in which an elected leader carries out a coup d'état against the constitutional order in an effort to remain in power.

4. The Fuerzas Armadas Revolucionarias de Colombia (FARC) and the Ejercito de Liberacion Nacional (ELN).

5. To an important extent these painful measures were a necessary response to the exhaustion of an inward-oriented development model that had been prevalent across the region for several decades. Yet the reforms were undertaken amid steady pressure from a succession of U.S. administrations and from international financial institutions that tended to pay scant attention to the domestic costs of restructuring.

6. Barbara Stallings and Wilson Peres, *Growth, Employment, and Equity: The Impact of the Economic Reforms in Latin America and the Caribbean* (Washington, D.C.: Brookings Institution/ ECLAC, 2000) provides a comprehensive and generally favorable overview of the impact of a decade of reform, but highlights the persistence of catastrophic levels of inequality and the prevalence of only modest growth rates.

7. The Farabundo Martí Front for National Liberation (FMLN) and the Sandinista Front for National Liberation (FSLN) were the principal leftist organizations that conducted a guerrilla war in El Salvador and ruled revolutionary Nicaragua, respectively.

8. We are grateful to Aldo Marchese for sharing information culled from the Uruguayan press during the fall of 2001.

9. Rolando Astarita, "Crítica al discurso de Hebe Bonafini y renuncia a la UMPM," *Debate Marxista* 3 (October 2001).

10. Paul Collier, *Greed and Grievance in Civil War.* Washington, D.C.: World Bank Development Research Group, 2000.

11. The FARC and ELN are not identical, but their differences are not relevant in this context.

12. In the parlance of the Maoist military theory used by the AUC, they seek to remove the water from the fish ("*quitar el agua al pez*"), an allusion to Mao's dictum that revolutionaries should move among the masses like fish in the water. The majority of the AUC's victims have no tie whatsoever with an armed group, but random terror functions as a powerful mechanism for getting rid of populations that get in the way.

13. "El gran garrote," *Revista Semana* 1017 (25 October–5 November 2001): 26–32.

14. For example, official figures indicate that the combat against the paramilitaries was more or less a direct result of U.S. pressure.

15. It is worth noting that Washington's ongoing confrontation with Cuba has not remained unaffected by the United States' embarking on a war against terrorism. Cuba has been included on the list of states deemed to support terrorism; this may be an artifact of domestic political calculations in the United States, but perceptions on the island as elsewhere in the region are that it marks an unnecessary and potentially dangerous escalation of the persistent war of words across the Florida Straits.

16. Appearing on television with photographs of the carnage in Afghanistan, Chavez asked viewers whether this was not also an example of terrorism.

17. Regulations on banking and financial transactions may constitute a third area of reforms that will have lasting economic implications. Financial security measures included in the U.S. Foreign Assets Terrorist Tracking Program aim to curtail money-laundering operations in the region. These will introduce new constraints for the Latin American banking system, particularly in several islands in the Caribbean, where off-shore banking has been a major element of development strategies in recent decades.

18. Formally known as trade promotion authority, fast track enables the president to send comprehensive agreements to the Congress without possibilities for line-item amendments.

19. Congressional rhetoric that accompanied the latest measures undertaken to protect U.S. domestic steel production, affecting Argentine and Brazilian exports, illustrated such tendencies.

20. See remarks by President Bush to the World Affairs Council National Conference, Organization of American States, 16 January 2002.

21. Since the terrorist attack on a Jewish community center in Buenos Aires in 1994, this area has been considered a hotbed of suspected terrorists.

22. An example of this kind of consequence is mentioned by Robert Luttwak when he acknowledges that in the new world setting it has become more difficult for Brazil—or India, China, and even South Africa—to aspire to become a member of the G-7. See *Veja* (14 November 2001).

23. The Rio Group is an intergovernmental roundtable formed in 1985 involving representative from South America, Mexico, and Central America and the Caribbean.

## 11. Muslims and the Politics of Multiculturalism in Britain, *by Tariq Modood*

1. Adapted from Tony Blair's slogan of the 1990s, "tough on crime, tough on the causes of crime," which played a major part in transforming the British Labour Party into "New Labour."

2. S. P. Huntington, "The Clash of Civilizations?" *Foreign Affairs* 72 (1993), no. 3: 22–49.

3. M. G. S. Hodgson, *The Venture of Islam*, vol. 2: *The Expansion of Islam in the Middle Periods* (Chicago and London: University of Chicago Press, 1974), and G. Makdisi, *The Rise of Humanism in Classical Islam and the Christian West*. Edinburgh: Edinburgh University Press, 1990.

4. It is a great tragedy that Muslims turned their backs on this intellectual current and that Europeans appropriated it without acknowledgment of its source. One step toward intercivilizational dialogue and less exclusive definitions of Europe and of Islam would be to excavate this history.

5. Eqbal Ahmad, "*Terrorism: Theirs and Ours*," address given at the University of Colorado, Boulder, 12 October 1998. Available from the web site of the Institute of Race Relations, London, www.irr.org.uk/terrorism/index.htm.

6. T. Modood, et al., *Ethnic Minorities in Britain: Diversity and Disadvantage*. London: Policy Studies Institute, 1997.

7. UKACIA, *Muslims and the Law in Multi-faith Britain: Need for Reform*. London: U.K. Action Committee on Islamic Affairs, 1993.

8. Muslim Parliament of Great Britain. *Race Relations and Muslims in Great Britain: A Discussion Paper*. London: Muslim Parliament, 1992.

9. Commission on Multi-Ethnic Britain, *The Future of Multi-Ethnic Britain*. London: Profile Books, 2000. In the past race-egalitarians ignored anti-Muslim racism; now they subsume it under "contamination by blackness," as if black ancestry is the ground of the hostility. P. Gilroy, "Diving into the Tunnel: The Politics of Race between Old and New Worlds," at www.open democracy.net/forum/document, 31 January 2002.

10. I borrow here in a compressed form my argument in T. Modood. "The Place of Muslims in British Secular Multiculturalism," in N. Alsayyad and M. Castells, eds., *Muslim Europe or*

*Euro-Islam: Politics, Culture and Citizenship in the Age of Globalisation.* New York: Lexington Books, 2002.

11. I. Young, *Justice and the Politics of Difference.* Princeton: Princeton University Press, 1990.

12. S. Benhabib, *Situating the Self.* New York: Routledge, 1992, and N. Fraser, "Rethinking the Public Sphere," in C. Calhoun, ed., *Habermas and the Public Sphere.* Cambridge, Mass.: MIT Press, 1992.

13. Hannah Arendt, *On Revolution.* New York: Viking Press, 1963; ibid., *The Human Condition.* London: University of Chicago, 1968; Jürgen Habermas, *The Theory of Communicative Action,* vol. 1: *Reason and the Rationalization of Society.* Boston: Beacon Press, 1983; Jürgen Habermas, *The Theory of Communicative Action,* vol. 2: *Lifeworld and System.* Boston: Beacon Press, 1987.

14. T. Modood, "British Asian Muslims and the Rushdie Affair," *Political Quarterly* 61 (1990), no. 2: 143–60; also in Donald J. and A. Rattansi, eds., *'Race,' Culture and Difference.* London: Sage, 1992.

15. Ibid., "Political Blackness and British Asians," *Sociology* 28 (1994), no. 3.

16. Ibid., "Catching Up with Jesse Jackson: Being Oppressed and Being Somebody," *New Community* 17 (October 1990), no. 1; also ibid., in *Not Easy Being British: Colour, Culture and Citizenship.* London: Runnymede Trust, 1992.

17. Modood et al., *Ethnic Minorities in Britain.*

18. Ibid.

19. Ibid.

20. For parallel reasons, recently a Jewish commission suggested that for the purposes and benefits of representation, "The Jewish community needs to see itself . . . as an ethnic group," rather than solely as a religious minority. Commission on Representation of the Interests of the British Jewish Community, *A Community of Communities.* London: Institute for Jewish Policy Research, 2000.

21. J. Rex, "National Identity in the Democratic Multi-Cultural State," *Sociological Research Online* 1 (1996), no. 2: www.socresonline.org.uk/socresonline/1/2/1.html.

22. UKACIA, *Muslims and the Law.*

23. T. Modood, ed., *Church, State and Religious Minorities.* London: Policy Studies Institute, 1997.

24. In the U.K., blasphemy is still punishable by law, though the last prosecution was in 1976. An attempt to prosecute Salman Rushdie under the law for his book *Satanic Verses* failed when the high court ruled that only the Anglican religion was covered by the law.

25. Muslim Parliament of Great Britain, *Race Relations,* and UKACIA, *Muslims and the Law.*

26. T. Modood, "Muslims, Incitement to Hatred and the Law," in J. Horton, ed., *Liberalism, Multiculturalism and Toleration.* London: Macmillan, 1993.

27. Ibid., "Anti-Essentialism, Multiculturalism and the 'Recognition' of Religious Minorities," *Journal of Political Philosophy* 6 (December 1998), no. 4: 378–99; B. Parekh, *Rethinking Multiculturalism.* Cambridge, Mass.: Harvard University Press, 2000.

28. Runnymede Trust Commission on British Muslims and Islamophobia, *Islamophobia: A Challenge to Us All.* London: Runnymede Trust, 1997.

29. Modood et al., *Ethnic Minorities in Britain.*

30. See British National Party web site.

31. *The Independent*, 4 January 2002.

32. In January 2002, a British Muslim in Pakistan claimed to have helped recruit more than 200 British volunteers to fight for the Taliban (*The Telegraph* [London], 8 January 2002) and it was confirmed that 3 of the first 50 prisoners from Afghanistan brought to the U.S. prison in Guantanamo Bay, Cuba, were Britons.

33. The "hijacking" theme was in fact most notably introduced by a charismatic white American Muslim, Hamza Yusuf (who was also consulted by President Bush) and who was taken up by the magazine of the young Muslim professionals, *Q News* (see the November 2001 issue). Dr Muqtedar Khan, director of international studies, Adrian College, Michigan, had an even more uncompromisingly "moderate" statement in the right-wing tabloid newspaper *The Sun,* but was not taken up by British Muslims with a comparable enthusiasm, perhaps because he, unlike Yusuf, did not visit Britain.

34. *The Independent* (London), 26 October 2001.

35. Ziauddin Sardar, *The Observer,* 23 September 2001.

36. Ibid., *Evening Standard* (London), 5 November 2001.

37. Yasmin Alibhai-Brown, *The Independent* (London), 5 November 2001.

38. Ziauddin Sardar, *The Observer,* 21 October 2001.

39. The cabinet minister responsible for "race relations."

40. A prime example of this local version of the clash-of-civilizations thesis was by Farrukh Dhondy, an Asian who had pioneered multicultural broadcasting on British television (Dhondy, 2001). "Our Islamic Fifth Column," *City Limits* (4).

41. H. Ouseley, *Community Pride, Not Prejudice: Making Diversity Work in Bradford.* Bradford: Bradford Vision, Bradford City Council, 2001.

42. Polly Toynbee, *The Guardian* (London), 12 December 2001; for the opposite view, see Commission on Multi-Ethnic Britain, *The Future of Multi-Ethnic Britain.* London: Profile Books, 2000, 237. I am grateful to Robin Richardson for many useful comments over the years on the blindness of secular antiracists to the racialized suffering of religious people (see CMEB, *Future of Multi-Ethnic Britain,* Chapter 5).

## 12. The Reach of Transnationalism, *by Riva Kastoryano*

1. G. Rivera-Saldago, "Mixtec Activism in Oaxacalifornia: Transborder Grassroots Political Strategies," *American Behavioral Scientist* 42 (1999), no. 9: 1439–58.

2. David Held et al., *Global Transformations.* New York: Routledge, 1999.

3. Cf. L. Basch et al., *Nations Unbound: Transnational Projects, Postcolonial Predicaments and Deterritorialized Nation-States,* 4th ed. London: Gordon Breach, 1997; R. Cohen, *Global Diasporas. An Introduction.* Seattle: University of Washington Press, 1997; A. Gupta and J. Ferguson, eds., *Culture, Power, Place.* Durham, N.C.: Duke University Press, 1997; U. Hannertz, *Transnational Connections: Culture, People, Places.* London: Routledge, 1996; A. Portes, "Transnational Communities: Their Emergence and Significance in the Contemporary World System," in R. P. Korzeniewicz and W. C. Smith, eds., *Latin America in the World Economy.* West-port, Conn: Greenwood Press, 1996; P. Levitt, "Local-Level Global Religion: The Case of U.S.-Dominican Migration," *Journal for the Scientific Study of Religion* 37 (1998), no. 1: 74–89; "Transnationalizing Community Development: The Case of Migration Between Boston and the Dominican Republic," *Nonprofit and Voluntary Sector Quarterly* 26 (December 1997), no. 4: 509–26.

4. For more details about the Kaplan movement in Germany see Riva Kastoryano, *Negotiating Identities: States & Immigration in France and Germany*. Princeton: Princeton University Press, 2002, 96–97.

5. Cf. J. Smith, C. Chatfield, and R. Pagnucco, eds., *Transnational Social Movements and Global Politics: Solidarity Beyond the State*. Syracuse, N.Y.: Syracuse University Press, 1997.

6. See B. Tibi, ed., *Arab Nationalism: A Critical Enquiry*. New York: St Martin's Press, 1990, Introduction.

7. See the typology developed by John A. Armstrong, "Mobilized and Proletarian Diaspora," *American Political Science Review*, June 1976. Armstrong defines a "mobilized diaspora" as an ethnic group that does not have a general status and advantage.

8. See M. Cohen for his analysis of Zionism and diaspora nationalism in *Zion and State: Nation Class and the Shaping of Modern Israel*, 2nd ed. New York: Columbia University Press, 1992, p. 49.

9. See B. Anderson, "Long Distance Nationalism," in *The Spectre of Comparisons: Nationalism, Southeast Asia, and the World*. London: Verso Press, 1998, pp. 58–74.

10. I am using multinational citizenship as an adaptation of Kymlicka's *Multicultural Citizenship* to a reality where "minorities" are a national group acting on a transnational level.

11. Thomas Faist, *The Volume and Dynamic of International Migration*. New York: Oxford University Press, 1998.

12. The definition proposed by the Convention on Human Rights is broad. According to Article 2 of the Convention of 1991, "The term minority designates a group that is numerically smaller than the rest of the population and whose members are inspired by the will to preserve their culture, traditions, religion and language."

13. R. Kastoryano, "Turkish Transnational Nationalism: How the 'Turks Abroad' Redefine Nationalism" (forthcoming).

14. P. Levitt, *The Transnational Villagers*. Berkeley, Calif.: University of California Press, 2001. Levitt calls this process "social remittance."

15. The same logic would have led them to consider themselves the sixteenth today.

16. Cf. R. Kastoryano, *Negotiating Identities: States and Immigrants in France and Germany*. Princeton: Princeton University Press, 2001.

17. Ibid.

18. Cf. J. Leca, "Individualisme et citoyenneté," in P. Birnbaum and J. Leca, eds., *Sur l'individualisme*. Paris: Presses de la FNSP, 1986, pp. 159–213.

19. Inspired by the famous sentence of Ernest Renan in *Qu'est-ce qu'une nation? et autres écrits politique*. Paris: Imprimerie Nationale, 1996.

20. Riva Kastoryano, ed., *Quelle identité pour l'Europe? Le Multiculturalisme à l'épreuve*. Paris: Presses de Sciences-po, 1998.

21. Jürgen Habermas, *The Inclusion of the Other: Studies in Political Theory*. Cambridge, Mass: MIT Press, 1998.

22. Jean-Marc Ferry, "Pertinence du postnational," *Esprit* 11 (November 1991): 80–94.

23. R. Bauböck, *Transnational Citizenship*. London: Edward Elgar, 1994.

24. Yasemin N. Soysal, *Limits of Citizenship: Migrants and Postnational Membership in Europe*. Chicago: University of Chicago Press, 1994, p. 143.

25. N. M. J. Pickus, *Immigration and Citizenship in the 21st Century*. Lanham, Md.: Rowman & Littlefield, 1998.

26. P. J. Spiro, "Dual Nationality and the Meaning of Citizenship," *Emory Law Journal* (1997): 46.

## 13. State and Faith: Secular Values in Asia and the West, *by Wang Gungwu*

Shortened titles refer to items in "Sources," below.

1. Lewis, *What Went Wrong?*, pp. 152–57.

2. Howard, "Stumbling into Battle," p. 17.

3. Martin, *General Theory of Secularization*, p. 1.

4. Madan, *Modern Myths, Locked Minds*, pp. 233–34; 260–65.

5. Eisenstadt and Schluchter, "Paths to Early Modernities, pp. 1–18; Eisenstadt, "Multiple Modernities," pp. 1–30.

6. Mahbubani, *Can Asians Think?*, and Sheridan, *Asian Values, Western Dreams*.

7. De Bary, *Sources of Chinese Tradition*, vol. 2, pp. 81–87.

8. Huntington, *Clash of Civilizations*, pp. 183–86, 207–9; Wang Gungwu, "Review of *Clash of Civilizations*," p. 70.

9. Wang Gungwu, "Future of Secular Values."

10. Kersten, *Democracy in Post War Japan*, pp. 109–22.

11. Shambaugh, *Beautiful Imperialist*, pp. 294–300.

12. Chadwick, *Secularization of European Mind*, pp. 14–18; McLeod, *Secularization in Western Europe*, pp. 178–84.

13. Thapar, "Secularism," pp. 17–19.

14. Tamini and Esposito, *Islam and Secularism in the Middle East*, p. 13.

15. Frykenberg, "Hindu Fundamentalism," pp. 233–55, 237.

16. Madan, *Modern Myths, Locked Minds*, pp. 235–47.

17. Ibid., pp. 138–44, 98–105.

18. Huff, *Rise of Early Modern Science*, pp. 169–86.

19. Weber, *Religion of China*, p. 228; Tu Wei-ming, "Ecological Turn in New Confucian Humanism," p. 245.

20. Wang Gungwu, *Power, Rights and Duties*.

21. De Bary, *Unfolding of Neo-Confucianism*, pp. 29–32.

22. Hu Qiaomu, "Questions on the Ideological Front," p. 145.

23. Kent, *Between Freedom and Subsistence*, pp. 44–50, 79–84; Wang Gungwu, *Power, Rights and Duties*.

### SOURCES

Chadwick, Owen. *The Secularization of the European Mind in the 19th Century.* Cambridge: Cambridge University Press, 1975.

De Bary, William T., ed. *Sources of Chinese Tradition.* Vol. 2. New York: Columbia University Press, 1964.

———. *The Unfolding of Neo-Confucianism.* New York: Columbia University Press, 1975.

———. *Asian Values and Human Rights: A Confucian Communitarian Perspective.* Cambridge, Mass.: Harvard University Press, 1998.

Eisenstadt, Shmuel N. "Multiple Modernities." *Daedalus,* Winter 2000 (issue on Multiple Modernities).

Eisenstadt, Shmuel N., ed. *The Origins and Diversity of Axial Age Civilizations.* Albany, N.Y.: State University of New York Press, 1986.

Eisenstadt, Shmuel N., and Wolfgang Schluchter. "Paths to Early Modernities: A Comparative view." *Daedalus,* Summer 1998 (issue on Early Modernities).

Frykenberg, Robert Eric. "Hindu Fundamentalism and the Structural Stability of India." In Martin E. Marty and R. Scott Appleby, eds. *Fundamentalisms and the State: Remaking Polities, Economies, and Militance.* Chicago and London: University of Chicago Press, 1993, pp. 233–55.

Gilbert, Alan D. *The Making of Post-Christian Britain: A History of the Secularization of Modern Society.* London: Longman, 1980.

Howard, Michael. "Stumbling Into Battle," *Harper's,* January 2002.

Hu Qiaomu. "Questions on the Ideological Front." In Wang Gungwu, *The Chineseness of China: Selected Essays.* Hong Kong: Oxford University Press, 1991.

Huff, Toby E. *The Rise of Early Modern Science: Islam, China and the West.* Cambridge: Cambridge University Press, 1993.

Huntington, Samuel P. *The Clash of Civilizations and the Remaking of World Order.* New York: Simon & Schuster, 1996.

Kent, Ann. *Between Freedom and Subsistence: China and Human Rights.* Hong Kong: Oxford University Press, 1993.

Kersten, Rikki. *Democracy in Post War Japan: Maruyama Masao and the Search for Autonomy.* London: Routledge, 1996.

Lewis, Bernard. *What Went Wrong? Western Impact and Middle Eastern Response.* New York: Oxford University Press, 2001.

Mahbubani, Kishore. *Can Asians Think?* Singapore: Times, 1998.

McLeod, Hugh. *Secularization in Western Europe, 1948–1914.* Basingstoke: Macmillan, 2000.

Madan, T. N. *Modern Myths, Locked Minds: Secularism and Fundamentalism in India.* Delhi: Oxford University Press, 1998.

Martin, David. *A General Theory of Secularization.* Oxford: Basil Blackwell, 1978.

Marty, Martin E., and R. Scott Appleby, eds. *Fundamentalisms and the State: Remaking Polities, Economies, and Militance.* Chicago and London: University of Chicago Press, 1993.

Shambaugh, David L. *Beautiful Imperialist: China Perceives America, 1972–1990.* Princeton: Princeton University Press, 1991.

Sheridan, Greg. *Asian Values, Western Dreams: Understanding the New Asia.* St. Leonard's, N.S.W.: Allen & Unwin, 1999.

Tamini, Azzam, and John L. Esposito, eds. *Islam and Secularism in the Middle East.* London: Hurst, 2000.

Thapar, Romila. "Imagined Religious Communities? Ancient History and the Modern Search for a Hindu identity." *Modern Asian Studies* 23 (1989), no. 2: 209–31.

———. "Secularism: The Importance of Democracy." In Hiranmay Karlekar, ed. *Independent India: The First Fifty Years,* Delhi: Oxford University Press, 1998.

Tu Wei-ming. "The Ecological Turn in New Confucian Humanism: Implications for China and the World." *Daedalus* 130, no. 4 (Fall 2001): 243–64.

Wang Gungwu. "Juxtaposing Past and Present in China Today. *The China Quarterly,* March 1975, pp. 1–24.

————. "*Power, Rights and Duties in Chinese History*." The Fortieth George Ernest Morrison Lecture in Ethnology. Canberra: Australian National University, 1979.

————. "Review of *The Clash of Civilizations* by Samuel P. Huntington." *The National Interest*, no. 46 (1996).

————. "After September 11: The Future of Secular Values." Social Science Research Council, 2001: www.ssrc.org/sept11/essays/wang.htm.

————. "The Limits of Secularism," *Straits Times*, 25 November 2001.

Weber, Max. *The Religion of China: Confucianism and Taoism*. Trans. Hans H. Gerth. Glencoe, Ill.: Free Press, 1951.

————. *The Agrarian Sociology of Ancient Civilization*, translated by R. I. Frank. London: New Left Books, 1976.

Wilson, Bryan R. *Religion in Secular Society*. Harmondsworth: Penguin, 1969.

# CONTRIBUTORS

## THE EDITORS

ERIC HERSHBERG is a program director at the Social Science Research Council, and adjunct professor at the School of International and Public Affairs at Columbia University. His most recent publications include "Development: Economic and Social Dimensions," in *The International Encyclopedia of Social and Behavioral Sciences* (2001), *Economic Governance and Flexible Production in East Asia* (coedited with Frederic Deyo and Richard F. Doner 2001), and numerous articles and contributions on democracy and development in Latin America.

KEVIN MOORE is a program director at the Social Science Research Council, where he is responsible for the Europe Program and the Program on International Higher Education. He has published articles on European politics and society, and also worked as a journalist and policy analyst.

## AUTHORS

KAMRAN ASDAR ALI is assistant professor of anthropology and Middle East studies at the University of Texas at Austin. He is the author of *Planning the Family in Egypt: New Bodies, New Selves* (2002). His current research is on the history of the labor and trade union movement in his country of origin, Pakistan.

SAID AMIR ARJOMAND was born in Iran and teaches sociology at the State University of New York at Stony Brook. He is the founder and president of the Association for the Study of Persianate Societies and the editor of *International Sociology.* His publications include "Civil Society and the Rule of Law in the Constitutional Politics of Iran under Khatami," in *Social Research* (2000), "Constitutions and the Struggle for Political Order: A Study in the Modernization of Political Traditions," in *European Journal of Sociology* (1992); and, *The Turban for the Crown: The Islamic Revolution in Iran* (1988).

DIDIER BIGO is a researcher at the Centre d'Etudes et de Recherches Internationale (CERI/FNSF), a professor of international relations at Sciences-Po, in

Paris, and editor of *Cultures & Conflits*. His recent publications in English include "Migration and Security Issues," in *Controlling Migration in Europe* (2001); "Internal and External Security(ies); the Möbius Ribbon," in *Identities, Borders and Orders, Borderlines* (2001); and "When Two Become One: Internal and External Securitisations in Europe," in *International Relations Theory and the Politics of European Integration, Power, Security and Community* (2000).

LUIZ CARLOS BRESSER-PEREIRA is professor of economics at the Getulio Vargas Foundation, and professor of political theory at the University of São Paulo. His books include *Economic Crisis and State Reform in Brazil* (1996); *Economic Reforms in New Democracies* (with José Maria Maravall and Adam Przeworski, 1993); and *Development and Crisis in Brazil* (1984).

FRANCISCO GUTIÉRREZ SANÍN teaches at the Instituto de Estudios Politicos y Relaciones Internacionales de la Universidad Nacional de Colombia. Among his recent publications in English are "Imitation Games and Political Discourse," in *Forum Qualitative Sozialforschung* (February 2001); "The Courtroom and the Bivouac: Reflections on Law and Violence in Colombia," in *Latin American Perspectives* (January 2001); and "Politicians and Criminals: Two Decades of Turbulence, 1978–1998," in *International Journal of Politics, Culture, and Society* (2000).

MONICA HIRST is executive director of the Fundación Centro de Estudos Brasileiros (FUNCEB), professor of international relations at Facultad Latinoamericana de Ciencias Sociales (FLACSO) in Buenos Aires and Professor of the Argentine Institute of Foreign Service, Ministry of Foreign Affairs (ISEN). Her numerous publications include "Strategic Coercion, Democracy, and Free Markets in Latin America," in *Strategic Coercion Concepts and Cases* (1998); and *Democracia, Seguridad e Integración* (1996).

KANISHKA JAYASURIYA is senior research fellow at the South East Asian Research Centre of the City University of Hong Kong. He is the coauthor of *Towards Illiberal Democracy in Pacific-Asia* (1995); and he is coeditor of *Politics and Markets in the Wake of the Asian Crisis* (1999), and *Globlisation, Law and Sovereignty: Regulatory State and Constitutionalisation Beyond the State* (forthcoming).

RIVA KASTORYANO is research fellow at the Centre national de la recherche scientifique/Centre d'etudes et de recherches internationales in Paris, and she teaches at the Institut d'etudes politiques de Paris. She is the author of *Negotiating Identities: States and Immigration in France and Germany* (2002); *Quelle identité pour l'Europe?: le multiculturalisme à l'épreuve* (1998); and *La France, l'Allemagne et leurs immigrés: négocier l'identité* (1996).

MAHMOOD MAMDANI, a national of Uganda, is Herbert Lehman Professor of Anthropology and Government and director of the Institute of African Studies at Columbia University. He is the author of *When Victims Become Killers: Colonialism, Nativism and Genocide in Rwanda* (2001) and *Citizen and Subject: Contemporary Africa and the Legacy of Late Colonialism* (1996), and the editor of *Beyond Culture Talk and Rights Talk: Comparative Essays on the Politics of Rights and Culture* (2000).

TARIQ MODOOD is professor of sociology, politics and public policy, and director of the Centre for the Study of Ethnicity and Citizenship at the University of Bristol, U.K. He is the coauthor of *Ethnic Minorities in Britain: Diversity and Disadvantage* (1997) and joint editor of *Debating Cultural Hybridity* (1997) and *The Politics of Multiculturalism in the New Europe* (1997).

LUIS RUBIO is director-general of the Center of Research for Development (CIDAC) in Mexico City. In addition to his frequent contributions to leading newspapers in Latin America and the United States, he is the author of numerous publications, including *Políticas Económicas del México Contemporáneo* (2002) and *La Democracia Verdadera: Information, Ciudadanía y Politica Publica* (1998) and, with Susan Kaufman Purcell, edited *Mexico Under Zedillo* (1998).

ACHIN VANAIK is currently a visiting professor at the Academy of Third World Studies at the Jamia Millia Islamia University in New Delhi. His previous books include *The Painful Transition: Bourgeois Democracy in India* (1990); *India in a Changing World: Problems, Limits and Successes of Its Foreign Policy* (1995); and a number of volumes he coauthored with Praful Bidwai, including *New Nukes: India, Pakistan and Global Nuclear Disarmament* (2000).

WANG GUNGWU is director of the East Asian Institute, National University of Singapore. His most recent books are *Bind Us in Time: Nation and Civilisation in Asia* (2002); *To Act Is to Know: Chinese Dilemmas* (2001); and *The Chinese Overseas: From Earthbound China to the Quest for Autonomy* (2000).

WILLIAM WALLACE is professor of international relations at the London School of Economics. Recent publications include *Rethinking European Order: West European Responses* (with Robin Niblett et al., 2001); *Non-state Actors in World Politics* (with Daphne Josselin et al. 2001); and, *Policy-making in the European Union* (with Helen Wallace et al., 2000).

# INDEX